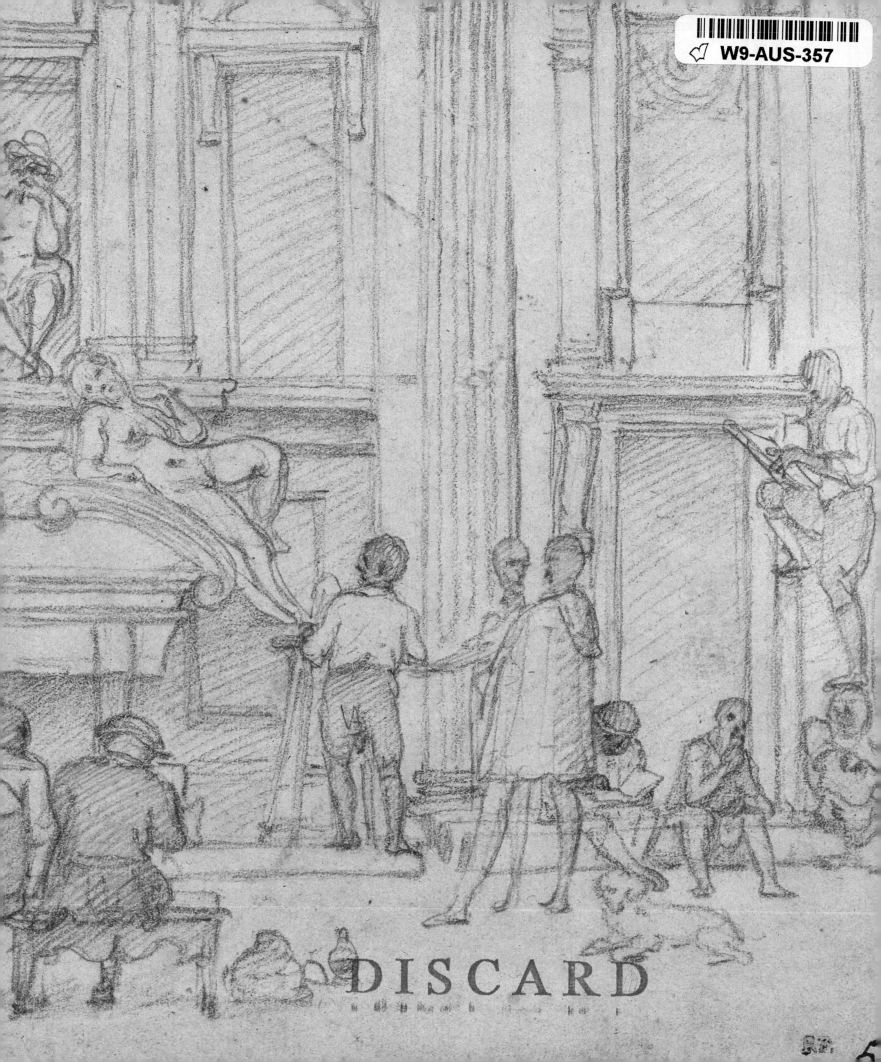

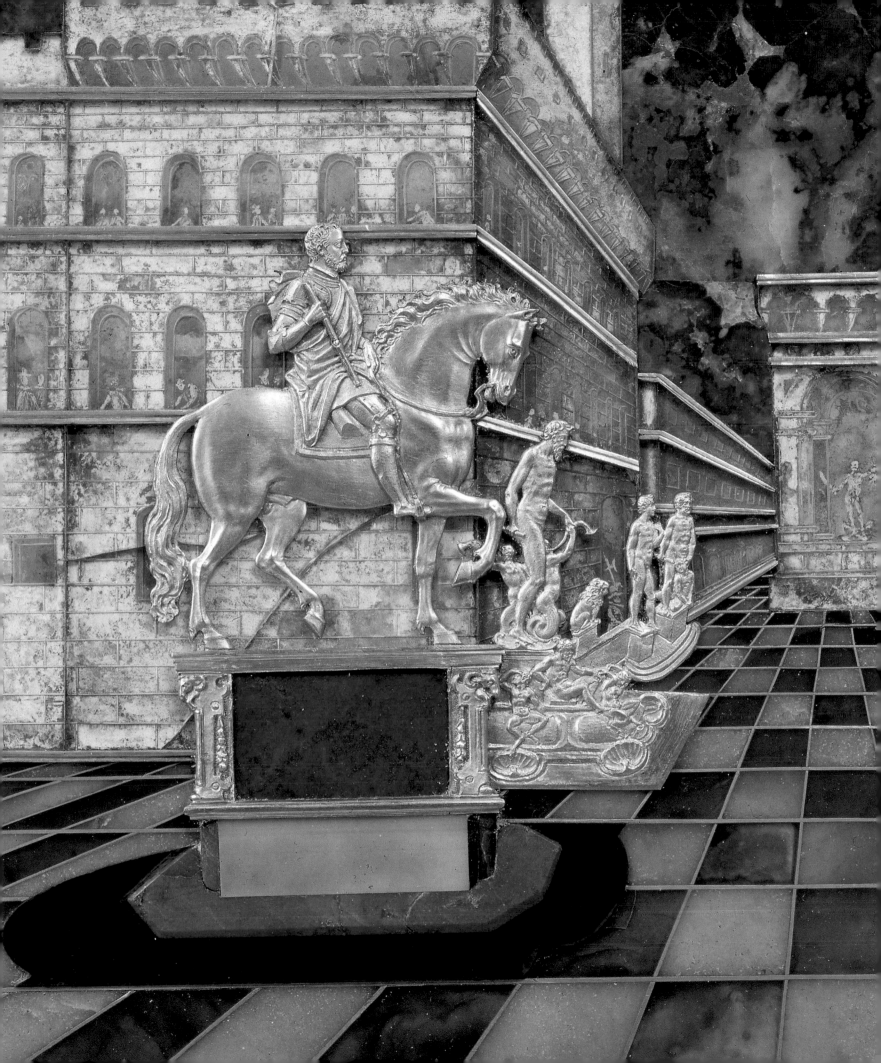

THE MEDICI,

& THE ART OF

YALE UNIVERSITY PRESS,
NEW HAVEN AND LONDON
in association with
THE DETROIT INSTITUTE OF ARTS

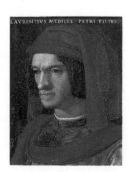
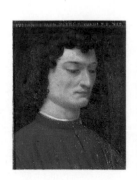
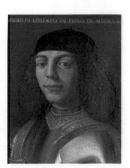

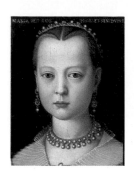

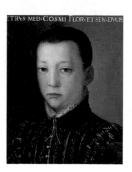

Michelangelo,

Late Renaissance Florence

Essays by

Cristina Acidini Luchinat, Suzanne B. Butters, Marco Chiarini,
Janet Cox-Rearick, Alan P. Darr, Larry J. Feinberg, Annamaria Giusti,
Richard A. Goldthwaite, Lucia Meoni, Kirsten Aschengreen Piacenti,
Claudio Pizzorusso, Anna Maria Testaverde

This book was published in conjunction with the exhibition:
Magnificenza! The Medici, Michelangelo, and the Art of Late Renaissance Florence (in Italy, *L'ombra del genio: Michelangelo e l'arte a Firenze, 1537–1631*)
Palazzo Strozzi. Florence, June 6, 2002 – September 29, 2002
The Art Institute of Chicago, November 9, 2002 – February 2, 2003
The Detroit Institute of Arts, March 16, 2003 – June 8, 2003

The exhibition was organized by the Detroit Institute of Arts, the Soprintendenza Speciale per il Polo Museale Fiorentina, and the Opificio delle Pietre Dure of Florence, Italy, with the close collaboration of the Art Institute of Chicago and Firenze Mostre, Florence.

The exhibition was made possible by Bank One.

Additional funding was received from the National Endowment for the Humanities, the DeRoy Testamentary Foundation, the National Endowment for the Arts, and an indemnity from the Federal Council on the Arts and the Humanities as well as the Italian Consul General and the Istituto Italiano di Cultura in Chicago, and the Italian Ministry of Foreign Affairs. The Ente Cassa di Risparmio, Florence, provided support and generous funding for the exhibition in the United States and Italy.

In Detroit the exhibition was supported by the Michigan Council for Arts and Cultural Affairs and the City of Detroit. In Chicago, the exhibition was supported by the Women's Board of the Art Institute of Chicago.

CURATORS OF THE EXHIBITION
Marco Chiarini, Alan P. Darr, and Larry J. Feinberg

INTERNATIONAL EXECUTIVE AND ADVISORY COMMITTEES

Cristina Acidini Luchinat	Annamaria Giusti
Kirsten Aschengreen Piacenti	Richard A. Goldthwaite
Giorgio Bonsanti	Martha McCrory
Marco Chiarini	Antonio Paolucci
Janet Cox-Rearick	Claudio Pizzorusso
Alan P. Darr	Anna Maria Testaverde
Larry J. Feinberg	Ian Wardropper

FRONT COVER Bronzino, *Young Man with a Lute* (detail; cat. no. 14).
BACK COVER Michelangelo, *David–Apollo* (detail; cat. no. 80).
PAGE i Garffurri and Bylivelt, oval plaque showing the Piazza Granducale (detail; cat. no. 114).
PAGES ii–iii Workshop of Bronzino, miniature portraits of members of the Medici family (see fig. 3).

FOR THE DETROIT INSTITUTE OF ARTS
Director of Publications: Susan Higman
Senior Editor: Judith A. Ruskin
Assistant Editor: Carole Lyn Piechota
Editorial Assistants: Kelli Carr, Alexa Ducsay

FOR YALE UNIVERSITY PRESS
Editorial/Design/Production: Gillian Malpass
Editorial/Design/Production: Elizabeth McWilliams
Editorial assistance: Sandy Chapman

Published by Yale University Press, New Haven and London
in association with the Detroit Institute of Arts

Printed and bound in Italy by Amilcare Pizzi S.p.A., Milan
2ⁿᵈ printing 2003
© 2002 The Detroit Institute of Arts

Library of Congress Cataloging-in-Publication Data

The Medici, Michelangelo, and the art of late Renaissance Florence / essays by Cristina Acidini . . . [et al.].
 p. cm.
 Published in conjunction with the exhibition "Magnificenza! The Medici, Michelangelo, and the art of late Renaissance Florence" held at Palazzo Strozzi, Florence, June 6, 2002 – Sept. 29 2002, Art Institute Chicago, Nov. 9, 2002 – Feb. 2 2003, and Detroit Institute of Arts, Mar. 16, 2003 – June 8, 2003.
 Includes bibliographical references.
 ISBN 0-300-09495-7 (cloth : alk. paper) –
 ISBN 0-89558-158-2 (pbk : alk. paper)
 1. Art, Italian – Italy – Florence – Exhibitions. 2. Art, Late Renaissance – Italy – Florence – Exhibitions. 3. Medici, House of – Art patronage – Exhibitions. 4. Michelangelo Buonarroti, 1475–1564 – Influence – Exhibitions.
 I. Acidini, Cristina. II. Palazzo Strozzi. III. Art Institute of Chicago. IV. Detroit Institute of Arts.

N6921.F7 M43 2002
709'.45'5109031–dc21

2002066183

CONTENTS

LENDERS TO THE EXHIBITION

Albertina, Vienna
Associazione Nazionale fra Mutilati ed Invalidi di Guerra Sezione Firenze
The Art Institute of Chicago
The Ashmolean Museum, Oxford
Basilica di San Clemente ai Servi e Convento, Siena
Basilica di S. Maria All'Impruneta, Florence
Biblioteca Marucelliana, Florence
Biblioteca Nazionale Centrale, Florence
The British Museum, London
Ca' d'Oro, Venice
Christ Church, Oxford
Collezione Longari, Milan
The Courtauld Institute Gallery, London
The Detroit Institute of Arts
Ente Casa Buonarroti, Florence
Galleria Colonna, Rome
Galleria degli Uffizi, Florence
Galleria dell'Accademia, Venice
Her Majesty Queen Elizabeth II
Hessisches Landesmuseum Darmstadt
Istituto Nazionale di Studi Etruschi ed Italici, Florence
The J. Paul Getty Museum, Los Angeles
The John and Mabel Ringling Museum of Art, Sarasota, Florida
Kunsthistorisches Museum, Vienna
Los Angeles County Museum of Art
The Metropolitan Museum of Art, New York
Musée des Beaux-Arts, Lille
Musée des Beaux-Arts, Orléans
Musée du Louvre, Paris
Musei Vaticani, Vatican City
Museo di Casa Martelli, Florence
Museo d'Arte Sacra, San Gimignano
Museo Giardino di Boboli, Florence
Museo del Prado, Madrid
Museo dell'Opificio delle Pietre Dure, Florence

Museo della Cattedrale di Pienza, Siena
Museo delle Cappelle Medicee, Tesoro della Basilica di San Lorenzo, Florence
Museo di Mineralogia e Litologia, Florence
Museo Internazionale delle Ceramiche, Faenza
Museo Nazionale del Bargello, Florence
Museo Nazionale di Palazzo Reale, Pisa
Museo di Capodimonte, Naples
Museo Statale d'Arte Medievale e Moderna, Arezzo
Museo Statale di Casa Vasari, Arezzo
Museo Stibbert, Florence
Museo Storico, Florence
Museo Topografico "Firenze com' era," Florence
Museum of Fine Arts, Boston
National Galleries of Scotland, Edinburgh
National Gallery of Art, Washington, D. C.
National Gallery of Ireland, Dublin
The Nelson-Atkins Museum, Kansas City, Missouri
Palazzo Barberini, Rome
Palazzo Pitti, Florence
Palazzo Vecchio, Florence
The Philadelphia Museum of Art
The Royal Armouries, Leeds
Sir John Soane's Museum, London
Staatliche Graphische Sammlung, Munich
Staatliche Kunstsammlungen, Dresden
The Toledo Museum of Art
University Art Museum, Princeton, New Jersey
The Victoria and Albert Museum, London
Villa Borghese, Rome
Villa Medicea della Petraia, Florence
Villa Medicea di Castello, Florence
The Walters Art Museum, Baltimore

and anonymous collectors

FOREWORD

Any scholarly endeavor builds on the research and discoveries of previous investigations in the field. The exhibition *Magnificenza! The Medici, Michelangelo, and the Art of Late Renaissance Florence*, and this catalog, which accompanies it, are no exceptions. Florence, the crucible of the Renaissance; the Medici, the city's ruling dynasty and great patrons of the arts; and Michelangelo, the most esteemed Florentine artist of the sixteenth century, have all been the subject, individually and jointly, of numerous exhibitions. The current exhibition closely examines the artistic and cultural developments in Florence from 1537 to 1631, during the rule of the Grand Duke Cosimo I de' Medici through the reign of Grand Duke Cosimo II de' Medici, and the far-reaching influence of Michelangelo on younger generations of Florentine artists.

The exhibition is an outgrowth of long-standing professional friendships and discussions among scholars of Italian Renaissance and baroque art in Italy and the United States, dating to 1995. At that time Marco Chiarini, then director of the Galleria Palatina at Palazzo Pitti in Florence, and Alan Phipps Darr, Walter B. Ford II Family Curator of European Sculpture and Decorative Arts at the Detroit Institute of Arts, began to pursue the idea of an exhibition covering this time period with Antonio Paolucci, superintendent of the State Art Museums in Florence, Cristina Acidini Luchinat, then vice-superintendent, and Kirsten Aschengreen Piacenti, director of the Stibbert Museum, with additional input from Larry J. Feinberg, Patrick G. and Shirley W. Ryan Curator in the Department of European Painting, and Ian Wardropper, then Eloise W. Martin Curator of European Decorative Arts and Sculpture at the Art Institute of Chicago. All enthusiastically offered their support.

An international exhibition of this type would not be possible without the generosity of those who have lent their works of art. Many of the objects from Florentine museums have not previously been exhibited in the United States; museums and collectors in this country and in Europe have provided the means for works made in Florence to return to their city of origin.

An exhibition planning grant awarded to the Detroit Institute of Arts in 1999 by the National Endowment for the Humanities enabled the exhibition's international executive and advisory committees, led by Darr and Chiarini, to meet in America and in Europe in order carefully to weigh issues, themes, and loan proposals. Subsequent grants from the National Endowment for the Humanities and the National Endowment for the Arts provided funds for the implementation of the exhibition, especially for the development of multifaceted outreach and educational programming. Additional funding was provided by the DeRoy Testamentary Foundation. We are further indebted to Alice Whelihan, indemnity administrator, museum programs, and the members of the indemnity board of the Federal Council on the Arts and the Humanities.

In Detroit and Chicago the exhibition was made possible by the generosity of Bank One, which offered to be the major national corporate sponsor for the two U.S. venues. The Ente Cassa di Risparmio of Florence provided funding for the exhibition in the United States and Italy, including the underwriting of photography for this catalog and the conservation of Michelangelo's marble *David–Apollo* and other works of art from Italian collections. In Detroit, the exhibition received support also from the Michigan Council for Arts and Cultural Affairs and the City of Detroit. In Chicago, the exhibition was supported by the Women's Board of the Art Institute of Chicago.

The extensive cooperation of the Italian government, especially the support of the Ministero per i Beni e le Attività Culturali, Minister Giovanni Urbani, Undersecretary Vittorio Sgarbi, General Director Mario Serio, and the Comitato di Settore, was crucial to making this exhibition a reality. Our thanks also go to Ferdinando Salleo, the Italian ambassador to the United States; Gianluca Alberini, the former Italian consul in Detroit; Enrico Granara, the Italian general consul in Chicago; Dr. Francesco Valente, consul for cultural affairs and director of the Istituto Italiano di Cultura in Chicago; Melvin F. Sembler, the U.S. ambassador to Italy; and Daria M. Hollowell, the U.S. consul in Florence.

Graham W. J. Beal
Director, The Detroit Institute of Arts

Antonio Paolucci
Soprintendenza Speciale per il Polo Museale Fiorentino

James N. Wood
Director and President, The Art Institute of Chicago

THE MEDICI AND THE LEGACY OF MICHELANGELO IN LATE RENAISSANCE FLORENCE: AN INTRODUCTION

Alan P. Darr

Florence's cultural history during the Renaissance is intimately associated with the Medici family, arguably the most famous and powerful of all Italian dynasties.[1] Two branches of the family, both descended from the patriarch Giovanni di Bicci, ruled Florence in succession from the fifteenth to the mid-eighteenth centuries, and were the city's most prominent patrons of the arts and sciences. Under Medici rule, Florence during the sixteenth century experienced a flowering of the arts through artists and architects such as Michelangelo Buonarroti, Jacopo Pontormo, Agnolo Bronzino, Giorgio Vasari, Benvenuto Cellini, Niccolò Tribolo, Bartolomeo Ammanati, Giambologna, and Bernardo Buontalenti. Celebrated in his own lifetime as a sculptor, architect, painter, draftsman, and poet, Michelangelo overshadowed much of the city's cultural and artistic life during the sixteenth century and his legacy is evident in the work of his many Florentine followers. As a result of his connection with the Medici family he was involved, directly and indirectly, with a number of Florentine cultural institutions, especially the Accademia del Disegno, co-founded with Cosimo I in 1563. It is the first Medici grand dukes from 1537 to 1631, when they were at the height of their powers, who are the focus of this catalog and the international exhibition "Magnificenza! The Medici, Michelangelo, and the Art of Late Renaissance Florence."

Originally bankers and merchants involved with international trade in wool, silk, metals, spices, and financial credit, the Medici came to power in 1434 when Cosimo de' Medici (1389–1464), known as Cosimo il Vecchio (the elder), became ruler of Florence.[2] Continuing success in economic ventures and adroit political maneuvering enabled the family to dominate the cultural and political life of Florence, commissioning works of art and buildings from local and foreign artists and architects as a means of promoting and reflecting their aspirations. Their zealous support of the arts and sciences transformed Florence into the cultural center of the Italian Renaissance (fig. 2).

Cosimo il Vecchio was the patron of such leading artistic figures as Donatello and Luca della Robbia. During the 1440s he commissioned first Filippo Brunelleschi and subsequently the architect and sculptor Michelozzo di Bartolomeo to create the monumental new Palazzo Medici on via Larga. Michelozzo produced a palazzo of unprecedented grandeur, which inspired many later palaces in Florence. Following his death in 1474 Cosimo was succeeded first by his son, Piero (1416–69), and then his grandson, Lorenzo il Magnifico (1449–92) – members of the main Medici line.

Lorenzo il Magnifico not only developed Florence's political role in Italian and pan-European politics but also created a much acclaimed court culture of painters, sculptors, poets, and philosophers. He studied antiques with Leon Battista Alberti in Rome in 1465, was an avid collector of artifacts, including gems and *intaglios*, a scholar of classical antiquity, poetry, architecture, and art, and with his family developed an important collection of books and manuscripts. A knowledgeable patron of the arts, he supported Sandro Botticelli, Leonardo da Vinci, Domenico Ghirlandaio, Giuliano da Sangallo, Fra Filippo Lippi, Andrea del Verrocchio, Bertoldo di Giovanni, and the young Michelangelo, who at Lorenzo's invitation lived in the Palazzo Medici until Lorenzo's death in 1492. In both Florence itself and the countryside he promoted major architectural projects, including the creation of a

Fig. 1 Detail of cat. no. 161 (larger than actual size).

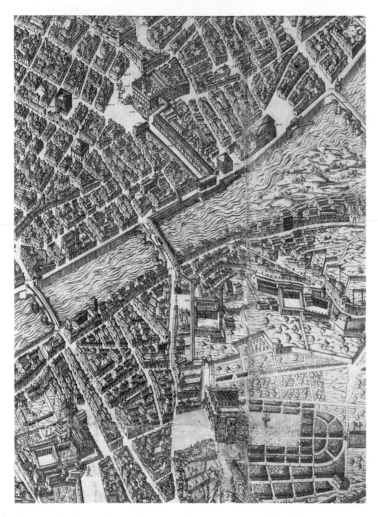

Fig. 2 Stefano Buonsignori, *Florence in 1594* (detail), engraving. Museo Typografico Firenze com'era, Florence.

sumptuous multicolor marble-and-bronze tomb by Verrocchio for his father and uncle, Giovanni de' Medici, in the Old Sacristy of the family church of San Lorenzo. From Giuliano da Sangallo he commissioned a new sacristy for Santo Spirito and a villa at Poggio a Caiano, his beloved country retreat outside Florence, which da Sangallo designed according to classical ideals. The building's interior, however, was decorated in the sixteenth century by Pontormo, Alessandro Allori, and other artists, for the next generation of Medici patrons.

Two years after Lorenzo's death in 1492, his eldest son and heir, Piero, was expelled from Florence, having secretly surrendered the city to the invading army of King Charles VIII of France, who plundered the Palazzo Medici. A new republican government was established that lasted until 1512, during which Florence enjoyed a sense of civic pride and cultural sophistication that revived the optimism of Lorenzo il Magnifico's rule. Among many important civic art commissions Michelangelo's colossal marble *David* of 1503 became a symbol of Florentine independence and liberty, placed in front of the seat of the city's government in the Palazzo della Signoria, later known as the Palazzo Vecchio.[3]

After Piero's death in 1503, the mantle of family leadership passed to his brother, Giovanni (1475–1521), who had become a cardinal in 1489 when he was not yet fourteen, and in 1513 was elected Pope Leo X. Prior to his accession to the papacy, Giovanni was able to use his position as papal legate to Julius II in Bologna to help the Medici return to power. By 1512 the Florentine Republic existed in name only and, for the year before he became pope, Giovanni was able to help lead a new government.

As the Medici regained control of the city, the leadership role fell to Piero de' Medici's only son, and Leo's nephew, Lorenzo, duke of Urbino. Lorenzo's death in 1519 prompted Leo, now in the Vatican, and his cousin Giulio – another Medici cardinal destined to be pope – to commission Michelangelo to produce a magnificent marble funerary chapel with Medici family tombs for Lorenzo and for Leo's recently deceased brother, Giuliano de' Medici, duke of Nemours (d. 1516), as well as for "the Magnifici" – Lorenzo il Magnifico and his brother, also called Giuliano. This was one of Leo's many commissions of Florentine artists to work in the New Sacristy of San Lorenzo, and elsewhere in Florence and Rome.

Lorenzo left only an infant daughter and Leo himself died in 1521, so the rule passed to Cardinal Giulio de' Medici (1479–1534), who became Pope Clement VII in 1523. During his tenure in Rome and Florence, Clement VII continued the family's generous patronage of Michelangelo, whom he had known since boyhood at the court of Lorenzo il Magnifico, commissioning the artist in 1524 to create the Laurentian Library at San Lorenzo in Florence for the display of the large and valued Medici collection of books and manuscripts. He governed Florence from afar, even after becoming pope – a situation that did not sit well with the city's populace. In 1527 he briefly took refuge in the Castel Sant'Angelo before fleeing to Orvieto and Viterbo in exile when the armies of the Holy Roman Emperor, Charles V, sacked Rome. A few weeks later the Medici were banished from Florence for a second time and a republican government reinstated. When the city was besieged by papal and imperial forces for ten months in 1529, Michelangelo, an ardent republican despite his close connection with the Medici, served as architect of the fortification of the city walls and bastions.

Clement VII's papal authority and careful politicking with Charles V again enabled the Medici to return to power in Florence in 1530. Despite Michelangelo's role in promoting the republic, for which he was pardoned,

he was chosen by Clement VII in 1533 to paint the *Last Judgment* for the altar wall of the Sistine Chapel in Rome. Michelangelo left Florence for Rome the following year. Although he never returned, he left behind a lasting reputation and a broad influence that inspired numerous artistic followers and rivals such as Cellini, Baccio Bandinelli, Tribolo, Pierino da Vinci, Bronzino, Vasari, Buontalenti, and others, several of whom had also worked in Rome and adulated Michelangelo.

On the Medici's return to power, there were no legitimate heirs to assume control of the daily governance of Florence and the position went to Alessandro, presented as the illegitimate son of Lorenzo, duke of Urbino, but in fact the illegitimate son of Clement VII. Elected head of the Florentine Republic in 1531, Alessandro was also appointed duke of Florence in 1532 by Emperor Charles V. He was not known as a great patron of the arts, although the monumental marble group of *Hercules and Cacus*, which Clement VII had commissioned from Bandinelli, was overseen by him and completed during his reign in 1534. A symbol of renewed Medicean strength, the sculpture was intended as a counterpoint to Michelangelo's *David*, a point reiterated by its prominent placement in the Piazza della Signoria.[4] Alessandro's primary architectural commission was the construction of the colossal Fortezzo da Basso (originally called Fortezza Alessandra) by Antonio da Sangallo the younger. Located within the northwest section of the city, the fortress was intended to protect Alessandro and his family more from internal civil aggressors than external, foreign enemies, giving concrete form to Alessandro's insecurities about his political future. History proved that his fears were warranted; an unpopular leader, he was murdered in January 1537 during a period of political unrest.

Alessandro left no male successors: the last of the main branch of the Medici family was Lorenzo's daughter, Catherine de' Medici, who married Henry II of France in 1533 and became queen of France in 1559, thereby cementing the Medici's international power and bringing further glory and wealth to Florence and the family. With the end of the main Medici line, control of Florence passed to a secondary branch of the family, descended from Cosimo il Vecchio's brother, Lorenzo, which established the Medici grand-ducal dynasty and ruled Florence without interruption until 1737.

The first grand duke, another Cosimo (1519–74), was the only child of Giovanni de' Medici delle Bande Nere, a descendant of Lorenzo, the patriarch of the secondary branch of the family, and Maria Salviati, a granddaughter of Lorenzo il Magnifico. Born in 1519, Cosimo was the godson of Pope Leo X, who suggested naming him Cosimo in memory of the "wisest, bravest, and most prudent man yet born to the house of Medici."[5] In 1537, with the blessing of Emperor Charles V, the young Cosimo was brought before the Florentine senate, which elected and designated him head of the Florentine Republic. The same year, he was also named duke of Florence, succeeding Alessandro. Cosimo I's marriage two years later to Eleonora of Toledo, the daughter of the Emperor's senior lieutenant, Don Pedro di Toledo, viceroy of Naples, further strengthened his political ties to Charles V.

Like generations of Medici before him, Cosimo quickly learned to use the arts, culture, diplomacy, and occasionally ruthless political maneuvering to ensure the family's hold on Florence. Determined to restore the once illustrious family to its former glory, Cosimo and Eleonora strove to create a dynastic image rivaling that of the greatest European courts. They embarked on a building campaign, completed by their heirs, that gradually transformed the architectural face of Florence, commissioning new buildings and refurbishing existing ones, always incorporating extensive paintings, sculpture, and decorative works of art. Sculpted portraits and other monuments in their honor were prominently placed over doorways and in the center of public squares. One contemporary critic wrote that "Cosimo was by nature marvelously inclined to magnificence and to the beautification of all things."[6] Giorgio Vasari dedicated to Duke Cosimo both the 1550 and 1568 editions of his influential artists' biographies, *Le Vite de' più eccellenti pittori, scultori et architettori italiani*, in which he extolled the art and architecture of Michelangelo, carefully linking him to the first branch of the Medici family, when the young artist trained under the eye of Lorenzo il Magnifico, and to the second, through the architecture and art created with the support of Cosimo I.[7] To establish further links with the past Cosimo commissioned Bronzino and his workshop to create two series of portraits, the first of the illustrious Cosimo il Vecchio branch of the family and the second of his own branch (fig. 3). He also claimed the title "Ducatis Etruriae," or duke of the Ancient Tuscany settled by the Etruscans, and commissioned marble busts of himself in the role of Augustus, the just leader, military commander and civic-minded Roman emperor (see cat. no. 53).

Through these means, Cosimo created a new image of Florence and of his family's central role in the city. He renovated the old Palazzo Medici, built by Cosimo il Vecchio, living there with his family until 1540. He then moved to the Palazzo Vecchio, where Bronzino, Medici court painter until 1555, painted refined frescoes for the Chapel of Eleonora, and Vasari oversaw an elaborate and complex redecoration program that lasted from 1555

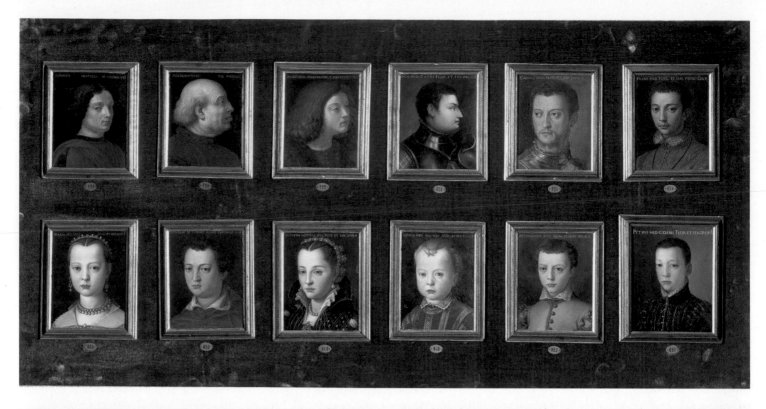

Fig. 3 Workshop of Agnolo Bronzino, miniature portraits of members of the Medici family, 1555–65, oil on copper. Galleria degli Uffizi, Florence.

to 1572 and included the creation of the Salone dei Cinquecento, a paen to the glory of the Medici family. Specially commissioned smaller rooms reflected the taste of individual family members: for example, Cosimo's son, Francesco I, created the Studiolo, a sophisticated study chamber that integrated his passions for art, alchemy, and the natural sciences into one complex decorative scheme.[8]

With the acquisition of the Palazzo Pitti, on the other side of the River Arno in 1550 the Medici were afforded a direct window onto the political intrigues and cultural activities of Florence while remaining physically apart. Where the Palazzo Vecchio dominated the architectural center of the city, the Palazzo Pitti provided access to the natural environs on the outskirts of Florence, with the large Boboli Gardens radiating behind it. This large tract of land prompted the commissioning of new fountains, pools, sculpture, and buildings for the enjoyment of courtiers and those members of the public allowed to visit the gardens. Some initial works were created by Niccolò Tribolo, who in 1537 had been commissioned to design a lavish garden at the Villa Castello, with elaborate marble and bronze sculptures, celebrating the power of the Medici over its enemies.

Of all of the Medici rulers, Cosimo I was the first truly professional head of state, efficiently and unremittingly dedicating himself to all the details of governing Florence.[9] Exceptionally disciplined, efficient, ambitious, pious, and personally frugal, he was also famously devoted to his wife and supportive of their family. He brought together Florence's scattered judicial and administrative offices in one location near the Palazzo Vecchio, commissioning Vasari to design the Uffizi – based in part on Michelangelo's Laurentian Library – to house new governmental offices. Concerned for his family's safety and the political future of the Medici dynasty, he also asked Vasari to create a safe passageway for use during times of civic strife. The resulting Corridorio Vasari provided a secret route for Cosimo, his family, and close members of the court to move unseen from the Uffizi governmental complex and neighboring Palazzo Vecchio to the Palazzo Pitti, via a walkway above the covered Ponte Vecchio. In 1569, despite his abdication in 1564, Cosimo became the first ruler of any of the Italian states to take the title of grand duke, which was granted by the Pope.

Cosimo and Vasari both died in 1574, the former succeeded by his son Francesco (1541–87). Among Cosimo's many accomplishments was the preparation of an orderly transition of power from father to son: to strengthen Francesco's right of succession, Cosimo had arranged the marriage of his son to Giovanna of Austria, sister of the future Holy Roman Emperor, Maximilian II – another alliance linking the Medici to the leading European powers. The nuptials were held in 1565, with the most elaborate festival to date, celebrated throughout the city.

Vasari's successor as artistic superintendent and chief architect of the Tuscan court was Bernardo Buontalenti, an architect, engineer, designer, painter, and inventor who trained with Vasari and was influenced by Michelangelo's architectural and sculptural work. He had been appointed by Cosimo and Eleonora to tutor the young Prince Francesco in 1547, initiating a lifelong friendship and passionate shared interest in the arts and natural sciences. He was also responsible for scientific experiments for Francesco in the 1560s and the invention of the techniques used to produce the first porcelains in Europe during the 1570s. In 1580 Buontalenti was appointed to complete the Uffizi, converting a series of rooms into interconnecting art galleries with natural lighting. He also built the octagonal domed Tribuna to display the family's greatest treasures (fig. 4). The largest building produced under the Medici grand dukes, the Uffizi was the first structure in the Western world to incorporate spaces designed specifically to house an art museum in the modern sense of the word.[10]

Like his father, Francesco included elaborate landscaping in his architectural projects. At Pratolino (see cat. no. 40b), which Francesco commissioned for Bianca Cappello, his mistress and later his second wife, Buontalenti created an extraordinary garden, complete with an elegant villa (1569–75), grottoes, fountains, automata, and the colossal sculpture of the *Appennine* (1580) by Giambologna.[11] In the Boboli Gardens, he designed the magical Grotto Grande (1580–5), which housed Michelangelo's *Four Slaves* and Giambologna's marble *Venus* beneath frescoes by Bernardino Poccetti, all surrounded by natural rock formations and foliage. This interest in gardens was passed to subsequent generations: Francesco's younger brother Ferdinando (1549–1609), a powerful cardinal in Rome, totally refurbished the elegant Villa Medici there and created magnificent gardens with suspended terraces; Ferdinando's son, Cosimo II, and his wife, Archduchess Maria Maddalena of Austria, commissioned Giulio Parigi to redesign and decorate the villa and gardens now known as the Villa del Poggio Imperiale, acquired in 1620. Francesco also continued his father's tradition of civic improvement and brought many foreign artists to Florence to work in his newly founded art workshops. He was not well liked by the Florentines, however, perhaps because he seemed more interested in obscure experiments involving the relationship between art, nature, and science than in governing the city.

Upon Francesco's death in 1587, his brother Ferdinando left the church and returned to Florence to take up the title of grand duke. The opposite of his brother – tall, affable, liberal, and an efficient administrator – Ferdinando decisively formalized the loose organization of decorative arts workshops (tapestry, rock crystal, glass, porcelain, metalwork, etc.) set up by Francesco in his private residence at the Casino di San Marco and transferred to the Uffizi in 1583. In 1588 Ferdinando added to the existing Uffizi workshops the Galleria dei Lavori,

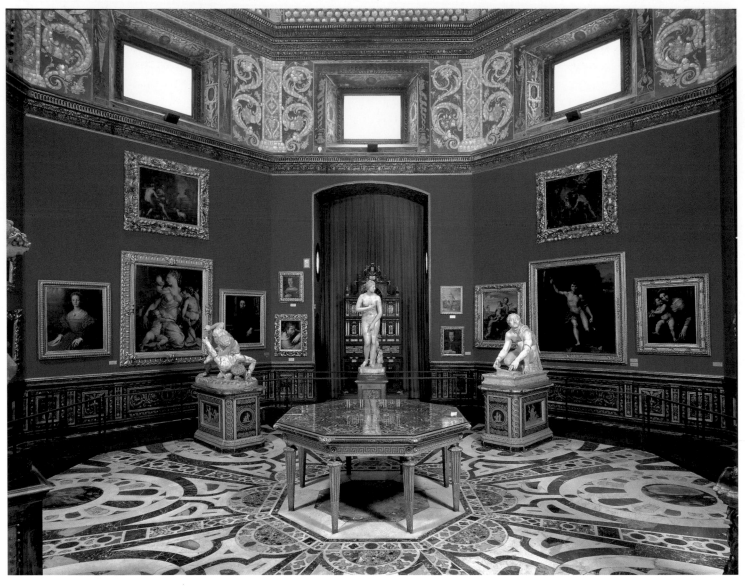

Fig. 4 The Uffizi "Tribuna," Florence.

now the Opificio delle Pietre Dure, for the production of inlaid mosaic work and sculpted precious and semi-precious hard stones, entrusting the general artistic super-intendency of Florentine artists, craftsmen, and musicians to Emilio de' Cavalieri, a musician, composer, and friend whom he knew from Rome. A promoter of theatrical and musical performances, Ferdinando also built a new theater in the Uffizi. For his wedding in 1589 to Christine of Lorraine, granddaughter of Catherine de' Medici, queen of France, he commissioned lavish musical and theatrical productions, including a series of elegant operatic interludes with beautiful stage sets, costumes, and special effects all designed by Buontalenti, performed between the acts of the comedy *La Pellegrina*, written for Christine. Similarly elegant court spectaculars were pro-duced in 1600 for the marriage of Ferdinando's niece Maria, daughter of Francesco, to Henry IV of France,

while the most sumptuous display was organized in 1608 to celebrate the marriage of Ferdinando's son, Cosimo II (1590–1621), to Maria Maddalena of Austria (1589–1631), sister of Emperor Ferdinand II and sister-in-law of Philip III of Spain.

To symbolize the enduring magnificence and achieve-ments of the Medici dynasty, Ferdinando commissioned the enormous octagonal Chapel of the Princes at San Lorenzo in 1604 to be the mausoleum for the grand-ducal Medici family. Decorated in *pietre dure*, the structure was built, according to his orders, adjacent to Michelangelo's Medici Chapel in the New Sacristy of the same church, with its famous sculptures of *Dawn*, *Twilight*, *Day*, and *Night*. In 1590 Ferdinando commissioned Buontalenti to build a new fortress, the Forte di Belvedere, directly over-looking the Palazzo Pitti, the Boboli Gardens, and all of Florence, thereby ensuring additional, though distant,

architectural dominance over the city and security against political unrest. He also commissioned monumental outdoor sculptures specifically to express and consolidate the centrality to Florentine culture of Medici power. He dramatically increased the scale of sculptural commissions, and had Giovanni Bandini carve his likeness in an over-life-size, full-length marble statue to overlook the port of Livorno. Having immortalized his father, Cosimo I, with a bronze equestrian monument by Giambologna in the center of the Piazza della Signoria, he commissioned the sculptor to create an equally grand bronze equestrian monument to himself for the center of Piazza SS. Annunziata. Following the deaths of both Giambologna and Ferdinando in 1608 and 1609 respectively, this monument was completed during the reign of Cosimo II by Pietro Tacca.

Cosimo II continued the Medici tradition of enlightened patronage of the sciences, arts, and cultural events. He supported Galileo's scientific research and his new theories about astronomy and physics and appointed him professor of philosophy and mathematics at the University of Pisa. At the same time he continued projects initiated by his father, attracting foreign artists such as Jacques Callot, Justus Sustermans, and Filippo Napoletano to the Medici court, and assembling a collection of northern European landscape paintings. As a result of many strategic marriages, including his own, between the Medici and other powerful reigning European dynasties, Florence enjoyed a period of peace, prosperity, and favorable international trade relations.

Following Cosimo II's death at the age of thirty in 1621, his wife and mother served as co-regents for his son Ferdinando II, then only ten years old. By the time of Maria Maddalena's death in 1631, three years after Ferdinando II had reached the age to govern as grand duke, Florence's fortunes had begun to fade. A self-imposed period of austerity reduced cultural initiatives and exhausted the grand-ducal treasury. Many artists chose to leave Florence for Rome, Naples, and other cities where the new Baroque style was rapidly gaining ascendancy.

By this time, Michelangelo's artistic hegemony had lasted nearly a century. The Medici grand dukes consciously appropriated his style, especially that of the Medici Chapel, as an authoritative visual language to be used for their own self-representation and promotion.[12] Perhaps inspired by the prominence and authority of Michelangelo's *David*, the grand dukes commissioned Cellini's *Perseus with the Head of Medusa*, Ammanati's *Neptune Fountain*, Giambologna's *Rape of the Sabines*, and many other sculptural monuments intended to evoke different aspects of civic pride and political symbolism.

Beginning with Cosimo I, the courts of the grand dukes were arguably the first in Europe to establish new systems of urban planning and actively to use cultural commissions to celebrate their accomplishments and secure their dynasty's future. Through an extensive building campaign, including new residences, government centers, and fortifications, and the beautification of the city and its environs with gardens, sculpture, fountains, villas and theatrical events, the first Medici grand dukes dynamically transformed Florence and created a significant, widespread, and lasting cultural influence on other European courts.

NOTES

1. For an introduction to the vast literature see, for example, Acidini Luchinat 1997a and Acidini Luchinat 1997b; *Le Arti del Principato Mediceo* 1980; Barocchi 1991; Butters 1996; Cochrane 1973; Cox-Rearick 1984; Goldberg 1983; Goldthwaite 1980; Goldthwaite 1995; Hale 1977; Hibbert 1974; Kent 2000; Langedijk 1981–87; *Palazzo Vecchio* 1980.

2. Kent 2000.

3. From the extensive literature on Michelangelo see, for an introduction, Acidini Luchinat's essay in this volume; also Ackerman 1961; *Il giardino di San Marco* 1992; *Giovinezza di Michelangelo* 1999; Joannides 1996; Ragionieri 2001; Wallace 1994; Wallace 1998b; Wittkower 1964.

4. Weil-Garris 1983.

5. Hibbert 1974, p. 261. See Cox-Rearick 1984, p. 295: "The Birth and Horoscope of Duke Cosimo de'Medici," who cites the original quotation by Giovanni de'Medici in Italian and its source: "il più savio, il più prudente, et il più valoroso huomo che sino alhora havessi havuto la Casa de' Medici, se gli ponesse nome Cosimo." Most recently see also the essays in Konrad Eisenbichler, ed., *The Cultural Politics of Duke Cosimo I de' Medici*, Aldershot, Burlington, Vermont, 2001.

6. See McCorquodale 1981, p. 68. The original quotation is from Giovanni Battista Cini's *Vita del Serenissimo Signor Cosimo I de' Medici primo granduca di Toscana*, Florence, 1611, quoted without a specific page reference in Gaetano Pieraccini, *La stirpe de' Medici di Cafaggiolo*, 2nd ed., 3 vols., Florence, 1986, vol. 2, p. 27. The original Italian reads: "Alla magnificentia et all'abbellire tutte le cose, era Cosimo per sua natura meravigliosamente inclinato."

7. See Rubin 1995.

8. See Berti 1967; Feinberg 1991; Butters 1996; and Feinberg's essay in this volume.

9. Levey 1996, p. 327.

10. Acidini Luchinat 1997a; Heikamp 1997b; and Gaeta Bertelà 1997.

11. Although much of the villa and its gardens later fell into ruin, except for the gigantic sculpture, all these elaborate decorations were seen and described fully by the traveler Montaigne in 1581 in his *Journal de voyage en Italie par la Suisse et Alegmagne*. See Montaigne 1895; Moryson 1907; Lightbown 1964; Gurrieri and Chatfield 1972 for the Boboli Gardens; and Pizzorusso's essay in this volume.

12. See Crum 1989; see also Cox-Rearick 1984, Hibbert 1974 and note 1 above.

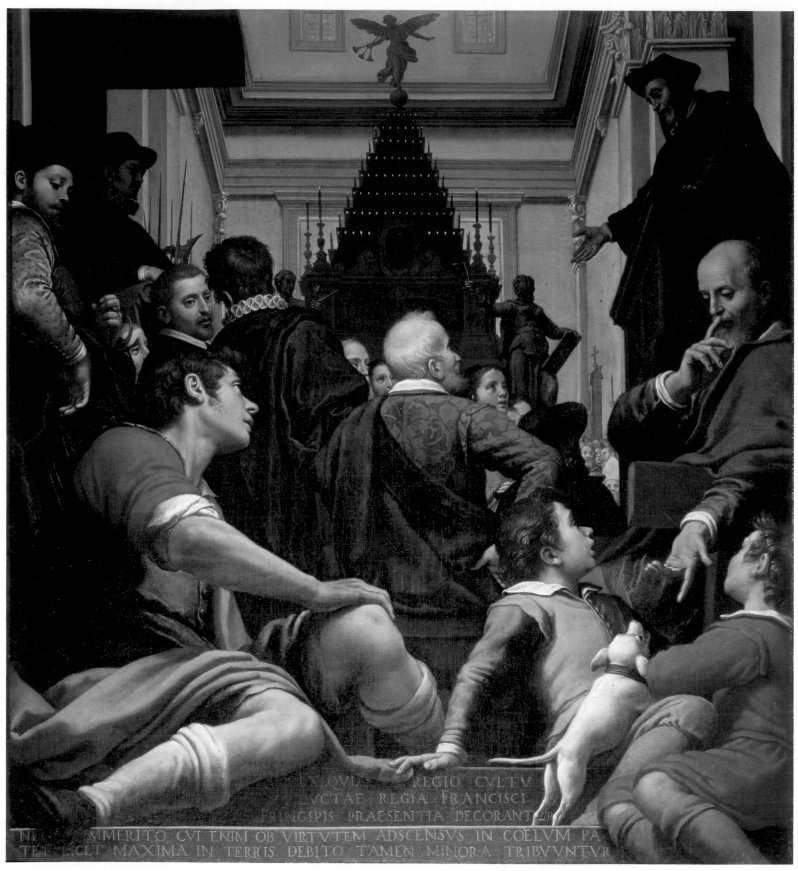

Fig. 5 Agostino Ciampelli, *Funeral of Michelangelo*, ca. 1613–35, oil on canvas. Museo di Casa Buonarroti, Florence.

MICHELANGELO AND THE MEDICI

Cristina Acidini Luchinat

The following essay is not a biography of Michelangelo but a new assessment of his relationship with the Medici family during the period from around 1490 to his death in 1564, and with the city of Florence, which he left to live in Rome in 1534. To keep to this framework, some of his most celebrated and important works, such as the Sistine Chapel or St. Peter's, will be mentioned only in passing, as they were executed in Rome for popes not belonging to the Medici family. At the same time, the artist's association with Florence and with the reigning Medici dynasty, including objects generated and collected after his death and up to the eighteenth century, are covered in detail.

STATE FUNERARY RITES

On 14 July 1564 a magnificent funeral was held in the church of San Lorenzo in Florence, honoring Michelangelo Buonarroti, the most famous artist of the century, who had died in Rome on 18 February at the age of eighty-nine (fig. 5). Michelangelo's exequies were a great public event, surpassing by far any of the ceremonies traditionally associated with San Lorenzo.[1] Only after Cosimo I de' Medici's funeral in 1574 was a series of such events initiated.[2] The very first such ceremonies, therefore, were celebrated in honor of an artist.

Those who attended the overcrowded church for the funeral would have seen emerging in the center of the nave amid the smoke of torches and incense a dark, square, terraced shape like a ziggurat. This was the catafalque, crowned by a pyramid, in turn supporting a sphere, above which the figure of Fame blew a three-cornered trumpet.[3] Its resemblance to the mausoleum of Augustus and the Septizodium in Rome deliberately evoked the imperial magnificence of antiquity.[4] The

solemn Mass of the Dead was celebrated in the presence of the nobility and artists, escorted by the Duke's Guards, followed by an oration from the scholar Benedetto Varchi, who stood in one of Donatello's bronze pulpits and proclaimed "the praises, the merits, the life, and works of the divine Michelangelo Buonarroti."[5]

While listening to Varchi, the "innumerable people"[6] would have seen selected episodes from the artist's life illustrated in the sculptures and paintings ornamenting the catafalque, as well as in the painted panels alternating with black drapes, skeletons, and symbols, that formed a consistent decoration throughout the church. The sculptures decorating the catafalque were in terracotta painted in imitation of marble. They included depictions of the Arno and Tiber rivers signifying Florence and Rome, the two cities associated with the life and work of both Michelangelo and the Medici. On a higher level, four groups of sculptures represented positive forces defeating their negative counterparts: intelligence and ignorance; Christian piety and vice; art and envy; work and sloth. Above this were the three arts of *disegno* — painting, sculpture, and architecture — as well as poetry. Finally two portraits of Michelangelo were surmounted by the figure of Fame.

The paintings illustrating Michelangelo's life ranged in subject from his artistic beginnings under the protection of Lorenzo il Magnifico to his arrival in the Elysian Fields, welcomed by the great artists of antiquity and of his time. An epitaph in Latin composed by Pier Vettori expressed the gratitude of the Accademia del Disegno in Florence. An elaborate composition, designed to amend in Christian terms the allusion to the pagan afterlife, depicted Michelangelo's soul ascending towards a celestial light, while an allegorical image represented the condolences expressed to Tuscany from all over the world.

Contemporary descriptions provide an insight into the preciousness of the ornamentation, ephemeral though it was, the somber magnificence of the black drapery, the subtlety of the epitaphs and mottoes, the repeated omen of the many skeletons, the splendor of the innumerable lights, the scent of the incense, the chants and the music, the orator's voice, the buzz of the crowds. In a transformation that would be repeated over the following centuries, San Lorenzo became a theater of death to celebrate glory – the glory of a single artist, whose reflected splendor extended over an entire dynasty of sovereigns, an entire city, even an entire state.[7]

But what was the significance of Michelangelo to the Medici? What had he represented, and what would he go on to represent, for Florence and its domain?

MICHELANGELO AND THE FIFTEENTH-CENTURY MEDICI

During the sixteenth century Michelangelo embodied for the Medici and for Florence the finest living proof of an age still fresh in the collective memory, a period hailed in Medici propaganda as a golden age:[8] the decades in the late fifteenth century when the "old" Medici, covertly governing the republican city, had fostered an extraordinary blossoming of the arts, letters, and sciences. Of key importance was the fact that Michelangelo in his youth – already by this time steeped in legend – had frequented the house of Lorenzo il Magnifico, the greatest art collector and patron of his time.

The known facts regarding Michelangelo's training before his association with the Medici are few, and derive from documents and the statements of his two biographers, Giorgio Vasari and Ascanio Condivi, which, however, must be treated with caution.[9] He was born on 6 March 1475 in Caprese, in the region of Casentino near Arezzo, to Francesca di Neri di Miniato del Serra and Ludovico Buonarroti, the local mayor. A few months after his birth the family moved to Florence and the child was given over to a nurse in nearby Settignano, a village of stone quarries, prompting Michelangelo later to joke that he had suckled his vocation to be a sculptor from the milk of his nurse, who was related to stonemasons by both birth and marriage.[10] Michelangelo's artistic beginnings were encouraged by the elder Francesco Granacci but strongly opposed by his father, a modest functionary with political and administrative duties who despaired at seeing his son abandon his studies in favor of a less prestigious laboring profession. By the age of twelve, however, Michelangelo was already working for the Ghirlandaio family, with a contract to train for three years in the art of painting.[11]

When he was sixteen Michelangelo's interests shifted towards sculpture, prompted perhaps by his contact with the workshop of Benedetto da Maiano and undoubtedly by his acquaintance with Bertoldo di Giovanni, a former assistant of Donatello's who was responsible for the supervision of the sculptures and antiquities collected in the Medici garden at San Marco, these objects being placed at the disposal of young and talented artists so that they might develop their skills, especially drawing.[12] It is indisputable that Michelangelo enjoyed special privileges, including lodging in the Palazzo Medici in via Larga, dining rights at the Medici table, and a salary of five ducats per month. The young artist was thus able to study the collections that Lorenzo il Magnifico had inherited and enriched, including the most private and precious of all – the glyptics. Michelangelo also encountered several personalities who would prove useful to him in the future: Giovanni, later Pope Leo X; and the family of Lorenzo di Pierfrancesco, Lorenzo il Magnifico's second cousin, who owned the house to the north of the city now known as the Palazzo Medici–Riccardi, where at least two important paintings by Sandro Botticelli, who was on friendly terms with both branches of the Medici family, were to be found.[13]

To the brief but influential period spent with Lorenzo il Magnifico from around 1491 to 1492 are attributed two early marbles by Michelangelo now in the Casa Buonarroti: the *Madonna of the Stairs* and the *Battle of the Centaurs*. The first reveals the influence of Donatello, while the second refers to antiquity, partly as a result of its mythological subject, chosen by Angelo Poliziano, the poet and scholar who also lived in the Medici household.

After Lorenzo's death a sudden political crisis prompted Michelangelo, temperamentally inclined to pessimism and anxiety,[14] to leave Florence in October 1494, only one month prior to the expulsion of Lorenzo's son and heir Piero de' Medici and the invasion of the king of France, Charles VIII. After a brief visit to Venice Michelangelo stayed in Bologna, where he completed the Arca di San Domenico.[15] By the end of 1494 he was again in Florence, where he sculpted a *Sleeping Cupid*, which was sold, at Lorenzo di Pierfrancesco's suggestion, as an antique to Cardinal Riario in Rome. The deceit was soon exposed, and Riario demanded to be reimbursed, but the young, talented "forger" was invited to Rome in June 1496, as a guest of Jacopo Galli.

Michelangelo's first experience of Rome's diverse environment broadened his horizons and benefited his learning and his art, while the artist continued to be protected by wealthy Florentine bankers and agents. The two marble sculptures that he executed there, a *Bacchus* (fig. 6), made for Cardinal Riario but acquired by Jacopo Galli,

and the *Pietà* now in St. Peter's, commissioned by the French cardinal Jean Bilhères de Lagraulas, marked the professional maturity of the artist in his early twenties. The *Boy Archer* in New York is also attributed to the young Michelangelo, albeit with some reservations.[16] The documentation of his paintings in this period is less definitive.[17]

BETWEEN THE FLORENTINE REPUBLIC AND JULIUS II

Michelangelo returned to Florence in 1501 as an established artist. When Lorenzo di Pierfrancesco died in 1503, the artist's relationship with the Medici family weakened, but he did not lack opportunities to work both for the Florentine Republic and for private patrons. In four years he produced a broad range of sculptures, varied in dimension, technique, and aesthetic principle. These included some of his most important works: *David*, symbol of republican liberty; *St. Matthew*, the only sculpture to be executed – although it was not finished – from a group of the apostles destined for the cathedral; and some smaller sculptures and marble reliefs, including four statues for the Todeschini Piccolomini Altar in Siena cathedral, the *Madonna and Child* for the Mouscron Chapel in Bruges cathedral, the *Taddei Tondo* (London, Royal Academy of Art), and the *Pitti Tondo* (Florence, Museo Nazionale del Bargello).

Michelangelo combined intensive and experimental sculptural work with the exacting task of realizing a fresco for the governor, Pier Soderini, showing the *Battle of Cascina* and intended to adorn the largest hall of the Palazzo della Signoria (later the Palazzo Vecchio) alongside Leonardo da Vinci's *Battle of Anghiari*. The artist executed only the preparatory cartoon for this fresco, which is known solely through copies, but these reveal that in the *Battle of Cascina*, as in his sculptures, particularly the *David*, Michelangelo was pushing his research on human anatomy to its extreme limits, exalting in the male nude the value of heroism. In the medium of sculpture this quality was given tangible form through the liberation of the human figure from hard, lifeless stone. The only surviving painting from this period, or just slightly later, is the *Holy Family*, also known as the *Doni Tondo*.[18]

The artist's second visit to Rome, in 1505, began with grandiose expectations but would in time turn to bitter disappointment – what Michelangelo described as the "tragedy of the tomb." Pope Julius II della Rovere intended to entrust Michelangelo with his mausoleum in marble and bronze for the Vatican basilica. The Pope later retreated from such an ambitious project, however, and all Michelangelo's subsequent relations with his successors were tainted by this controversy.

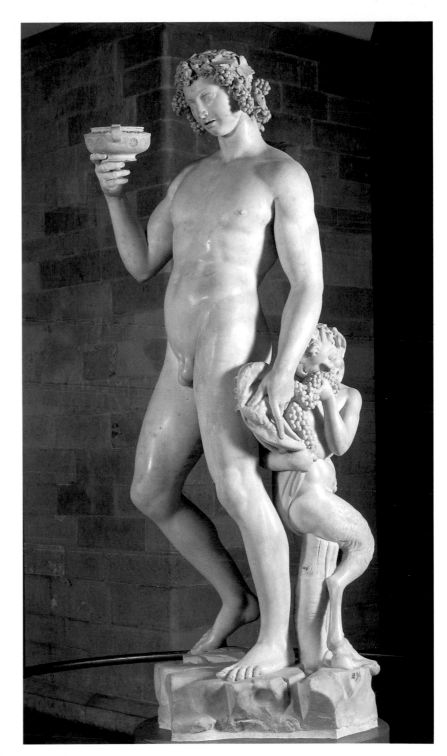

Fig. 6 Michelangelo, *Bacchus*, ca. 1496, marble. Museo Nazionale del Bargello, Florence.

Reconciled with the artist in Bologna in 1506, Julius II persuaded him to paint the long vault of the Sistine Chapel with stories from the Old Testament, an assignment that Michelangelo carried out in solitude between 1508 and 1512. An entire generation of painters, especially those of central Italy, was profoundly inspired by this exemplary work: without the Sistine Chapel the forms and colors of the most representative painters of the early Mannerist period, such as Pontormo, Rosso Fiorentino, and Beccafumi, would be unthinkable. But even more decisive, in terms of the Florentine artistic developments that would follow, was Michelangelo's prodigious architectural and sculptural legacy in the complex of San Lorenzo in Florence.

THE MEDICI POPES AND SAN LORENZO

Following the death of Piero de' Medici in 1503, the leadership of the exiled dynasty passed to his brother, Giovanni, who in March 1513 became pope, taking the name Leo X and thus establishing a close connection with his native city, which was symbolized by a lion, the *marzocco*.[19] The return of the Medici to Florence, which Leo had helped to engineer, was hailed as the revival of a golden age, and the Pope's brother Giuliano, duke of Nemours, and his nephew Lorenzo di Piero, duke of

Urbino, who now took on the leadership of the city, were welcomed with parades and festivals. Leo X's tenure as pope was followed by the brief papacy of Adrian VI (1522–23), and subsequently by that of Leo's cousin Cardinal Giulio de' Medici, under the name Clement VII. Both Medici popes concentrated their efforts on the church of San Lorenzo – already consecrated to the memory of their dynasty – and they commissioned Michelangelo to conceive and execute magnificent schemes, although these were only partially realized. This renewed interest in San Lorenzo marked the revival of projects that had been conceived, and perhaps initiated, by Lorenzo il Magnifico – the New Sacristy[20] and the Laurentian Library[21] – while Michelangelo's employment by the new generation of patrons in itself represented a link with the earlier Medici.

Leo sent Michelangelo back to Florence, where from 1516 to 1517 he was entrusted with the completion of the angular arcade of the Palazzo Medici in via Larga with walls in *pietra forte*. The windows, which came to be termed *inginocchiate* ("kneeling") because of the two long consoles running under the sills, established a prototype that had great success in palatial architecture and became one of the most typical features of historical Tuscan cities.

On 19 January 1519 Leo X assigned Michelangelo the task of producing a façade for San Lorenzo, the original one being unfinished (as it remains today).[22] The artist

Fig. 7 Michelangelo, model for the façade of San Lorenzo, ca. 1518, wood. Museo di Casa Buonarroti, Florence.

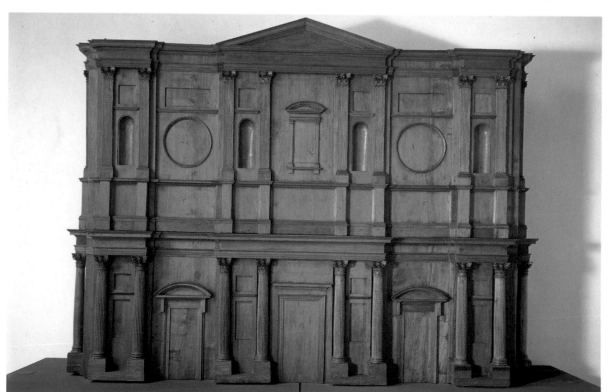

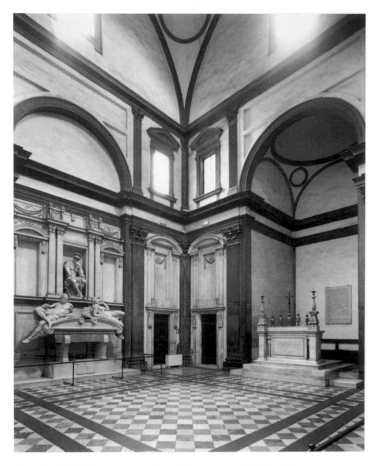

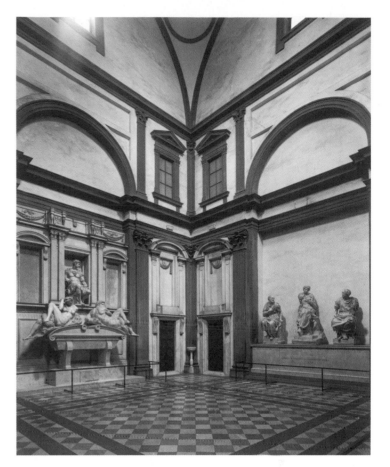

Fig. 8 Michelangelo, tomb of Lorenzo de' Medici, ca. 1520–34. San Lorenzo, Florence.

Fig. 9 Michelangelo, tomb of Giuliano de' Medici, ca. 1520–34. San Lorenzo, Florence.

personally supervised the choice and extraction of the marble for the façade, first in Carrara and later in Pietrasanta, working from two models. The smaller of these is now lost, but a large-scale model made of various woods and reflecting the final project is in the Casa Buonarroti (fig. 7). Despite Michelangelo's formal engagement, however, the Pope had a change of heart only shortly after the foundations had been laid. By the time the first column arrived in Florence in 1521 the contract had already been revoked, to the bitter disappointment of Michelangelo.

The death of Lorenzo, duke of Urbino, in 1519 shifted the attention of Michelangelo's Medici patrons towards the construction of a funerary chapel for the remains of Lorenzo and Giuliano, duke of Nemours, who had died in 1516, and for those of Lorenzo il Magnifico and his brother Giuliano il Magnifico, who for decades had rested in a temporary tomb (figs. 8 and 9). The plan and foundations of a new burial chapel, or New Sacristy, had been established in about 1491, based on the original scheme by Filippo Brunelleschi, which had included a chapel placed symmetrically to the Old Sacristy. The funerary monument of Cosimo il Vecchio, situated immediately in

front of the high altar of San Lorenzo set into a great subterranean pier, would provide a balancing and unifying element between the two Medici generations.[23] Building works began, after a brief planning period, on 4 November 1519 under Michelangelo's resolute guidance. The structure was completed by the end of 1523, and in the first months of 1524 the lantern was placed atop the dome, featuring a polyhedral ball in gilded copper. Surviving documents allow for a reconstruction of Michelangelo's typical working week, from which we know that he put himself under enormous physical strain, due partly to the heavy organizational tasks for which he was responsible.[24]

The inside of the Sacristy and the wall tombs form a powerful and harmonious unity of architecture and sculpture, integrated according to a cohesive design that emerges forcefully despite the interruption of the work following Michelangelo's final departure from Florence in 1534 and the Sacristy's completion by others. A rigorous scheme in two colors, achieved by alternating *intonaco dealbato* (white plasterwork) and marble with *pietra serena* (gray sandstone) delineates the structure, with two orders of Corinthian pilaster strips surmounted by four lunettes

with perspective windows. The dome, supported by four pendentives, is divided into five layers of coffers, like that in the Pantheon. Although the eye of the spectator is instantly attracted to the superb statues on the walls, the astounding architectural and plastic elements that would inspire Florentine architects throughout the century are located in the corners of the room: the tapered pilasters, channeled and cabled; the tabernacles above the doors; the windows with jutting tympanums; and a whole array of cornices, pateras, festoons, consoles, balusters, and masks.

The works were interrupted by the imperial siege of Florence in 1529–30. Michelangelo sided with the precarious Florentine Republic against the Pope, by this time Clement VII. The artist even supervised the city fortifications as a military engineer. After the defeat of the Florentine Republic he remained in hiding, fearing the Pope's revenge. Hindsight shows that his fears were unfounded, however, since his personal political choices were as irrelevant as his role in San Lorenzo was irreplaceable. Not only out of magnanimity, therefore, but out of a wisely directed egotism, Clement VII forgave Michelangelo, placing him once again at the head of the San Lorenzo project.

Seven marble statues were brought almost to completion by Michelangelo's hand: *Giuliano, Duke of Nemours*, with *Night* and *Day*, *Lorenzo, Duke of Urbino*, with *Dawn* and *Dusk*, and a *Madonna and Child*. Two further figures, *St. Cosmas* and *St. Damian*, were executed with the help of Raffaello da Montelupo and Giovannangelo Montorsoli. Work began on a number of other marble sculptures: the *Trophies of Arms* commenced by Silvio Cosini are still to be found *in situ*; a crouching *Youth* (St. Petersburg, Hermitage) provides evidence of a scheme for two pairs of sorrowful figures in the attic story above the lateral tabernacles of the tombs.[25] Niccolò Tribolo collaborated on a project to represent rivers, for which the original designs by Michelangelo survive,[26] and on statues of *Heaven* and *Earth*, but none of these figures was translated into marble.[27]

When Michelangelo moved to Rome in 1534, he left the Sacristy unfinished and without order. Only the statues of the dukes were in place; the four *Times of Day* lay on the ground, not yet mounted on the sarcophagi; and the *Madonna* and the *St. Cosmas* and *St. Damian* (unfinished) were in an adjacent room. For centuries these Sacristy statues have formed the focus of the debate on Michelangelo's *non-finito*: whether the concept was developed as a deliberate expressive means, or as a symbolic message, or simply due to an interruption of his work, or for some other reason altogether.[28]

The progressive reduction and eventual abandonment of the original project are among the factors that continue to make an understanding of the iconography of the Sacristy, beyond the obvious intention of celebrating the Medici dynasty, problematic. Already much debated, the question cannot be re-examined here in full, but it is worth mentioning that alongside a widely accepted Neoplatonic reading, a more political interpretation has emerged.[29]

The general principle behind the choice of the figures subordinate to the dukes relates to time as an eternal sequence, expressed in the four *Times of Day*.[30] In the Sacristy–mausoleum time is viewed not only as the entity that reveals and grants immortal glory but also as a destructive force that annihilates its own creatures, exhibiting the most fearful aspect of the ancient *chronos*. Michelangelo's amplification of this pessimistic vision is alluded to in a celebrated passage from Condivi's biography (instigated and personally reviewed by Michelangelo): "And for the representation of time he wanted to depict a mouse, as a little marble was left on the work (but which he did not make, in the end, as he was prevented), because this animal constantly gnaws and eats away at things, not unlike time, which devours everything."[31]

But where exactly was the mouse to be sculpted? Possibly on the figure of *Day*, cited by Condivi just prior to his reference to the mouse: an attack by the rodent on the diurnal personification would have expressed the tragedy in all its magnitude. And Michelangelo did indeed intend to depict a tragedy: the end of the dynastic hopes of the Medici descendants of Cosimo il Vecchio, and the entrustment of the dynasty's continuation to the illegitimate Alessandro, son of Lorenzo, duke of Urbino. In the fifteenth century, mottoes and heraldic devices had expressed in words and images the proud certainty of the perpetual renewal of the Medici family; now a mouse sufficed to announce its imminent extinction.[32] The person who prevented Michelangelo from sculpting the ominous mouse remains anonymous, but I believe it was Ottaviano di Bernardetto, a Medici kinsman who perhaps acted in the interests of his lineage by softening the harshness of the metaphor.

As long as the Sacristy remained a work in progress those who gained access could cast a libertine eye over the voluptuous female sculptures lying on the floor, and climb nonchalantly on the unfinished pieces.[33] The room was, however, already viewed as an awesome and memorable site, suitable to be shown to both sovereigns and the public.[34] Within its walls Michelangelo's legacy was assimilated by generations of Florentine and foreign artists, providing at first a direct personal experience but eventually becoming a legend. From the moment it was accessible to the public, and in the centuries thereafter

the Sacristy, particularly its statues and details, were copied,[35] with drawings and models spreading its fame.[36]

Duke Alessandro, elected head of Florence in 1531 but assassinated in 1537, initiated repeated attempts to call Michelangelo back from Rome to finish the Sacristy and other works in San Lorenzo, but these all proved fruitless. Although Clement VII died only two days after the artist's arrival in Rome, he had sufficient time to entrust Michelangelo with the task of painting the *Last Judgment* on the altar wall of the Sistine Chapel, which is therefore nominally a Medici commission. It was confirmed by Clement's successor, Paul III, and this and successive works, particularly the supervision of the construction of St. Peter's, kept Michelangelo in Rome for the rest of his life.

It therefore fell to Florentine artists to define the layout of the Sacristy that survives to the present day. Tribolo had the statues mounted on the sarcophagi and the *Madonna* and *Saints* moved from the adjoining room into the Sacristy. After Tribolo's death in 1558, Vasari worked on the floor, the plasterwork, and the window-panes, completing the Sacristy interior, while the exterior remained – and remains today – incongruously unfinished. Regular religious offices began in 1563, but this did not prevent the Accademia del Disegno – founded in the same year by Vasari and Vincenzo Borghini – from holding lessons there.[37]

Michelangelo had left behind two other architectural landmarks at San Lorenzo, one complete and the second unfinished: the Tribune of the Reliquaries and the Laurentian Library. The Tribune, which formed a ciborium within the church, was commissioned from the artist in 1525 by Clement VII to display precious ancient vases of rock crystal and semi-precious stone converted into reliquaries. These had belonged to Lorenzo il Magnifico and been reacquired by Clement VII following the dispersal of the family treasures in 1494. They therefore represented another Medici project at San Lorenzo marked by continuity between generations.

Supported by the inner façade, the Tribune was built between 1531 and 1533, although the vase–reliquaries were already displayed there in December 1532, having been donated to the basilica by two papal bulls. The architectural structure elaborated by Michelangelo, deliberately intended to reflect elements by Brunelleschi in the inner façade, consists of a slightly overhanging balcony with a balustrade, supported by two slender Corinthian columns. On the balcony three doors open into the depth of the façade[38] – the central door being crowned by a triangular pediment – each framed by a pair of pilasters carved with vegetal festoons in high relief. A private and ironic joke by the artist appears to be the only explanation for the otherwise mysterious difference between the capital of the left pilaster and its corresponding number to the right.[39] The Tribune is an unusual architectural piece, plain and sober in appearance but in fact pervaded by many tense elements.[40] Here the magnificence of private collecting is paired with public devotion.[41]

Cardinal Giulio commissioned the Laurentian Library in 1519, but Lorenzo il Magnifico had already had stonemasons working on marbles and blocks of stone in the garden of San Marco for a building where he could place a magnificent library. From one of those blocks the young Michelangelo had carved a head of an old faun, which Lorenzo admired, though with some good-natured irony.[42] The foundation of the Library represented a strong sign of continuity for both the Medici and Michelangelo but the original project underwent several refinements and alterations due to Giulio's changing whims.[43] It was only after 1523 that Giulio, now Pope Clement VII, established its location on the first floor of the San Lorenzo complex,[44] and the construction of the long rectangular reading room began in April 1525. From 1526 construction began on the *ricetto*, the high entrance vestibule destined to accommodate the staircase that leads from the first floor of the cloister to the reading room (fig. 10).[45]

When he left Florence in 1534, Michelangelo had completed the building of the reading room, its walls punctuated by pilaster strips and hollowed out by wide tabernacle windows. He had also defined the scheme for the ceiling and the design of the reading desks. The vestibule was under construction, and the walls, excluding those of the upper floor, were complete, with pairs of mighty columns embedded within them and floating consoles on the lower level combining a number of heterodoxical architectural orders. As far as the staircase was concerned, there were only "signs on the floor" and some sketches, together with "many stones" prepared but not installed.[46] The final reading room and vestibule, with its staircase completed by other architects, represents a variety of personal interpretations that only occasionally follow the vague instructions given by Michelangelo.

In 1548 construction of the ceiling in carved linden wood was begun. Santi Buglioni executed the floor, following a complex iconographic program realized in terracotta in red and white *impasto* (plaster).[47] The installation in 1568 of magnificent panes of glass decorated with grotesques by Flemish artists concluded the project. The dominance in the Library of ornamental motifs, dynastic mottoes, subjects taken from the antique, and symbolic images marks the transformation of Michelangelo's groundbreaking legacy into a common heritage that would enjoy widespread diffusion, the foundations of a repertoire that would be enriched and varied

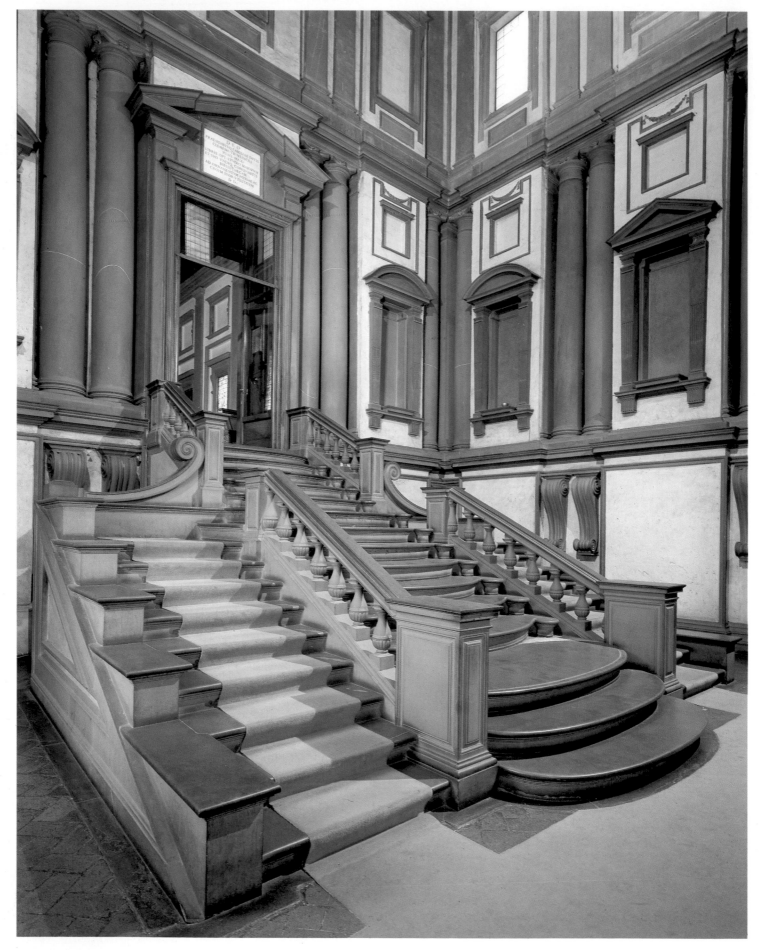

Fig. 10 Michelangelo, vestibule and staircase of the Laurentian Library. San Lorenzo, Florence.

throughout the century, never veering too far from its original course.

The vestibule remained unfinished. The task of building the staircase on the basis of Michelangelo's vague reminiscences proved to be too difficult for Tribolo. Vasari later took on the same challenge and succeeded in extracting from the aging artist the memory of a beautiful plan for a tripartite staircase with rectilinear steps on each side and a central flight resembling thin "oval boxes" of decreasing size. These oval forms probably referred to the functional but elegant objects designed to hold stationery seen in fifteenth-century images of saints in their studies. Bartolomeo Ammanati finally obtained from the exasperated Michelangelo[48] a small model that he received in Florence in January 1559, and thanks to this he was able to complete the staircase in gray sandstone. The Library was at last inaugurated in 1571.

"FATHER AND TEACHER OF ALL," EVEN FROM AFAR

When he was in Rome Michelangelo's ties to Florence and the Medici were almost never broken, being maintained through a tight correspondence – direct or indirect – and visits from his compatriots. His isolation, although proclaimed with harsh pride, was theoretical rather than actual. He was always surrounded by Florentine people, including bankers, agents, merchants, priests, artists, competitors, and rivals: even the group of stone-carvers building St. Peter's was teeming with natives of Michelangelo's home town, Settignano.[49] Just as he was kept informed of news of his family and his city, so in Florence his actions were always known, even the brusque words he pronounced during the last days preceding his death.[50]

Remaining spiritually and emotionally close to his native city, he continued to participate in what we would today call its cultural life, without, however, relenting in his ironic attacks against it, expressed uninhibitedly even to the popes.[51] He remained a staunch admirer of his great compatriots, whose work he had studied in his youth, and venerated Brunelleschi to the point of asking for drawings and measurements of the dome of Florence cathedral to be sent to him before he began work on the dome of St. Peter's.[52] He acted as mentor to Ammanati and Vasari during their early years, and later to Daniele da Volterra, who remained devoted to him in his old age. He also provided five drawings in 1559 for the centralized plan of the church of San Giovanni dei Fiorentini, the construction of which was about to be undertaken. His opinion was requested and followed on numerous occasions.[53]

Elevated to the position of the "lights of Florentine glory,"[54] he was honored as the greatest representative of the Florentine arts on an occasion little known even to modern scholars in 1549, at the same time that the proofs for the Torrentino edition of Vasari's *Lives* were being produced, concluding with his biography – the only one of a living artist. The city of Antwerp was setting up ceremonial apparatus for the entry of Prince Philip of Spain, son of Charles V, including the ornamentation of a triumphal arch financed by the Florentine colony ("nazione"). Adorned, like the rest of the decorations, with ephemera imitating valuable materials, the arch featured equestrian statues of the Medici; St. John and the lion, symbols of Florence; the three greatest Florentine authors – Dante, Petrarch, and Boccaccio; and, finally, two artists in the form of two over-life-size silver statues – Giotto and Michelangelo. Thus, through an international cultural policy, the vision of the arts fostered by the dukes and by Vasari was promulgated abroad, trumpeting the rebirth of artistic life in Italy, taken to its apogee by two Florentines.[55]

Michelangelo's reputation was tainted neither by his republican stance nor by his well-known links to Florentine exiles in Rome. A living tutelary deity, he rose closer to the status of "divine" with each passing year, not only due to his legendary artistic talent, but also because of the breadth of his literary culture, particularly his in-depth knowledge of Dante and his own poetic output.[56] Vasari's *Life of Michelangelo* of 1550 affirmed the master's supremacy in the firmament of past and present artists, attributing to his art insuperable perfection. Such a view already enjoyed a general consensus and it continued to gain ever-increasing acceptance. But the biography was resented by its subject, who was displeased at anything he believed to be an omission or a distortion. He therefore induced his faithful collaborator, Ascanio Condivi, to transcribe his memoires in a second biography, hastily published in 1553. Even this version, which he had personally overseen, failed to satisfy Michelangelo, as is indicated by the notes of disagreement that he added to the publication.[57]

A second, extended edition of Vasari's *Lives* was published by Giunti in 1568, four years after Michelangelo's death. Vasari could at last complete the parable of the master's long life, collecting verbal recollections about him that circulated in Rome following his death[58] and taking a personal satisfaction in reiterating and explaining in detail those facts that Michelangelo had denied through Condivi. The dedication of two biographies to a living artist and a third shortly after his death is in itself an astonishing reflection of the master's legendary status, reinforced during the following centuries. Michelangelo,

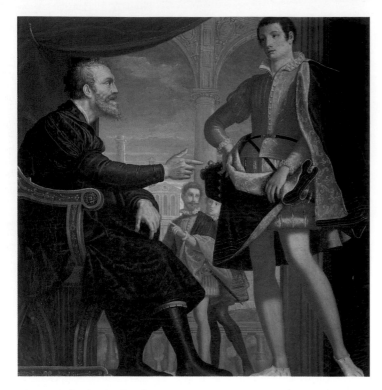

Fig. 11 Cosimo Gamberucci, *Prince Francesco de' Medici Pays Homage to Michelangelo*, ca. 1613–35, oil on canvas. Museo di Casa Buonarroti, Florence.

as has been rightly observed, was the first and foremost maker of his own myth, turning his life into a masterpiece that initiated, developed, and perfected itself through a continuous dialectic between his biographers and himself.

It is not surprising, then, that Cosimo de' Medici tried on many occasions to bring the prodigious master back to Florence. Michelangelo remained elusive. Neither visits to Rome[59] nor the flattering role bestowed on him of "deputy leader" to the Duke (fig. 11) in the newly founded Accademia del Disegno[60] sufficed to achieve its goal. To the Duke's final request that Michelangelo return to finish the Sacristy or instruct members of the Accademia on its completion, the artist responded with succinct elegance that he was unable to reply because he did not use his hand to write.[61] Vasari's posthumous explanation for Michelangelo's refusal to return to Florence – "that his having been absent from Florence for many years had only been because of the air quality"[62] – is highly dubious.

THE BEGINNINGS OF AN APOTHEOSIS

Michelangelo died following a brief illness, having worked until the very last on a marble *Pietà* and a wooden *Crucifix* for his nephew Leonardo.[63] Arriving in Rome too late, Leonardo had the sense to save the body

from appropriation by the Pope, and sent it secretly to Florence in a case camouflaged as a bale of merchandise. The aura of a miracle was soon added to the already keen devotion to the great deceased artist, when his body was found to have remained uncorrupted. Vasari and all the members of the Accademia del Disegno rejoiced, seeing in the solemn exequies their first public occasion.[64] This event was considered so momentous that the academicians did not hesitate to state that Michelangelo was fortunate to have died after the foundation of the Accademia and while Benedetto Varchi was still alive.[65] The Duke himself instructed Varchi to prepare and recite the funerary oration.[66] Furthermore he granted the use of San Lorenzo, already decorated by Michelangelo for the Medici, and ensured the financing of the expensive exequies, which took four months of preparation, orchestrated by artists supervised by Vincenzo Borghini. In Cosimo's view these honors were all appropriate to the political weight that the event was intended to convey, exalting through his universally celebrated and "divine" subject the hegemony of the small Tuscan state in the European arts.

Proposals were soon put forward for a funerary monument for the artist in Santa Croce, where the tombs of illustrious Florentine citizens were to be found. Leonardo Buonarroti intended to incorporate in this scheme one or more of the statues originally destined for the tomb of Julius II that had remained unfinished in Michelangelo's workshop in via Mozza: the *Victory* and the four *Slaves*.[67] But because Vasari was strongly opposed, he resolved to donate all five statues to Cosimo (with the early *Madonna of the Stairs* and others), to compensate the Duke for the lack of drawings in his inheritance. (Michelangelo had in fact burned many drawings in the last days of his life.) Vasari initiated with Borghini a project for a sepulcher, completed only in 1578 – a complex of sculptures and frescoes surrounding a sarcophagus, dominated by a marble bust of Michelangelo by Battista Lorenzi and surmounted by a fresco of the *Lamentation of Christ* by Battista Naldini. Around the sarcophagus three marble personifications stood in doleful attitude: *Painting* by Lorenzi, *Architecture* by Giovanni Bandini, and *Sculpture* by Valerio Cioli, representing the grief of the three sister arts (fig. 12).[68]

MICHELANGELO IN THE ART AND COLLECTIONS OF MEDICEAN FLORENCE

The myth of Michelangelo, initiated while he was still alive, would become more potent during the decades following his death, as would the obsession with material

proof of his divine talent. The search for works to add to those already present in Florence was, however, a hard task, even for the Medici. Since the 1550s Cosimo had owned the so-called *Apollo–David*, that had belonged to Baccio Valori. From Tommaso de' Cavalieri he obtained, almost under duress, what was possibly the first drawing by the master to enter his collection, a sheet with two *Cleopatras*.[69] Once he had received the five statues from via Mozza, Cosimo was able to install the *Victory* group in a sculptural display in the Salone dei Cinquecento in the Palazzo Vecchio, intended to symbolize the supremacy of Florence over Siena.[70] He renounced, on the other hand, a model of a river god (now in the Casa Buonarroti), which remained in the Sacristy, and donated it to Bartolomeo Ammanati, who in turn gave it to the Accademia del Disegno in 1583.

The noble families close to the court emulated the Medici in attempting to acquire works by the artist: examples were to be found in the residences of the Bettini, the Vecchietti, and the Albizzi.[71] Guglielmo del Riccio, whose family had been on friendly terms with Michelangelo, ordered that a copy by Taddeo Landini of the *Christ Holding the Cross* in Santa Maria Sopra Minerva in Rome be installed in his chapel in Santo Spirito. In the same church a copy of the Vatican *Pietà* had been installed before 1546. Other concepts by Michelangelo, recorded in the finished drawings that scholars define as "presentation drawings," continued to be copied in various derivations and interpretations.

Through the mediation of Diomede Leoni, Francesco de' Medici succeeded in 1570–71 in securing the *Bacchus* from the Galli Palace that was later placed in the Uffizi in a display comprising two antique sculptures and portraits. Also during Francesco's reign, a prominent setting was given to the four unfinished *Slaves*. Bernardo Buontalenti, devoted to Michelangelo's memory,[72] drew inspiration from these sculptures for the first chamber of the Grotta Grande di Boboli (1585–88), creating an architectural and figurative system alluding to the primordial era, the starting point of a metamorphosis of inanimate matter into life. Within the Grotta the *Slaves*, embedded in the corners between the rustic walls, embodied the typically Michelangelesque theme of the human form struggling to free itself from the restrictions of the stone.[73]

The bust of *Brutus*, conceived for Cardinal Ridolfi, arrived in Florence at the instigation of Ferdinando I, who bought it from the estate of Diomede Leoni in 1590.[74] Later the *Doni Tondo* would enter the Uffizi. Objects by Michelangelo that could not be brought to Florence were present in the city through derivations or copies.[75] Furthermore there were memorabilia, such as the medal dedicated to Michelangelo by Leone Leoni,[76]

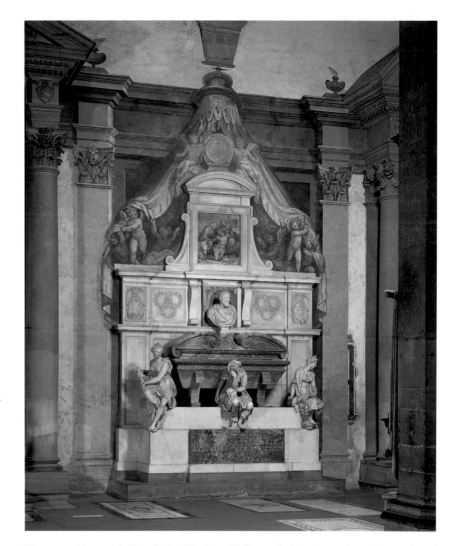

Fig. 12 Giovanni Bandini, Valerio Cioli, and Battista Lorenzi, tomb of Michelangelo, after 1564. Santa Croce, Florence.

and versions of the bronze portraits executed by Daniele da Volterra.[77] A remarkable homage to Michelangelo came from within his own family, following the decision of Michelangelo the Younger (the third son of Leonardo) to transform the Buonarroti residence in via Ghibellina into a magnificent memorial, the project being realized between 1612 and 1637.

The last, grandiose acquisition of Michelangelo's work made by the Medici dates to the time of Cosimo III, when it was finally possible to transfer to Florence the group of the *Pietà* that had been left in Rome in the garden of the bankers Bandini. The majestic marble group was eventually transported to the cathedral, joining in 1722 the new setting of Bandinelli's choir.[78] Thus for the first time Michelangelo, already present through his work and memorabilia in San Lorenzo, Santo Spirito, and Santa Croce, asserted his presence through one of his sculptures in the cathedral. The group was placed under Brunelleschi's dome, emphasizing the closeness of the two masters, the younger admiring his elder so much as to measure himself against the latter's masterpiece.[79]

This was the ultimate gesture of the city and of the reigning dynasty, whose days were numbered, concluding the uninterrupted process that had exalted Michelangelo as the father of Florentine and Italian arts in a sort of cultural canonization followed by a lay veneration. Paraphrasing Vasari one could say that as the Florentines could not have him while he was alive, they would never cease to honor him after his death "with every sort of magnificence."[80] This anxious, almost obsessive desire to fill a void, assuaging the pain of the artist's absence with a posthumous reappropriation, expressed itself in a constant pursuit of Michelangelo's work, the appreciation of his spiritual and material legacy, the recognition of a personal supremacy that overlapped and coincided with that of his native city, and, finally, the consolidation of a myth that we cultivate to this day.

Notes

1. See Ciseri 1993 and related articles.

2. On the subject of these ceremonies, reserved for the grand dukes, their relations, and their allies, see *La morte e la gloria* 1999, and preceding bibliography.

3. As the Florentine *braccio* corresponds to about 58 centimeters, we can deduce from contemporary descriptions that the base of the catafalque measured about 6 × 5 meters (11 × 9 *braccia*), and that it was 16 meters (28 *braccia*) in height.

4. For this and other references to the exequies see Vasari–Barocchi 1962, vol. 1, pp. 134–86; vol. 4, pp. 2145–222.

5. "le lodi, i meriti, la vita e l'opere del divino Michelagnolo Buonarruoti."

6. "il populo innumerabile."

7. Following Duke Cosimo's orders, the decorations remained in place for several weeks and attracted many visitors. Varchi's orations were printed and numerous poems were created for the occasion.

8. See Cox-Rearick 1984.

9. Following publication of the 1998 edition of Condivi's biography, the subject was covered again in several essays published in *Giovinezza di Michelangelo* 1999.

10. Weil-Garris Brandt in *The Genius* 1992.

11. The discovery of a decisive document, dated 28 June 1487, was made by Cadogan (1993). The same author confirms that it is currently impossible to identify Michelangelo's hand in Ghirlandaio's paintings (Cadogan 2000).

12. The garden at San Marco has been the subject of a long controversy among scholars, dividing those who credit at least partially Condivi's and Vasari's accounts, and those who consider their writings to be celebratory rhetoric. According to many authors the garden not only existed as a site fulfilling a variety of purposes, but also constituted an early outdoor "museum"; see Acidini Luchinat 1991; C. Elam in *Il giardino di San Marco* 1992; and N. Baldini in *Giovinezza di Michelangelo* 1999.

13. The well-known inventory of the Medici collections compiled in 1498 (copied in 1499) identifies the *Primavera* and the *Pallas with the Centaur* as being present at the palazzo.

14. The recurrent signs of a visionary anxiety in the young Michelangelo, such as his dream apparition of the dead Lorenzo de' Medici and his nocturnal vision of the "three rays," are discussed in Spini 1999, as is the larger question of Savonarola's influence.

15. Niccolò dell'Arca died on 2 March 1494. For his sarcophagus, Michelangelo sculpted *St. Procolo*, *St. Petronius*, and a *Candelabrum-Holding Angel*. The latter two were displayed in the exhibition *Giovinezza di Michelangelo* 1999; see the relevant catalog essay and entries. Following the exhibition, the *St. Petronius* was restored and reinforced by the Opificio delle Pietre Dure in Florence in 2000–1.

16. See *Giovinezza di Michelangelo* 1999.

17. To this period are attributed, beside a lost painting of the *Stigmatization of St. Francis* for San Pietro in Montorio, the *Manchester Madonna* and the *Entombment of Christ*, both now in the National Gallery, London. A reasoned analysis confirming the attribution of the two paintings – which is, however, still doubted by some (for instance Barolsky 1995) – is in Hirst and Dunkerton 1994.

18. Usually dated in relation to the Doni marriage in 1504, Natali (in *L'officina della maniera* 1996) has suggested 1507, the date of the birth of the couple's daughter, Maria. The *tondo*, complete with its splendid original frame, was included in the Medici collections in the seventeenth century and exhibited in the Uffizi, where it remains.

19. Leo probably also valued his name's evocation of the magnanimity and piety of St. Leo IX (1049–54). During his reign the leonine head indicated both the Pope and his native city. The recurrent presence of a diamond ring around the emblem further identified it with the Medici family, an allusion immediately perceived at the time.

20. For this theory, supported also by Wilde, Elam, and Saalman, see P. Ruschi in *San Lorenzo 393–1993* 1993.

21. See Acidini Luchinat 1991; and P. Ruschi in *San Lorenzo 393–1993* 1993.

22. It is possible that the Pope first employed Michelangelo to provide only the statues, planning to entrust the architectural structure to others. Vasari mentions a kind of competition, in which Baccio d'Agnolo, Antonio (or more probably Giuliano) da Sangallo, Andrea and Jacopo Sansovino, and Raphael participated (see H. A. Millon in Millon and Smyth 1988). However, Michelangelo soon obtained the commission for the entire façade.

23. J. Beck in Beck, Paolucci, and Santi 1993.

24. See Wallace 1998a. The week in question was from Monday 24 to Sunday 30 July 1525; on this subject see also Wallace 1994. For this and other episodes of Michelangelo's professional and private life it is essential to consult his *Ricordi* 1970.

25. A drawing generally believed to be by Michelangelo with a trophy in the center of the attic and crouching pairs of figures on the sides, is in the British Museum, London (1859-5-14-823). Further detail can be seen in the crowded drawing for Giuliano's tomb in the Louvre (838), attributed to Stefano Lunetti or an anonymous follower, or rarely to Michelangelo himself. On the entire question of the Hermitage marble see the catalog for *L'Adolescente* 2000.

26. Florence, Casa Buonarroti; on the small wax model see the entry in *I bozzetti* 2000, pp. 38–41.

27. Around 1552 two large "clay sketches" ("bozze di terra") were still to be seen on the floor of the Sacristy. See Doni 1552, vol. 2, p. 22: "*Peregrino:* What are these marvelous clay models down here? *Fiorentino:* They were going to be two large marble figures that Michelangelo intended to make."

28. On the much-discussed theme of Michelangelo's *non-finito* an abundant bibliography has been produced since the sixteenth century, taking into account those works that Michelangelo considered unfinished (such as the *Battle of the Centaurs* or the *Brutus*). Among the most recent contributions see an entire chapter devoted to this subject in Rosenberg 2000.

29. Trexler and Lewis 1981.

30. The identification of the four *Times of Day*, suggested for the first time by Varchi, is based on a reading of the sleeping figure as *Night*, this being the only sculpture with attributes: a crescent moon, star, nocturnal bird of prey, mask, and a bunch of poppies (or pomegranates, as Balas 1992 suggests). The identification of the three remaining figures rests on that of the first.

31. "E per la significazione del Tempo voleva fare un topo, venendo lasciato in sull'opera un poco di marmo (il qual poi non fece, impedito), percioché tale animaluccio di continuo rode e consuma, non altrimenti che 'l tempo ogni cosa divora." Condivi 1998, p. 20. It is worth noting the presence of the greedy mouse in the subjects of *vanitas*, plague, and decay in seventeenth-century art, especially in northern Europe.

32. The meaning of the Medici mottoes "Semper" and "Le tems revient," and of the image of the *ouroboros* – the snake who bites its tail, forming the circle of eternity – as well as the flowering branch, are assessed in particular by Ames Lewis 1979.

33. Two drawings by Federico Zuccaro (Louvre 4554 and 4555), are fundamental in showing the layout of the Sacristy, with one of Cosini's *Trophies*, which was mounted on trial on the attic of Lorenzo's tomb and subsequently removed.

34. Charles V briefly visited the Sacristy when he was in Florence on 4 May 1536 and greatly admired it; it was shown to a great crowd of people the following year on the occasion of the exequies for Duke Alessandro de' Medici; see Ridolfi 1958, p. 560.

35. As well as Rosenberg 2000, which is extensively illustrated, see *Vita di Michelangelo* 2001.

36. Tribolo seems to have initiated this circulation of images, executing soon after 1534 small-scale terracotta copies of the sculptures, of which the *Night* went to Vasari and the *Madonna* to Ottaviano de' Medici. In 1557 Daniele da Volterra made plaster copies of Michelangelo's statues (Rosenberg 2000). The Sacristy was also visited by the young Giorgio Vasari and Bartolomeo Ammanati, paying early homage to Buonarroti. Admiration for the artist had spurred Vasari and Francesco Salviati as young boys to brave the uprising against the Medici in 1527 to collect the fragments of *David*'s arm, crushed by a piece of furniture thrown from the upper floors of the Palazzo della Signora (this was the left arm, now visibly repaired). The fragments remained safe until, several years later, Duke Cosimo had them "put back together, held by copper pins." An account is in Vasari–Milanesi 1878–85, vol. 7, pp. 8–9.

37. At the time that Pontormo painted the choir, between 1546 and 1556, the Sacristy was open to young artists (see Rosenberg 2000, p. 134). The presence of the members of the Accademia is documented in the two drawings by Federico Zuccaro mentioned in note 33, which show artists and noblemen in the act of making copies and discussing the works.

38. "The opening in the thickness of the wall for the reliquaries" ("Il vano nella grossezza del muro per le reliquie"), according to the caption added by the artist to his drawing, now in Oxford, Ashmolean Museum, n. 311r.

39. The differences are eloquently described by F. Salvi in *San Lorenzo 393–1993* 1993, p. 115. In view of the disagreements that inevitably arose between Michelangelo (somber and intolerant), his patrons (busy and distant), and the intermediaries (worn out and impatient), I am inclined to give the following reconstruction of events: Michelangelo, as usual, proposed two different solutions for the capitals; he did not receive a clear response to indicate the Pope's choice and therefore had them executed by his stonemasons and installed, believing that the distance of the capitals from the ground would be enough to shield him from criticism.

40. For example, its relationship with the pre-existing inner façade, and the duplicity of its function as an armoire for precious objects as well as the chosen place for the display of venerable remains.

41. A public display occurred on Easter Day and on the day following All Souls Day, while a procession took place on 13 December, the anniversary of the arrival of the vases (I. Ciseri in *San Lorenzo, i documenti* 1993, p. 41).

42. "testa di fauno vecchio." See *Giovinezza di Michelangelo* 1999.

43. A "secret library" for rare books, known from two wonderful drawings in the Casa Buonarroti (A79r and A80r), was designed with a visionary triangular plan (a structure intended to fortify the intellect) but never built; in the main Library, the layout of the reading tables, and therefore the design for the ceiling and its complementary floor, were changed several times.

44. A summary of the events surrounding the project and its construction is provided by V. Tesi in *San Lorenzo 393–1993* 1993, pp. 135–40.

45. In June 1526 one column was already completed and four more were added shortly thereafter but problems of financing caused work to slow down until 1530 (Vasari–Barocchi 1962, vol. 1, p. 59; vol. 3, pp. 867–74).

46. "Segni in terra," and "molte pietre" (Vasari–Barocchi 1962). With some of these stones Tribolo dared to finish four large steps, but he eventually gave up this enterprise. On the staircase see Vasari–Barocchi 1962, vol. 1, p. 59; vol. 3, pp. 878–87. Documents support the hypothesis that construction was never initiated; see Argan and Contardi 1990, p. 195.

47. Catalano 1992.

48. The entreaties from Florence had troubled Michelangelo, prompting Cardinal Rodolfo Pio da Carpi to write to Cosimo de' Medici in his defense. Cosimo sent the Cardinal a polite, although slightly annoyed, reply (Buonarroti 1988, n. 305, p. 101).

49. Francesco di Bernardino d'Amadore (also sometimes spelt Amadori or Amatori) known as Urbino, mentioned the "good tongues" ("buone lingue") of the gossiping stone-cutters, calling them "cicadas" ("cicale") and adding that Michelangelo "never wanted to entertain a conversation with anybody" ("mai ha voluto conversatione con nissuno." Letter to Leonardo Buonarroti of 17 September 1552; Buonarroti 1988, n. 265, pp. 40–41.)

50. Leonardo Buonarroti was kept informed by Tiberio Calcagni, Daniele da Volterra, and Diomede Leoni, who were all close to the aging artist, as were Tommaso de' Cavalieri, Federico Donati (the physician of Cardinal Pio), and Antonio del Francese.

51. Particularly memorable is his

irreverently caustic letter to Clement VII about the colossal 55-foot-high statue that he was asked to install near San Lorenzo, to which the Pope nevertheless replied with equanimous indulgence (Buonarroti 1965–83, vol. 3, pp. 191, 194–95).

52. Letter from Michelangelo in Rome to Leonardo Buonarroti in Florence, dated 30 July 1547; Buonarroti 1965–83, vol. 4, n. 1086, pp. 271–72. On the relationship between the two masters see Tolnay and Squellati 1977.

53. When he was consulted on the restructuring of the Palazzo Vecchio he suggested raising the ceiling of the Salone dei Cinquecento and Vasari put this advice into practice (letter to the Duke dated 25 April 1560; Buonarroti 1965–83, vol. 5, 1330, pp. 221–22; Conforti 1993, pp. 150–53). A letter from Vasari in Rome to Duke Cosimo in Pisa, dated 9 April 1560, mentions Michelangelo and his discussions on the subject of the bridge of Santa Trinita; see Frey 1923–40, vol. 1, pp. 559–60.

54. "Luci della fiorentina gloria." Varchi–Milanesi 1857, vol. 3, p. 177.

55. See J. Becker, "'Surpassing Zeuxis and Apelles in the Arts': A Silver Monument for Michelangelo in 1549," a conference paper presented to the Dutch University Institute of the History of Art in Florence on 20 April 2001.

56. In the context of the widespread acceptance of the Horatian notion of *ut pictura poesis*, the equivalence between the art of Michelangelo and the poetry of Dante was already a topos in the sixteenth century when Michelangelo was still alive (see Vasari–Barocchi 1962, vol. 6, 1983, pp. 1983ff).

57. The amendments, published for the first time by Ugo Procacci, have been published anew, with a critical assessment, by Elam and Hirst in Condivi 1998.

58. From one anonymous correspondent of Michelangelo, Vasari learned anecdotes about the signature that the artist placed on the Vatican *Pietà*, chiseling it at night, and about the "turn"

("giro") he applied to Moses' head (letter to Giorgio Vasari dated March 1564 in Frey 1923–40, vol. 2, pp. 64–66).

59. During April 1560, when several delegations from Florence went to Rome on the occasion of the young Giovanni de' Medici's election to cardinal, Vasari visited Michelangelo many times, touring with him the building site of St. Peter's (Frey 1923–40, vol. 1, pp. 558ff). A couple of years later it appears that Prince Francesco also visited him, declining to sit down so that the aging artist could sit instead – probably an apocryphal incident but much beloved by artists for the obvious prestige it bestowed upon them. This episode was later depicted by Santi di Tito in the decorations for Michelangelo's exequies and by Cosimo Gamberucci in the Casa Buonarroti.

60. Michelangelo was considered "first academician, and leader of all" ("primo accademico e capo di tutti") despite his absence from Florence (letter from Vasari dated 17 March 1563; Buonarroti 1965–83, vol. 5, 1386, pp. 298–305). His personal emblem on marble – three intertwined circles, perhaps a simplified version of the three diamond rings that formed the symbol of the "old" Medici – was converted into the academy's emblem of three crowns, representing the three interconnected arts of *disegno*.

61. Michelangelo forwarded his apologies to the Duke via the Florentine ambassador Averardo Serristori, and to Vasari via his nephew Leonardo Buonarroti. Beyond the formality of his reply, I think it likely that he was horrified at the mere idea of a flood of images extraneous to his own project being created by the artists of the academy and installed within the spaces he had conceived.

62. "che l'essere stato molti anni assente da Firenze non era per altro stato che per la qualità dell'aria." Vasari–Barocchi 1962, vol. 1, p. 143, pp. 2146, 2162. Despite the continued insistence on Michelangelo's Florentine identity, it did not seem appropriate to include his figure among

the artists depicted around Duke Cosimo in the ceiling dedicated to him in the Palazzo Vecchio.

63. According to Leonardi 1995 this is the *Rondanini Pietà*, bequeathed to Antonio del Francese also known as Taruga, and now in the Castello Sforzesco in Milan; the wooden *Crucifix* is possibly that in the Casa Buonarroti.

64. Vasari–Barocchi 1962, vol. 1, pp. 136ff.

65. "Truly Michelangelo was most fortunate not to have died before our academy was founded, since his funeral was celebrated with such honor and magnificent display." ("E nel vero, che grandissima fortuna fu quella di Michelagnolo non morire prima che fusse creata la nostra Accademia, dacché con tanto onore e con sì magnifica ed onorata pompa fu celebrato il suo mortorio." Vasari–Barocchi 1962, vol. 1, p. 185.) Benedetto Varchi died the following year.

66. Letter of Duke Cosimo in Pisa to Benedetto Varchi in Florence, dated 9 March 1564; Buonarroti 1988, n. 361, p. 178.

67. While he was in Rome Leonardo asked Daniele da Volterra, Giacomo del Duca, and Giacomo Rocchetti for a design (Cecchi 1993). Furthermore he commissioned two portrait heads of his uncle from Daniele.

68. For the entire episode see Cecchi 1993.

69. For the *Cleopatras*, given to the Casa Buonarroti in the early seventeenth century, see M. Hirst in Barocchi 1989.

70. Heikamp 1980, p. 208.

71. Vasari–Barocchi 1962, vol. 1, p. 68, vol. 3, pp. 1124ff.

72. Vasari tells that, while all the other artists involved in the creation of decorations for Michelangelo's exequies were paid, Buontalenti painted the apparatus representing *The Soul of Michelangelo* "not, like the others, under commission . . . but of his own will, with the help that his noble and honorable friends gave him, thanks to his personal value." ("non come gli altri per commessione . . . ma spontaneamente, e con quegli aiuti che gli fece la sua virtù avere da' suoi cortesi et onorati amici." Vasari–Barocchi

1962, vol. 1, 1976–80, vol. 4, pp. 2208–9.)

73. The first (and still one of the most convincing) interpretations of the room was given by Francesco Bocchi in 1599, who referred to the Ovidian myth of Deucalion and Phyrras, or the generation of humanity from stone (Bocchi–Cinelli 1677, p. 138.) The ingenious placement of the statues represents a key interpretative contribution by Buontalenti on the theme of Michelangelo's *non-finito*. In 1909 the statues were installed in the Galleria dell'Accademia and replaced by copies in the Grotta.

74. In view of the anti-Medicean qualities of the *Brutus* it seemed prudent to display it in the Uffizi with the accompaniment of a couplet – perhaps by Anton Maria Salvini – explaining the unfinished state of the sculpture due to a sudden horror of tyrannicide experienced by Michelangelo during the execution of the work: "DUM BRUTI EFFICIEM SCULPTOR DE MARMORE DUCIT / IN MENTEM SCELERIS VENIT ET ABSTINUIT" ("While the sculptor executed the effigy of Brutus in marble, his mind alighted on the murder, and he stopped sculpting.")

75. In the Uffizi Tribuna, set up as *sancta sanctorum* of the Medicean collections, was displayed in 1589 a miniature by Giulio Clovio representing the *Rape of Ganymede*, deriving from the presentation drawing that had belonged to Tommaso de' Cavalieri, now in the Fogg Art Museum, Cambridge, Massachusetts; see the article in *Vita di Michelangelo* 2001. Also from Clovio's circle was a miniature version of the Sistine Chapel's *Last Judgment* on parchment paper of around 1570; this belonged in turn to the Medici Guardaroba, then to the Uffizi (inv. Gallerie Fiorentine 1890, n. 810), and then from 1932 to the Casa Buonarroti (Agosti 1989).

76. A silver version of the medal is in Florence at the Bargello Museum; other bronze examples are in the National Gallery in Washington and in Brescia; see *Vita di Michelangelo* 2001. The *verso* of the medal represents an

old blind man walking, guided by a dog. Barolsky (1990) interpreted the image as an allusion, based on the writings of St. Paul, to Michelangelo as a pilgrim on earth, guided by faith.

77. Numerous versions of the head are known. Two were requested by Leonardo Buonarroti (Cecchi 1993), one of which is in the Casa Buonarroti. Another version in marble is in an external niche on the Casa Buonarroti. Differences can be noted between the various versions, in the inclination of the head, the clothing, and the base. See Barolsky 1979, n. 27, p. 112.

78. When it was removed from the choir, the *Pietà* was located in the Museo dell'Opera del Duomo. On the events connected with the choir see *Sotto il cielo della cupola* 1997.

79. See note 52. An interesting suggestion, yet to be confirmed, is the attribution to Michelangelo of the design of a section of the multicolored marble floor below the dome, which in its octagonal plan complements the dome itself.

80. "con ogni sorta di pompa." Vasari–Barocchi 1962, vol. 1, p. 133.

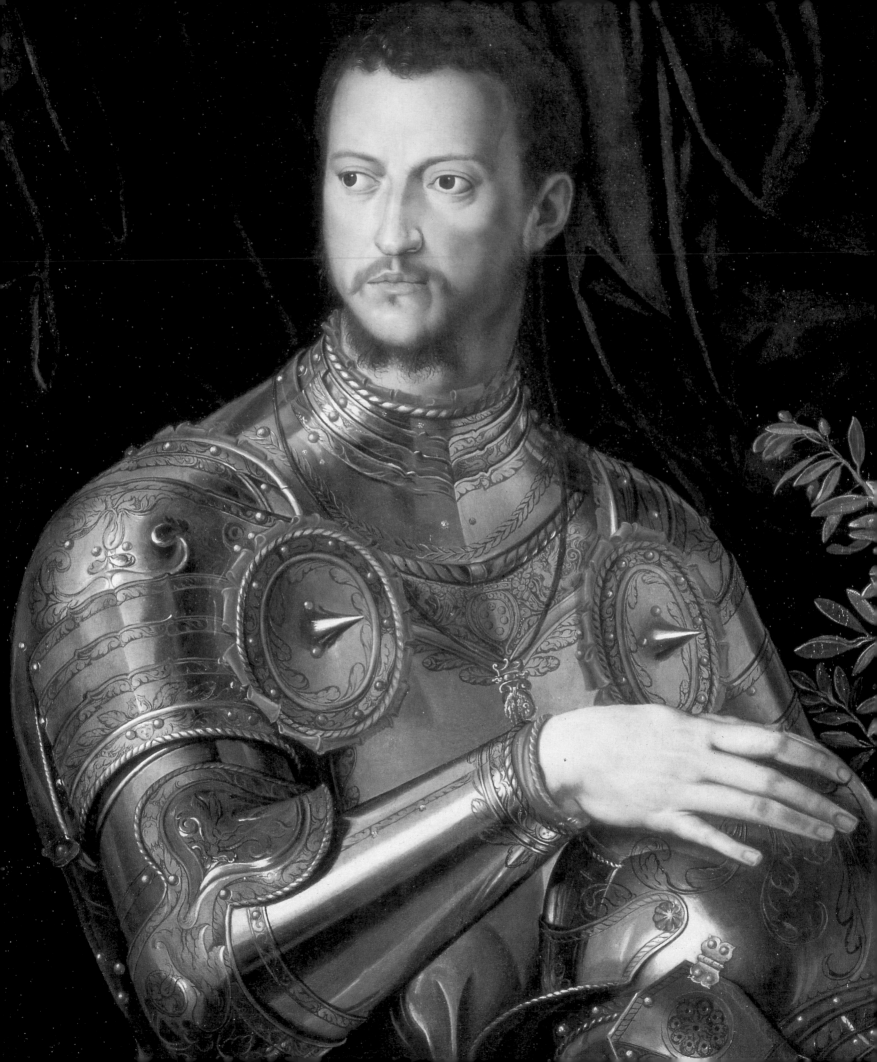

THE MEDICI GRAND-DUCAL FAMILY AND THE SYMBOLS OF POWER

Kirsten Aschengreen Piacenti

Italy was united only in the mid-nineteenth century, having been divided since the early Middle Ages into city states and principalities or republics. One of these was Florence and the Tuscany of today was created by one man, Cosimo I de' Medici (1519–74). The following is a brief account of how this came about; how, through force and diplomacy, Cosimo shaped the future greatness of the Grand Duchy while the exalted marriage alliances that he fostered also created a web of new contacts in the world of the arts. The essay will focus in particular on the crowns, robes, jewels, and artworks with which the early Medici surrounded themselves to assert their power.

As the sixteenth century dawned, the future of Florence looked bleak. The French army had invaded the city, ending in the sack of the Medici Palace in via Larga in 1494. The Medici had been expelled, although the honor of the family was upheld in Rome under the two Medici popes, Leo X (1475–1521) and Clement VII (1478–1534). In 1512, the Medici returned under Lorenzo, duke of Urbino (1492–1519) but fifteen years later the republic was reinstated, Michelangelo rushing to take part in the defense of the beleaguered town. It would have been difficult then to predict that in fifty years' time the city would be the seat of a brilliant court under a dynasty linked by marriage to the principal royal families of Europe.

The year 1530 saw the final collapse of the Florentine Republic and the elevation of Alessandro de' Medici (1510–37), illegitimate son of Lorenzo. In 1536 he was married to Margaret of Austria, illegitimate daughter of Charles V, but on the night of Epiphany 1537, he was murdered by his own cousin, leaving only a young illegitimate son. The situation in Italy was critical and the senate feared the results of a long regency. So on 9 January they elected Cosimo, of the younger line of the Medici, as "capo e primario del governo della città di Firenze e suo dominio."[1]

Cosimo was then eighteen. He acceded to a strife-ridden city state and left to his successors a flourishing grand duchy. He managed, little by little, to play off his enemies and even to assert himself against Charles V (1500–58), the powerful Holy Roman Emperor, but he had to tread warily and at times to be extremely ruthless. Charles granted him the title of duke (as he had to Alessandro), and the Toson d'or (Order of the Golden Fleece). In 1539 he married Eleonora of Toledo, the wealthy daughter of the viceroy of Naples, whom he had met four years earlier while accompanying Duke Alessandro on an embassy to Naples. Politically sound, the marriage also happened to be a love match. The couple soon moved into the Palazzo Vecchio, which had been splendidly redecorated, and in 1550 Eleonora bought the ruined Palazzo Pitti with acres of garden. It was not completed until two years before her death but it was to be the seat of the rulers of Tuscany for four centuries.

For his son and heir, Francesco, Cosimo obtained the hand of Giovanna of Austria. She was the daughter of Ferdinand, successor to Charles V as Holy Roman Emperor, and the sister of Maximilian II, who succeeded Ferdinand, so the union was extremely exalted. They were married in Florence in great splendor in 1565, by which time Cosimo had "retired" in favor of his son.

To win precedence over the other Italian states Cosimo had long aspired to become grand duke and on 27 August 1569 Pope Pius V finally granted him the title, the first of its kind in Italy (Cosimo had done the papacy a great favor by handing over Pietro Carnesecchi, accused of herecy, to the Inquisition). The papal bull arrived in Florence and was read aloud in the Palazzo Vecchio on 13 December amidst much cheering. The Emperor was

Fig. 13 Detail of cat. no. 11. 25

offended, however – he felt that only he had a right to grant titles – and became even more so when the Pope insisted on carrying out a coronation ceremony in Rome.

Cosimo set off for Rome with great pomp and circumstance and was royally received. The coronation, on 5 March 1570, was a magnificent occasion, recorded in a series of drawings by Stradanus. These, in their turn, were used by Giambologna in one of the reliefs on the plinth of the equestrian statue of Cosimo in the Piazza della Signoria, commissioned by Ferdinando. The event reflected the imperial coronations of the past.[2] The Pope arrived in the papal palace's Sala del Concistoro, where already thirty-three cardinals were assembled. Cosimo entered, magnificently dressed. After the salutations, the Pope advanced towards the chapel, with Cosimo holding his train, and took a seat under the canopy. Mass began and, after the Gospel was read, Cosimo knelt in front of the Pope and pronounced his oath to uphold the Christian faith. Marc Antonio Colonna came forward with a crown, which the Pope rested on the head of the

Grand Duke, placing a scepter in his right hand, whereupon he kissed Cosimo on both cheeks. The Grand Duke presented the Pope with a chalice in gold, a gold clasp, and a set of magnificent vestments and received in return the papal rose. At the end of the ceremony Cosimo walked to his lodgings with the crown on his head, the scepter in one hand and the rose in the other, and all the cardinals in his wake.

THE MEDICI CROWNS

The crown that Cosimo wore was in fact made in Florence and brought by him to Rome, although the shape had been decided upon by the Pope and communicated to Cosimo in the papal bull (see fig. 16). As the title of grand duke was newly invented it required a new type of crown. The result was always described as a royal crown and was royal in so far as it was open. It had seventeen rays, with the lily of Florence in the center and smaller lilies as finials on alternate rays. There was little time to make this important object.[3] However, the diarist Lapini pronounced it to be magnificent and of great value – 200,000 scudi.

By 1569 Cosimo already had a crown, however. As a duke he of course had a right to a ducal coronet, like Alessandro before him, and this is normally shown over the Medici arms during this period. But in the central panel of the ceiling decoration of the Salone dei Cinquecento in the Palazzo Vecchio, representing the apotheosis of Cosimo and executed by Giorgio Vasari between 1563 and 1565, a small *putto* holds a different kind of crown next to Cosimo, while another crowns him with a laurel wreath (fig. 14). The crown is described in detail in an inventory of 1566. It had an arch topped by a cross consisting of a large diamond and four rubies, thus making it a closed crown, as befits an emperor. Its circlet, set with jewels, carried a row of lilies alternating with large pear-shaped pearls. Two of the lilies, richer than the rest, symbolized Florence and Siena – after the conquest of Siena in 1555, Cosimo was indeed ruler over two states and evidently felt that he was entitled to a closed crown. After the papal bull, however, this crown was clearly no longer considered acceptable and was melted down.

Cosimo died on 21 April 1574. On 2 November 1575 Emperor Maximilian II signed a patent granting the title of grand duke to Cosimo's heir, Francesco, securing the position in the eyes of contemporaries who had not accepted the papal investiture. With imperial recognition of the title, Tuscan ambassadors henceforth took precedence over all but the Venetians. In the secrecy of his workshops Francesco ordered a new crown.[4] The old one

Fig. 15 Scipione Pulzone, *Christine of Lorraine*, 1590, oil on canvas. Galleria degli Uffizi, Florence.

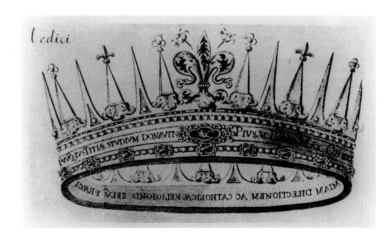

Fig. 16 "The Grand-Ducal Crown as laid down by the Papal Bull," published on 13 December 1569; engraving from R. Galluzzi, *Istoria del Granducato di Toscana*, Florence, 1781.

Fig. 14 (*facing page*) Giorgio Vasari and assistants, *Florence Crowns Cosimo I with Oak Leaves*, 1563–65, oil on canvas, central roundel of the ceiling decoration in the Salone de' Cinquecento, Palazzo Vecchio, Florence.

Fig. 17 Cigoli, *Grand Duke Cosimo I de' Medici*, 1602–03, oil on canvas. Palazzo Medici Riccardi, Florence.

particularly splendid and huge stone, in this case a large square emerald "of perfect color."

The crown is listed in all subsequent inventories. It underwent certain minor changes during the seventeenth century,[6] and is the first item in the list of "State Jewels of Tuscany" drawn up by the Electress Palatine in 1741.[7] In 1743 Francesco Stefano, successor to the grand-ducal throne, had the crown brought to Vienna – where he was the crown should be as well. Accordingly, when the next grand duke, Pietro Leopoldo, arrived in Florence to take up the government of Tuscany on the death of his father, the crown returned to Florence. It was destroyed by Pietro Leopoldo himself in 1789: by this time it had lost its significance as a "Herrschaftszeichen" (symbol of power) and could be turned into cash. After the coronation in Rome there does not seem to have been a single ceremony where a living grand duke appeared wearing his crown. However, they all wore it, together with the other regalia, on their *lits-de-parade*.

ROBES

In the grand-ducal inventories the crown is listed with the jewels, while the coronation robes appear at the end of the list of clothing, where they are always referred to as royal ("vestimenti alla reale da Granduchi").[8] There were two sets, each consisting of a mantle and a "sottana" (undergarment), handed down from father to son, although after Francesco the red coronation mantle disappears.

All accounts of the coronation agree that Cosimo was wearing a royal red velvet mantle lined with ermine, as well as an ermine cape, and a rich brocaded velvet "sottana" with looped metal-thread pile and a turquoise ground. Documents relating to his journey to Rome record that 5,600 fiorini were spent on clothing alone. From these accounts it appears that two royal mantles were prepared, the second even more splendid in brocaded velvet with gold and silver thread, which Cosimo is reported to have worn for his lying-in-state. The sumptuous textiles were produced in Florence but the garments themselves were made up by the Pope's tailor. The ermine furs were of the finest quality where it showed, ermine lining from other garments being reused for the more hidden parts.

The first dated portrait of a grand duke in "royal" robes shows Cosimo in the red velvet mantle.[9] The rich brocaded mantle is seen in the first full-length portrait by Lodovico Cardi, called Il Cigoli, of 1602–3, again representing Cosimo (fig. 17).[10] Cigoli was given the robes to copy in September 1602, so by then these were the offi-

was melted down, and the new crown executed between 1577 and 1583. It is depicted with great attention to detail in the portrait of Christine of Lorraine of 1590 by Scipione Pulzone (fig. 15), with obvious symbolic intent,[5] and is fully described in the "Inventory of Jewels and Gold" (Inventario di Gioie et Oro) of 1591. It follows the design laid down by the Pope but incorporates many more stones, each of the rays having three sets of stones: an emerald, a ruby, and a diamond. The central lily was heavily encrusted with large cabochon rubies and, true to tradition, above the forehead of the prince was set a

cial "royal" robes. His painting became the model for all later full-length portraits, of which three series are known.[11] One was commissioned in 1628 from Domenico and Valore Casini for the large Sala dei Novissimi in the Palazzo Pitti; this included the two Medici popes and the two queens of France and was obviously meant as a statement of Medici power. The second was created for Vienna, sent to impress the imperial relatives. Then, between 1602 and 1628, a third series was painted for the Hospital of Santa Maria Nuova and is today in the Palazzo Medici Riccardi, Florence. All these portraits are fairly stereotypical, and the robes were undoubtedly copied from the Cigoli painting.

The general shape chosen for this all-important brocaded mantle goes back to the fifteenth century and recalls that of the doges of Venice, who were chief of Italian princes. This did not escape the notice of sixteenth-century costume experts such as Cesare Vecellio. Writing in 1590 he states "the costume of the Grand Duke of Tuscany differs from that of the prince of Venice only in the headgear because one wears a horn and the other a crown; for the rest they are almost alike. The ducal robe of this prince is a crown [he is referring to the cape] like that of a king but shorter; it covers the shoulders and the mantle with ermine, and the undergown ['veste di sotto'] is of cloth-of-gold; he holds a scepter in his hand and a sword by his side to indicate his superior status and justice."[12] It should be remembered that another contemporary, Lapini, called the mantle a toga, evoking the robes of magistrates.[13]

On feast days the grand dukes wore the mantle of the Grand Master of the Order of St. Stephen, and thus they were entombed, according to the rules of the order. For his lying-in-state Cosimo was dressed in his royal robes with the crown on his head, the scepter in his hand, and the sword by his side, his head resting on a silk cushion and the mantle of St. Stephen at his feet, folded to show the red cross. The large sleeves of his splendid mantle were turned back to show the tight-fitting sleeves of the rich undergarment. His legs were mailed ("armati") and round his neck hung the Toson d'or.[14]

Before the burial all the royal symbols were removed and sent to the grand-ducal Guardaroba. As the clothes in which Cosimo was buried have been preserved, we know that he was dressed in one of his usual simple doublets in red silk satin, with red woolen breeches under the voluminous white moire silk mantle of St. Stephen, its sleeves lined in red taffeta.[15] The scepter was buried with him but has, of course, disappeared, the tomb having been robbed before it was first opened in 1857; it was made of silver, topped by a red orb and surmounted by a red lily.

Resplendent in public, Cosimo was extremely modest in his private life.[16] The same applies to Eleonora.[17] The famous portrait of her by Bronzino, in the Uffizi, shows her wearing a dress of a sumptuous textile similar to that of Cosimo's coronation mantle. It is an official statement, intended to bear witness to the skill of Florentine craftsmen. Normally she wore garments in satin, velvet, or taffeta, with only slightly more gold-thread decoration than that allowed by the sumptuary laws of the Duke. This is well illustrated by the dress recently discovered in Pisa[18] and the one in which she was buried.[19] The bodice of the latter dress shows sign of wear, while the satin doublet in which her son, Don Garzia, was buried even has a darn on one sleeve, although his black mantle is of rich damask, with a meter-long pattern.[20]

Like any other Florentine gentlewoman, Eleonora was responsible for the family's wardrobe and the household furnishings, and kept a watchful eye on everything. Archival documents record her bursts of anger at some unsatisfactory article prepared for the Duke. Cosimo and Eleonora's tailors were on the list of salariati and were paid as much as Bronzino. The court embroiderer, Antonio Bachiacca, brother of the painter, had independent status and was held in even higher esteem.

Cosimo very deliberately patronized the all-important Florentine silk industry. The court purchased from a variety of silk producers but Eleonora also had installed in the Palazzo Vecchio her own weaver, Madonna Francesca di Donato, who was, unusually, a woman, who produced textiles for clothing and especially for wall hangings. Costly Florentine silk brocades were available to any princess[21] – but only the grand duchess of Tuscany had weavers at her beck and call. When seven-year old Don Francesco was sent to Genoa to greet King Philip II of Spain, or another son, Don Giovanni, went to Rome as newly elected cardinal, their wardrobes were of unparalleled magnificence to enhance the impression of the wealth and power of Tuscany.[22]

DECORATIVE ARTS

Cosimo wanted a splendid court and to this end he surrounded himself with works of art: he called in Flemish tapestry weavers and set up the grand-ducal Arazzeria (tapestry workshops),[23] and he acquired costly artifacts in pietre dure (hard stone) from the Milanese workshops. Gaspero Miseroni served the Medici from 1552 onwards and at least two massive sea monsters from his workshop are still in the Florentine collections.[24]

Meanwhile a Medici of the elder line, Catherine, had become queen of France and, since 1559, regent for her

Fig. 18 Giovanni Antonio Maggiore, ivory globe with miniatures, ca. 1580. Museo degli Argenti, Florence.

young son. There was no love lost between her and Cosimo but both had an interest in *pietre dure* and bought avidly from the same Milanese workshops. Catherine left her collection to her favorite granddaughter, Christine of Lorraine, and through her the *pietre dure* vessels (as well as the Valois tapestries) came to Florence, when in 1589 she was married to Ferdinando, Cosimo's younger son, who was obliged, upon the death of Francesco in 1587, to leave the cardinal's hat to succeed his brother as grand duke.

Christine's paternal grandmother, after whom she was named, was the daughter of the exiled Danish king, Christian II. She had come to Milan as a child bride to the old Duke Sforza and at his death was married to the Duke of Lorraine. Through the Lorraine connection, links were strengthened between the Medici and the Wittelsbachs, another art-loving family. Albrecht V of Bavaria (1528–79), founder of the *Schatzkammer*, had traveled in Italy and was in touch with all the most important princes in order to obtain pieces for his collection. In 1572 Cosimo sent him several objects of "exotica" including a crocodile (presumably stuffed).[25] In 1568 Albrecht's son and heir, Wilhelm V (1548–1626), was married to Renata, Christine of Denmark's daughter, and during the wedding celebrations the Commedia dell'Arte played in Munich for the first time. Two gondola jewels in the Medici collections were inspired by this event.[26] Wilhelm and Renata's son, Maximilian I, married the sister of Christine of Lorraine in 1595.

The dukes of Bavaria commissioned rock-crystal vases from the famous Milanese workshops, just as Catherine and Cosimo had done. They succeeded in obtaining from Milan the first ivory turner, Giovanni Ambrogio Maggiore, who executed an ivory globe on an ebony stand that in 1582 was sent as a gift to the Grand Duke (fig. 18).[27] A rock-crystal *intaglio* portrait of Duke Albrecht V, of 1580–81, was probably part of the same gift.[28]

In Florence Francesco set up a series of workshops in the garden of his newly finished residence, the Casino di San Marco, where he spent much of his time and even on occasion conducted business of state. He was passionately interested in the alchemy of materials. In this he may have been influenced or at least encouraged by the architect Bernardo Buontalenti, who in 1547 at the age of 15 had been nominated teacher to the young prince and who remained the artistic head of the grand-ducal workshops till his death in 1608. The production of porcelain was attempted, as was the smelting of rock crystal; glass blowers were called from Venice; and two Milanese families of *intagliatori* of *pietre dure* were persuaded to come to Florence: in 1572 Stefano Caroni arrived with his brother Ambrogio, followed in 1575 by

Giorgio Gaffuri, thus launching Florentine *pietre dure* production.

Cabinetmakers from Munich were employed to execute ebony furniture for the Tribuna, the central hall of the Uffizi, filled with all the wonders produced for the court.[29] They initiated the production of ebony caskets and cabinets with *pietre dure* panels that remained a renowned Florentine speciality for centuries to come. Jewelers and goldsmiths from abroad were also attracted by the splendid opportunities of Medici patronage: from Holland, Hans Domes arrived in 1563 and Jaques Bylivelt in 1573; Odoardo Vallet came from France in 1586; and Jonas Falck of Sweden arrived in 1610. Florence of course had its own local goldsmiths operating within the guild laws of the town.[30] Occasionally one entered the court entourage, as did Giovan Battista Cervi (1532–86), with a workshop in the Mercato Nuovo, who produced work for the Medici between 1571 and 1586.[31]

Only a fraction of the work of these court jewelers has been preserved – in fact only the gold enameled mounts for the *pietre dure* vases produced in the workshops of the Milanese *intagliatori* remain. Cervi, for instance, was responsible for the snake added to a lapis lazuli shell in 1576.[32] Of the work of Hans Domes, who remained in Florence till his death in 1601, we know only of fragments of mounts, such as a spout in the shape of a peacock's head of 1578, or the mask of a lapis lazuli vessel of 1579.[33]

Jaques Bylivelt, born in Delft in 1550, became head jeweler to Francesco, for whom he executed the grand-ducal crown mentioned above, as well as the mount of a lapis lazuli urn (fig. 19), dated 1583, based on a drawing by Buontalenti – perhaps the best known of all *pietre dure* vases.[34] Under Ferdinando his reputation grew. He was made head of the grand-ducal workshops, was sent on a mission to Queen Elizabeth I of England in 1597, and in 1599 was in Rome negotiating the acquisition of a particularly large raw diamond. The diamond was finally bought in 1601, and cut in Florence by the Venetian Pompeo Studentoli between 1605 and 1615. Weighing 139 carats, it was known as one of the largest diamonds in the world. It was yellowish, pear-shaped ("a mandorla") – in accordance with the Grand Duke's wishes – faceted on both sides, and mounted on a gold enameled snake. On the 1741 list of state jewels it figured as the second item, but has now disappeared.[35]

Another item on the list of state jewels is the equally renowned set of three strings of pearls (each numbering eighty-two) that Christine of Lorraine is seen wearing in the Pulzone portrait, which were sent to France as a gift to Christine from Ferdinando before their nuptials. They too were taken to Vienna in 1743 and disappeared after

Fig. 19 Jaques Bylivelt, after design by Bernardo Buontalenti, vase, 1583, lapis lazuli. Museo degli Argenti, Florence.

World War I. Christine's ruby necklace, which survived to become part of the state jewels, was amongst many items that were broken up and sold.

On his death in 1603, Bylivelt's workshop was maintained by Odoardo Vallet, who was eighty years old in 1619 and died in 1621. The one piece known from his hand is the mount of a large crystal vase, finished in 1618, in the style of his youth, which by then was completely out of date.[36] Long before, agents had been sent out to Germany to find a master jeweler to replace Bylivelt, and, in 1610, Jonas Falck arrived from Augsburg. He was responsible for the jewelry part of a *pietre dure* relief showing Cosimo II in prayer – all that is left of a gold antipendium executed between 1617 and 1624 and intended as an ex-voto for the altar of San Carlo Borromeo.[37] The Grand Duke died before its completion so it was never sent to Milan but kept in the Guardaroba until its partial destruction under Pietro Leopoldo.

Evenutally the grand-ducal workshops were transferred from the Casino di San Marco to the Uffizi, and 1588 saw the official establishment of the Galleria dei Lavori, which in time became the Opificio delle Pietre Dure, which still exists today.[38] The gallery, centered around the Tribuna on the top floor of the Uffizi, was completed in 1589. The first inventory dates from that year, and includes in an appendix the objects from Catherine's collection, housed in a separate chamber, the Sala di Madama, named after the French grand duchess Christine of Lorraine.

Subsequent marriages further strengthened both the Medici's prestige and their collections. Of Francesco and Giovanna's two daughters one married Vincenzo, duke of Mantua, the other, Maria, married Henry IV in 1600 to become the second Medici queen of France, whither she was accompanied by Bylivelt, among others. Rubens was present in Florence at the marriage by proxy, and later glorified Maria in the wall paintings of the Palais de Luxembourg.

The marriage of Cosimo II to Maria Maddalena of Austria, sister of Emperor Ferdinand II, brought a second imperial grand duchess to Florence. Her exalted title lives on in the name of the Villa del Poggio Imperiale (Villa of the Imperial Hillock), which she bought in 1622.

In 1628 their daughter, Margherita, married Odoardo Farnese, duke of Parma, bringing to an end the century-long enmity between the two families who had struggled for supremacy in Italy. Margherita remained in Parma even after her husband's death but was greatly attached to Florence, and through her, Florentine works are found today in the Capodimonte Museum, Naples.[39] Her brother, the young Grand Duke Ferdinando II, was in Vienna in 1628 to placate their imperial relative's wrath against the Farnese. On his way back he stopped over in Innsbruck where his aunt, Claudia, was married to Leopold, archduke of the Tyrol. As a present he received the large Hainhofer cabinet that is still in Florence.[40] In 1646 Claudia's son married yet another Medici, Anna, Margherita's sister.

The family connection with the Holy Roman Emperor involved young Prince Mattias (1613–67) in the Thirty Years War. In 1632 he took part in the siege of Coburg by the imperial army, which ended in the sack of the town. Mattias's part of the booty was thirty turned ivory vases from the ducal palace of Ehrenburg, executed by Marcus Heiden and Johann Eisenberg for the Duke of Coburg between 1618 and 1631.[41] These extraordinarily delicate objects were sent across the Alps to Florence, where they were registered in the Uffizi inventory on 1 April 1633. In years to come they were to serve as a source of inspiration to yet another German ivory turner, Philip Sengher, called to Florence by Cosimo III.[42]

By the end of the period the Medici were firmly established amongst the great families of Europe. They gave up banking, and wine was no longer sold from the portals of the Palazzo Pitti. However, they remained "low profile" as far as regality was concerned, conscious that they were being watched by the "world that counts," both in Italy and abroad, and – worse still – by the Florentines. No coronation ceremonies were performed in Florence, they did not "dine in public," nor amass silver furniture à la Louis XIV (only the Electress did so while in Düsseldorf), and refrained from having another royal crown made when they received the right to royal treatment in 1692, limiting its use to portraits and seals. However, their legacy is still the life and glory of Florence today.

NOTES

1. "Ruler of the city of Florence and all its territories"; see Diaz 1976, p. 67.
2. The event is vividly described in Lapini 1900, pp. 166–69. See also Galluzzi 1822, lib.III, cap.VI, p. 111.
3. Work was still in progress after the coronation ceremony had taken place, see Fock 1970, p. 197, note 2.
4. The renewal of the crown sounds like a personal decision. It is never mentioned in the official documents but is recorded in the accounts and the diary of the goldsmith who made it, Jaques Bylivelt; see Fock 1970, pp. 197–209, appendix with inventory of 1591, pp. 208–9.
5. Uffizi Gallery, inv. 1890, no. 9161. It is also placed next to Maria Maddalena in the portrait of her with her young son Ferdinand by Giusto Sustermans, inv. 1890, no. 2246, before 1623.

6. This becomes apparent when comparing the crown in the Christine portrait with the pen-and-wash drawing of the early eighteenth century by Giovanni Casini for John Talman, Victoria & Albert Museum, London, inv. 7899–1.

7. See Sframeli 1988 on the lost state jewels of Tuscany.

8. A full account, with all the documentary material, is found in Lazzi 1989.

9. By Giovanni Battista Naldini, executed in 1585 when Cosimo was long dead, but probably based on a lost Bronzino; Uffizi Gallery, inv. 1890, no. 2238.

10. Cigoli, Palazzo Medici-Riccardi, inv. 1890, no. 3784.

11. Langedijk 1978.

12. "L'habito del Granduca di Toscana è differente da quello del Prencipe di Venetia nell'ornamento della testa; perchè uno porta il corno e l'altro la corona; nel resto poi convengono quasi del tutto. L'abito ducale dunque di questo Principe è una corona simile a quella de Re, ma alquanto più bassa; copre le spalle con una mozzetta d'armellini il manto e la veste di sotto sono di panno d'oro a opera; tiene in mano lo scettro e la spada a lato in segno di superiorità e giustizia." Vecellio 1590 and 1598, p. 180; see also Lazzi 1989, p. 106.

13. Lapini 1900, p. 166.

14. Lapini 1900, p. 185.

15. *Moda alla Corte dei Medici*, pp. 97–103.

16. See Ricci 1993.

17. Lazzi 1993; Orsi Landini 1993.

18. A costume in the Palazzo Reale of Pisa, recently discovered and restored by the Soprintendenza, has convincingly been related to the Duchess, see Burresi 2000, p. 57; inv.no. 1545.

19. *Moda alla Corte dei Medici* 1993, pp. 79–87.

20. *Moda alla Corte dei Medici* 1993, pp. 88–96; see also Westerman Bulgarella 1996–97, with English transaltion insert.

21. In a portrait of 1573, Elisabeth of Austria (1544–92), consort of Charles IX of France, is wearing a dress made up of a textile very similar to that of Eleonora's in the Bronzino portrait, see *Felipe II* 1993, no. 107.

22. *Moda alla corte dei Medici* 1993, pp. 23 and 44. The famous Medici wardrobe was sold after the death of the Electress Palatina in 1743.

23. See Meoni 1998, especially "I maestri fiamminghi e l'introduzione della manifattura di arazzi a Firenze," pp. 35ff.

24. The sea monster in heliotrope, Museo degli Argenti, inv. Gemme no. 764, was acquired in 1557; the one in mottled lapis lazuli, Museo di Mineralogia, inv. 1947, no. 13683/647, in 1563.

25. The complete list is in Stockbauer 1970, p. 76.

26. Hackenbroch in *I Gioielli dell'Elettrice Palatina* 1988, cat. nos. 1 and 2. I have suggested that the larger jewel, cat. no. 2, may have

come to the Medici from the Wittelsbach family (Piacenti 1985); however, it seems that the type was quite popular at the time. I am grateful to Dr. Kurt Locher, Nürnberg, for this information.

27. In the Museo degli Argenti, inv.bg.no. 39; see Diemer 1985. Later the master himself traveled to Rome, recommended by the Grand Duke.

28. The *intaglio* (inv. Gemme no. 327), executed in 1580–81 by Valentin Drausch, was based on a silver medallion by Hans Asslinger of 1558, with a mount by Heinrich Wagner; see Lietzmann 1994, 1.7, p. 1802, ill. 1.

29. The "Studiolo Nuovo" or "tempietto," the central cabinet in the Tribuna, was executed by Bartolomeo d'Erman (Hermann), helped by other German cabinetmakers, from a drawing by Bernardo Buontalenti, between 1584 and 1586; see Heikamp 1988, p. 55; and Heikamp 1997a. Names of further German cabinetmakers are listed in Piacenti in *Artisti alla corte granducale* 1969, p. 147.

30. Liscia Bemporad 1993, 1, section on "Profili biografici," p. 389ff.

31. For a recent essay on the court goldsmiths, see Sframeli 1997.

32. In the Museo degli Argenti, inv. Gemme no. 413.

33. In the Museo degli Argenti, inv. Gemme nos. 496 and 713; also the snake handles of 1588, added

to an antique vase in agate, inv. Gemme no. 410.

34. In the Museo degli Argenti, inv. Gemme no. 802.

35. Sframeli 1988, pp. 18–19. The diamond appears for the first time in the inventory of 1621; it still has its snake-mount in the inventory of 1740, just as it appears from the drawing in the Victoria & Albert Museum, inv. no. 7900.41.

36. In the Museo degli Argenti, inv. Gemme no. 490.

37. The central panel is in the Museo degli Argenti, inv. Gemme no. 489. The preparatory drawing is by Giulio Parigi, the *intagliatori* were Michele Castrucci and Gualtieri Cecchi, while Cosimo Merlini (1580–1641) was the goldsmith responsible for the two side panels. For an early-eighteenth-century watercolor drawing of the complete panel, in an album for John Talman, today in the collection of J. Paul Getty Jr., see Piacenti 1994.

38. For the Florentine production of *pietre dure*, see Giusti 1988.

39. *Museo e Gallerie Nazionali di Capodimonte* 1996, cat. nos. 6,92–94; see also Piacenti 1996.

40. In the Museo degli Argenti, inv. O.d.A. no. 1541.

41. Only twenty-seven pieces have survived and are in the Museo degli Argenti, see Piacenti 1989.

42. Piacenti 1963.

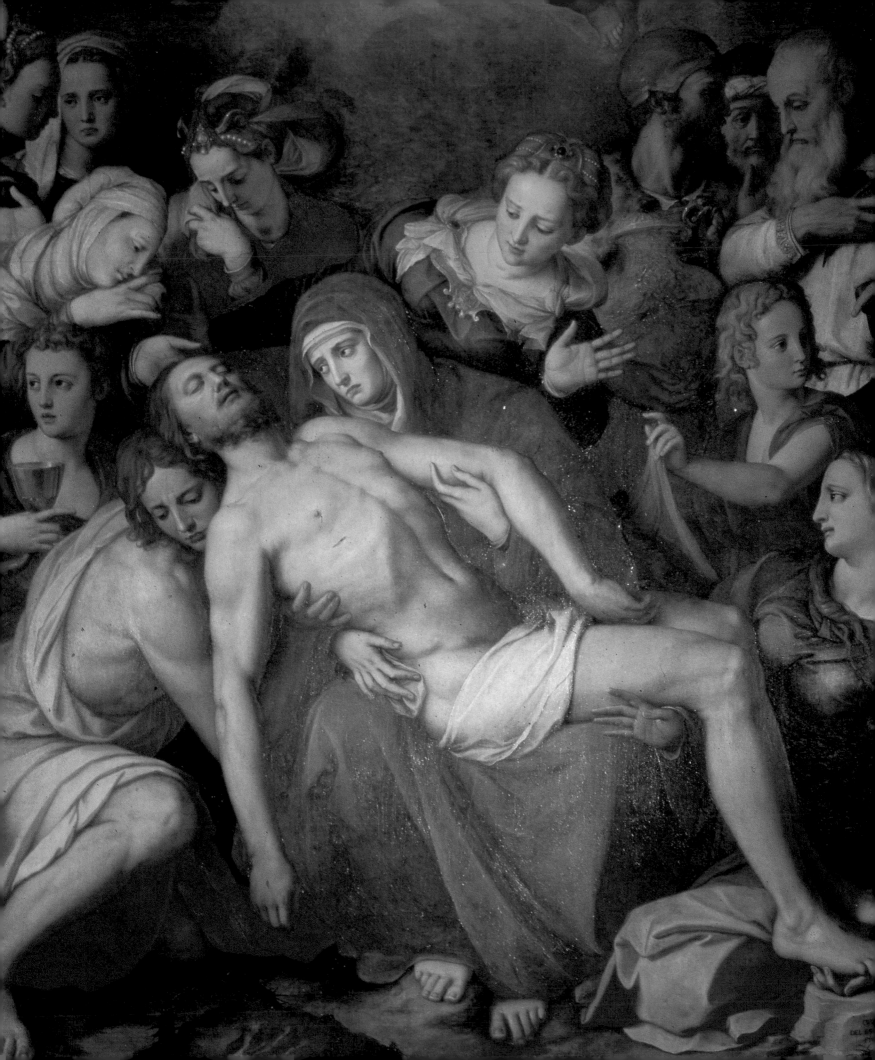

ART AT THE COURT OF
DUKE COSIMO I DE' MEDICI (1537–1574)

Janet Cox-Rearick

To the Most Illustrious and Excellent Lord, Cosimo de' Medici, Duke of Florence:
... for indeed is it not only with your gracious support that there have come to
light (and still do) these our arts, but that in imitation of your ancestors you are
their sole father, lord, and unique protector? Hence, it is only right and reasonable
that so many most noble pictures and statues and so many marvelous buildings of
all sorts should be created in your service and [dedicated] to your eternal memory.

Giorgio Vasari, dedication of the *Lives of the Artists*, 1568.[1]

Not long after his elevation by Emperor Charles V to the dukedom of Florence in 1537 Cosimo I de' Medici became an active art patron, using the arts as an instrument of power and bringing them under the same tight control that he exercised over his state.[2] After her marriage to the Duke in 1539, the Spanish noblewoman Eleonora of Toledo joined him in this endeavor, becoming a patron in her own right by the mid-1540s.[3] From the wide range of work that the couple commissioned over almost four decades – not only Vasari's "noble pictures and statues and so many marvelous buildings" but the so-called minor arts as well – this essay will focus mainly on painting and sculpture.[4]

IMAGES OF DUKE COSIMO I DE' MEDICI,
DUCHESS ELEONORA OF TOLEDO, AND THEIR CHILDREN

Throughout his long rule Cosimo privileged the art of portraiture, which served both his desire to promote the superiority of Medici rule in Florence and the need to document the new Medici dynasty he had founded with Eleonora. From childhood, representations of the future Duke Cosimo were dynastic in character, establishing the theme of his predestined rule of Florence and the legitimacy of his claim to the dukedom based on his descent from both branches of the Medici family.[5] The earliest securely identified and dated portrait of the future duke is Ridolfo Ghirlandaio's portrayal of him at age twelve in 1531.[6] It is inscribed COSMO MED. and the young Cosimo displays a medal, which is effaced but must have represented his father, the famous condottiere Giovanni de' Medici (delle Bande Nere). The portrait was painted at the beginning of the rule of Cosimo's cousin and predecessor Alessandro de' Medici, first duke of Florence.

On becoming second duke of Florence in 1537, Cosimo commissioned two unusual and imaginative portraits of himself. The first, painted by Jacopo Pontormo in 1537, shows him dressed as a soldier – probably in homage to his father – ready to defend Florence, symbolized by the fortress behind him (fig. 21).[7] He wears a gold chain (possibly a gift from Charles V, his feudal lord) and proudly displays a hat badge of *Hercules and Antaeus*, which refers to a medal of the subject executed for him in 1537 by Domenico di Polo.[8] The second portrait is a bizarre portrayal of the Duke in the guise of the mythical Orpheus (cat. no. 17). Painted by Agnolo Bronzino around 1539, it marked the beginning of the artist's career as court portraitist to the ducal family.

After 1543, the year in which Cosimo consolidated his territorial power in Florence, Bronzino responded to the

Fig. 20 Detail of fig. 23.

35

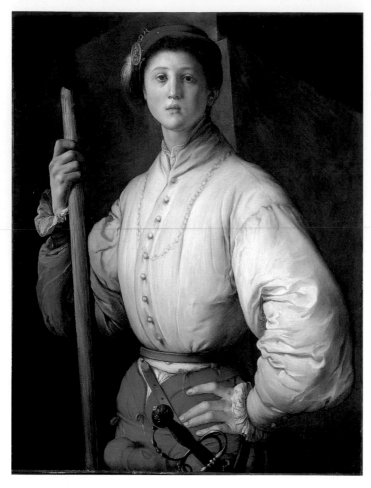

Fig. 21 Pontormo, *Halberdier*, ca. 1528–30, oil on panel. J. Paul Getty Museum, Malibu.

any other portrait of him (fig. 22).[10] In a marble bust of 1543–44, based on a bust of Hadrian in the ducal collection, Bandinelli depicted a more impassive Cosimo, similar to Bronzino's *Portrait of Duke Cosimo I de' Medici in Armor* (cat. no. 11).[11] His cuirass is embellished with a head of Capricorn (the zodiac sign that was the ascendant in his horoscope) and with lions holding the traditional Medici device of diamond rings.

There were many later portraits of the Duke, both painted and sculpted. Bronzino painted a second state portrait (1556–57) in celebration of Cosimo's anticipated title, duke of Florence and Siena, after Cosimo's conquest of Siena in 1555.[12] Bronzino portrayed Cosimo for the last time in 1569 (shortly before he became grand duke), wearing the badge of the Order of the Golden Fleece that he had received from Charles V over two decades earlier.[13] Bandinelli produced a bronze half-length of the Duke (cat. no. 51), represented *all'antica*, about the same time as Bronzino's state portrait and in 1567, toward the end of Cosimo's rule, Pietro Paolo Galeotti depicted him in a profile bust in armor on a series of medals celebrating his achievements (cat. no. 98), copied by an anonymous Florentine artist in a precious lapis lazuli cameo (cat. no. 109).

After Pope Pius V elevated Cosimo to the title of grand duke in 1569, subsequent portraits represented him wearing the grand-ducal crown.[14] The most imposing of these is Cigoli's over-life-size portrait of 1603 showing Cosimo full length wearing an ermine cloak with the crown and scepter – emblems that emphasized the legitimacy of his hereditary title as founder of the grand-ducal dynasty, as well as his royal pretensions. His symbolic setting is the courtyard of the Palazzo Vecchio, formerly the Palazzo della Signoria, city hall of the Florentine Republic.[15]

Duchess Eleonora was portrayed by Bronzino in a series of state portraits analogous to those of Cosimo.[16] The first was painted shortly after her marriage and represents her as a bride: the gesture of her right hand placed below her breast (and wearing the large diamond wedding ring Cosimo gave her) signifies marital faithfulness, and she wears a red-and-gold dress similar to that described in accounts of her arrival in Florence in 1539.[17] In the summer of 1545 Bronzino painted a dynastic state portrait, the largest and most important of the Duchess, *Eleonora of Toledo and Her Son Giovanni*, depicting her as Eleonora genetrix, the producer of heirs who will ensure the continuity of a new Medici dynasty. Even the pomegranates on her magnificent brocaded dress proclaim this theme, for the fruit was a common symbol of fertility. The marshy landscape in the distance represents the Medici domain, making the work an image of territorial

need for an official image of the Duke and depicted him as a commander-at-arms . Many versions of this painting were made in Bronzino's workshop to satisfy the Duke's need for replicas of his state portrait (cat. no. 11).[9] The dynastic theme is prominent in this work, which depicts the Medici *impresa* (device) of the evergreen laurel growing from the tree stump on which Cosimo rests his helmet, alluding to Cosimo as a new branch of the enduring Medici tree.

Sculptors were also pressed into service to portray the Duke. Baccio Bandinelli, who began to work for Cosimo in 1540, and Benvenuto Cellini, who returned to Florence in 1545 from the court of Francis I, king of France, were the most important of these, along with Niccolò Tribolo – not, however, a portraitist. They developed another effective mode of conveying ducal power: the portrait bust *all'antica*, in the style of busts of Roman emperors. Cellini's colossal bronze of 1545–47 (once gilded, with white enamel eyes) shows the Duke dressed in imaginary antique armor with bold details, the imperious turn of the head lending it a greater vivacity than

as well as dynastic power – a true counterpart to Bronzino's *Portrait of Duke Cosimo in Armor*.[18] As with the portraits of Cosimo, there are workshop replicas of Bronzino's portraits of Eleonora, including the one shown in the current exhibition (cat. no. 8). Bronzino painted another dynastic portrait of the duchess in 1549, this time with the Medici heir, known as Principe Francesco (cat. no. 9), and depicted her for the last time in 1556–57 – alone and ill with tuberculosis.[19]

The ducal couple was often portrayed together in various media. A large onyx cameo, designed by Vasari about 1557 (cat. no. 108) and executed by Giovanni Antonio de' Rossi, is a dynastic image of the youthfully idealized pair with five of their children (cat. no. 107). After Eleonora's death in 1562 and Cosimo's abdication in 1564 (he died in 1574), they were memorialized in pendant portraits commissioned by Francesco in 1572 for his Studiolo in the Palazzo Vecchio.[20]

DUKE COSIMO I DE' MEDICI AS PATRON OF ART

By 1539 – barely two years after his elevation to the dukedom – the twenty-year-old Cosimo had brought a group of painters, sculptors, and architects into his service, commissioning from them public monuments and decorations both permanent and ephemeral. Absent from this retinue was Michelangelo, Florence's greatest artist, who had departed for Rome in 1534, and the young Giorgio Vasari, who was to dominate the production of art for the Duke after 1555.

Cosimo's patronage was facilitated by his appointment of Pierfrancesco Riccio, first as his private secretary, then in 1545 as major-domo.[21] Responsible for most of the Duke's commissions, Riccio acted as intermediary with artists, encouraging competition among them and gathering around himself a clique – including Bandinelli, Tribolo, and Pontormo – dependent on him for commissions and access to the Duke. Those not favored had a difficult time at the court: Cellini fought an uphill battle for commissions and Francesco Salviati, probably called into the Duke's service in the hope that he would lend a Roman luster to Cosimo's decoration of the Palazzo Vecchio, remained only five years before returning to Rome in 1548.

The Duke's cultural patronage in general and of art in particular was fueled by a need to shore up his young regime and to legitimize his right to the Florentine dukedom. The first great opportunity for his *politica culturale* was the *apparato* (decoration) for his marriage to Eleonora in June 1539.[22] The team of artists who worked on these decorations would dominate his commissions in

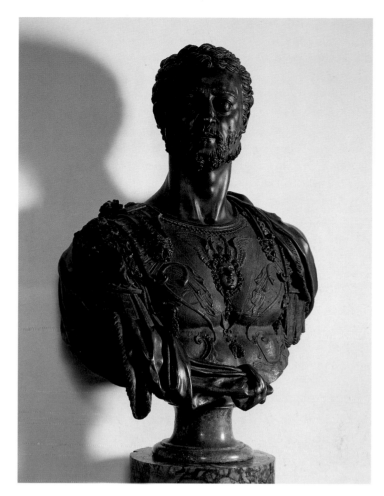

Fig. 22 Benvenuto Cellini, *Duke Cosimo I de' Medici*, 1545–47, bronze. Museo Nazionale del Bargello, Florence.

the 1540s: Niccolò Tribolo and Aristotile da Sangallo were the general directors; the major painters, besides Bronzino and Salviati, were Francesco Bacchiacca and Ridolfo Ghirlandaio.[23]

From 1539 onward Cosimo styled himself as a princely patron responsible for a restoration of the arts after a fallow period following the Siege of Florence in 1530 during the rule of Alessandro. By mid-century poets and painters celebrated Cosimo in this role. In 1559, for example, Vasari painted a *tondo*, *Duke Cosimo I de' Medici with His Architects, Engineers, and Sculptors*, in the room dedicated to Cosimo in the Quartiere di Leone X in the Palazzo Vecchio.[24] Vasari's Duke is a munificent prince, the very personification of Liberalitas, protector and inspirer of the arts (a notion that would later be formalized in the Accademia del Disegno). He is depicted in larger scale than his artists and is styled as an architect of a new golden age of the arts (even holding a compass and a T-square) – the first example of the topos of the Medici as architects.[25] Vasari included some of the artists whose works are shown in the current exhibition (although

Bronzino, his chief rival in painting, is absent). He shows himself in the role of architect, displaying a ground plan for rooms and a stairway in the Palazzo Vecchio, of which he was *capomaestro* (artistic director) after 1555. To the right of the Duke, Tribolo holds a model of his *Fountain of Hercules and Antaeus* in the garden of the Villa Castello. Just above Tribolo is Bartolomeo Ammanati, sculptor of the bronze *Hercules and Antaeus* atop Tribolo's fountain (cat. no. 47). Facing him in profile is Luca Martini, an engineer who was one of Cosimo's closest advisors and a friend of Bronzino, who portrayed him at about this time holding a map of his canal system for Pisa (cat. no. 16). To the left of Cosimo, the rival sculptors Bandinelli and Cellini, whose *Perseus* had recently been unveiled in the Piazza della Signoria, face one another in tense confrontation.

Commemorations of Cosimo as patron continued throughout his life. The reverses of the series of medals of 1567 by Galeotti mentioned above celebrated the Duke's important achievements, including monuments of architecture – the Laurentian Library, the Palazzo Pitti, and Vasari's Uffizi – and engineering – Florence's water supply, symbolized by Ammanati's *Fountain of Neptune* in the Piazza della Signoria with a zigzag aqueduct leading to it.[26]

Cosimo also institutionalized art and letters under his protection and supervision. In 1540 he supported the Accademia degli Umidi, whose members comprised the leading Florentine literati. This was transformed in 1541 into the Accademia Fiorentina, which was overtly dedicated to the glorification of the Duke and programmatically concerned with the promotion of the vernacular – a Tuscan language for a Tuscany united under Cosimo's *principato* (principate).[27] The process of bringing cultural life under ducal control reached a climax with Cosimo's foundation in 1563 of the Accademia del Disegno ("disegno" referring to both the act and the concept of drawing). This was a major expression of his *politica culturale*, the promotion of *disegno* being seen as analogous to that of the Tuscan vernacular, and both conceived as a means of unifying the state. Among other programmatic goals, the Accademia del Disegno united artists for the first time as a single community, reviving their old confraternity (the Compagnia di San Luca), and it was dedicated to their training and to theoretical discussion of artistic practice.[28] The importance of the Accademia for the organization of artists' activities is indicated by Vasari's conclusion of his *Lives of the Artists* of 1568 with a long section devoted to a number of living Florentine artists. These included Bronzino, Cellini (who submitted designs for the Academy's seal, cat. nos. 167 and 168), and Ammanati, all of whose biographies were subsumed under the title "On the Academicians of Drawing – Painters, Sculptors, and Architects and Their Works."[29]

The institution virtually sanctified Cosimo as protector of the arts and Michelangelo as its patron saint, proclaiming the artist "Guide, Father, and Maestro."[30] It vigorously promoted and controlled Michelangelo's work, such as the renovation of the New Sacristy at San Lorenzo, and events related to him, such as his funeral in 1564 and the funerary monument in Santa Croce, for which Giovanni Bandini made a terracotta model for the mourning figure of *Architecture* (cat. no. 52).[31]

THE TRANSFORMATION OF THE PALAZZO VECCHIO INTO THE PALAZZO DUCALE

The locus of Cosimo's patronage was the Palazzo della Signoria (today known as the Palazzo Vecchio, the name that will be used here), former seat of the Florentine Republican government, which he transformed into a lavishly decorated ducal residence.[32] There he commissioned works of art intended to legitimize his rule by analogy with heroes of the Old Testament (Moses, Joseph), with Roman emperors (Augustus) and generals (Camillus), and – later – with the gods of antiquity (Saturn, Jupiter).[33]

The first phase of the palace's decoration began after Cosimo's move there in 1540 and continued into the early 1550s. Work on the lower floor consisted of a transformation of the Salone dei Cinquecento, former Council Hall of the Florentine Republic. Within the hall was built Cosimo's Udienza (reception stage), a neoclassical dais with a triumphal arch, the niches of which were eventually filled with statues of famous members of the Medici family, mainly by Bandinelli.[34]

On the second floor work began with Eleonora's apartment, which was decorated by four of the artists who had contributed to the wedding *apparato*. In 1540–42 Ridolfo Ghirlandaio frescoed a reception room, known as the Camera Verde,[35] and after 1545 Salviati frescoed the ceiling of a tiny storeroom for valuables, with a depiction of Abundance (*Dovizia*) as its centerpiece.[36] The most important decoration in the apartment was that of its little chapel, entirely decorated by Bronzino in 1540–45 (fig. 23). Bronzino was the most influential painter in mid-sixteenth-century Florence and the most sophisticated artist to embody that highly self-conscious and elegant style known as the Maniera, a second phase of Mannerism that began in Florence about 1530, which Vasari called the *bella maniera* (beautiful style) and which has been aptly termed the "stylish style."[37] His decoration

of the Chapel of Eleonora was the first major work painted in this style.[38]

Bronzino frescoed the walls with *Stories of Moses: The Crossing of the Red Sea and Moses Appointing Joshua, The Brazen Serpent, Moses Striking the Rock,* and *The Gathering of Manna.* Multileveled political meanings were encoded in this decoration. Moses, who led his people to the promised land, was understood to allude to Cosimo, who would restore Medici Florence to its former glory, while the chapel as a whole celebrated the marriage of Cosimo and Eleonora and the birth in 1541 of their heir, Francesco. Aesthetically, the most justly celebrated part of the decoration is the altarpiece of the *Lamentation,* one of the masterpieces of the Florentine Maniera. Today in the Musée d'Art et d'Archéologie, Besançon, it was replaced by the artist himself with another version in 1553.

The preparatory studies for the chapel reveal the wide range of Bronzino's Maniera draftsmanship.[39] There is a compositional drawing for the vault[40] and a beautiful nude study for St. Michael (cat. no. 157), who appears over the altar. While he was decorating the chapel, Bronzino also painted an exquisite *Annunciation* on panel (cat. no. 12). Although almost miniaturist in scale and delicacy of technique, its style is similar to his work in the Chapel of Eleonora (it might also have been painted for the Duchess).

The next room undertaken on the second floor of the palace was Cosimo's audience hall, the Sala dell'Udienza.[41] In 1543–45 Salviati frescoed the east and south walls with *Stories of Camillus,* the Roman general whose triumphs Cosimo sought to emulate, and painted allegorical subjects relating to the Duke on the other two walls. Salviati's Romanized decorative and painterly style was very different from Bronzino's sculptural, more indigenous Florentine manner, and he included in these scenes landscape, virtually abandoned by his Florentine contemporaries. He was also a prolific and fluent Maniera draftsman and executed many pen-and-wash studies for these frescoes.[42] One (cat. no. 202) was for *Peace Burning Arms* over the doorway of the east wall between two of the Camillus scenes. This extravagantly decorative work maintains the room's themes of Peace and Justice, already embodied by a statue of *Justice* in a lunette over the same doorway made by Benedetto da Maiano during the time of the Republic.

Salviati's frescoes were complemented by decorative tapestries designed between 1546 and 1553 by Bacchiacca and hung on the lower walls.[43] These were woven in a tapestry workshop established by Cosimo in 1545, employing imported Flemish weavers. The audience hall's *Portiere* (doorway hangings), designed by Bronzino, are

allegories of Cosimo's rule: *Abundance* (cat. no. 138) alludes to Florence's prosperity, *Justice Freeing Innocence* to the Duke's "liberation" of the city, and *Spring* uses a Medici conceit of the return of spring as a symbol of the family's return to power.[44]

Other types of tapestry were produced in the ducal workshop. The Medici–Toledo *stemma* (coat-of-arms) was a favourite decorative and dynastic motif, as shown in an example by Benedetto Pagni da Pescia (cat. no. 140). Tapestries depicting sacred themes were woven from designs by Salviati, revealing the artist to be Bronzino's most important rival as a practitioner of the Maniera in sacred as well as secular art in the 1540s.[45]

But the Duke's most important tapestry commission was for the design of twenty large tapestries showing the *Story of Joseph* for the Sala dei Dugento in the Palazzo Vecchio, given to Bronzino, Pontormo, and Salviati.[46] Like the *Stories of Camillus* in the Sala dell'Udienza, the *Joseph* tapestries are a large-scale public cycle with a political subtext. They tell of Joseph, second founder of his line, whose epic was seen to parallel the history of Cosimo – a second Medici founder (after Cosimo il Vecchio) under whose rule Florence would regain her former glory. Like Joseph, Cosimo established a dynasty, founded a state, and ensured an orderly transfer of his power.[47]

The designers of the *Joseph* cycle achieved a remarkably homogeneous style and the tapestries are one of the major ensembles of the Florentine Maniera. Bronzino designed sixteen cartoons: some, such as *Benjamin Received by Joseph* (cat. no. 139), had vertical formats perfectly suited to the Maniera artist's predilection for rising compositions using the *figura serpentinata* – an attenuated figure of flame-like torsion invented by Michelangelo. Others were square in format, such as *Joseph Telling His Dream of the Sun, Moon, and Stars,* for which there is a compositional study. Three tapestries were assigned to Pontormo, whose designs for two vertical tapestries feature the *figura serpentinata.*[48] Apparently they did not please the Duke and Pontormo left the project, having won a coveted commission to fresco the choir of San Lorenzo (see below). Salviati contributed only one tapestry, *Joseph Explaining the Pharoah's Dream,*[49] before his return to Rome in 1548. The *Joseph* cycle makes it abundantly clear that in the 1540s Cosimo privileged the flexible and stylish visual language of the Maniera to promote his concept of his rule and destiny. This style would remain a hallmark of the art of his court in subsequent years.

The second phase of the decoration of the Palazzo Vecchio and of Cosimo's patronage began in 1555 when

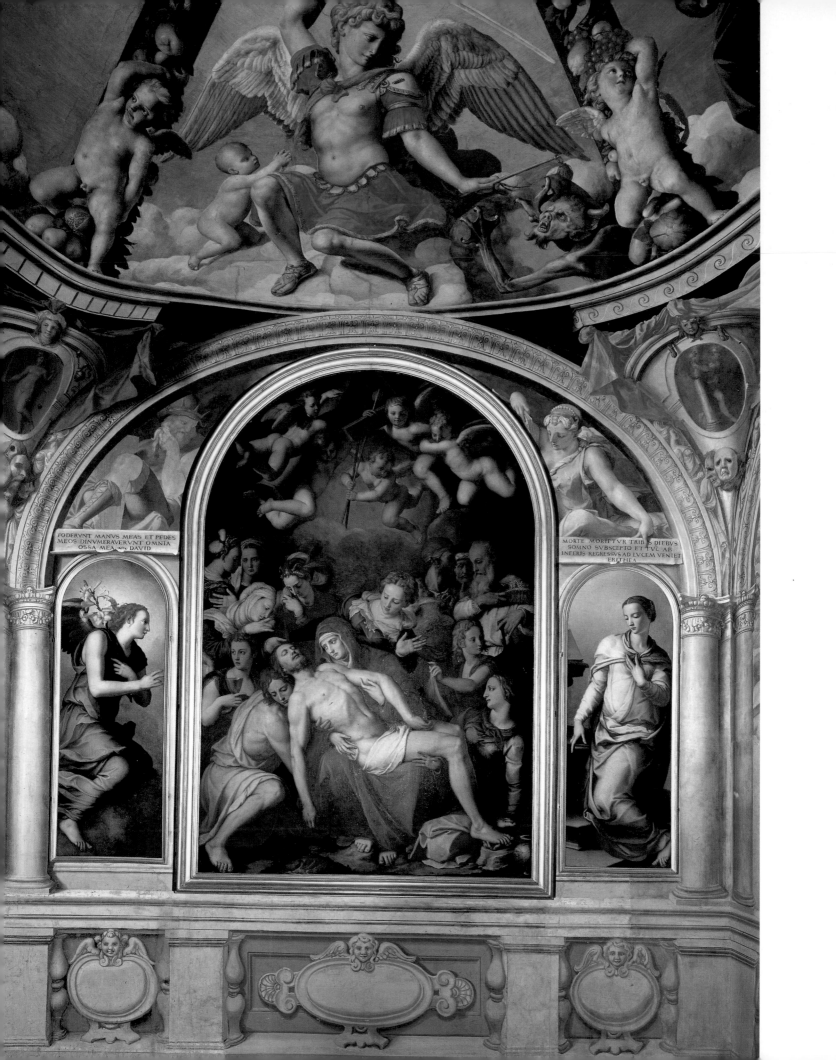

FODERVNT MANVS MEAS ET PEDES
MEOS DINVMERAVERVNT OMNIA
OSSA MEA. ... DAVID

MORTE MORIETVR TRIBVS DIEBVS
SOMNO SVSCEPTO ET TVC AB
INFERIS REGRESSVS AD LVCEM VENIET
ERITHEA

he appointed Vasari *capomaestro* of the works in the palace. Vasari was to direct a campaign of decoration much larger in scale and complexity than that of the 1540s, one which also contrasted with the first in other ways. Bronzino's frescoes and Salviati's tapestry designs depended mainly on narratives encoded with political meaning. Vasari, however, developed an accommodating and expandable style that could combine narratives and personifications as demanded by the occasion – and the whim of the Duke. The increasingly politicized art of this phase also had a pronounced literary component. It was characterized by complex programmatic inventions devised by Vasari's learned antiquarian advisers Cosimo Bartoli and Vincenzo Borghini. Moreover, it had a literary legacy. In his *Ragionamenti*, a fictitious dialog with Francesco I, Vasari presented Cosimo as an ideal ruler and princely patron, glossing his painted decorations and detailing their political significance in relation to the Duke's rule.[50] He emphasizes the Medicean meanings (calling them "il senso nostro") of the decorations of the first floor (Quartiere di Leone X), which celebrate the family's history, and those of the second floor (Quartiere degli Elementi), which depict a genealogy of the gods. The upper rooms allude, Vasari says, to the historical narratives of the floor below, creating, as he puts it, a "doppio orditura" (double order) of the two floors that equates the "dei terrestre" (the Medici) with the "dei celesti" (the gods).

Vasari's Quartiere di Leone X (1555–59) consists of a series of rooms dedicated to the illustrious Medici leaders of fifteenth-century Florence: Cosimo il Vecchio and Lorenzo il Magnifico; the two Medici popes, Leo X and Clement VII; Cosimo's father Giovanni delle Bande Nere; and, of course, the Duke himself.[51] Vasari made compositional studies for all these decorations, some with inscriptions identifying the persons represented and Latin mottoes explicating the meanings of the scenes. Among these is a large and precisely detailed compositional study for the ceiling of the Sala di Giovanni delle Bande Nere (cat. no. 212) – a classic example of Vasari's style, combining narratives of Giovanni's victories in battle and appropriate allegorical personifications, such as Fortezza.

On the floor above, the most grandiose room of the Quartiere degli Elementi is the Sala degli Elementi, decorated between 1555 and 1557, the only room signaled as referring personally to Cosimo, whose *imprese* are painted on the ceiling.[52] Punning on the wordplay Cosimo/Cosmos, Vasari celebrated the Duke's dominion through an alchemical scheme based on Air, Earth, Fire, and Water, with a wall devoted to each. The Fire wall depicts *The Forge of Vulcan* (over the fireplace), for which there is a preparatory drawing (cat. no. 210), but Cosimo

is most specifically celebrated in *The First Fruits of the Earth Offered to Saturn*, for which Vasari made a large compositional drawing (cat. no. 209). A tableau of the golden age of Saturn, it draws on the conceit of Cosimo as Saturn, planetary ruler of the sign of Capricorn, which is represented by the goat seated below Saturn–Cosimo, which holds a red *palla* (ball) from the Medici coat-of-arms.[53]

The last and most ambitious element in this second phase of work on the palace was the redecoration of the Salone dei Cinquecento (1563–65) with myriad paintings that sum up Cosimo's accomplishments. The wall frescoes depict Florence's military victories and the extension of her power to all of Tuscany under Cosimo, and the compartmentalized ceiling contains (among other subjects) scenes of Tuscan history and allegories of ducal territories.[54] The great *tondo* at the center of the ceiling, *The Apotheosis of Duke Cosimo I de' Medici*, is described by Vasari as "the key and conclusion to the histories in this room."[55] Cosimo, "triumphant and glorious," achieves immortality in the heavens as Divus Augustus, encircled by the *stemme* of the Florentine guilds and crowned with an Augustan oak wreath by a personification of Florence, while a *putto* holds up his grand-ducal crown.

Further works of art, installed for the inauguration of the Salone in 1565 on the occasion of Principe Francesco's marriage to Giovanna of Austria, portrayed the theme of military conquest in a typical Vasarian juxtaposition of narratives and personifications. Two sculptures, larger than life-size, both based on the Maniera motif of the *figura serpentinata*, were introduced, while large canvases depicting Republican Florence's victory over Pisa and ducal Florence's over Siena hung on the walls above them.[56] Michelangelo's marble *Victory* of 1532–34, executed for the tomb of Julius II but only recently acquired by Cosimo, was placed below the scene of the Duke's victorious annexation of Siena in 1555, while Giambologna's plaster model for *Florence Victorious over Pisa*, inspired by Michelangelo's sculpture, was commissioned for the occasion.[57] Cosimo thus assimilated the *Victory*, executed by Michelangelo for a great papal commission, in a celebration of his own personal victory.

VILLA DECORATION

In 1537 Cosimo initiated a grandiose scheme for the embellishment of the old Villa Castello, home of his mother Maria Salviati and one of the Medici villas depicted in Giusto Utens' series of panoramic views of 1599 (cat. no. 40). The artist chosen for the decoration of the villa's loggia was Pontormo, an experienced fresco

Fig. 23 Agnolo Bronzino, Chapel of Eleonora of Toledo, 1540–45. Palazzo Vecchio, Florence.

painter who in 1536 had decorated a loggia at the Villa Careggi for Duke Alessandro (destroyed).[58] Earlier he had painted the lunette of *Vertumnus and Pomona* in the *salone* at the Villa Poggio a Caiano, and had been commissioned by Pope Clement VII in 1530 to complete the *salone's* unfinished decoration.[59] There is a study by Pontormo of a reclining nude woman (cat. no. 197) for a *Venus and Adonis* planned for this decoration. This black-chalk drawing, of pronounced Michelangelesque character, recalls Michelangelo's famous cartoon of *Venus and Cupid* (1533), which Pontormo, always closely linked with the master, had used for a painting for the bedchamber of the Florentine banker, Bartolommeo Bettini.[60]

Pontormo's frescoes in the Castello loggia depicted personifications of the liberal arts and alluded to a revival under Cosimo – a new Augustus. Here, as elsewhere in works commissioned by Cosimo, these conceits were expressed by depictions of planetary gods such as Mars and Saturn, whose aspects in Cosimo's horoscope were seen to predict his exalted astrological destiny and to link him with the Roman emperor.[61] Like that at Careggi, this important decoration was destroyed, but a number of preparatory studies record its imagery. One in red chalk shows an elegant reclining nude, possibly for Mars hermaphrodite (cat. no. 198).[62]

Sculptures in the gardens of the Villa Castello also focused on the theme of the return of a golden age (a topos of Renaissance garden design) under Cosimo's rule. The project was entrusted to Tribolo, whose *Fountain of Hercules and Antaeus* included a marble base with two sets of playful *putti*, strikingly similar to those on Bronzino's contemporaneous vault of the Chapel of Eleonora – four seated to support the basin like caryatids, and four – one holding a goose – dancing around the drum above (cat. no. 89).[63]

CHURCH DECORATION

In the mid-1540s, with the first campaign for the transformation of the Palazzo Vecchio into a ducal residence underway, Cosimo shifted his attention to the adjacent piazza (see below), and to the embellishment of certain Florentine churches. Although he commissioned Bandinelli to design and make sculptures for a new choir for the Duomo in 1547,[64] he naturally turned first to the Medici church of San Lorenzo, which was the central focus of his church patronage. In 1540, still concerned with legitimizing his claim to the dukedom, Cosimo commissioned from Bandinelli a monument to his father.[65] Originally intended for Giovanni delle Bande Nere's tomb in the church, but now located outside it,

in the Piazza San Lorenzo, the marble statue shows him as a general, dressed *all'antica* with reliefs of his military victories set into the high base.

The next project undertaken on Cosimo's initiative at San Lorenzo was located in the New Sacristy (the Medici Chapel).[66] The effigies and the *Times of Day* that Michelangelo had executed after 1520 for the tombs of Lorenzo the Younger and Giuliano de' Medici, as well as the *Madonna and Child* that was to surmount the tombs of the Magnifici (Lorenzo il Magnifico and his brother Giuliano) opposite the altar, had not been installed when the sculptor departed for Rome in 1534. A copy of his design shows his intended placement of the sculptures for the tombs, never completed as planned (cat. no. 182). In 1545, under the direction of Tribolo, the marbles were finally put in place, and the chapel became accessible to artists. Salviati studied the *Dawn* in the late 1540s, probably as one of a series recording the installation (cat. no. 200). The chapel was a mecca for artists, as is suggested by Federico Zuccaro's drawing from the late 1560s or 1570s of a lively group sketching there (cat. no. 215). As Vasari, writing of the artists who were finishing the chapel, said in a letter to Michelangelo, "there is not one of them who didn't learn everything he knows in this sacristy."[67]

At about the same time Michelangelo's sculptures were installed in the New Sacristy, Cosimo commissioned frescoes in the choir of San Lorenzo, the most important church decoration of his rule. Its significance for the Medici cannot be overestimated, for no frescoes had been painted in their church in the century since Brunelleschi's austere interior had been completed. Clement VII had attempted to persuade both Bandinelli and Michelangelo to undertake the decoration of the Cappella Maggiore, and Salviati competed for the prestigious commission in 1545, but his decorative manner did not appeal to Cosimo, who must have contemplated for this conspicuous Medicean space a Florentine response to Michelangelo's recently completed *Last Judgment* in the Sistine Chapel.[68] The prize, then, was awarded to Pontormo, Michelangelo's most profound Florentine interpreter.

Pontormo devoted the last decade of his life to the frescoes, which depict scenes of the history of humanity from the Creation to the Last Judgment. As in Michelangelo's *Last Judgment*, the program for this cycle drew on the ideas of Church Reformers, the *spirituali* who followed the doctrine of Justification by Faith Alone.[69] Pontormo's frescoes have been destroyed, but an etching of the choir as decorated for the funeral of Philip IV of Spain in 1598 shows (in reverse) the upper end wall over the altar with *The Fall of Adam and Eve, Christ in Glory and the Creation of Eve*, and *The Expulsion* (the lower

register is draped with funerary hangings). Pontormo left about thirty highly expressive black-chalk drawings for the work, mostly of nude figures, which leave no doubt as to its highly Michelangelesque character.[70] Three of these are exhibited here (cat. no. 199), of which a drawing of a mass of knotted nudes for a small section of the *Resurrection of the Dead* on the right lower wall (a large area unbroken by windows), must have vividly evoked Michelangelo's great fresco.

Pontormo's choir decoration also featured a *Martyrdom of St. Lawrence*, titular saint of the church. In 1565 Cosimo commissioned Bronzino to paint an enormous fresco of the same subject on the left nave wall of the church, which was unveiled on the feast day of the saint, 10 August 1569 (fig. 24).[71] The stylistic language is again that of Michelangelo, but with a more academic accent than Pontormo shows, and the two works must have been seen as antipodes of Michelangelism. The fresco by Bronzino, the leading painter of the Accademia (save Vasari), is a gigantic demonstration piece of academic painting. There are twenty-seven nudes, some quoted from Michelangelo's sculptures in the Medici Chapel, as his study for one figure clearly demonstrates (cat. no. 158).

Cosimo's last great church project was the ambitious modernization and decoration of the two large late medieval mendicant churches of the rival Dominican and Franciscan orders – Santa Maria Novella and Santa Croce.[72] In 1565 Cosimo commissioned Vasari to direct their reconstruction, which involved tearing down the old monks' choirs to create vast naves with unobstructed views of the pulpit and high altar, and building identical chapels in the style of tabernacles along the nave walls. With Borghini as advisor, the artists and subjects of the altarpieces were chosen according to a rigorously organized aesthetic and post-Tridentine theological program that reflected the Duke's political positioning in relation to the Pope and to the edicts of the Council of Trent (1545–63). The paintings were by younger members of the Accademia, and all were in the prevailing sober, classicizing style, bringing Cosimo's cultural and political programs into tight accord under his centralized authority.

THE DECORATION OF THE PIAZZA DELLA SIGNORIA

Turning to the old civic center of the Florentine Republic, some of Cosimo's most important and enduring contributions as patron of sculpture and architecture were in and near the Piazza della Signoria. This highly symbolic and politically charged space was already populated by sculptures relating to Florence's government and rulership. These, and later sculptures, are shown in

Fig. 24 Agnolo Bronzino, *Martyrdom of St. Lawrence*, 1565–69, fresco. San Lorenzo, Florence.

Bernardino Gaffurri and Jaques Bylivelt's large oval relief in gold and *pietre dure* (hard stone) depicting the piazza as it appeared at the end of the sixteenth century (cat. no. 114).

Donatello's *Judith with the Head of Holofernes*, Michelangelo's *David*, and Bandinelli's *Hercules and Cacus* had long been in place when Cosimo commissioned Cellini's *Perseus with the Head of Medusa* in 1545, which can be seen in the left arch of the Loggia dei Lanzi in Gaffurri's relief.[73] Perseus was to be read as Cosimo, who rescues Florence as the son of Jupiter had rescued Andromeda. But the statue also echoes Donatello's *Judith*: Cellini's Perseus, who holds up to the Florentines his apotropaic Medusa-head trophy, is a warning of the consequences of rebellion. As so often in Maniera art, violent themes are linked with forms of extraordinary beauty, and Cellini's lithe bronze, with its highly decorated base, is the epitome of Maniera decorative elegance. Cellini worked on this group, probably Cosimo's most important sculptural commission, for almost a decade, making many preparatory *bozzetti* (sketches), including a bronze statuette of the whole (cat. no. 57) and a bronze model for the head of Medusa (cat. no. 58).

To the left in Gaffurri's relief, at the corner of the Palazzo Vecchio, is Ammanati's *Fountain of Neptune*, com-

missioned by Cosimo in 1562 and partially installed for the wedding of Principe Francesco in 1565. Neptune, god of the Ocean, was an apt choice for a fountain that not only celebrated the Duke's rule but also commemorated his introduction of a water supply to Florence.

In the far background is Vasari's monumental Uffizi and its piazza, built to house the governmental offices of the Cosimo's newly centralized bureaucracy.[74] Commissioned in 1560, the building suggests a kind of Augustan forum for the Duke,[75] a theme made explicit in Vincenzo Danti's *Cosimo as Augustus–Hercules* (1571–73), originally installed high on the cross-arm of the façade and portraying Cosimo in his Augustan guise for the first time on a public monument.[76] The Uffizi's piazza was also the subject of one of Galeotti's medals, inscribed PVBLICAE COMMODITATI and showing a personification of Justice–Abundance standing in Vasari's grand public space with the Palazzo della Signoria in the background (cat. no. 98k reverse). The Piazza della Signoria and its buildings and sculptures are seen in the foreground of Gaffurri's relief from a vantage point just in front of Giambologna's equestrian statue, *Grand Duke Cosimo I de' Medici*, a work of imperial grandeur installed in 1595 by his second son, Grand Duke Ferdinando, and already dominating the civic center of the city.[77]

NOTES

1. "All'Ill.mo ed Ecc.mo Signore Il Signor Cosimo de' Medici, Duca di Fiorenza: . . . non pure col vostro aiuto e favore uscirono da prima ed ora di nuovo in luce, ma siete voi, ad imitazione degli avoli vostri, solo padre, signore ed unico protettore di esse nostre arti? Onde è bene degna e ragionevole cosa, che da quelle sieno fatte in vostro servigio, ed a vostra eterna e perpetua memoria, tante pitture e statue nobilissime, e tanti maravigliosi edifizi de tutte le maniere." Vasari 1568, vol. 1, p. 6 (author's translation).

2. From the vast bibliography on Cosimo's patronage, see the overview by Cochrane 1973, book 1, ch. 5, and bibliographical note, pp. 510–28. Most material on Cosimo as patron of art is found in studies devoted to particular artists and works: for example, Allegri and Cecchi 1980 (on the decoration of Palazzo Vecchio); Langedijk 1981–87, vol. 1, pp. 97–120 (on portraiture); Rubin 1995, pp. 197–215 (on the years after 1555, especially Vasari); Cox-Rearick 1993 (especially on the 1540s); and Costamagna 1994 and Pilliod 2001, pp. 11–42 (both on Pontormo). For Cosimo's personal imagery (including astrological), see Richelson 1978; Cox-Rearick 1984, pp. 228–91; Rousseau 1985; and Cox-Rearick 1993. For works of art of all types commissioned by Cosimo, see

Palazzo Vecchio 1980 (the only exhibition before the current one in which a wide range of such works was exhibited).

3. For Eleonora's patronage, see Edelstein 1995; Smyth 1997, pp. 72–98; Hoppe 1999, pp. 227–45, 279–81; Edelstein 2000, pp. 295–319; and Edelstein 2001a, pp. 225–61.

4. Commisions for works of art in Tuscan cities outside Florence and diplomatic gifts of art works are not included; also omitted (or not detailed) are areas of ducal patronage such as ephemera (especially triumphal entrances), medals, jewelry, objects in precious hard stones, and villa design and gardens, which are treated in other essays in this volume.

5. For portraits of the Duke, see Forster 1971, 65–104; Simon 1982; Langedijk 1981–87, vol. 1, pp. 407–530 and no. 27.

6. Florence, Galleria degli Uffizi; see Langedijk 1981–87, no. 27,46.12.

7. This work, long known simply as *Portrait of a Halberdier*, is identified by Cropper 1997 as Francesco Guardi, a republican solider. For the identification as Cosimo, see Simon 1982, pp. 170–87; Langedijk 1981–87, no. 27,50; Cox-Rearick 1989; and Costamagna 1994, no. 76.

8. For the medal, see Langedijk 1981–87, no. 27,163.

9. See Simon 1983, pp. 527–39.

10. See Langedijk 1981–87, no. 27,127; Avery and Barbaglia 1981, no. 41; and Pope-Hennessy 1985,

pp. 215–17.

11. Florence, Museo Nazionale del Bargello; see Langedijk 1981–87, no. 27,105.

12. Turin, Galleria Sabauda (autograph replica); see Langedijk 1981–87, no. 27,36; Simon 1982, pp. 151–58, no. B25.

13. See Langedijk 1981–87, no. 27,33; and Simon 1982, pp. 159–62, no. C1–31.

14. An exception is a series of busts made for overdoors by Giovanni Bandini in 1572, which show the Duke draped *all'antica*, but with the regalia relegated to the framing elements. See Langedijk 1981–87, no. 27,112–17, showing the grand-ducal crown held over the Duke's head, the chain and emblem of the Golden Fleece below.

15. See Langedijk 1981–87, no. 27,43; for other grand-ducal portraits, see nos. 27,40–42 and 27,47–49.

16. For the portraits of Eleonora, see Langedijk 1981–87, no. 35; Cox-Rearick 1993, pp. 36–53, and her book-in-progress, *Bronzino and Eleonora di Toledo: Portraiture and Costume at the Medici Court*.

17. See Langedijk 1981–87, no. 35,10f; and Cox-Rearick 1993, p. 36.

18. See Cox-Rearick 1993, p. 37 (with bib.); and Langdon 1994, chap. 5. Contemporaneous with this portrait are bronze busts by Bandinelli of Cosimo and Eleonora (Florence, Museo Nazionale del Bargello; see Langedijk 1981–87, nos. 27,104

and 25,23).

19. Washington, National Gallery (workshop replica); see Langedijk 1981–87, no. 35,14.

20. See Langedijk 1981–87, nos. 27,182 and 35,38 (as Bronzino school); Simon 1982, pp. 344–45; Allegri and Cecchi 1980, p. 327; Lecchini Giovannoni 1991, nos. 190–91; Cox-Rearick 1993, pp. 52–53 (all as by Allori). For the decoration of the Studiolo, see Feinberg's essay in this volume.

21. See Cox-Rearick 1993; and Cecchi 1998a, pp. 115–43.

22. See Cox-Rearick 1993, pp. 22–33, and the essay by Testaverde in this volume.

23. Pontormo, an important painter in the Duke's service, was not among those employed on the wedding *apparato* or, for that matter, on the decorations in the Palazzo Vecchio, begun the next year. This was simply because in 1537 Cosimo had commissioned him to paint the decorations at the Villa Castello, which occupied this notoriously slow worker until 1543 (see below).

24. See Kerwin 1971, pp. 105–22; and Allegri and Cecchi 1980, p. 145.

25. See Langedijk 1981–87, vol. 1, pp. 139–74.

26. See Langedijk 1981–87, no. 27,146.

27. See Plaisance 1972, pp. 361–438; and Plaisance 1974, pp. 149–242.

28. For the Accademia del Disegno under Cosimo, see Waźbiński 1987; and Barzman

2000, pp. 23–59.

29. "Degli accademici del disegno, pittori, scultori ed architetti e delle opere loro." See Vasari 1568, vol. 7, pp. 593–641. Only his own biography followed this section.

30. "Guida, Padre e Maestro." Quoted in Waźbiński 1987, vol. 1, p. 86.

31. See Waźbiński 1987, vol. 1, pp. 75–110 and 155–76, on the Accademia and Michelangelo.

32. The palace was known from 1540 to 1569 as the Palazzo Ducale and until the end of the Medici dynasty in the eighteenth century as the Palazzo Granducale.

33. See Allegri and Cecchi 1980, pp. 33–37.

34. For Cosimo and Eleonora's patronage of Bandinelli, see Cox-Rearick 1993, pp. 155–78.

35. See Allegri and Cecchi 1980, pp. 30–31; and Edelstein 1995, pp. 188–205.

36. See Allegri and Cecchi 1980, p. 48; and Edelstein 1995, pp. 217–54.

37. By Shearman 1965, p. 19.

38. See Allegri and Cecchi 1980, pp. 21–29; Cox-Rearick 1993; and Edelstein 1995, pp. 295–398.

39. See Cox-Rearick 1971, pp. 7–22.

40. See Edelstein 2001b.

41. See Allegri and Cecchi 1980, pp. 40–47; and A. Cecchi in Monbeig Goguel 1998, pp. 61–63.

42. See Monbeig Goguel 1998, nos. 54–58.

43. Florence, Soprintendenze alle Gallerie. See Adelson 1980, pp. 141–200; and Meoni 1998, nos. 24–33.

44. Florence, Palazzo Pitti,

Deposito Arazzi. On the foundation of tapestry production in Florence and these early tapestries, see Adelson 1983, pp. 899–924; and Meoni 1998, nos. 20–21.

45. For Salviati's Lamentation, Florence, Galleria degli Uffizi, see C. Adelson in Monbeig Goguel 1998, cat. 117; and Meoni 1998, no. 15.

46. The cartoons were finished in 1549 and the weaving was completed in 1553. See Adelson 1985, pp. 145–177; and Meoni 1998, nos. 1–10 (those of the series that are in Florentine museums).

47. See Smith 1982a, pp. 183–96; and Cox-Rearick 1993, pp. 291–92.

48. All in Rome, Palazzo Quirinale, see Costamagna 1994, p. 92 and nos. 81–83.

49. See C. Adelson in Monbeig Goguel 1998, cat. 120; and Meoni 1998, no. 4.

50. See "Ragionamenti sopra le invenzioni delle storie dipinte ne le stanze del Palazzo Ducale," in Vasari 1568, vol. 13, pp. 9–225 (published only in 1588 with a dedication to Cosimo's son, Grand Duke Ferdinando). For political meanings in the "Ragionamenti" see McGrath 1985, pp. 117–34; and Tinagli 2001, pp. 63–76 (with bib.).

51. See Allegri and Cecchi 1980, pp. 114–60.

52. See Allegri and Cecchi 1980, pp. 63–73.

53. See Cox-Rearick 1984, pp. 276–78.

54. See Allegri and Cecchi 1980, pp. 235–55; and Starn and Partridge 1993, pp. 151–212. Recent studies include Williams

1998; Scorza 1998; and Van Veen 1998.

55. "...la chiave e la conclusione delle storie in questa sala." See the "Ragionamenti" in Vasari 1878–85, vol. 7, p. 20.

56. From 1567 to 1571 Vasari painted frescoes of these subjects on the walls of the Salone. See Allegri and Cecchi 1980, pp. 256–67.

57. As a result of Vasari's efforts, Michelangelo's nephew presented the Victory to Cosimo after the master's death in 1564. For the two sculptures, see Allegri and Cecchi 1980, pp. 268–73; and D. Heikamp in Palazzo Vecchio 1980, nos. 645 and 673. For the installation and its significance, see Heikamp 1980, pp. 208–10; and Campbell 1983, pp. 826–27.

58. See Cox-Rearick 1981, pp. 287–92, nos. 312–20; and Costamagna 1994, p. 85.

59. See Cox-Rearick 1981, pp. 282–87; and Costamagna 1994, p. 85.

60. See Costamagna 1994, cat. 70.

61. See Cox-Rearick 1984, pp. 253–83.

62. See Cox-Rearick 1981, pp. 302–08, nos. 336–44; and Costamagna 1994, pp. 90–91, no. 78, for the project and other studies for it.

63. See Conti 1989.

64. For this aborted project Bandinelli executed marble reliefs of prophets to form a choir screen and monumental marble statues, of which the most important is the Dead Christ with an Angel now in Santa Croce. See Heikamp 1964, pp. 32–43.

65. See D. Heikamp in Palazzo

Vecchio, no. 648; and Langedijk 1981–87, no. 56,19.

66. For the Medici Chapel under Duke Cosimo, see Waźbiński 1987, vol. 1, pp. 75–110.

67. "...poiché non ci è nessuno di loro che in questa sagrestia non abbi inparato quel che sa." See Frey 1923–40, vol. 1, p. 739. Vasari often referred to "la scuola della Cappella"; see Waźbiński 1987, vol. 1, pp. 89–95.

68. As argued by Costamagna 1994, pp. 94–95.

69. For this aspect of Pontormo's work, which is beyond the scope of this essay, see Costamagna 1994, pp. 92–93. Other recent literature on this subject includes Trento 1992, pp. 143–44; Simoncelli 1995; Firpo 1997; and Cialoni 1998.

70. For these, see Cox-Rearick 1981, pp. 318–42, nos. 350–79; see also Cox-Rearick 1992, pp. 238–39; Costamagna 1994, no. 85; and Falciani 1996, pp. 163–210.

71. See Waźbiński 1987, vol. 1, pp. 197–213.

72. See Hall 1979; and Waźbiński 1987, vol. 1, pp. 357–79.

73. See Avery and Barbaglia 1981, nos. 57–63; and Pope-Hennessy, 1985, pp. 163–86.

74. See Crum 1989.

75. See Kauffmann 1967.

76. Florence, Museo Nazionale del Bargello; see Langedijk 1981–87, no. 27,130; D. Heikamp in Palazzo Vecchio 1980, no. 668; and Cox-Rearick 1984, p. 282. A replacement statue of Cosimo by Giambologna was later installed there.

77. See Gibbons 2001.

THE STUDIOLO OF FRANCESCO I RECONSIDERED

Larry J. Feinberg

In a fit of patronage both self-indulgent and practical, Francesco I de' Medici commissioned in the winter of 1569–70 the decoration of the small room that would become his principal legacy – the so-called Studiolo in the Palazzo Vecchio in Florence (fig. 25). The Studiolo was not, as its name implies in English, a study, but served as a vault room for the young prince's collection of small, precious, unusual, and rare objects – similar to what was known in northern Europe as a *Wunderkammer*.[1] In contrast to the immense public Sala Grande created by his father, Cosimo I, which was painted with historical scenes by an army of artists to serve a grandiose political agenda, the adjoining Studiolo was a private retreat for the introverted and restless Francesco, who was less dedicated to statecraft than to scientific and aesthetic pursuits. His myriad interests ranged from alchemy to zoology, and included such fields as geology, glass-making, and metallurgy. In the Medici laboratories (located at first in the Palazzo Vecchio, the Medici's main residence, but later transferred to the Boboli Gardens, and eventually to the Uffizi and Casino di San Marco), Francesco conducted countless metallurgical and pharmaceutical experiments.[2] There, as well, according to the contemporary accounts of foreign visitors, he discovered ways to revive the luster of pearls, developed new types of porcelain, and carried out research into crystals. His predilection for semi-precious and other stones led to his founding of the *pietre dure* (hard stone) industry in Florence.

In order to store some of the most important ingredients and products of these enterprises, Francesco engaged the architect and painter Giorgio Vasari to create a room similar to one fashioned for Cosimo I years earlier, the Sala delle Carte Geografiche (begun 1563), where the senior Medici had cabinets painted with maps that indicated the place of origin of their contents. With the schol-

arly aid of Vincenzo Borghini, the learned prior of the Ospedale degli Innocenti and first lieutenant of the artists' academy in Florence, Vasari devised an elaborate decorative program for Francesco's vault room, which had as its principal theme the dynamic relationship between art and nature. These dual, transformative forces that produced Francesco's treasures, were in turn related, through personifications in the Studiolo's ceiling frescoes, to the four elements, the four seasons, and the four temperaments.

Organized mainly according to their affiliations with the four elements – the Pythagorean tetrad of earth, air, fire, and water – Francesco's objects were deposited in nineteen cupboards distributed along the four walls. The north wall was assigned to fire, the east to earth, the south to water, and the west to air. Covering or adjacent to each cabinet was a panel with a representation of a scene – religious, mythological, historical, or industrial – that in some way referred to the cupboard's content. For example, Butteri's painting the *Discovery of Glass* adorned the door to the cabinet in which Francesco placed his prized samples of glasswork, ancient and contemporary. Because heat is required for glass-blowing, the glass objects and the Butteri painting were installed on the fire wall. Pearls, coral, and other objects associated with the sea were kept in cabinets on the water wall, behind or near related panel paintings. In all, thirty-four of these pictures adorned the Studiolo, set in two registers, punctuated by eight pieces of bronze mythological statuary, beneath the intricately painted ceiling and frozen gazes of portraits of Francesco's parents, Cosimo and Eleonora of Toledo. Presiding over the ensemble, at the apex of the ceiling, was (and is) Francesco Poppi's depiction of Prometheus, the mythological champion of mankind, who gave fire to the human race, spurring its technological advance.

Fig. 25 View into the Studiolo of Francesco I. Palazzo Vecchio, Florence.

Thirty-one of the more (and less) gifted artists of late Renaissance Florence participated in the decoration: twenty-three painters – including Poppi, who contributed two panels in addition to frescoing the ceiling – and eight different sculptors, Giambologna among them.[3] Consequently, the Studiolo became not only a room for examining Francesco's collection of remarkable specimens of nature and handicraft, but a kind of intimate *salon*, featuring the works of the young members of the relatively new artists' academy, and showcasing virtually all the trends of painting then current in Florence.

Although the Studiolo still exudes today much of its original opulence, the room no longer contains its valued collection of objects and specimens, nor do the paintings assume their intended arrangement. In 1586, only eleven years after the room was fitted out, Francesco had it dismantled, transferring at least half a dozen of the art works to the newly finished Tribuna of the Uffizi. For over three centuries, the decorations of the Studiolo remained dispersed, their original function and importance largely forgotten. Then, in 1908, the historian Giovanni Poggi came across a series of letters in the Rasponi Spinelli Archive concerning the Studiolo, written by Borghini to Vasari between 9 August and 5 October 1570.[4] The six letters, accompanied by two *invenzioni* (iconographic schemes), permitted Poggi to locate the forty-two dismembered parts of the decoration and to identify the room, its vault frescoes, niches, and cupboards (in the lower registers of the walls) still relatively undisturbed. On the basis of Borghini's *invenzioni* and letters, Poggi was able to situate the eight bronzes correctly and to confirm that the room had contained only the thirty-four panels he had reassembled and no more. But the documents did not elucidate the precise disposition of the paintings. For this, the *invenzioni*, written by Borghini before the final scheme was determined, offered only general guidelines:

> I think the program should *conform to the substance and quality* of the things that will be placed there, so as to make the room pleasing and not wholly inappropriate. Indeed, it should serve partly as *an indication and classification for finding things*, the statues and paintings above and upon the cupboards alluding in some way to their contents . . . Considering that such things are the work of neither nature nor art alone, but a little of each, the one helping the other . . . I thought that the whole program might be dedicated to nature and art, with statues representing the inventors or the cause or . . . teachers and provosts of nature's treasures, and narrative paintings that would also show their diversity and skill.[5]

Consequently, Poggi's arrangement of the paintings, based on intelligent guesswork, nevertheless entailed a number of discrepancies, iconographical and otherwise, not least of which was, for the late sixteenth century, an uncharacteristic asymmetry caused by two disturbing spaces in the lower register of two of the walls, filled by Poggi with wooden panels.

To this day, Poggi's reconstruction of the Studiolo has not been altered, despite the discovery some twenty years ago of a document that sheds additional light on the room's organization. In 1981, Michael Rinehart published a newly discovered sheet of Borghini's notes for the Studiolo, which listed some of the materials and objects that Francesco planned to store in the room and also provided a preliminary list of subjects for the paintings.[6] Although jotted during one of the early planning stages of the Studiolo, the document afforded two important pieces of information concerning the room's arrangement: painters were almost always assigned pairs of pictures, which were installed together vertically; and the room originally contained a large *studiolo* – a cabinet or desk, probably with numerous compartments and a dropfront on which to place and examine objects.[7] Pointing to a cornice that extends across two panel widths at the center of the south (water) wall, Rinehart astutely proposed that the cabinet at one time occupied the lower part of that wall, thus accounting for the extra, unadorned spaces in the room.

As concerns the assignment of pictures, it stands to reason that Vasari would have charged each artist to paint contiguous panels (one rectangular, one oval) to ensure some stylistic consistency and for the sake of expediency. And since vertically adjoining panels alluded to related materials that would have shared a cupboard (behind the lower panel), it seems likely that Borghini would have previously conceived and then dictated the subjects to Vasari in such pairs. In the document found by Rinehart, Borghini also gave some tentative indications as to which paintings were to be installed on which walls. Rinehart relied on these clues to sort – by element and wall – the majority of pictures, and was further able to surmise, through iconographical association, which pictures were connected with and installed beneath the eight sculptures.[8] He observed also that some of the oval pictures of the lower register are markedly wider than others and that the placement of these works would have to reflect and continue the rhythmic scheme established in the end (air and earth) walls, where wide panels are bracketed by narrow ones (in keeping with the niches above).[9] Thus, properly distributed across the Studiolo walls, the panels would create a symmetrical and rhythmic sequence of aba/abaccaba/aba/abaccaba in both the upper and lower registers.

Fig. 26 Santi di Tito, *Moses Parting the Red Sea*, ca. 1571–72, Studiolo of Francesco I. Palazzo Vecchio, Florence.

Fig. 27a Schematic plan of the Studiolo of Francesco I; proposed reconstruction.

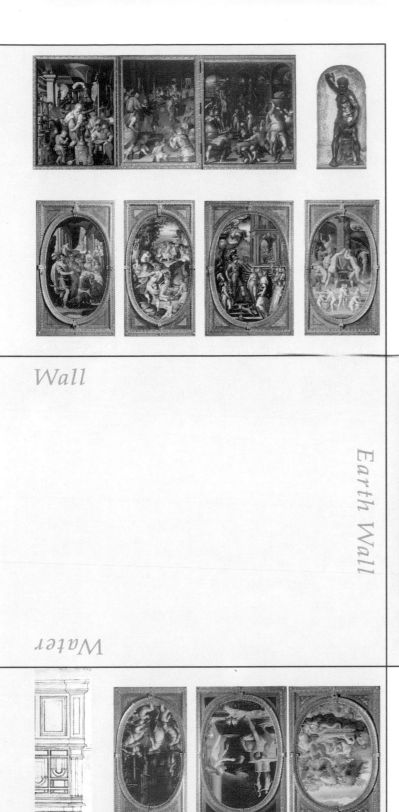

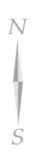

N

S

Earth Wall

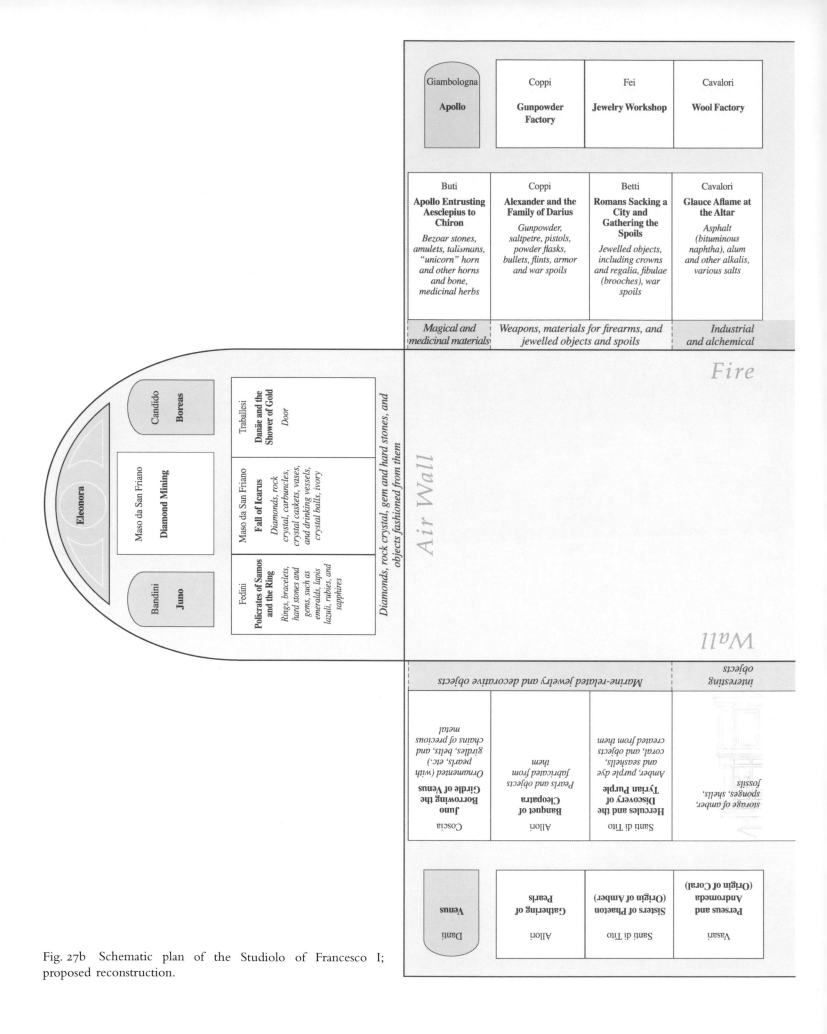

Fig. 27b Schematic plan of the Studiolo of Francesco I; proposed reconstruction.

Stradano — Francesco I in his Alchemy Laboratory

Butteri — Glass Factory

Poppi — Bronze Foundry

Rossi — Vulcan

N

S

Stradano	Butteri	Poppi	Casini
Circe and the Companions of Ulysses	**Discovery of Glass**	**Alexander Giving Campapse to Apelles**	**Forge of Vulcan**
Sulphur, mercury, sal ammoniac, and other alchemical supplies, alchemical "specimens"	*Glasswork, mirrors, enamels, alchemical vessels*	*Ancient and contemporary coins and medals, small bronzes*	*Small bronzes, bronze vessels, bells, mortars, iron and steel objects, such as locks*

chemicals supplies | *Forged works of metal and glass*

Wall

Earth Wall

Sciorna — **Hercules and the Dragon** — *Various objects of gold and silver, timepieces, chalices, and other objects with damascening, samples of gold ore, lodestones*

Minga — **Deucalion and Pyrrha** — *Vases, cameos, and other objects fabricated from agate, carnelians, jasper, porphyry, sardonyx, and other hard stones, fossils, stones with "chance" images, ebony and other rare woods*

Marsili — **Race of Atalanta** — *Various objects of gold and silver, damascened objects, Medici heraldic devices, samples of gold*

Gold, silver, hard stones, and objects crafted from them

Poggini — **Plutus**

Zucchi — **Mining**

Ammanati — **Ops**

Cosimo

Water

Precious and marine | *Medicinal materials* | *Decorated seashells*

Studiolo — *Display and coral, pearls, and marine*

Naldini — **Allegory of Dreams** — *Ambergris, opium and narcotics, various samples, stimulants, such as tranquilizers, aqua nitrose (salnacis), and other waters*

Macchietti — **Medea and Aeson** — *Mineral water samples, various stimulants, such as digitalis, aphrodisiacs and potions*

Portelli — **Oceanus Giving the Conch to Pan** — *Ornamented nautili, conchs and other shells*

Moses Parting the Red Sea — Santi di Tito

Gathering of Ambergris — Naldini

Baths of Pozzuoli — Macchietti

Amphitrite — Lorenzi

Rinehart did not attempt to specify the exact locations of most of the individual panels and did not follow up all the implications of his observations. Moreover, despite some tantalizing bits of information in the Borghini document he found, Rinehart chose not to investigate thoroughly some of the inscriptions concerning the materials in the cupboards, for which, unfortunately, no inventory has ever been discovered. Yet, taking into consideration these inscriptions and other information that Rinehart brought to light, as well as Francesco I's practical and mnemonic needs — that similar materials be stored together for easy location and access — one can propose with some confidence the disposition of the art and contents of Francesco's vault room.[10]

THE WATER WALL

As the diagram and photomontage of our reconstruction of the Studiolo show (figs. 27 a and b), the large cabinet, or *studiolo*, would have been installed in the center of the south (water) wall, surmounted by Vasari's *Perseus and Andromeda* panel and Santi di Tito's *Moses Parting the Red Sea* (fig. 26). As Rinehart recognized, Vasari usually delegated two paintings to each artist to execute. In his own case, however, Vasari painted just one panel for the complex and Santi was commissioned to paint three. Rinehart thought that Santi's *Moses Parting the Red Sea* and *Hercules and the Discovery of Tyrian Purple* would have been paired vertically and his *Sisters of Phaeton* installed over the *studiolo*. It seems more likely, however, that the grandly staged *Moses Parting the Red Sea* — larger than Santi's other panels, the only unsigned one, and representing a religious rather than a mythological subject — was conceived separately from his other two works. In fact, as the only religious painting in the Studiolo, and because of its iconographical significance for the Medici and for Francesco specifically, it is probably fair to assume that the painting was intended to hold a privileged central position above the cabinet in the Studiolo scheme.

Janet Cox-Rearick has documented well the primacy of Moses in Medici dynastic propaganda.[11] Heeding Niccolò Machiavelli's recommendation, the Medici venerated Moses as a leader and political role model, a divinely appointed figure who established a state for his people.[12] Cosimo promoted himself as a "new Moses" and the Hebrew leader was exalted in the frescoes of Eleonora of Toledo's private chapel in the Palazzo Vecchio.[13]

In the context of the Studiolo, with its program entailing many miraculous and magical transformations, Moses' presence has connotations beyond the political. Presumably owing to his contests with the Pharaoh's magicians,

recorded in the Old Testament Book of Exodus (7–9), some ancient traditions held that Moses himself was a magician. The ancient author Pliny, in his first-century A.D. *Natural History* (XXX, 11) declared that a branch of magic was derived from Moses and his contemporaries, Jannes and Lotapes.[14] According to the Hebrew Cabala, Moses learned virtually all of the secrets of nature when he received the Ten Commandments.[15] The philosopher Marsilio Ficino, who, for Cosimo il Vecchio de' Medici, translated the alchemical texts of the mysterious Hermes Trismegistus (*Corpus Hermeticum*) from Greek into Latin in 1463, connected Moses with the beginnings of alchemy. Ficino knew the assertions of the ancient historian Artapas, quoted by Eusebius of Caesaria, that Hermes and Moses were not only contemporaries but the same person.[16] Later, the eminent philosopher and sometime Medici courtier Pico della Mirandola, drawing on his knowledge of Cabala, reinforced Ficino's view of Moses as a divinely sanctioned magician.[17] In this respect, the axial and commanding location of the Moses panel would seem especially appropriate, as it affirms the act of divine intervention in the operations of art and nature. No less appropriate is the placement of the Moses composition, with its magical and alchemical associations, directly across the room from Giovanni Stradano's painting of Francesco I in his alchemy laboratory; while Moses parts the waters with his wand, Francesco stirs a liquid alchemical preparation with a spoon. In certain alchemical texts, Moses' division of the Red Sea was seen to symbolize the division of the *prima materia* (the supposed, underlying primitive matter of all substances) into the four differentiated elements of earth, air, fire, and water.[18]

Distributed around the central works by Santi and Vasari, the other water-wall pictures are arranged so that the broader ovals — Macchietti's *Medea and Aeson* and Allori's *Banquet of Cleopatra* — are set in the "b" positions, and the twelve paintings are logically grouped with respect to the materials contained in the proximate cupboards. At the west end of the water wall, Alessandro Allori's two paintings, the jewel-like *Gathering of Pearls* and *Banquet of Cleopatra*, were located beside Santi's *Sisters of Phaeton* and *Hercules and the Discovery of Tyrian Purple*, with cupboards hidden behind the lower, oval pictures.[19] These cupboards, close to the statue of Venus, would have held an assortment of precious materials from the sea, used in *objets d'art*, jewelry, and other beautiful adornments. The Allori pictures denote pearls, which are shown being gathered in one painting and, in the Cleopatra painting, being dissolved in vinegar and swallowed.[20] Santi's *Sisters of Phaeton* represents the mythological origins of amber (the tears of grieving women who metamorphosed into riverside poplars), and his *Hercules*

and the Discovery of Tyrian Purple illustrates the ancient tale of the discovery of murex purple dye (actually a deep maroon) in a species of seashell or mollusc.[21] Therefore, in one cabinet would have been Francesco's exquisite and unusual specimens of pearls, and sharing the other would have been amber and purple shells and dye (*purpura blatta*), as well as works crafted from them – necklaces, pendants, examples of dyed cloth, and so forth. These would have been joined by some of the marvels in Francesco's collection that years later delighted foreign visitors to Florence – pyramids of pearls, carved amber clocks and cups, and fossilized lizards and other creatures captured in amber.[22] A number of these items, notably girdles, chains, and belts embellished with pearls or amber, probably spilled into the adjacent cabinet, which had on its door Coscia's painting, *Juno Borrowing the Girdle of Venus*. As indicated in Gilles Corrozet's *Blasons domestiques* (Paris, 1539), in which the contents of a large collecting cabinet are described, girdles and chains or necklaces were usually placed together.[23] Perhaps safeguarded with the other objects in the Coscia cupboard was the extravagant necklace, ornamented with pearls, diamonds, and rubies, that Cosimo I gave to Giovanna of Austria, his new daughter-in-law and wife of Francesco I, on the occasion of their first meeting on 8 December 1565.[24]

The majority of Francesco's samples of coral, the subject of Vasari's painting, were probably placed in the marine-related cupboards.[25] One may presume, however, that some of Francesco's most spectacular specimens of coral and amber would have been displayed and stored in the many compartments of the large *studiolo* or cabinet beneath Vasari's panel.[26] Since, from ancient times, coral and amber were both believed to ward off evil and were often employed as amulets, it would not be coincidental that Santi's *Sisters of Phaeton* was installed beside Vasari's *Perseus and Andromeda*; the figure scale and composition of the *Sisters of Phaeton* suggest that Santi knew his picture would be placed beside Vasari's and designed it to correspond stylistically.

The set of paintings on the east end of the water wall, between the Santi di Tito *Moses* and Lorenzi's bronze *Amphitrite*, generally concern aquatic medicines or potions, rather than jewelry and other cosmetic materials. Macchietti's painting, the *Baths of Pozzuoli*, celebrates the reinvigorating mineral baths in a town near Naples, while his *Medea and Aeson* panel (placed below), illustrates the story from Ovid's *Metamorphoses* (VII, 163–293) of how the sorceress Medea rejuvenated her aged father-in-law with a magical potion.[27] Likewise, the subject of one of Naldini's nearby pictures, ambergris – a waxy substance that originates in the intestines of sperm whales – was a touted medicine in antiquity and similarly thought to have restorative properties. Rinehart pointed to a passage in Pliny's *Natural History* (XXXII, 116), in which the odiferous rennet of a whale is recommended as an inhalant for those suffering from lethargy.[28] Ficino, writing at the fifteenth-century Medici court, also believed ambergris to have an invigorating effect, and prescribed it along with musk, for the elderly, especially as a remedy for dullness and forgetfulness.[29] More significantly, he considered ambergris to be an effective treatment for an excess of black bile, one of the four humors or bodily fluids.[30] Melancholy, or chronic depression, from which Francesco I (and Ficino) famously suffered, was believed, from ancient times through to the Renaissance, to result from a dominance of black bile. The dedication of a painting to the subject of ambergris probably indicates how greatly Francesco valued this material, which would have been a key ingredient in the anti-depressant medications he concocted for himself. Naldini's companion picture, the lyrical *Allegory of Dreams*, depicts, scattered about the realm of the mythological kingdom of Sleep, opium poppies, probably one of many sleep aids and other drugs that Francesco possessed. In addition to narcotics and ambergris, the pharmaceutical cupboards would have contained other stimulants and tranquilizers that he employed in self-medication, as well as plants believed to engender sanguine dreams.[31]

From Borghini's notes, we can surmise that the medicinal cupboards would also have included containers of water from "health-giving baths" (such as those at Pozzuoli) and something he calls "*acqua salmacis*."[32] This can be identified as *aqua nitrose*, that is, a natural mineral water with a high content of sodium carbonate. Pliny (XXXI, 36) relates that this water, considered both salty and acidic (*salma* plus *acidus*, hence *salmacis*), flowed from the desert in streams into the Red Sea.[33] For this reason, it would have been appropriately stored behind the *Allegory of Dreams*, in the cupboard closest to Santi's *Moses* painting. "*Aqua salmacis*" also had another connotation in classical times and the Renaissance; the term evoked the legendary fountain of Salmacis in Caria, a district of Asia Minor. According to Ovid (*Metamorphoses*, IV, 285–389), the waters of this magical fountain transformed the male Hermaphroditus into a "half-man," and had the effect of making "soft and weak" – more "effeminate" – any man who bathed in its waters.[34] Francesco's sample of *aqua salmacis* may account for Borghini's intention to include, as indicated in his sheet of preliminary notes for the Studiolo, a depiction of the myth of Hercules and Omphale.[35] As described in Apollodorus's *Bibliotheke* (second century, B.C.; 2, 131–33), Ovid's *Fasti* (first century, A.D.; II, 303–58), and other sources, Hercules, as

a slave of Omphale, Queen of Lydia, became servile and effeminate, wearing women's clothes and adornments.[36] This theme was never realized in paint; Borghini apparently opted, instead, for the Moses subject.

At the southeast corner of the water wall, beneath the statue of the sea deity Amphitrite (holding a nautilus shell and coral), would have been Portelli's painting, *Oceanus Giving the Conch to Pan*, no doubt signaling the presence of ornamented conchs, nautili, and other shells in the cupboard it embellished.[37] Based on an obscure mythological tale, which Borghini probably read in Angelo Poliziano's *Miscellaneorum Centuria Prima* (1489) or Vincenzo Cartari's *Le imagini de i dei de gli antichi* (1556), Portelli's picture perhaps alludes to Medici political and military prowess.[38] Since the time of Lorenzo il Magnifico, Pan had been associated with Medici rule.[39] In the Studiolo work, Pan receives a conch with which he would later create a trumpet-like blast that would cause the gods and Titans, in the midst of a battle, to cease their fighting and flee.

THE FIRE WALL

The cupboards and paintings on the north (fire) wall would have been organized in a manner similar to that of the water wall. The upper part of the wall, with its series of manufacturing scenes, was conceived as a self-congratulatory exposition on Florentine industries, a tribute to Medici, Inc. So placed, the panels on the north wall conform to the abaccaba scheme, with two broad, oval panels depicting incidents from the life of Alexander the Great in the "b" positions of the lower register. The pictures that illustrate Florence's enduring wool industry (cat. no. 18) and Francesco's alchemy laboratory, in which the prince is prominently portrayed, are centrally featured in the upper register. The works to either side of these relate to the adjoining sculptures and pictures (e.g., Poppi's *Bronze Foundry* painting is beside the statue of Vulcan (cat. no. 83), which is in turn above Casini's *Forge of Vulcan* panel), and are grouped in accordance with the materials stored behind or beneath them.

Behind and below the panel paintings contributed by Poppi (*Alexander Giving Campaspe to Apelles* as well as the *Bronze Foundry*) and by Butteri (the *Glass Factory* and *Discovery of Glass*), at the east end of the fire wall, Francesco would have kept objects that were forged or otherwise manipulated by fire – sophisticated examples of glasswork, both ancient and modern, and elegant small bronzes, Greek, Roman, and Etruscan.[40] Borghini, in his letter of 3 October 1570, indicates that he would group together Francesco's specimens of iron, steel, and glass,

and assign them to the area of the room near the statue of Vulcan.[41] In the *Discovery of Glass* cupboard, Francesco probably would have stored part of his collection of fine enamels and mirrors, remarkably pure and uniform for their time, which the glassworkers he imported from Murano had crafted. Because of their extremely high quality, these glass mirrors had come to supplant those of polished metal. Borghini mentions in his notes that "mirrors for solar furnaces" were destined for the Studiolo.[42]

Along with a few bronze sculptures, Francesco would have placed in the cupboard behind Poppi's *Alexander and Campaspe* panel *medaglie*, antique coins and contemporary medals. This can be inferred from Borghini's letter of 5 October 1570, in which he states that he does not wish to have too many *botteghe* (workshops) as subjects in the Studiolo and so recommends that, instead of depicting a mint, Poppi should represent the generic story of how Alexander presented his mistress, Campaspe, to the artist Apelles, who loved her.[43] Nevertheless, to make the contents of the cabinet evident to Francesco, Poppi inserted, in the background of his picture, one figure carrying a tray of medals and another man stamping a medal or coin with a hammer and die. We can speculate that Francesco's coins and medals would have been sorted in the Poppi cupboard according to material, since Vasari reports in his *Ragionamenti* that Cosimo's medal collection was arranged in that manner.[44]

What could not be accommodated in the Poppi cupboard would have been stored in the adjacent one, adorned by Casini's painting the *Forge of Vulcan*, in which ceremonial vessels and other bronze objects such as bells and mortars would have been housed together with, according to Borghini, "artifices of iron and steel and locks and other gadgets that open and shut."[45] Similarly, because of space limitations, some small, intricate glass vessels used in alchemical operations may have been stored in the cupboard next to Butteri's *Discovery of Glass*, since that cupboard, graced by Stradano's *Circe and the Companions of Ulysses* and beneath his *Francesco I in his Alchemy Laboratory*, would have received materials related to Francesco's alchemical practice, such as quicksilver (Mercury, the divine messenger, is present in the Circe picture), various forms of sulphur, sal ammoniac (ammonium chloride), and, reportedly, a "nail half turned into gold," said to be the work of the famous sixteenth-century German alchemist, Leonhard Thurneisser zum Thurn.[46]

The contents of the cupboards at the west end of the fire wall are only slightly more difficult to surmise. In the compartment enclosed by Coppi's *Alexander and the Family of Darius* and below the painting of the *Gunpowder*

Factory, Francesco would perhaps have stored, unwisely, containers of gunpowder, saltpeter and other chemical components of gunpowder, and some of the shrapnel bombs or grenades (*scacciadiavoli*) he devised with his friend, the architect Bernardo Buontalenti. More likely, this cupboard would have been filled with elaborately ornamented pistols (which were supposedly first manufactured around 1540 in the nearby Tuscan town of Pistoia, a Medici fiefdom from which they derived their name), finely crafted powder flasks, flints for firearms, bullets, small pieces of armor, and other war spoils.[47] The presence of *spolia* can be inferred from the subject of Coppi's oval painting, which illustrates an episode from the military campaigns of Alexander the Great in which the emperor-general magnanimously and respectfully receives the family of his enemy, Darius, whom he has just slain in battle.[48] Many of the same kinds of object would have been kept in the adjacent cupboard, behind Betti's painting *Romans Sacking a City and Gathering the Spoils*.[49] There, too, would have been placed ancient Greek and Roman brooches, or *fibulae* (noted by Borghini), and antique and contemporary jewelry, as well as various jeweled objects, to which Fei's painting of the *Jewelry Workshop*, directly above, alludes.[50] In 1644, the English traveler John Evelyn reported seeing in the Medici collection what were claimed to be "the sword of Charlemagne" and "Hannibal's headpiece."[51] Whether these treasures were actually in Francesco's possession in the sixteenth century is unknown, but the presence of the grand-ducal crown in Fei's picture suggests that some crowns and other regalia were located in the Betti cupboard.[52]

The contents of the nearby cupboard, covered by Cavalori's richly colored, oval painting, have remained, until now, something of an enigma. However, careful reconsideration of Borghini's notes not only reveals the material to which Cavalori's picture refers, but also indicates that the long-standing identification of the subject matter of the work, the ancient story of Lavinia at the altar, is incorrect. At the top of his sheet of notes, Borghini lists, among the materials to be preserved in the Studiolo, "Dead Sea bituminous naphtha."[53] This substance can be identified as naturally occurring asphalt, for which the Dead Sea area was renowned.[54] A sometimes fluid, sometimes brittle, black petroleum residue, also called "bitumen of Judea," "Jew's pitch," and, in the Old Testament, "slime," asphalt was used by Egyptians as a mortar in construction and as a preservative for embalming.[55]

Hard-pressed for a classical or mythological subject that involved this exotic material, Borghini consulted one of his favorite antique sources, Pliny's *Natural History*

(II, 235), and found under the discussion of bituminous naphtha an appropriate, if obscure, version of a mythological story for Cavalori to depict. Pliny writes: "Naphtha is . . . the name of a substance that flows out like liquid bitumen in the neighborhood of Babylon and the parts of Parthia near Astacus. Naphtha has a close affinity with fire, which leaps to it at once when it sees it in any direction. This is how Medea in the legend burned her rival, whose wreath [or crown – the Latin *corona*] caught fire after she had gone up to the altar to offer sacrifice."[56]

Pliny seems either to be referring to a now-lost version of the tale of Medea and Glauce, the voyager Jason's new wife who was set ablaze by the jealous ex-wife Medea's poison, or, more likely, Pliny has simply speculated about the chemical agent involved in Glauce's death, after having read in Strabo's *Geography* (first century, B.C.) an account of a person deliberately burnt by naphtha.[57]

In any case, Cavalori has followed Pliny fairly literally, as he represents flames surrounding the sacrificial lamb on the altar, shooting directly toward the head of the young woman. This new identification of Cavalori's subject – and the material to which it refers – explains why one of the foreground figures possesses a large excavator's pick (asphalt hardens with time) and why the picture, heretofore presumed to represent an episode from Virgil's *Aeneid* (VII, 52–77) – Princess Lavinia at the altar – fails to include some of the key features of that story, notably, Lavinia's father, King Latinus of Latium, holding a torch.[58] Iconographically, Borghini's pairing on the fire wall of episodes from the stories of the two most famous sorceresses in classical mythology, Medea and Circe (in Stradano's adjacent painting), makes for an interesting symmetry. This symmetrical arrangement would complement that of the two Alexander panels on the same wall.

Along with the bituminous naphtha in the cupboard behind Cavalori's *Glauce Aflame at the Altar* (fig. 28), would have been related minerals and chemicals, particularly those employed in the wool industry, illustrated just above in Cavalori's *Wool Factory* painting (cat. no. 18). Borghini's decision to have the painter depict the prosaic scene of men laboring over vats cleaning and processing wool rather than, say, portraying Cosimo's celebrated Arazzeria (tapestry workshops), has always seemed puzzling. We can now understand that Borghini chose this subject because he needed to allude to chemicals involved in the mordanting process of wool, particularly alum or potash. After the raw wool was washed in a solution of water and urine, it was soaked in these alkaline minerals to prepare the fibers to receive dye.[59] The pile of rocky, white material in the left foreground of the *Wool Factory*

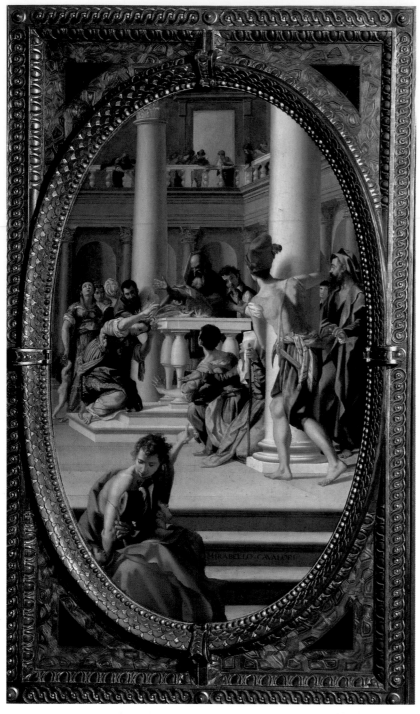

Fig. 28 Mirabello Cavalori, *Glauce Aflame at the Altar*, ca. 1570–71, Studiolo of Francesco I. Palazzo Vecchio, Florence.

is probably alum, the mordant most commonly used in the Renaissance.[60] Cavalori, whose father was a dyer, would have known the technical procedures well.[61]

Utilized in glass-making and tanning as well as dyeing, alum had been, since 1466, an extremely profitable commodity for the Medici. In that year, they signed an agreement with the Pope to exploit the huge alum deposits recently discovered in Tolfa, near Civitavecchia in the Papal States. Before then, most European alum supplies had been imported from Asia Minor. Thus, the Medici, with banking and commercial offices or representatives in major cities across the continent and in England, were able quickly to establish themselves as the principal miners and distributors of the material in Europe.

That Francesco would have possessed – and kept together with his bituminous naphtha – various alums and other alkalis is confirmed by an examination of the contents of a contemporary collection of mineral specimens in the Vatican. The Vatican archivist, naturalist, and superintendent of the papal botanical gardens, Michele Mercati (1541–93), assembled in the later sixteenth century a collection of minerals, marine fossils, and antique statuary that he cataloged in a volume called the *Metallotheca Vaticana*. Written around 1585, but first published only in 1717, the *Metallotheca* manifests the mineral-collecting interests and scientific organizing principles of Francesco's time. In fact, the Metallotheca, the storage chamber, itself, may have been based to some degree on Francesco's Studiolo. Vasari's correspondence of 12 January and 25 January 1572, suggests that the Pope wished to learn the scheme of the Studiolo for a similar room that he planned to construct.[62] And an engraving of the now-lost Metallotheca, probably dating to around 1585, reveals that the room was in some ways similar to the Studiolo; it, too, entailed a series of cabinets approximately the size of the Studiolo cupboards, placed beneath a barrel vault with bronze sculptures in high niches in the four corners of the room.[63]

Whatever the relation between the physical design of the Studiolo and the Metallotheca, the classification system for the materials they contained would almost certainly have been cognate. Mercati's catalog makes it clear that bituminous naphtha or asphalt, as well as alum and other alkalis such as *aphronitro* or washing soda (sometimes used to clean wool), were grouped together and stored in contiguous cabinets, the industrially valuable alums allotted an entire compartment.[64] Moreover, the installation of the Cavalori cupboard beside the Stradano cupboard, with its sulphur and alchemical supplies, was quite appropriate; in the Metallotheca, the bituminous naphtha and sulphur were deposited in the same cabinet.[65] The "salts produced from water in various

ways," mentioned by Borghini in his notes, would have been kept in one of these Studiolo cupboards as well; in the Metallotheca, salts were stored with the *nitrum* or alkalis.[66] In their categorization of materials, Francesco and Mercati were both generally following the groupings established by the ancients, including Pliny, who discusses sulphur, bituminous naphtha, and alum in consecutive passages in the *Natural History* (XXXV, 174–90).[67]

THE EARTH WALL

Thanks to Borghini's *invenzioni* and a surviving design by Vasari, it is easier to speculate about the contents of the cupboards on the short, end walls – those dedicated to the elements of earth and air. On the lower east (earth) wall, beneath Zucchi's depiction of *Mining* and statues of *Plutus* and *Opi* (cat. no. 48) – deities of the riches of the earth – were three storage compartments. One of Vasari's preliminary studies for this wall, preserved in the Musée des Beaux-Arts in Dijon, indicates that works of gold and silver were to be stored here, including timepieces and other objects damascened with these precious metals.[68] In sixteenth-century Italy, objects with damascening (gold and silver wire inlay) from Damascus, Persia, and Turkey, were much admired. By Francesco's time, Italian craftsmen, particularly armorers, had developed considerable expertise in the technique.[69]

The two lower, end paintings, Sciorina's *Hercules and the Dragon in the Garden of Hesperides* and Marsilli's *Race of Atalanta*, allude subtly to objects of gold: three golden apples from the tree in the Garden of the Hesperides, shown in the left picture, are, in the right painting, dropped by Hippomenes to distract his lovely competitor, Atalanta, in their foot race.[70] Scott Schaefer has commented on how Francesco would have appreciated the pictures' discreet references to the Medici heraldic symbol of golden *palle* or balls.[71] The Sciorina and Marsilli cupboards would have probably contained objects bearing the Medici device, along with other gold and silver artefacts and even a few spherical specimens of unworked metal or ore. During a trip to Florence in 1645, John Evelyn saw in the Uffizi Tribuna, to which Francesco moved his objects when he dismantled the Studiolo, "a piece of pure virgin gold as big as an egg."[72] It is possible that the Hercules cupboard also contained magnets or lodestones, which in ancient times and the Renaissance were sometimes called *lapis Hercules*.[73] If so, the lodestones would have been kept just beside the cupboard that housed the iron and steel objects, to which magnets are attracted.

Some gold items may have been kept in the central compartment behind Minga's representation of the story of *Deucalion and Pyrrha*, but more probably, its shelves were lined with vases and other objects carved from hard stones, such as agate, jasper, porphyry, and sardonyx.[74] Recalling the details of the Ovidian myth, in which Deucalion and his wife, Pyrrha, tossed over their shoulders rocks that miraculously transformed into human beings and repopulated a flood-ravaged world, Schaefer has cleverly speculated that Francesco also kept behind Minga's panel fossils or images, possibly anthropomorphic, in natural rock formations.[75] Pliny, in the *Natural History* (XXXVII, 5–6), describes a remarkable agate that belonged to King Pyrrhus, which had natural markings that seemed to represent Apollo with his lyre and the nine Muses.[76] Francesco, his father, and brother, Ferdinando, were fascinated by these *fantasie di natura*. Such images, "made by chance," were proudly displayed in many Renaissance collectors' cabinets, including that of Emperor Rudolf II of Prague, who, like the Medici, had natural images in agate and jasper enhanced by craftsmen to define more clearly the suggested human and landscape forms.[77] Kept with these reworked "chance" stones in the Minga cupboard may have been figurative cameos and carnelians, the latter so-named for their flesh-like color.

THE AIR WALL

It is probable that gemstones such as emeralds and rubies – some mounted, some loose – which were used in jewelry and medicinally, were stored not on the earth wall, but across the room in the air-wall cupboards, close to the pearls, diamonds, and other precious materials set into rings and bracelets. Fedini's painting, *Policrates of Samos and the Ring*, was mounted, no doubt, in front of the compartment that held rings. But the story, which Borghini would have read in Pliny's *Natural History* (XXXVII, 3–4), actually focuses more on a gemstone, which King Policrates tossed into the sea to appease the gods and atone for his prosperity.[78] Carved gems such as sapphires may have shared shelf-space with or adorned badges and rings behind the Fedini panel. Given Francesco's obsession with poisons (many of which he extracted from his menagerie of vipers and other venomous snakes, cat. no. 179), one is tempted to conjecture that some of these rings may have been the notorious *anelli della morte* – rings with hidden reserves of poison, delivered furtively into a drink or, through a spring-activated hollow prong, into flesh.

Next to the Fedini cupboard, the central compartment concealed by Maso da San Friano's *Fall of Icarus* (fig. 29) would have held diamonds, rock crystals, carbuncles, and

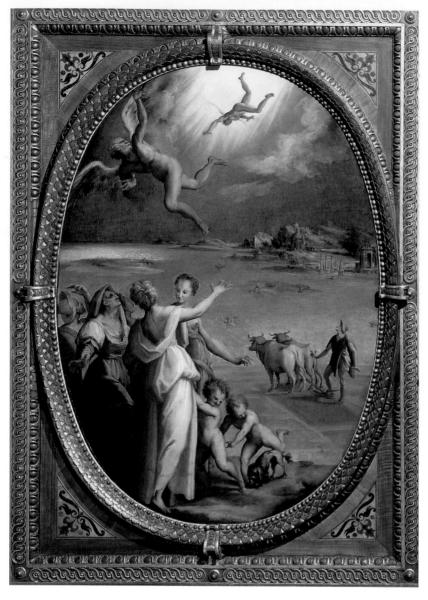

Fig. 29 Maso da San Friano, *Fall of Icarus*, 1570–72, Studiolo of Francesco I. Palazzo Vecchio, Florence.

objects created from them.[79] Maso's *Diamond Mining* was affixed directly above that cupboard, and Borghini closely associated diamonds and crystals in his second *invenzione*.[80] Medici craftsmen produced some of the most refined and beautiful carved crystal vessels – caskets, vases, and ewers – of the period.[81] For prognostication, the Medici may have ordered the manufacture of crystal balls, which were perhaps stored in the Maso cupboard as well. Francesco himself reportedly sought to develop a process for melting and shaping rock crystal.

The selection for this wall of the mythological story of Icarus, who fatally fell from the sky when he flew too close to the hot sun with his fabricated, feather-and-wax wings, is somewhat perplexing, and has prompted the hypothesis that Francesco kept here mosaics made with feathers.[82] Such objects do not really relate to the other materials in the air-wall cupboards, however. A simpler explanation for Borghini's choice of the Icarus theme is that he wished to have illustrated an easily recognizable classical subject that involved air or wind. A less obvious reason may be that Borghini wished the myth to serve as a metaphor for the formation of rock crystal. Pliny (*Natural History*, XXXVII, 25–26) and the ancients believed that "moisture from the sky," cooling as it fell through the atmosphere, solidified into rock crystals.[83] The ancient author added that rock crystal "cannot stand heat." Because of this notion that rock crystal was produced by frigid air Borghini located a sculpture of the cold north wind god, Boreas (cat. no. 56), on this west wall, where the warm west wind god of spring, Zephyr, would have been more appropriate.[84]

In his left hand, the bronze Boreas clutches an animal horn – not a common attribute for the wind deity – rather than the piece of crystal Borghini had originally proposed in a letter.[85] This substitution suggests that horns and tusks, or at least carved ivory, may have been deposited in the west-wall cupboards as well. Further, this may explain why Borghini's notes indicate that, at one point, he intended to include a depiction of the story of Pygmalion on the lower air wall; in the Greek myth, the sculptor Pygmalion's ivory statue of a woman, with whom he has fallen in love, comes to life.[86]

Beneath the sculpture of Boreas, Traballesi's painting, *Danäe and the Shower of Gold*, was installed.[87] Borghini decided to insert the Danäe myth in the Studiolo program before he knew exactly where the picture would be placed or what objects would be stored behind it; on his sheet of notes he listed the *pioggia d'or[o]* ("shower of gold") alternately on the fire wall and the water wall, later crossing out both inscriptions and assigning it to the earth wall.[88] Eventually, the uninspired picture was located

on the air wall, where it covered a door rather than a cupboard.[89]

In the northwest corner of the room, beside Traballesi's work and beneath Giambologna's sculpture of Apollo, was Buti's painting, *Apollo Entrusting Asclepius to the Care of Chiron*. Since Ovid, in the *Metamorphoses* (II, 629–30), and other classical authors, relate that the centaur, Chiron, instructed Asclepius in the medicinal arts, Schaefer has theorized that Francesco may have kept in the cupboard behind this panel his bezoar stones – concretions found in the alimentary organs of roosters, antelopes, goats, llamas, and various ruminants, which were supposed to possess magical, curative, and antidotal properties.[90] Francesco and his second wife, Bianca Cappello, believing that they had been poisoned, clutched such stones, to no avail, on their deathbeds. The stones remained in the Medici collection for years afterwards; the English traveler Fynes Moryson, examined one in the Uffizi Tribuna in 1594.[91] Sometimes bezoars were shaved and added to liquids, which were drunk for purported medicinal effect. The widespread faith in these stones cannot be underestimated: the Vatican Metallotheca had an entire cabinet devoted to bezoars and *alectorius* (cockstone), and Rudolf II had an ample supply of bezoar stones in his *Kunst-und-Wunderkammer* in Prague.[92]

In addition to the bezoar stones, Francesco would have stored in the Buti cupboard "medicinal" bone and horn – which Borghini explicitly associated with Apollo in his *invenzione* – as well as herbs, balsam, and other alleged antidotes and amulets.[93] As noted above, those pharmaceuticals that relate closely to water were probably stored on that element's wall, behind Macchietti's *Medea and Aeson* and Naldini's *Allegory of Dreams*. But purportedly magical, curative stones and talismanic objects, "unicorn" horns, and medicinal herbs would have, appropriately, rested behind an image of Asclepius who, owing to the influence of Ficino, was as much associated with magic as with medicine at the Medici court. Of the hermetic texts Ficino studied or translated for Cosimo il Vecchio, the philosopher considered two, *Pimander* and particularly *Asclepius*, to be the most important and "divine."[94] His admiration of these arcane literary works led Ficino to introduce a strong component of *magia* into his Neoplatonism and to advocate the use of astrological amulets and talismans and magical herbs. In fact, in his book entitled *On Obtaining Life from the Heavens* (*De vita coelitus comparanda*, 1489), Ficino presents a virtual manual for the use of herbs, amulets, and talismans to attract "celestial spirits."[95] Well-acquainted with the writings of the Medici court philosopher, Francesco would have also possessed toadstones (fossils believed to have curative powers) and

alchemical amulets such as those fabricated by the German alchemist Thurneisser. Moreover, the many gems and hard stones located on the nearby air wall were all believed to have medicinal power; diamonds and emeralds were thought to be effective against poisons, and therapeutic properties were ascribed to bloodstones, carbuncles, and lapis lazuli in natural, engraved, or (edible) powdered form.[96]

Another staple of the Renaissance *Wunderkammer*, usually associated with bezoars, was "unicorn" horn, in most cases fraudulently or wishfully misidentified narwhal tusk. Ficino declares that, among other items, unicorn horn and bezoar especially are "endowed with occult properties of the Graces. And therefore, not only if they are taken internally, but even if they touch the flesh, and warmed thereby, put forth their power; they introduce celestial force into the spirits by which the spirits preserve themselves from plague and poison."[97] From ancient times, through the Middle Ages and into the Renaissance, the unicorn's horn was thought to rid waters of poison. For this reason, the mythological animal is often represented in art dipping its horn into a poisoned stream, and many drinking vessels were carved from supposed samples of its magical appendage.[98] Borghini's letter of 3 October 1570 records that Francesco possessed a "unicorn" horn, which he wished to keep in the Studiolo with his "precious medicines, such as balsam, poison antidotes, and similar things."[99] Drawing attention to Francesco's "unicorn" horn is the Studiolo's bronze Boreas, who, horn in hand, points to the cabinet in which it was stored. Perhaps because of a similar pride of ownership, the inventory of Rudolf II's *Kunst-und-Wunderkammer* listed the "unicorn" horn first among all the emperor's possessions.[100]

Although conceived in the *Wunderkammer* tradition, the Studiolo reflects interests and ambitions beyond those invested in the typical Renaissance curiosity cabinet. Fulfilling some of Francesco's practical needs for storage, the Studiolo contained many utilitarian materials in addition to those objects intended to inspire awe and wonder; together with the Prince's most precious treasures were valued industrial chemicals and alchemical and medicinal supplies. In fact, Francesco's vault room probably had relatively few of the oddities and accidents of nature usually associated with such study collections. Rather, in his concern for the skillful manipulation of precious metals and stones, the development of new craft and industrial techniques, and the search for effective medicines, Francesco demonstrated his desire to improve upon, and even perfect, nature – not dwell on its mistakes.

This same faith in technology directed the Prince's efforts toward self-improvement, which involved both his

acquisition of wide-ranging scientific knowledge and, in his practice of alchemy and self-medication, a wish to attain for himself a proper healthful balance, in accordance with the balance or harmony of the four temperaments (and humors) represented on the Studiolo ceiling. Indeed, in this latter regard, the Studiolo would have been for Francesco no less an extension of the self, a projection of his identity, than the figure of Prometheus at the center of its ceiling, to whose role as consummate creator and inventor Francesco earnestly aspired.

NOTES

Several scholars and colleagues aided me in the preparation of this essay. I would particularly like to thank Dr. Martha McCrory, Rabbi Byron L. Sherwyn, Frank Zuccari, and Dr. Meg Koster. I am especially indebted to Dr. Koster, who, while a Mellon Fellow at the Art Institute, brought important sources to my attention and served as an invaluable, critical "sounding board" for my ideas as they evolved.

1. The standard references for the Studiolo are: Lensi 1929; Berti 1967; Schaefer 1976; Lensi-Orlandi 1977; Allegri and Cecchi 1980; Bardeschi et al. 1980; Bolzoni 1980; and Rinehart 1981.

2. For Francesco's scientific interests, some useful sources are: Saltini 1883; Grassini 1906 and 1907; Lensi-Orlandi 1978; and *La corte, il mare, i mercanti* 1980.

3. The painters who contributed to the Studiolo were: Alessandro Allori (1535–1607), Niccolò Betti (active 1570–1617), Domenico Buti (active 1560–90), Giovan Maria Butteri (ca. 1540–1606), Vittorio Casini (active 1567–72), Mirabello Cavalori (1535–72), Jacopo Coppi (1523–91), Francesco del Coscia (active ca. 1570–76), Giovanni Fedini (active ca. 1565–82), Alessandro Fei (1543–92), Girolamo Macchietti (1535–92), Maso (Manzuoli) da San Friano (1531–71), Sebastiano Marsilli (active ca. 1570), Andrea del Minga (after 1540–96), Francesco Morandini, called Il Poppi (1544–97), Giovanni Battista Naldini (1537–91), Carlo Portelli (before 1510–74), Santi di Tito (1536–1603), Lorenzo della Sciorina (ca. 1535–98), Giovanni Stradano (Jan van der Straet; ca. 1523–1605), Bartolomeo Traballesi (active 1570–85), Giorgio Vasari (1511–74), and Jacopo Zucchi (1541–89/90). The Studiolo sculptures were created by Bartolomeo Ammanati (1511–92), Giovanni Bandini (1540–99), Elia Candido (active 1567–74), Vincenzo Danti (1530–76); Giambologna (ca. 1524–1608), Stoldo Lorenzi (1534–83), Domenico Poggini (1520–90), and Vincenzo de' Rossi (1525–87). There is some uncertainty among scholars as to whether Allori or a member of Bronzino's workshop executed the Studiolo portraits of Cosimo and Eleonora.

4. These documents are published in Frey 1923–40, vol. 2, pp. 522–23, 526–28, 530–35, and 886–91.

5. "L'inuentione mi pare che si dimandi conforme alla materia et alla qualita delle cose, che ui si hanno a riporre, talche la renda la stanza uaga et non sia interamente fuor di questo proposito, anzi serua in parte come per un segno et quasi inuentario da ritouar le cose, accennando in un certo modo le figure et le pitture che saranno sopra et intorno et negl' armadij quel che e serbono dentro da loro . . . considerando che simil cose non sono tutte della natura ne tutte dell' arte, ma ui hanno ambedue parte, aiutandosi l'una l'altra . . . però hauea pensato che tutta questa inuentione fusse dedicata alla natura et all' arte, mettendoci statue che rapresentino quelli che furno ò inuentori o cagione ò . . . tutori et preposti à tesori della natura, et historia di pittura che mostrino anche loro la varieta et l'artificio di quelle." Frey 1923–40, vol. 2, pp. 886–87. The italics were imposed by the present author.

6. Rinehart 1981, pp. 275–89. The document, datable to after 5 October 1570, is preserved in the Florentine state archive as *Carte Strozziane*, prima serie, CXXXIII, fol. 139.

7. Rinehart 1981, p. 279.

8. Rinehart 1981, p. 282.

9. Rinehart 1981, pp. 283–84.

10. The use of systems of spatial organization to aid memory became a topic of keen interest in the Renaissance. Borghini was probably familiar with the contemporary literature on the subject, particularly Giulio Camillo's influential *L'idea del Theatro* (1550). See Bolzoni 1980 and Yates 1969.

11. Cox-Rearick 1993, pp. 213–37 and 294–319.

12. Cox-Rearick 1993, p. 296 and Machiavelli 1950, pp. 20–22 and 95.

13. Cox-Rearick 1993, pp. 294–319.

14. Pliny 1979, vol. 8, p. 285.

15. Various Cabalist writings, such as Moses ben Nahman's *Commentary on the Torah* (thirteenth century) and the *Sepher Rezial Hemelach* (*The Book of the Angel Rezial*, ca. thirteenth century), state that God revealed to Moses in the Sinai 49 of the 50 "Gates of Understanding," disclosing divine secrets and occult mysteries; see Ramban 1971, pp. 9–10; *Sepher Rezial Hemelach* 2000, p. 141; and Gager 1972, pp. 136–41. The view of Moses as a sorcerer should also be considered with respect to the centuries-old belief that Jews were magicians *par excellence*; for this tradition, see Trachtenberg 1939, first chapter. I am grateful to Rabbi Byron L. Sherwyn of the Spertus Institute for directing me to these sources on Cabala.

16. Gentile and Gilly 1999, pp. 22–23 and 31. A number of other alchemical writings were ascribed to Moses, such as the *Diplosis of Moses* and the *Chemistry of Moses*; see Gager 1972, pp. 152–55.

17. Mirandola 1557; Mirandola 1948; and Wirszubski 1989, p. 126.

18. Abraham 1998, pp. 168–69. The subject of the Red Sea closing on the Pharoah and the Egyptians is probably tied to the common alchemical theme (and image) of a king drowning in a mercurial sea, another metaphor for the initial stage of the transmutation process; see St. Thomas Aquinas (attrib. to), *Aurora consurgens*, 1966, p. 133, and Abraham 1998, pp. 110–12 and 179. Possibly making alchemical allusion is the curious, isolated detail in the central foreground of Santi's picture, directly beneath the parted sea – a young boy and girl in a clinch, seemingly about to kiss. Another symbol for the "Red Sea" ("first work") stage of the alchemical operation was the image of young siblings in an embrace, signifying the marriage of opposites (male, sulphur, solar vs. female, mercury, lunar); see Abraham 1998, p. 106, and, for example, *Pretiosissimum Donum Dei [per] Georgium Anrach*, seventeenth century, Bibliothèque de l'Arsenal, Paris, Ms. 975, fol. 13, reproduced in Klossowski de Rola 1973, fig. 37.

19. In his large preparatory design for the *Banquet of Cleopatra* (cat. no. 148), preserved in the Courtauld Institute, Allori drew tapestries depicting the Labors of Hercules on the back walls of the palace. These tapestries, not included in the painting, would have connected Allori's composition more closely to Santi's neighboring *Hercules and the Discovery of Tyrian Purple*. Instead, Allori depicted in the background of his painting statues of Venus and Juno in niches, corresponding to Danti's bronze *Venus* and Bandini's *Juno* in the nearby corner of the Studiolo.

20. Schaefer 1976, vol. 1, p. 277, traced the theme of Allori's *Gathering of Pearls* to Pliny's *Natural History* (IX, 108), which affords an explanation for the artist's depiction of many figures gazing into the sunset; according to Pliny, the hues of the pearls are affected by the coloration of the sky when they are harvested. The subject of Allori's other picture, the *Banquet of Cleopatra*, also derives from Pliny's *Natural History* (IX, 57), which recounts how Cleopatra won a wager with Marc Antony, who ventured that she could not spend ten million sesterces on a single banquet. Soon after, at a grand feast, Cleopatra dropped a huge pearl into a cup of vinegar, which dissolved it, and then drank the solution.

21. Borghini's source for the story of the *Sisters of Phaeton* was probably Ovid's *Metamorphoses* (first century, A.D.; II, 324–65). There, it is written that after the death of Phaeton, his sisters, the Heliades, mourned over his body day and night until they found themselves rooted on the bank of the River Eridanus, where he had drowned. The girls had transformed into poplars and their tears became drops of amber; see Ovid 1984, vol. 1, pp. 82–85. As Schaefer 1976, vol. 1, p. 395, has suggested, Borghini probably consulted Julius Pollux's *Onomasticon* (late second century, A.D.; I, 46) for the story depicted in Santi's other work, *Hercules and the Discovery of Tyrian Purple*. Pollux relates how Hercules' dog inadvertently discovered the purple dye when it bit into a mollusc on the beach. When the dog returned to him, Hercules noticed its stained lips.

22. The English traveler Fynes Moryson saw these items in the Uffizi Tribuna during his visit to Florence in 1594; see Moryson 1907, vol. 1, p. 322.

23. Jervis 1989, pp. 30–31.

24. Lapini 1900, p. 148.

25. The story of Perseus, Andromeda, and the origin of coral – blood from the severed head of Medusa – is told in Ovid's *Metamorphoses* (IV, 633–764). Vasari's painting may have been installed beside Santi's *Moses* panel because Pliny (*Natural*

History, XXXII, 21) associated coral with the Red Sea.

26. Francesco is known to have formulated a special liquid in which he preserved for study interesting fish and other marine fauna. It is quite possible that a few of these specimens, said to have retained their colors extremely well, were also kept in the cabinet; see Ciardi and Tomasi 1984, p. 48.

27. In his *Natural History* (XXXI, 12) Pliny praises the healthful mineral waters of the ancient Roman city of Puteoli (Pozzuoli). In his rendition of the subject of Medea and Aeson, Macchietti follows Ovid's account fairly closely; Medea, with a long, withered olive branch, stirs a potion that will soon be poured into her father-in-law's slit throat and which will make him forty years younger. Macchietti has rendered what appear to be digitalis plants (also known as foxglove), with their distinctive, bell-shaped blossoms arrayed on single stalks, in the right foreground of the *Medea and Aeson*. A cardiac stimulant, digitalis was recognized for its medicinal value and named in the first half of the sixteenth century by the German physician and botanist Leonhart Fuchs, who included it in his important treatise, *De historia stirpium commentarii insignes* (1542), pp. 892–95; see the facsimile edition in Meyer, Trueblood, and Heller 1999, vol. 1, pp. 63, 590–91, and 626–27, vol. 2, pp. 892–95. Digitalis's salutary properties (due to its potency as a stimulant and pronounced effects on the circulatory system) would have been known to Francesco I, for whom the artist Jacopo Ligozzi recorded the plant in a watercolor, reproduced in Berti 1967, fig. 110. Francesco's appreciation of the medicine would have been based on (largely uncomprehending) observation rather than a knowledge of causes; a true understanding of the circulatory system was not attained until the next century, with the researches of William Harvey.

28. Rinehart 1981, p. 289, note 39.

29. Ficino, *Three Books on Life* (1, 25, 19; 2, 9, 25–43; 2, 13, 8–27), 1989, pp. 159 and 193. Ficino

uses the word *ambra* to refer to both amber and ambergris. It is apparent, however, from the contexts in which it occurs in the *Three Books*, that Ficino is most often speaking of the more aromatic material, ambergris.

30. Ficino, *Three Books on Life* (1, 10, 39), 1989, pp. 113 and 135. Ficino would have read of this "remedy" in Hippocrates and other ancient medicinal texts; see *Hippocrates* 1938, vol. 5, p. 59.

31. Balm and bugloss are recommended for "merry" dreams in Giambattista della Porta's influential book, *Magiae naturalis libri XX in quibus scientiarum naturalium divitiae et deliciae demonstrantur*, first published in Naples in 1558 and, again, in an expanded edition, in 1589; see Porta 1957, p. 220.

32. Rinehart 1981, pp. 284–85.

33. Pliny 1979, vol. 8, pp. 398–99.

34. Ovid 1984, vol. 1, pp. 198–205.

35. Rinehart 1981, pp. 284–85.

36. Apollodorus 1975, p. 49; and Ovid 1989, pp. 78–85.

37. See Schaefer 1976, vol. 1, pp. 390–91. For decorated shells in the Medici collections and elsewhere in Renaissance Europe, see Piacenti 1967, pp. 170–71, nos. 734–56, pls. 28–30; Lipinsky 1977, pp. 1–13; and Mette 1995.

38. Cartari 1996, pp. 116–17. For Poliziano and ancient sources on the story of Pan and the shell, see Lightbown 1978, vol. 1, p. 93, and vol. 2, p. 55.

39. See Cox-Rearick 1984, pp. 83–86.

40. The story of the accidental discovery of glass is told in Pliny's *Natural History* (XXXVI, 1901). For the Florentine glass industry and the variety of glasswork produced under Francesco, see Heikamp 1986a, pp. 63–80.

41. Frey 1923–40, vol. 2, p. 530.

42. "specchi da fuoco," Rinehart 1981, pp. 284–85. These heat-generating mirrors may have been similar to the parabolic glasses used for kindling fires discussed at length in Porta 1957, pp. 371–77.

43. Frey 1923–40, vol. 2, p. 534. The story of Alexander and Apelles is recounted in Pliny's *Natural History* (XXXV, 86–87), among other sources.

44. Vasari 1878–85, vol. 8, pp. 58–59.

45. "Nell' altra nicchia metterei Vulcano per le minere forti, come acciaj, ferri, dove ha il principal luogo in operare il fuoco, e per molti lauori di oriuoli, madre d' amprontare, ingegni da aprire et serrare." Frey 1923–40, vol. 2, p. 888.

46. Moryson 1907, vol. 1, p. 322. Virgil (*Odyssey*, X, 133–574) and Ovid (*Metamorphoses*, XIV, 246–440) tell of how the sorceress Circe transformed Ulysses' shipwrecked men into animals. Ulysses himself was spared the ordeal, as Mercury gave him a drug called "moly," which rendered Circe's potions ineffective.

47. Francesco's pistols would not necessarily have been manufactured in Pistoia, but may have come from the important firearms centers of Brescia and South Germany; Cosimo is known to have possessed a South-German wheellock gun decorated with ivory (1544; Konopiste Castle, near Prague); see Dolinek and Durdik 1993, p. 303, fig. 372. Flints are listed in Borghini's notes; see Rinehart 1981, pp. 284–85. Moryson 1907, vol. 1, p. 322, reported that Francesco had invented fragmenting bullets (or shells) that "breake and murther."

48. Borghini would have read of this incident in either Quintus Curtius Rufus, *History of Alexander* (III, 12–26), trans. John C. Rolfe (Cambridge and London, 1962), vol. 1, pp. 140–45 or the Pseudo-Callisthenes' *Life of Alexander of Macedon*. Alexander's graciousness is also extolled in Arrian, *Anabasis of Alexander* (IV, 20–21), trans. P. S. Brunt (Cambridge and London, 1976), vol. 1, pp. 404–7.

49. Although the pendant carried by the soldiers in the picture bears the letters *SPQR* (Senatus Populusque Romanus), identifying the plunderers as Romans, it is difficult to say if Betti has represented a particular event. He does not simply depict random looting, but, in the foreground, presents an older Roman soldier emphatically instructing a younger one to collocate the booty. This narrative element suggests the influence of Machiavelli's *Discourses*. In his discussion of the proper ways in which the ancient Romans con-

ducted their wars, Machiavelli lauded them for collecting and placing booty all together in the republic's treasury, rather than allowing individual soldiers to keep the spoils; see Machiavelli 1950, pp. 300–1. Francesco would have much approved of this practice.

50. Rinehart 1981, pp. 284–85.

51. Evelyn 1936, p. 94.

52. The crowns and regalia would most likely have been antique or foreign; as Martha McCrory has pointed out (e-mail to the author of 10 September 2001), state ceremonial objects would have probably been kept in the Guardaroba in the Palazzo Vecchio.

53. "Mar morto la naphta al bitume"; see Rinehart 1981, pp. 284–85.

54. See, for instance, *The Geography of Strabo* (16, 2, 42), 1983, vol. 7, pp. 292–95. Strabo calls it the "Asphaltites Lake."

55. For the employment of asphalt in embalming, see *The Geography of Strabo* (16, 2, 45), 1983, vol. 7, p. 297. It was with asphalt or "slime" that the infant Moses' mother daubed – and waterproofed – his basket before setting it in the river (Exodus 2:3).

56. Pliny 1979, vol. 1, p. 361.

57. The most complete account of Medea's bizarre murder of Glauce appears in Euripides' play *Medea* (431 B.C.); see *Euripides' Medea* 1963, pp. 46–54. For the passage in Strabo (16, 1, 15), see Strabo 1983, vol. 7, p. 217. According to della Porta's *Natural Magick*, it was a prostitute that Medea burnt in this manner; see Porta 1957, p. 295. The sixteenth-century mineralogist Georgius Agricola reports that bituminous naphtha was so closely associated with Medea that the Greeks called it "oil of Medea"; see Agricola 1545, book I, p. 115; and Agricola 1955, pp. 61–68.

58. Virgil 1978, vol. 2, pp. 6–7.

59. In his notes, Borghini tentatively lists among his subjects for the Studiolo, "*una caverna di tartari per pota[ss?]e.*" Rinehart 1981, pp. 284–85, translated this inscription as a "Tartar's cave," but the phrase could also be read as a "cave of stalactites (or deposits)." In "Della

architettura" Vasari used the word "*tartari*" to refer to stalactites formed in caves by the action of water (see *Vasari on Technique* 1960, p. 87). The last word in the inscription is very difficult to decipher, but in the context of Francesco's chemical holdings, *potasse*, or potashes, would make sense. It may be that Borghini's intention – never realized – was that a painter should depict either a cave with stalactites or deposits as a reference to potash, or, as a fanciful pun on the word "*tartari*," Tartars – that is, the inhabitants of Tartary – in a cavern.

It is also possible that the mention of a cavern was Borghini's shorthand reference to the kingdom of Sleep, which Ovid, in the *Metamorphoses* (XI, 591–615), describes as a fantastic cave in the side of a mountain. Therefore, Borghini's note might record an initial conception for the setting of the *Allegory of Dreams*, otherwise omitted from his preliminary scheme. Just a few years earlier, in 1565, the float dedicated to Sleep in the wedding procession for Francesco I and Giovanna of Austria was conceived as an elaborate cavern (see Vasari 1878–85, vol. 8, p. 584). In the Studiolo painting by Naldini, Ovid's description of the domain of Sleep was rejected in favor of those offered by Homer (*Odyssey*, XIX, 562–67) and Virgil (*Aeneid*, XI, 893–900), who speak of a remarkable architecture with "twin portals, one made of ivory and one made of horn"; see Homer 1978, vol. 2, pp. 268–69; and Virgil 1978, vol. 1, pp. 570–71. Homer explains that "those dreams that pass through the gate of sawn ivory deceive men, bringing words that find no fulfillment," while "those that come forth through the gate of polished horn bring true issues to pass, when any mortal sees them."

60. The traditional use of alum in the mordanting and dyeing processes are described in Gioan-ventura Rosetti's *Plictho de L'arte de Tentori* (Venice, 1548). For English translations of Rosetti, see Sandberg 1994, pp. 64 and 85.

61. Vasari 1878–85, vol. 7, p. 613, note 4.

62. Frey 1923–40, vol. 2, pp. 634

and 638.

63. Mercati 1717, repro. p. lxi. A letter from Mercati to Francesco I, dated 29 June 1585, indicates that the men had previously met and that Mercati for some reason felt indebted to him. In this letter, Mercati also mentions that he has almost finished his manuscript for the *Metallotheca Vaticana*, which affords us a more accurate date for that catalog, heretofore assigned by scholars to ca. 1580; see Barocchi and Gaeta Bertelà 1991, no. 304, pp. 272–73.

64. Mercati 1717, pp. 44–45, 53–57, and 83.

65. Mercati 1717, pp. 77 and 83 (cabinet v).

66. "Sale che si fa dall' aqua in piu modi." Rinehart 1981, pp. 284–85, and Mercati 1717, pp. 25–51 (cabinet II). When they examined the Borghini document on 16 March 2001, Gino Corti and Meg Koster deciphered the words "*dall' aqua*" in the inscription. The word "*nitrum*" was used in antiquity and the Renaissance to refer to all (alkaline) hydrous sodium carbonates.

67. Pliny 1979, vol. 9, pp. 388–403. The sulphur, kept in the Stradano cupboard, was also occasionally used in wool processing; according to Pliny (xxxv, 175), sulphur was employed for "smoking woolens from beneath, as it bestows whiteness and softness"; see Pliny 1979, vol. 9, p. 391.

68. Rinehart 1964, pp. 74–75.

69. For damascened armor, see Pyhrr and Godoy 1998.

70. The mythological tale of Hercules slaying the dragon in the Garden of Hesperides is related in Apollodorus's *Library* (II, 113), p. 46. The golden apples in the garden are also mentioned in Hesiod's *Theogony* (215), for which, see Hesiod 1982, pp. 94–95. Borghini would have found the story of Atalanta and Hippomenes in Ovid's *Metamorphoses* (v, 560–707), 1984, vol. 2, pp. 104–15. The swift Atalanta, having stooped to pick up the apples and slowed by their weight, lost the race to her suitor, Hippomenes.

71. Schaefer 1976, vol. 1, p. 347.

72. Evelyn 1936, p. 185.

73. See Pliny, *Natural History*

(xxxvvi, 127), 1979, vol. 10, pp. 100–1; and Agricola 1955, pp. 83–85. In his volume on natural magic, della Porta devotes an entire book to lodestones; see Porta 1957, pp. 190–216.

74. These materials, beloved by the Medici, are mentioned in Borghini's *invenzioni*; see Frey 1923–40, vol. 2, pp. 887–88. Borghini also indicated in the *invenzioni* that samples of ebony and other rare woods would be stored on the earth wall (Frey 1923–40, vol. 2, p. 887). There may be a reference to one of these specimens in Borghini's sheet of notes, which bears the partially legible inscription "*attrita ligna mar s[ale?],*" possibly translated as "Salt Sea driftwood (or fossilized wood)." Although Borghini, elsewhere in his notes, employs the appellation "Dead Sea," in this instance he may be using the biblical name for that highly saline body of water; for the inscriptions, see Rinehart 1981, pp. 284–85.

75. Schaefer 1976, vol. 1, p. 350. The story of Deucalion and Pyrrha, the classical equivalent to the biblical account of Noah and the Flood, is told in Ovid's *Metamorphoses* (I, 260–473), 1984, vol. 1, pp. 20–33. In light of the ancient belief that fossils spontaneously generate within the earth, their placement behind the *Deucalion and Pyrrha* panel would have been most fitting (see Rudnick 1972, pp. 34–36). Moreover, in other late sixteenth-century collections of minerals, fossils were typically associated and stored with various kinds of stones, as, for example, in the "ark" or cabinet containing the mineral collection of the physician Johann Kentmann of Torgau (1518–74), illustrated and published in Conrad Gesner's book *On fossil objects*; see Gesner 1565 (into which is bound the catalog of the collection of his friend, Kentmann, entitled *Nomenclaturae Rerum fossilum, quae in misnia praecipue & in aliis quoque regionibus inveniuntur*), and Rudnick 1972, pp. 11–12. Like Pliny, Renaissance mineralogists usually did not differentiate between fossils and stones. Pliny (*Natural History*, XXXVII, 150–51) inserted into his

list of mineral stones a number of once-organic forms, including *brontia* (fossilized sea urchins) and *bucardites* (fossilized clamshells); the naturalists Gesner and Agricola followed him in this intermixing of geological materials; see Agricola 1955, pp. 97–98 and 142; and Gould 2000, p. 58.

76. Pliny 1979, vol. 10, p. 167.

77. McCrory 1997, pp. 170–71. Also see Chiarini 1970.

78. Pliny 1979, vol. 10, pp. 164–67.

79. Borghini grouped these three stones in his *invenzioni* (Frey 1923–40, vol. 2, p. 887). Agricola (1955, p. 83,) considered gemstones and certain other transparent or translucent stones, such as diamonds, rock crystal, carbuncles, and (in the nearby Studiolo cupboard) emeralds and sapphires to be of the same genus; he assigned most hard stones, including agate, jasper, porphyry, and sardonyx (that is, those stones on the opposite, earth wall) to a different genus.

80. Frey 1923–40, vol. 2, p. 891.

81. For rock-crystal and hardstone vases at the Medici court, see Fock 1974; and Fock 1980, pp. 317–63.

82. Schaefer 1976, vol. 1, p. 355. The Icarus myth is told in Ovid's *Metamorphoses* (VIII, 183–235).

83. Pliny 1979, vol. 10, pp. 182–83.

84. Borghini (see Frey 1923–40, vol. 2, p. 535) carefully noted this intentional discrepancy.

85. Frey 1923–40, vol. 2, p. 887.

86. The tale of Pygmalion and his statue, enlivened by Venus, is found in Ovid's *Metamorphoses* (X, 243–97), 1984, vol. 2, pp. 80–85.

87. The popular story of how the god Zeus, in the form of a golden cloud, ravished Danäe, who had been cloistered in a high tower by her father, is recounted by numerous classical authors, including Apollodorus (*Library*, II, 4) and Ovid (*Art of Love*, III, 415).

88. Rinehart 1981, pp. 284–85.

89. The assertion made by Rinehart (1981, p. 278) and others that the Studiolo originally had four doors seems highly unlikely. Not only would so many passageways be unnecessary and undesirable for such a small, private chamber, but they would

have lessened considerably the already very limited space for cupboards. Alessandro Cecchi (letter of 30 March 2001 to the author) is probably correct in suggesting that, before it was dismantled in the mid-1580s, the Studiolo had only one door, on the west wall. It is possible, however, that the enlarged oval of the Portelli *Oceanus* panel was intended to indicate discreetly the presence of a door hidden behind it, leading to the staircase at the south-east corner of the room.

90. Ovid 1984, vol. 1, pp. 104–5; and Schaefer 1976, vol. 1, p. 294.

91. Moryson 1907, vol. 1, p. 322.

92. See Mercati 1717, pp. 171–213 (cabinet VIII); and Bauer and Haupt 1976.

93. Frey 1923–40, vol. 2, p. 888. Perhaps among the medicinal herbs in the Buti cupboard would have been that species of the *panaces* plant known as "asclepion" or "asclepiade," discussed in Pliny's *Natural History* (XXV, 30), 1979, vol. 7, pp. 155–57 and Fuchs' *De historia stirpium*, 1999, pp. 129–30.

94. Yates 1964, pp. 40–41.

95. Ficino, *Three Books on Life*

(3, 12, 36–38), 1989, p. 301. From his study of Cabala, Pico della Mirandola also came to advocate the magical powers of amulets; see Trachtenberg 1939, pp. 137–38.

96. Pliny, *Natural History* (XXXVII, 61), 1979, vol. 10, p. 211; and Kunz 1971, pp. 369–72 and 376–80. Francesco is known regularly to have consumed precious materials such as the "elixir of life," a form of potable gold, believed to alleviate melancholy; see Berti 1967, p. 22.

97. Ficino, *Three Books on Life* (3, 12, 36–38), 1989, p. 301.

98. For unicorn mythology and the fabrication of drinking vessels, see Freeman 1976, pp. 29 and 53–54. In the center of his ceiling fresco, *Prometheus and Nature*, Poppi juxtaposed a unicorn with a snake.

99. "[d]oue staranno medicine pretiose, come balsami, corno d'unicorno, rimedij di ueleni et simil cose." Frey 1923–40, vol. 2, p. 530.

100. Bauer and Haupt 1976, p. 4.

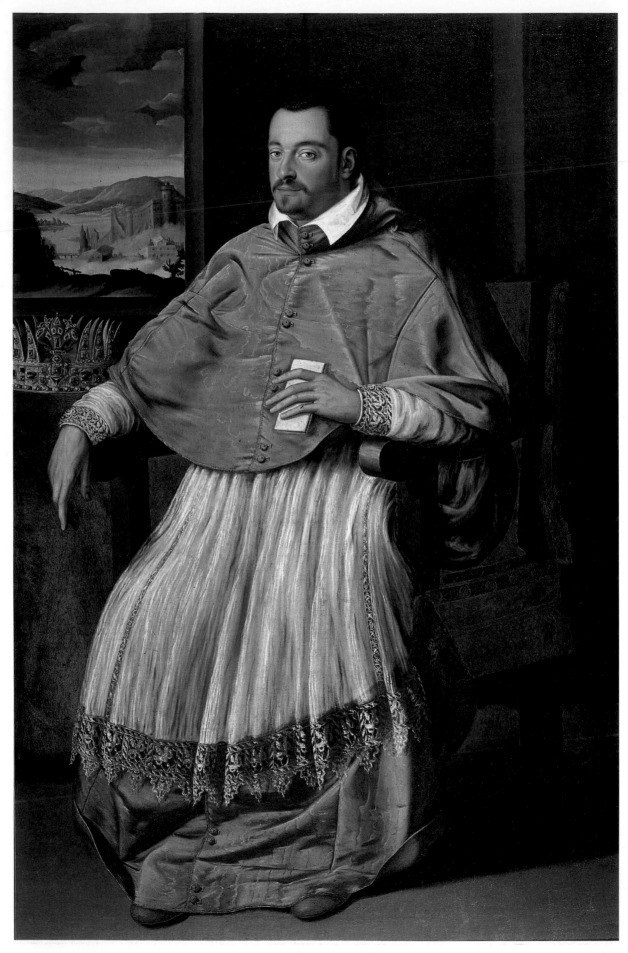

Fig. 30 Alessandro Allori, after Scipione Pulzone, *Cardinal Grand Duke Ferdinando I de' Medici*, 1587/88, oil on canvas. Galleria degli Uffizi, Florence.

FERDINANDO DE' MEDICI AND
THE ART OF THE POSSIBLE

Suzanne B. Butters

In 1588 Ferdinando de' Medici was quite unlike any other ruler in Italy. A portrait shows him dressed as a cardinal, the rank he had enjoyed for twenty-five years but would soon renounce, and flanked by a table bearing the grand-ducal crown, sign of the temporal office to which he had succeeded on the death in October 1587 of his brother and predecessor, Francesco I (fig. 30).[1] The brief reign of the elderly Cardinal Henrique of Portugal as king of that country from 1578 to 1580 had demonstrated that cardinals who were scions of ruling dynasties might take up the reins of secular power in the absence of another family heir,[2] and it was for this very reason that Ferdinando, also a cardinal prince, had remained a deacon, without taking the final vows that would have made him a priest. But the anomaly of Ferdinando's position became more pronounced when he began negotiations to renounce the purple in order to marry and to father dynastic successors. Sixtus V had hoped the Cardinal would remain celibate, an authentic church presence at the heart of the government of what was arguably then one of Italy's most formidable states. Indeed, no precedents could be found for a cardinal having given up a hat that he had willingly accepted (Cesare Borgia's renunciation of his cardinalate was justified on the grounds that he had been raised to the purple against his will).[3] Dynastic necessity prevailed over papal preference, however. Ferdinando donned secular dress on 30 November 1588, having had himself portrayed in armor a few days before,[4] and consummated his marriage with Christine of Lorraine, daughter of Charles II of Lorraine and granddaughter of the Queen of France, Catherine de' Medici, on 3 May 1589.[5]

Ludovico Buti's idiosyncratic image of Christine (fig. 31), projected on a mirror from the underside of an anamorphic portrait of her father on thirty-seven paper-covered wooden lathes, was executed for Ferdinando in 1592. Originating in an optical invention by Egnazio Danti, a Medici protégé and a renowned Dominican mathematician, cartographer, and architect,[6] it suggests some of Ferdinando's interests and values. With the daughter a literal projection of her father, it managed to evoke significant relationships of both dynasty and gender, in a form that entertained the intellect with an optical puzzle while alluding to hallowed metaphors of virtue and governance, the *Speculum Virtutis* and the *Speculum Principis*.[7] The references were not casual, for Ferdinando soon discovered that, when necessary, he could safely entrust important political matters to his new French wife.[8]

Though not an unwilling candidate for the College of Cardinals, this Medici ruler had certainly been an unlikely one. As the fourth of Cosimo's six surviving sons, the first groomed for rule in Tuscany (Francesco), the second for the Church (Giovanni), and the third for a military career (Garzia), the thirteen-year-old Ferdinando had been thrown into prominence by the sudden death of Giovanni and Garzia in 1562,[9] just as he would be in a more exalted fashion when Francesco died unexpectedly in 1587. That these events were somehow fated was suggested by Ferdinando's astrological chart at birth, which, it was said, had predicted that he was destined to rule the Tuscan state.[10] Despite Cosimo I's apparent suppression of the prognostication – he was acutely aware of its power to stimulate unrest among his subjects and heirs – knowledge of it seems not to have been forgotten in Ferdinando's circle of intimates, to judge by some idiosyncratic works of art he commissioned as cardinal (see fig. 34).[11]

Perhaps it was these abrupt and unexpected turns of fortune, coupled with the astrological promise of a spectacular dynastic future, that lent Ferdinando his

Fig. 31 Ludovico Buti, *Christine of Lorraine*, 1592. Museo delle Scienze, Florence.

characteristic ability to seize fleeting opportunities while still hatching grand long-term strategies. Nature had endowed this once dull and sickly child with a high degree of political astuteness and "natural cheerfulness,"[12] together with a physical stamina that withstood the eventual assaults of gout and obesity (in 1588, one Florentine noblewoman compared his appearance in secular dress to "a barrel of anchovies"[13]). Nurture had provided him with patronage models of princely magnificence that his propensity to extravagance tempted him to emulate but also with models of frugality, caution, and timing that his transparent wish to be admired led him to draw upon when the moment suggested that magnificence might be inappropriate.

So it was with the land transformation schemes that attracted the young Cardinal's attention. Reclaiming Lake Trasimeno and the flood plains of the Chiana Valley with a view to creating lucrative farmlands were only two of the grand territorial ambitions that Ferdinando would have to give up temporarily, and with them greater wealth for himself and opportunities for Medici architects and engineers.[14] During his ecclesiastical career, his taste for projects of this type and on this scale, fed by a desire to compete with the great public works undertaken by his father and celebrated with medals,[15] had to be reined in and redirected. His interest in farming and husbandry, memorably prefigured at Lorenzo il Magnifico's Poggio

a Caiano,[16] and, more recently, on the Tuscan estates of Cosimo I and Eleonora of Toledo,[17] was pursued at La Magliana, a rented property conveniently located between Rome and Ostia that Ferdinando never succeeded in buying outright.[18]

Somewhat rashly, he had stated that he preferred building residences *ex novo* to acquiring them from others,[19] but he made an exception for this venerable edifice associated with Leo X, for whose memory Ferdinando had a particular affection. This gap between rhetoric and reality persisted, for almost all of his residential constructions would be modifications of previous ones, including the Palazzo di Firenze and Villa Medici in Rome; the Ambrogiana, La Petraia, and Montevettolini in Tuscany; and the rear additions to the Palazzo Vecchio in Florence.[20] Only Artimino – the villa that he called his "creatura" and that others very quickly referred to as "La Ferdinanda" – approached Ferdinando's stated ideal, being virtually *ex novo* despite the presence of some earlier foundations.[21] The cycle of topographical representations of seventeen family villas that he commissioned to hang in Artimino's principal *salone* show how attached he was to residences built by others when they embodied the wealth and taste of his own ancestors.[22]

High-ranking visitors were lavishly housed at La Magliana, where an apartment hung with fine tapestries was also kept ready for papal visits,[23] and they were entertained on hunts that vied in scale with those organized there by the legendary huntsman, Leo X,[24] and emulated those of Ferdinando's parents and siblings in Tuscany.[25] At La Magliana, his guests could also observe the country accoutrements he had put in place: fine gardens and vineyards, a *pollaio* of imported ornamental poultry, and a dairy farm with Lombard cattle.[26] His large stable reflected Ferdinando's attachment to all that horses represented; noble carriage, the hunt, the races, military prowess, and chivalric values. As grand duke, he would claim qualities for one of his horses that recalled those of epic heroes and of Alexander the Great,[27] and have Allori paint six life-size portraits of horses at his San Marco stables in 1592,[28] inspired no doubt by Giulio Romano's Gonzaga series at the Palazzo Te, which Ferdinando had seen in 1584.[29] It is not surprising, then, that he commissioned an equestrian monument of himself, tellingly cast in bronze taken from the Turks in battle so as to emphasize its martial credentials (fig. 32),[30] nor that among the legends of Hercules, hero of the Florentines and the Medici, he was particularly partial to the one involving those hybrids of man and horse, centaurs.[31] On 24 June 1588 tapestries depicting centaurs, designed by Alessandro Allori and bearing the arms of Cardinal Grand Duke Ferdinando, were hung in a street near the Mercato

Nuovo as part of Florence's decoration for the feast day of its patron saint, John the Baptist,[32] while in 1600, meter-high sugar sculptures depicting centaurs abducting women ornamented the banquet tables Ferdinando commissioned for Maria de' Medici's proxy marriage to Henry IV, king of France, an equestrian sculpture of whom hovered mysteriously in the air before the royal bride.[33]

Ferdinando's taste for hydraulic engineering and striking land transformations found an outlet in his cosupervision of the extension of Rome's Acqua Vergine, his supervision for Sixtus V of the construction of the Acqua Felice,[34] and the project by Ammanati, unrealized but recorded in Zucchi's fresco as a future intention, to restructure the steep slope that lay below his Roman villa on the Pincian hill with terraces, ramps, and a spectacular Pegasus fountain that must have been envisaged for public use by the Romans.[35] Similarly, one or two public fountains would figure in Ferdinando's later plan, also unrealized, to transform the challenging slope in front of the Palazzo Pitti.[36] As grand duke, he would sponsor the construction of an aqueduct for Pisa, a project that his physician listed among "the almost divine works of Ferdinando I,"[37] but his dream of bringing distant water to the hilltop Artimino, an echo perhaps of what he had expected to achieve in Rome once the Acqua Felice arrived at his Pincian garden and an emulation of Francesco's famous conversion of the sterile, rocky site at Pratolino to one abounding in flora, fauna, and water, remained a dream.[38]

Like his father Cosimo, Ferdinando was a builder by inclination, and like Cosimo he had a military strategist's sensitivity to location, as his acquisition in early 1574 of the Ambrogiana's site shows.[39] Twenty-six kilometers west of Florence, at the confluence of the Arno and Pesa rivers, the site was pivotal in major Florence–Pisa and Florence–Rome lines of communication and perhaps, therefore, better in Medici hands, as the participation in a plot against Francesco in 1575 by the son of the property's previous Ridolfi owner probably confirmed.[40] The Cardinal intended the villa he began expanding from the earlier nucleus to be his finest rural construction in Tuscany, but when Prince Filippo, Francesco's only legitimate male heir, died in 1582, Ferdinando made the Ambrogiana over to Don Antonio de' Medici, the illegitimate son *ante matrimonium* of Francesco and Bianca Cappello.[41] The gesture, made in the teeth of Ferdinando's dynastic fears about the Medici succession as well as his bitterness over his brother's marriage to this mistress in 1579 and his suspicion that Don Antonio was being groomed for the principate, demonstrated his pragmatic ability to renounce pleasures in hand in order to reap

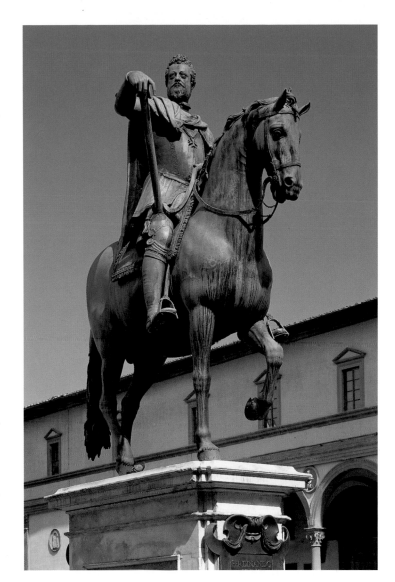

Fig. 32 Giambologna and Pietro Tacca, equestrian monument to Ferdinando I, 1601–08, bronze. Piazza Santissima Annunziata, Florence.

future benefits. His lavish expenditures in Rome had outstripped his generous income, and Ferdinando hoped that one such benefit would be a personal loan of 80,000 scudi from Francesco, a request his brother did not grant.[42] On his succession, Ferdinando took back the Ambrogiana and speedily carried the project to conclusion.

During his long period in Rome, where he began to reside regularly from 1569 on, six years after being raised to the purple, Ferdinando had matured as an individual, a politician, and a patron. His purse, at first relatively restricted but by the early 1570s amply stocked with an increasingly princely income from Florence as well as with benefices,[43] was sufficient to allow him to make significant spending choices as a patron of the arts. But no one, however well financed, can select without also

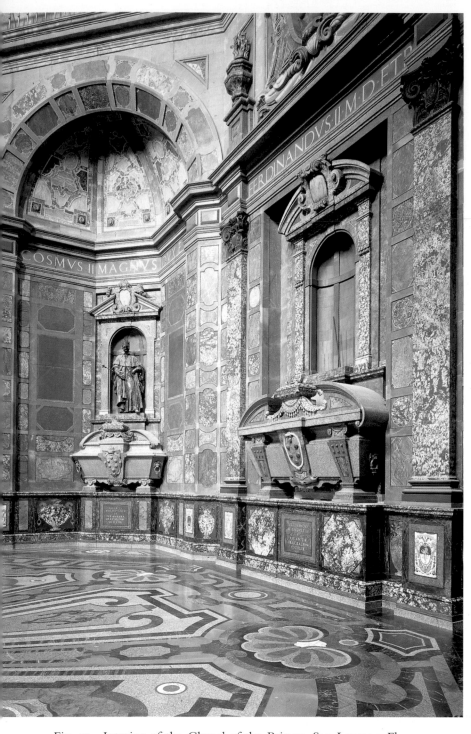

Fig. 33 Interior of the Chapel of the Princes, San Lorenzo, Florence.

excluding, so one must ask what criteria governed Ferdinando's choices. Was he to strike off in novel directions, taking risks on little known but promising artists, as his successor to the purple, Cardinal Francesco Maria Dal Monte, would do with Caravaggio? Ferdinando's protection of the mysterious Tuscan Piero Simoni da Barga seems to have been in this mode, but this sculptor's beautiful small bronzes after renowned ancient and modern works of sculpture were few in number and visible only to those with access to the Cardinal's residences.[44] More accessible to the public would be the full-size bronze cast of Carlo Muti's ancient marble *Silenus with the Infant Bacchus* that Ferdinando commissioned from the better known Jacopo del Duca,[45] a Sicilian and a favorite of Pius IV, the pope who had made Ferdinando a cardinal.

Was it better, perhaps, to emulate one or more prevailing tastes? And if so, of which individual or group? Rome was notable for its ancient and wealthy baronial clans, and Ferdinando certainly knew that his patronage would be compared to that of his most powerful rival at the Roman court, Alessandro Farnese, cardinal and baron.[46] On the other hand, Ferdinando and his Medici predecessors had marriage links with the Orsini. The live bear ("orso") that Ferdinando exhibited at the Villa Medici, like the later Salone dell'Orso at Artimino,[47] probably alluded to the family of his brother-in-law and nephew, and so too did the artificial "monte" he had raised in his Pincian garden (the residential enclave in Rome of the Orsini clan, Montegiordano, was popularly known as "Il Monte"). After Ferdinando left Rome, his garden mount would be identified as a Parnassus, although its slopes would never be populated by statues of Apollo and the Muses like Francesco's artificial Parnassus at Pratolino.[48]

How wise, or even possible, was it to emulate the patronage of popes and their relatives? Popes died, their relatives fell and they often favored artists from their native provinces (four popes, respectively from Milan, Boscomarengo, Bologna, and Montalto in the Marche, reigned during Ferdinando's cardinalate). Ferdinando's associations with papal art works suggest responsiveness but no consistent pattern of emulation. Pius IV's exemplary Tridentine ceiling for St. John in Lateran stimulated Ferdinando and his advisors to commission a striking new *soffitto* showing the Litany of the Virgin, made for his *titulus*, La Navicella.[49] Pius V's dispersal of papal antiquities chiefly benefited Cosimo and Francesco,[50] thereby stimulating Ferdinando not, as Francesco and Pius V would have preferred,[51] to give up his growing wish to compete in this area but to compete all the more.[52] Gregory XIII's opulent marble-clad *Cappella Gregoriana* in St. Peter's and Sixtus V's showy reliquary and mortuary

chapel in Santa Maria Maggiore would both provide inspiration for Ferdinando's Chapel of the Princes in San Lorenzo (fig. 33), but Cosimo I's intention to build such a chapel, recorded by Vasari, was probably more significant.[53] Sixtus V's claim that Ferdinando himself had suggested the Roman programme of street building and obelisks so firmly identified with the Montalto pontificate is plausible, given the example of Cosimo I's recent introduction of column monuments as urban markers in Florence.[54]

Was Ferdinando to be guided by the patronage of the Medici family, or the Florentines, or the Tuscans? These were certainly options with political advantages, options with a provincialism that could be presented as patriotism. Moreover, as a cardinal prince shadowed by a long family history of public and private patronage, Ferdinando would have been open to criticism had he failed to enter this competitive arena. Family and *patria*, then, as well as financial savings, led Ferdinando to exploit the proven talents of Medici experts, like Jacopo Zucchi, Alessandro Allori, Giambologna, and Ammanati. His understanding of "family" was wide enough, however, to embrace as mentors and models those Medici friends and allies whose own impressive patronage could be understood as a noteworthy extension of Tuscan excellence. The Del Monte axis stemming from the Tuscan family of Julius III, for example, was ultimately responsible for supplying Ferdinando with the three Roman properties that, with his enlargement and further ornamentation, came to exemplify his taste: the Palazzo di Firenze, the Vigna del Popolo with its antiquities, and, through Cardinal Giovanni Ricci of Montepulciano, the Villa Medici, with its spectacular hilltop site next to the walls of Rome.[55] Ricci's collection of Giovian portraits, assembled at this retreat and purchased with it by Ferdinando, had in turn been based on the copies that Ferdinando's father Cosimo had commissioned for his palace Guardaroba, a series that Francesco would display in the Uffizi.[56] Ferdinando's collection of oriental porcelain and maiolica took its cue from that of Ricci but could also call forth comparisons with the artificial porcelain that Francesco produced at the Casino Mediceo.[57] Works commissioned by Ricci, Cosimo, and Francesco provided models for the inlaid marble and *pietre dure* (hard stone) tables that Ferdinando commissioned (fig. 34), while the Cardinal's Roman palace workshops, in which they were produced, recalled the palace workshops of his father and brother.[58]

In 1588, Ferdinando would assign to the cultivated Roman, Emilio de' Cavalieri, the superintendency of the workshops that Francesco had transferred to the Uffizi five years before,[59] while continuing to foster a volumi-

Fig. 34 Zodiac tabletop, before 1587, pietre dure and marble. Museo degli Argenti, Florence.

nous production of tapestries at the workshop near San Marco founded by Cosimo I,[60] and building a new, independent workshop and foundry for Giambologna next to his house in Borgo Pinti.[61] In the Uffizi, outstanding works were realized, like Ferdinando's new *studiolo* for the Tribuna and a spectacular table top for Emperor Rudolf II, inlaid with hard and semi-precious stones, including many from imperial Bohemia. Eight years in the making, at an estimated cost of 20,000 scudi, this seamless surface of agates, jaspers, carnelians, garnets, chalcedonies, and amethysts seemed "the eighth wonder of the world" to the Emperor's physician and expert on stones, De Boodt.[62] Unusual works like these were still variations, however, on themes already developed by the *artefici* working for Ferdinando's two predecessors.[63] The sheer

quantities and diversity of *pietre dure* envisaged for the Chapel of the Princes, however, would reflect a specialization of this proven family taste that could be said to be idiosyncratically Ferdinando's, even though this had been shaped with the counsel of able advisors, ranging from family members (Christine and the dilettante architect Don Giovanni de' Medici) to full-time architects (Pieroni, Buontalenti, and Nigetti) and painters and sculptors with architectural talents (Santi di Tito, Lodovico Cardi, called Il Cigoli, and Francavilla).[64]

With political, social, and familial constituencies to satisfy, a patron of the arts like Ferdinando needed to stand out, but not so much so as to look foolish; to spend, but not so much so as to appear reckless; and to aim at a variety of audiences, but without appearing to lack discrimination. And, like any such patron, Ferdinando understood that he would be judged not only by the new works that he commissioned but also by the ready-made ones that he acquired. This opportunistic exercise depended on the market availability of such products and on networks of dependable friends, dealers, and agents: without these, Ferdinando would never have been able to purchase the much sought-after Della Valle-Capranica collection of antiquities in 1584, or the newly excavated group of *Niobids*, casts of whose impressive figures he had executed and shipped to Florence soon after his succession.[65] The originals, like most of his antiquities, remained in Rome, where they continued to serve as a cultural magnet for visitors and an implicit dowry for the next Medici cardinal.

Having grown up at a court where the arts were discussed *ad nauseam* by philosophers, literati, and artists themselves, Ferdinando also knew that "right opinion" was important and that his choices would be discussed and judged. Many friends and courtiers would help him to navigate in these difficult waters, counseling him on the choice of objects to acquire and imagery to promote.[66] The repeated attempts by Diomede Leoni, Michelangelo's friend, to discourage Ferdinando from buying a coconut in a "gothic" silver-gilt mount suggests, however, that princely taste could be resistant to the counsel of learned arbiters.[67] But his admiration for works by Andrea del Sarto conformed to what was by then received wisdom in Florence and abroad,[68] while his acquisition of striking works by the Bassanos was adventurous, and, as it proved, politically wise; copies of these were much sought after in Spain,[69] as were copies of the Arcimboldesque heads that Francesco Zucchi, Jacopo's brother, had painted for Ferdinando.[70]

Ferdinando never returned to Rome after his autumn visit of 1587, when Francesco and Bianca Cappello died, nor to the straitened financial circumstances that he claimed to have endured there. Much of the wealth set aside by his brother, and much of the buoyant state income, would be needed for utilitarian enterprises, many of which, like construction of a second citadel for Florence at the top of the Boboli Hill, or the continuing construction of the port, fortifications, and town of Livorno,[71] offered opportunities to architects, engineers, and figurative artists. He had Ammanati design a large rusticated addition to the Palazzo Vecchio – already transformed by Cosimo I – in keeping with Arnolfo di Cambio's *pietra forte* original, though Bernardino Gaffurri's shimmering hard-stone view of 1599–1600 for the Grand Duke would render this austere sandstone in mother-of-pearl, and the square's marble and bronze statuary in gold.[72]

Giambologna's equestrian monument of Cosimo I, already planned under Francesco I and foregrounded in Gaffurri's plaque, was one of these monuments and also the first of many public dynastic effigies that Ferdinando would commission, the greatest number and some of the largest being devoted to himself. These included over-life-size statues of him in Pisa,[73] Arezzo,[74] and Livorno,[75] and his equestrian monument in Piazza Santissima Annunziata (fig. 32).[76] In Rome, he had amply demonstrated this penchant for large-scale sculpture, both modern and antique, and he would do so again in Florence in striking ways. Both Giambologna's *Hercules and the Centaur* for the Canto de' Carnesecchi, which marked the junction of three streets,[77] and the four figures of the seasons erected in 1608 at the four corners of the Ponte Santa Trinita,[78] could perhaps be most fully appreciated by those who took up the practice of social promenading that Ferdinando introduced into Florence.[79] Taken together, this array of monumental public statuary suggests that Scipione Ammirato was not just toeing his master's line when he compared the opportunities given "Giambologna by Ferdinando favorably with those given him previously by Francesco. Giambologna used to complain that, although God had created him to make colossal sculptures and great contrivances, Grand Duke Francesco, because of the needs which arose, continuously used him to make small birds, little fish, lizards, and other tiny animals, but that Grand Duke Ferdinando had freed him from that tedium, and kept him busy making the most noble equestrian statue of the most noble prince, Grand Duke Cosimo, his father."[80]

In some cases, Ferdinando exploited effectively the opportunities that were thrust on him. Following the tragic fire of 1595 in Pisa cathedral, his architect Raffaello di Pagno, in collaboration with numerous Florentine sculptors and a master caster, designed and executed three new pairs of bronze doors for the façade,[81] which were so admired that attempts were made to

secure them for the entrance of Florence cathedral.[82] The fact that they were installed in Pisa, as intended, is explained in part by Ferdinando's habit of residing there with his family every winter.[83] In other cases, one must ask why he failed to take up an opportunity, such as the construction of the façade of Florence cathedral, a prestigious civic project for which he continued to consider models by Florence's principal architects as his brother had done before him. Did Ferdinando fear that Florentines might react as badly as they had to Buontalenti's recent destruction of the ancient façade under Francesco?[84]

At the start of his reign, the Cardinal Grand Duke made public display of the largesse that he wanted to be as prominent a feature of his court as frugality had been of his predecessor's.[85] Liberated from debt, he demonstrated generosity, hospitality, and spending plans on such a scale that one ambassador wrote that the court now seemed to be the court of a king.[86] And knowing that he would be freed from his vow of chastity, which he had always observed more in the spirit than the letter, Ferdinando began to pursue women, both maiden and married, sufficiently openly to earn him the nickname among his critics of "Sardanapalus,"[87] the legendary Assyrian king whose sybaritic lifestyle consisted of eating, drinking, and enjoying the company of women.[88] Although this unseemly burst of courtship would subside, its enthusiastic focus survived in the genteel form of the cycle of portraits of sixty-six exemplary gentlewomen that Ferdinando commissioned for Artimino.[89] The spectacular

hospitality and celebrations for his marriage to Christine of Lorraine in early 1589, which called forth ingenious and flamboyant inventions from his artists, literati, and musicians, stripped his coffers of an estimated 200,000 scudi.[90] These memorable entertainments served as a fitting launch for what would be a most successful match, whether judged by marital trust and affection, or by their numerous offspring,[91] who, as potential heirs, cardinals or wives of princes, provided Tuscans and the world with evidence of the security and power of the Medici regime.

Within a short time, however, floods, famine, and unemployment put more sobering demands on the well-stocked grand-ducal coffers,[92] demands that now threw Ferdinando's natural talents as a ruler into prominence. The continuing opulence of his principate was visible less in his private lifestyle, then, than in the magnitude of his public works, the generosity of his hospitality and gifts, and the amount of time that he increasingly devoted to favorite personal projects, such as Artimino and the Chapel of the Princes. The magnificent celebrations he commissioned in 1600 for the marriage of his niece Maria to Henry IV, king of France, described and illustrated in print, together with Maria's 600,000-scudi dowry,[93] were calculated to impress the princes of Italy and Europe as well as Florentines, as were equally the theatrical festivities, mounted on the Arno as well as in the streets, squares, and Medici properties, on the occasion of his heir's marriage to Maria Maddalena of Austria in 1608.[94] Once again, Ferdinando understood what money spent on art made possible, and acted accordingly.

NOTES

1. On the portrait, a variation on Scipione Pulzone's of the early 1580s and almost certainly by Alessandro Allori, see Langedijk 1981–87, vol. 2, pp. 720–21, 729, and Cecchi Hochman 1999, pp. 136–39. On the grand-ducal crown, see Fock 1974. On Ferdinando, see Usimbardi 1880; Andres 1976, I, pp. 206–328; Butters 1991a; Sanfilippo and Sanfilippo 1991; Calonaci 1996; Fasano Guarini 1996; Fasano Guarini 1998; Butters 1999; and Calonaci 2000, all with previous bibliography.
2. Hierarchia Catholica 1923, p. 30; Pastor 1958–64, vol. 5, p. 208; and Ricci 1972, pp. 251, 254, 271.
3. "Questo atto di rinontia

del capello [cardinalizio di Ferdinando] et la cerimonia usata in questa occasione ha bisognato hora di novo formar et regolar, perché mai più si trova che d'alcuno cardinale il qual'habbia accettato 'l capello dopo 'haverlo accettato sia stato rinontiato. Et il caso di Cesare Borgia dicono che non fu rinontia di capello ma fu una decchiaratione ch'essendo per forza del padre fatto cardinale, l'elettione s'intendesse nulla, per esser stato atto violente et sforzato." (Archivio di Stato di Venezia, Senato III [Secreta], Ambasciatori, Dispacci, Roma 22, letter from Venetian ambassador Giovanni Gritti to Pasquale Cicogna, doge of Venice, Rome, 3 December 1588, fols. 385v–386r.)
4. Butters 1999, pp. 38–39.

5. Lapini 1900, pp. 283–84.
6. Langedijk 1983, vol. I, p. 190, note 43, and pp. 657–58. On Danti's career and writings on perspective, see Fiore 1986a and Kemp 1990, pp. 78–83 and passim, both with bibliography. On the construction of anamorphoses, including this one by Danti and others, see Kemp 1990, pp. 208–12 and passim, and Baltrusaitis 1969. On Ferdinando's long-standing rapport with Danti, see Fiore 1986a, p. 660 and Butters 1991a, p. 173. On Buti, see Meloni Trkulja 1972.
7. Shapiro 1975; Skinner 1978, I, pp. 88–94, 118–28; and Skinner 1988, pp. 389, 391, 423–24, 431–33, 441, and 443–45.
8. Bertoni 1985, p. 38. Christine's period of rule after the death of

Ferdinando, judged by Bertoni to be disastrous, needs to be reassessed.
9. Pieraccini 1986, vol. 2, pp. 105–18, 119–24, 125–61, 185–214, 217–49, respectively on Giovanni, the cardinal (1543–62), Garzia (1547–62), Francesco (1541–87), Pietro (1554–1604), and Giovanni, son of Cosimo I and Eleonora degli Albizzi (1567–1621); Pietro, or "Don Pedricco" (1546–47) and Antonio (1548) died in infancy (Pieraccini 1986, vol. 2, pp. 81–83, 85). Ferdinando was born in 1549 – 19 July according to his secretary–biographer, Piero Usimbardi, and 30 July according to Usimbardi's editor, Saltini – and he died on 15 February 1609 (Pieraccini 1986, vol. 2, pp. 282–304).

10. Usimbardi 1880, p. 371.

11. Butters 1999, pp. 23–26.

12. Usimbardi 1880, p. 391 ("giocondità naturale").

13. "un barilotto d'acciughir." Butters 1999, p. 39.

14. Butters 1991a, p. 178; Butters 1991c, pp. 379–80; Butters 1999, pp. 35–36; and Calonaci 2000, pp. 42–43; and on Medici holdings in the Tuscan Chiane and Francesco I's acquisitions in the Chiane of the papal states, see Parigino 1999, pp. 48, 82, 108, 124, 131, 139, 177. On the monument of 1595 celebrating Ferdinando's reclamation of the Aretine countryside, see below, note 74.

15. For example, Langedijk 1981–87, vol. I, p. 486, those celebrating Cosimo's land reclamation and construction of a new aqueduct for Florence.

16. Lillie 1993.

17. Parigino 1999, pp. 75–106.

18. Usimbardi 1880, p. 386; Coffin 1979, pp. 112–31; Butters 1991a, pp. 182–83; and Butters 1991c, pp. 351–52, 356, 387, 390, 398, 400.

19. Butters 1991a, p. 181; and Villa Médicis v, letter from Cardinal Ferdinando to Cardinal Ricci da Montepulciano, 9 November 1573 ("Se ben' mi piacciono molte cose d'altri, et so che potrei haverle così fatte con minore spesa, tuttavia inclino molto più, senza guardare in altro, a fabricarmene da me stesso, et per questa via disegno di provedermi di case et di ville dove io stimarò buono d'haverne").

20. Usimbardi 1880, p. 386; Butters 2001a, pp. 76, 357 (note 128). On the Roman constructions, see Andres 1976; Butters 1991a, pp. 179–81, 190–91; Butters 1991b; and Toulier 1991, all with bibliography. On the Ambrogiana, see below, notes 39–41. On La Petraia, see Butters 1991a, pp. 177–78; Butters 1991c, passim; Acidini Luchinat and Galletti 1992, pp. 139–65; and Acidini Luchinat and Galletti 1995. On Montevettolini, see Mignani 1993, pp. 48–49, 95–97.

21. See, for example, Brown 1969; Mignani 1993; Cassarino 1990; Fara 1988, pp. 255–60; and Parigino 1999, pp. 151–53, 156.

22. On the cycle, see Mignani 1993; see cat. no. 40; Cassarino 1990, fig. 34, for a view of the lunettes in situ; and Butters, "Land, Women, and War."

23. Villa Médicis v, documents for 29 November 1573 and 12 February 1574.

24. Coffin 1979, pp. 122–27.

25. The practice is reflected in the voluminous Medici legislation prohibiting hunting, fowling or fishing without ducal permission in many areas of Tuscany; Duke Cosimo I's bando of 4 February 1550 (stile moderno) prohibiting "[il] cacciare, uccellare, o imberciare nelle bandite, et altri luoghi infrascritti" can be taken as an example of the type, as can Cardinal Grand Duke Ferdinando's renewal of all prohibitions regarding "caccie, pescagioni, et uccellagioni nel Dominio Fiorentino" of 6 February 1588 (stile moderno) (Pratilli and Zangheri 1994, I, pp. 60–63, 305–8). A 1740 map of Medici hunting preserves within twenty miles of Florence shows how invasive they were (Ginori Lisci, p. 133, fig. 140, and figs. 141–43 for particular bandite). Formalized hunts and combats between animals featured as urban entertainments in many Medici weddings of the time (for example, Gaeta Bertelà and Petrioli Tofani 1969, pp. 204 and 216, in 1584 and 1608; Saslow 1996, pp. 163–64, in 1589), as did set-piece hunts at Medici villas, like that in 1579 at Poggio a Caiano (Gaeta Bertelà and Petrioli Tofani, p. 202), where the residence already contained most of the large cycle of tapestries devoted to hunts originally commissioned by Cosimo I (Meoni 1998, pp. 210–31). Ferdinando staged lion hunts for the visits to Florence of Cardinals Montalto and Del Monte in 1602, and of Archduke Maximilian of Austria in 1604 (Gaeta Bertelà and Petrioli Tofani, pp. 208–9, 210). Sculpted hunting scenes of men and animals covered the banquet tables for Maria de' Medici's marriage in 1600 (Mamone 1987, p. 62).

26. Butters 1999, pp. 29–30.

27. Butters 1999, p. 38.

28. "In faccia d'un Corridore, che vi è coperto per poter far gl'esercizi [della Cauallerizza] in tempo di pioggia sono dipinti al naturale sei Caualli di mano d'Alessandro Allori i quali sono oltre modo vaghi, mostrando ogn'uno di loro diversa attitudine, e varia movenza." (Bocchi and Cinelli 1974, pp. 16–17; and Lecchini Giovannoni 1991, p. 77.)

29. Konrad Oberhuber, in Gombrich et al., 1989, pp. 340–41, and Renato Berzaghi, in Gombrich et al., 1989, pp. 394–95, on Giulio's 1536 Camera dei Cavalli for Duke Federigo Gonzaga in the Palazzo Ducale in Mantua. On Ferdinando's visit to Mantua, where he accompanied his niece, Eleonora de' Medici, newly married to Prince Vincenzo Gonzaga, see Butters 1991c, p. 392.

30. Watson 1983, pp. 160–86; and Avery 1987, pp. 164, 258.

31. On Giambologna's marble Hercules Killing a Centaur, the precise subject of which is almost certainly a parergon to the hero's fourth Labor (The Capture of the Erymanthian Boar) rather than Hercules Slaying Nessus (cf. Anthony Radcliffe and Manfred Leithe-Jasper, in Avery and Radcliffe 1978, p. 128), see below, note 77.

32. Lecchini Giovannoni 1991, pp. 254–55, and Meoni 1998, p. 505. On this series of centaur tapestries, commissioned by Ferdinando for his palace in Pisa, and the earlier series commissioned by Francesco I for Poggio a Caiano, see Meoni 1998, pp. 268–69, 290–95.

33. Watson 1978, pp. 22–23; and Watson 1983, p. 29 and pp. 153–54, note 7.

34. Butters 1991c, pp. 401–7.

35. Butters 1991c, pp. 362–65.

36. Cf. Anthea Brook in Avery and Radcliffe, 1978, p. 205 and Morrogh 1985a, pp. 137–40; Buontalenti's version of the project, seemingly taken up again by Cigoli for Ferdinando as grand duke (Gambuti 1973, pp. 120–21), may well have been for Francesco in the later 1570s (Morrogh 1985a, p. 138), and so be in closer rapport than has been realized to Ammanati's Roman scheme for the Cardinal, datable to 1576 (Butters 1991b, p. 258; and Butters 1991c, pp. 358–65).

37. "le opere quasi divine di Ferdinando I." M. T. Lazzarini and R. Lorenzi, in Livorno e Pisa, 1980, pp. 64–67; and cf. Usimbardi 1880, p. 386 ("[l'acquedotto di Pisa] dette la sanità a quella città"). Raffaello di Pagno, who already had experience of aqueduct construction from the Acqua Felice in Rome (Butters 1991c, pp. 402–3), was in charge of the project, which he began to study in 1589; fresh water from the Monti Pisani arrived in Pisa in 1595.

38. "Un'altra acqua havea [Ferdinando] disegnato di condurre da certi monti lontani alla sua villa Ferdinanda, con spesa eccessiva." (Usimbardi 1880, p. 400); on Pratolino's water supply, see Lazzaro 1990, p. 161.

39. Villa Médicis V, 24 March 1571 and 5 February 1574 (stile moderno); Vasić Vatovec 1984, pp. 7–10 (which mistakenly gives 1573 rather than 1574); and Parigino 1999, pp. 156–57.

40. Piero di Lorenzo Ridolfi and others were implicated in the plot that Orazio di Pandolfo Pucci mounted against Francesco I in 1575 (Ricci 1972, pp. 148–50).

41. Vasić Vatovec 1984, pp. 10–11; and Butters 1991a, p. 188. The donation is dated 5 January 1583 (stile moderno).

42. Butters 1999, pp. 30–31.

43. Calonaci 2000, pp. 29–39.

44. Butters 1991a, pp. 183–85; Massinelli and Tuena 1992, pp. 67, 140–43; and Hochmann 1999, pp. 208–11.

45. Butters 1991a, p. 185; Heikamp 1997a, pp. 53–54; and Hochmann 1999, pp. 200–1.

46. On Farnese, see Robertson 1992.

47. Butters 1991c, pp. 366–70.

48. Butters 1991c, pp. 377–86.

49. Butters 1991a, pp. 175–77; and Butters 1999, pp. 37–38.

50. Deswarte-Rosa 1991, pp. 158–61.

51. Butters 1991a, p. 179.

52. Butters 1991b, pp. 299–300; Gasparri 1991 and 1999; and Butters "Making Art Pay."

53. Morrogh 1985b, pp. 319–20; Ostrow 1990, pp. 254–56; and cf. Butters 2000, pp. 138, 176–77, App. v, on Ferdinando's project, briefly entertained, for a stone- and mosaic-encrusted dynastic funerary chapel, costing 100,000 scudi, in Florence cathedral. On the Chapel of the Princes, see

below, note 64.

54. Butters 1999, p. 35.

55. For the Del Monte connections, see for example Tesoroni 1889; Coffin 1979, p. 171; Deswarte-Rosa 1991, pp. 112–15; Butters 1991b, p. 280; Butters 1991c, p. 383; and Parigino 1999, pp. 82, 107, 253

56. See most recently, Butters 1999, pp. 27, 42 (note 39); Cecchi 1999, pp. 242–45; and Butters, "Land, Women, and War."

57. Deswarte-Rosa 1991, pp. 124–25; Heikamp 1997a, pp. 403–4; and Hochmann, pp. 214–21. On Francesco's Casino workshops, see most recently, Butters 2000, pp. 164–65, 172–76, App. III.

58. Deswarte-Rosa 1991, pp. 150–52 and Butters 2000, pp. 144–66, both with bibliography.

59. Butters 2000, pp. 144–45, 154–55, 163–66, 172–76 (App. III), and 178–79 (App. IX). On Emilio de' Cavalieri, see Kirkendale 1979 and 2000.

60. Meoni 1998, pp. 35–119.

61. Watson 1983, pp. 16–17; and K. Watson, in Avery and Radcliffe 1978, pp. 34–39.

62. Giusti 1992, p. 138.

63. On the Emperor's table, see Del Riccio 1979, fols. 103–4; Distelberger 1997, pp. 192–95; and Giusti 1992, pp. 31, 74, 137–38, on the relationship between hard-stone craftsmen in Florence and Prague under Ferdinando I and Cosimo II. On the Tribuna and Ferdinando's *studiolo*, see Heikamp 1997a. On work in *pietre dure* for Cosimo I and Francesco I, see Giusti 1992, pp. 35–79; Massinelli and Tuena 1992, pp. 58–144; and Butters 2000.

64. Borsi 1993, pp. 251–89, 314–43, and for an example of Francavilla's architectural activity, see M. T. Lazzarini and R. Lorenzi, in *Livorno e Pisa* 1980, pp. 273–75. On the Chapel of the Princes, and these contributors, see Baldini, Giusti, and Pampaloni Martelli 1979; Giusti 1992, pp. 77–79; and Przyborowski, in *Magnificenza* 1997, p. 303.

65. On the group, see Gasparri 1999, pp. 162–67, with bibliography; on the plaster casts ("numero quindici fiure di gesso grande al naturale della storia di Niobe le quali sono venute in Firenze sino il dì 3 di settembre 1588, e le mandò messer Marentio Marenti [from the Villa Medici in Rome])," see Archivio di Stato di Firenze, Guardaroba Medicea 79, fol. 33r.

66. Butters 1991a, 173–75; 185–86; on Ferdinando's humanist mentor, Pietro Angeli da Barga, see Morel 1991a, pp. 303–9.

67. Butters, "Making Art Pay."

68. Cecchi 1991, pp. 495–96, 502, 504; Cecchi 1999, pp. 61, 52, 250–53; and on the Bracci *Holy Family* and its donation to Ferdinando, A. Cecchi, in *Andrea del Sarto* 1986, pp. 137–39; and Butters 1999, p. 27. On the contemporary Florentine enthusiasm for Andrea's work, nicely explored in Francesco Bocchi's *Discorso sopra l'Eccellenza dell'opere d'Andrea del Sarto, Pittore fiorentino* of 1567, the period when Ferdinando's taste was taking shape, see Williams 1997, pp. 191–201.

69. Cecchi 1991, pp. 493, 495, 498, 502, 504; Cecchi's catalogue entries for Cecchi 1999, pp. 260–65; and Butters, "Making Art Pay."

70. Butters, "Making Art Pay"; and Strinati 1991, pp. 563–64.

71. On the citadel, see Fara 1988, pp. 226–36; Dario Matteoni, in *Livorno* 1980, pp. 121–47; and Butters 2001a, pp. 75–77.

72. Butters 2000, pp. 138–40.

73. S. Renzoni, in *Livorno e Pisa* 1980, pp. 371–73; and Langedijk 1981–87, vol. 2, pp. 753–54; executed by Pietro Francavilla after a design by Giambologna between 1593 and 1595, it was displayed until 1872 on the Lungarno Paccinotti, in front of the ducal palace (De Francqueville 1968, p. 64). Ferdinando went on to commission an over-life-size marble statue of Cosimo I from Francavilla (1594–96), for the Piazza dei Cavalieri in Pisa (S. Renzoni in *Livorno e Pisa*, 1980,

pp. 369–71, and Langedijk 1981–87, vol. 1, 478–80).

74. Executed by Francavilla after a design by Giambologna, the monument is dated 1595 and bears an inscription recording that it was raised by the Aretines in thanks for his reclamation of the city's countryside and consequent improvement of its salubriousness (Langedijk 1981–87, vol. 2, pp. 752–53).

75. Begun in 1595 and transported to Livorno in 1601, Giovanni Bandini's figure was finally raised into place under Cosimo II (Pera 1988, pp. 6–9); the idea of the four bronze slaves chained at his feet, realized under Cosimo by Tacca, had been conceived for Ferdinando I (Watson 1983, p. 166).

76. See above, note 30. On other sculpted public images of Ferdinando, see Langedijk 1981–87, vol. 2, pp. 743–55.

77. Pope-Hennessy 1986, pp. 388–89; Avery 1987, pp. 114–19; Evans Dee 1971, no p., number 12, on Zocchi's drawing; and Ciabani 1984, pp. 128–31, on the three streets (via dei Cerretani, via dei Rondinelli, and via de' Banchi) that formed the *canto*.

78. Francavilla's *Spring*, Giovanni Caccini's *Summer* and *Autumn*, and Taddeo Landini's *Winter*; the figures had been removed from the garden of Alessandro Acciaioli (De Francqueville 1968, pp. 24, 63, 86–87, note 160), adjacent to the Arno near the Ponte Vecchio (Bocchi and Cinelli 1974, pp. 120–21).

79. "Andando hiermattina con Sua Altezza [Ferdinando] in cocchio, l'Altezza Sua entrò a ragionar con me di volersi dar piacere et di voler introdurre in Fiorenze ché i gentilhuomini andassero a spasso come si fa nelle altre città, et le gentildonne." (Archivio di Stato di Modena, Archivio Segreto Estense, Carteggio degli Ambasciatori, Firenze 28, letter 406, Hercole Cortile, Ferrarese ambassador in Tuscany to Alfonso II, Duke of

Ferrara, Florence, 2 January 1588, stile moderno.)

80. Ammirato 1853, pp. 155–56.

81. Usimbardi 1880, p. 386; De Francqueville 1968, pp. 69–71, 167–68, 170–71; and Watson 1983, pp. 114–23. The Duomo's restoration was apparently financed by increasing the price of salt (Dallington 1983, p. 44). On Raffaello di Pagno and Ferdinando, see for example, Butters 1991b, pp. 299–300.

82. Scalini 1988, p. 27.

83. Dallington 1983, p. 71. The new Medici Palace in Pisa that Buontalenti began in 1583 was completed just before Francesco's death, in October 1587 (M. T. Lazzarini and R. Lorenzi, in *Livorno e Pisa* 1980, pp. 276–81).

84. Butters 2001b, pp. 491–96, 500–1, with previous bibliography.

85. Butters 1999, p. 31.

86. "questa corte pare una corte hora di Re . . ." (*Villa Médicis* v, 4 November 1587).

87. Butters, "Land, Women, and War."

88. Furlani, 1936.

89. Emanuela Fiori, in *Palazzo Vecchio* 1980, pp. 303–8; Butters, "Land, Women, and War"; and Usimbardi 1880, p. 392.

90. Saslow 1996, pp. 176–78.

91. Bertoni 1985, and Pieraccini 1986, vol. 2, pp. 305–22.

92. Licata and Vanzulli 1976; and Butters 2001a, pp. 75–77.

93. Mamone 1987, pp. 21–22; Christine of Lorraine's dowry of 600,000 crowns had been roughly similar, but it also included the restitution of all Medici properties formerly held by Queen Catherine de' Medici (Bertoni 1985, p. 38; Saslow 1996, p. 177; and Parigino 1999, pp. 51–56).

94. "Nelli spettacoli et feste pubbliche [Ferdinando] fu magnifico a maraviglia, come si vedde nelle nozze sue, in quelle della regina Maria nipote, et in quelle del principe suo figliuolo, in forma più simili a miracoli che a cose naturali, perchè non si contentava senza l'eccesso." (Usimbardi 1880, p. 390.)

COSIMO II AND
MARIA MADDALENA OF AUSTRIA

Marco Chiarini

When Cosimo II de' Medici succeeded Ferdinando I as grand duke of Tuscany in 1609, he inherited a princely state that was thriving. The reign of his grandfather, Cosimo I, had been followed by the troubled rule of Francesco I, whose weakness and introversion tainted his administration, absorbed as he was with a personal interest in the sciences and amorous pursuits, including his long-standing relationship with Bianca Cappello. But Ferdinando I, Francesco's brother, restored the administration to its former vitality, giving it, as his father had before him, a fresh impetus and a strong identity that brought it to the forefront of European affairs. At the same time, more royal blood was introduced to the Medici family, Francesco I having married Giovanna of Austria in 1565, when Catherine de' Medici, queen of France, promoted the marriage of Ferdinando to her granddaughter Christine of Lorraine, which took place in 1589. Ferdinando also founded strategic alliances by orchestrating the marriage of his niece, Maria, daughter of Francesco and Giovanna, with Henry IV of France in 1600, and, eight years later, that of his son and heir, Cosimo II – in honor of whom the title *Gran Principe*, "Great Prince," was coined – with Maria Maddalena of Austria – daughter of Archduke Charles – whose brother would become emperor Ferdinand II of Austria ten years later.

Because of the diplomatic ties that existed with the Spanish royal household, this union with the Medici family received the approval of Philip III of Spain, who was married to Maria Maddalena's sister, Margaret of Austria. The event – which, in keeping with the custom of the time, took place by proxy, in Graz on 14 September 1608 – was celebrated with unprecedented magnificence on 18 October of the same year. The bride made her triumphal entrance into Florence through the Porta al Prato, which was embellished for the occasion with decorations by Cigoli. A seemingly endless cortège preceded and followed the carriage, which was covered in "red golden cloth, all embroidered, and pulled by four chargers also superbly adorned."[1] The procession progressed through several imposing triumphal arches, while the city teemed with revelers, lining the route to greet the bride's arrival and crowding the Piazza Pitti, which was impressively decorated with carpets and tapestries. In the evening, the routes along the Arno and the squares and major buildings were illuminated by lanterns, flares, and fireworks to encourage the merrymaking of the Florentines. The celebrations continued for several days, with banquets, dances, theatrical displays in the Palazzo Vecchio and Palazzo Pitti, and ceremonies in the basilica of San Lorenzo, the Medicean church *par excellence*. A performance took place on the Arno dedicated to the Argonauts, alluding to the conquest of the Golden Fleece, and so celebrating the Order of the Golden Fleece, whose decoration the Medici grand dukes proudly wore. The subject also served to remind the audience of the imperial origins of the bride, a descendant of the Holy Roman Emperor Charles V and of the emperors of Austria.

The celebrations in honor of the Crown Prince of Tuscany marked the beginning of a period characterized by Cosimo II's passion for music and theater. The tradition of performance had already taken root in the time of Cosimo I, when comedies were staged on special occasions, such as Cosimo's marriage to Eleonora of Toledo in 1539. It was only on the occasion of Ferdinando I's wedding to Christine of Lorraine in 1589, however, that the first performance with musical *intermezzos* (namely *La Pellegrina* by Girolamo Bargagli) took place, in the Uffizi Theater. This was followed by the first opera, *Euridice* by Jacopo Peri, in the Salone delle Commedie in the Palazzo

Fig. 35 Detail of cat. no. 116.

77

Fig. 36 Bernardino Poccetti, *Port of Livorno*, 1608–12, fresco. Sala di Bona, Palazzo Pitti, Florence.

Fig. 37 Filippo Napoletano, *Cosimo II de' Medici*, 1618–19, oil on canvas. Museo Stibbert, Florence.

Pitti, to celebrate the union of Maria de' Medici with Henry IV of France. Under Cosimo II, this aspect of court life became dominant and the Grand Duke never let an important occasion – a visit by prominent personages or a family wedding – pass without some public performance in the squares or on the Arno, demonstrating a creativity that is reflected in the Florentine art of the time (see Anna Maria Testaverde's essay in this catalog).[2]

Born in 1590, Cosimo reigned for just over ten years (1609–21). The brevity of his tenure perhaps explains why his political identity within the government of the Tuscan state is less well-defined than that of his predecessors and successors. Nevertheless he was extremely popular among his subjects, as was pointed out by historian Domenico Moreni: "On 28 February 1620 [in fact 1621] at the young age of thirty-two, the Grand Duke Cosimo II, son of Ferdinando I, died, and people of all extractions sincerely mourned his loss, as he possessed all the qualities that beget the peoples' love. Indeed no sovereign of the Medici family, before him or after, was ever so well-loved as he. Clemency and moderation formed his character and the passionate love and kindness he had for his subjects all but won him their worship. His brief government, blessed by his people, was equally blessed by heaven, and in dying he had the comfort of leaving Tuscany in the most prosperous state it had enjoyed."[3]

A passion for the arts was characteristic of the Medici princes; it originated with Lorenzo il Magnifico's treasure, which passed into the grand-ducal collections, and developed even further during the reign of Francesco I, who created the Studiolo in the Palazzo Vecchio and the Tribuna in the Uffizi.[4] Under Ferdinando I the production and collection of precious objects increased, especially with the creation of the *pietre dure* (hard stone) and other grand-ducal workshops. Cosimo II was the keen successor to such initiatives. His union with a Hapsburg princess probably accentuated his personal inclination to commission precious objects, not only for his own collections, but also for various beneficiaries. The masterpiece among these works was the Fiori Sparti (scattered flowers) table, executed between 1614 and 1621 from a design by Jacopo Ligozzi (now in the Uffizi). At the same time magnificent gifts reached the Florentine court, such as the lapis lazuli panel with Antonio Tempesta's painting *Pearl Fishing in the Indies*, now in the Louvre and too fragile to be presented in the current exhibition.[5]

The splendor of the Tuscan court under Cosimo II became legendary, especially in the area of public festivals and performances – "Here at court we pass the time gaily, and we always shall, as long as the Grand Duke is healthy," according to a contemporary witness in 1618.[6]

Moreover Cosimo, in spite of his precarious health, which occasionally curtailed his activities, realized ambitious architectural projects. In 1611 he enlarged the harbor at Livorno through the construction of a new jetty, with the intention of creating a major port (fig. 36). He initiated the enlargement and decoration of the Palazzo Pitti according to plans by Giulio Parigi, the ingenious set designer who had staged shows in the palace's Salone delle Commedie. And the Boboli Gardens were also enriched with new statues and paths, such as the *viottolone*, which took visitors to the new *isolotto* ("islet") complex, dominated at a later date by Giambologna's *Ocean* fountain.

In 1613 Cigoli, the most celebrated artist of the time, left Florence. Nevertheless, many artists remained to satisfy the Grand Duke and his wife's interests in the arts: Passignano, Bernardino Poccetti, Jacopo da Empoli, Giovanni Bilivert, Cristofano Allori, Giovanni da San Giovanni, Pietro Tacca, Gaspero Mola, Jacques Callot, and Filippo Napoletano (fig. 37) among others. Cosimo's brothers, Carlo and Don Lorenzo followed his example, creating fine art collections in both their city and country residences.[7] The Grand Duke's involvement in the arts, as well as his broader European policy, pay testimony to his intention to follow his father's example, maintaining the great prestige achieved by Tuscany in Ferdinando's time.

Giulio Parigi, the court architect and stage designer, introduced the Grand Duke to Jacques Callot, a Lorraine artist who had studied with Parigi when he arrived in Florence in 1613 and who was destined to become one of the greatest printmakers of the century. The Grand Duke appreciated Callot's talents and employed him at court, commissioning representations of contemporary events, starting with scenes from the life of his father, Ferdinando (see cat. no. 218), which still stand as an invaluable document of Florentine life at that time. Callot learned from his contemporaries, but above all he looked back to the Florentine tradition of the sixteenth century, from Michelangelo through to Buontalenti. As a result he developed a supple, elegantly Mannerist etching style that lent itself to the prolific illustration of Medici courtly events (fig. 38). A few examples suffice to demonstrate the influence of Callot's Florentine etchings on the contemporary art of the city: Cosimo II's portrait (cat. no. 162), and the *Caprices with Various Figures*, dedicated to Prince Don Lorenzo (1617), are two such instances, while the *Sfessania Dances* are echoed in some of the statues by Romolo Ferrucci del Tadda in the Boboli Gardens, and many other etchings became sources of inspiration for artists such as Giovanni da San Giovanni and his whimsical decorative inventions (fig. 39).

The atmosphere of enlightened amusement, of a new golden age, during Cosimo II's reign, is reflected in Callot's nostalgic words, written in Nancy in August 1621 to Curzio Picchena, the Grand Duke's secretary, following the artist's departure from the Medici court: "This is to present my humblest respects to Your Lordship, and to thank you for the honor you made me of comforting me with such kindness and graciousness at the time of my departure, which truly I undertook much against my will and with great sorrow, as I never had any other wish than to remain in the noblest city of Florence to serve the Most Serene Princes with all my devotion."[8]

It would have been uncharacteristic of Cosimo II not to take advantage of Callot's genius for the depiction not only of the performances inside and outside the court, but also of the victorious expeditions of the fleet of the Knights of St. Stephen, which continued the naval enterprise initiated by Ferdinando I. A few years earlier, on 20 October 1608, the Tuscan galleys had won a naval battle against the Turkish galleons near Rhodes, bringing back a rich bounty. Callot illustrated episodes such as this, just as Poccetti had depicted for Ferdinando in the Palazzo Pitti's Sala di Bona — itself named after the seizing of an Algerian fortress in 1607 — the victories of the Tuscan fleet and armies. In the series of etchings entitled *The Seizing of two Cargo Ships of Tunis in Corsica by Four Tuscan Galleys*, or in *Battle of Four Galleys*,[9] the artist commemorated an event that took place on 23 November 1617, when the Pisan galleys caught a Turkish galleon, yielding for the Grand Duke a sizeable amount of goods as well as many slaves. The episode was also illustrated by Filippo

Fig. 38 Jacques Callot, *Battle of the Tinters and the Weavers*, 1619, pen, ink, and watercolor. Gabinetto Disegni e Stampe degli Uffizi, Florence.

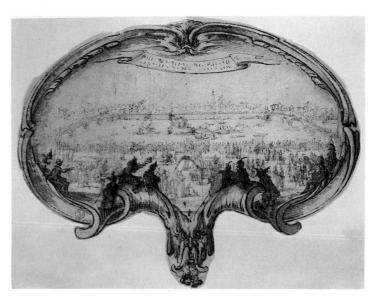

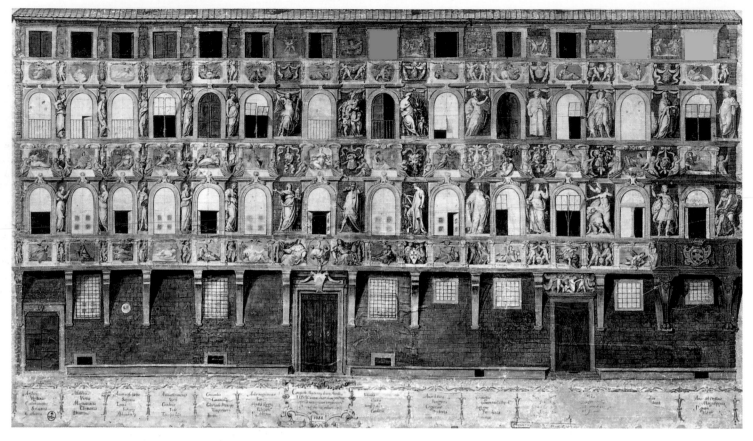

Fig. 39 Giovanni da San Giovanni, *Project for the Façade of the Palazzo dell'Antella in Piazzza Santa Croce*, ca. 1620, pen, ink, and (?)watercolor. Gabinetto Disegni e Stampe degli Uffizi, Florence.

Napoletano in a wonderful drawing of 1617, now in the Louvre,[10] which was apparently a source of inspiration to Callot.

These commissions emphasize the chivalric ideals of Cosimo II, who, probably inspired by Torquato Tasso's *Jerusalem Liberated*, dreamed of a new crusade to bring the Holy Sepulchre to Florence. Inspired by such fantasies he went so far as to have himself portrayed as *St. Louis, King of France* in a canvas commissioned from Matteo Rosselli in 1613, destined for the altar dedicated to the French community in the church of the Madonna del Carmine in Livorno.[11]

Contemporary evidence reveals that Cosimo liked to surround himself with amusements within his palace, poor health rendering him unfit for hunting, and these distractions would also feature around the city during the carnival or the festivities in July and August. But above all he devoted himself to decorating the palace, where he established the first unified gallery of paintings and sculptures, as reported by the courtier and diarist Cesare Tinghi: "I cannot overlook recounting that His Highness had taken residence once again in the upper rooms of the Palazzo Pitti, and his mind alighted on a loggia on the aforesaid floor . . . within four days he made it into a gallery adorned with many marble figures and heads . . . and he had it filled with paintings by the most valued men, namely Raphael of Urbino [it should be noted that the Grand Duke had received the portrait known as *Donna Velata* from his special ambassador in Spain, Francesco Botti, and that the painting remains in the Pitti to this day], Leonardo da Vinci, Titian, Antonio del Pollaiuolo, Andrea del Sarto, the Venetian Giorgione, Parmigianino, and among the more recent artists Agnolo Bronzino, Cigoli, Santi di Tito, Passignano, Bilivert, Rosselli, and many other painters of our time."[12] Thus Cosimo created the nucleus of the present Galleria Palatina, also known as the Galleria Pitti.[13]

Cosimo's deep interest in art and artists is demonstrated by his prevention, as early as 1610, of the export of any objects, through the "prohibition of taking paintings out of the state," and by his constant enrichment of the collections established by his predecessors through the purchase of works by artists – not exclusively Florentine – from both the past and his own time (Hans Holbein, Artemisia Gentileschi, Battistello Caracciolo, Guercino, Gerrit van Honthorst, Cornelis van Poelenburgh).

Fig. 40 Jacopo Ligozzi, *Madonna Appearing to St. Francis*, 1618, oil on canvas. Galleria Pitti, Palazzo Pitti, Florence.

Florentine sculptors such as Pietro Tacca, Francavilla, Caccini, and others were also encouraged: some small bronzes by these artists were sent as a gift to Henry, Prince of Wales and heir to the throne of England, in the hope that Cosimo's sister, Caterina, would become the prince's wife (the project failed, however, because Henry died prematurely).

The Grand Duke was also concerned that the Galleria dei Labori, by then internationally renowned, should increase its activity, as well as providing decorations for the

Chapel of the Princes in San Lorenzo (see cat. nos. 121 and 122). Apparently, one of the immediate consequences of the Galleria's work was the emergence of a new technique of painting on *paesina* (or *lineato dell'Arno*) stone.[14] This invention seems to be traceable back to Filippo Napoletano (see cat. no. 30), who had arrived in Florence at the Grand Duke's invitation in the summer of 1617. He, in turn, introduced to the court Justus Sustermans, who would become the portraitist for three generations of Medici. As noted by Baldinucci, Cosimo II – particularly when bedridden with gout – would delight in watching the painter work on his small pictures, often on copper plate, depicting the lively, dynamic figures that were his claim to fame and that appear to be a painterly version of Callot's etchings. Perhaps it was also through his conversations with Napoletano that Cosimo II first heard of Adam Elsheimer, a celebrated German painter whose work was much sought after. Cosimo succeeded in acquiring in Rome Elsheimer's masterpiece, a tabernacle with the *Stories and Glorification of the Cross*, which he placed in his bedroom (it is now in the Staedelsches Kunstinstitut in Frankfurt).

Cosimo also drew inspiration from classic models. It was probably the decoration of one of the halls in the Palazzo Te in Mantua, owned by his Gonzaga relations and dominated by Giulio Romano's depiction of the horses of Ferdinand II Gonzaga, that spurred him to commission life-size canvases (now lost), from Filippo Napoletano of the horses in his own stables. Napoletano's facility in realistically reproducing his subjects but at the same time turning them into mannerist "caprices" is illustrated by his *Shells*, also painted for Cosimo, who was fond of natural history and sciences (see cat. no. 29). This passion earned him the dedication of the *Sidereus Nuncius* by the famous court astronomer and mathematician Galileo Galilei, with prints illustrating Galileo's most sensational astronomical discoveries.

Cosimo II's broad outlook led him into contact with international figures such as the famous English collector Lord Arundel – whom he perhaps met through the court of St. James – whose collection of portraits by Hans Holbein the Younger was renowned throughout Europe. Indeed, it was to Lord Arundel that the Grand Duke applied to obtain the portrait of Sir Richard Southwell, still a prized possession of the Uffizi collections and relinquished, not without regret, by its owner.[15]

The Grand Duchess Maria Maddalena, in her own way, also participated in a cultural efflorescence reminiscent of the Renaissance, by collecting precious reliquaries (see cat. nos. 128, 129, and 131). These were placed in the armoires of a specially constructed chapel in her Pitti apartment, with doors painted by Bilivert, Rosselli, Tarchiani, and Boschi.[16] In 1622 the Grand Duchess had purchased the Baroncelli Villa outside the San Pier Gattolini Gate, known today as the Porta Romana. She commissioned Giulio Parigi to rebuild it, renaming it the Villa del Poggio Imperiale (Villa of the Imperial Hillock) because of its geographical position, and ordained that it was the private property of the grand duchesses. The building was decorated with frescoes, paintings, and furnishings ("[she] had that beautiful villa built near the Florentine walls, and she adorned and embellished it lavishly with everything . . . including beautiful ancient paintings by celebrated artists"[17]). The altar in the chapel of the villa hosted Jacopo Ligozzi's canvas of the *Virgin Appearing to St. Francis*, executed in 1618 and today in the Pitti (fig. 40). Ligozzi had a pivotal position within the court, and played an active role in perfecting the production of hard stones, for which he contributed original designs. He was Maria Maddalena's favorite painter, and it was for her that in 1620–21 he painted four scenes from the Passion of Christ destined for the villa, where they remained until the nineteenth century (they are today in the Palazzo Pitti).[18]

Following her husband's death, Maria Maddalena continued to decorate some minor rooms in the Palazzo Pitti, employing painters who had learned from Poccetti. Like him they continued to ornament with grotesques, but often added stucco decorations, a trend that would reach its apex some decades later in the "baroque" decoration of the grand-ducal apartment by Pietro da Cortona.[19] Maria Maddalena also continued the tradition of public performances at court. On 3 February 1625, at her instigation, Giulio Parigi staged in her villa a spectacular ballet entitled *The Freeing of Ruggiero from the Island of Alcina* to celebrate the visit of Ladislav Sigismond, prince of Poland and Sweden (the Grand Duchess's brother-in-law, who married two of her sisters successively).[20]

The marvelous central panel of an altar frontal that, according to the will of Cosimo II, was destined for the altar of San Carlo Borromeo in Milan (it is now in the Pitti, Museo degli Argenti, see fig. 35 and cat. no. 116), but was left unfinished when he died, seems to symbolize the ideals of a prince who looked back to chivalric exemplars and the Renaissance in order to pursue the same perfection during his own time.

NOTES

1. ". . . di tela d'oro rossa, tutta ricamata, e tirata da quattro corsieri al pari superbamente guarniti." Camillo Rinuccini, *Descrizione delle feste fatte nelle reali nozze de' Serenissimi Principi di Toscana, Cosimo de' Medici e Maria Maddalena, Arciduchessa d'Austria*, Florence, 1608.

2. For an exhaustive documentation of these events see Gaeta Bertelà and Petrioli Tofani 1969.

3. "A dì 28 febbraio 1620 (ma 1621) nella fresca età di 32 anni cessò di vivere il Gran Duca Cosimo II, figlio di Ferdinando I, e tutti gli ordini di persone ne compianse sinceramente la perdita, mentre era egli fornito di tutte le qualità atte a conciliarsi l'amore dei popoli. Mai infatti non vi fu né prima né dopo alcun Sovrano della casa Medici amato al par di lui. La clemenza e la moderazione formavano il di lui carattere, ed il trasporto, con cui amava, e beneficava i suoi sudditi, lo rendeva ad essi presso che adorabile. Il suo breve governo, oggetto perpetuo di benedizioni di tutto il suo popolo, fu ugualmente favorito dalla benedizione del cielo, ed ebbe morendo la consolazione di lasciare la Toscana nel più florido stato, che avesse giammai goduto." Moreni 1827, p. 189ff.

4. See Heikamp 1997a.

5. Cecchi 1986.

6. "Qui a corte s'attende a passare il tempo allegramente, come si farà sempre quando il Granduca è sano." Pieraccini 1986, p. 329.

7. On the subject of Cardinal Carlo and Don Lorenzo de' Medici's collections, see Fumagalli, Rossi and Spinelli 2001, pp. 72–84, and Borea 1977, pp. 13–26.

8. "Questa sara per fare humil.ma riverenza a V.Sig.a et ringraziarla del honore che Lei si è degnata di farmi in confortarmi con tanta gentilezza e cortesia de la mia partenza che veramente mi è stato con mio grandissimo disgusto e contra mia voglia perche non o mai avutto altro desiderio che di stare in quella nobiliss.ma cita di firenze per servire con tutto core a quei Ser.mi Principi." Ternois 1962, p. 220.

9. Lieure 1924–27, vol. 3, pp. 76–78, n. 194.

10. See *Il Seicento fiorentino*, vol. 2, *Drawing, Etching, and Minor Arts*, n. 2.150.

11. Fumagalli, Rossi, and Spinelli 2001, p. 147, note 3 (cat. no. 24).

12. "Non si mancherà di dire come Sua Altezza era tornato ad abitare le stanze di sopra del Palazzo de'Pitti, e li venne a memoria un bel pensiero che una loggia in sul piano di ditte stanze . . . in quattro giorni la fece diventare una bella galleria adorna di molte figure et teste di marmo . . . e la fece parare di quadri di pitture de magior valenti uomini che siano stati al mondo, cioè di Rafaello d'Urbino (del quale si ricordi che il granduca aveva ricevuto in omaggio da Francesco Botti, suo ambasciatore straordinario in Spagna, il ritratto femminile detto "La velata" ancora oggi a Pitti), di Lionardo da Vinci, di Tiziano, del Pollaiolo, d'Andrea del Sarto, del vinitiano Giorgione, del Parmigiano et de moderni del Bronzino, del Cigoli, di Santi di Tito, del Passignano, del Bilivert e del Rosselli et di molti altri pittori de nostri tempi." Tinghi 1600–15 (partially reported by Solerti 1905).

13. See *La Galleria Palatina*, pp. 31–32.

14. About this particular technique see Chiarini, Maetzke, and Pampaloni Martelli 1970, pp. 1–4, and Chiarini and Casciu 2000, pp. 13–26.

15. See Webster 1971 (cat. no. 28).

16. *Palazzo Pitti* 2000, pp. 54–56.

17. ". . . ha fatto bella quella villa vicino qui alle mura di Fiorenza, et l'ha addobbata e ornata riccamente d'ogni cosa . . . et belle pitture antiche e di mani celebrate." Tinghi 1600–15.

18. Padovani 2001.

19. Acanfora 2000.

20. See Chiarini and Savelli 1995, cat. no. 11.

ARTISANS AND THE ECONOMY IN SIXTEENTH-CENTURY FLORENCE

Richard A. Goldthwaite

Two dynamics converged to generate the energy that drove the art market in early Medicean Florence: a strong economy and court patronage – a combination that hardly obtained in the other great cities of sixteenth-century Italy. Of the four other major economic centers, Genoa and Venice remained oligarchies without a court, while the princely capitals of Milan and Naples saw their courts become outposts of the distant Spanish monarchy and their economies subjected to the fiscal policy of an international empire. The other courts of Renaissance Italy were located in small provincial capitals of slight economic importance and some of the most famous of these – including the d'Este in Ferrara and the Gonzaga in Mantua – were not destined to survive long. Rome, of course, was the seat of by far the most sumptuous court in Italy, if not Europe, but the art market there was oriented around an ecclesiastical court with a unique non-dynastic and corporate structure and was under-pinned by an economy heavily burdened with the fiscal demands of papal government.

When, in 1530, the Medici transformed the republic of Florence into a princely state, they found themselves rulers with an economic base that no other Italian prince enjoyed. The new dukes had both the wealth and the artisan resources to build a spectacular court that went beyond the passive acceptance of traditional princely models. The story of Medici patronage is, in fact, inter-twined with the performance of the economy in general and the local art market in particular; artistic innovation in grand-ducal Florence cannot be understood in isolation from this larger context.

★ ★ ★

PERFORMANCE OF THE ECONOMY[1]

Underpinning the vigor of artisan activity in the sixteenth century was an economy that was generally strong, notwithstanding the slow but steady erosion of the city's former pre-eminence on the international scene. The reorientation of trade from the Mediterranean to north-west Europe and across the Atlantic slowly, in the course of the century, left Italy behind as an economic back-water. The Genoese alone took initiatives to dominate the growing Spanish market as well as international exchange banking in southern Europe at the so-called Besançon fairs, and they presented the Florentines with increasingly stiff competition in Italy itself, especially in the kingdom of Naples and papal Rome. Yet the leading sectors of the Florentine economy – merchant banking and textile pro-duction – were still performing well with respect to foreign markets. Merchant bankers continued to enjoy a strong presence in Lyons until the end of the century; they showed up in strength at Antwerp when it became the leading international trade emporium; and a few moved into the expanding markets of central and eastern Europe to open major operations, especially in Nurem-berg and Krakow, an area where the Florentines had never before ventured. At home the wool industry developed a new lighter luxury fabric – rash – that for the first time in the industry's long history found markets in northern Europe, and production levels reached an all-time high. The newer silk industry, which had developed in the fif-teenth century, also found booming markets all over the Mediterranean and in northern Europe by reducing pro-duction of luxurious velvets and brocades to target instead a niche market with simpler, lighter fabrics, such as satins, that were less subject to changes in fashion. The

Fig. 41 Detail of cat. no. 104 (larger than actual size).

85

industry further strengthened the local economy by forging backward linkages to the supply of raw silk from within Tuscany itself.

At home the economy enlarged its resource base in both land and population. With the acquisition of Siena and its territory in 1555, the Florentine state expanded to include almost all of what today constitutes the region of Tuscany. The population of Florence itself, after remaining virtually stagnant at around forty thousand throughout the fifteenth century, grew to sixty thousand by 1580, up by fifty percent (although still far below its level before the disasters of the plague in the fourteenth century). Even this growth was not sufficient to meet the demand for skilled labor from the textile industries, to judge from the notable presence of both immigrants and women on employment rosters.

Whatever the level of economic performance, the political system could hardly have been more favorably disposed to promote growth. Cosimo I took initiatives to strengthen business activities of various kinds and his successors followed his lead. They kept the merchants' court in place to assure the sanctity of contracts, they streamlined the guild structure, and Francesco pursued what was widely considered to be a model monetary policy. In the traditional sector of international trade, the dukes took the first steps towards building up the port of Livorno; and although not particularly successful, Francesco tried to advance the interest of Florentine merchants in Spain and the Ottoman Empire and to gain for them some control over the spice trade at Lisbon. In support of the silk industry the dukes had a comprehensive and thoroughgoing policy to promote sericulture in the countryside and to assure the quality of its production, and they also established a secondary center of the industry at Pisa. Searches for minerals were promoted throughout the state, measures were taken to obtain coral to supply a local industry, a sugar refinery was set up and a company to produce saltpeter organized as a state monopoly, and spies were sent to Venice to learn the secrets of making glass. At the urging of the merchant Bernardo Saliti, Cosimo I set up two Flemish tapestry-makers in separate ducal workshops, and concern about the inadequacies of the local printing establishment prompted him to persuade another Fleming to operate a press as official printer to the duke.

Besides offering privileges to attract such craftsmen to Florence, the dukes also encouraged invention by freely granting patents to inventors, their numbers reaching all-time highs under Francesco and Ferdinando. Many of these concessions were made to stimulate the productive sectors of the economy, especially textiles, and such a policy had the effect of mobilizing technical knowledge on an international level to the advantage of local industry. The Medici dukes directed their policies to both strengthening exports of locally produced luxury products, such as tapestries, and cutting into imports of more ordinary products, such as glass and maiolica. Technicians and craftsmen were attracted from abroad to work at the ducal court, including mining experts from Germany, armorers and cutters of hard stone from Milan, and jewelers and goldsmiths from Venice and the Low Countries.

The energy and persistence with which the dukes pursued these interests leave no doubt about their determination to strengthen the economy. It was an extraordinary policy, much ahead of its time, and it clearly arose from Cosimo's initiatives and enthusiasm. "Presumably," writes Giorgio Spini, "Cosimo was aware that if he wanted to dominate a city of capitalists he himself had to become the biggest capitalist in Florence." In the opinion of Judith Brown, Cosimo formulated a veritable political economy, fully informed by the view that "there was an ordered economic realm that followed its own laws and that could be manipulated within limits toward certain economic and political ends," and he pursued this policy with an "activism aimed at the transformation of the entire economy."[2]

For the most part the initiatives of the first three grand dukes are known only in bits and pieces. We lack a comprehensive overview of all the activity they sponsored, let alone an evaluation of their policy based on the performance of these various enterprises in the market as opposed to the court economy. Much of this effort produced few results, especially in the commercial and mining sectors. Yet the Venetian ambassadors, reporting to their government on the state of things in Tuscany at the end of the sixteenth century, drew a highly positive picture of the economy. They considered Tuscany a "most fertile country . . . abundant in all the things necessary for human life," and although, among other reservations, they found the countryside sterile (and it certainly was compared to the Veneto they knew, then undergoing considerable agricultural development), they nevertheless remarked that on the whole the place was "quite comfortable thanks to its industry and culture." They were impressed by "the extraordinary industry of its inhabitants," and by how rich Florence had become as a result of the development of crafts and industry; and they estimated that textile exports brought in several times more wealth than they had a century earlier. One ambassador commented that "there is not a trading center in the world where Florentines do not have plenty of capital, so that one can understand how commercial the city is."

Another found evidence of all this wealth in the sumptuousness and magnificence of the city's many palaces, villas, and gardens.[3]

The picture is not without its heavy shadows and threatening clouds, however. For all its vigor the economy did not undergo any structural changes. The potential of the accumulated capital that came with growth was limited by lack of investment in technical or organizational innovations that could have lowered costs, broadened markets, and increased competition, and probably little economic growth resulted from increased productivity. Moreover, Florence, not being a port city plugged into the expanding world economy, never developed the financial infrastructure of an international trade emporium as did contemporary Antwerp and later Amsterdam. The most obvious shortcoming of this economic growth shows up at the micro level in the lives of working men, whose wages lagged behind the rise in prices resulting from the so-called Price Revolution that occurred throughout Europe in the course of the century. The fall in real wages was evident enough to the Venetian ambassador who in 1588 reported that "the lower classes are poor and go begging" and that there were "many poor."[4] Yet the stickiness of wages in a period of price inflation and their seemingly impenetrable ceiling were structural features of the pre-industrial economy everywhere in Europe, even in the booming centers of international trade in the northwest.[5] Economic growth, as we know only too well from contemporary experience, does not necessarily improve the distribution of wealth.

THE ARTISAN SECTOR

One of the most positive indicators of the state of the economy in the sixteenth century is the increasingly strong performance of the artisan sector. In fact, the extraordinarily high level of craftsmanship being celebrated in the current exhibit represents not just the enlightened patronage of the Medici princes but also the culmination of a long historical development. At the time of Dante and Giotto, when the economy was undergoing a vigorous expansion driven by international merchant banking and the wool industry, the profile of artisan society still resembled that found elsewhere in medieval Europe. But by the end of the fifteenth century the outstanding variety and quality of the city's craftsmen had become one of the glories of the Florentine Renaissance. The luxurious cloths produced by the silk industry required workers with new kinds of skills, ranging from manufacturers of gold and silver thread to designers and embroiderers of figured patterns, weavers of velvets and other fine cloths, and tailors to construct finished products for ecclesiastical and lay consumers. The veritable boom in the building of churches and palaces stimulated the demand for stonemasons and sculptors to produce all the necessary decorative elements required by the new Renaissance taste, while the furnishing of these new ecclesiastical and domestic spaces brought into existence a veritable army of carpenters, painters, goldsmiths, metalworkers, glass and ceramic workers, and other highly skilled artisans, many of whom produced objects that had hardly existed a century earlier.

The investment in human capital continued to grow in the sixteenth century, for the increased wealth generated by the economy, if it did not lead to structural transformation, was nevertheless effectively preserved through consumption. Moreover, greater spending brought into play a new dynamic: demand for new kinds of objects and for changes in fashion that generated further demand for replacement. These dynamics are all too familiar in our own economy but they appear, if not for the first time at least with greater force, in the behavior of Italian elites during the later Renaissance.

This spending was concentrated on clothing and on the furnishing of homes and churches.[6] Clothing had always constituted the single most important category of expenditure in the budget of the rich, although little of it survives as evidence. In the course of the Renaissance, dress required an ever greater abundance and variety of stuffs put together in more complex constructions, and the dynamic of changing fashion accelerated. At the same time the world of fashion widened its social base, and the taste for more elaborate clothing became so diffused throughout society that sumptuary legislation took a completely new direction in organizing dress codes according to social categories.

In the area of household furnishings demand was driven by the desire not just for more objects but for more elaborate and new kinds of objects, and as houses filled up with these goods, their spaces took on a more precise functional organization. By the third quarter of the century Vasari found the earlier bedroom–study that was at the center of the fifteenth-century home old fashioned, a thing of the past.[7] Within another generation, by the opening of the seventeenth century, the interior of a patrician palace was a far different place than it had been in the quattrocento: now there were separate rooms for eating and sleeping, for receiving and entertaining guests, for books and works of art, and for worship. And the variety of objects filling up these

spaces, from tableware to furniture, from decorative objects to pictures on the walls, grew to the point of defying morphological categorization, while at the same time undergoing increasingly rapid stylistic transformations.

Finally, spending on religious objects, from devotional art in the home to family chapels, also increased in the sixteenth century, driven both by Counter-Reformation zeal and by an ever-increasing pace of change in artistic style. Moreover, the church's strong reaffirmation of luxury as a highly desirable attribute of its ritualistic practices, in defiance of Protestant reformers and even its own mendicant traditions, virtually lifted all limits on spending for the entire panoply of liturgical utensils and furnishings accompanying Catholic religious practice in its numerous forms. In short, the extraordinary rise in spending on clothing and on furnishings and interior decoration for both home and church greatly stimulated the internal market for luxury consumer goods. In Florence this intense demand was almost entirely satisfied by local artisans.

Emblematic of the scale of consumer spending are the elaborate chapels some of the rich built for themselves, such as those built by Giovanni Niccolini at Santa Croce, Niccolò Gaddi at Santa Maria Novella, and Averardo Salviati at San Marco, while the banker Giovanni Battista Michelozzi outdid all these with the monumental altar in inlaid stone at Santo Spirito. The building accounts for the Salviati Chapel underpin the impressive grandeur of these projects with solid documentation of what it cost to realize them. Salviati, a merchant banker, budgeted some 34,000 florins for his project, ten times more than the cost of the most elaborate chapel of the fifteenth century, that of the Portuguese cardinal in San Miniato al Monte, built for the son of a king and outfitted with work by the Della Robbia, Pollaiuolo, Baldovinetti, and others. In fact, the Salviati Chapel, built in the 1580s, cost no less than Filippo Strozzi had paid for his palace almost a century earlier, by far the largest in the city at the time, with single rooms larger than the entire Salviati Chapel. But whereas Strozzi's money ended mostly in the hands of constructions workers – masons, kilnsmen, stoneworkers, manual laborers – Salviati's went to highly skilled artisans for frescoes, paintings, bronze reliefs, marble statues, elaborate inlaid stonework, and rich liturgical furnishings and utensils.[8]

The most conspicuous consumers were, of course, the grand dukes. Their demand, moreover, went well beyond the usual needs of a court, for it was fired by a genuine personal interest in craft technology and production and by skill in inspiring productive competition among the artisans who worked for them. They opened workshops under their direct auspices, creating a kind of state enterprise for the production of prestigious objects, and they consciously sought to stimulate the development of unique skills within their operation. Cosimo put various kinds of artisans – cutters of hard stones, goldsmiths, jewelers, restorers of antiquities, weavers, distillers – to work under his own eyes, in rooms in the Palazzo Vecchio, his official residence, and he was often to be found among these craftsmen.[9] By 1577 Francesco I, whose personal interests in some of these crafts was inspired by a passion for the alchemical transformation of natural matter such as hard stones, had established a veritable arts-and-crafts center at the Casino di San Marco, which he built on property purchased in 1568. Eventually Francesco moved many of these workshops into what was called the Galleria dei Lavori on the upper floor of the west wing of the new Uffizi, the office building designed to bring together much of the state bureaucracy under a single roof. Outside of this large central operation the Medici subsidized major workshops for sculpture: Cosimo set up Baccio Bandinelli in the cathedral workshop, in effect appropriating it as a sculptural studio for his own commissions, and later he provided Giambologna with a palace as a residence and studio, which after his death was turned over to his successors as court sculptors. Besides all this, the Medici employed a host of painters, sculptors, and architects in their many building projects, including the Palazzo Vecchio, the Uffizi, the Palazzo Pitti with its garden, as well as numerous villas in the countryside.[10]

Taken together, all this artisan activity added up to something like a manufactory producing an enormous variety of luxury objects and a research laboratory directed to discovering how to make new kinds of things, such as porcelain, glass blown from rock crystal, and inlaid and carved stonework. The artisans who worked for the dukes came from France, Flanders, Holland, and Germany, as well as from all over Italy, forming a veritable international pool of talent in all the luxury crafts. Ferdinando, shortly after becoming grand duke in 1587, imposed a more formal organization on the various operations by putting them under a general superintendent, the prominent Roman aristocrat musician and composer Emilio de' Cavalieri.

The letter of Cavalieri's appointment, dated 3 September 1588, gives a good idea of all the activity then being sponsored by the grand duke. It names him superintendent of jewelers, carvers of every kind, cosmographers, goldsmiths, miniature painters, gardeners of the gallery, turners, confectioners, clock makers, porcelain makers, distillers, sculptors, painters, the master of the mint – "in short all the artists and craftsmen of every profession, condition, and rank, who work for us, either by

Fig. 42 Detail of cat. no. 120.

89

the day or by appraisal or on salary." In addition, he was put in charge of the entire musical establishment of the court. The only men excluded from Cavalieri's charge were three who had an especially close relation to the duke: the jeweler Bylivelt, the gunsmith Anton Maria Bianchi, and the sculptor Giambologna. Cavalieri could hire and fire, he had discretionary power over salaries and leaves of absence, and he oversaw financial arrangements with outside suppliers of court artisans. In all this he was accountable only to the prince. All together he managed some twenty shops with around fifty artisans (plus about as many in the musical establishment), a much larger industrial complex than could be found anywhere in the private sector. For this he was paid an annual salary of 300 scudi, approximately eight times more than an unskilled laborer who managed to work full time could hope to earn in a year, and almost three times more than Brunelleschi earned over a century earlier as manager of one of the largest building projects of his age. Numerous documents, ranging from his vast correspondence to simple orders of payment, testify to Cavalieri's close supervision of the entire artisan operation.[11]

Surprisingly, the vast project of the first Medici grand dukes, like their protomercantilist economic policy, has never been comprehensively studied as an economic enterprise, not even in a brief survey (although specific activities have been well documented by art historians). It will take much research to measure the magnitude and evaluate the impact on the economy of all this artistic activity. Production was clearly directed to supplying the grand dukes with a larger range of choices in the gift exchange of art objects – especially tableware, furnishings, and decorative objects of all kinds – that figured so prominently in the foreign policy of early modern princes. For example, the Medici porcelain works, the first in the West to approximate the Chinese art, presumably did not direct any of its considerable production of extraordinary and much-admired pieces to the market. There was, however, much spillover from this ducal operation into the local economy: its artisan–employees depended on other craftsmen working outside the court for materials and finished work, and some ducal commissions went to non-court artisans.[12]

We would like to know more about the extent to which production was also directed to supplying – and even stimulating – demand in the open market, thereby promoting the pre-eminence of Florentine luxury crafts at home and abroad. At least two grand-ducal enterprises enjoyed some commercial success: the tapestry works – which by the end of the century, according to the Venetian ambassador, were the envy even of the Flemings – and the works that became in effect Europe's most

famous manufactory of decorative objects made of inlaid stone. Emblematic of a protomercantilist component of the court patronage of these first grand dukes was the measure Ferdinando took in 1593 to promote one of Florence's strongest traditional crafts by clearing the Ponte Vecchio of the butchers whose indecorous shops had long been concentrated there and relocating the city's goldsmiths onto this prestigious spot right in the center of the city (where they remain today).

THE STATUS OF ARTISANS

A corollary of this growth of human capital was the distinctive cultural status gained by some of the city's artisans during this period. This well-documented process goes back as far as the beginning of the fourteenth century, to the considerable fame enjoyed by Giotto. With Giotto began a communal – even populist – tradition of praise that slowly gained momentum and incorporated other artists. By the later fifteenth century Lorenzo il Magnifico appropriated this tradition to sponsor public monuments for several deceased artists and to promote living ones abroad. A few intellectuals, too, took an interest in the subject. Some artisans, especially painters, themselves became ever more self-conscious about their work, developing sophisticated shop practices informed by a rudimentary knowledge of classical art and a nascent sense of history and theory.[13]

In the middle decades of the sixteenth century this slowly emerging status of art surfaced as a major cultural phenomenon. Intellectuals dedicated letters and sonnets to artists; they associated – if somewhat hesitantly – with artists in a literary *salon*; they wrote about artists – including those of the past – and theorized about art (albeit with some condescension). As for patricians, they became conscious of the possibilities of their own self-fashioning through patronage of art; they developed a sense of connoisseurship in the collection of paintings and even drawings, including now, for the first time, both copies and engravings of the work of deceased artists; they took up painting as an amateur pastime and at least a few – like the grand dukes – dabbled in various other crafts and even set up artisan workshops in their own houses.[14] It was in this charged atmosphere that the first grand duke, Cosimo I, fabricated the myth of Medici patronage of the arts as a way of legitimizing the recently gained princely status of the family. That the newly established prince could conceive of such a myth and then utilize it for political purposes is itself evidence of the cultural status art and artists had gained in Florence by the mid-sixteenth century.

Artists, too, vigorously promoted their own claims: they gave vent to intellectual pretensions in literary efforts, and several wrote treatises to educate non-artists about art. In 1563 they gained the honor of being organized in a quasi-learned institution under grand-ducal auspices, the Accademia del Disegno (although it did not live up to expectations), and the next year they dramatized their new status with the spectacle of Michelangelo's state funeral. Finally, with Vasari's massive multi-volume collection of artists' biographies, the second and much enlarged edition of which was published in 1568, they gained a kind of historical canon for their self-imaging, founded on a solidly researched text complete with a theoretical structure. Building on the older view of a "rebirth" of painting with Giotto, Vasari went on to recount the subsequent history of art as a story of progress through the two intervening centuries down to his own time, centering in Florence but now extending throughout Italy. It hardly comes as a surprise that this environment generated, in 1602, the first legislation in Italy for the protection of the artistic patrimony by blocking the export of works by eighteen deceased painters (and procedures were laid down for allowing artists themselves, through their academy, to add others to the list). Not until the eighteenth century did other Italian states follow suit.[15]

In this rising trajectory of the status of art, the painter, sculptor, and architect emerge as the leading figures. But for all the intellectual effort that went into trying to elevate art to the level of the traditional liberal arts, the distinction between the "higher" arts and craftsmanship, between artist and artisan, was not clearly defined or even addressed. Although Vasari specified painters, sculptors, and architects in the very title of his work, many other kinds of virtuoso artisan showed up in his text, and he held that all these craftsmen in fact shared an overriding sense of *disegno*, or design – the fundamental criterion in the definition of art. Nor were explicit efforts made to rescue artisans of any kind from the general condemnation of manual labor that gained ground in the course of the sixteenth century among Italian elites anxious to establish their distinct noble status within the social order.

It is in the marketplace that we might expect the relative worth of artists as compared with craftsmen to have been put to the test. In fact, in view of the prestige artists and artisans enjoyed, the question presents itself: how did the forces of increased demand and higher cultural value play out in the marketplace, especially with respect to the artist's behavior as an economic operator and to the monetary assessment of enhanced human capital? There are two ways to find the answer to this question: one is through the price of works of art, and the other is through the earnings of artists. No study has collected data of this kind for the sixteenth century,[16] but we can at least glimpse at the market through the surviving record book of Alessandro Allori (1535–1607), who had one of the largest workshops of the period, the prestige of which was assured by the frequent patronage of the grand dukes themselves.[17] The prices of the altarpieces turned out by Allori, ranging from 100 to 200 florins, fell entirely in line with those that had obtained a century earlier and remained standard throughout Italy during the sixteenth century, even as the demand for art objects rose. This discrepancy between price and demand could hardly be illustrated more dramatically than by Allori's payment for the gigantic altarpiece he painted for the aforementioned Salviati Chapel in San Marco: at 200 florins it was hardly worth itemizing in the total of 34,000 florins budgeted for the chapel. Since these sixteenth-century altarpieces were on the whole much larger than earlier ones and turned out in less time, one might expect that, notwithstanding the inertia of prices, Allori nevertheless increased his productivity. Yet, his earnings fell within the traditional range for a highly skilled artisan. At the time of his death, his estate, along with that of his brother (also a painter), consisted of the family residence, four-and-a-half small houses, three small shops, and seven miscellaneous parcels of land in the countryside – not an insignificant patrimony for the two men, but one entirely in line with that of any number of prosperous fifteenth-century artisans.[18]

Allori, the son of a swordmaker, obviously did not build up enough of an estate to improve much the social status of his family, and in fact the only one of his sons who did not enter the Church himself became a painter. No Florentine painter – and very few in all of Italy – had the financial resources to elevate his family out of the artisan class, except those, like Michelangelo and Vasari, who as architects and sometimes sculptors moved out of the marketplace and into a bureaucratic position at the court of a prince. The pretensions of Michelangelo about the origins of his family and his obsession with establishing his social credentials in Florence were, perhaps, all the more exaggerated because of a conscious defiance of the reality of artists' economic and social status at the time.

In short, notwithstanding the heightened demand for painting in the sixteenth century and, above all, the greatly enhanced cultural value of that product as art, the market made little distinction between artist and artisan. If any claims could be made about such a distinction, the painter had the strongest argument: the communal tradition of praise was directed chiefly to painters, as was the classical tradition taken up by the humanists. Painters

along with sculptors and architects were singled out in the title of Vasari's book, they were the principal members of the Accademia, and only painters' work came in for protection in the legislation of 1608. It is in view of this prestige that the contradictions in the art market of late Renaissance Florence are not easy to explain: rise in demand yet stickiness of prices, increased output yet modesty of earnings, and – to go outside the economic sphere – higher cultural status yet social immobility. Clearly something was missing in the full development of the art market within a capitalist economy. The artist's products failed to trigger the normal demand–supply mechanism inherent in the modern market, or perhaps it was instead that the artist failed to behave in the market according to the prescribed ways of *homo œconomicus*. In any event, these constraints are symptomatic of a structural feature of the pre-industrial economy that, as already observed, imposed parameters on the performance of craftsmen and other workers in the marketplace.

Whatever the explanation, Vasari, for one, clearly understood the situation, and he had this advice for his fellow Florentine artists: "If you want to do more than live like an animal day to day and desire instead to become wealthy, you must get yourself away from here and sell the quality of your works and the fame of Florence abroad . . . because Florence does with its artisans what time does with its things: once they are made it unmakes them, and it consumes them little by little."[19] By advising the artist to get "away from here" and go "abroad," he meant not so much a flight from Florence itself as an escape from the market to find sanctity in a court, where the artist could depend on the magnanimity and generosity of a patron.

And Vasari was right: the art market in Florence, as elsewhere in Italy, was conditioned by the increasing intrusion of princes exercising their own countervailing economic force in the form of patronage and largesse in pursuit of the prestige that art now brought them. They could be generous but also utterly erratic. Cellini worked on his *Perseus* without a contract, relying on a grand gesture from the duke. Yet when he asked for 10,000 scudi, he was offered only 3,500, paid, moreover, in installments that stretched out for years. At the time of his death Giambologna was paid a salary second only to that of the superintendent of the ducal workshops; but the grand duke was not nearly so generous with Giambologna's successor, Pietro Tacca, who was constantly oppressed by financial problems.[20] As for the court architects, Vasari did well by the grand duke, ending up with palaces in Florence and his native Arezzo; but Buontalenti died in poverty. In any event, the salaries alone earned by state artists, from Vasari to Cavalieri, though handsome by artisan standards, could not possibly have financed an ascent in the social ladder to a level even approaching that of the upper class. In the end, it was the grand gesture that counted. The splendor of Medici patronage was not circumscribed by normal market mechanisms.

CONCLUSION

The Medici greatly strengthened Florence's long tradition of highly skilled craftsmanship: they founded their very legitimacy in its prestige and they stimulated growth through both economic policy and creative court patronage. Although the artisan sector's overall production may have constituted only a small part of gross national product, it at least succeeded in keeping in the home market much of the enormous wealth increasingly being spent on luxury. Growth of this sector, more than that of any other, resulted in the increase of human capital, which can be defined as that combination of skill, knowledge, and imagination that producers incorporate into their production. In the following century the major sectors of the Florentine economy underwent a steady contraction: production of wool cloth for export fell off rapidly after 1610, and ever fewer merchant bankers ventured abroad. The silk industry continued to hold its own into the following century, but it too eventually disappeared. What remains today is the city's deeply rooted artisan tradition. In this respect the flourishing of the arts and crafts in Renaissance Florence, so spectacularly represented at the court of these early grand dukes, is as notable a success of the city's economic system as its more studied international merchant banking and textile sectors, for it generated both the artistic patrimony and the human capital off which the city is still living.

NOTES

1. For an expanded version of this survey of the economy of sixteenth-century Florence, see Goldthwaite 2000. See also Malanima 1982.

2. Spini 1983, p. 184; Brown 1983, p. 281. Recent studies of specific aspects of ducal policy are Molà 2000, and Battistini 1998.

3. Segarizzi 1912–16, vol. 3, pt. 2, pp. 20, 41–43, 106.

4. Ibid., p. 42.

5. See, for example, Soly 1993, p. 41; and, for London and Amsterdam, de Vries and van der Woude 1997, pp. 630–32, 666, 672.

6. See Goldthwaite 1993 for a general overview of domestic and ecclesiastical furnishings; and, for clothing, Muzzarelli 1999, especially pp. 268–349.

7. From the life of Dello.

8. The accounts for the Salviati Chapel have been published by Karwacka Codini and Sbrilli 1996; and those for the San Miniato Chapel by Hartt, Corti, and Kennedy 1964.

9. Allegri and Cecchi 1980; Cecchi 1998a.

10. Recent publications on these craftsmen include *Magnificenza alla corte dei Medici* 1997, and *Arti fiorentine* 1998–2000.

11. On Cavalieri, see Kirkendale 2000, especially ch. 4.

12. Corsini 2000; Miniati 2000 pp. 285–92.

13. The status of artists in the fifteenth century is assessed by Ames-Lewis 2000, and the idea of art by Kemp 1997, ch. 3. See also Goldthwaite 1999 and Leonard Barkan 1999, pp. 102–17.

14. On private workshops see Acidini Luchinat 1980a, p. 166; and Bury 1985, pp. 19–20.

15. Emiliani 1978, pp. 32–39; Guerzoni 1997.

16. Data for the fifteenth and early sixteenth centuries, however, have been collected by Michelle O'Malley and Susanne Kubersky-Piredda, and their work will appear in the published papers of the conference "The Art Market in Italy (15th–17th centuries)" held in Florence in June 2000. Much useful data has also been collected by Gerin-Jean 1998.

17. Allori 1908.

18. Archivio di Stato, Florence, Decima granducale, 2365, fols. 378–79 (1608).

19. From the life of Perugino.

20. Watson 1983, pp. 91–94.

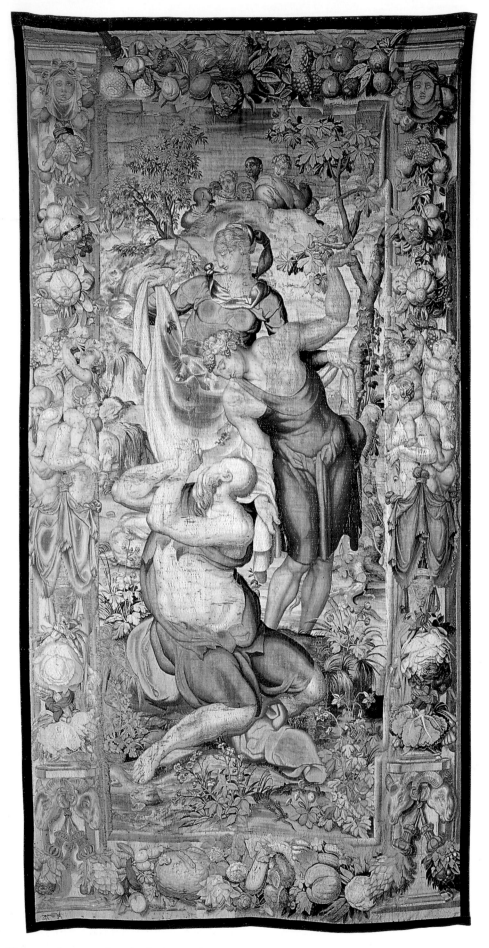

Fig. 43 *Lament of Jacob*, design and cartoon by Pontormo, 1545, woven by Giovanni Rost, 1553. Palazzo del Quirinale, Rome.

THE LEGACY OF MICHELANGELO IN THE GRAND-DUCAL TAPESTRY WORKSHOPS OF FLORENCE, FROM COSIMO I TO COSIMO II

Lucia Meoni

Michelangelo's opinion of weavers, as reported in Francisco de Holanda's *Dialogos em Roma* of 1538, was contemptuous. In a discussion about establishing the value of a painting, he argued that the basis should be not the time deployed but the artist's ability and talent, otherwise, as he ironically stated, a lawyer would not be able to earn in one hour as much as a weaver earns for all the cloths produced in a lifetime or as much as a farmer who labors all day long.[1] Michelangelo's dislike of the textile arts was widely known – in 1665 Bernini recalled it in a conversation with Paul Fréart de Chantelou: "If one room were covered with tapestries of velvet and gold thread and another decorated with a single beautiful statue, the second would seem regally adorned and make the first appear like a nun's room by comparison."[2]

Since in these texts only cloth weavers and velvet textiles are directly mentioned, it may seem strained or unjustified to extend Michelangelo's negative judgments to tapestry and tapestry-weavers, as modern critics have done.[3] However, such an interpretation takes on greater validity when seen within the context of the artist's concept of the arts, founded exclusively on the Florentine dogma of *disegno*, or design,[4] and given the absence of any mention of tapestry in his correspondence and his opinions reported in Vasari's *Lives*.[5] In the Torrentino edition of the *Lives* of 1550, written – as is well-known – under Michelangelo's influence, Vasari includes biographies of no tapestry-weavers, nor does he discuss the theory of the craft, which he nevertheless describes as "the beautiful invention of woven tapestries."[6] Both omissions were redressed in the second edition of the *Lives*, in accordance with a list of addenda compiled by Vasari after 1564.[7]

Michelangelo's attitude seems to go against, or perhaps to be a reaction to, the prevailing current of the time in Italy, which was marked by a new appreciation of tapestry following the innovative *Acts of the Apostles* series, commissioned by Leo X for the Sistine Chapel and made from cartoons by Raphael. The decisive influence of these hangings on subsequent weaving production marks the definitive supremacy of the "modern manner" in tapestry, an art hitherto stuck in the Gothic age, when it was first developed. Their importance was recognized by a man of such cultivated taste as the Venetian Marcantonio Michiel after the display of the first seven of the ten tapestries in the Sistine Chapel on St. Stephen's Day 1519. Reporting the judgments he overheard and probably his own opinions, Michiel described the series as "the most beautiful thing of its kind ever made in our time."[8] Eighteen years later, the verdict of the sensitive critic Pietro Aretino provides further evidence of the tapestries' seminal impact: in a letter of 1537 he observed that "truly the manner [of making tapestries] began to change as soon as Leo's tapestries in the [Sistine] Chapel were seen."[9]

Whereas Michelangelo focused his artistic research on the world of ideas and on the complexity and variety of form, Raphael explored the potential offered by different means of expression, such as tapestry-making or print-making, playing an important role in the development of the new style. The novelty of this attitude lay in the view that a different medium, such as textile, could give rise to new interpretations of traditional stories, in accordance with the Mannerist pursuit of *varietà* (variety) through form, material, and expressive means to produce new interpretations and innovations, or *meraviglie* (marvels).[10]

The new cultural climate stirred a revival of interest in tapestry among Italian princes, and the workshops of the

courts of Ferrara and Mantua were reopened in 1536 and 1539 respectively. In 1545 Cosimo I de' Medici invited to Florence the Flemish tapestry-weavers Jan Rost and Nicolas Karcher, for each of whom he established a workshop to produce decorations for the reception halls of the Palazzo Vecchio, which had become his residence only a few years earlier. In the two masters' contracts, dated 1546, Cosimo stipulated their obligation to teach the art of tapestry-weaving to Tuscan apprentices, creating the basis for the development and long-term duration of the workshop, which indeed remained active for the two following centuries.

Raphael's innovative model, not only for the Sistine Chapel, but also for the Vatican Stanze, which were decorated with both tapestries and frescoes, was first adopted in Florence in the Sala delle Udienze of the Palazzo Vecchio. Below Francesco Salviati's frescoes depicting the story of Furius Camillus were hung *spalliere* tapestries made from cartoons by Francesco Bacchiacca featuring grotesques, a genre that was introduced to tapestry by Raphael in the pilasters of the Sistine *Acts of the Apostles*, and that enjoyed great success in Flanders. Bacchiacca's series was one of the first two woven in the new Medicean workshops.

The other was the celebrated *Story of Joseph*, made for the Salone dei Dugento, also in the Palazzo Vecchio, between 1545 and 1553 from cartoons by Jacopo Pontormo, Agnolo Bronzino, and Salviati. It comprised twenty tapestries, placed in front of the doors as well as the windows, their lower borders brushing the floor, and laid out to create a homogeneous ambience throughout the room, following the tradition of northern European countries. Several series of hangings for the private apartments of the Palazzo Vecchio, executed a few years later under Vasari's direction, were conceived for a similar display.[11] Although, according to de Tolnay all European art after 1540 was indebted to Michelangelo,[12] the *Joseph* series was woven by Rost and Karcher from cartoons by three major Mannerist painters who, far from being mere imitators, showed personal and original interpretations of Michelangelo's ideas and creations.

Pontormo, who looked to Michelangelo constantly and, in his later work, even obsessively,[13] executed three cartoons. The compositions of *Joseph Holding Benjamin* and the *Lament of Jacob* (fig. 43) present one of the most recognizable artifices of the Mannerist idiom, the *figura serpentinata* ("serpentine figure"), defined by Michelangelo himself, according to Lomazzo's *Trattato* of 1584, as "the pyramidal figure, twisted and elongated, and multiplied by one, two, or three."[14] The complex twists of the figures refer to one of Michelangelo's fundamental concepts, according to which the artist, when freed from the bounds

of natural representation, can re-create and interpret the body "to display the artifice."[15] In the *Ragionamenti*, a dialog reporting supposed conversations with Francesco de' Medici about the Palazzo Vecchio, Vasari used this very argument when justifying some figures he painted in the Sala degli Elementi.[16] Pontormo's collaboration with tapestry workshops concluded with his third cartoon for *Joseph*, the previous two having not been well received, according to Vasari, by either Cosimo or the tapestry-weavers.

With the exception of one cartoon by Salviati, the series was completed by Bronzino, whose *maniera* (manner) seemed more suited to a textile interpretation.[17] Bronzino focused on *varietà*, which in Mannerist terms was considered to be itself an ornament. To further emphasize his deliberate stylistic artifice, he used cold, unreal colors, apparently aimed at sterilizing all passion.[18] Even nudity was used as a stylistic artifice, as seen in *Joseph Fleeing Potiphar's Wife* (fig. 44), or in the two door hangings showing *Spring* and *Justice Liberating Innocence*, where Bronzino plays on the erotic effect achieved through the figures' suggestive gestures. These provocative elements, frequently found in Bronzino's work,[19] shocked his contemporaries, if we believe Raffaello Borghini's claim in the *Riposo* that late in life the artist intended to "cleanse himself of his lustful notoriety," painting "honest women, with covered bosoms."[20] His attitude concerning the nude was a direct legacy of Michelangelo, whose *Last Judgment* was the subject of moralizing censure focused not only, according to Lomazzo, on "exposed organs," but especially on the titillating poses of figures such as St. Catherine of Alexandria, who "stands in such a way that she stirs lust in the spectator."[21]

The accusation that Mannerist painters inspired lustfulness is documented in a letter of 1549 by a zealous Florentine Catholic who, true to the cultural attitudes sparked by the Council of Trent, stated that "the obscene and dirty marble figures" of Adam and Eve by Baccio Bandinelli in Florence cathedral (today in the Bargello) were influenced by "Michelangelo Buonarroti, the inventor of filth, whose art can be honored, but not his religious devotion."[22] The depiction of emotions was also an artifice,[23] because single episodes, such as the embrace in *Benjamin Received by Joseph* (cat. no. 139), fail to affect the viewer, producing an almost narcotic effect.

Bronzino's cartoons combined northern European elements with lively, monumental, Michelangelesque figures, rendered in cold, pearly hues.[24] In *Joseph's Dream of the Sheaves of Grain*, for example, he created a compact mass of bodies in the foreground and saturated the scene with secondary episodes, following a typically Flemish compositional formula. Bronzino's designs for the door hang-

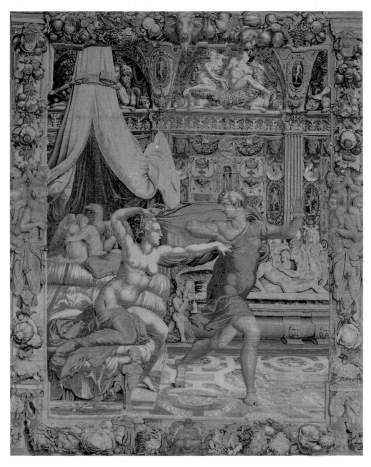

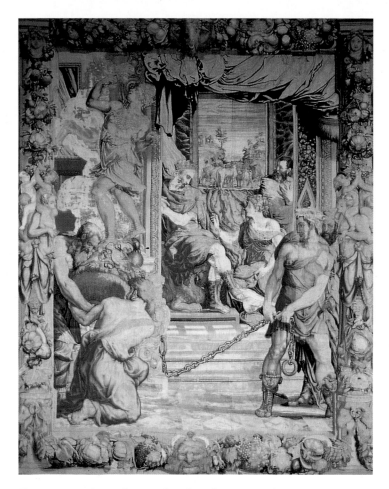

Fig. 44 *Joseph Fleeing Potiphar's Wife*, design and cartoon by Bronzino, 1548–49, woven by Nicola Karcher, 1549. Palazzo Vecchio, Florence.

Fig. 45 *Joseph Explaining the Pharaoh's Dream*, design and cartoon by Salviati, 1547, woven by Nicola Karcher, 1548. Palazzo Vecchio, Florence.

ings showing *Abundance* (cat. no. 138) – Rost's test piece when he arrived in Florence – and *Spring* include depictions of northern European landscapes, whereas his borders for the *Joseph* series, while also influenced by northern European examples, feature an Italianate greenery, or *verdure*, offering the weavers ample room for artistic expression in the designs' wealth of visual detail. This partnership is typical of the way that the gradual melding of painter's vision and weaver's ability gave rise to the most innovative designs of the early phase of Florentine tapestry production. Rost and Karcher's central position within the court, a role equal to that of the most prominent painters and one never again bestowed on tapestry-weavers in Florence, was undoubtedly fundamental in reaching such fine results.[25]

Salviati's only cartoon for the *Joseph* series, *Joseph Explaining the Pharaoh's Dream* (fig. 45), painted in 1547, displays exceptional inventiveness, as well as the clear influence of Michelangelo in the serpentine movement of the figures on the left. This figural pyramid culminates in a freely adapted representation of one of the ancient statues of the *Dioscuri* on the Quirinal Hill in Rome, the same sculpture copied by Raphael in his cartoon for the tapestry of the *Conversion of Saul*. This gesture has been read by Candace Adelson as Salviati's pictorial response to Michelangelo's affirmation of the supremacy of sculpture over painting in the lively cultural debate on the differences between the arts known as the *Paragone*, initiated by Benedetto Varchi in March 1547 for the Accademia del Disegno.[26] Salviati seems to take a direct stand in the dispute by portraying Michelangelo himself (see fig. 46) in the figure witnessing the Pharaoh's dialog with Joseph; Michelangelo's presumed portrait appears similar to that in Vasari's fresco in Rome's Palazzo della Cancelleria of 1546 executed just one year prior to the *Joseph* cartoon.[27] The representation in a tapestry of an ancient statue derived from a model by Raphael together with a portrait of Michelangelo appears to be Salviati's sarcastic gesture of defiance, perhaps alluding to a more complex question about the hierarchy of the arts. The sophisticated coloristic passages, especially in Salviati's altar cloth representing the *Lamentation*, rendered with elaborate

Fig. 46 Detail of fig. 45.

weaving techniques by Karcher, who realized all of Salviati's cartoons, derive from a personal interpretation of Michelangelo's chromatic range, adopting the subordination of bright to muted tones, and introducing his *varietà* and iridescence of color, which, according to de Tolnay, inspired the Roman painters, as well as Pontormo, Bronzino, Salviati, and Vasari.[28]

The cartoons for the door hangings representing the Toledo and Medici Arms (cat. no. 140) were recently attributed to Benedetto Pagni da Pescia, an artist active in the workshops of Raphael and Giulio Romano. Versions of one of the door hangings and half of the other were woven by 1549 by the first independent weaver in Florence, Francesco di Pacino. The allegory shown appears to be a manifesto of the rise of the solid, noble family created by Cosimo I and Eleonora of Toledo, and its composition may derive from a drawing by Salviati, now in Oxford. Pagni, however, filtered Michelangelo's influence through the artistic ideas of Giulio Romano as realized in Mantua, specifically the *sotto in su* effect of the river god figures, and the images of Apollo and Minerva inspired by the School of Fontainebleau, with clear reminiscences of Bronzino, to whom the cartoons were originally attributed.[29]

In little over eight years Cosimo I not only completed the refurbishment of several rooms in the Palazzo Vecchio but also succeeded in his objective of training Florentine tapestry-weavers. Vasari's return to Florence from Rome in the summer of 1554 seems to have coincided with the Duke's decision to reorganize the tapestry workshops. Following Karcher's departure for Mantua after 6

February the commercial enterprise – a major aspect of the workshops from the start – remained with Jan Rost and his San Marco workshop. Meanwhile, production for the court was entrusted to two new workshops under the direction of Giovanni Sconditi and Benedetto Squilli, staffed by "Creati Fiorentini" trained by the two Flemish masters. This marks the beginning of the grand-ducal tapestry works, supervised by the Guardaroba Generale (the general wardrobe, which administered the household properties of the grand-ducal family). At this time, its activity was dedicated almost exclusively to tapestries for the decoration of the private apartments in the Palazzo Vecchio, a project organized under the artistic direction of Giorgio Vasari to bring glory to the sovereign.[30]

Vasari consulted Michelangelo, who often gave advice on Roman and Florentine matters of artistic importance, about the decoration of the Palazzo Vecchio. Correspondence on the subject, also directly involving Duke Cosimo, seems, however, to imply that Michelangelo offered his counsel only regarding the Salone dei Cinquecento.[31] Certainly the notion of combining tapestry and paintings, frescoes and glass decoration, stucco, marble, and wood, in stylistic and iconographic harmony from floor to ceiling, as was realized by Vasari in the rooms known as the Quartiere degli Elementi and the Quartiere di Eleonora, and perhaps also in Cosimo and Francesco's quarters,[32] is hardly reconcilable with Michelangelo's concept of the arts. In the debate on the *Paragone* he asserted the supremacy of sculpture, and, as we know from Bernini, he also scorned a room ornamented with tapestries. Some of Vasari's references in the *Lives*, and later in his *Ragionamenti*, on the subject of Cosimo's wish to complete the furnishing of his palace with tapestries, can be interpreted as defensive in tone: "And what [designs] could not be used for the ceiling, were used for the friezes of each room, or for the tapestries that the Duke commissioned."[33]

Vasari's collaborators in the palace's decoration, those who painted the frescoes and drew cartoons for the tapestries, became the new generation of painters who, in Francesco I's Studiolo in the Palazzo Vecchio from 1570 to 1575, would create a new artistic climate in Florence, with implications for the development of late European Mannerism at the end of the sixteenth century, for example at the courts of Rudolf II in Prague and William V in Munich.[34] *Hercules Defeats the Centaurs at Hyppodamia's Wedding* of 1557–58, the only surviving tapestry from a cartoon by the young Girolamo Macchietti, one of the future painters of the Studiolo, displays an intensity and dynamism in the plastic relief of the bodies absent in his later work. This is probably the result of the artist's early study of Michelangelo's models and of

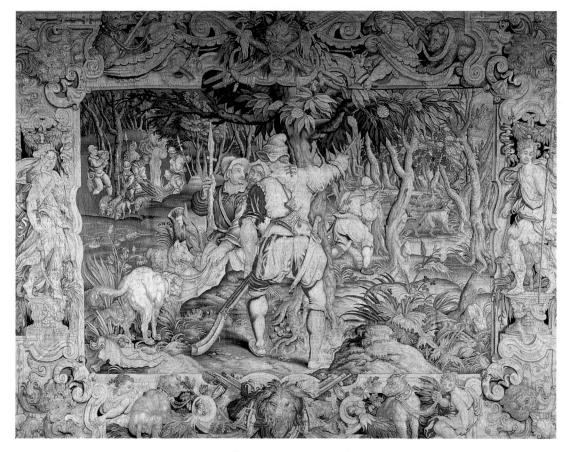

Fig. 47 *Arquebus Hunt of the Wild Boar*, design by Stradano, 1566, woven by Giovanni Sconditti, 1566. Tapestry Depository of Palazzo Pitti, Florence.

Fig. 48 *Baptism of Christ*, design and cartoon by Alessandro Allori, 1586, and Giovanni Maria Butteri (borders), woven by Benedetto Squilli, 1588. Tapestry Depository of Palazzo Pitti, Florence.

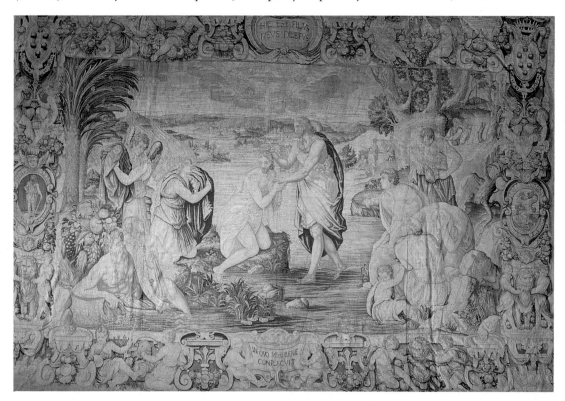

his contemporaries Salviati, Bronzino, and Vasari.[35] Three cartoons by Friedrich Sustris of the *Florentine Stories*, woven in 1563–64, although closely influenced by Salviati, seem to indicate a return to Michelangelo's plasticism, translated into ornamentation following the Flemish taste. Sustris's Florentine experience would leave traces in the work he later produced at the court of William V in Munich, where he became supervisor of artistic projects in 1579.[36]

The remaining tapestries realized for the Palazzo Vecchio and for the villa at Poggio a Caiano between 1557 and 1576 were all designed by the Flemish artist Jan van der Straet (Italianized by contemporaries to Giovanni Stradano), who probably arrived in Florence with Rost, and who took part in the Studiolo project. Experienced in Flemish techniques of cartoon production, he succeeded in speeding up the weaving process, and soon became the main designer of the tapestry works. In a span of nearly twenty years he collaborated on at least seventeen series, including the *Life of Man*, in thirteen pieces, and the *Hunts* for Poggio a Caiano, in twenty-eight tapestries, delivered between 1566 and 1577.

Stradano had spent time in Rome, probably in two visits between 1550 and 1560, and this proved fundamental as it permitted him to study Michelangelo's work and to familiarize himself with Florentine practice, working alongside Tuscan artists such as Salviati and Daniele da Volterra. His fourteen drawings in the Uffizi from the *Last Judgment*, probably executed between 1559 and 1560, demonstrate his adherence to the intellectual cult of the great Michelangelo, so prevalent in Florence's Accademia del Disegno, where Stradano was elected first consul with Alessandro Allori in 1563. Michelangelo's ideas and examples represented, in the most progressive Florentine artistic circles, the context for the development of an artistic vocabulary. This was enriched by the *maniera* of Bronzino, Salviati, and Vasari, and of the northern European artists who had followed the tapestry masters in Florence or came later to the Casino di San Marco on the orders of Francesco I.

Revisiting Michelangelo's models in a northern spirit, Stradano accentuated the gigantic nature of the bodies, notably in the tapestry series of the *Stories of Roman Women* (1562–63) or *Esther and Ahasuerus* (1563), and more markedly still in the *Hunts* (1566–77) (fig. 47), or even in tapestries depicting the life of Cosimo il Vecchio (1571). The inevitably grotesque and caricatural poses thus obtained are softened by refinements inspired by Salviati

and Vasari, elaborated in compositions of large active figures to produce a rich decorative effect. The enrichment of Stradano's *maniera*, inspired by Salviati's talent for decoration, was reflected in exuberant borders, a model subsequently adopted by his successor, Alessandro Allori.[37]

Following Stradano's departure from Florence in 1576, Allori was appointed as a designer to the tapestry workshops, a role he would retain for over thirty years, through the reigns of Francesco I and Ferdinando I, during which he collaborated with two master tapestry-weavers, Squilli and later Guasparri Papini. Early in his career, he was introduced by his master, Bronzino, to Florence's most up-to-date cultural milieu, and assisted Bronzino in the preparation of the cartoons for the *Story of Joseph*.

The study of Michelangelo's work and of anatomy – in both its scientific and naturalistic aspects – were, for Allori, a true passion, which set him apart from Bronzino. As a result he was soon well known for his draftsmanship and his ability to represent human anatomy, both talents crucial to the new Accademia del Disegno. These skills also echoed the interest in the sciences and alchemy of Francesco I, for whose Studiolo Allori executed two paintings. Allori visited Rome in 1560, where he may have met Michelangelo, whose controversial *Last Judgment* he reproduced in numerous drawings and copied in part. His sojourn coincided with a debate over the work, in which Florentine artists and intellectuals came down firmly on the side of their great master. The nude figures and crowded scenes of Allori's tapestry cartoons for the series of *Hunts of Marsh Birds* and *Hunts of Bulls* (1578–82) as well as those for the various series entitled *Paris* (1583), *Niobe* (1585–86), and *St. John the Baptist* (1586–94) (fig. 48), also display Michelangelo's influence. Michelangelo continued to be an inspiration, even when Allori, swept up by the Counter-Reformation tendency of the 1570s, executed several models for the *Passion* (1589–1616), the only Medici workshop tapestries of a devotional nature up until then.

Following Allori's death in 1607 his cartoon series were taken over by Bernardino Poccetti, Bernardino Monaldi, and Michelangelo Cinganelli (cat. no. 137) during the reign of Ferdinando I and then of his successor, Cosimo II. Their work shows only the remotest traces of Michelangelo's legacy; meanwhile, Salviati's elegant yet straightforward decorative manner continued to permeate Florentine tapestry production well past the first half of the seventeenth century.[38]

NOTES

1. ". . . um tecclão por quantas telas tece em toda a vida." Francisco de Holanda 1984, p. 57/1993, pp. 142–43. See Clements 1961, p. 328/1964, p. 388.

2. "Si une chambre était ornée d'une tapisserie de velours relevée d'or, et que dans une autre il n'y eût qu'une belle statue celle-ci paraîtrait ornée à la royale, et l'autre come una stanza di monache." Chantelou 1885, p. 103; see Clements 1961, p. 328/1964, p. 388.

3. Clements 1961, p. 328/1964, p. 388; Collareta 1985, p. 62.

4. Collareta 1985, p. 62; Summers 1981, pp. 269, 271–72.

5. See the indexes in Buonarroti 1965–83; Buonarroti 1994; Vasari 1994.

6. ". . . la bellissima invenzione degli arazzi tessuti." Vasari 1966–, vol. 1, p. 16.

7. Collareta 1985, pp. 62–63 points out a note by Vasari, dated after 29 April 1564, published by Frey 1923–40, vol. 2, p. 78, which mentions tapestries among the addenda and corrections to be included in his new edition of the Lives.

8. ". . . la più bella cosa, che sia stata fatta in eo genere a nostri giorni." Michiel 1861, pp. 49–50.

9. ". . . veramente si cominciò a mutar verso tosto che si viddero i panni di Leone in Cappella." Aretino 1957–60, vol. 1, pp. 87–88 note LV. For a recent bibliography on the subject see Meoni 1998, pp. 28, 33.

10. For Raphael's relationship with the engravers see Levenson, Oberhuber, and Sheenan 1973, p. xxiiii; for an interpretation of artistic concepts in Mannerism see Shearman 1967, especially pp. 52, 58, 140–51.

11. Meoni 1998, pp. 29, 35–61.

12. de Tolnay 1960, p. 3.

13. On the relationship between Pontormo and Michelangelo see Vasari 1962, pp. 1935–43; and Conti 1995, pp. 23–24, 63–65.

14. ". . . la figura piramidale, serpentinata e moluplicata per uno, doi e tre." Lomazzo 1973b, p. 29.

15. ". . . per mostrar l'arte." Vasari 1878–85, vol. 8, p. 26. See Shearman 1967, pp. 52–53.

16. Shearman 1967, pp. 52–53; Vasari 1878–85, vol. 8, p. 26.

17. Meoni 1998, pp. 57–58.

18. Shearman 1967, pp. 64, 146–49, 150.

19. Parker 2000, pp. 128–67.

20. ". . . per purgar la fama della lascivia"; ". . . femmine honeste e col petto velato." Borghini 1584, pp. 91–92.

21. "quei membri sì aparenti";

". . . in certo atto sta che più lussuria genera nelle menti de riguardanti." Lomazzo 1973a, pp. 101–2.

22. ". . . le lorde et sporche figure di marmo"; "dallo inventor delle porcherie, salvandogli l'arte ma non devotione, Michelangelo Buonarruoto." Gaye 1839–40, vol. 2, p. 500.

23. Shearman 1967, p. 101.

24. On the relationship between Bronzino and Michelangelo see Parker 2000, pp. 53, 63, 205 note 26, 206 note 41.

25. Meoni 1998, pp. 57–58, 63–67, 93–94.

26. Adelson 1990, pp. 177–79, 374–75; Summers 1981, pp. 269–70.

27. The possibility that this may be a portrait of Michelangelo has been confirmed by Paola Barocchi, to whom I express my gratitude, both for her advice and for her generous cooperation. On the subject of the portrait painted by Vasari in the Cancelleria fresco see Steinmann 1913, pp. 35–36, pl. 25.

28. De Tolnay 1949, pp. 100–1. For the relationship between Salviati and Michelangelo see Mortari 1992, pp. 10, 14, 36, 45, 50, 79, 85 and Monbeig Goguel 1998, passim.

29. Adelson 1990, pp. 120–30;

Meoni 1998, pp. 168–71.

30. Adelson 1990, p. 56; Meoni 1998, pp. 64–72.

31. Gaye 1839–40, vol. 3, p. 29; Gotti 1875, vol. 2, pp. 142–43 note 38; de Tolnay 1960, p. 9.

32. Allegri and Cecchi 1980, pp. 184, 187.

33. "E quello che non si poté mettere nel palco si mise nelle fregiature di ciascuna stanza, o si è messo ne' panni d'arazzo che il signor Duca ha fatto tessere." Vasari 1966–, vol. 5, p. 525; vol. 6, pp. 234, 243, 399; Vasari 1878–85, vol. 8, pp. 51–52; Meoni 1998, p. 63.

34. On this subject see Paolucci 1988, pp. 309–10.

35. Privitera 1996, pp. 23–24, 92–93; Meoni 1998, pp. 67, 192–95.

36. Meoni 1998, pp. 68–69, 204–7.

37. Barocchi 1963, pp. 39–40; Heikamp 1969a, pp. 47–57; Baroni-Vannucci 1997, pp. 20–22, 182–84; Meoni 1998, pp. 67–78, 196–203, 208–23, 232–47.

38. Heikamp 1956–58, pp. 105–55; Heikamp 1969a, pp. 57–61; Lecchini Giovannoni 1991, pp. 9, 35–38, 41–46, 53; Meoni 1998, pp. 79–85, 93–114, 224–31, 248–461.

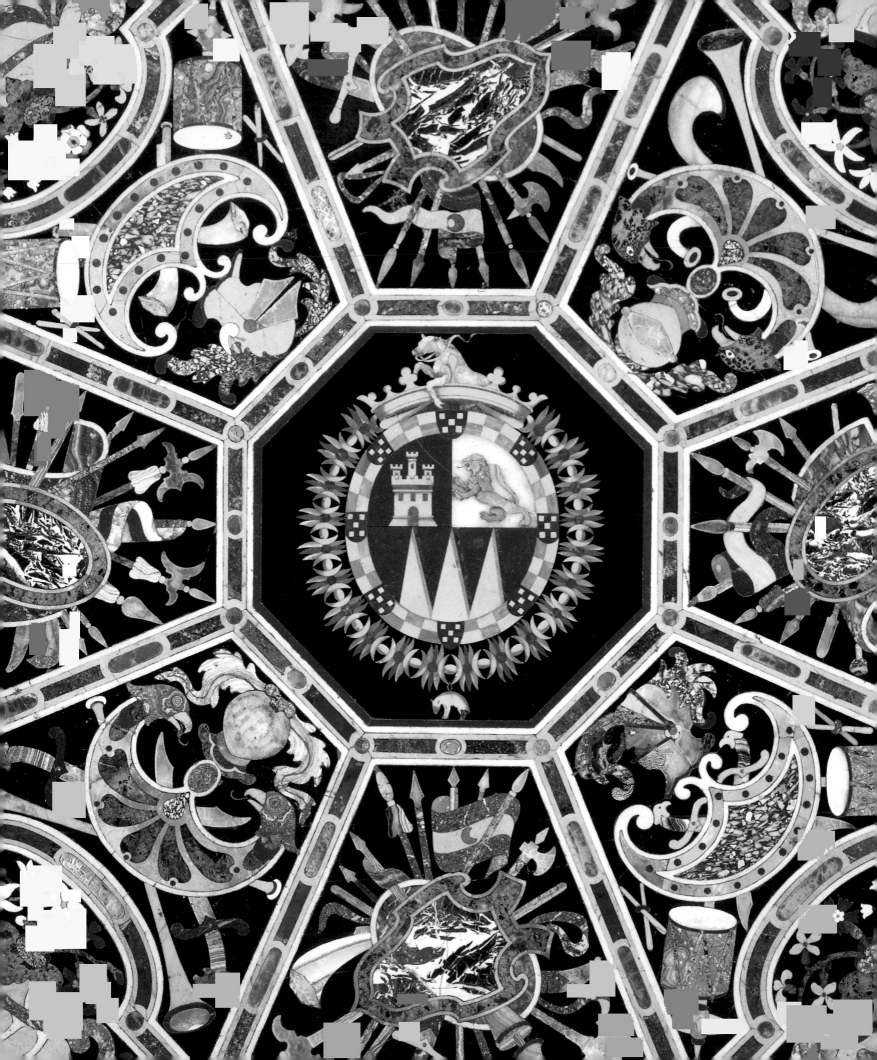

THE ORIGINS AND SPLENDORS OF
THE GRAND-DUCAL *PIETRE DURE* WORKSHOPS

Annamaria Giusti

During the course of the sixteenth century Florence gradually lost its role as the leading artistic center of the Renaissance. But the same period saw a brilliant and long-lived efflorescence of the decorative arts that was integrally linked to the Medici dynasty. In 1588 Ferdinando I de' Medici became the first European sovereign to found "state" workshops to produce an array of decorative artworks exclusively to satisfy the sophisticated and demanding artistic tastes of the court. His Galleria dei Lavori became a model for other royal manufactures, including Louis XIV's Gobelins,[1] and achieved international fame for its creations in *pietre dure* (hard stone). This Florentine speciality ensured not only that the Galleria outlived the Medici dynasty but also that it has continued its activity to the present day under the title Opificio delle Pietre Dure.[2] While it was Ferdinando, both an able statesman and a passionate patron of the arts, who consolidated the court workshops as a "stable organization,"[3] an extraordinary technical virtuosity in Florentine *pietre dure* had already been fostered by the patronage of Ferdinando's father Cosimo I, the first grand duke, and by Ferdinando's brother, the experimental Francesco I, second grand duke of Tuscany.

The love of glyptics that had inspired Piero il Gottoso and Lorenzo il Magnifico to form a princely collection of cameos and antique and modern vases in the past,[4] was revived by Cosimo I, who was further encouraged by the widespread popularity among collectors during the sixteenth century of *pietre dure* vases. As antique works, which had been relatively easy to find in the previous century, became increasingly rare, the work of Milanese *intagliatori* (gem-cutters) became renowned. These craftsmen were able to execute pieces that could compete with antique models in their technical proficiency and sensitivity to materials, with stones carved into the bizarre metamorphic shapes valued by Mannerist taste. The greatest specialists in this genre, responsible for supplying the most important European courts and collectors, including Cosimo, were found in the workshops of the Saracchi, the Miseroni, and Annibale Fontana. Giorgio Vasari wrote that "one could see some most beautiful crystal vases and cups"[5] at the workshop of the brothers Gasparo and Girolamo Miseroni, noting that two "miraculous" pieces as well as a large lapis lazuli vase had been executed for Cosimo. The adamantine translucence of rock crystal, available in Milan from the nearby Gottardo Mountains, and the brilliant blue of Persian lapis lazuli, made these the preferred materials for sixteenth-century *intaglio*, favored over agate and chalcedony despite the noble status attributed to the latter materials in antiquity. One example is the lapis lazuli cup in the Museo di Mineralogia in Florence (fig. 50), in the shape of a shell clutched by a sea monster and supported by a tortoise, a wax model of which was presented to Cosimo for preliminary approval by Gasparo Miseroni in 1563.[6]

While newly produced vases were acquired by almost all the collections, antique cameos and carved gems were still on the market, and occasionally archeological discoveries yielded new pieces. Thus, with the help of his wife, Eleonora of Toledo, who also had a passion for ancient *intaglio*, Cosimo was able to augment the collection of antiques he had inherited, which had been reduced to a somewhat modest size by dispersals. For example, a table casket belonging to him features twelve superb cameos by different artists that seem to date back to the classical period, the masterly treatment of the gold and the gems making this an outstanding piece. (Recently rediscovered in a private collection, it is still in need of further study.)[7]

Fig. 49 Detail of cat. no. 125.

103

Fig. 50 Gasparo Miseroni, cup, 1563, lapis lazuli. Museo di Mineralogia, Florence.

The circulation of classical cameos prompted an increasing number of skilled and distinguished artists to engage in the genre, which had been successfully revived in the fifteenth century. Florence enjoyed its own tradition, which had blossomed under the celebrated Giovanni delle Corniole at the time of Lorenzo il Magnifico, and was continued under Cosimo I, who benefited from the talents of the *intagliatore* Domenico di Polo, trained by Pier Maria Serbaldi da Pescia, who in turn had previously worked for Lorenzo. Nevertheless, Cosimo preferred to use the Roman workshops and such internationally famous artists as Giovanni Antonio de' Rossi for more important work – for example, a large chalcedony cameo featuring a portrait of Cosimo and his family (cat. no. 107), inspired by ancient Roman imperial cameos (Florence, Museo degli Argenti).

Rome was the source for another application of *pietre dure*: *commesso* (inlay work), conceived as an imitation of *opus sectile*, a technique dating back to Pliny's time that combined sumptuous polychrome marbles extracted from the ancient city's inexhaustible quarry.[8] Such *commesso* works appeared in Rome around the mid-sixteenth century, taking the form either of the wall and floor coverings typical of antiquity, or of table tops for use on occasions of exceptional importance. These works were soon much sought after by collectors, who were prepared to pay handsomely to acquire the new and desirable status symbols. It is not surprising, therefore, to learn that the European courts fought over the celebrated "master of tables," Giovanni Minardi of France, known as the "Franciosino" ("the Frenchman"), who had frequented Michelangelo's artistic circle in Rome in the 1560s and 1570s,[9] and who eventually chose from his many illustrious suitors Catherine de' Medici, queen of France.

Cosimo himself obtained ancient marbles and inlay table tops from Rome, but he also sought to cultivate Florentine talent in this field by assigning an area of the new ducal residence in the Palazzo Vecchio to a workshop. Here worked the *intagliatore* Bernardino di Porfirio da Leccio, who, according to Vasari, was "from the Florentine countryside," the author of "small table tops . . . made of inlayed gems,"[10] who executed a project by Vasari for Cosimo and his son, Prince Francesco, in the 1560s.

With Francesco de' Medici, a man as ill-suited to matters of state as he was sympathetic and innovative in those of art, Florence succeeded in developing a unique role in the production of luxury objects, and especially in the crafting of precious stones. Francesco, like Cosimo, was passionate about techniques of production, and even trained in the decorative arts to become a skilled craftsman. He sought to promote and to be directly involved with the creation of inlay work and glyptics, striving to elevate Florentine production to a level where it could compete with similar works from Milan and Rome and with other refined specialities such as Venetian glass or Chinese porcelain. On this subject the Venetian ambassador, reporting to the Republic of Venice in 1576, observed that Francesco "has placed all his passion in some arts, to which he claims that he finds, and adds, many new elements."[11] Thus Francesco's ambition was not restricted to mere technical imitation, in itself a bold enterprise: he aimed for innovation, and to this end he could rely on the fruitful combination of the craftsmen's abilities and the inventiveness of the artists in his circle.

One of the outstanding figures of Francesco's coterie was Bernardo Buontalenti, a versatile creative genius who was the architect of the Casino di San Marco, where the workshops founded by Francesco were located. Anticipating his father Cosimo's invitation of a master glass artist from Murano to Florence in 1569, Francesco was assisted by Buontalenti in establishing a furnace for the production of glass in the Venetian style. Buontalenti made models for the project, of which only three drawings survive,[12] but these are sufficient to prove his originality and independence from prevailing Venetian prototypes. However, the subsequent output of the Medicean glass manufactories, which were still active in several areas of the Grand Duchy in the seventeenth century, did not escape the dominating fashion of the Venetian models, and it is now difficult to distinguish Tuscan works from those made in Venice and acquired by the grand-ducal collections.

More distinctive qualities, and therefore wider renown, were, however, achieved in Medicean porcelain,[13] which was typically marked with two different symbols: Brunelleschi's dome for Florence cathedral, or, more infrequently, the Medici *palle* (balls). Production in this genre was also originated by Francesco, prompted by his desire to create objects in imitation of Oriental porcelain, which was much sought after by contemporary collectors and already well represented in the Medici collections. The Venetian ambassador again provides valuable evidence, writing in 1575 that "Francesco has found the way to produce 'Indian' porcelain" and that "it has taken him ten years to discover the secret."[14] Although produced in soft-paste, the final result of the Prince's tireless efforts was true porcelain.[15] The shapes and decoration adopted were influenced in part by Chinese porcelain and Islamic maiolica, but also by the ceramic ware of Faenza and Urbino, which Francesco particularly appreciated, summoning craftsmen from these areas to work at the Casino di San Marco.[16]

The fruition in 1575 of Francesco's lengthy experiments with porcelain is further verified by a letter from Francesco to his brother Ferdinando, then a cardinal in Rome, which mentions a few porcelains that he was sending, which had been "made as a sample."[17] In subsequent years the output of the porcelain works increased and more and more gifts were sent to illustrious recipients as part of a generous public relations policy practiced by all members of the Medici dynasty that aimed to win prestige for the small Grand Duchy of Tuscany among other European potentates through the rarity and quality of its artistic offerings. An example of Florentine porcelain was sent to Portugal in 1577, where, the Medici envoy reported, "they considered it a miracle."[18] In 1582 Philip II of Spain was given porcelain bottles featuring his coat of arms, a gift that he particularly appreciated and used for the "refreshments" he took in his carriage. Italian members of the nobility, such as Don Alfonso d'Este, Guglielmo Gonzaga, and Francesco Cornaro, also received several porcelains from Francesco "produced in the foundry."[19] Despite the distribution of many such pieces around Europe, when Francesco died in 1587, 820 porcelain items survived in the Guardaroba, proof of the frantic activity of his workshops. The quality of this output is demonstrated today by some sixty surviving examples.[20]

Almost all of the Medici works in porcelain were created in the period between 1575 and 1587. Although Ferdinando assiduously collected ceramics while he was a cardinal and Chinese porcelains when he was grand duke, he supported the Florentine workshops at a much reduced rate in comparison to Francesco, combining

Fig. 51 Ancient stones from the Medici collection. Opificio delle Pietre Dure, Florence.

porcelain production with maiolica in the Faenza style. Intending to foster the development of new manufactories in Tuscany, Ferdinando entrusted Niccolò Sisti with a kiln in 1593 for the production of porcelain and maiolica in Pisa, where we know that Sisti was still active in 1620.

However, a genre for which the two brothers shared an equal passion and one that they passed to their descendants was that of *pietre dure*, which represented an ideal marriage of nature, art, and science that appealed to the interests and imagination of late Mannerism. Francesco's passion for alchemy and the sciences, as well as his sophisticated artistic taste, led him to favor such precious *pietre dure* works over the ancient marbles revered by sixteenth-century antiquarians. The value of such works was increased by the ingenuity needed to craft the *pietre dure* materials – their resistance itself a guarantee of durable splendor into creative artistic inventions. It is no accident that for the Medici mausoleum, intended to immortalize the memory of the reigning family, Francesco conceived a sheathing of "the precious stones chalcedony, plasm, sardonyx, agate, and jaspers of various colors, all diligently found by him, and destined for this purpose."[21] This enterprise initiated Francesco's incomparable collection of precious stones from the remotest and most disparate places, which was supplemented on a grand scale by Ferdinando's efforts to meet the monumental requirements of his Chapel of the Princes, and which survives, with its grandiose relics, to the present day (fig. 51).

Francesco did not stop at sourcing an impressive array of raw materials. Too demanding to be content with the few local gem-cutters who worked for his father or with

Cosimo's splendid collection of vases from outside Florence, he decided to transplant to the city the rare talents of the Milanese craftsmen to give fresh impetus to the inventiveness of Buontalenti and the other artists of the Medici court – an experiment destined to achieve great success. In 1572 the Milanese brothers Ambrogio and Stefano Caroni took up residence in Florence, attracted by Francesco's generous remuneration. They were followed in 1575 by Giorgio Gaffurri, also from Milan, the head of a family workshop that, like the others, was housed in the Casino di San Marco. Completed in 1574 as Francesco's home and the official site of his artistic and scientific laboratories, the Casino foreshadowed the Galleria dei Lavori founded by Ferdinando towards the end of the following decade. The Venetian ambassador left a detailed account of the building: "In the fashion of a small arsenal various masters work on a variety of things in different rooms, keeping here all their apparatus and the tools of their art."[22]

Francesco thus instigated collaborations between artists of different backgrounds and temperaments that, if not always harmonious on a personal level, were extremely felicitous from an artistic point of view.[23] Proof of this is the famous lapis lazuli flask in the Museo degli Argenti, Florence (see fig. 19), its supremely elegant lines designed by Buontalenti, carved by the "virtuoso" Milanese masters,[24] and exquisitely completed with mounts in gold and enamel by the Flemish goldsmith Jaques Bylivelt. Wishing to attract the most outstanding inlaid marble specialists to his court, Francesco was among those who tried in vain to woo "il Franciosino." Vasari listed a number of small tables inlaid with gems that were realized for Francesco from his designs but these are now lost, leaving only a few table tops that can be legitimately dated to the time and taste of the second grand duke. These are distinguishable from Roman tables and from those made during the reign of Ferdinando by the emphasis given to the materials in preference to the composition; for example, a well-known table in the Museo degli Argenti, features an abstract geometrical pattern that is outshined by the brilliant polychromy of the jaspers with which it is fabricated (fig. 52).

Fig. 52 Tabletop with geometric hardstone inlay. Palazzo Pitti, Museo degli Argenti, Florence.

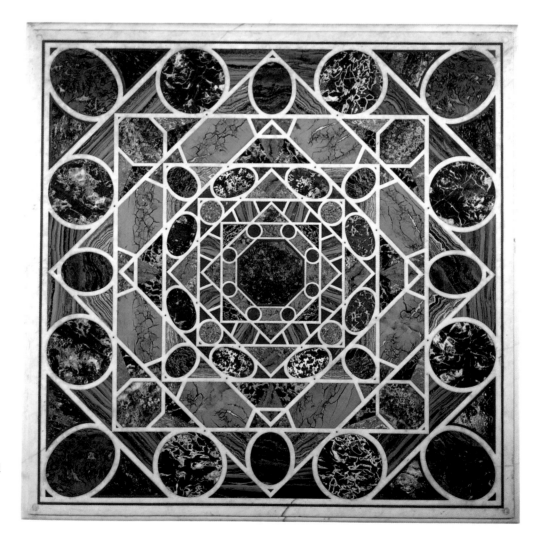

Fig. 53 (*facing page*) Tabletop with a pair of vases and eucharistic symbols, 1610. Galleria Palatina, Palazzo Pitti, Florence.

Shortly after succeeding his brother in 1587, Ferdinando oversaw the transfer of the workshops from Francesco's private residence in the Casino di San Marco to the more official building of the Uffizi. Ferdinando's scheme, reflecting a mentality both quintessentially Florentine and Medicean, consolidated in a single building, designed by Vasari, the government of the state, the Florentine workshops, and the Tribuna, a showcase for the finest pieces in the Medici collections that exalted the grand dukes' taste and patronage. Ferdinando unequivocally elevated the *pietre dure* workshops above the others to further his ambitious project for the Chapel of the Princes. As far as vases were concerned, even as he maintained the production initiated by Francesco, Ferdinando returned to the Milanese workshops of the Saracchi and Fontana families, probably to concentrate the efforts of the Florentine workshops on a new genre of glyptic – mosaic *pietre dure* sculptures – and on perfecting a new technique of inlay.

Although both glyptics and inlay can be classified as *pietre dure*, they involve different techniques, usually practiced by distinct specialists, as for instance in the court of Prague, where the Miseroni masters, despite their proficiency in glyptics, never tackled any of the inlay works that Emperor Rudolph I so appreciated.[25] Even in the grand-ducal workshops in Florence a distinction, not just nominal but factual, was made throughout the seven-teenth century between the "masters of plain inlay" and "masters of relief."[26] During Ferdinando's reign, however, the Caroni and the Gaffurri experimented with a new technique that immediately achieved outstanding results.

Inlay had hitherto been employed almost exclusively for abstract decorative motifs, such as shields and scrolls deriving from the Roman tradition or the geometrical monograms favored by Francesco. Ferdinando did not suddenly forsake antique marble and classical Roman *intarsia* ornamentation, which he had occasion to appreciate first hand during his long residence in Rome as a cardinal. Many tables in the Roman style were executed and collected in Florence at the end of the sixteenth century, and in one particular example – the table for the Duke of Osuna (cat. no. 125). However, the technique launched by Ferdinando, which acquired enduring fame, was, in the words of the Grand Duke himself, a "new kind of mosaic with marbles inlaid together,"[27] which, like painting, permitted the illustration of an unlimited array of subjects; indeed the stone was deliberately manipulated to produce painterly effects. In this style converged the Mannerist predilection for artifice and the Counter-Reformation taste for an eloquent and illustrative type of art, marking the departure of Florentine inlay work from the precedent of abstract Roman *intarsia* to create "paintings in stone" designed to surprise and enchant.

The new approach achieved one of its first celebrated results in the table top (now lost) commissioned by Emperor Rudolph II of Hapsburg and executed by Stefano Caroni between 1589 and 1597, displaying an array of trophies, birds, landscapes, and vases of flowers realized in Bohemian jaspers. Even such a connoisseur as Agostino del Riccio, who was working at the time on his *Istoria delle pietre*, was particularly impressed by the novelty that the table top appeared to be "all of one piece, not in marble, *bardiglio*, or any other sort of marble inlay, like the table tops made in Florence and Rome."[28] Thus the new technique had no borders: the ground was rendered invisible to give the chromatic composition free expression, like a jigsaw puzzle fitted together with such precision as to appear as a single unbroken unit.

The *pietre dure* masters executed the effect to perfection in objects, which, considering their laborious complexity, were produced at remarkable speed. Some outstanding examples include a view of the port of Livorno with its frothy waves on a table top executed in 1604 by Cristofano Gaffurri from a design by Jacopo Ligozzi (Florence, Galleria degli Uffizi);[29] the iridescent table top in oriental chalcedony with shining vases, ears of corn, vine shoots, and exotic birds created in Gaffurri's workshop as an altar frontal for the Chapel of the Princes (fig. 53);[30] and the remarkably painterly series of sacred stories and landscapes produced during the first twenty years of the seventeenth century from designs by the finer painters of the Medici circle and realized by the masters of inlay, by this time steadily growing in number.[31]

Although the Caroni and the Gaffurri were undoubtedly responsible for the success of this style of *pietre dure* inlay, their virtuosity was soon emulated by other artists in the receptive and cultivated artistic milieu of Florence. Craftsmen both local and from other centers became specialists in the genre: for example, Francesco Ferrucci, from a Fiesole family that specialized in works in porphyry, created inlay portraits and floral decorations at the end of the sixteenth century; and a number of German masters worked on a variety of artistic projects in the cosmopolitan Medici circle, their most distinguished representative being Jacopo di Jan Flachs.

These Florentine *pietre dure* inlay pieces constituted a remarkable refinement of the already established technique of inlay and of *opus sectile* originating in Roman antiquity. Although the latter had been a medium for figurative illustration, mainly using the more malleable calcareous marbles, such large stone sections were more suited to striking abstract effects than pictorial flexibility, which in ancient Rome was more typically achieved through mosaic in minuscule *tesserae*. The grand-ducal

pietre dure inlay works overcame the limitations of this technique through precise wire cutting of minute *pietre dure* sections with elaborate contours to fill the lines of the design in a fluid manner. To achieve this it was necessary to section each individual element manually and with supreme precision, by means of a hacksaw and with the help of an abrasive substance, as well as filing and subsequently leveling the borders of the pieces, so that in the final assembly the gaps between the numerous inlays would appear virtually invisible.

Beside the laborious mechanical aspects of this process, the successful outcome of the work depended heavily on the choice of a range of stones that would allow faithfulness to the pictorial model while bringing out the unique chromatic nuances of the stones themselves. Hence for craftsmen to practice their painstaking and creative art it was necessary to have access to a rich and varied supply of semi-precious stones, as accumulated by the earlier generation of Medici. The writer Filippo Baldinucci perceptively described the process: "The best inlay craftsman [*commettitore*] must ensure that nature has already accomplished with unlimited colors and in minute detail the effects he seeks to obtain and the endless images he wishes to represent; certainly he will not be able to do this unless he observes the myriad marks revealed in the hardest gems and other stones, and primarily he must be practiced in the art of painting."[32] Accordingly the painters who collaborated with the Galleria, such as Cigoli and Giovanni Bilivert,[33] were required to "find the marks in the *pietre dure*,"[34] and towards the end of the eighteenth century the painters responsible for producing models for the workshops — by this time under the Lorraine dynasty — also fulfilled the role of "chooser of the stones."[35]

Concurrently with the debut of the new style of *pietre dure* inlay, Ferdinando sought to extend the activity of the *pietre dure* workshops in the field of *intaglio*. Beside the already established production of vases and cameos a new genre of sculpture appeared, realized by combining various carved hard stones. The earliest and most outstanding example of this type is the *aedicola* in rock crystal now in the Kunsthistorisches Museum, Vienna, produced by the Caroni and the Gaffurri workshops between 1591 and 1600.[36] On a fantastic landscape background rendered in an inlay of semi-precious stones, this *aedicola* represents the episode of Christ and the Samaritan Woman at the Well, sculpted in the round. Here for the first time were harmoniously combined the two techniques that would be the pride of Florence for centuries to come: *pietre dure* inlay — this is one of the first experimentations using this technique to represent a landscape, a theme that would

recur throughout the seventeenth century – and mosaic sculpture, in which the different parts of the figure were separately carved in *pietre dure* of varying colors.[37]

Those works that survive and the many known only from documents, attest to the apotheosis of the grand-ducal factories during the reign of Ferdinando I, when the workshops were engaged in producing strikingly inventive creations to sheath the interior and altar of his monumental Chapel of the Princes, and in supplying an unparalleled number of other stately furnishings. During the brief reign of Ferdinando's son, Cosimo II (1609–21), the impetus given to the workshops by their founder continued to produce brilliant results, partly due to the requirement to execute many works for the chapel initiated in the previous decade. Those works created for the Florentine court and to indulge prestigious recipients abroad – Cosimo maintained his father's policy of munificence – introduced a new feature that would have an enduring effect on the development of Florentine *pietre dure* inlay: a naturalistic setting, product of the lively imagination of the elderly painter Jacopo Ligozzi.

"A chronicler of the sublime in nature," as he has been aptly described by Gonzàles Palacios,[38] Ligozzi displayed his talent for meticulous and lyrical observation in a series of enchanting watercolors of botanical and zoological subjects that reflected Francesco's scientific interests. Invited by Ferdinando to collaborate on pictorial models for *pietre dure* inlay, Ligozzi introduced exquisite naturalistic details, as in such compositions as the previously mentioned altar frontal for the Chapel of the Princes, which features vases and eucharistic emblems and in which Ligozzi imaginatively introduced exotic birds, transforming the symbolic subject into an earthly paradise. It was only towards the end of his career, however, when a northern taste for still life became widespread within the cosmopolitan circle of Cosimo II's court, that Ligozzi turned to naturalistic compositions of flowers, fruit, birds, and insects – new themes that became dominant in Florentine inlay work and remained popular for over a century thereafter.

This new approach saw the light or iridescent grounds preferred during Ferdinando's time superseded by the velvet black *paragone* ground of Flanders, an ideal backdrop that intensified the vivid colors of the *pietre dure* used to crystallize the ever-changing vegetal and animal worlds in shapes of unfading splendor. The almost infinite variations of these natural themes obtained first by Ligozzi and then by his successors, and the spectacular variety of the Medici's extraordinary collection of raw materials, kept any risk of repetition at bay. Such works were soon sought outside the Medici court, as is testified by contemporary documents and the presence of many of these items in major royal collections around Europe. The most outstanding piece, proof of the success of the collaboration between Ligozzi and the grand-ducal workshops, is the Fiori Sparti ("Scattered Flowers") table, in the Galleria degli Uffizi, produced over seven years and requiring the direct involvement of the painter in the choice of the stones in order that their nuances of color might accurately render the botanical display against its reflective black ground.[39] The naturalistic inspiration of works in *pietre dure* inlay during the reign of Cosimo II is evident also in the increasing fashion for landscape scenes. Many such images were created by Giovanni Bilivert, a progressive artist who painted the Villa La Petraia from life for a series of views of Medicean villas, his scene being translated into semi-precious stones on the central door of a cabinet now in the Palazzo Vecchio.[40]

The last sumptuous creation commissioned by Cosimo II shows not a celebration of nature – however inspiring this might be as a visual subject – but an exaltation of the magnificence of the Medici. The piece is an ex-voto destined for the altar of San Carlo Borromeo in Milan and conceived as an eloquent celebration of the Grand Duke of Tuscany, who features in the image, robed in regal vestments studded in rubies and diamonds, against a background showing Florence cathedral (cat. no. 116).[41] As in the *aedicola* of *Christ and the Samaritan Woman at the Well*, *pietre dure* inlay and mosaic sculpture are combined in a dazzling display of splendid precious materials, crafted, with the obsessive perfection typical of the grand-ducal manufactories, by a range of specialists: goldsmiths, jewellers, and masters of inlay and relief.

Cosimo II died three years before this masterpiece was completed, but the *pietre dure* to which he had entrusted his image maintained the artistic celebrity of Florence for many years.

NOTES

1. The administrative organization of Louis XIV's workshop was not dissimilar from that of its illustrious Florentine model, which was well known to the French court. In order to establish pietre dure production in 1668 the French manufactory asked the Grand Duke of Tuscany to transfer some of the virtuoso masters of the genre to France. See Gonzàlez Palacios 1993, vol. 1, pp. 19–60.

2. The name "Opificio delle Pietre Dure" (Hard-Stone Workshop) originated in the second half of the nineteenth century when Italy was united as a national entity. The grand-ducal workshop, alongside its traditional output, sought to take advantage of technological progress and to sell its creations to the public in order to replace the financing of the grand-ducal administration. Within the less opulent bourgeois society of the late nineteenth century, however, the costly, elitist creations of the Opificio found only a restricted market and it soon became apparent that the most appropriate application of the craftsmen's rare skills was in the restoration of Italy's artistic heritage, a role that revived the ancient Medicean institution as a center of artistic excellence. For over a century the Opificio delle Pietre Dure has devoted its skills to the conservation and restoration of many works of art, while the products of its illustrious past are kept in its museum.

3. "Stabile ordinamento"; from Ferdinando's official letter, dated 3 September 1588, instituting the Galleria dei Lavori, to be housed in the Uffizi and to comprise several artistic workshops and many different types of production, including "confectionery makers and distillers of aromatic essences" ("confettieri e distillatori di essenze odorose"). The complete text was published by Zobi 1853, pp. 162–65.

4. The most exhaustive essay on this subject remains that in the exhibition catalog, *Il Tesoro di Lorenzo il Magnifico* 1972. See also Casarosa Guadagni 1997.

5. "s'é visto vasi e tazze di cristallo bellissime." Vasari–Milanesi 1878–85, vol. 5, p. 389.

6. *Splendori di pietre dure* 1988, p. 80.

7. The cabinet was recognized by the author (1997) as a work produced between 1562 and 1569 for Cosimo I, whose exploits are illustrated on the front in twenty-eight golden reliefs made by two craftsmen associated with Cellini (possibly Poggini and Galeotti).

8. This type of stone mosaic pavement, popular in Rome since the period of the First Empire and featuring decorative or figurative images with sections of polychrome stone, is mentioned by Pliny in his *Natural History*, XXVI, 51. Sixteenth-century Roman *commesso* works were almost exclusively abstract.

9. Tuena 1988.

10. "del contado di Fiorenza"; "tavolini . . . di gioie commesse." Vasari–Milanesi 1878–85, vol. 8, p. 375ff.

11. "ha risposto tutti i suoi diletti in alcune arti, nelle quali fa professione di ritrovarvi, ed aggiungervi, molte cose nuove." Gussoni 1841, p. 377.

12. Heikamp 1997f.

13. Cora and Fanfani 1986; Spallanzani 1994, pp. 61–87, and Heikamp 1997e, with preceding bibliography.

14. "il Granduca Francesco de' Medici ha ritrovato il modo di fare la porcellana dell'India"; "essergli occorsi più di dieci anni prima di scoprire il segreto." Gussoni 1841.

15. As pointed out by Heikamp 1997f, the recipe for the realization of the Medicean porcelain is transcribed in a *codice magliabechiano* in the National Library of Florence.

16. Documents mention Flaminio Fontana, present in Florence from 1573 to 1578; Jacopo di Filippo da Faenza, described as the "master of the whites" ("maestro dei bianchi"), who is mentioned in 1574 and again in 1577; and Pier Maria, known as "the porcelain-maker from Faenza" ("il faenzino delle porcellane"), who also appears in 1577 and was still active at the time of Ferdinando I.

17. "fatte per saggio." Quoted in Spallanzani 1994, p. 63.

18. "la terriano per miracolo." Quoted in Spallanzani 1994, p. 76.

19. "fabbricate nella fonderia." Spallanzani 1994, p. 85.

20. A complete list of these items was compiled by Cora and Fanfani 1986, p. 24.

21. "preziose pietre Chalcidonii, Prasme, Sardonici, Agate e Diaspri, di variati colori, tutte da se con propria deligenza ritrovate, e di già a quest'uso destinate." This excerpt, published by Berti 1967, p. 123, is taken from *Oratione de le lodi di Francesco de' Medici*, 1586, by L. Giacomini, a man of letters in the Medici court.

22. "In guisa di un piccolo arsenale in diverse stanze ha diversi maestri che lavorano diverse cose, e quivi tiene i suoi lambicchi e ogni suo artifizio." Gussoni 1841.

23. Berti 1967, p. 238, n. 36, mentions that Seriacopi, a trusted kinsman of the Grand Duke, worriedly reported the drinking excesses and card-playing habits of Gaffurri and his family and the consequent tensions that arose between them and the somber Ligozzi.

24. As they were defined by an admiring Agostino del Riccio, a Florentine Domenican friar who in 1597 wrote the *Istoria delle pietre*, a key text for information on artistic collections and production in Florence at the time of Francesco I and Ferdinando I.

25. Ottavio Miseroni, who moved to the Hapsburg court in Prague in 1588, and his descendants, who remained active there for almost a century, devoted themselves exclusively to masterly glyptics such as vases, cameos, and mosaic reliefs. For inlay work Rudolph II turned to Florence, whence Cosimo Castrucci was summoned some time around the 1590s, his son and nephew subsequently continuing the production of Florentine mosaics at the court of Prague for almost thirty years.

26. "maestri di commesso in piano"; "maestri di rilievo."

27. "nuovo modo di rappresentare in marmi comessi insieme." The passage is in a letter accompanying a gift to Clement VII of his portrait executed in marble inlay, published by Zobi 1853, p. 187.

28. "tutta d'un pezzo e non commessa in marmo o bardiglio o in altra sorta di marmo, come si fanno I tavolini in Firenze e in Roma." Riccio 1996, p. 183. Destroyed in a fire in one of the Hapsburg residences during the eighteenth century, the table top is described with admiration by del Riccio as well as by the Venetian ambassador at the court of Prague, and Anselm Boetius de Boodt, the personal physician of the emperor and himself a naturalist. See Giusti 1992, pp. 137–38.

29. *Splendori di pietre dure* 1988, p. 140.

30. Transformed into a table top by the joining of the two original panels during the Lorraine period, it was based on a model by Bernardino Poccetti, who had in turn utilized drawings of naturalistic details by Jacopo Ligozzi and Daniel Froeschl, and was produced in the Gaffurri workshop between 1603 and 1610. See *Magnificenza* 1997, p. 180.

31. These renowned works are now to be found in various collections. An extensive bibliography has been written on them; see Giusti 1997b, p. 130.

32. "L'ottimo commettitore deve . . . in ogni minima e minissima sua fattura cercare e trovare che la natura abbia fatto da sé stessa quel tanto che egli intende di voler fare, e questa con ciascheduna delle infinite cose che egli vuol rappresentare che sono di colori quasi infiniti; il che al certo non potrà fare se non coll'osservare l'infinite macchie che scuoprono le durissime gemme e altre pietre, e così primieramente che eli sia pratico nel tignere pittoresco." Baldinucci 1845–47, vol. 3, p. 219.

33. Giusti 1988, p. 14.

34. "trovar le macchie delle pietre dure." Baldinucci 1845–47, p. 219.

35. "sceglitore di pietre." Archivio di Stato di Firenze, Imperiale e Real Corte Lorenese), f. 2374, c. 103.

36. Giusti 1992, p. 74.

37. It is likely that this treatment

of precious stones derives from ancient Roman types, such as small polychrome busts comprising different stones, which were present in a number of sixteenth-century collections, including the famous Studiolo of Francesco I and the Tribuna of the Uffizi. Colored mosaic cameos and small hard-stone sculptures were executed in the same years – perhaps anticipating the Florentine manufacture – by Ottavio Miseroni for the court of Prague. Florence, however, would retain its primacy in terms of the quality, quantity, and longevity of production of this virtuoso artistic genre.

38. "Narratore di sublimi casi naturali." Gonzàles Palacios 1993, vol. 1, pp. 389–99.

39. The preparation of the table top took place between 1614 and 1621; see Giusti 1997b, p. 134, and preceding bibliography.

40. See *Splendori di pietre dure* 1988, p. 148.

41. *Splendori di pietre dure* 1988, p. 138, and preceding bibliography.

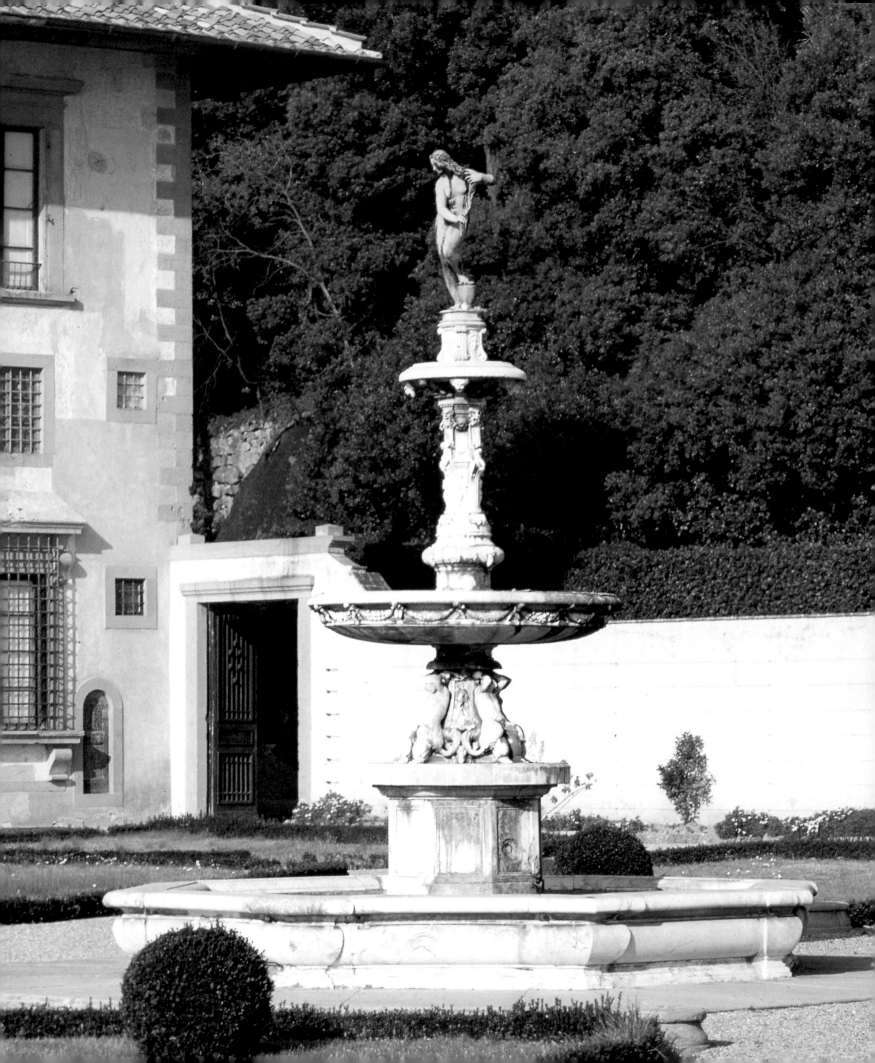

GALILEO IN THE GARDEN: OBSERVATIONS ON THE SCULPTURAL FURNISHINGS OF FLORENTINE GARDENS BETWEEN THE SIXTEENTH AND SEVENTEENTH CENTURIES

Claudio Pizzorusso

"The truth never seems true. Try telling someone a story: unless you modify it, he will find it unbelievable, made up. Modify it and it will seem more real than reality itself. To appear more real than reality: that is the object."[1] These words, inspired by Ovid's celebrated dictum "materiam superabat opus,"[2] were written by the creator of the detective Maigret, the most "real" protagonist of mystery fiction. The detective himself would have objected that it is first necessary to investigate the notion of reality held by the observer, the listener, or the reader, since "modified" reality appears to be more real only because it adheres to a preconceived notion of truth. Maigret would have found it incredible that the similar statements voiced by Giovanni Boccaccio ("beautiful work conquers matter"),[3] Angelo Poliziano ("matter is surpassed by workmanship")[4] and Torquato Tasso ("matter is conquered by work")[5] were based on a single, identical concept of natural reality. Galileo Galilei, who had some experience in matters of reality and nature, would have agreed.

An avid reader of Ludovico Ariosto and Tasso among others, Galileo vehemently criticized the latter in the *Considerations*, long familiar to art historians through the work of Erwin Panofsky.[6] Galileo's indifference, or rather violent intolerance, towards Tasso and his "mind wandering in countless cloudy fancies"[7] is expressed most forcefully in response to an example of "modified" reality in Tasso's work: the palace and garden of Armida. The scientist is irritated by the tangled web of "oblique and uncertain" roads and the diabolical edifice built in an "inscrutable, confused" order.[8] The disturbance of the

natural order, which Tasso believed to be necessary for eloquence, adhering to Longinus's treatise on the *Sublime*,[9] appeared to Galileo only as a source of unlikely anamorphic images, similar to a "confused and chaotic blend of lines and colors, whence with difficulty one can make out the images of rivers or tortuous alleys, barren shores, clouds, or wild fancies."[10]

It is apparent that Galileo differed from Tasso not only in his notion of poetry, but also in that of gardens. In a simple reference note he contrasts the garden of Armida with the hanging garden in Logistilla's citadel, conjured by Ariosto as a magical image of a golden age outside the boundaries of time.[11] Galileo sees the contrast between these two literary gardens – one set in the present and one in the past – reflected in two real-life gardens close to his native city of Florence: those at Pratolino and Castello. The *Considerations* therefore served to map the course of sixteenth-century Florentine gardens, of which Castello and Pratolino represented chronological and conceptual poles: if the garden is an image of nature modeled according to an idea, Castello and Pratolino mirrored deeply divergent thoughts, as different as the ideas of Cosimo I and Francesco I who commissioned the gardens, and of Niccolò Tribolo and Bernardo Buontalenti who realized them.

"Cosimo de' Medici, following the turmoil he survived during the first year of his reign when he defeated his enemy at Montemurlo, began to allow himself some distractions, and particularly to frequent the villa at Castello, two miles from Florence."[12] Vasari's account is not merely a prolix reference to the year 1537 in the history of

Fig. 54 Niccolo Tribolo and Giambologna, fountain of *Fiorenza*, 1538–48. Villa Medici, Castello.

Florence. He emphasizes that Castello was created, according to the wishes of the new duke of Florence, as a place of entertainment and relaxation, compensating for the recent political disturbances. The refurbishment of the villa and its gardens was intended to reflect the *topos* that since antiquity had signified the antithesis between city and countryside, palace and villa, active life and contemplative life. Furthermore, Vasari not only contrasts the peace of the country residence with some generic "turmoil," but he emphasizes specifically the victory of Montemurlo, aware that Castello was emblematic of that particular historical episode and of its consequences for the Medici state. The iconographic program of the new garden – possibly planned at first by Luca Martini and later by Benedetto Varchi, but never fully realized – was expected to function as a kind of eulogy honoring the Duke's exploits, an approach that for the first time interpreted a garden as a locus of political celebration.

Following the traditional literary pattern of the purifying journey from "dark wood" to earthly paradise, Cosimo's guest began the tour of the garden with an ascent from the villa towards the top of the hill: but true knowledge was acquired in the opposite direction (and a close reading of Vasari's detailed description shows that he, too, followed exactly this double course).[13] High up, "a forest of cypresses, firs, holm oaks and laurels, and other evergreens"[14] surrounded a pond of clear water, in the middle of which, on a rocky islet, in an image worthy of Dante, rose the torso of Appennine, the god of Tuscany's mountains and rivers. The wild and frigid features of his old face transformed the figure into an allegory of Winter, a tormented thaw causing drops of primeval waters to fall, as Michel de Montaigne observed, like sweat and tears.[15] From the primordial chaos of the dark wood the visitor progressed to man-made order, discovering that the descent from the wood led to an artificial plain. Here a womb-like cave may have housed Pan and Neptune, both peacemakers and kings of land and water, just as Cosimo was the sovereign of Tuscany; or possibly the figure of Orpheus, whose harmonious voice delighted the waters, the rocks, and all the creatures. Anyone familiar with Medicean culture, from Lorenzo il Magnifico to Pope Leo X to the young Cosimo himself, would have recognized in this figure a symbol of concord, peace, and civilization.[16]

To the sides of the garden, between citrus espaliers, nature bestowed on the Tuscan soil its primary gift: water. Mounts Senario and Falterona, represented by two large stone sculptures, generated respectively Mugnone and Arno, the rivers of Fiesole and Florence.[17] These appeared at the head of a grand lower terrace with, at its center,

"a forest of cypresses thick and high, and laurels and myrtles, forming a circular labyrinth surrounded by box-trees 2.5 *braccia* high."[18] Following the labyrinth's tortuous path, the visitor arrived at the center to find a large basin filled with water from which rose a white fountain with two basins – the "candelabra" type typical of the fifteenth century – with a statue of *Venus* towering above, squeezing water from her hair. The goddess was presented as a personification of Fiorenza, clearly identified by the joined arms of the seven principal cities of the Medicean state, and by goat heads, the sign of Capricorn, which was in the ascendant when Cosimo was born.[19]

Finally, the visitor proceeded across a plain that spread before the villa, leading to the terminus of the route through the garden – a square, apparently bounded by greenery, resembling an Eden-like *hortus conclusus*. Just as the square perimeter of the foundations of Rome had encircled a pit filled with fruit trees, the primary source of all provisions, so here the central square housed a large fountain, from which, above three basins, emerged a sculpture of *Hercules and Antaeus*. The hub of the garden's vast hydraulic system, the fountain functioned as a siphon for natural spring water rising from the ground. At its summit, Hercules seized his opponent in such a tight hold that from Antaeus's mouth "instead of air . . . pours out an abundance of water through a pipe."[20] Antaeus's exhalation of death produced, in the sunlight, a vibrant image of vitality, suggesting that from the victory of good over evil, of Hercules over Antaeus, and of Cosimo over his anti-Medicean enemies, a new world, perhaps a new golden age, was born. To dispel any possible doubt as to the meaning of these images, Varchi suggested that the niches in the lower terrace should be filled with statues that "denoted and displayed the greatness and the goodness of the Medici family."[21] Thus six civic virtues and their six consequences were to be twinned with twelve Medici portraits, while at each corner four allegorical representations of the seasons were to signify the eternal cycles of time. These elements were not, however, realized.

This composition, exalting the harmony attained under Cosimo I, alluded to an earthly paradise – associated in Medicean mythology with the figure of Lorenzo il Magnifico and his era – temporarily lost but now regained. At Castello, Cosimo sought to present himself as a direct descendent of Lorenzo's time, choosing themes from Marsilio Ficino's philosophy (Philosophy, Astrology, Geometry, Arithmetics, Music) as the inspiration for a series of frescoes by Pontormo in one of the galleries, and displaying in the villa Botticelli's *Birth of Venus* and the *Primavera*. These celebrated paintings were inspired by an equally famous octave by Poliziano:

You could swear that the goddess had emerged from the waves, pressing her hair with her right hand, covering with the other her sweet mound of flesh; and where the sand was imprinted by her sacred and divine step, it had clothed itself in flowers and grass.[22]

Both poem and painting must have been consciously reflected in the orchestration of the garden, focused as it was on the mythology of Venus Anadyomene-Fiorenza, the genetrix of an eternal springtime in the kingdom of Flora-Fiorenza.

If Varchi's program had been fully realized, the Villa Castello would have had "the richest, most magnificent, most ornate garden in Europe."[23] Niccolò Tribolo, who brought the scheme to fruition, dedicated his life to this masterpiece, from 1538 almost until his death in 1550; the entire formal arrangement of the garden, at least in its central part, was designed by him. The exceptions to this homogeneity were the bronze half-figure of *Appennine*, realized by Bartolomeo Ammanati between 1563 and 1565, although this was fully integrated within Tribolo's scheme; and the cave, modified and decorated with excessive ornamentation by a team of artists led by Vasari after 1555.[24] The rest of the decorative apparatus of Castello, as well as its structure, fully reflected the cohesive plan conceived by Tribolo.

In view of a revival of the esthetic ideals of the Laurentian circle, Cosimo's choice of Tribolo as the garden's sculptor could not have been more appropriate, as, through Michelangelo, he had become sensitively attuned to humanist culture. Furthermore, during his sojourns in Rome, Tribolo had been associated with the world of Raphael through Lorenzetto and Baldassare Peruzzi, and from them he learned the laws of esthetic harmony and a love of the sculpture of antiquity. Equilibrium and a noble clarity imbued the perspectival approach adopted in the layout of Castello, where the tripartite levels and the mono-axial arrangement were evidently inspired by Bramante's Vatican Belvedere and Raphael's Villa Madama. It is no accident that Baccio Bandinelli, who was familiar with these Roman gardens,[25] evoked them as models when commenting in 1551 on the first arrangement of the Boboli Gardens, for which Tribolo essentially repeated the same structure as that of Castello.[26]

Each individual element at Castello stemmed from a consistent set of references. The entrance to the cave had an immediate precedent, well known to the sculptor, in the garden executed by an unknown artist in Rome in 1538 for Cardinal Giovanni Gaddi. Annibal Caro's 1538 account of this garden describes similar features to those at Castello, with an artificial construction created from rocks, stalactites, and waterfalls placed in a "disorderly order," simulating a natural environment.[27] The marine creatures that populated the antique basins of Gaddi's garden – "little fishes, corals, small rocks . . . crabs, mother-of-pearl, sea-snails" – also appeared encrusted in the perfect white borders of Tribolo's marvelous basins *all'antica*, which call to mind an Art Nouveau ceramic. The roars and whispers, gurgles and trickles, orchestrated in the Roman cave as a bucolic concert combining sight and sound in harmonious delight, were reproduced in the cave at Castello, and also in the sonorous oak tree set up by Tribolo in the principal garden, known only from Vasari's amazed description: "It cannot be fully expressed how many directions the water follows, springing from the oak tree in various copper devices leading the water where one wants, and with these same instruments obtaining different sounds and pipings from the water."[28]

These elements of pastoral rusticity, perfectly consonant with the Laurentian tradition, appear also to be based on the poetry of Jacopo Sannazzaro, and on his "sylvan songs engraved in the rough bark of the beech trees."[29] To the Arcadian poet's rhetorical question "Who doubts that a natural fountain springing from the rocks, surrounded by green grasses, is more pleasing to the human mind than all other fountains artfully created in white marbles, dazzling with gold?"[30] Tribolo responded by juxtaposing the *Hercules* and *Fiorenza* fountains with their white marbles and the wall fountains representing mounts Senario and Falterona, the rivers Mugnone and Arno, and, above all, Fiesole, all realized (or at least planned) in *pietra bigia* (gray stone) among backgrounds of sponge.

In his personification of Fiesole Tribolo explored the theme of the metamorphosis of a nymph, petrified because of her cruelty in love, clearly referring to a literary precedent that lead back not only to Dante and Boccaccio but also to Lorenzo il Magnifico: "her limbs appear like a figure sketched in hard stone but not finished."[31] Lorenzo's verse evokes in the modern reader Michelangelo's notion of *non finito* and the lines of his celebrated sonnet: "The best of artists never has a concept / A single marble block does not contain / Inside its husk . . ." – a manifesto in defense of the Neoplatonic notion of sculpture.[32] Remaining within the Neoplatonic context, Tribolo may have added to these ideas Leonardo's celebrated thinking on the figurative potential of the natural elements when exploited by an artist who turns them into "proper and good shape."[33] Thus the nymph, deep in thought in a deliberate quotation of Michelangelo's *Night*, is brought out of the natural

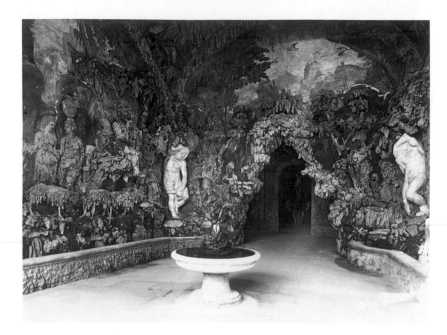

Fig. 55 The Great Grotto with Michelangelo's *Slaves*. Boboli Gardens, Florence.

Fig. 56 Niccolo Tribolo and Bartolommeo Ammanati, fountain of *Hercules and Antaeus*, 1538–59. Villa Medici, Castello.

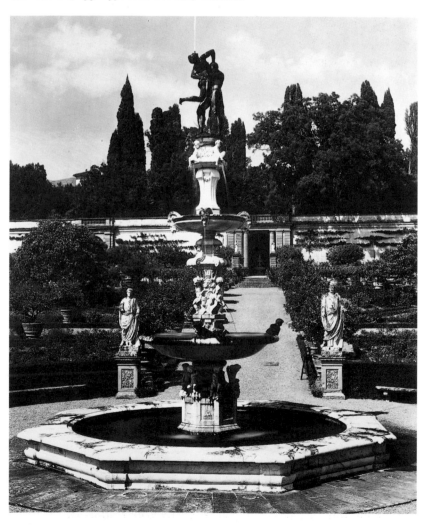

magma by the imagination of the artist, reversing the order of her metamorphosis. The *Fiesole* embodied a formal and conceptual antecedent to the "rustic" placement of Michelangelo's *Slaves*, employed by Buontalenti in 1585 as telamons at the corners of the Grotta Grande in the Boboli Gardens (fig. 55), heralding a widespread fashion for caves populated with anthropomorphic figures that continued throughout the second half of the century.

Tribolo's design for the two great marble fountains also illustrated his continuing reflections on the relationship between art and nature. Both based on the multi-basin model, they included features that suggested a historical continuity with the fifteenth century, a theme that pervaded the entire project of the Villa Castello. Ammanati conformed to this approach in his bronze group of *Hercules and Antaeus* of 1559 (fig. 56; cat. no. 47), either out of personal choice or out of respect for Tribolo's scheme. Thus the clinch of the two figures referred to Antonio del Pollaiuolo's realizations of this subject in a painted panel (now in the Galleria degli Uffizi, Florence) and a bronze (now in the Museo Nazionale del Bargello, Florence), known from painted and sculpted versions in the Medicean collections and adopted by the young Cosimo in one of his medals. Equally *Fiorenza* (fig. 54), the "nude Venus" who "squeezes the water from her soaked hair,"[34] executed in the early 1570s by Giambologna, celebrated the revival of Botticelli and at the same time reflected Tribolo's interest, influenced by Raphael, in high classicism; the figure shows traces of the *Venus* in Peruzzi's fresco at the Villa Farnesina in Rome, where, moreover, the goddess was represented with the figure of Capricorn.

In both fountains the marble parts, made by Tribolo or by Pierino da Vinci and other assistants, were inhabited by a concrescence of rustic and aquatic creatures: marine caryatids, groups of *putti* with geese, festoons of greenery, satyrs and masks, lions' feet, goat-headed spouts, and bronze *putti* frolicking and diving into the water, grasping the marble flesh of the figures. In this triumph of Hellenistic taste Tribolo concealed the structural parts within the anthropomorphic and zoomorphic shapes, combining this radical concept with the fifteenth-century fountain type, the most distinguished of which – because of its location in the Palazzo di via Larga – was the extraordinary work by Antonio Rossellino and Benedetto da Maiano, which may have been a starting point for Tribolo.[35] The latter's innovation was soon assimilated into theoretical artistic debate when, disputing the relative primacy of painting and sculpture in 1547, Bronzino listed among the useful aspects of sculpture its capacity to "employ figures instead of columns or consoles to support [a structure], and for fountains to be outlets of

water."[36] The same observation was taken up and elaborated by Varchi: "Statues can sometimes be used as consoles or columns, supporting something or fulfilling another purpose, as can clearly be seen in the garden at Castello and many other places."[37] Even in his admiration for Tribolo, however, the scholar did not spare him a cutting criticism: "Such things being incidental and outside the context of the arts, I should not give them too much weight, as some appear to do."[38] Nevertheless, a new approach to the plastic and architectural concept of fountains was opened.

Before the garden at Castello was even completed, Duke Cosimo's concept of what a garden should be had changed and broadened. The Villa Castello was intended to be a separate place in antithesis of the city. But with the acquisition in 1550 of the Palazzo Pitti, the Duke brought Castello to the city, reviving Leon Battista Alberti's definition of the suburban villa as a place combining active and contemplative life.[39] Situated behind the palace that was to be the residence of the grand dukes, the garden had to contain a political dimension. Castello was an ideal prototype, and Tribolo, with the help of the same team of hydraulic engineers and sculptors, was given just enough time to reproduce his earlier scheme at the Palazzo Pitti's Boboli Gardens, with a few variations.[40]

Over the five years following Tribolo's death, work on the Boboli Gardens continued according to the scheme devised by the sculptor, but a few alterations were made by Baccio Bandinelli, who took over work on the garden. Two of these had a dazzling impact: the decoration of the Grotta di Madama and the statue of the *Countryman Pouring Water from a Barrel*, both realized around 1554 by Giovanni Fancelli, reveal Bandinelli's forceful approach. Inside the Grotta di Madama a billy goat protected its flock of goats, distributed according to a geometric symmetry to form a triangle suggesting the symbol of the Trinity, a layout that reflected a departure from Tribolo's Arcadian vein to a more rigorous and concise interpretation of the antique (Bandinelli cherished the poetry of Virgil and Horace).[41] Thus the image of the *Countryman*, given a noble aspect by the austere carving of the marble, retained a dignified tone despite its subject because it derived from a Hellenistic model known in Rome. This led the way for other rural figures, especially those executed for the animated fountains of Pratolino by Valerio Cioli, which subsequently formed the basis of naturalist, burlesque, and genre reproductions in a series of small bronzes by Giambologna and in seventeenth-century stone sculptures.[42]

But times changed fast, and already in 1555 Cosimo was preoccupied with new concerns. With the conquest of Siena and the substantial reunification of the Etruscan region he felt the need to make a mark of great magnitude and resonance on the city of Florence. Accordingly he commissioned a series of fountains to form a constellation of landmarks for citizens walking around the city, and work on these continued uninterrupted for twenty years. The Palazzo Vecchio was also subject to three different interventions that expressed Cosimo's grand ambitions. And, to bestow on Florence the magnificence it deserved in its new role, Vasari and Ammanati were urgently summoned back from Rome with the clear intent of setting them in competition against Bandinelli, and also – as the master himself would not be persuaded to come back – to bring back to Florence the legacy of Michelangelo.

In April 1554 Donatello's bronze *David* had been removed from the entrance courtyard of the Palazzo Vecchio in order to reactivate a water supply and make way for a fountain that would "enliven the courtyard and the city."[43] Between 1555 and 1557 a porphyry fountain by Francesco Ferrucci (known as Il Tadda) crowned by Verrocchio's *Putto with Fish* was set up in this location. The enterprise was not grandiose but was defined by Vasari as "of extraordinary beauty,"[44] and was important for two reasons. Firstly the choice of Verrocchio's *Putto*, removed from the Villa Careggi, was a clear homage to the "old" Medici, a gesture that Cosimo had already signaled in his choice of decorations at Castello and that was significant from both a cultural and a political point of view. This tribute was further confirmed by the fountain's careful placement so that it did not disturb the existing courtyard, designed by Arnolfo and Michelozzo. At the same time the fountain's basin and its base in porphyry marked a deliberate return to the magnificence of antiquity, as Tadda was one of the most supremely able of Florentine craftsmen, having succeeded in discovering that which "was missing from the perfection of our arts" – the secret of carving the medium of porphyry, unparalleled in its hardness.[45] Tadda's ability caused "much amazement" even in Michelangelo, and Vasari, in his adulation of Cosimo, went so far as to credit the Duke personally with this discovery.[46] "Enriched by this rarest gift, so keenly desired until now,"[47] Florentine sculpture could at last equal the lost splendors of the past.

When Cosimo turned his attention to the decoration of the Palazzo Vecchio's Salone dei Cinquecento, he decided that in front of the Udienza (reception stage) – where a sort of three-barrel-vaulted imperial arch celebrating the dynasty of the new Augustus was slowly being constructed by Bandinelli – a fountain should exalt the sound government of the state and the welfare of its citizens. *Prudence*, Cosimo's virtue (bearing a resemblance to representations of Apollo and also to the softer traits of

Michelangelo's *David*), and an abundant *Flora-Fiorenza* (which even in its martial appearance made unequivocal reference to the iconography of Botticelli's *Primavera*) were to stand beside figures representing Air (*Juno*) and Earth (*Cerere*), gifts of the cosmos, together with Water, which supplied the sources of the Arno and Parnassus – represented by two seated figures inspired by Michelangelo – to nourish Florentine civilization.

The project, which received the blessing of Michelangelo, was assigned to Bartolomeo Ammanati, who worked on it for almost ten years from 1555 without eventually having the satisfaction of seeing it installed in its intended location.[48] Although unfinished, it was notable because it represented the inclusion within an enclosed architectural structure at the heart of the palace of a decorative element more usually installed in the open air. With its sculptures twirling on the arc of a marble rainbow, its clouds, rocks, animals, garlands, baskets and cornucopias of fruit, and its water effects, Ammanati's fountain was a clear response to those who claimed the greater representational versatility of painting over sculpture.[49] It was conceived as a "poetic concert of statues,"[50] in keeping with the tradition of garden sculpture. Where the Palazzo Pitti brought the garden of Castello to the city, this fountain brought it within the palace. Apparently unprecedented, the experiment can be explained only in the context of the development of ephemeral urban structures with the evolution of Medicean theatrical performances. At the southern end of the Salone dei Cinquecento – used as a performance room occasionally after 1547 and more systematically from 1565[51] – Ammanati's fountain would have appeared as a permanent stage set in which, through theatrical artifice, *Juno* and the peacocks with which she was typically associated were suspended in mid-air, weightless despite their marble bodies. A *tour de force* not strictly reflecting Michelangelo's influence, although it quoted the master in more than one element, the fountain would have perplexed both the explosive Buontalenti[52] and the unimaginative Giambologna.

The link with theatrical apparatus became even more evident in another intervention at the palace: the installation of the *Neptune* fountain, first conceived by Cosimo in the 1540s and recommissioned after a long and damaging chain of events from Ammanati in 1560. Designed in 1550 by Bandinelli, the fountain was intended to revive the tradition of fountains in public squares, and because of this municipal aspect it was to focus, unlike the fountain of the Salone dei Cinquecento, on symbols easily understood by the public, such as the figure of Neptune. Placed at the corner of the palace, the fountain functioned as a focal point unifying the separate areas of the Piazza della Signoria. In the version finally realized by Ammanati, executed between 1560 and 1575, the artist renounced the fifteenth-century multi-basin form (which, however, was not considered obsolete), favoring instead the creation of a tableau vivant around a perimeter defined by minimal architectural elements, thereby importing to Florence a model inaugurated in 1557 with the fountain of *Neptune* by Montorsoli, a Florentine who worked in Messina. *Neptune's* triumphal chariot floated, immovable, within the fountain's octagon of white and colored marble, with shining bronzes and iridescent arches of water surrounded by a court of satyrs, tritons, and nereids, arranged as though participating in a perennial masquerade.[53]

The scenic approach was even more pronounced in Ammanati's grandiose contribution to the Palazzo Pitti, where the sculptor-architect, newly returned from creating the "theatrical" Villa Giulia in Rome, began work in 1560 on the area connecting the palace to the garden (an element that had been weakly resolved at Castello). To provide an architectural solution he invented the peristyle courtyard, with three sides opening onto the large amphitheater-shaped meadow of Boboli (fig. 57). Nevertheless, Ammanati's contribution to the new residence's "imperial" appearance did not stray substantially from the basic structure designed by Tribolo, and on the central axis of the garden, as at Castello, were placed two fountains with subjects bearing a clear political significance: on the summit of the hill an irate *Neptune* made by Stoldo Lorenzi between 1565 and 1572 struck the surrounding waters, awakening the storms that caused the rebirth of the earth; at the bottom of the hill, a placated *Neptune* by Giambologna (also dated 1565–72) watched over his rivers and the peaceful ocean. Together the sculptures represented the regeneration of the state, and they were conceptually related to the *Neptune* in the Piazza della Signoria, so that these two great sites with their allegories of good government were united through a symbolic *corridorio vasariano*. At the Pitti, a key difference from the Castello scheme, beside the increased magnitude of scale to which Giambologna adapted his giant *Neptune*, mounted on Tribolo's huge basin of Elba granite made in 1550, was the viewpoint: Ammanati shifted the ideal perspective to the first floor of the palace, which provided a view encompassing the entire hill. Thus the garden appeared fixed within its perspective and "painted," just as the cypresses, laurel trees, and box-trees in Castello had seemed "made with a brush" to Vasari.[54]

Let us return to Galileo immersed in his reading of Ariosto, contemplating the eternally pulsating universe of a garden where art and nature are harmoniously balanced, where "matter and artistic adornment / compete, so that

it is arduous to judge / which one between them is more magnificent."[55] Galileo then turns to Tasso's *Jerusalem Liberated*, opened at canto XVI, and we must read his laborious commentary on the palace and the garden of Armida in its entirety:

> In this *round building*, realized in a new form of architecture, some things deserve to be considered, and perhaps criticized. First, this building is not a city nor a castle, but a palace . . . This palace is *round, and within its enclosed womb, which is almost its center*, it contains a garden, in a structure contrary to the usual, because it is normal to see palaces within gardens, but not the opposite. And this garden, although it can almost be said to be the center of the palace, nevertheless contains hills, valleys, forests, caves, rivers, and ponds, all on the top of a high mountain. Thus if one were to estimate its extension from the center to the perimeter, this palace must have measured hundreds of miles, although it was built on the top of a mountain. And if one can guess the size of the base of the mountain from its summit, it must have been a circuit of thousands of miles. And it being one of the Canary Islands, this island must have been the largest in the world: which goes against the truth, as they are all very small.[56]

This description of nature subverted is oddly at one with the masterful villa and garden at Pratolino, begun in 1569 by Grand Duke Francesco and his artistic advisor, Bernardo Buontalenti.[57] The strong formal and conceptual link between Buontalenti's work and Tasso's description was probably already clear in the mind of the young Galileo and his contemporaries, as Baldinucci, in one of his anecdotes collected from contemporary sources, mythologized the episode of Buontalenti and Tasso embracing in the middle of the via Maggio.[58]

The factor that most deeply differentiated Francesco's attitude from that of his father Cosimo, was his reluctance to adhere to governmental convention and political practice. Among many examples that could be cited, this is nowhere more eloquently illustrated than at Pratolino: the choice of a site so impervious and so far removed from the capital city appeared as an intentional inversion of Cosimo's strategy in moving from the Villa Castello to the Palazzo Pitti. Such a decision was not even motivated by a return to a harmonious alternation of city and countryside, and so seemed to be a defiant gesture undermining the accepted order of things. Similarly, in preference to the celebration of Medici glories in the Sala Grande, Francesco preferred the seclusion of his Studiolo, boundless despite its minute dimensions; or he withdrew to pick flowers in the garden created for him

on the Loggia dei Lanzi in front of the site of the government; or, in 1583, he broke the unity of the civic monuments in the Piazza della Signoria by adding Giambologna's *Rape of the Sabines*.

Francesco's transgression of the given order was reflected in the very structure of Pratolino. Like Castello and the Boboli Gardens, Pratolino was also crossed by a central axis: this extended from a statue of *Zeus* as creator at the top of a hill, through a formal labyrinth to Giambologna's enormous *Appennine*, and from there through a large area with ancient statues to the villa. At the bottom of the hill, the axis led from the villa to the cave of Mugnone, and along a principal avenue lined with jets of water, to a basin with a statue of a *Laundress*. The axis was split into two visually incompatible halves, however, and many important decorative elements were hidden from sight by thick, high vegetation, and reached only via irregular paths through the woods or along serpentine water canals. Unlike Castello and Pitti, Pratolino could not be viewed in its entirety from one privileged, static viewpoint: like Giambologna's *Rape of the Sabines* the garden could be enjoyed only in segments, and apprehended as a whole only after a number of visits.[59] It implied, therefore, not abstract contemplative time, but rather "natural" time, extending over a duration, occasional in nature, layered in memory.

The disregard shown by Francesco and Buontalenti for the rules of unity was expressed in a deliberate demonstration on the occasion of the inauguration of the Uffizi Theater in 1586. Instead of asking the author Giovanni de' Bardi to base his six *intermezzi* on a single theme, the request was that "he should pursue variety so that it was necessary to renounce unity, and consequently the value that can be gained through this. And seeing that his composition must contain many different elements, he did all that was possible to turn the above-mentioned unity into variety and disunity."[60] This obsessive pursuit of "disunity" implied movement. The fractured perception of the garden has already been discussed in these terms, but movement was also introduced by a spectacular array of mechanical and hydraulic automata that — as well as acting as marvels to entertain the guests — served primarily to delight Francesco and Buontalenti, who had enjoyed playing with similar toys as young boys and, as grown men, succeeded in defeating the laws of physics to create a mechanical instrument in perpetual motion.[61]

As for variety, the patron and the architect had pursued it as their only guide in building Pratolino: lacking a unified iconographic program, the themes presented in the garden followed a constantly varying organic sequence, going against all the rules of classical poetry, from the sublime-heroic (Zeus, Perseus, and the ancient)

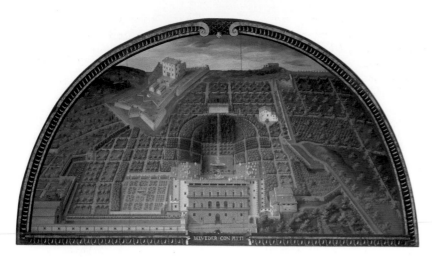

Fig. 57 Giusto Utens, *Palazzo Pitti and Belvedere*, 1599, oil on canvas. Museo Typografico Firenze com'era, Florence.

to the middlebrow-lyrical (Pan and Syrinx, Cupid, Narcissus), and the humble-comical (the *Laundress*, the *Countryman*). With equal indifference, the garden's furnishings – unlike those at Castello, which were all made as part of a single scheme – were often realized by gathering miscellaneous works extraneous to the project. Bandinelli's *Zeus*, Ammanati's *Juno* fountain, Danti's *Perseus*, Cellini's *Narcissus*, Fancelli's *Countryman*, were all brought together, acquiring new meanings in their new context in a way that almost suggests the modern "ready-made" and following the pragmatic principles of economy and expediency characteristic of ephemeral decorations for the theater (the same would happen to Michelangelo's *Slaves* when they were mounted in the Grotta Grande in the Boboli Gardens, which followed a similar esthetic approach to that at Pratolino).

At Pratolino, nature and art in their constant interchange finally became one, as at the magical garden of Armida, where "it looks as though nature in her artfulness, to amuse herself, / imitates the imitation of nature."[62] The human mind comprehends the unity of nature and art through a fragmentary and ever-changing perception, just as the appearance of things is also fragmentary and ever-changing. Natural and artificial spectacle could no longer be distinguished at Pratolino: the garden was a theater, the theater a garden, a concept realized in practice at the inauguration of the Uffizi Theater, when, surrounded by a "real, most delightful garden,"[63] full of flowers, fruits ripe and unripe, and live birds flying, a florid image of spring being reborn from a barren winter landscape was displayed.[64] A poetic celebration of the vital flux of nature that sees all human endeavor eventually decay, the project of Pratolino, in an ironic confirmation of its own themes, perished soon after its prince, and was dismantled in 1588, not without leaving a deep impression on the evolution of European gardens.

If Galileo did not appreciate Tasso's garden, it follows as a corollary that he must not have liked Pratolino either, just as it is well known that he had no fondness for Francesco's Studiolo.[65] We shall imagine him, therefore, in the early seventeenth century, fascinated by the works extending the Boboli Gardens towards the Porta Romana and enchanted by the regulated pace of its "regal" perspectives, its marbles, its harmonious landscapes, painted and sculpted. As a preferred text to accompany him in his wanderings, we will suggest the poetic promenade by Gabriello Chiabrera, a courtly celebration of the new Medicean springtime: "Enter the Pitti, with its incomparable entrance, / across its regal threshold . . ."[66]

NOTES

1. "La vérité ne paraît jamais vraie . . . Racontez n'importe quelle histoire à quelqu'un. Si vous ne l'arrangez pas, on la trouvera incroyable, artificielle. Arrangez-là, et elle fera plus vrai que nature . . . Faire plus vrai que nature, tout est là." Simenon 1950, p. 38.
2. "Work conquers matter." Ovid, *Metamorphoses*, 11, 5.
3. "Vincea la materia il bel lavoro." Boccaccio 1974, 4, 12, p. 158.
4. "Vinta è la materia dal lavoro." Poliziano 2000, 1, 95, 4, p. 82.

5. "Vinta è la materia dal lavoro." Tasso 1881, 16, 2, 6, p. 315.
6. Panofsky 1954.
7. "mente distratta in molte torbide imaginazioni." Galilei 1970, pp. 627–28.
8. "oblique e incerte"; "inosservabile e confuso." Tasso 1881, 16, 1ff, p. 315ff.
9. See Praz 1975, pp. 97–117.
10. "una confusa e inordinata mescolanza di linee e di colori, dalla quale anco si potriano malamente raccapezzare imagini di fiumi o sentier tortuosi, ignude spiagge, nugoli o stranissime chimere." Galilei 1970, p. 604.
11. Ariosto 1882, 10, 61–63, vol.

1, pp. 181–82.
12. "Il signor Cosimo de' Medici, uscito che egli fu de' travagli che ebbe il primo anno del suo principato per aver rotti i nimici a Monte Murlo, cominciò a pigliarsi qualche spasso, e particolarmente a frequentare assai la villa di Castello, vicina a Firenze poco più di due miglia." Vasari-Milanesi 1878–85, vol. 6, pp. 70–71.
13. For a complete documentation of the Villa Castello, see Acidini Luchinat and Galletti 1992.
14. "un salvatico di cipressi, abeti, lecci ed allori, ed altre verzure

perpetue." Vasari-Milanesi 1878–85, vol. 6, p. 76.
15. Montaigne 1983, pp. 180–81.
16. For this interpretation of Orpheus in Medicean iconography, see Langedijk 1976. On the theory suggesting the presence of a figure of Orpheus at the center of the cave, see Del Bravo 1978, pp. 109–37.
17. Vasari-Milanesi 1878–85, vol. 6, pp. 77–78.
18. "un salvatico d'altissimi e folti cipressi, lauri e mortelle, i quali girando in tondo fanno la forma d'un laberinto circondato di bossoli alti due braccia e mezzo." Vasari-Milanesi 1878–85, vol. 6,

p. 74.

19. On the *Fiorenza* fountain see Acidini Luchinat 1987.

20. "in cambio dello spiritoesce per una canna acqua in gran copia." Vasari-Milanesi 1878–85, vol. 6, p. 81.

21. "denotassino e mostrassero la grandezza e la bontà della casa de' Medici." Vasari-Milanesi 1878–85, vol. 6, p. 83.

22. "Giurar potresti che dell'onde uscissi / la dea premendo colla destra il crino, / coll'altra il dolce pome ricoprissi; e, stampata dal piè sacro e divino, / d'erbe e di fior l'arena si vestissi." Poliziano 2000, I, 101, 1–5, p. 87. English translation Quint 1979.

23. "il più ricco, il più magnifico, ed il più ornato giardino d'Europa." Vasari-Milanesi 1878–85, vol. 6, p. 84.

24. Nevertheless Vasari himself credited Tribolo with the invention of the architecture and the rustic ornamentations; Vasari-Milanesi 1878–85, vol. 1, p. 141 and vol. 6, p. 77.

25. Bandinelli had kept his studio and his academy at the Belvedere, and in the Villa Madama he executed two giants made of plaster, 4.5 metres high, that "held in the center the door to the forest" ("mettono in mezzo la porta che va nel salvatico"). Vasari-Milanesi 1878–85, vol. 6, p. 144.

26. Letter from Baccio Bandinelli to Jacopo Guidi dated 11 February 1551, in Bottari and Ticozzi 1822–25, vol. 1, p. 52.

27. See MacDougall 1978.

28. "Né si può dire a pieno per quante vie si volge la detta acqua della quercia con diversi instrumenti di rame per bagnare chi altri vuole, oltre che con i medesimi instrumenti se le fa fare diversi rumori e zuffolamenti." Vasari-Milanesi 1878–85, vol. 6, pp. 82–83.

29. "silvestre canzoni vergate ne li ruvidi cortecci de' faggi." Sannazzaro 1961, prologue, 2, p. 3.

30. "chi dubita che più non sia a le umane menti aggradevole una fontana che naturalmente esca da le pietre vive, attorniata di verdi erbette, che tutte le altre ad arte fatte di bianchissimi marmi,

risplendenti per molto oro?" Sannazzaro 1961, prologue, 3, p. 3.

31. "le membra mostron come suol figura / bozzata et non finita in pietra dura." Medici 1992, 41, 7–8, p. 908.

32. "Non ha l'ottimo artista alcun concetto / c'un marmo solo in sé non circoscriva / col suo soverchio." Buonarroti 1928, sonnet 149, 1–3, p. 81. English translation Gilbert 1963.

33. "in integra e bona forma." Vinci 1970, vol. 1, p. 254.

34. "madidas exprimit imbre comas." Ovid, *Ars amatoria*, III, 224.

35. See Caglioti 2000, vol. 1, pp. 359–79.

36. "servire di sue figure per reggere, in cambio di colonna o di mensole, o sopra fontane per gittar acqua." Quoted in Varchi and Borghini 1998, p. 68.

37. "Le statue servono alcuna volta ancora per mensola o colonne, sostentando alcuna cosa o faccendo alcuno altro ufizio, come si può vedere ampiamente nel giardino di Castello et in molti altri luoghi." Varchi and Borghini 1998, p. 50.

38. "Di simili cose, per l'essere accidentali e fuora dell'arti, non fareici per me troppo gran caso, come pare che facciano alcuni." Varchi and Borghini 1998, p. 50.

39. See Rinaldi 1981.

40. On the early stages of the work at Boboli, see Rinaldi 1991.

41. Colasanti 1905.

42. See Heikamp 1986b; Brook 1991; and Montigiani 2001.

43. ". . . rallegri il cortile et la città." Giorgio Vasari, letter to Cosimo I, 30 May 1557, quoted in Allegri and Cecchi 1980, p. 228. For the documentation of this fountain see Allegri and Cecchi 1980, pp. 227–29; and Caglioti 2000, vol. 1, pp. 115–16.

44. "di straordinaria bellezza." Vasari-Milanesi 1878–85, vol. 1, p. 112.

45. "mancava alla perfezione delle nostre arti." Vasari-Milanesi 1878–85, vol. 1, p. 111.

46. "molta maraviglia." Vasari-Milanesi 1878–85, vol. 1, p. 112, and more generally on the treatment of porphyry pp. 108–13.

47. "Arricchita di questo rarissimo dono, cotanto invano insino a oggi desiderato." Vasari-Milanesi 1878–85, vol. 1, pp. 112–13.

48. On the iconography and complex history of Ammanati's fountain, see Heikamp 1978.

49. See for example Vasari's response to Benedetto Varchi's query in Varchi and Borghini 1998, p. 63.

50. "concerto poetico di statue." Giovanni Guerra, see Heikamp 1978, fig. 26.

51. See Zorzi 1977, pp. 61ff.

52. It should be noted that the fifth performance with musical *intermezzi* staged by Buontalenti at the Uffizi Theater in 1586, entitled *The Dearest Friend / Amico Fido*, featured Juno's flying chariot, pulled by two peacocks beneath an overarching rainbow; see *Il luogo teatrale a Florence* 1975, p. 109.

53. On the fountain of *Neptune* see Heikamp 1995; and Acidini Luchinat 1995a.

54. "fatti col pennello." Vasari-Milanesi 1878–85, vol. 6, p. 74.

55. "la materia e l'artificio adorno / contendon sì, che mal giudicar puossi / qual de le due eccellenze maggior fossi." Ariosto 1882, 10, 60, 6–8, vol. 1, p. 181.

56. "In questo *tondo edificio*, con nuova architettura fabbricato, sono alcune cose degne di considerazione, e forse di reprensione. E prima, questo edificio non è una città o un castello, ma un palazzo . . . Questo palazzo è *tondo e nel più chiuso grembo, che è quasi centro*, ha un giardino, con architettura contraria alla comune, perché si veggon ben palazzi in mezzo de' giardini, ma non per l'opposito. E questo giardino, ben che sia quasi centro del palazzo, nulla di meno contiene in sé colline, valli, selve, spelonche, fiumi e stagni, tutte robe costituite su la cima d'un alto monte: onde se dal centro si può raccorre la circonferenza, questo palazzo doveva girar centinai di miglia, ben che fosse piantato nella cima d'un monte; e se dalla cima si può arguire la pianta del medesimo monte, doveva aver di circuito migliaia di miglia; ed essendo in

una dell'isole Canarie, essa isola doveva esser la maggior del mondo; il che ripugna al vero, perché son tutte piccolissime." Galilei 1970, pp. 617–18 (author's italics).

57. The link between Tasso's garden and Pratolino has been pointed out before: see Berti 1967, pp. 85ff; Venturi 1981; and Ulivi 1981. For the entire documentation used in this article regarding Francesco I and Pratolino, see Berti 1967 and the exhibition catalog *Il Giardino d'Europa* 1986; for an interpretation of Francesco's personality that supports my own view, see Del Bravo 1997.

58. Baldinucci 1845–47, vol. 2, pp. 523–24.

59. See Pizzorusso 2000, particularly p. 229.

60. "s'attendesse alla varietà: di maniera, che gli fu necessario, per cotal riguardo, perderne l'unità, e per conseguente il pregio, che per essa può guadagnarsi. E veggendo, che il suo componimento esser conveniva di molti capi, si dispose per ogni guisa di voler mettere nella varietà, e disunione la sopraddetta unità." *Il luogo teatrale a Firenze* 1975, p. 109.

61. Borghini 1584, p. 613; Baldinucci 1845–47, vol. 2, pp. 493, 529–30.

62. "di natura arte par, che per diletto / l'imitatrice sua scherzando imiti." Tasso 1881, 16, 10, 3–4, p. 317.

63. "vero e amenissimo giardino." Baldinucci 1845–47, vol. 2, p. 511.

64. Baldinucci 1845–47, vol. 2, pp. 510ff.

65. Galilei 1970, pp. 502–3.

66. "Entra ne i Pitti, incomparabil mole, / varca sue regie selve . . ." Chiabrera 1730. For an interpretation of the garden of Boboli in the first thirty years of the seventeenth century, see Pizzorusso 1989.

SPECTACLE, THEATER, AND PROPAGANDA AT THE COURT OF THE MEDICI

Anna Maria Testaverde

INTRODUCTION

The history of Florentine ceremonial ritual and spectacle between Cosimo I's wedding in 1539 and the death of Cosimo II in 1621 is directly related to the rise to power of the Medicean principate.[1] From the outset, Cosimo I's cultural policy aimed to define a new tradition of public celebrations and, though he never expressly overturned the customs of republican Florence, he nevertheless redrafted the calendar of city festivals to accommodate the cult of the Medici.[2] The feast honoring St. John the Baptist, patron saint of Florence, was transformed into a celebration of the emerging dynasty, and new anniversaries, such as the feast of Saints Cosmas and Damian and that of St. Lawrence, were introduced. The anniversary of Cosimo's election and of his conquest of Siena, and later the birthdays of each of the grand dukes, also became festive days.

Until the reign of Ferdinando I, the new tradition remained at a formative stage and its main objectives were to involve the entire community in Medici family occasions such as baptisms, weddings, funerals, and solemn entrances (fig. 59), and to insinuate allegories and symbols of the rising regime into key public events and political and religious rituals such as official visits, the feast of St. John, and carnival. The success of the policy grew as the Medici family's traditional "artistic patronage" became a "strategic patronage," exercising a state monopoly over artistic culture by incorporating intellectuals and artists within academic associations controlled by the dynasty.[3] These academies were key to the Medici's claim to be the successors of the ancient city's traditions, both historical and political. During the reigns of Ferdinando I and his son Cosimo II, the new celebratory traditions were codified and became huge public events, promoted by campaigns in print and recorded in illustrations. Trans-

formed into an art by the expertise of court technicians, Florentine spectacle soon gained public recognition and a deserved supremacy.

THE COURT SPECTACLE WORKSHOPS

In the years following his difficult rise to power, Cosimo actively fostered intellectuals and artists by providing financial support and promotion to create "cultural mines," from which the Medici court could gain the most qualified advice in matters of theater, music, literature, and art. During the 1540s and 1550s, as the Florentine government was transformed into a principate, Cosimo continued actively to promote theatrical activities, delegating their organization to the Accademia Fiorentina. Established in 1542 through the transformation of the Accademia degli Umidi, the Accademia Fiorentina had the official task of developing and diffusing the Tuscan vernacular as the supreme language, and, with the help of its young scholars, it was responsible for a number of theatrical innovations.[4] Cosimo furthermore entrusted the Accademia with the management of its own theater, the prestigious Sala del Papa, famed since the time of the republic.[5] Between the 1560s and 1580s, as the Medici court took control of every aspect of Florence's theatrical activities and spectacles, the Accademia Fiorentina lost its original function, and, like the Accademia degli Alterati and the Accademia della Crusca, focused on the study of comedy, tragedy, and *intermezzi*, a form of entertainment based on music, drama, and dance that was revolutionizing the conventions of the theater.[6]

The Accademia degli Alterati was founded in 1568 by some of the Accademia Fiorentina's deputies, sponsored

Fig. 58 Detail of fig. 59.

Fig. 59 Cigoli, *Project for a Triumphal Arch*, 1608, pen and ink. Gabinetto Disegni e Stampe degli Uffizi, Florence.

by the Medici. It maintained a tradition of musical and literary discussion but was also involved in aspects of contemporary theater, including a production of Aristotle's *Poetics* with commentary by Alessandro Piccolomini, a debate on the merits of tragedy versus comedy, and the establishment of the new "mixed genre" ("genere misto") of tragicomedy.[7] This academy, recognized today for its debates on music theory and for its creation of *melodramma*, counted among its members individuals who initiated remarkable advances in music and theater: Giovanni de' Medici;[8] Girolamo Mei; Ottavio and Alessandro Rinuccini; Alessandro Adimari;[9] Michelangelo Buonarroti the Younger; and especially Giovanni dei Bardi and Jacopo Corsi, in whose palace the first operas were staged. The product of the experiments in *melodramma* undertaken within this lively circle was the famous opera *Euridice* by Ottavio Rinuccini, performed for the first time at court in 1600.

A further association, the Accademia degli Elevati, focusing on selected aspects of music theory, was founded in the early seventeenth century by Marco da Gagliano, chapel master at the Medici court.[10] The institution brought together the most important representatives of the Florentine musical world, who were also attached to the court: the famous singer Jacopo Peri, known as "Lo

Zazzerino"; the poet Ottavio Rinuccini; the singer Giulio Caccini; and the dramatists Francesco Cini, Michelangelo Buonarroti the Younger, and Jacopo Cicognini.[11] As well as participating in courtly spectacles, these academicians also created theatrical plays and poetic compositions for *intermezzi* and supplied ideas for elaborate allegorical masquerades for the carnival.[12] Above all, they were responsible for "propagandistic literature for festivals" – prolix descriptions commissioned to promulgate a positive image of the Medici court throughout Italy and Europe. The first pamphlet of this kind was produced in 1539 on the occasion of Cosimo de' Medici's wedding to Eleonora of Toledo. The academician Pierfrancesco Giambullari focused his description on three key moments – the entrance of the bride, the theatrical presentation staged by Bastiano da Sangallo, and the banquet – writing his text in the form of an epistle addressed to Giovanni Bandini, Cosimo's orator, who was recognized as an official Florentine representative by the court of the Holy Roman Emperor, Charles V.[13]

Among all the sixteenth-century academies favored by the Medici, however, the most productive in terms of Medicean spectacle was undoubtedly the Accademia del Disegno, founded in 1563 by the court architect Giorgio Vasari with the official purpose of "preserving the originality of the Tuscan manner."[14] The Accademia elected Cosimo "Prince, Father, and Lord, first Academician and universal protector," and Michelangelo – whose artistic legacy and teaching it extensively appropriated in the service of the court – "leader, father, and master of all."[15] The Accademia became the crucible for the grand dukes' celebrations, formalizing the rituals of dynastic festivities and defining a celebratory iconography for the Medici. It was also responsible for teaching the "art of spectacle," the preparation of festive decorations being included in the curriculum of its young artists. Indeed, in the early stages of their careers all artists were required by a statutory rule of the Accademia formally to train as revelers (*festaioli*) for the institution's internal celebrations.[16] Cosimo de' Medici and his successors employed not only the Accademia's artists, but also its counselors and deputies to "forge the identity of Medicean power,"[17] thus ensuring the promotion of Florence's new supremacy in the arts.

Alongside the splendor of Florentine public festivals existed the amateur theatrical activities of the city's traditional confraternities. These were typically religious associations that often took the title of "Accademia" but accepted all social classes, in contrast to the more elite and erudite new academies. The companies, whose work is still not given due attention, were also associated with the Medici through their performance of comedies at

court theaters.[18] Their members included the youth of the Florentine elite and, in the seventeenth century, the young members of the Medici family. In the first quarter of the seventeenth century such companies engaged in a constant round of lively activity that even in its autonomy was often financed by the Medici.[19] Following the death of Cosimo II in 1621, court spectacles declined in number and the less prestigious institutions gradually took over the task of providing entertainment.

In 1618 Giovanni de' Medici supported the Accademia degli Incostanti, which specialized in improvised plays and made use of premises in the Medici private residence at the Casino di San Marco. Among its members were Cicognini, the painter Filippo Furini, and the architect–set designer Cosimo Lotti. Another academy active in the same years was the Accademia degli Storditi, which in 1619 staged *La Fiera* by Michelangelo Buonarroti the Younger in the court theater at the Uffizi. Also noteworthy were the Accademia degli Infiammati and the Confraternity of the Archangel Raphael,[20] which counted among its members musicians and singers such as Peri, Caccini, and Marco da Gagliano, and painters such as Baccio del Bianco and Lorenzo Lippi. The court's contact with these institutions tended to be managerial in approach, devoted to promoting a livelier and more innovative type of theatrical production, and as a result their work was able to rise above the merely propagandistic.[21]

TYPES OF SPECTACLE AND THEIR ORGANIZATION

In the 1560s, the Medicean principate, having achieved its political objectives, began to establish an organized structure for its customs, and in particular to formalize its rituals into ideologically recognizable models. The validation of dynastic rituals and ceremonies reached a turning point in 1565 on the occasion of Francesco de' Medici's wedding to Giovanna of Austria. As patrons, the Medici took personal control of the intellectuals and artists involved in the preparations.[22] Vincenzo Borghini, the deputy of the Accademia del Disegno and court iconographer, shared with the trusted architect Giorgio Vasari a privileged relationship with Duke Cosimo but main responsibility for the success of the celebrations fell to Borghini. He acted as intermediary with the artists of the Accademia – Alessandro Allori, Giovanni Stradano, Lamberto Sustris, Mirabello Cavalori, Girolamo Macchietti, Andrea Boscoli, and Maso da San Friano – whom he selected on grounds of age and reliability. His task began with a survey of court spectacle and existing types of temporary decorations.[23] From this thorough review of contemporary entertainments he concluded that, in the context of dynastic history, nuptial rites were the most important festivities, and that the moment of the bride's triumphal entrance into the decorated city provided the strongest occasion for propaganda.

Borghini's program perfected the festive scheme orchestrated in 1539 for the marriage celebrations of Cosimo and Eleonora by a group of artists that included Niccolò Tribolo, Ridolfo del Ghirlandaio, and Francesco Bacchiacca – all supporters of the Medici.[24] For this occasion the artists had installed a cycle of ephemeral apparatus along a processional route that differed from that used for republican celebrations, following instead the perimeter of the ancient Roman encampment on which Florence was built and so symbolizing the revival of Florence's illustrious past in the cultural, artistic, and political innovations brought about by the Medici in the San Marco area.[25]

The iconography of the decorations for the triumphal entrance in 1565 centered upon the theme of the apotheosis of the Medici, giving an ideological significance to the processional route. Cosimo, the "new Augustus," and his political ascent, were celebrated through the established iconography of the *Renovatio imperii* (renewal of the empire), heralding the revival of Florence's artistic, literary, and military supremacy.[26]

But although the decorations for this event are considered to represent the canonical moment of ephemeral Florentine art, the entrance in 1589 of Christine of Lorraine, granddaughter of Catherine de' Medici and bride of Ferdinando I, most clearly imprinted on the public the ideological link between the ancient encampment route, the Medici iconography, and the decorations. For this event, the new deputy of the Accademia, Niccolò Gaddi, conceived a broad program intended to promote the supremacy of Florence and Tuscany and the political and diplomatic role of the Grand Duchy in Europe. Emphasis was given to the veneration of the imperial power and to a celebration of the victory of the grand-ducal fleet over the Turks, which was illustrated in Taddeo Landini's decoration for the entrance in via del Proconsolo. Giovannantonio Dosio of Rome, whose artistic theories about architectural orders were quite alien to Florentine artistic traditions, probably influenced the structural and ideological organization of the cycle: his decorations for the Palazzo Vecchio symbolically affirmed the grand-ducal state by using the Tuscan composite order.[27]

For the first time in the history of the propagandistic description of Medici festivals, extensive graphic documentation of the decorations was included alongside an account of the celebrations. The illustrations were made by Raffaello Gualterotti, an academician, amateur artist, and "most knowledgeable astrologer," highly respected at

court.[28] As Gualterotti himself declared in his dedication to Christine of Lorraine, the illustrations were intended to serve as a visual testimony for all outside Florence of the magnificent results of the artistic activity fostered by Cosimo's reign.

The 1589 celebrations saw the emergence of an "entrepreneurial" approach to the organization of Medicean festivals, being directed by Ferdinando and a team of collaborators. The court's involvement was devolved to three intermediary bodies: the General Depository (the state treasury), the Guardaroba (which supervised the work of artists and manufacturers), and the Magistrate of the Fortress (who was responsible for assembling and keeping the raw materials).[29] The new approach no longer allowed for a personal monopoly over the events, as was exercised in 1565, but instead distributed tasks on the grounds of specialization. The body in charge of organizing the events had an administrative structure akin to that of the state, being run by superintendents, treasurers, and secretaries, and was active for one-and-a-half years, with the exclusive task of preparing the festivities and arranging official uniforms, decorations for the route, and theatrical performances. Artists were especially employed through the court or tied to the Medici by contracts, executing commissions awarded by the Guardaroba, their work subsequently being scrutinized by Alessandro Allori before they were given any remuneration.

Similar organizations were responsible for another type of dynastic ritual during these years: the funeral ceremony. The grand duke would choose a team composed of deputies and one superintendent from among the most trusted courtiers of the Accademia del Disegno, such as the brothers Dell'Antella, who dominated the creation of such spectacles for seventy years. During the seventeenth century the representatives were selected from the most eminent ranks of the state, often because of their membership of Florentine intellectual circles, in particular the Accademia Fiorentina and the Accademia degli Alterati. As well as undertaking financial management of the project, the superintendents were responsible for supervising artistic production and maintaining contacts with the grand duke, the stage designer, and the group of artists executing the work. Workshops for the creation of these funeral honors were located in the basilica and the chapter house of San Lorenzo.[30]

The iconography of these funeral ceremonies, as for weddings, was entrusted to the Accademia del Disegno, which had distinguished itself in this field since its origins, having organized the 1564 exequies in the basilica of San Lorenzo for the "divine master" Michelangelo.[31] On this occasion the funerary decorations were used as a pretext to praise Cosimo's patronage of the new Accademia and his active promotion of Florentine arts, which was implicitly compared to that of Lorenzo il Magnifico, who had himself supported Michelangelo. The iconographic scheme for the funeral of Cosimo I in 1574 was modeled on this illustrious precedent and also on the complex decorations alluding to the sacred nature of the royal body made for the 1558 exequies in Brussels of Charles V, with whom Cosimo liked to be identified.[32] These "exequies in effigy" – ceremonies celebrating the memory of illustrious political figures – allowed Michelangelo's disciples to perpetuate the memory of their master and to spread the artistic prestige of the Medici family outside Florence with sumptuous ephemeral decorations. During the seventeenth century, members of the principal academies, accustomed to speculating on moral, literary, and rhetorical themes, offered their expertise in conceiving such projects,[33] while the translation of the schemes into visual terms was assigned to academicians linked to the court: for example, Lodovico Cardi, called Il Cigoli, who made the exequies for Philip II of Spain in 1598; or Giulio Parigi, who created the exequies for Henry IV of France and Margaret, queen of Spain, sister of Maria Maddalena, in 1610 and 1612 respectively.

After the death of Ferdinando in 1609 and the rise to power of Cosimo II, Medicean spectacle changed radically due to the intervention of two important figures: Cosimo's mother, Christine of Lorraine, and his wife, Maria Maddalena of Austria. Reflecting their strong personalities, their patronage influenced both the organization of the ceremonies and the type of spectacles performed.

From the time of her arrival in Florence in 1589, Christine of Lorraine, supported by the pro-French policy of the Grand Duchy, had taken a leading role both politically and in the sphere of public festivals and she invariably supplanted Cosimo in the decision-making process. Numerous memorable festivals were realized while she was in power, mostly coinciding with major wedding celebrations: the sumptuous wedding of Maria de' Medici to Henry IV of France in 1600; the marriage of Cosimo II to Maria Maddalena in 1608; the union of Catherine de' Medici with Ferdinando Gonzaga in 1613; and the wedding of Claudia de' Medici to Leopold, archduke of Austria in 1626. Grand presentations were also performed when illustrious figures visited Florence: for example, Cardinal Montalto and Cardinal del Monte in 1595; the Prince of Modena in 1605; and the Prince of Urbino in 1616. But these dynastic spectacles revealed an ever-dwindling artistic creativity. For example, when Cigoli was appointed to orchestrate the marriage of Cosimo II in 1608, he found himself limited by financial constraints imposed by the court and was forced to

recycle decorative elements from earlier spectacles, such as eighteen canvases employed in the exequies in effigy of Philip II of Spain.[34]

The extensive documentation of courtly ceremonies under Cosimo II, carefully recorded in the diary of his chamberlain Cesare Tinghi, provides a richer image than it has been possible to reconstruct for the spectacular activity of the earlier grand dukes. Life at court presented moments for playful entertainment quite separate from official events, such as dancing parties (*festini del ballare*) and ballets staged by the princesses, pages, and young prince. Cosimo, who loved extravagant celebrations, also introduced new forms of spectacle to the festive calendar of the court, as did his mother,[35] and these became highly popular in the following years. They were characterized by variety performances, music and dance being the most favored forms, combining the themed tournament – a legacy of the Este dynasty – with masquerades and equestrian ballets featuring sumptuous choreographic displays with stunning visual effects. During the seventeenth century this form of spectacle overflowed into the streets and squares of Florence, encouraging the citizens to become involved in the courtly diversions. Conversely, public entertainments, such as the traditional game of *calcio a livrea* (soccer played in costume) became popular among members of the court, and on several occasions Cosimo II requested that the game be performed outside the traditional carnival period.[36] The prototype for the new style of spectacle favored by Cosimo was tested in 1608, when Giulio Parigi staged a show, *La Giostra dei Venti*, in the Piazza Santa Croce that included an equestrian ballet, a tournament – in which Cosimo participated – an allegorical masquerade, and a dance performed by the cavalry.

Allegorical masquerades, dazzling stage costumes, and elaborate choreographies were key elements for many different kinds of spectacle: the *barriere* (equestrian performances taking their name from the barrier dividing two battlefields), performed in the courtyard of the Palazzo Pitti in 1579 and 1589 and in the Uffizi Theater in 1613; the equestrian ballets of 1616, *Guerra d'Amore* and *Guerra di bellezza*, directed by Giulio Parigi, who also designed the costumes, and staged in the Piazza Santa Croce; and displays for private occasions performed in the rooms of the Palazzo Pitti, comprising exotic or allegorical ballets – *Mascherata di villanelle in Castello* and *Mascherata di ninfe di Senna* in 1613, *Mascherata di Selvaggi* in 1614, and *Ballo di donne turche* in 1615. Such forms of purely visual entertainment derived from the types of spectacle staged by Borghini, Vasari, and the circle of artists from the Accademia during the reign of Cosimo.[37]

Fig. 60 Alfonso Parigi, *Liberation of Ruggero from the Island of Alcina Poggio imperiale*, etching. Gabinetto Disegni e Stampe degli Uffizi, Florence.

Following Cosimo II's death in 1621, Christine of Lorraine acted with Cosimo's wife, Maria Maddalena, as co-regent for Cosimo's young son, Ferdinando II, but these years saw a decline in theatrical diversions and entertainments. Between 1617 and 1624 Maria Maddalena accepted the initiatives of her mother-in-law but subsequently she became the main patron of court spectacles,[38] commissioning new types of performance that were moved away from the traditional city venues to the Villa del Poggio Imperiale and to the new Medici "garden of delights."[39]

THE SETTINGS OF MEDICEAN THEATRICAL PERFORMANCES

In each new residence the Medici commissioned new theatrical venues to be created in spaces not traditionally designated for this purpose. This work was entrusted by the court to technicians, who assumed primarily technical and scientific or didactic roles quite distinct from the art of performance. Unlike the artists of the Accademia, trained to translate into visual terms the allegorical themes of the Medici iconography, these architects and engineers developed their skills within their own fields, subsequently applying them to theatrical representations. Within about a century four generations of architect–stage-designers – Bastiano da Sangallo, Giorgio Vasari, Bernardo Buontalenti, and Giulio and Alfonso Parigi (fig. 60) – succeeded in combining their technical expertise with stage practice. They inherited a long tradition of the enrichment of the Florentine theater through feats of engineering – as Filippo Brunelleschi's

engineering work for spectacles amply demonstrates[40] – and were interested especially in the mechanical aspects of theater and in the pursuit of spatial solutions that would allow the staging of increasingly grandiose scenographic effects.

The adaptation of palace spaces for theatrical use began in 1539, when Bastiano da Sangallo was asked to transform into a theater the second courtyard of the Palazzo Medici in via Larga for the presentation of the comedy *Il Commodo*, written by Antonio Landi, with *intermezzi* composed by Francesco Corteccia and written by Giovan Battista Strozzi.[41] Sangallo had worked on a similar scheme with Ridolfo Ghirlandaio and Franciabigio on the occasion of the wedding of Lorenzo, duke of Urbino, to Maddalena de la Tour d'Auvergne in 1518,[42] and Vasari wrote that on that occasion he "outdid himself, always improving and varying."[43] His innovative design in 1539 focused on the transformation of the stage, where he introduced unusual stage devices, including a small organ that set in motion a sun-shaped device, which, as well as illuminating the scene, symbolized the passing of time on the stage.[44]

Following the move in 1540 of the Medici residence to the ancient Palazzo della Signoria, later renamed the Palazzo Vecchio, Vasari identified the prestigious Salone dei Cinquecento as the most suitable – albeit temporary – space for a court theater.[45] The inauguration of the theater took place in December 1565 for the celebration of Francesco's marriage to Giovanna of Austria. The opera staged was *La Cofanaria* by Francesco d'Ambra, with *intermezzi* by Giovan Battista Cini and music by Alessandro Striggio and Francesco Corteccia.[46] It is probable that Vasari proposed that the space should be an interpretation of a classical theater, as is suggested in his description of the arrangement as being "in the fashion of ancient theater."[47] But his greatest innovation was his refinement of Sangallo's scenographic ideas for stage sets. He expanded the spatial capacity of the backstage area and of the stage itself, providing "stages and rooms, staircases, with many conveniences,"[48] and he projected a revolutionary "functional sky obtained through a half barrel with wooden curtains, all covered in canvases, and painted with the air full of clouds, and this turned around, like the entire stage."[49] The stage and the marvels of its technical devices were concealed from sight until the beginning of the performance by a splendid stage curtain, one of the first documented examples, on which the young Federico Zuccaro had painted a hunt scene over a background of a view of Florence. Vasari was aided in his work on the theater by another rising star: "Bernardo Timante, capricious Painter, graced by the Illustrious Prince," the creator of the "pulls of the sky" (meaning the pulling

mechanisms concealed in the ceiling) and of the "exits under the stage."[50]

Particularly innovative was the theater's assembly system, created by Vasari to facilitate speedy construction and transformation of the space. This allowed the Salone dei Cinquecento to be subsequently fitted out for an official banquet, a new form of self-celebratory spectacle that became part of the tradition of Medicean festive rituals. Even when theatrical performances were moved to the adjacent Uffizi, the Salone dei Cinquecento continued to be used for commemorative banquets, in particular that of October 1600 celebrating the marriage of Maria de' Medici to Henry IV of France, for which Vasari's successor, Bernardo Buontalenti,[51] as artistic director, organized a choreographed banquet of supreme refinement that included marvels of stage engineering set on the sumptuously decorated tables.[52]

It was Buontalenti, close friend and advisor of Francesco I de' Medici, who took the decisive steps towards the establishment of an autonomous theatrical space that could be permanently used to store stage machinery. His ability to integrate his expertise in the field of mechanics and hydraulics with the practice of stage design – perfected in those years through his creation of automata for the gardens of the Villa Pratolino – made him the leading figure in the court theater during the last thirty years of the sixteenth century. Buontalenti fitted out the new venue, one of the first permanent court theaters, first in 1586 and again in 1589, with the assistance of technicians, artists, and specialized manufacturers, further developing many of the devices invented for the Salone dei Cinquecento some twenty years earlier. It was located within the Uffizi in a space about the same size as the Salone dei Cinquecento, employing two different types of stage furnishing and providing two different ways of subdividing the seating for the audience. For the inauguration in 1586, on the occasion of Virginia de' Medici's wedding to Cesare d'Este, when a performance of the comedy *L'amico fido* by Giovanni de' Bardi with *intermezzi*[53] was staged, the venue was decorated as a charming "garden of delights" reminiscent of the Este traditions, perhaps as a tribute to the groom.[54]

The refurbishment of the theater for the 1589 wedding of Grand Duke Ferdinando I, consisted of the reconstruction of "a perfect amphitheater,"[55] decorated with allegorical statues and ornaments made in plaster and wood, simulating the precious polychrome marbles used at the time in Florence's celebrated inlay work (*commesso*).[56] Progressive techniques were used to bring air and light into the room, and the ingenious arrangement of the stage – *paradiso* (upper stage), garret, backstage, service areas, lateral galleries and galleries above the

stage, trap-cellar – brought the Medicean court theater instant fame.[57] But even more memorable were the *intermezzi* invented for the occasion by Giovanni dei Bardi with music by Luca Marenzio, Emilio dei Cavalieri, Ottavio Rinuccini, and Cristofano Malvezzi for the comedy *La Pellegrina* by Girolamo Bargagli,[58] played by members of the Accademia degli Intronati of Siena.[59] By this stage *intermezzi*, with their complex dynamics, had broken with the ethos of the Aristotelian unity of the play, and Florentine theaters explored a multiplicity of scene changes to replace the typical background view of Florence. In his treatise on perspective, Ignazio Danti noted that as early as 1569, in the Salone dei Cinquecento, Baldassarre Lanci of Urbino had adopted a revolutionary system of rotating prisms (*periaktoi*)[60] in order to achieve the scene changes for the *intermezzi* of the comedy *La Vedova* by Giovan Battista Cini (fig. 61).

The common theme of the 1589 *intermezzi* – the allegorical representation of air, earth, fire, and water through harmony and music – expressed philosophical concepts derived from Marsilio Ficino, and was clearly influenced by the musical theories developed at this time by the Camerata dei Bardi and the Accademia degli Alterati.[61] The event was also made memorable by Buontalenti's representation of the four elements through the integration of performance, music, dance, costume, and an early form of *recitar cantando* (singing and play acting).

For the same wedding celebrations, a courtyard in the Palazzo Pitti was transformed into an unusual, multifunctional theater, where Buontalenti displayed all his engineering expertise.[62] The performance included a choreographed *barriera* and a *naumachia* (a staged naval battle simulating a combat between Christians and Turks) – a thoroughly unusual spectacle within the Florentine tradition.[63] The use of this courtyard within the Palazzo Pitti foreshadowed the adaptation of new areas in response to the different needs and activities of the court of Cosimo II. Cosimo's poor health, and the daily performance of private spectacles such as *festini del ballare* led to the adaptation of many rooms within the palace into theatrical spaces: the Sala delle Commedie, the Sala delle Figure, the Sala della Foresteria, the Sala Grande.

Despite its success, the Uffizi Theater increasingly acquired a merely representative function, becoming a monument to the Florentine art of theater; a marvel to admire; a repository of mechanical equipment – pulls, winches, spindles – to be preserved; a collection of machinery – mechanical clouds, ships, and monsters; a display of stage sets – sea, hell, and heaven. Buontalenti's devices became showpieces that were no longer functional, a set of models to be copied and used elsewhere. Before its closure around 1640, the court theater opened

Fig. 61 Baldassare Lanci, *Design for a Stage Set with the City of Florence for "La Vedova,"* 1569, pen, ink, and watercolor. Gabinetto Disegni e Stampe degli Uffizi.

rarely. It was still in use in 1600, for the conclusion of the wedding celebrations of Maria de' Medici and Henry IV of France with a performance of the opera *Il Rapimento di Cefalo* by Gabriello Chiabrera, with music by Caccini and stage design by Buontalenti and Alessandro Pieroni.[64] In 1608 it opened again for the marriage of Cosimo II to Maria Maddalena, when *Giudizio di Paride* by Michelangelo Buonarroti the Younger was performed.

It was in the same year that Giulio Parigi made his debut, becoming the first of a new generation of theater technicians, although his scheme met with little success. Parigi had entered the court in 1603 as an instructor of "mathematics, design, military, and civilian architecture" for the young princes and pages.[65] Only after Buontalenti's death in 1608 did he truly begin his successful career in the theater, in theory arbitrating on decisions related to performances, like his predecessor, but in fact becoming the main force behind the Florentine school for stage techniques. Within his academy in via Maggio a tradition of spectacle was born that would influence – although indirectly – theatrical activities in courts outside Florence: celebrated architect–stage-designers, such as Inigo Jones of England and Joseph Furttenbach of Germany, learned stage techniques from his school and then went on to implement them in their own countries. The foremost illustrators of Medici spectacle, Remigio Cantagallina and Jacques Callot, received their training in his academy and their reproductions of Medici spectacles document the innovations that Parigi made, building on the legacy of Buontalenti.

Cantagallina and Callot's well-known images, along with official reports of the shows, confirm that no revolutionary structural changes were introduced at the Uffizi Theater, with Buontalenti's machines and stage sets being continually recycled for the few perfomances staged there. In a print by Remigio Cantagallina for the fifth *intermezzo*, called *La Fucina di Vulcano* of 1608, in which the trap-cellar is revealed to the audience, disclosing the secret of the marvelous scene changes, the court theater is treated as a model to be advertised. Jacques Callot also represented the Uffizi Theater – almost unchanged from the architect's original plan – when it was used in 1617 as the venue for a new form of display, the *veglia* – a kind of spectacular armed contest that combined *intermezzi* and choreographed dance – entitled *La liberazione di Tirreno e Arnea.*[66]

In the 1630s, Parigi designed an amphitheater in the spectacular setting of the gardens of the Palazzo Pitti, creating the last theatrical venue of Medicean Florence and concluding the dynasty's long theatrical season.

NOTES

1. On the subject of court ceremonies, particularly in Florence, see Fantoni 1994, pp. 23–48.
2. On the transition from the republican to the new Medici tradition see the key text Jacquot 1980.
3. The main features of the relationship between the court and the academies have been outlined recently in Mazzoni 2000. The nature of this relationship during the seventeenth century is currently the theme of an extensive research project coordinated by Professor Sara Mamone at the Department of the History of Theater and Spectacle within the Faculty of Letters and Philosophy at Florence University. Among its first products are Mamone 1996a; Mamone 1997a; Mamone 1997b; and Mamone 2001.
4. On the history of these institutions see Plaisance 1973; Plaisance 2000; and Bareggi 1973.
5. The Sala del Papa was built in the monumental complex of Santa Maria Novella to welcome Pope Martin V in 1418, but it was famed particularly as the venue in 1439 for the ecumenical council presided over by Pope Eugene IV.
6. On the subjects studied at the Accademia, see Weinberg 1972; on debates about the theater see Plaisance 1995.
7. On the subject of this academy see Palisca 1993.
8. For the relationship between Giovanni de' Medici and the Accademia degli Alterati, see Landolfi 1991; on the role of Giovanni as a theater impresario, see Ferrone 1993, pp. 137–90.

9. See Mamone 1997a.
10. On the subject of this accademy see Maylender 1930, vol. 2, pp. 262–63; and Strainchamps 1976.
11. For the musicians attached to the court, see Kirkendale 1993.
12. On these entertainments see Plaisance 2000, p. 36.
13. See Molinari 1987.
14. From the broad bibliography I will mention only a few contributions that provide valuable reconstructions of the "spectacular" activity of the Accademia; see Barzman 1984; Barzman 1987; Wazbinski 1987; Barzman 1989; Scorza 1995; Goldstein 1996; Adorno and Zangheri 1998; and Barzman 2000. I would also like to point out an interesting and previously unpublished thesis on the festive activities of the Accademia, Materassi 2001. I wish to express my gratitude to Professor Sara Mamone, the supervisor of this thesis, who kindly allowed me to follow its development, helping me with several aspects of this essay.
15. "preservare l'originalità della maniera toscana." "Principe, Padre e Signore primo Accademico e protettore universale"; "capo, padre e maestro di tutti." Letter from Vasari to Michelangelo, 17 March 1563; see Vasari–Milanesi 1878–85, vol. 8, p. 367.
16. See Adorno and Zangheri 1998, p. 9. The *festaioli* were young members of the Accademia, elected by three consuls on the basis of the scrutiny of the entire academic body. For a more in-depth study of the activity of the *festaioli* in

the Accademia see Materassi 2001.
17. "forgiare l'identità del potere mediceo." Fantoni 1994, p. 41.
18. For example on 26 December 1565 the Compagnia of San Bernardino and Santa Caterina performed the comedy *La Cofanaria*, created by a member of the confraternity, Francesco d'Ambra, who was also a member of the Accademia Fiorentina, while in 1589 the members of the Accademia degli Intronati staged *La Pellegrina* by Girolamo Bargagli. See Gareffi 1991, p. 305.
19. On this subject see Mamone 1996a; Mamone 1996b.
20. On this confraternity see Eisenbichler 1998.
21. On this subject see the enlightening comments by Mamone 2001.
22. On the formalization of court etiquette see Fantoni 1994, ch.3; on the codification of Medicean rituals see the collected essays in Fagiolo 1980.
23. On Borghini's cultural preparation, leading to the programming of the festival, see Acidini Luchinat 1980b; and Testaverde 1980b; on Borghini's artistic organization of the 1565 celebrations see the essays Scorza 1981; Scorza 1985; Scorza 1991; and Scorza 1995; on the subject of Borghini's working notebook see Scorza 1991.
24. For the 1539 celebration see the key texts Nagler 1964, and Minor and Mitchell 1968.
25. On this subject see Testaverde 1988–90.
26. On the imperial symbols employed in Cosimo's iconography see Checha 1981; Morel 1993; and Corrias 1994.

27. See Testaverde 1998–90.
28. "intendentissimo astrologo" Rossi 1990. See Nadia Bastogi's catalog entries in *L'arme e gli amori* 2001, pp. 114–16; on Gualterotti see Rossi 1990.
29. For the management of the 1589 celebrations see Testaverde 1982.
30. On the organization of exequies in effigy see *La morte e la gloria* 1999, pp. 75–79.
31. For this episode see Wittkower 1964, pp. 11–15; *Feste e apparati* 1969, pp. 11–14; Gareffi 1991, pp. 243–302.
32. On Cosimo's funerary rites, modeled on those of Michelangelo, see Borsook 1969–70b; Strocchia 1992; Bertelli 1990; and *La morte e la gloria* 1999.
33. For example, in 1612 the academician Ottaviano de' Medici, inspired by a lesson on the distinction between "allegory" and "metaphor" at the Accademia Fiorentina, created the iconographic scheme for the exequies of Margaret, queen of Spain.
34. On this episode see Boorsook 1969–70; and Testaverde 1979; on the custom of recycling materials see Mamone 1992; on urban decorative apparatus in general see Testaverde 1979.
35. On Christine of Lorraine's theatrical and musical commissions see Kirkendale 1993, ch.4.
36. For the tradition of "calcio" (soccer) see Bredekamp 1993.
37. For example, *La genealogia degli Dei gentili* organized by the academicians Girolamo Macchietti, Mirabello Cavalori, Alessandro Allori, and Pompilio Lancia; and the *Canto dei Sogni*,

considered to be the work of Prince Francesco and his favorite artists; on the *Genealogia degli Dei* see *Mostra di disegni vasariani* 1966; for the *Canto dei Sogni* see Dezzi Bardeschi 1980; and Gandolfo 1971.

38. On the subject of Maria Maddalena's patronage and on her disagreements with her mother-in-law see Harness 1998.

39. "giardino di delizie." For a comparison of the inaugural spectacle for the Villa del Poggio Imperiale (*La liberazione di Ruggero dall'isola di Alcina*, by Ferdinando Saracinelli, 1625) and the Este gardens see Testaverde 2001.

40. For Brunelleschi's engineering activity during the first thirty years of the fifteenth century, see Zorzi 1977.

41. On the courtyard's evolution into a theater see *Il luogo teatrale a Firenze* 1975, pp. 81–82 and the illuminating comments by Zorzi 1977.

42. These artists were asked to organize scenic perspectives for comedies. According to some theories these were *La Mandragola* by Machiavelli, il *Falargo* by Lorenzo di Filippo Strozzi, and, also by Strozzi, *La Pisana*. See Gareffi 1991, ch.4–5.

43. "vinse se stesso, sempre migliorando e variando." Vasari–Milanesi 1878–85, vol. 6, p. 441.

44. A description of the stage device realized by Sangallo is in Vasari–Milanesi 1878–85, vol. 6, p. 442. On Sangallo's scheme and on his expertise of stage techniques, see Zorzi 1977, p. 26; on the subject of the *intermezzi* see Minor and Mitchell 1968; and Pirrotta and Povoledo 1975, pp. 173–87.

45. On Vasari's projects for buildings or rooms destined to be theaters see Scocchera 1995 (for the theater of the Sempiterni in Venice) and Simoncini 2001 (for the theater of the Fraternità dei Laici in Arezzo). On rooms adapted into theaters during that period see Starn-Partridge 1992.

46. For the 1565 *intermezzi* see Pirrotta and Povoledo 1975, pp. 200–13; and Katritzky 1999.

47. "ad uso di teatro antico." Testaverde 1992.

48. "palchi and stanze, scale, con tante comodità." Mellini 1565, p. 10.

49. "cielo a uso di mezza botte con cortine di legname, tutto coperto di tele, e dipinto con aria piena di nuvole, che girava in tondo, secondo che faceva tutta la Scena." Mellini 1565, p. 10.

50. "Bernardo Timante Pittor capriccioso, and in non poca gratia dell'Illustrissimo Signor Principe"; "tirari del cielo"; "uscite di sotto 'l palco." Mellini 1565.

51. On Buontalenti see Fara 1995 and related bibliography.

52. On the 1600 banquet see Mamone 1987.

53. For the musicians who worked on the *intermezzi* for this presentation, see Kirkendale 1995, pp. 49–52.

54. For this theory see Testaverde 2001; on the relationship between Francesco de' Medici, Bianca Cappello, Giovanni de' Bardi, and the spectacular culture of Ferrara, see Newcombe 1980; and Chater 1985.

55. "uno anfiteatro perfetto." Rossi 1589, p. 16.

56. On the decorations for the 1589 festivities see Fenlon 1988; and Testaverde 1992.

57. For the construction of the Uffizi Theater see Testaverde 1991; and Saslow 1996.

58. For the preparation of the text for the comedy, which was adapted to the royal occasion, see Testaverde 1979; and Testaverde 1996.

59. On the philosophical and musical significance of the 1589 *intermezzi* see Newman 1986; Morel 1990; Morel 1991b; La Via 1993; and Ketterer 1999.

60. See Barozzi 1583.

61. See Palisca 1993.

62. The space had, in fact, already been transformed into a site for exhibitions and spectacles on the occasion of the 1579 celebrations for the marriage of Francesco de' Medici to Bianca Cappello, which included a spectacular *barriera* divided into different choreographed sections – joust, allegorical parade, and mythological representation.

63. The *naumachia* was, however, the centerpiece of the 1548 festivities in Lyons for the entrance of Catherine de' Medici and Henry II; see Sceve 1997, pp. 121–25; on the technical preparation of the stage in the courtyard of the Palazzo Pitti see Testaverde 1991.

64. On these spectacles and on the entertainment policy of Maria de' Medici, see Mamone 1987.

65. "matematica, disegno, architettura militare e civile." On Parigi see Baldinucci 1681, vol. 4, p. 123; Blumenthal 1980, p. 33; and Lamberini 1990.

66. On this spectacle, staged for the marriage of Catherine de' Medici to Ferdinando Gonzaga, see Portioli 1882, Nagler 1964, pp. 131–33; and Weaver, pp. 100–1.

NOTE TO READERS

The following catalog is organized by media (paintings, sculptures, decorative arts, works on paper), then alphabetically by the artist's last name, or, if no artist is known, then chronologically by the date (or approximate date) of the work of art. Measurements are given in centimeters; height precedes width, which precedes depth unless otherwise noted.

CONTRIBUTORS TO THE CATALOG

AUTHOR	INTIALS
Phillip Attwood	P. A.
Alessandra Baroni Vannucci	A. B. V.
Monica Bietti	M. B.
Giorgio Bonsanti	G. B.
Antonia Boström	A. B.
Suzanne B. Butters	S. B. B.
Miles L. Chappell	M. L. C.
Marco Chiarini	M. C.
Michael W. Cole	M. W. C.
Lucilla Conigliello	L. C.
Philippe Costamagna	Ph. C.
Janet Cox-Rearick	J. C.-R.
Alan P. Darr	A. P. D.
Charles Davis	C. D.
Maria Cecilia Fabbri	M. C. F.
Larry J. Feinberg	L. J. F.
Cristina Giannini	C. G.
Alessandra Giannotti	A. G.
Annamaria Giusti	A. M. G.
Florian Härb	F. H.
Paul Joannides	P. J.
Meg Koster	M. K
Martha McCrory	M. M.
Lucia Meoni	L. M.
Catherine Monbeig Goguel	C. M. G.
Peta Motture	P. M.
Jonathan Katz Nelson	J. K. N.
Roberta Orsi Landini	R. O. L.
Donatella Pegazzano	D. P.
Claudio Pizzorusso	C. P.
Mario Scalini	M. S.
Eike Schmidt	E. D. S.
Anna Maria Testaverde	A. M. T.
Susan Tipton	S. T.
Louis Alexander Waldman	L. A. W.
Roger B. Ward	R. B. W
Ian Wardropper	I. W.

CATALOG OF THE EXHIBITION

following pages Detail of cat. no. 5.

Paintings

1

ALESSANDRO ALLORI
Florence, 1535–1607

The Virgin Crowned by the Infant Christ
ca. 1590
oil on canvas
133 × 94 cm

Florence, Palazzo Pitti, Galleria Palatina

FLORENCE ONLY

This painting is one of the best – and undoubtedly the most widely known – versions of this particular subject, which was clearly popular with patrons, as is indicated by the existence of a number of copies in a range of formats and with slight variations, executed by Alessandro Allori at various dates (for a list of these copies see Lecchini Giovannoni 1991, pp. 286–88).

The traditional theme of the *Virgin and Child*, represented here in the mouth of a cave on the right of the landscape, is enriched with the symbolism favored by the Counter-Reformation: the two crowns, one of thorns and the other of flowers, that mother and son playfully exchange foreshadow Christ's Passion on the cross and the Assumption of the Virgin to heaven. These allusions, however, do not detract from the serene, intimate tone of the image note the laundry basket in the foreground – apparently focused on the affection between the two figures.

The "affecting" lyricism so well expressed by Allori was, according to Gregori (in *Mostra del Cigoli* 1959, cat. no. 104) the inspiration for Cigoli's painting of the *Virgin Teaching the Child to Read* of around 1595 (Florence, Pitti Museum). Withfield (1982, p. 5) has suggested that a panel exhibited in 1982 in London at Colnaghi's, signed by Allori and much smaller than the Pitti canvas (100.3 × 76.8 cm), might be a prototype for the *Virgin Crowned by the Infant Child*, a theory later supported by Lecchini Giovannoni (1991,

1

p. 287, n. 145). On the back of the panel a pen inscription "details various sums due in the form of an account, headed by the date 1586." Even accepting that the date 1586 truly corresponds to the execution of the Colnaghi painting, to which Whitfield attributes the invention of the theme, the Pitti example represents a version certainly as important and of equal quality, executed by Allori

for the Medici court around 1590 (Chiarini 2001, p. 36) or 1592 (Ciardi 1985, vol. 2, p. 647).

The recent restoration of the Pitti canvas has brought to light the confident and accurate execution of the landscape details and the Virgin's dress, as well as revealing similarities between her features and simple hairstyle and those of the young woman busy at her daily chores in the frescoes for the vault

of the Loggetta in the Pitti, commissioned by Ferdinando I de' Medici and decorated in 1588 under Allori's supervision (for the dating see Bellesi 1998). In view of the quality of the painting and the originality of the theme, it is reasonable to suggest that the present work was linked to the patronage of Ferdinando's wife, Christine of Lorraine, for whom Allori worked on at least two other

occasions: in 1589 he created the pictorial decorations – now lost – for her private chapel on the first floor of Palazzo Pitti; and in 1596 he signed and dated for her an altar panel with the *Vision of St. Giacinto* for the church of Santa Maria Novella.

M. C. F.

2

ALESSANDRO ALLORI
Florence, 1535–1607

St. Jerome in the Wilderness
1577–78
oil on copper
22.5 × 16.5 cm

New York, Private Collection

This small copper plate with a curved top is a very recent discovery by Lecchini Giovannoni, who has published it, correctly, as a work by Alessandro Allori, within the context of a wider study dedicated to some previously unknown paintings linked with Ferdinando I and Christine of Lorraine (Lecchini Giovannoni 2001). The scholar has suggested dating the *St. Jerome* to the late 1570s, around the time of Allori's series of frescoes made in 1577 for the vault of the Gaddi Chapel in Santa Maria Novella, which also features this subject.

The small painting, related to other small-format works by Allori also featuring the subject of solitude and contemplation (see *Santa Maria Maddalena*, Bergamo, Private Collection; *San Giovanni Battista*, New York, Private Collection), represents the penitent saint with his traditional lion, beating his breast with a stone in front of a vision of the crucifix. Beyond the wilderness in the background can be glimpsed a landscape. In its vigorous, energetic depiction of the anatomy of the saint, this scene is clearly an homage to Bandinelli's treatment of human anatomy, influenced in turn by Michelangelo. This approach is adopted in further studies of the same theme by Allori, also in small-format paintings, executed

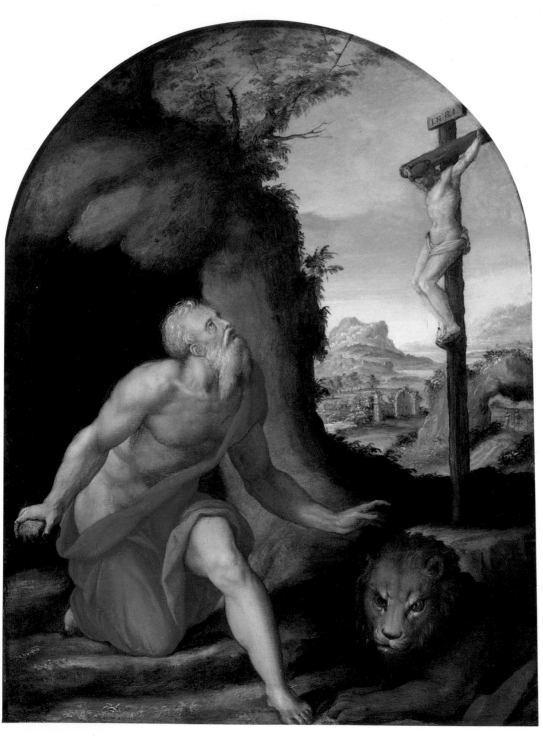

2

in the following years (*St. Jerome*, New York, Private Collection, dated 1594; *St. Jerome*, Princeton University Art Museum, dated 1606, for which see Lecchini Giovannoni 2001, figs. 7 and 8). Another important aspect of this painting is the vegetation covering the cave and in the landscape background, realized with a meticulous observation typical of the Flemish landscapes that Allori studied from the early 1570s in examples by Giovanni Stradano.

M. C. F.

that rises from the hollow of a blasted tree stump, symbolizing spiritual renewal or rebirth. She has apparently just averted her attention to the sculpture from the book in her lap, open to the words, "Blessed are those whose sins have been remitted" – part of the first line of Psalm 31.[2] This is one of the penitential psalms and the sentence concludes "and whose sins are covered."[3] Paul quotes this psalm in his letter to the Romans (4, 7).

1. In addition to references cited within the text, see Cantelli 1974, vol. 2, p. 64; and *Il Seicento fiorentino* 1986, vol. 3, p. 85.
2. "Beati quorum remissae sunt iniquitates."
3. "et quorum tecta sunt peccata."

L. J. F.

3

ALESSANDRO ALLORI
Florence, 1535–1607

Penitent Magdalene[1]
ca. 1601–02
oil on canvas
193 × 155 cm

Florence, Museo Stibbert

Recently cleaned, the *Penitent Magdalene* is one of Allori's most compelling late-works. As Lecchini Giovannoni (1991, p. 293) has observed, the painter departed from traditional depictions of the Penitent Magdalene, which present her in a cave and covered only by her long hair, to create a more sympathetic and visually rich image. In light of the fact that the picture entered the grand-ducal Guardaroba in May of 1602, it is likely that Allori created the work with Medici tastes in mind; the birds and plants are rendered in a careful, almost scientific, manner, and there is an extensive, Flemish-inspired landscape – features that would have been well appreciated by Ferdinando I.

Despite these details and embellishments, the painting has a compositional simplicity that is typical of Allori's late paintings, in which his Bronzinesque style is tempered in response to the austere, Counter-Reformation pictures of Santi di Tito and others. The Magdalene kneels reverently before a polychromed wood sculpture of the *Crucifixion*

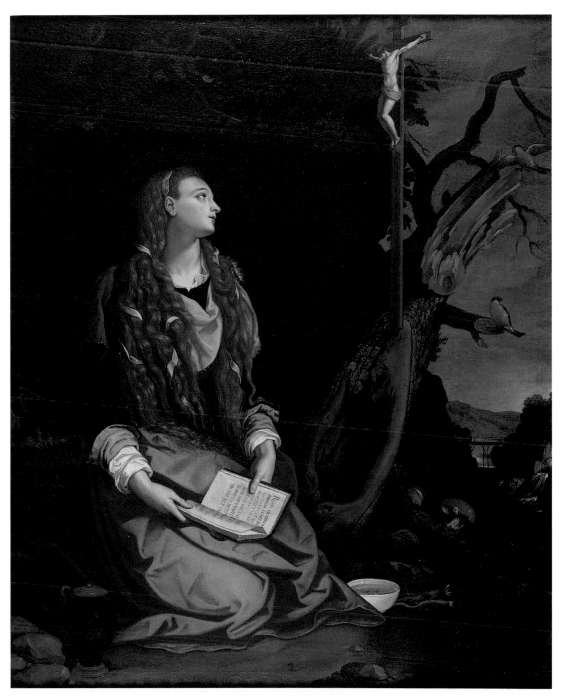

3

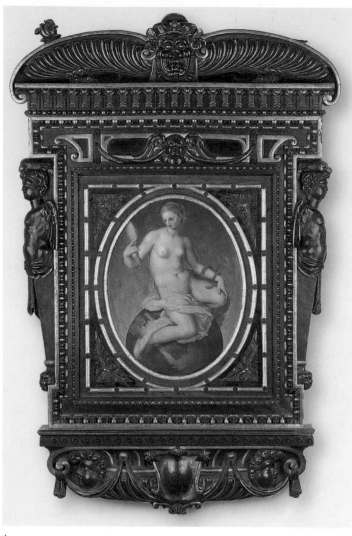

4

4

ALESSANDRO ALLORI
(attributed to)
Florence, 1535–1607

Allegory of Prudence
ca. 1567–70
oil on canvas
35 × 24 cm

Soprintendenza per i Beni
A.A.A.S. di Arezzo/Fraternità dei
Laici di Arezzo

The subject of a long,
controversial debate about its
attribution, the *Allegory of
Prudence* in the Casa Vasari,
painted in an oval on the
removable cover of a
sumptuously framed mirror, has
been variously attributed to
Vasari, Gherardi, Coppi, and
Bizzelli, and most recently to
the old Bronzino or the young

Alessandro Allori. This last
theory was suggested with some
caution by Antonio Paolucci
(in Paolucci and Maetzke 1988,
pp. 142–43), who assessed the
painting after a light cleaning,
basing his observations on the
fine quality of the painting and
on the refined modeling of the
small, mother-of-pearl-colored,
nude figure sitting on a globe,
with all the traditional attributes
of the cardinal virtue of
prudence: a mirror with which
she looks behind her, a double
face, and a serpent wrapped
around her right arm.

Defining the painting as
representing "a particularly fine
moment of Alessandro Allori,"[1]
Paolucci compared it to the
stylistically similar *Gathering of
Pearls* executed by Allori in 1571
for the Studiolo of Francesco I
de' Medici. According to Cecchi
(1987), however, the *Prudence*

can be linked to a group of
paintings cited by Vasari at the
end of his *Life* of Bronzino, and
executed by the elderly artist as
a commission from the Pistoiese
notary, Carlo Gherardi: among
these is mentioned "a *Prudence*
who looks in the mirror,"[2]
painted on the cover of a *Judith
with the Head of Holofernes*, also
by Bronzino. This attribution is,
according to Cecchi, supported
by comparison with late works
by Bronzino, especially the
Allegory of Happiness of 1567
now in the Uffizi, in which the
elongated and lithe bodies of the
figures are similar to the nude
exhibited here, particularly in
their physiognomy. Cecchi's
theory, which Paolucci himself
credits as a valid alternative to
his own suggestion, is supported
by Lecchini Giovannoni, who
has not included this work in
her catalog of Alessandro Allori
(Lecchini Giovannoni 1991).

In view of the small
dimensions of the painting and
the absence of any documentary
evidence, it is my opinion that
this difficult question ought to
be "prudently" left open. It is
possible that when the frame
was partially remade between
the sixteenth and seventeenth
centuries (according to
M. Trionfi Honorati, cited by
M. Collareta in *Palazzo Vecchio*
1980, pp. 288–89, n. 571),
Bronzino's *Judith*, mentioned by
Vasari, was lost and replaced
with a mirror. However, the
Prudence shown in the act of
looking in a mirror
is symbolically related to the
function of the object it covers.
If the present painting is an
early work by Allori, it
represents a strict adherence to
the style of his elderly master,
whose manner of painting was
well suited to the refined
elements of the mirror.

1. "un momento particolarmente
felice di Alessandro Allori."
2. "una *Prudenza* che si specchia."

M. C. F.

5

CRISTOFANO ALLORI
Florence, 1577–1621

Judith and Holofernes[1]
ca. 1616–18
oil on canvas
139 × 116 cm

Florence, Palazzo Pitti, Galleria
Palatina

CHICAGO AND DETROIT ONLY

Baroque painting in the period
of the later Medici has been
significantly reappraised as a
singular development combining
Florentine tradition with a new
concern for drama and
persuasion. Cristofano Allori's
sublime, elegant *Judith* has
become an almost canonical
example of the style. Painters
of the time shared goals with
composers of the Florentine
Camerata – Bardi, Corsi, Peri,
and Caccini – whose new
operas and songs in the *stile
rappresentativo* sought clear
expression of drama and lyricism
in the melodic line (Chappell
1998). Allori's new style in this
image, combined with the overt
yet eloquent autobiographical
statement made by the portraits
of his beloved, la Mazzafirra, for
the heroine and himself for the
vanquished general, contributed
to its great fame as did its
celebration in poetry by Ottavio
Rinuccini in 1616 and
Giovanbattista Marino in 1619
(Pizzorusso 1982, pp. 46–51,
70–73, 128–29).

Almost immediately the
demand arose for replicas, of
which there are four types with
slight variations, and for copies
by other artists (Chappell 1984,
pp. 78–81, no. 25; p. 120). Versions
are recorded early in the history
of many Florentine collections
and in Rome, Venice, Spain, and
Paris. Although the composition,
dating as early as 1610, is seen
with an individualized model
in the painting of 1613 in the
Queen's Collection at Hampton
Court (Shearman 1979), the
most prevalent rendering shows
the elegant heroine seen here.
Around 1616, while already
suffering the illness that

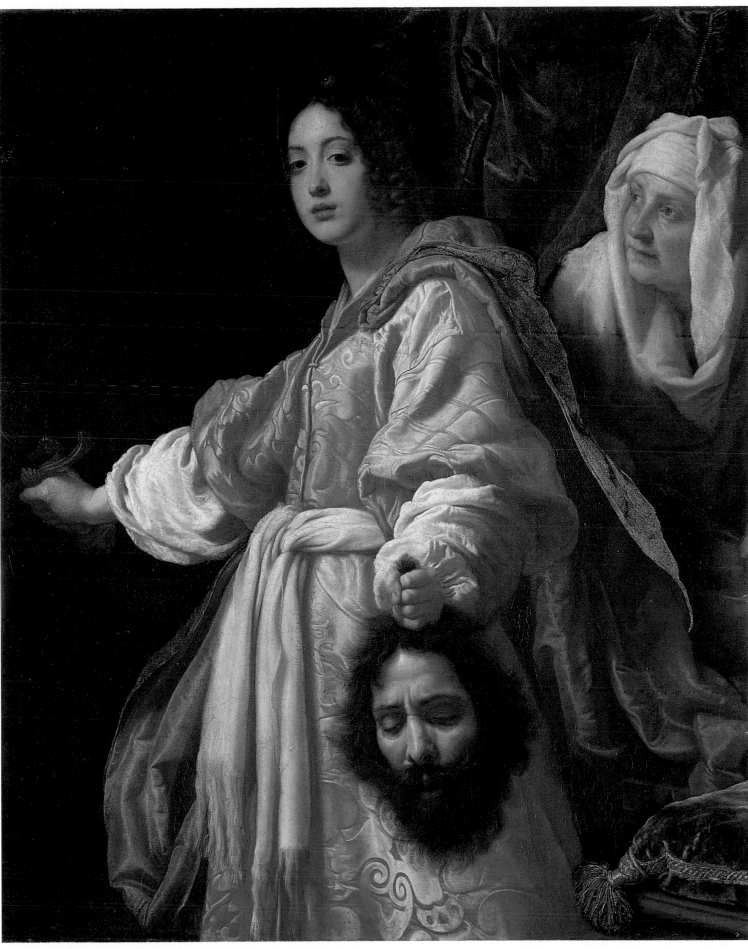

6

1. In addition to references cited within the text, see Shearman 1983, no. 2; and C. Pizzorusso in *Il Seicento fiorentino* 1986, pp. 189–91, no. 1.72.

M. L. C.

6

CRISTOFANO ALLORI
Florence, 1577–1621

Maria Maddalena of Austria[1]
1608–09
oil on canvas
65 × 50.5 cm

Florence, Palazzo Pitti, Galleria Palatina

In the large historical scene painted by Justus Sustermans before 1626 (Florence, Uffizi Gallery), *The Senators of Florence Swearing Allegiance to Ferdinando II and to the Regents Christine of Lorraine and Maria Maddalena of Austria on 11 March 1621*, the heroic, Michelangelesque personifications of Florence and the Arno that glorify the action disguise the reality of the ten-year-old prince's proud, formidable regents, whose true legacy was, in the end, so damaging to the Grand Duchy (L. Goldenberg Stoppato 1986, pp. 315–16). In contrast, Allori's likeness presents a younger Maria Maddalena of Austria and evokes a less well-known aspect of her personality. The portrait has been identified by Chiarini (1999) as a pendant to *Cosimo II* (cat. no. 7) and attributed to Cristofano Allori as a work painted between Maria Maddalena's marriage in 1608 and her becoming grand duchess in early 1609.

In showing the half-length figure in rich dress and jewels and with a collar framing the face, Allori adopts a popular format in late Medici court portraiture well seen in the "Bellezze di Artimino" series of the early 1600s (Florence, Uffizi Gallery). But where these likenesses of court beauties show a repetitive, almost formulaic design, Allori's portrait is distinguished by its individual characterization of the young

woman as attractive, pensive, and sympathetic. She was charming, lively, robust, and healthy and took much pleasure as grand duchess in court life, festivals, theatricals, as well as in events and hunts in the country. She was very proud of her lineage as the daughter of Archduke Charles of Austria and sister of Emperor Ferdinand II (Micheletti 1983, pp. 188–202). Dedicated to her faith and devoted to relics (Tarchi 1989), her piety would verge toward bigotry in later years, and came to the fore after Cosimo II's death in 1621, when she and her mother-in-law, Christine of Lorraine, were named as regents for the young Ferdinando II. This "regno delle tutrici" or period of the Regents marked a new chapter in Florence's history in which, as Hale (1977, p. 177) observed, the double regency was to interfere with Tuscan affairs of state and virtually emasculate the young Grand Duke for much of his career.

Far more positive was Maria Maddalena's artistic patronage, which left a strong impression on Florence. She apparently had a preference for works by Cigoli and his circle, such as his ill-fated *Assumption* (1612) and its companion, Passignano's *Pentecost*, for her chapel in the Palazzo Pitti (both lost; Chappell 1992, p. 196), Allori's many portraits and his *Judith* (cat. no. 5), and Bilivert's *Death of Cleopatra* (Florence, Gallerie Fiorentine; Contini 1985, pp. 75, 97). Notable are the numerous portraits of her and her family by Justus Sustermans, who once painted her as Mary Magdalen (Florence, Uffizi Gallery; C. Pizzorusso in *Sustermans* 1983, p. 35, no. 14). Her principal artistic projects were the Chapel of Relics in the Palazzo Pitti, designed by Giulio Parigi in 1610 and decorated by Poccetti, Bilivert, Tarchiani, Boschi, Rosselli, Cinganelli, and others from 1612 onward (Chiarini 2000), and the renovation of Santa Elisabetta delle Convertite in 1624. Her greatest legacy was a villa acquired in 1622 that was rebuilt by Parigi and decorated

would delay many of his last commissions, Allori was making versions of the painting for Cardinal Alessandro Orsini and perhaps for Carlo Davanzati and the Gonzaga in Mantua. One version was commissioned by the Medici Guardaroba for the Count of Villamediana (Pizzorusso 1982) and another was finished in 1618, as Maria Maddalena of Austria reported to Cosimo II (Tarchi 1989). The present painting is possibly this documented work which was not, however, consigned to the Medici until Allori's death in 1621. Because of its prestigious location in the collections first of Cardinal Carlo de' Medici and then of Grand Duke Ferdinando II in the seventeenth century, this painting – distinguished by the missing strap across the bodice and by the plain white sash rather than the striped one seen in other versions – served as the model for many early copies. (The practice continued in the nineteenth century when it was,

as documents show, one of the most replicated paintings by students and professional copyists in the Uffizi Gallery.)

The *Judith* attests to the great patronage Allori enjoyed from Cosimo II and Maria Maddalena of Austria – whose youthful portraits (cat. nos. 6, 7) he also painted – and, as already seen, to the new tendencies in Florentine painting. It indicates that Allori was one of few to transcend the artistic isolationism ascribed by many writers to Tuscan painters of this period. His response to Caravaggio's idiom was profound and influential: in Rome in 1610, he was apparently among the first to respond to the *David with the Head of Goliath* (Rome, Galleria Borghese), appropriating Caravaggio's composition and self-referential conceit for the *Judith*. It was, however, his distinctive synthesis of Caravaggesque light and Tuscan "shading" that left the most enduring legacy for Florentine Baroque painting.

by Rosselli (Panichi 1975, pp. 14–22). Calling it the Villa del Poggio Imperiale in honor of her origins, Maria Maddalena designated it in perpetuity as a retreat for the grand duchesses of Tuscany.

1. In addition to references cited within the text, see *Die Pracht der Medici* 1998, p. 127, no. 60.

M. L. C.

7

Cristofano Allori
Florence, 1577–1621

Cosimo II de' Medici[1]
1608–09
oil on canvas
66 × 55 cm

Florence, Palazzo Pitti, Galleria Palatina

The portrait of Cosimo II de' Medici as a young prince was proposed as a pendant to that of his wife (cat. no. 6), and both have been attributed by Chiarini (1999) to Cristofano Allori as works dating between Cosimo's marriage in 1608 and his becoming Grand Duke on the death of his father, Ferdinando, on 7 February 1609. Historians trace a bleak profile of Cosimo II as a weak ruler, sick from tuberculosis, dominated by his mother and wife with their religious bigotry and often conflicting political ambitions, and, thus, a protagonist in the decline of the Medici and of Florence's economic and political fortunes. In contrast, this early portrait conveys the great expectations for the future Grand Duke, expressed in 1610 by Galileo, who described him as having qualities of clemency, kindness of heart, gentleness of manner, splendor of royal blood, nobility in public affairs, and excellence of authority and rule (Galileo 1957, pp. 24–25).

Although many historians credit Cosimo with little culture, his contribution to Florence's intellectual and artistic life during a reign of barely twelve years was considerable and suggests that, as a patron of the

arts and letters, he warrants new study. His life was framed by art, from the ceremony of his baptism to the pageants for his marriage, conceived on a scale unseen in Florence (the statues on the Ponte Trinita are a lasting memorial), to his funeral, at which he was celebrated by Pietro Accolti for the "rebirth of learning" in Tuscany. In 1610, Cosimo proclaimed Galileo "matematico soprastraordinario" at the University of Pisa and "Mathematician extraordinary to the Grand Duke, without obligation to instruct or to reside at Pisa";[2] he sponsored theatrical spectacles, ballets, tournaments, and festivals; he patronized the composers Peri and Frescobaldi; and he was close to the poets Chiabrera and Michelangelo Buonarroti il Giovane. To the latter, who was dedicated to commemorating his great ancestor in the Buonarroti Palace, Cosimo donated in 1616 Michelangelo's *Madonna of the Stairs* (Florence, Casa Buonarroti). Cosimo sought works by leading contemporary artists, among them the sculptors Orazio Mochi and Pietro Tacca and the painters Cigoli, his disciples Allori and Bilivert, and Matteo Rosselli, who redecorated the Casino di San Marco. He sought works by foreigners such as Gerard van Honthorst and Adam Elsheimer, and his sponsorship of Jacques Callot launched the French printmaker's career. Delighting in architecture, he employed Matteo Nigetti and Giulio Parigi to enlarge the Palazzo Pitti, and he completed the expansion of the port of Livorno.

Dedicating himself to the Medici art collection and its display in the Palazzo Pitti, Cosimo created a collection of small-scale paintings on stone and other materials in the Galleria delle Colonne, by artists such as Filippo Napoletano (see cat. no. 30) and Cornelis van Poelenburgh. He transformed the central loggia of his apartment into the "bella galleria" described by the courtier Cesare Tinghi in his *Diario* (entry for 21 September

7

1620) as adorned with classical busts and statues and with pictures by famous painters such as Leonardo, Raphael, Titian, del Sarto, and leading contemporaries, among them Cigoli and Allori (this later became the Gallery of the Statues).[3]

Florence continued to flourish artistically under Cosimo II, who was highly regarded by both his subjects and protégés. Gratitude and protocol were joined, no doubt, by sincerity in the dedication to him of works by, among others, Buonarroti il Giovane; Callot, in his famous print *The Fair at Impruneta* (1620); and Galileo in the *Sidereus Nuncius* or *Starry Messenger* (1610) mentioned above. In its dedication, Galileo named Jupiter's four moons, which he had just discovered with the telescope, in honor of his patron, "le Stelle Medicee" – the Medicean Stars.

1. In addition to references cited within the text, see E. Fasano Guarini in *Dizionario biografico degli italiani* 1984, vol. 30, pp. 48–54; and *Die Pracht der Medici* 1998, p. 126, no. 59.
2. "Filosofo del serenissimo Granduca senza obbligo di leggere e di risiedere né nello Studio né nella città di Pisa." Dorini 1982, pp. 477–84.
3. On the gallery and Tinghi's *Diario*, see Mosco 1983, pp. 31–32; and Chiarini 2000.

M. L. C.

8

AGNOLO BRONZINO
(and workshop)
Florence, 1503–1572

*Eleonora of Toledo and Her Son
Giovanni*
after 1545
oil on panel
121 × 100 cm

The Detroit Institute of Arts
Gift of Mrs. Ralph Harman
Booth in memory of her
husband Ralph Harman Booth

CHICAGO AND DETROIT ONLY

In the summer of 1545 Duke
Cosimo I de' Medici's court
painter, Bronzino, portrayed the
Duke's wife Duchess Eleonora
of Toledo with her second
son, Giovanni, born in 1543
(Langedijk 1981–87, no. 35, 10;
Cox-Rearick 1993, p. 37;
Langdon 1994, pp. 196–260).
This portrait is mentioned in
contemporary letters and by
Vasari in his *Life* of Bronzino:
"And no long time passed [after
the *Cosimo in Armor* and a
portrait of the Duchess alone]
before he portrayed the same
Lady Duchess once again, to
do her pleasure, in a different
manner from the first, with the
Lord Don Giovanni, her son,
beside her."[1] The work, the
largest and most important of
Bronzino's portraits of Eleonora,
is the companion piece to his
portrait of the Duke.

Cosimo in Armor and *Eleonora
with Her Son Giovanni* are state
portraits and exemplary images.
In the Cosimo portrait the
Medici symbol of the tree stump
with sprouting laurel suggests
that it is through him that the
Medici house is renewed. In
the Eleonora portrait Bronzino
created the Medici dynastic
portrait, showing the Duchess
as the regal bearer of sons who
would continue Cosimo's
principate into succeeding
generations. Eleonora's
personality is suppressed in favor
of a relentless concentration on
the essentials of the power
image, of which an important
element is her expensive attire.
She is rigidly imprisoned in

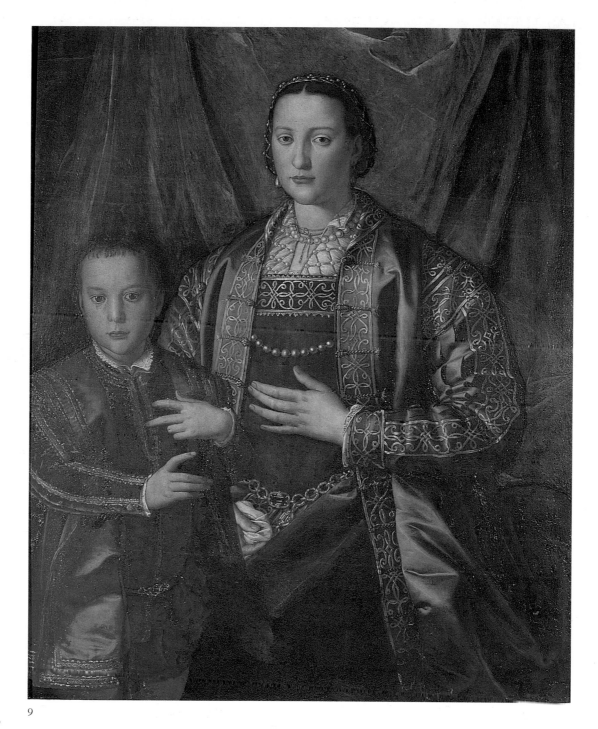

9

her remarkable dress, with its
arabesques of black velvet and
gold pomegranates standing
out against the white satin
background, which seems as
much the subject of the painting
as the Duchess herself. Her rich
accessories feature her favorite
pearls: earrings; a long, double-
looped necklace; a gold-and-
pearl netted snood and partlet
that fills in the bodice of her
dress; and a jeweled girdle
ending in a large tassel of
seed pearls.

Bronzino's portrait remained
the standard image of Eleonora,
regardless of two later ones he
painted of her (see cat. no. 9).
Just as *Cosimo in Armor*, the
official image of the Duke, was
replicated whenever a new
likeness was needed, so *Eleonora
and Giovanni* was copied in
Bronzino's workshop. Already
classed as a copy (Langedijk
1981–87, no. 35, 9), the Detroit
version has been analyzed as
a collaborative production by
Bronzino and his assistants (Urry

1998). The figures were painted
from the original cartoon but on
a larger panel than the Uffizi
original (115 × 96 cm), so that
there is more space to the left
side, and more of Eleonora's
dress is shown at the bottom.
Moreover, some of the colors
are different, suggesting that it
was conceived as a less expensive
version of the original: the
costly ultramarine blue of
the background in the Uffizi
painting is gray–brown and
Giovanni's violet costume is

brown. There are also technical indications that it was painted by more than one hand – piecework fabrication, as it were, with numerous errors in copying. However, the most important parts of the portrait (the head, the upper part of the bodice including the pearls, and the hands) are superior in handling and have a luminosity and enamel-like finish characteristic of Bronzino's own technique.

1. "E non andò molto che ritrasse, sì come piacque a lei, un'altra volta la detta signora duchessa, in vario modo dal primo, col signor don Giovanni suo figliuolo appresso." Vasari 1568, vol. 7, p. 598. English translation, de Vere 1912, vol. 10, pp. 6–7.

J. C.-R.

9

AGNOLO BRONZINO
(and workshop)
Florence, 1503–1572

Eleonora of Toledo and Her Son Francesco
ca. 1549
oil on panel
116 × 94 cm

Pisa, Museo Nazionale di Palazzo Reale

FLORENCE ONLY

Following the success of his state portrait of Duke Cosimo I de' Medici's consort, Eleonora of Toledo, and her son Giovanni, Bronzino produced another dynastic portrait of her with the Medici heir, Francesco, in 1549. The most important version of this portrait is this one in Pisa, which is often held to be Bronzino's original (Langedijk 1981–87, no. 35, 12; Simon, 1982, p. 76) but may have involved workshop participation (Cecchi 1998a, p. 128).

A confusion about the identity of the children portrayed with Eleonora in the portraits now known as *Eleonora and Giovanni* and *Eleonora and*

Francesco can be resolved by descriptions of these works in inventories of art owned by Duke Cosimo and stored in the Palazzo Vecchio, which are valuable sources for details of the Duke's patronage of his court artists. *Eleonora and Francesco* is listed in an inventory of 1553 as measuring 2 *braccia* (about 114 cm) in height, corresponding with the height of the Pisa painting: "A portrait of the Lady Duchess and Lord Don Francesco by Bronzino . . . measuring 2 *braccia*."[1] In an inventory of 1560 both portraits are listed on the same page, eliminating any possibility of confusion: "A portrait of the Illustrious Lady Duchess by Bronzino, with the Lord Don Giovanni when he was a child . . . a portrait of the same person by the same artist, with the Prince [Francesco] when he was a child."[2]

Having had four pregnancies since Bronzino portrayed her in 1545, Eleonora is heavier and more mature in appearance. She wears a sumptuous outfit consisting of a dark violet satin gown and overgown, both embroidered in gold, but her jewels are similar to those of the earlier portrait. With a gesture of her left hand she subtly indicates Francesco, who is dressed as an adult in a doublet, paned trunk hose, and cassock of red satin embroidered in gold. Born in 1541, he appears to be about eight years old, which would establish a date of ca. 1549 for the portrait. He stands forward of his mother, gesticulating to her with his right hand and echoing her gesture towards himself with his left, as though explaining the dynastic significance of their relationship.

Like the earlier *Eleonora and Giovanni*, in the 1550s *Eleonora and Francesco* became a prototype for the Duchess's image. It was replicated a number of times: one version was seen most recently on the Paris art market and another is in the Cincinnati Art Museum (extensively damaged and repainted). Bust-length images of Eleonora alone were also extracted from

10

the composition, such as two oval ones by Vasari in the historical frescoes in the Apartment of Leo X de' Medici in the Palazzo Vecchio (1559–60).

1. "Uno ritratto della S.ra Duchessa et il S.or Don Francesco, di mano del Bronzino . . . di braccia 2." Florence, State Archives, GM 28, f. 28v.
2. "Un ritratto della Ill.ma S.ra Duchessa, di man del Bronzino, dentrovi ritratto il S.or Don Giovanni quando era piccolo . . . Un ritratto della detta, di man del medesimo, entrovi il principe quando era piccolo." Florence, State Archives, GM 45, f. 60r.

J. C.-R.

10

AGNOLO BRONZINO
(workshop)
Florence, 1503–1572

Don Garzia de' Medici
1550
oil on panel
48 × 38 cm

Madrid, Museo del Prado

CHICAGO AND DETROIT ONLY

As court painter to Duke Cosimo I de' Medici and Eleonora of Toledo, Bronzino was charged not only with the execution of portraits of the ducal couple themselves but of their numerous children, two of whom – Giovanni and Francesco – he depicted with their mother in his state portraits of the Duchess of 1545 and 1549 respectively (cat. nos. 8 and 9). In the early 1550s many portraits of the individual children (and in turn studio replicas) were painted by the master and his workshop assistants. This portrait

of Garzia, the couple's blond and blue-eyed third son, born in 1547, is identifiable on the basis of the child's physical resemblance to a documented portrait of him painted by Bronzino in 1551 (Lucca, Pinacoteca). He is dressed in red silk and holds a rattle, recalling the composition of Bronzino's well-known portrait of Giovanni de' Medici of 1545, which shows the two-year-old child also dressed in red and holding a toy (Florence, Galleria degli Uffizi). The Madrid portrait has been attributed to Bronzino himself (Langedijk 1981–87, no. 46, 3; Lecchini Giovannoni 1968, no. 11) and to Allori (Emiliani 1960, p. 71). It seems more likely, however, to be a studio replica by another hand, since the handling of the minutiae of the costume and jewelry is neither Bronzino's nor Allori's.

No suggestions have been made as to the date of the lost original of the Madrid portrait. However, the apparent age of the little boy indicates that it is a version of Bronzino's first portrait of Garzia, painted in July 1550, a year earlier than the Lucca portrait, on the occasion of his lavish baptismal celebration in the Palazzo Vecchio and the ceremony in the Florentine Baptistery. A portrait of Garzia (along with one of Giovanni, also by Bronzino) was sent before the baptism to Pope Julius III as a diplomatic gift. In a letter of 10 June 1550 the Pope informed the ducal couple that he was sending a representative to the baptism and that he had already received the "portrait [of Garzia] painted on a panel."[1]

1. "... il ritratto dipinto in tavola." Florence, State Archives, Pergamene Medicee 90, p. 32r.

J. C.-R.

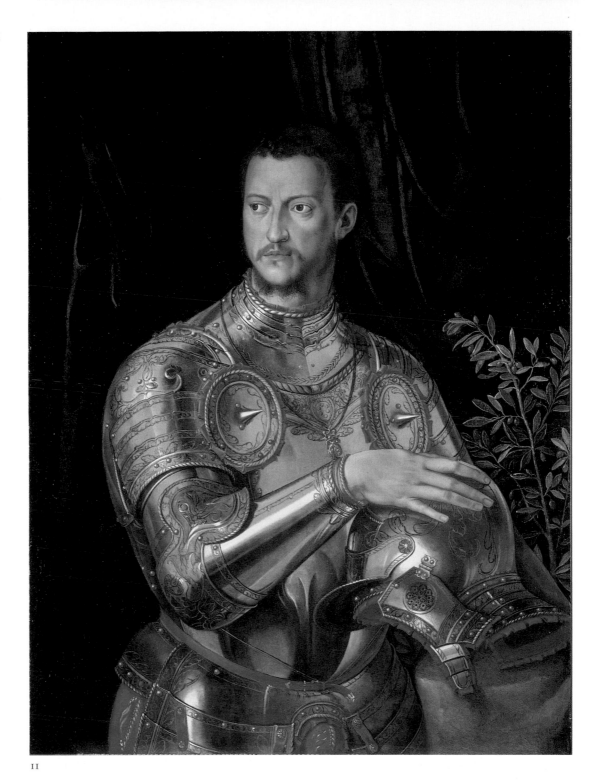

11

11

AGNOLO BRONZINO
(workshop)
Florence, 1503–1572

Duke Cosimo I de' Medici in Armor[1]
after 1545
oil on panel
101 × 77.8 cm

Toledo, Ohio, Toledo Museum of Art, Gift of Edward Drummond Libby in 1913

The young Cosimo I de' Medici, who became duke of Florence in 1537, commissioned Bronzino, his court portraitist, to portray him in an official state portrait in 1543, the year in which he consolidated his power. Vasari mentions it in his life of the artist: "The Lord Duke ... had him paint a portrait of himself when he was a young man, fully clad in bright armor and with one hand on his helmet."[2] A first version of this portrait shows Cosimo bust length, dressed in armor, yet the image is peaceful, not bellicose (Florence, Galleria degli Uffizi, inv. dep. 28). It was followed in 1544 by a three-

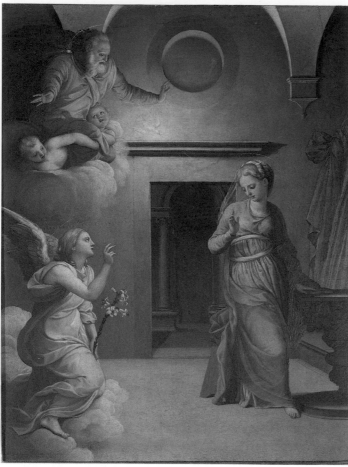

12

1. In addition to references cited within the text, see *The Toledo Museum of Art* 1976, pp. 31–32.
2. "Il signor duca . . . fece ritrarre sè, che allora era giovane, armato tutto d'arme bianche e con una mano sopra l'elmo." Vasari 1568, vol. 7, pp. 597–98. English translation de Vere 1912, vol. 10, p. 6.

J. C.-R.

12

AGNOLO BRONZINO
Florence, 1503–1572

Annunciation
ca. 1540–41
oil on panel
57 × 43.5 cm

Florence, Galleria degli Uffizi, Tribuna

This small devotional panel entered the Medici grand-ducal collections in the seventeenth century (Archivio segreto, Palazzo Pitti, 1773). It was attributed to Giovanni Bizzelli on the basis of Raffaello Borghini's notice (1584, p. 632) of an *Annunciation* painted by the artist for Eleonora di Francesco I de' Medici. The untenable attribution of the painting to Bizzelli persisted for some time (Collareta in *Palazzo Vecchio* 1980, no. 572; Berti 1967, p. 229 and pl. 21, who called it "Bronzinesco"), but the authorship has been recognized (Bellosi 1977, p. 265; Meloni Trkulja in Berti 1979, no. P315; Rizzo 1990; Cecchi 1996, p. 37) and it is now listed by the Uffizi as "attributed to Bronzino."

The change of attribution to Bronzino was in part due to Robert Simon (cited by Meloni Trkulja in Berti 1979), who connected the painting with an engraving published by Hieronymous Cock (inscribed "BRONZINO FLOR./INVEN./COCK EXCUD 1553"), in which the Virgin and the angel are reproduced. The engraving belongs with two others published by Cock in 1553 after works by Bronzino dating ca. 1540–41 – a *Nativity* (after the painting in Budapest, Szépmüvészeti Museum) and

The Crossing of the Red Sea (after a lost drawing for the fresco in the Chapel of Eleonora) – and it clearly derives from a lost preparatory drawing by Bronzino for the Virgin and angel of the Uffizi panel.

The Uffizi *Annunciation* is closely related in style to the paintings in the Chapel of Eleonora, and its light and luminous colors are those of the chapel frescoes (Cecchi 1996). The Virgin, in particular, resembles the delicate little figure of Justice on the vault and the Holy Woman in red in the *Lamentation* altarpiece (Besançon, Musée des Beaux-Arts et d'Archéologie), while God the Father's gesture of widespread arms finds its counterpart in the St. Francis of the vault. But the most striking comparison is with the *Nativity*, a small devotional panel of almost exactly the same size and identical delicacy of handling, in which the Virgin and St. Joseph are closely analogous to the Virgin and God the Father in the Uffizi panel.

The Virgin and angel are strongly reminiscent of the *Annunciation* painted by Bronzino's master, Pontormo, ca. 1527 in the Capponi Chapel, Santa Felicita. Moreover, the upper part of the architectural background, with its fictive *pietra serena* details, recalls the setting of Pontormo's fresco (Collareta in *Palazzo Vecchio* 1980). The *tondo* in the center of the wall in Bronzino's painting also raises a question as to whether Pontormo originally planned a Brunelleschian *oculus* in this location rather than the arched oblong window that was actually installed, and whether his pupil was familiar with this alternative design.

The patron of this beautiful little work is unknown. It is possible that it was painted for Eleonora of Toledo (Cecchi 1996), newly arrived in Florence as the bride of Duke Cosimo I de' Medici in 1539, but there is no evidence that it was a Medici commission.

Bronzino's composition was well known in the late sixteenth century and seems to have

quarter-length version, now in Sydney, which includes a tree stump inscribed with Cosimo's name, sprouting a laurel branch in reference to the Duke's descent from the older branch of the Medici family, one of whose devices was the laurel (Simon 1983). These state portraits remained the official images of the Duke for over a decade and they were frequently replicated by Bronzino's workshop (more than twenty-five examples are known) as the need arose for versions for various purposes, including diplomatic gifts.

The portrait in Toledo is such a replica. It was attributed to Bronzino himself (or partially to him) in the older literature and in the catalog of the museum, but most recent scholars have relegated it to Bronzino's workshop, with an indefinite date after 1545 up to about 1560 (Langedijk 1981–87, no. 27, 35; Simon 1982, cat. A23). It is one of a group of replicas after the composition of the version in

Kassel, Gemäldegalerie, which is about 8 centimeters longer than the Sydney version, showing the top part of the Duke's red codpiece. In these, the inscription on the tree stump is absent, an olive branch, signifying peace, substitutes for the laurel, and the beard of the Duke (now older) is fuller. These changes suggest that this group of replicas may have been painted considerably later than 1545, when the Duke's regime was more securely established and the need to emphasize the theme of Medicean continuity was no longer pressing. As in the Kassel version, the format of the Toledo painting is extended below and to the right so that more of the branch is shown, but its author has also extended the green curtained background to the left and above. The resulting portrait is "more spacious, stately, and openly pacific – if also less dynamic and concentrated" than Bronzino's original (Simon 1982, cat. no. A23).

been the model for the lost "quadretto" by Bizzelli mentioned by Borghini (Rizzo 1990). Also by Bizzelli after Bronzino are a small painting ("tavoletta") in the Convento della Santissima Annunziata, Poppi, and its preparatory study, which was sold Christie's, London, 4 July 1995, lot 301 (Rizzo 1990). Other derivative works (not by Bizzelli) are a tabernacle fresco in Pozzolatico near Florence (with the figures close together as in Cock's engraving and with a similar background), and a later copy on panel with a similar composition (location unknown). The author thanks Robert Simon for these references.

J. C.-R.

13

Agnolo Bronzino
Florence, 1503–1572

Laura Battiferra degli Ammanati[1]
ca. 1561
oil on panel
83 × 90 cm
signed: "BRONZINO"

Comune di Firenze, Palazzo Vecchio, Quartieri Monumentali, Fondazione Charles Loeser

This splendid painting, unique among Bronzino's portraits in showing the sitter in profile, is signed "BRONZINO" in the lower left corner of the panel. It has been attributed to him since the early eighteenth century (Milan, Arese Collection), but the identification of the sitter has been problematic. Because she displays a book open to manuscripts of two sonnets by Petrarch (64, "Se voi poteste per turbati segni," and 240, "L'ho pregato Amor"), it was long thought to be an imaginary portrait of Laura, the poet's beloved, but in the 1920s she was identified as the cultured gentlewoman and poet Laura Battiferra (Urbino, 1523–Florence, 1589). In 1550 Laura married Bartolomeo Ammanati, the sculptor and architect in the service of Duke Cosimo I de'

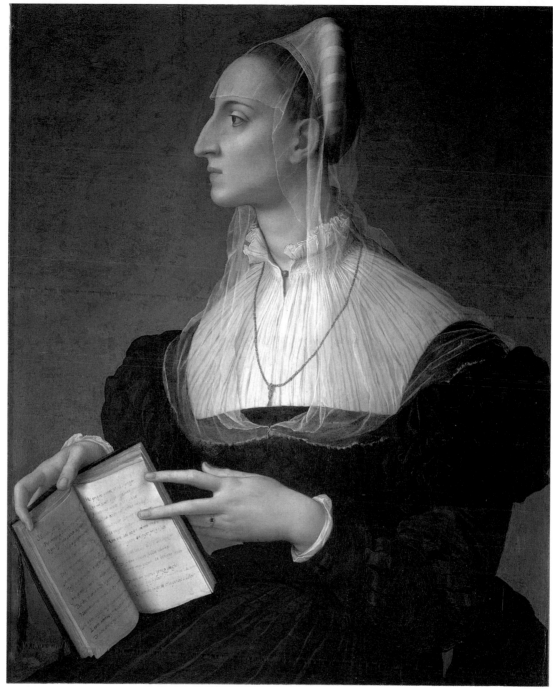

13

Medici, and henceforth signed her name Laura Battiferra degli Ammanati (Kirkham 1998). She became one of an inner circle of court literati, mentored by Benedetto Varchi (leader of the Accademia Fiorentina) and favored by Duchess Eleonora of Toledo, to whom she dedicated her first book of poetry, *Il primo libro delle opere toscane* in 1560 (Kirkham 1996).

Bronzino is known to have painted a portrait of Battiferra; it is mentioned in one of his sonnets, in one of Laura's, and in one by Anton Francesco Grazzini (Plazzotta 1998). Although these poems give no details, scholars agree that the Loeser portrait is this work. The portrait is generally dated 1555–60, but a date of 1561, after the publication of *Il primo libro*, is perhaps more logical (Kirkham 1998).

The portrait is complex and multileveled. Battiferra and Bronzino were platonic intimates and after 1555 exchanged Petrarchan sonnets, which were

published in Laura's *Il primo libro* and in Bronzino's *Delle rime del Bronzino pittore*. His portrait is a double homage to his friend – at once a new Petrarch and a modern counterpart of Petrarch's Laura. She is also a new Dante, a conceit which may have prompted Bronzino to portray her displaying her own Dantesque profile (Bellosi 1980, p. 45). Such intermingling of the visual and the literary evokes the sixteenth-century concept of the *Paragone* (comparison)

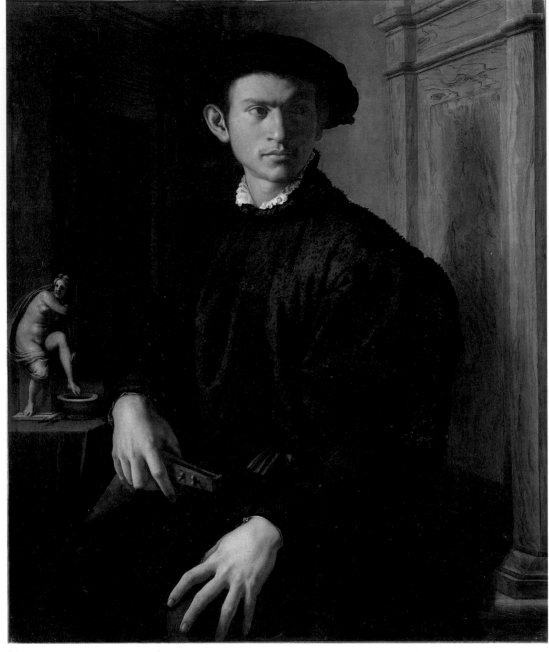

14

AGNOLO BRONZINO
Florence, 1503–1572

Young Man with a Lute[1]
ca. 1532–34
oil on panel
98 × 82.5 cm

Florence, Galleria degli Uffizi

The *Young Man with a Lute* came from the Medici grand-ducal collections and in 1666 it was inventoried as by Bronzino in the collection of Cardinal Carlo de' Medici. The youth is seated in a claustrophobic and spatially ambiguous corner with a door to the left and a piece of wooden furniture to the right. His simple, black, velvet-belted jerkin is worn over a white shirt, ruffled at the collar, and his black beret follows the contemporary fashion.

The portrait is generally dated early in Bronzino's career, shortly after his return from Pesaro in 1532. It is evidence of Bronzino's acute awareness of Michelangelo's sculpture as a model for a new canon of portraiture. Bronzino derived the youth's pose and the hand holding the lute from the sculptor's *Giuliano de' Medici* (completed before 1534 but not yet installed in the Medici Chapel at San Lorenzo). Bronzino used the same pose in a contemporaneous portrait drawing of his master, Pontormo (Florence, Uffizi 6698F; Cox-Rearick 1981, cat. A130a), and in the *Ugolino Martelli* (Berlin, Gemäldegalerie) of ca. 1536.

The *Man with a Lute* is the only portrait by Bronzino for which there is a preparatory study for the whole figure, although it is without the background and accessories (Chatsworth, Duke of Devonshire Collection, Trustees of the Chatsworth Settlement inv. 714). For a later portrait drawing by Bronzino of a male sitter's head alone, see cat. no. 155.

No convincing identification of Bronzino's young man has been made, but two attributes signal him as a cultured member

of painting and poetry. By exploiting Laura's Dantesque mien and showing her holding a Petrarch manuscript in her hand (Kirkham 1998), Bronzino gives pictorial form to her place in the grand tradition of Tuscan poetry.

In one of his poems Bronzino characterized Laura as "iron within and ice without",[2] a wordplay on her name and also an apt description of this painted image of her. Her proud demeanor evokes her inner qualities of intellect and virtue, and her iconic appearance is enhanced by her expensive and

elegant attire, the details and textures of which Bronzino depicted with typical virtuosity. Her low-cut black silk dress has puffed epaulettes and deep red velvet sleeves constructed in an intricate alternating pattern of plain and slashed bands, the latter revealing a green lining. She wears an extravagantly pleated linen shirt, its embroidered neckband fastened with a gold button at the throat. A gold chain knotted at the bottom lies over the shirt and disappears under her bodice. Finally, a detail redolent with

meaning is the gray cuffia striped in white (a type of headdress popular in Laura's native Urbino), from which a transparent veil – alluding to Petrarch's Sonnet 64 (Kirkham 1998) – falls over her shirt and shoulders.

1. In addition to references cited within the text, see Emiliani 1960, pp. 34–35, pl. 91; and Smith 1996.
2. "tutta dentro di ferro e fuor di ghiaccio."

J. C.-R.

of the Florentine elite. The lute he holds in his right hand and the statuette with an inkwell (a quill pen lies next to it) allude to the activities of music and writing, perhaps poetry. These accessories contribute to the highly charged atmosphere of the portrait, which is established by the dramatic lighting (unusual for Bronzino) and the tense posture of the sitter (Currie 1997). The lute is almost hidden, showing only the pegbox – suggestively phallic in its placement – and the inkwell is sharply highlighted, like the youth's face and hands. The statuette represents the bathing Susanna of the Old Testament at the moment of her discovery by the elders, pulling a drapery over herself, twisting and looking over her shoulder. Bronzino drew on an antique source for this statuette. Like the figure of Fame in his *Portrait of a Sculptor* (Paris, Musée du Louvre), Susanna is derived from an antique *Crouching Aphrodite*, of which many examples existed and which Marcantonio depicted in a widely known engraving (Holo 1978–79, p. 33). (Michelangelo also derived the pose of the *ignudo* above and to the left of the Libyan Sibyl on the Sistine ceiling from this antique sculpture.) Like Raphael before him (in *David and Bathsheba*, Vatican Logge), Bronzino transformed Aphrodite into a biblical figure, in this case Susanna. He reduced the scale of the marble statue, colored it red, added the dramatic swirl of drapery that emphasizes Susanna's vulnerable nudity, and changed the legs so that the bathing figure has one foot in the water–ink. The lute and inkwell thus underscore the tension of Bronzino's youth, who hides his lute, grips his left knee, and warily looks out of the picture to the right, echoing in reverse the dramatic vignette of Susanna.

1. In addition to references cited within the text, see Smyth 1949; Emiliani 1960, p. 30, pl. 18; and Smyth 1971, pp. 3–4, 82.

J. C.-R.

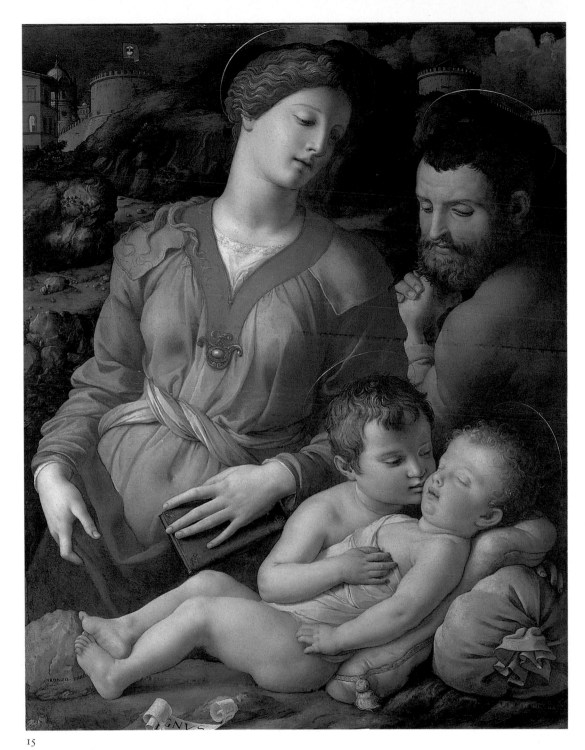

15

15

AGNOLO BRONZINO
Florence, 1503–1572

Holy Family with St. John the Baptist (the *Panciatichi Madonna*)
ca. 1540–45
oil on panel
116 × 89.3 cm
signed: "BRONZ[IN]O
FIORE[N]TI[NO]"

Florence, Galleria degli Uffizi

The *Panciatichi Madonna* entered the Galleria Palatina, Palazzo Pitti, from the Panciatichi family and was transferred to the Uffizi in 1919. It is signed on the stone to the lower left "BRONZ[IN]O FIORE[N]TI[NO]." The scene depicts the return of the Holy Family from Egypt, an episode signaled by the Christ Child sleeping on Joseph's sack. The little St. John, identified by the scroll in the foreground inscribed "[A]GNVS [DEI]," welcomes the Child with a kiss.

In the sixteenth century this work was one of Bronzino's most renowned paintings. In his life of the artist Vasari describes it along with another Madonna: "For Bartolommeo Panciatichi he painted two large pictures of Our Lady with other figures, beautiful to behold and executed with infinite diligence."[1] Later Raffaello Borghini saw these

16

Madonnas: "In the house of Carlo di Bartolommeo Panciatichi, *cameriere* [gentleman-in-waiting] of the Grand Duke, are two paintings [by Bronzino] of the glorious Virgin with other beautiful figures."[2] The Uffizi painting is identifiable as one of the Panciatichi Madonnas by a banner with the black-and-white coat-of-arms of the family flying from fortifications in the left background.

The painting's patron, Bartolommeo Panciatichi ([?]Lyon, 1507–Pistoia, 1582) was a merchant who spent his youth in Lyon and later became an important member of the elite circle of literati at the court of Duke Cosimo I de' Medici. Portraits of him and his wife Lucrezia painted by Bronzino ca. 1540 (Florence, Galleria degli Uffizi) are mentioned by Vasari just after the passage quoted above. The other *Panciatichi Madonna* by Bronzino is lost or unidentified, although it has been suggested that it might be the *Madonna with St. John and*

St. Elizabeth in the National Gallery, London (Levey 1967, p. 31) or (less convincingly because of its later date) the *Holy Family with St. John and St. Elizabeth* in the Kunsthistorisches Museum, Vienna (Smith 1982b).

There has been little agreement on the date of the *Panciatichi Madonna*. Following Vasari's implied chronology, some scholars have placed it in the 1530s (Smyth 1949, pp. 202–5; Smith 1982b), but it has been dated as late as 1548 by others (Emiliani 1960, pl. 61). A more likely date is 1540–45, at the time of Bronzino's frescoes and *Lamentation* altarpiece (Besançon, Musée des Beaux-Arts et d'Archéologie) from the Chapel of Eleonora (Florence, Palazzo Vecchio), which it resembles in its sculptural yet decorative style. These works all show Bronzino at a moment of intense rapport with antique sculpture after a Roman trip in 1539, which is evident in the Virgin, who is modeled on a Praxitelian Venus, and St. Joseph, who depends on

a Roman portrait of the Severan period (Vermeule 1964, pp. 79–81).

The one surviving preparatory drawing for the painting is a delicate black-chalk model study for the upper body of the sleeping Christ Child, in Florence (Uffizi 6639F; Cox-Rearick 1964, p. 76; and Smyth 1971, pp. 2–3).

1. "A Bartolommeo Panciatichi fece due quadri grandi di Nostre Donne con altre figure, belli a maraviglia, e condotti con infinita diligenza." Vasari 1568, vol. 7, p. 595. English translation de Vere 1912, vol. 10, p. 5.
2. "In casa Carlo di Bartolommeo Panciatichi cameriere del gran Duca sono di sua mano due quadri della Vergine gloriosa con altre figure bellissime." Borghini 1584, p. 535.

J. C.-R.

16

AGNOLO BRONZINO
Florence, 1503–1572

Luca Martini[1]
ca. 1551–55
oil on panel
101 × 79 cm

Florence, Palazzo Pitti, Galleria Palatina

FLORENCE ONLY

The portrait of Luca Martini portrays Bronzino's close friend, to whom the painter – also a poet – dedicated burlesque poems and whose death in 1561 he lamented in sonnets. The portrait exemplifies the closed world of the court of Duke Cosimo I de' Medici, in which the ducal patron, his artists, courtiers, and intellectuals were closely linked. While Bronzino was Cosimo's court portraitist, Martini was a prominent humanist and art patron who from 1547 was the Duke's principal advisor and superintendent in Pisa ("Provveditore di Pisa"). In his capacity as engineer, he was particularly noted for a scheme of drainage canals that he invented for the marshy and

malarial swamps of the Duke's seaside domain.

Bronzino celebrates this accomplishment in the Pitti portrait, one of several (*Lorenzo Lenzi* in Milan, Castello Sforzesco; *Dante* in Washington, National Gallery; *Ugolino Martelli* in Berlin, Gemäldegalerie; and *Laura Battiferra*, see cat. no. 13) in which he used written materials to identify his sitter's interests or accomplishments. He depicts Martini as a courtier, richly dressed in a black satin doublet, trimmed with bands and epaulettes of black velvet. Martini regards the spectator while unrolling and pointing to his plan for the Pisan canal system. The portrait is a variant on the Renaissance topos of the architect displaying his plan for a building, such as Titian's contemporaneous portrait of Giulio Romano (Mantua, Palazzo Te) or Vasari's *Duke Cosimo I de' Medici and His Architects, Engineers, and Sculptors*, in which Vasari shows himself holding up a plan for the renovations of the Palazzo Vecchio.

In his life of Bronzino Vasari devotes a passage to the painter and Martini. He mentions a portrait painted in Pisa (which must have been this one, although Vasari gives no details) as well as a *Madonna and Child with Luca Martini*, the theme of which is the agricultural prosperity made possible by Martini's canal system: "He [Bronzino] executed some portraits . . . for Luca Martini, who was very much his friend, and not of him only, but also attached with true affection to all men of talent, he painted a very beautiful picture of Our Lady, in which he portrayed Luca with a basket of fruits, from his having been the minister and proveditor for the said Duke [Cosimo] in the draining of the marshes and other waters that rendered unhealthy the country around Pisa, and for having made it in consequence fertile and abundant in fruits."[2] The Madonna with Luca as donor is lost but there is a portrait from

Bronzino's workshop derived either from it or from the Pitti portrait (Faenza, Pinacoteca), which shows Martini with a basket of flowers (Golfieri 1964, no. 14).

Bronzino's *Luca Martini* has been dated ca. 1560, just before the sitter's death or even posthumously (Cecchi 1996, p. 71), but a date in the early 1550s seems more likely. It is similar in style to other portraits from these years, such as that of Lodovico Capponi (New York, Frick Collection) and those of the Duke's children painted in 1551 in Pisa. Moreover, Martini was extremely active in Pisa in these years: Pierino da Vinci portrayed him in a relief of 1549, *Duke Cosimo I de' Medici as Patron of Pisa*, which Martini himself commissioned (see cat. no. 95), showing the engineer, astrolabe in hand, in the train of his patron. Duke Cosimo also ordered an altarpiece for Pisa cathedral from Bronzino (lost) – a commission obtained for the artist in February 1554 by none other than his friend Martini.

1. In addition to references cited within the text, see Emiliani 1960, pl. 93; and Nelson 1995.
2. "Fece [Bronzino] alcuni ritratti . . . a Luca Martini, suo amicissimo, anzi non pure [un ritratto] di lui solo, ma di tutti i virtuosi affezionatissimo veramente, un quadro di Nostra Donna molto bello, nel quale ritrasse detto Luca con una cesta di frutte, per essere stato colui ministro e provveditore per lo detto signor duca nella diseccazione de'paduli ed alter acque, che tenevano infermo il paese d'intorno a Pisa, e conseguentemente per averlo renduto fertile e copioso di frutti." Vasari 1568, vol. 7, p. 600. English translation, de Vere 1912, vol. 10, p. 8.

J. C.-R.

17

AGNOLO BRONZINO
Florence, 1503–1572

Duke Cosimo I de' Medici as Orpheus[1]
1539–40
oil on panel
94 × 76.5 cm

Philadelphia, Philadelphia Museum of Art, Gift of Mrs. John Wintersteen

CHICAGO AND DETROIT ONLY

This allegorical portrait was once attributed to Bronzino's workshop or to his pupil Alessandro Allori and its subject was misidentified as Duke Cosimo I de' Medici's son, Francesco. It has been established, however, as Bronzino's earliest portrait of Duke Cosimo, dated 1539–40 and showing him a few years younger than he appears in Bronzino's state portrait of 1544 (cat. no. 11), with the beginnings of the beard that he would wear for the rest of his life. The figure has all the characteristics of Bronzino's style around 1540: the emphatically lidded eyes, the crystalline *disegno* (drawing) for which he was renowned, the serpentine twisting of the body (the *figura serpentinata*, a hallmark of Mannerism), and the sculpturesque treatment of form (the nude is quoted in reverse from the famous *Torso Belvedere* in the Vatican).

This audacious and unusual image juxtaposes the portrait likeness of the Duke with the heroic antique torso, framed by

17

18

that Cosimo–Orpheus holds suggesting male and female sex organs, and his grasp of the bow emphasizing its phallic shape and placement. Like other Bronzino figures of Cupid who lasciviously play with the darts of love, and his *St. Sebastian* of ca. 1532 (Madrid, Museo Thyssen-Bornemisza), who similarly handles one of the arrows of his torture, Cosimo delicately holds the bow.

Technical analysis shows that these erotic features, as well as the figure's full nudity, were introduced after the painting was well advanced (Tucker 1985). Given the gender conventions of the Renaissance, it seems unlikely that these changes were made in light of a gift to Eleonora, but the work certainly celebrates Cosimo's heroic persona (the *Torso Belvedere* was thought in the Renaissance to represent Hercules) and his sexual prowess. Its homoerotic appeal is also undeniable and may allude to Orpheus's legendary reputation as a homosexual (Simons 1997, pp. 31–32, 42). This theme and the painting's icy sensuality mark *Cosimo as Orpheus* as the first of Bronzino's seductive male nudes, some of which (such as *St. Sebastian*), have homoerotic overtones (Cox-Rearick 1987, pp. 155–62).

1. In addition to references cited within the text, see Langedijk 1981–87, vol. 1, p. 117, no. 27, 30.

J. C.-R.

18

MIRABELLO CAVALORI
Florence, 1535–1572

Wool Factory[1]
ca. 1570–72
oil on panel
127 × 91 cm
inscribed: "MIRABELLO CAVALORI"

Comune di Firenze, Palazzo Vecchio, Quartieri Monumentali, Studiolo di Francesco I

CHICAGO AND DETROIT ONLY

a brilliant crimson cloak. It is a double-layered image in which Cosimo is at once himself and Orpheus, the legendary musician of antiquity, shown interrupting the act of singing to the animals to turn his gaze to the observer. The Duke is thus likened to a new Orpheus, echoing the political theme of a Medici ruler as a Florentine peacemaker that

Bandinelli had introduced in the previous generation in his marble *Orpheus* (Florence, Palazzo Medici), which alludes to the peaceful intentions of Pope Leo X de' Medici (Langedijk 1976, p. 48). But the overriding theme of this intimate portrait is the personal identification of Cosimo with Orpheus as the legendary lover

of antiquity. The image could be seen to portray Cosimo as the husband of Eleonora of Toledo, whom he married in June 1539 – his Euridice, whom he engages with his gaze and who might have been the recipient of the portrait (Simon 1985). The work is suggestively erotic, with the shapes of the bow and pegbox of the *lira da braccio*

One of the most talented and progressive Florentine painters of his generation, Cavalori contributed two brilliantly colored paintings to the Studiolo of Francesco I, the *Glauce Aflame at the Altar* and the *Wool Factory* (see pp. 57–58 above). Like his Studiolo contemporaries and fellow academicians Macchietti, Maso da San Friano, Naldini, and Poppi, he carefully studied and emulated the works of earlier Florentine masters – Michelangelo, of course, but, to a greater degree, Pontormo and Sarto. In fact, Cavalori figured prominently in what has been described as a "Pontormo revival" in the latter part of the sixteenth century. Whereas his colleagues mined Pontormo's art principally for motifs, Cavalori looked to the older artist's life studies and more naturalistic paintings, such as the *Supper at Emmaus* of 1525 (formerly Florence, Certosa di Val d'Ema, now Florence, Uffizi), in order to understand and simulate Pontormo's way of seeing and describing, carrying Pontormo's most advanced researches in the handling of light and space to the next stage.

Nowhere is this more evident than in the *Wool Factory*, where Cavalori's workers, hardly altered from his preparatory drawings of posed models in the studio, inhabit a space that is convincingly defined by a cold yet vibrant illumination. The web-like patterning of the composition, with elements arranged in different spatial planes so that they seem barely to touch, is also derived from Pontormo, notably his *Vertumnus and Pomona* fresco of 1520–21 (Poggio a Caiano, Villa Medici). Despite this mannered effect, Cavalori has attained a naturalism that would influence Macchietti, Santi di Tito, and others of the major reformers of art in late cinquecento Florence.

The son of a dyer, Cavalori's painting describes in prosaic fashion the activities involved in the processing of wool. He reconstructs, albeit with some classicizing hyperbole, the interior of a *tiratoi*, one of the

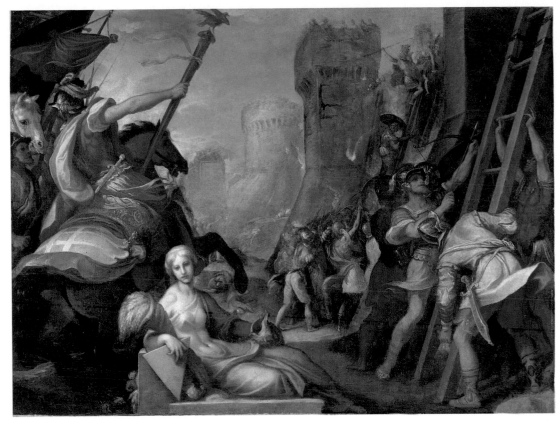

19

barn-like structures along the Arno that housed labyrinths of stairs, terraces, and usually enough racks to hang thousands of yards of wool. Some of the workers are shown washing the wool in large vats containing solutions of water and urine (or ammonia). As noted on pages 57–58 above, other *lavatori* treat the wool in baths of alum, in a process known as mordanting, so that it will more easily receive dye. At left, a worker appears to be shoveling alum, one of the materials that would have been stored in the cupboard directly beneath the painting. A red-chalk life study for the man with the shovel, the only known surviving drawing for the *Wool Factory*, is preserved in a private collection in New York.

1. See Feinberg 1986, pp. 24–26, 89, 92–105, 233–36, no. 17; Watteville 1988, vol. 2, p. 674; Feinberg 1992, pp. 423, 425–26; and Privitera 1996, pp. 41, 53–55.

L. J. F.

19

LUDOVICO CARDI,
CALLED IL CIGOLI
Florence, 1559–Rome, 1613

Siege of Jerusalem
ca. 1590–1600
oil on canvas
151 × 201 cm

Dublin, The National Gallery of Ireland

FLORENCE ONLY

In this image a recumbent figure, recalling Michelangelo's *Dawn*, commands a panorama of soldiers attacking city walls. Her somber expression and attributes – the conch shell, flat triangle, roses, cornucopia of wheat – identify the scene even though the precise subject has different interpretations.

The identity of the artist was questionable until Charles Carman (1978) attributed the painting to Cigoli and proposed a date of around 1590, noting comparisons with Santi di Tito's treatment of soldiers and with Cigoli's early works. The

suggestion is supported by comparison of the intense passages of color with treatments now visible in Cigoli's recently restored *Resurrection* of 1590 (cat. no. 20). As a result, the *Siege* has been dated just after 1600 by Faranda (1986, p. 145, no. 46) and around 1600 or possibly 1608 by Contini (1991, p. 94, no. 28). Admiration for the painting is indicated by a hitherto unknown copy, an anonymous pen drawing that clarifies some details (Wright 2000, p. 16, no. 5, listed erroneously as A. Tempesta). The *Siege* has also been cited (Garofalo 2000, p. 66, no. 25) as relating in some details to the composition of a recently discovered Cigoli drawing depicting soldiers on ladders attacking a fortress at a harbor and possibly relating to the decorations for the wedding of Cosimo II to Maria Maddalena of Austria in 1608.

The *Siege* raises questions about its subject and purpose. The combination of historical scene and allegorical figure suggests a decoration for a court pageant in Florence. Carman and

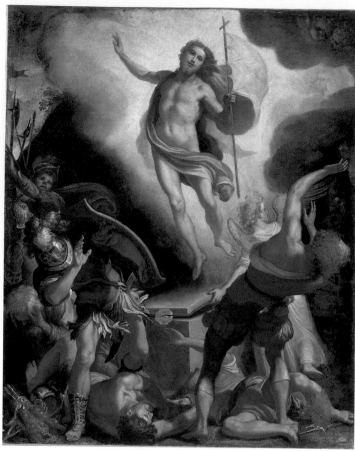

20

Contini have observed stylistic relationships to Cigoli's *Manfred Overcoming Charles of Anjou*, known from a print after the lost painting, which was made for a decorated arch through which Christine of Lorraine entered Florence on the occasion of her marriage to Ferdinando I in 1589. Carman has suggested that the painting was in the spirit of the allegories made for the proxy marriage of Maria de' Medici to Henry IV of France in 1600 or for the marriage of Cosimo II. Proposing that the subject derives from Tasso's *Gerusalemme liberata* and that the painting depicts *Godfrey of Boulogne and the Liberation of Jerusalem*, Carman has interpreted the bird as a dove signifying Godfrey's divine mission and the allegorical figure as symbolizing both the Church and Jerusalem as the New Church. Although this reading has been maintained by Spinelli (2001, p. 66), the painting is generally called the *Siege of Jerusalem*.

Another reading can be suggested: the bird on the

horseman's standard can be understood as the eagle of Rome; the subject as Titus attacking Jerusalem in A.D. 70; and the scene can be seen to be inspired in part by Dante's *Paradiso* (canto VI). There, in a few lines, Dante traces the eagle as a symbol of just monarchy from Aeneas to Rome and cites Titus's destruction of Jerusalem as necessary vengeance for the death of Christ. The somber woman could personify Jerusalem and allude through the roses and wheat to her destruction and revival; through the triangle and stones to building; and through the conch to eternity and new life. The choice of subject may relate to the resurgence of interest in the *Divine Comedy* in the 1590s in the Accademia Fiorentina and to Cigoli's other illustrations of Dante. The small size of the monumental scene, its painterly freedom in the manner of a *bozzetto* (oil sketch), and the allegorical scene itself, suggest that the painting was a *modello* for an architectural decoration

in fresco and quite possibly conceived with a pendant painting.

M. L. C.

20

LUDOVICO CARDI, CALLED IL CIGOLI
Florence, 1559–Rome, 1613

Resurrection
1590
oil on canvas
145.5 × 117 cm

Florence, Palazzo Pitti, Galleria Palatina

Long considered lost and only recently rediscovered in damaged condition, Cigoli's restored *Resurrection* is important for understanding his early style and career (Chappell 1974). Although he worked under Alessandro Allori on decorations for Medici court events, such as the funeral for Cosimo I in 1574 and the marriage of Ferdinando I to Christine of Lorraine in 1589, Cigoli was an independent artist when he painted this work, a commission that was to shape his career.

According to his biographer and nephew, G. B. Cardi, Cigoli was approached by Don Giovanni de' Medici when Grand Duke Ferdinando became dissatisfied with proposals for an altar painting for the Cappella dei Forestieri or Visitors' Chapel, under construction in 1590–91 in the area adjacent to what is today the Sala di Bona in the Palazzo Pitti. From the documented history traced by Bellesi (1998) and Padovani (2000) of the now destroyed Quartiere dei Cardinali e Principi Forestieri, two scarcely known decorators, Francesco Mati and Luca Ranfi, were charged with ornamenting the chapel in fresco, and the altarpiece was commissioned to Andrea Boscoli. His painting was judged unsatisfactory, but was paid for and returned to him. Cigoli's commission could relate to the fact that he was working at just this time in the Palazzo Pitti on the decoration of

Christine of Lorraine's apartment with a ceiling painting of *Flora* (now lost). But his selection was more likely owing to the fame of his *Martyrdom of St. Lawrence* of 1590 (Figline, La Collegiata di Santa Maria), a night scene that apparently created a sensation for its dramatic light effects and carefully conceived spatial setting.

Cardi's account that the *Resurrection* was a particular challenge because of its narrow proportions, and that Cigoli made many preparatory studies, is corroborated by a drawing dated 1590 showing the composition and marginal sketches (New Haven, Yale University Art Gallery; Pillsbury and Caldwell 1974, no. 42) and other studies in the Uffizi, the Louvre, and private collections (Chappell 1992, pp. 17–19, no. 10). Additional studies for the angel and for Mary are found on a recently sold drawing attributed to Cigoli's disciple Sigismondo Coccapani (London, Christie's South Kensington, 16 April 1999, no. 20). Cigoli took inspiration from a model he himself had earlier copied, Santi di Tito's greatly admired *Resurrection* ca. 1574 in Santa Croce, Florence (see cat. no 208). Compressing Santi's composition into an even more vertical format and simplifying the scene, Cigoli created a balanced arrangement of carefully studied complementary figures with accentuated movements, a disposition he further simplified in the more concentrated *Resurrection* of 1591 for the Convent of Montevarchi in Arezzo (now Arezzo, Pinacoteca Comunale). The painting for the Cappella dei Forestieri reflects Cigoli's dedication to more realistic light and color, an interest that led him from the Mannerist colorism of Alessandro Allori to study of Barocci and then Correggio. We see Cigoli balancing the sharp, defining light of Santi di Tito with his own more atmospheric treatment, but we can observe him delighting in color combinations of intense hues and chromatic juxtapositions still recalling Alessandro Allori. He

soon makes the transition to the more suave color harmonies of works such as the *Resurrection* of 1591, the *Siege of Jerusalem* (cat. no. 19), and the *Martyrdom of St. Stephen* of 1597 (Florence, Palazzo Pitti; see the preparatory drawing exhibited here, cat. no. 169).

Cigoli's *Resurrection* must have pleased because it marks the beginning of his long association with the Medici. His principal patron was Ferdinando I, who was to obtain for him the prestigious commission for an altarpiece in St. Peter's in Rome and who, in his turn, was to be commemorated by a funeral for which Cigoli supervised the decorations.

<div align="right">M. L. C.</div>

21

JACOPO COPPI, CALLED JACOPO DEL MEGLIO
Peretola, Florence, 1523–Florence, 1591

St. George and the Dragon[1]
ca. 1571–72
oil on canvas
70 × 56 cm

Private Collection

Among the so-called 'minor' painters who participated in the collective project for the Studiolo of Francesco I de' Medici in Palazzo della Signoria, Coppi is today the focus of new scholarly attention, thanks to the rediscovery of several of his works. Although his early lunette with the *Deposition* (*ante* 1570; Florence, in the deposits of the Galleries; see. Acanfora 1994, fig. 61 pl. IV), close in style to his better-known *Pietà* (Florence, Banca Toscana), confirmed that his youthful work was influenced by Rosso and Pontormo, the recent rediscovery of the panel of *The Virgin in Glory with Saints* (1576; Calci, Pisa, Oasi del Sacro Cuore; formerly cathedral of Pisa) has cast a new light on his later activity, previous to his Roman period.[2] The present work, a sophisticated small painting representing *St. George and the Dragon*, was brought to

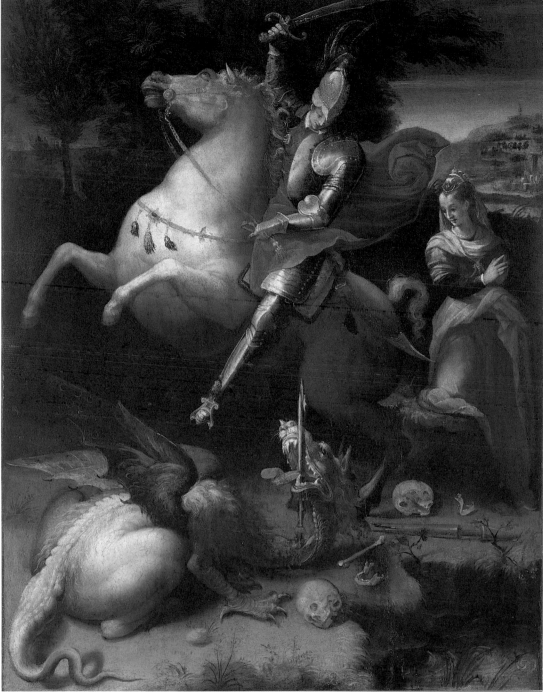

21

public notice by Luciano Berti. It dates to a period between the works cited above and must be contemporary with or slightly later than the two signed paintings made by Coppi for the Studiolo, *The Invention of Gunpowder* and *The Family of Darius Before Alexander*. The lively movement of Saint George, holding his weapon and fixing his gaze on the dragon at his feet, is a slightly varied version of the equally energetic gesture of the attendant grinding gunpowder in *The Invention of Gunpowder*. The saint on horseback seems directly taken from the equestrian figure of Alexander in *The Family of Darius*. The stylistic features of the present painting, as has been remarked by scholars with regard to the two Studiolo panels, reveal a noticeable refinement of his pictorial language, which tempers the strong echoes of Rosso. And whereas the elongated figures are influenced by Salviati, the perceptive depiction of background details and of the skulls and bones scattered in the foreground around the dragon derive from the work of northern artists, particularly Giovanni Stradano.

1. In addition to references cited within the text, see Berti 1967, p. 229, n. 39; Collareta 1980, p. 288, cat. no. 570; Privitera in *La pittura in Italia*, vol. 2, p. 685.
2. Carofano 1997, pp. 140–45, pl. 4.

<div align="right">M. C. F.</div>

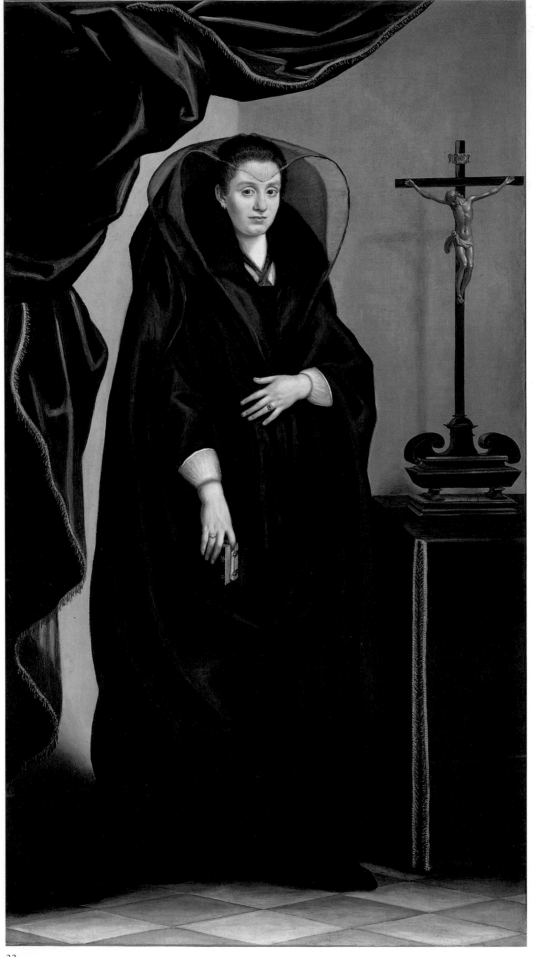

22

22

JACOPO DA EMPOLI
Florence, 1551–1640

A Noblewoman Dressed in Mourning
ca. 1610–20
oil on canvas
221 × 122.5 cm
inscribed on the pedestal of the crucifix: "A L. HT B."

Art Institute of Chicago,
The Louise B. and Frank H.
Woods Purchase Fund

FLORENCE AND CHICAGO ONLY

This poignant portrait of a noblewoman dressed as a widow, celebrated for her devotion and piety, is a significant visual document of social custom in Medici Florence even while posing many unanswered questions. Christopher Lloyd (1993, pp. 76–79) has traced the provenance and discussed proposals for authorship, date, and the identity of the sitter. Acquired as a *Lady of the Medici Family* from the Villa Salviati in Florence for Nicholas Vansittart (d. 1851), first Baron Bexley, the painting subsequently changed hands several times, with an attribution to Justus Sustermans, the long-lived portraitist at the Medici court. The attribution to Empoli made separately by Hermann Voss, Roberto Longhi, and Federico Zeri, shortly before its acquisition in 1960 by the Art Institute of Chicago, was accepted by Bianchini (1980), Cantelli (1983, p. 42), and Marabottini (1988, p. 226, no. 67; for the attribution history, see Lloyd 1993, pp. 76–79).

Important for understanding the *Noblewoman* is the painting Lloyd described as "almost certainly a pendant," the *Portrait of a Youth* in a private collection. Close in size, this full-length painting shows a youth with light hair and a sensitive expression wearing an elegant black costume and standing in a corner setting, with a tile floor and a curtain serving as a framing device (Lloyd, p. 76, fig. 1). The painting also shows an inscription printed in a comparable manner, ".A.M.B.F.

158 22

/15[?]93" and has a provenance also from the Vansittart Collection, circumstances that led to the dating of both portraits around 1593.

The *Noblewoman* was identified as a member of the Medici family by nineteenth-century tradition, as a Salviati by Marabottini, or possibly as a Strozzi by Lloyd. The latter has observed that a definitive interpretation of the inscriptions could modify ideas regarding the attribution, dating, and identification of the painting. Some alternative proposals can be made. A later dating of 1610–30 is suggested on the basis of stylistic comparisons with Empoli's painting, of portrait conventions in Florence employed by artists such as Cristofano Allori, Tiberio Titi, and Justus Sustermans, and of the costume. The widow's hood is comparable to that worn by Christine of Lorraine in portraits painted by Titi and Sustermans after Grand Duke Ferdinando's death in 1609 (Florence, Galleria degli Uffizi). The costume and hat of the *Portrait of a Youth* compare with the dress in portraits of these years: his flared, plain collar in the Spanish style is seen in images of the young Leopoldo de' Medici (Florence, Galleria degli Uffizi) and of Mattias de' Medici (Florence, Galleria degli Uffizi and Poggio a Caiano) painted by Sustermans in the 1620s (see S. Meloni Trkulja in *Sustermans* 1983, p. 101, no. xxxi, and pp. 104–5, nos. xl and xliii) and in a form embellished with lace in Francesco Curradi's *Young Man with a Skull*, painted after 1611 (Staatsgalerie, Stuttgart; see B. Santi in *Il Seicento fiorentino* 1986, pp. 168, no. 1.56).

That the *Noblewoman* and *Portrait of a Youth* were not made as true pendants by the same hand is suggested by differences in style, size, setting, the pattern of the floor, the treatment of perspective, and the sources of light, but even with these disparities, they do relate to one another and reflect their time. Empoli's portrait evokes the piety and pride behind much of the patronage of art

23

during the austere "regno delle tutrici," the period when Christine of Lorraine and Maria Maddalena of Austria ruled as joint regents.

M. L. C.

23

ANONYMOUS ([?]RAFFAELLO GUALTEROTTI)
Florence, 1543–1639

"Calcio a livrea" in Piazza Santa Croce[1]
ca. 1589
oil on canvas
87.6 × 116.2 cm

Sarasota, Collection of The John and Mable Ringling Museum of Art, Bequest of John Ringling

CHICAGO AND DETROIT ONLY

Calcio a livrea was very popular among the Florentines and a game of ancient tradition, deriving from *harpastum*, which had been played by the legionaires of Roman *Florentia*. The game, which was usually held during the Carnival season, had become part of Medicean celebrations in

particular since the marriage of Alessandro de' Medici with Margaret of Austria, the daughter of Emperor Charles V, in 1536, and continued to be played into the seventeenth century. On 4 May 1589, during the public celebrations for the marriage of Grand Duke Ferdinando I with Christine of Lorraine, a match took place between the Grand Duchess's team, dressed in deep blue, and the Grand Duke's, in purple. The present painting illustrates a match in Piazza Santa Croce between two teams wearing outfits very close in color to those described by the contemporary sources for that occasion, although the three masked figures in the foreground suggest that this particular match may have been played during Carnival, when spectators (including the Grand Dukes and their guests) could attend the game wearing fancy dress.

Tomory remarked that the painting reveals the influence of Alessandro Allori and Giovanni Stradano, pointing out that the two knights in the foreground derive from an engraving, *The War of Siena*, by the latter (Tomory 1972). This painting has

also been attributed to Raffaello Gualterotti, a famous man of letters, who belonged to the Accademia Fiorentina, the Accademia della Crusca, and the Accademia degli Apatisti (Tomory 1972). He was also a well-known astrologer, a connoisseur of hardstones and an amateur painter. He wrote numerous poems, but his name is linked above all with the literature commissioned by the Medici court to record their public festivities. In 1579 he compiled a list of the festivals staged in that year for the marriage of Grand Duke Francesco with Bianca Cappello, and in 1589 he wrote a *Descrizione*, complete with illustrations, of the theatrical machinery designed to fill the streets during the entry of Christine of Lorraine into Florence.

1. See Suida 1949, no. 36; Tomory 1976, pp. 26–27, no. 20; Blumenthal 1991, p. 22, cat. no. 11; Chiarini and Marabottini 1994, p. 83, cat. no. 21; Saslow 1996b, pp. 245–46, n. 69; Marcenaro and Boragina 2001, II.12, 109.

A. M. T

24

FRANCESCO LIGOZZI
Florence, 1590s–Florence, 1641

Dante and Virgil in Hell[1]
1620
oil on *pietra paesina*
31 × 33 cm

Florence, Museo dell'Opificio
delle Pietre Dure

This work can be attributed to
Francesco Ligozzi, the son of the
more renowned Jacopo, and the
father of Bartolomeo, a still-life
painter who was the last
representative of his family's
artistic tradition in Florence.
Francesco was also a professional
painter, but his work, which has
only recently become the focus
of scholarship, was eclipsed by
the fame of his father's work-
shop, where for a long time he
was active anonymously. Two
documents from the Guardaroba
of Cosimo II record payment for
and delivery of the present
painting in August 1620. The
few stylistic elements visible in
this work reflect Francesco's
painterly approach, evident in
contemporary canvases by him
in Empoli and Poppi. The motif
at the lower left derives directly
from a work by Jacopo – a keen
illustrator of Dante's *Divine
Comedy* – a drawing representing

*Dante and Virgil at the Doors of
Hell* (reproduced in an engraving
by Egidio Sadeler), in which the
doors are unhinged and broken.
The iconographic quotation is
faithful in the physiognomy and
the pose of the two figures, but
Francesco eliminated the dark
cave invented by his father and
instead opened the scene toward
the right, giving a perspective on
a view that includes several
episodes from Dante's *Inferno*,
with the damned suffering
various torments at the hands of
their torturers.

1. See Chiarini, Maetzke, and
Pampaloni Martelli 1970, no. 5;
Chiarini, in *Il Seicento fiorentina:
Pittura*, p. 200, cat. no. 1.85;
Conigliello 1994, pp. 41–52.

L. C.

25

JACOPO LIGOZZI
Verona, ca. 1547–Florence, 1627

The Rape of the Sabine Women[1]
ca. 1605–15
oil on canvas
130 × 186.5 cm

Private Collection

This signed painting is the only
known work by Jacopo Ligozzi

24

on a subject from ancient
history. Most of his paintings
represent religious subjects,
moral allegories or themes from
more recent history (including
the late medieval, Renaissance,
and contemporary periods)
which have a celebratory or
political significance. This is true
of the large paintings on slate of
the early 1590s, in the Salone
dei Cinquecento in Palazzo della
Signoria in Florence illustrating
The Mission of Boniface VIII and
*The Coronation of Cosimo I de'
Medici*; of the paintings made on
the occasion of the funeral of
Grand Duke Francesco I in 1587
and for the commemoration in
Florence of the death of Philip
II of Spain in 1598; of the two
narratives painted in 1604–07 for
the church of Santo Stefano dei
Cavalieri in Pisa, *The Return from
Lepanto* and *The Capture of
Nicopolis*; and of his late
historical cycle of canvases, *The
Devotion of Verona to the Doge*,
commissioned by the Council
of his native city.
 Rich in ideas, *The Rape of the
Sabine Women* is a work both
complex and contradictory in its
cultural allusions. On the one
hand, as was pointed out by
Ettore Camesasca (1951, vol. 2,
p. 1350), the composition recalls
the Veronese and the Lombard
styles of painting, particularly in
the Mannerist treatment of the
contorted and disproportioned
figures, as well as in the
rendition of facial expressions,
reminiscent of Giulio Cesare
Procaccini's style. On the other
hand, there is a clear reference
to Giambologna's *Rape of the
Sabine Women*, the low-relief
included in the sculptural group
in the Loggia dei Lanzi in
Florence, which was widely
disseminated at the time through
a woodcut by Andrea Andreani.
The most interesting element,
however, is the strong Roman
aspect of the painting, present in
the unusually solemn approach
by the artist to his subject as he
attempts the representation of
pathos typical of the classical
tradition. I believe that this
canvas was influenced by
Ligozzi's direct observation of
late classical art during his

Roman travels, but especially of
Raphael's Stanze in the Vatican,
particularly *The Fire of Borgo* in
the Stanza of Heliodorus. In the
early seventeenth century
Ligozzi made many trips to
Rome and his activity there is
still to be fully studied.
 In my opinion the canvas
should be dated between 1605
and 1615, a slightly earlier date
than that suggested by Mina
Bacci (1963, p. 71), because of its
stylistic proximity to some of the
artist's most celebrated Florentine
works, such as *The Miracle of
Saint Raymond* in Santa Maria
Novella (1606) and *The
Martyrdom of Saint Lawrence* in
Santa Croce (1611). The female
figure in the centre of the scene
echoes a similar figure in *The
Allegory of Death* (New York,
Pierpoint Morgan Library), a
drawing signed and dated 1597.

1. In addition to the references cited
within the text, see Congiliello 1992,
pp. 31 and 43.

L. C.

26

FRANCESCO MORANDINI,
CALLED IL POPPI
Poppi, 1544–Florence, 1597

The Palace of the Sun[1]
ca. 1570–72
oil on panel
45 × 61 cm

Soprintendenza per i Beni
A.A.A.S. di Arezzo–Gallerie
Fiorentine di Firenze

Conceived with the poetry and
preciosity of the paintings in
Francesco I's Studiolo, and
probably executed at the same
moment, Poppi's *Palace of the
Sun* illustrates a passage in Ovid's
first-century A.D. *Metamorphoses*
(II, 1–102). The ancient author
tells of how Phaëthon persuaded
his reluctant father, Phoebus (or
Helios, the Sun), to lend him his
chariot, so that he could drive
his winged horses for a day.
Following Ovid's description,
Poppi has depicted Phaëthon
in the middle ground of the
composition, making his request

25

on bended knee before the magnificent palace where the Sun begins and ends its quotidian voyage. In keeping with Ovid's tale, the Four Seasons are present: the young Spring clutches flowers; recumbent Summer holds stalks of grain; Autumn displays his harvested grapes; and old Winter, congealed in pose and thought, rests beside leafless tree branches. The "swift Hours," who, according to Ovid, yoked Phaëthon's steeds, fly by at regular intervals. The painter portrays the "writhing serpent," which Ovid says is "far to the right," as biting its tail (forming an endless loop), a symbol of infinity since late antiquity. At left, the winged figure of Time presides over the events and over an abandoned pile of objects denoting worldly life and pursuits. The skull beneath him,

a *memento mori*, is no doubt intended in the context of the myth to allude to Phaëthon's impending fall and death, signaled also by the young woman in the right distance, probably one of the naiads who would bury Phaëthon, who now prophetically points to the ground.

As Collareta (in *Palazzo Vecchio* 1980, pp. 282–83, no. 547) has observed, Time's pose is loosely based on that of Michelangelo's *Victory* for the tomb of Julius II of 1525–30 (Florence, Palazzo Vecchio) and his *Winter* on the tomb figure of Lorenzo de' Medici of 1524–34 in the Medici Chapel in S. Lorenzo. Poppi's attempt, in Michelangelesque fashion, to convey a profound psychological state through pose is somewhat undermined by the general, fluttering whimsy of his

composition. Nevertheless, such quotations would have been appreciated by the patron of the work, the sophisticated collector, Niccolò Gaddi, in whose possession Raffaello Borghini viewed it. Poppi's black-chalk study for the figures of Winter and Autumn is preserved in the Louvre (no. 2238).

1. In addition to references cited within the text, see Acidini Luchinat 1980a; Giovannetti 1992; and Giovannetti 1995, pp. 11, 35, 87, 212, and 213, and nos. 15 and D11.

L. J. F.

27

FRANCESCO MORANDINI, CALLED IL POPPI
Poppi, 1544–Florence, 1597

Antonio Ricci, Bishop of Arezzo[1]
ca. 1587–90
oil on panel
194 × 115 cm

Florence, Galleria Martelli

FLORENCE AND CHICAGO ONLY

This full-length portrait, identified as Antonio Ricci by Civai (1990, pp. 43, 112, n. 14, fig. 126) and mentioned in the monograph on the painter by Giovannetti (1995, pp. 109–10, n. 69), who also refers to it in an earlier biography (1988, vol. 2, p. 775). It bears in the lower right corner the unmistakable monogram of Poppi. Poppi's work as a portraitist, well

26

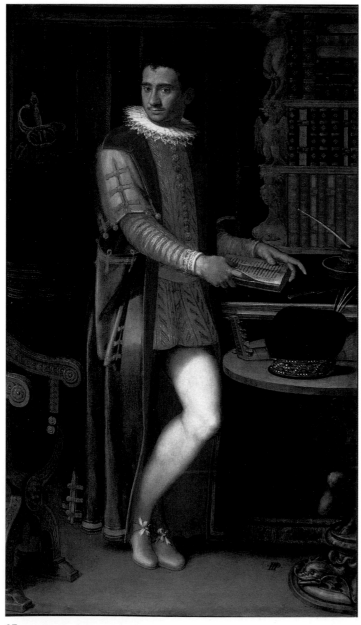

27

documented by Rafaello Borghini (1584), is known today only from this full-length portrait and from another example in the collection of the Cassa di Risparmio in Prato.

Giovannetti (1995) notes that an anonymous typed guide in the Palazzo Martelli dated 1964 describes the painting as *The Page Antonio de' Ricci*. The identification of the figure is certain: the open book held by the gentleman (a preparatory drawing exists for this detail: Florence, Gabinetto Disegni e Stampe degli Uffizi, 6408F) clearly reads "M. ANTONII DE RICCI," and on the hilt of the sword in the background on the left of the canvas the family coat of arms is evident, with clearly recognizable small hedgehogs (*ricci*).

Antonio di Vincenzo di Pier Francesco Ricci was born in 1562, the beloved nephew of Saint Caterina dei Ricci. In 1602 he became the governor of Ancona and he was the chamberlain of Scipione Borghese. In 1611–12, with the support of the Medici, he became the Bishop of Arezzo, donating the relics of St. Ignatius of Loyola and St. Filippo Neri to the city. He was also associated with the church of San Marco in Florence, where he commissioned the construction of his family altar, decorated with a mosaic *all'antica*. He died in 1637. This painting entered the Martelli Collection through the bequest of Caterina de' Ricci, the wife of Niccolò Martelli, whom she married in 1802. In her testament of 1854 she describes the portrait as: "the painting representing one of my ancestors, the Bishop of Arezzo, with the letters on the shelf, painted by Poppi, which is in the Martelli Gallery."[2]

The painting features a number of attributes that suggest the subject must have been wealthy, influential, and a lover of music and literature: the lute on the table, partly concealed by an unusual hat studded with precious stones and pearls; the open book with an inkwell and pen; and the well-stocked library of leather-bound books. He is richly dressed in a gold brocade outfit with short, puffed-up breeches; a corset with a row of tightly spaced spherical buttons; a rich lace ruff collar; a long cape in blue silk with a red velvet lining and half-open sleeves, ornamented by golden braided loops in the Spanish fashion of the 1590s; tight-fitting stockings; and shoes with a bow. The library and the table are decorated with wooden elements reminiscent of Michelangelo's sculptures and particularly Tribolo's works for the Medici court.

Ricci's apparent age of between twenty-five and twenty-seven years supports the evidence of his clothes, allowing us to date the portrait to around 1587–90. It must have been made after 1584 because Borghini, who undoubtedly would not have neglected to refer to it in view of the importance of the subject, does not mention it.

1. In addition to references cited within the text, see Archivio di Stato di Firenze, Raccolta Sebregondi, n. 4436; and Digiesi 1998, with preceding bibliography.
2. "il quadro rappresentante un mio antenato Vescovo di Arezzo, avente le Pistole (ossia le epistole) nell'altare (ossia nello scaffale), dipinto dal Poppi, che trovasi nella Galleria Martelli." 1854, in Archivio di Stato di Firenze, Fondo Martelli, 1427, n. 34.

M. B.

28

FILIPPO D'ANGELI, CALLED FILIPPO NAPOLETANO (Rome or Naples, ca. 1589–Rome, 1629)

The Triumph of Neptune and Amphitrite[1]
1618
oil on canvas
1.175 × 1.695 m

Florence, Palazzo Pitti, Galleria Palatina

FLORENCE AND CHICAGO ONLY

28

This painting, recorded in an extant document as *The Triumph of Neptune*, was delivered to the Guardaroba of Cosimo II de' Medici on 16 July 1618 with other paintings by Filippo Napoletano (see cat. no. 29). The artist had arrived in Florence about a year earlier, at the invitation of the Medici, and had become court painter to the Grand Duke, who, like his brother Cardinal Carlo, greatly admired his work. Also in 1618, Filippo painted his Florentine masterpiece, *The Fair of Impruneta* (Florence, Palazzo Pitti, Appartamenti Reali), which would inspire the famous print by Jacques Callot on the same subject, published two years later. Napoletano's painting shows the portraits of Cosimo II surrounded by his courtiers, and of Maria Maddalena of Austria, who is seen holding one of her daughters by the hand.

The Triumph of Neptune demonstrates Napoletano's talent for working in a variety of styles, depending upon the taste and personality of his respective patrons. His work in general displays an astonishing, mimetic ability, which enabled him, while he was working in Florence, to imitate stylistically both the foremost artists in the city, and particular works in the Medici collections. In the case of *The Triumph of Neptune and Amphitrite*, the predominant influence is that of Jacopo Zucchi, the favorite artist of Grand Duke Ferdinando I, who, while still a cardinal, had commissioned works from him for his villa on the Pincio in Rome. Napoletano was prob-ably inspired mainly by Zucchi's precious paintings on copper, in which the Tuscan–Roman artist had represented mythological scenes (see cat. nos. 43 and 45).

In the present painting, the plastic rendition of figures reminiscent of Michelangelo in their poses and the depiction of many natural objects (like those found in *Wunderkammern*) have important precedents in works by Zucchi, for example, *The Kingdom of Zeus* (Florence, Uffizi) or, even more strikingly, two versions of *The Kingdom of Amphitrite* (Ukraine, Leopolis Museum, and Rome, Galleria Borghese). The details taken from nature (corals, pearls, shells, marine monsters) in Napoletano's painting signal an acceptance of the fantastic worlds created by Mannerist painters, particularly those found in the works for the Studiolo of Francesco I in Palazzo della Signoria.

The Triumph of Neptune and Amphitrite possesses also a scenographic quality and an immediacy of representation that reveals Napoletano's interest in the grandiose spectacles for which the court of Cosimo II was renowned. In reading Baldinucci's description of the extraordinary staging of the triumph of Neptune by Giulio Parigi for the Carnival of 1612 (probably known to Napoletano through prints), it would appear that this painting, whose subject may have been suggested by the Grand Duke himself, was intended as a visual commemoration of that event.

1. See Chiarini, in *Capolavori sconosciuti a palazzo Pitti*, p. 48(19).

M. C.

163

29

29

FILIPPO D'ANGELI, CALLED
FILIPPO NAPOLETANO
(Rome or Naples,
ca. 1589–Rome, 1629)

Two shells
1618
oil on canvas
39 × 56 cm

Florence, Pitti Palace, Galleria
Palatina

This small painting was delivered
to the Pitti Palace in July 1618,
together with other paintings by
Filippo Napoletano (see cat. no.
28). It represents two shells: on
the left is a *Tridacma elongata*, on
the right, a *Cassis cornuta*,[1]
probably depicted in life size. It
is likely that these were chosen
from the shells kept in the no
longer extant Stanzino dei
Nicchi (Room of the Shells) in
the Uffizi. As pointed out by E.
Fumagalli, "the subject – and the
manner in which it is presented
– constitutes an isolated case in
comparison with the type of
works usually collected by
Cosimo II . . . so that it appears
to be closer in spirit to [the
taste of] his predecessors
Francesco I and Ferdinando I
[respectively the uncle and the
father of Grand Duke Cosimo
II]."[2] This remark is important
for understanding the
superficially attractive,
Mannerist appearance of the
image, in which, as in paintings
on *pietra paesina* (see cat. no. 30),
natural forms are used to achieve

sinuous abstract effects that
are reminiscent of some of the
ornamental motifs employed by
Michelangelo. Michelangelo
himself, in certain marginal and
decorative details of his work,
employed anthropomorphic
motifs that bordered on abstract
forms, for example in the tombs
of the New Sacristy of San
Lorenzo (Goldscheider 1967,
figs. 192–95), or in the project
for a salt cellar (see cat. no. 190).
It is no coincidence therefore
that we can recognize a
grotesque human profile in the
shell on the left.

1. E. Fumagalli, in *La natura morta a
palazzo e in villa*, pp. 142–43
2. "il soggetto, nonché il modo in
cui è presentato, costituisce un caso
isolato rispetto al genere di opere
collezionate da Cosimo II . . . tanto
da risultate più vicino, in spirito,
ai suoi predecessori Francesco I
e Ferdinando I." Ibid.

M. C.

30

FILIPPO D'ANGELI, CALLED
FILIPPO NAPOLETANO
(Rome or Naples,
ca. 1589–Rome, 1629)

Ruggiero Frees Angelica[1]
1619
oil on *pietra paesina* (*lineato
d'Arno*)
27 × 43 cm

Florence, Istituto Nazionale di
Studi Etruschi ed Italici

On the back of the frame of
this painting is an early
annotation: "Andromeda." This
corresponds with the title
originally given to the work in
a document of 1619 in the
Archivio di Stato in Florence,
which describes it as "Perseus
flying through the air, coming
to the rescue of Andromeda,"
and which states that it arrived
at the Pitti Palace on 29
October 1619. Nevertheless, as
was pointed out for the first
time by Anna Maria Maetzke
(Chiarini, Maetzka, and
Pampaloni Martelli 1970, cat.
no. 16), the subject of this
painting derives from Ariosto's
Orlando Furioso (canto X. 92
ff.), in which Ruggiero saves
Angelica from the orc, seen
here attacking her on the left of
the image (see Fumagalli, Rossi,
and Spinelli 2001, p. 208, cat.
no. 76). That the knight riding
the mythical Hyppogriphe is
the Ariostesque hero and not
Perseus, the mythological hero
of antiquity, is proved by the
type of armour he wears and
by the fact that he is not

holding a shield with the image
of Medusa's decapitated head.

This painting, largely
influenced by the Mannerist
style, is one of the most
sophisticated of Napoletano's
Florentine output. He was
probably the inventor of the
technique of painting on the
stone known as *lineato d'Arno* or
pietra paesina, developed during
the time of Cosimo II in
concurrence with the hardstone
production of the Galleria dei
Lavori at the Uffizi.

Jaques Callot, active in
Florence in the same period,
worked on an analogous subject,
known to us through two
drawings in the Uffizi; this
image, however, portrayed
Perseus freeing Andromeda, and
the decorative elements typical
of Mannerism are particularly
evident (see Jaques Callot 1592–
1635, p. 209, cat. nos. 121–22).

1. In addition to references cited
within this text, see Chiarini and
Casciu 2000, p. 62, no. 9.

M. C.

31

DOMENICO CRESTI,
CALLED PASSIGNANO
(Passignano, 1559–Florence, 1638)

The Entombment of St. Sebastian
1602
oil on canvas
178 × 129 cm

Naples, Museo di Capodimonte

FLORENCE ONLY

30

The presence of the artist's signature and of the date 1602 did not prevent this painting – one of Passignano's most intense – from being attributed in the nineteenth century to Donato Creti, an artist from Emilia, and, in 1911, to Palma the Younger. These erroneous attributions would not have been helped by the total lack of documentation about the circumstances of the painting's execution. A first mention of this work dates back to 1802, when it was purchased in Rome from the merchant Pietro Vitali by the Bourbon emissary Domenico Venuti. According to Nissman the work is to be identified with the *Saint Sebastian* that Cresti possibly sent from Florence to Cardinal Pompeo Arrigoni in Rome just before Cresti moved there in 1602 or in early 1603 (*Il Seicento fiorentino*, pp. 123–24, cat. no 1.27). Chappell, however, believes that the painting was executed in Rome around the end of 1602 (*The Age of Caravaggio*, pp. 164–65, cat. no. 46).

The subject, contrary to what was proposed in the Neapolitan exhibition of 1999 (Spinosa 1999, p. 186, cat. no. 173), is not St. Sebastian cured by Irene, but, as suggested by Nissman, the retrieval of St. Sebastian's body from the *Cloaca Maxima*, where the martyr had been thrown after being beaten to death by order of Diocletianus. The scene represents the moment at which the Roman matron Lucina, assisted by other followers of the saint, recovers Sebastian's body during the night in order to bury him honorably in the catacombs next to the tombs of St. Peter and St. Paul. The setting, with the statues of those saints on the right, and with a view of Rome, including Trajan's column in the background, facilitates the identification of this subject.

It is notable that the body of the saint appears to derive from the figure of Christ in a *pietà*, with clear references – as has been noticed by scholars – to works on that theme by Michelangelo, Perugino, Andrea

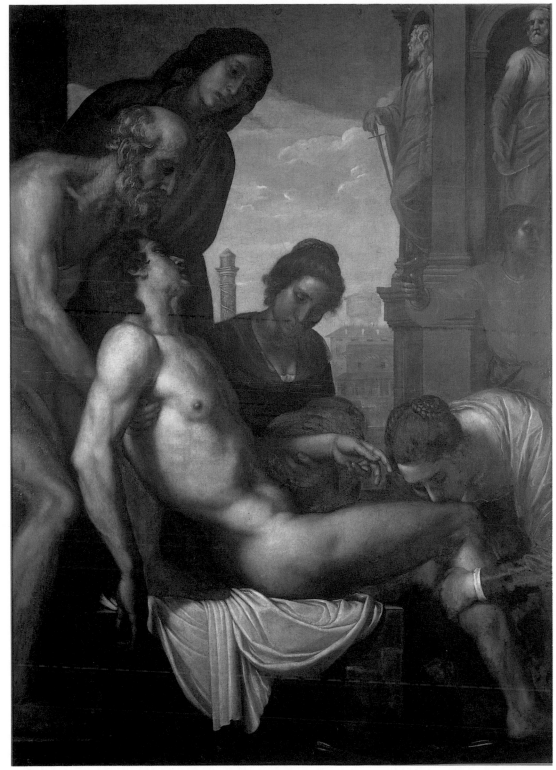

31

del Sarto, Fra Bartolomeo, Pontormo, and Cigoli.

The melancholic atmosphere that pervades the painting is achieved both by the sorrowful countenances of the figures, engaged in the slow and distressing removal of the body, and by the dull, almost monochromatic, palette of the canvas, which was restored in 1995. These features reflect the artist's early experience in Venice, and, as pointed out by Chiarini (Jaffé 1992, pp. 80–82, cat. no. 19), possibly the influence of paintings by Caravaggio in the Contarelli Chapel in San Luigi dei Francesi and in the Cerasi Chapel in Santa Maria del Popolo in Rome.

M. C. F.

32

Jacopo Carrucci,
called Pontormo
Pontorme, Empoli,
1494–Florence, 1556

Giovanni della Casa[1]
1541
oil on panel
102.1 × 78.8 cm

Washington, D.C., National
Gallery of Art. Samuel H. Kress
Collection, 1961

The painter of this magnificent portrait was correctly identified as Pontormo when it was acquired by the National Gallery in Washington in 1956. It depicts a prelate holding his ecclesiastical hat and a half-open book, in shadow, in a room giving into the interior of a typical Florentine church, the city cathedral, Santa Maria del Fiore. This reference to Florence cathedral has been the main basis for the suggestion made by some authors that the subject is Niccolò Ardinghelli, canon of Santa Maria del Fiore, who is mentioned by Vasari (Vasari–Milanesi 1878–85, 6, pp. 273–74) as being portrayed by Pontormo around 1527 (see Costamagna 1994, p. 196, no. 58). It has been proved, however, that an earlier identification of the subject as Giovanni della Casa was well founded. Although challenged by Terribile (1999), this identification has been definitively established by Fedi (2000), who has succeeded in dating the portrait's execution to between January and March 1541, when Giovanni della Casa was sent to the Tuscan capital by Pope Paul III as an apostolic commissioner to settle the delicate question of the collection of pontifical tithes.

Born 28 July 1503, della Casa was a member of the Accademia della Virtù, founded in Rome by Claudio Tolomei, and already a well-known writer when this portrait was painted. On 11 February 1541 he was admitted to the new Accademia degli Umidi, which the next year, under the auspices of Cosimo de' Medici, became the Accademia Fiorentina. On the important occasion of della Casa's inauguration, held at the house of Roberto Bartoli, central figures in the Florentine art world such as Niccolò Tribolo and Agnolo Bronzino also became members of the Accademia. On 31 March of the same year Michelangelo was admitted to the literary academy, but did not attend any of its meetings; opposed to Cosimo I's government, he refused all invitations to return to Florence.

The conception of Pontormo's portrait is inseparable from the context of the Accademia degli Umidi, as the book held by the subject would indicate. In Pontormo's work no element is fortuitous: the setting of the city of Florence is indicated not by the cathedral's dome and exterior, as was traditional, but by an interior view of the base of the vault. The subject's dress conveys his official function as apostolic commissioner, while his literary powers are emphasized by the presence of the book. The portrait was commissioned, therefore, to commemorate the political and personal success of his Florentine mission.

Giovanni della Casa might have commissioned Bronzino, then a fashionable portrait painter and a fellow member of the Accademia degli Umidi, but both personal and intellectual ties must have inclined him to turn to Pontormo, who himself had links with various members of the Accademia. The affinity of this last known oil work by Pontormo with Bronzino's portraits of the same period, especially *Portrait of a Young Man* (New York, Metropolitan Museum), confirms that the two artists maintained close working links.

1. In addition to references cited within the text, see Costamagna 1994, pp. 90, 245–47, no. 80 (with bibliography).

Ph. C.

33

33

Jacopo Carrucci,
called Pontormo
Pontorme, Empoli,
1494–Florence, 1556

*Maria Salviati and a Child
([?]Cosimo I)*[1]
ca. 1537 or 1543
oil on panel
88 × 71.3 cm

Baltimore, Maryland, The Walters
Art Museum, Acquired by
Henry Walters, 1902

In 1612 this painting was listed in the collection of Riccardo Riccardi in Florence as being a portrait of Maria Salviati with "una puttina" by Pontormo. Despite the general abrasion from the passage of time and successive restorations, its attribution to Pontormo is incontestable. Identification of the subject as the mother of Duke Cosimo I is confirmed by the fresco by the studio of Vasari depicting Maria Salviati in the room dedicated to Cosimo's father, the Sala di Giovanni delle Bande Nere in the Palazzo Vecchio, for which the present portrait was clearly the model. Only the identity of the child remains problematic due to the absence of discernible male or female features. According to the editor of the Riccardi inventory, one body of opinion took the child to be female, positing with equal likelihood Giulia, daughter of Cosimo I's predecessor, Alessandro (cared for by Maria after the assassination of her father); Bia, natural daughter of Cosimo, born in 1537; or Maria, his legitimate daughter born in 1540. If the child is a boy, he can only be Maria's son Cosimo. This last possibility is supported by the attitude of the hands, which links the child to the medallion worn by Maria Salviati, and would make the work one of the first official portraits painted in Florence. The medallion, its inscription now illegible, could therefore be that either of Giovanni delle Bande Nere, thus symbolizing

167

34

the role played by Maria Salviati, faithful to the memory of her husband and dedicated to her son's education, or that of Cosimo Pater Patriae, legitimizing Cosimo's assumption of power. In either case, by commissioning this portrait Cosimo expressed gratitude to his mother for the education she had given him, which equipped him to take power in 1537.

Dating of this portrait, a difficult matter because of its fragile state of preservation, depends in part on identification of the child. If it is a girl, the portrait could only have been painted after Cosimo's accession in 1537; if the girl were Maria this would set a date after 1543, as has been suggested by Falciani (1995), who attributes the portrait to the circle of Bronzino. If the child is Cosimo, the portrait could have been painted either after the death of Giovanni delle Bande Nere in 1527, or after Cosimo's

assumption of power in 1537 — during which period Vasari (Vasari–Milanesi 1878–85, 6, p. 282) mentions a portrait of Maria Salviati painted by Pontormo as well as one of Cosimo, who is sometimes taken as the subject of Portrait of a Halberdier (Los Angeles, J. Paul Getty Museum) — or posthumously, after the death of Maria Salviati in 1543. A date of around 1527 would seem the least probable; between 1526 and 1537 Maria Salviati experienced grave financial problems (see Paragino 1999, pp. 36–38). That this portrait is the one commissioned from Pontormo in 1537 is no more probable; another portrait of Maria Salviati (Florence, Galleria degli Uffizi), in which she is depicted pregnant with her son, might equally be the one mentioned by Vasari. The fact that Cosimo commissioned numerous portraits of members of his family with the aim of

enhancing the legitimacy of his dynasty might be reason to believe that the present portrait was painted at a later date (see Cropper 1997, pp. 3–5).

1. In addition to references cited within the text, see Costamagna 1994, pp. 90, 236–38, no. 77 (with bibliography).

Ph. C.

34

Jacopo Carrucci, called Pontormo
Pontorme, Empoli, 1494–Florence, 1556

Alessandro de' Medici[1]
1534
oil on panel
35.3 × 25.8 cm (painted surface 31.4 × 25.8 cm)

The Art Institute of Chicago, Mr. and Mrs. Martin A. Ryerson Collection

In his *Life* of Pontormo (Vasari–Milanesi 1878–85, 7, p. 278), Vasari mentions a small portrait of Duke Alessandro, the size of a "carta mezzana," which the artist used as a model for a full-size portrait (Philadelphia, John G. Johnson Collection; see Costamagna 1994, pp. 222–24, no. 72). The work shown here was recently recognized as this small portrait, long considered to be lost (see Lloyd 1993, pp. 197–202). Painted from life, it depicts only the face of the Duke, highlighting the psychological dimension. The two portraits were painted around the time of the death of Pope Clement VII on 15 September 1534, and in the full-size portrait the Duke is in mourning attire. In the latter, the coat of mail is of inferior workmanship to the rest of the painting and is certainly a later addition – probably by Cristofano dell'Altissimo – intended to lend a less austere and more official air to the work. It is this modified version of the Duke's portrait (conserved in the Medici collections) that served as model for the

disseminated image of his physical appearance, as the large number of known copies demonstrates (see Langedijk 1981–87, 1, pp. 221–24).

After the fall of the last Florentine republic, Pontormo was obliged to enter the employ of the Medici family. He was entrusted by Ottaviano de' Medici with the task of completing the decoration of the Salone of the Villa Poggio a Caiano (in which he was unsuccessful), and by Alessandro with that of building the loggias of the Villa Careggi, left partly unfinished on the death of the Duke. During the same period, at Michelangelo's request, he made a painting of the cartoon *Venus and Cupid*, composed for Bartolomeo Bettini, a close friend of the sculptor and himself known for his republican sympathies. Alessandro acquired the picture (Florence, Galleria dell' Accademia; see Costamagna 1994, pp. 217–20, no. 70) from Pontormo's studio, much to Michelangelo's dissatisfaction. Relations between Michelangelo and the young duke were particularly strained, and the former feared retaliation from Alessandro, who despised him. In 1534 Michelangelo left Florence for good, declining all later invitations from Duke Cosimo to return. Indeed, at the instigation of Donato Giannotti, he offered Cardinal Niccolò Ridolfi a bust of Brutus (Florence, Museo Nazionale del Bargello), which was an idealized portrait of Lorenzino de' Medici, deliverer of Florence from the tyranny of Alessandro.

1. In addition to references cited within the text, see Costamagna 1994, pp. 86, 221–22, no. 71 (with bibliography); and Langedijk 1981–87.

Ph. C.

35

SCIPIONE PULZONE
Gaeta, ca. 1550–Rome, 1598

*Ferdinando I de' Medici,
Third Grand Duke of Tuscany*
1590
oil on canvas
142 × 120 cm
inscribed on the back: "Scipione
da Gaeta faciebat l' 1590"

Florence, Galleria degli Uffizi

This portrait, along with one of
Grand Duchess Christine of
Lorraine, was part of the
so-called "courtly series"
commissioned by Francesco I
de' Medici (see S. Meloni Trkulja
in Berti 1979, p. 700; and
Langedijk 1981–87, p. 137ff) and
are mentioned by Giovanni
Baglione in his biography of the
artist: "And when he was invited
he set out to Florence to go to
Ferdinando who had then been
made Grand Duke, to execute
his portrait with madame the
grand duchess; when he arrived,
he gave such a faithful depiction
of them both that the only
thing they missed was the
capacity for speaking."[1]

As a younger brother,
Ferdinando, son of Cosimo I
and Eleonora of Toledo, was
destined for an ecclesiastical
career. He was appointed
cardinal at the age of fourteen,
and when he reached his
majority he moved to Rome,
where he lived in a villa on the
Pincian hill, which he
refurbished as his own residence
and which henceforth bore his
family name. There he
accumulated a remarkable
collection of works of art,
including paintings, *objets d'art*,
and precious furnishings,
acquiring in particular antique
marble to decorate the rear
façade of the villa and the
garden. Among contemporary
painters he favored Jacopo
Zucchi, who executed a
valuable series of small pictures
on copper which were based
mainly on mythological subjects,
and most of which are in the
Galleria degli Uffizi (see
Hochmann 1999).

Like his father, Ferdinando
possessed great governing
abilities. Following his accession
in 1587 he reorganized the
Florentine state and boosted its
administrative and defensive
structures. Through economic
development of the port of
Livorno he succeeded in
strengthening the naval power
of the Order of the Knights of
St. Stephen, whose victorious
enterprises in the Mediterranean
and on the coast of northern
Africa he commissioned
Bernardino Poccetti to depict in
a series of frescoes in the Sala di
Bona of the Palazzo Pitti (see
cat. no. 195).

In the context of the arts,
Ferdinando distinguished himself
by maintaining his father's policy
of patronage, sponsoring great
sculptors such as Giambologna
and Pietro Tacca, who executed
the equestrian monument
dedicated to Cosimo I in the
Piazza della Signoria and that
of Ferdinando in the Piazza della
Santissima Annunziata
respectively. Thus he continued
the process of decorating
Florence's key squares that had
begun in the early sixteenth
century. Intending to enrich the
city with important public works
that would also glorify the
Medici dynasty, he founded the
Galleria dei Lavori in the Uffizi
and initiated the Chapel of the
Princes next to San Lorenzo.
The new building was
remarkable for its sumptuous
decoration in precious marbles
and *pietre dure*, which became
the pride of Florentine artistic
production, acquiring
international fame as the
"Florentine mosaic."

Ferdinando's marriage to
Christine of Lorraine was a
political move intended to
promote the image of the
Medici dynasty. Born in 1565,
Christine was the daughter of
Charles III of Lorraine and
Claudia of France, in turn the
daughter of Henry II and
Catherine de' Medici, and was
therefore a distant relation of
Ferdinando. As Catherine's
favorite granddaughter, Christine
inherited a part of her collection

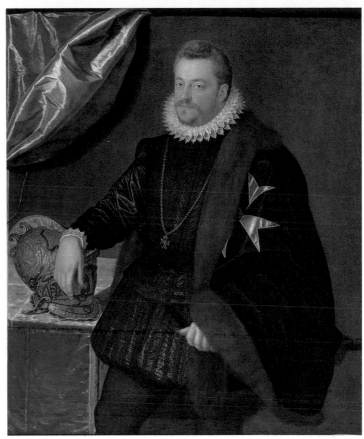

35

of valuable artworks. A strong-
willed woman, she supported
the policy of her husband, who
succeeded in placing another
Medici on the throne of France
– Maria, daughter of his brother
Francesco, who married Henry
IV in 1600 – and orchestrated
the marriage of his son and heir
Cosimo to the Austrian
Archduchess Maria Maddalena
of Hapsburg (see cat. no. 6). On
Ferdinando's death Christine
became very influential within
the Florentine court, assuming
the title of co-regent with her
daughter-in-law when her son
Cosimo II died in 1621 and
maintaining a powerful role until
her death in 1636 (see Martelli
1999). It is likely that the
patronage generously bestowed
on Jacques Callot and his success
at court (see cat. nos. 161–64
and 218–19) were due partly to
the fact that, like the grand
duchess, he was originally from
Lorraine.

1. "E parimente chiamato andò a
Fiorenza da Ferdinando all'hora fatto

gran Duca, accioche lo ritrahesse in
maestà assieme con Madama gran
Duchessa; giunsevi, e l'uno, e l'altra
si al vivo espresse, che non mancava
loro altro, che la parola." Baglione
1642, p. 53.

M. C.

36

FRANCESCO DE' ROSSI,
CALLED SALVIATI
Florence, 1510–Rome, 1563

The Raising of Lazarus[1]
ca. 1541–42
oil on panel
89 × 65.5 cm

Rome, Galleria Colonna

CHICAGO AND DETROIT ONLY

This painting was regularly listed
in the collection of the Salviati
family, first in Florence, then in
Rome, until the last member of
the family, Zeffirina Salviati,
married the constable Fabrizio
Colonna in 1718. The traditional
attribution to Francesco Salviati

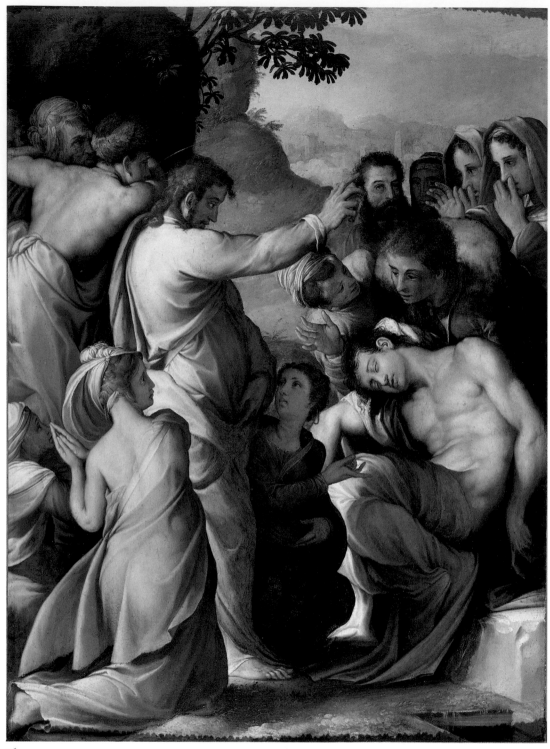

36

his depiction of the witnesses' attitudes of disgust Salviati is at pains to indicate the odor of putrefaction given off by Lazarus's body. In this he follows a long tradition dating back to Giotto (Padua, Arena Chapel) and Agnolo Gaddi – according to Vasari's description of a lost work by the artist – and continuing with Sebastiano del Piombo (London, National Gallery) to Girolamo Muziano (Vatican, Pinacoteca Vaticana), in which the witnesses cover their noses with a veil.[2] Salviati gives an original, more realistic and dynamic interpretation of the group, which he depicts in the same manner in the tapestry *The Sacrifice of Alexander* (Naples, Museo di Capodimonte; see Mortari 1998, p. 292, no. 11), a work of uncertain date. The expressive gesture of the holding of the nose also appears in an engraving, *Antique Sacrifice* of 1542 by Enea Vico after Salviati. Around 1543 Giulio Clovio, in the Roman circle of Salviati, depicted similar figures in the illuminated borders of *The Triumph of Death* and *The Raising of Lazarus* in the Farnesi Book of Hours (New York, Pierpont Morgan Library, ff. 79v and 80r).

Salviati's *Raising of Lazarus* probably belongs to the same period, after the artist's journey to northern Italy in 1539–40, during which he had the opportunity to familiarize himself with the work of Parmigianino, whose presence is felt here in the contrasting palette and lateral illumination. The figure of a man standing on the far side of this group has been identified as Alamanno Salviati, giving rise to the idea that the work was executed in Florence during the artist's time there between 1543 and 1548, but after the exhibition *Francesco Salviati ou la Bella Maniera* of 1998 this dating was shown to be too late. The spirit of the work is more closely linked to the culture of Rome, as demonstrated by the borrowings from Raphael's frescoes in the Vatican. A study in the Louvre for a seated male nude (inv. 10913; C. Monbeig Goguel in

was dropped in the eighteenth century, and in Colonna's inventory of 1783 the work appears under the name Parmigianino.

From his youth, the painter Francesco de' Rossi adopted the name of his patron, Cardinal Giovanni Salviati, a great collector, one of the most influential figures at the

pontifical court, and leader of the Florentine *fuorusciti*, who opposed the coming to power of Alessandro and then Cosimo de' Medici. The presence of this picture in the Salviati family's Florentine palace seems to suggest that *The Raising of Lazarus* was painted not for the Cardinal but for his brother Alamanno, resident in Florence,

who promoted the painter's return to his native city and his entry into the service of Cosimo I after 1543.

The subject, assimilated into the Roman Catholic Church during the Renaissance, took on particular significance in the sixteenth century during the years between the Reformation and Counter-Reformation. In

Monbeig Goguel 1998, no. 16),[3] attributed to Salviati in 1998, shows the artist's interest in the depiction of slightly twisted, youthful, muscular bodies, his subjects clearly being derived from antiquity rather than from life. It is interesting to compare Salviati's treatment of the male body here with the nudes of Pierino del Vaga (Genoa, Palazzo Doria, *Fall of the Giants*, or Rome, San Marcello al Corso, Chapel of the Crucifixion, *Adam*) and that of Bronzino (cat. no. 17) – also Mannerist responses to Michelangelo.

1. In addition to references cited within the text, see P. Costamagna in Monbeig Goguel 1998, pp. 158–59, no. 42 (with preceding bibliography); and Costamagna 2001.
2. To these examples given by Costamagna 1998 may be added the great window by Guillaume de Marcillat, Vasari's master, in the choir of Arezzo cathedral.
3. Attribution of this unusual drawing to Salviati, confirmed by comparison with *The Raising of Lazarus*, was accepted by Petrioli Tofani 2001, n. 50, who writes of "impressioni dal vero."

C. M. G.

37

FRANCESCO DE' ROSSI, CALLED SALVIATI
Florence, 1510–Rome, 1563

Christ Carrying the Cross[1]
ca. 1547
oil on panel
66 × 45 cm

Florence, Galleria degli Uffizi

The size of this painting, a "most important painting jewel,"[2] is suggestive of a small devotional picture intended for a private room or oratory in the palace of some Florentine noble. It is currently shown in the Tribuna of the Uffizi, in the collection of masterpieces of Florentine painting. The work must have appealed to the refined taste of the Tuscan aristocracy for its "Flemish" air, luminous facture reminiscent of Bronzino, and exceptional

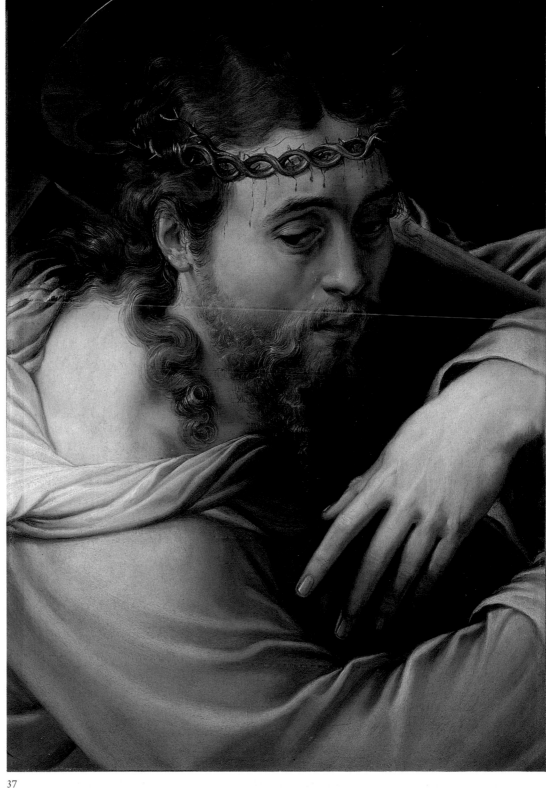

37

richness of detail, and for its display of meticulous goldsmith work, from the gilded, individually depicted curls of Christ's hair to the flowing beard composed of gold chips, and the minuscule drops of blood beading on his forehead, bruised by the thorns of his crown.

In a context that linked spirituality with eroticism, as with Parmigianino, the work's sensuality does not invalidate its function as a devotional image. Its half-length depiction of Christ carrying the cross derives from the large-scale paintings of Sebastiano del Piombo, but it is far less solemn in its content and monumental in its forms; one can understand why Michelangelo did not support Salviati in Rome and preferred

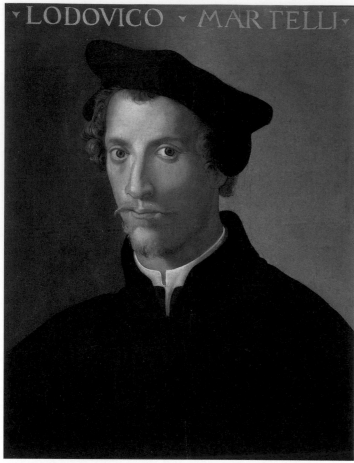

LODOVICO · MARTELLI ·

38

TOMMASO MANZUOLI,
CALLED MASO DA SAN
FRIANO (attributed to)
Florence, 1531–1571

Lodovico Martelli[1]
ca. 1560–65
oil on canvas
58.5 × 45 cm

Florence, Museo di Casa Martelli

FLORENCE ONLY

The identification of the sitter as the poet Lodovico di Lorenzo Martelli has been accepted by scholars despite the fact that many elements of his life and that of his eponymous cousin Lodovico di Giovan Francesco have been conflated. The coincidence in the names of the two contemporaries – one a celebrated poet and the other renowned for his military enterprises – has caused confusion between their two biographies, further complicated by a lack of documentary evidence.

Lodovico di Lorenzo was born on 31 March 1500 and died after 1528. We know that in 1527 he left Florence for political reasons: according to some sources he went to Salerno at the invitation of Ferrante Sanseverino, while others say he went to Naples to serve Alfonso of Avalos, with whom he participated in the battle of Capo d'Orso (28 April 1528), writing a short poem on the subject. Tiraboschi (1824) reports that in 1531 Claudio Tolomei wrote a letter accompanying a tragedy by Lodovico Martelli entitled *Tullia*, informing his addressee that the poet was dead. The tragedy was published posthumously in an edition by Giovanni Gaddi by the publisher Blando in Rome in 1533. A complete edition of Martelli's works, including his translation of book IV of the *Aeneid*, was published by Giunti in Florence in 1548.

The quality of the Martelli portrait is good, and with the evidence of its most recent restoration in 2001, Civai's theory that it may be a copy or

a replica of the panel among the Gioviana series of portraits in the Uffizi appears unfounded (Civai 1990, p. 38, nn. 11–13). It is more likely that this posthumous representation derives from the full-length portrait now in the Loeser Collection (Florence, Palazzo Vecchio), with variations that suggest an expressive freedom in its artist, prompting Gregori (1986) to suggest that it may be by the hand of Maso da San Friano. The idea is convincing, and although the painting does not reveal the typical elements of Maso's portrait style, it shows affinities with his historical paintings of the 1570s. A cruder version of the Loeser painting, previously attributed to Pontormo but in fact by a painter close to Michele Tosini, was sold at Sotheby's, Florence, in September 1983 and published by Costamagna (1994, p. 289).

The image of the poet has enjoyed great popularity. The Loeser version, slightly cut down on the top, is probably the original, executed while Lodovico was still alive and therefore dating to around the end of the 1520s or the early 1530s, as the style of the work and its background, as well as the clothing, also suggest. The Sotheby's version seems to have been painted slightly later; it preserves the original dimensions and bears an inscription on a piece of paper on the table that makes it clearly identifiable. It may have a copy, perhaps commissioned by the poet's relations to be given to Giovanni Gaddi in Rome. The sequence continues with the work exhibited here, painted in a style very close to Maso's, following the typical format of the Martelli family portrait collection, from which the portrait of Baccio Martelli (Museo di Casa Martelli) also survives, with similar dimensions and an identifying inscription, painted soon after 1564 by Santi di Tito. The last of the series is the Gioviana version, but its poor state of conservation does not allow detailed analysis. It has been attributed to Cristofano

Daniele da Volterra, although the two shared political friendships and patrons, including with Giovanni Salviati. Stylistically, the panel takes its place between the *Lamentation of Christ* in the Galleria Palatina (see P. Costamagna in Monbeig Goguel 1998, pp. 144–45) and that painted in 1547–48 for the Dini Chapel, Santa Croce (see Hall 1979, pp. 122–23). It must therefore date from Salviati's sojourn in Florence in 1547–48, when he was working on the great *Deposition* above the altar of the Dini Chapel, with which *Christ Carrying the Cross* has many stylistic affinities.

The painting is first mentioned in the 1654 inventory of Medici property, when it was located at the Villa Poggio Imperiale. It is likely that it was then offered to a member of the ruling family, perhaps to the Grand Duchess Vittoria della Rovere, who was living at the villa. Curiously, the attribution to Salviati was lost for some

time and the work appears in inventories under the name Giorgio Vasari, friend and biographer of the artist. A studio replica (Rome, Gallery Corsini; see Mortari 1992, no. 80; and A. Cecchi in Monbeig Goguel 1998, p. 134) showing variations – especially on the shoulder, which bears beating marks – and an early copy in the Frescobaldi Collection in Florence, are evidence of the interest aroused by the painting.

1. In addition to references cited within the text, see A. Cecchi in Monbeig Goguel 1998, pp. 134–35, no. 28 (with bibliography); and Jaffé 1998.
2. Jaffé 1998.

C. M. G.

dell'Altissimo but may well have been painted by an artist of the following generation.

1. In addition to references cited within the text, see *Letteratura Italiana: Gli autori* 1991, vol. 2, p. 1154.

M. B.

39

SANTI DI TITO
Borgo di San Sepolcro,
1536–1603

Adam and Eve[1]
ca. 1588–90
oil on canvas
82 × 138 cm

Florence, Museo di Casa Martelli

FLORENCE AND CHICAGO ONLY

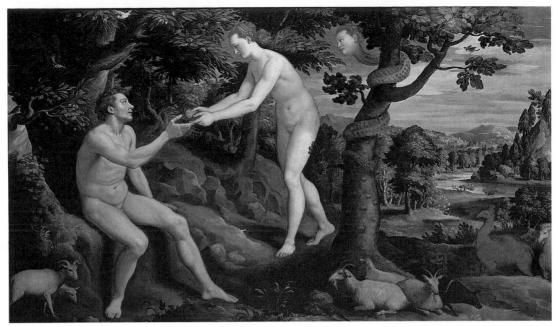

39

Santi di Tito provides an unusual and original treatment of this subject. Seated on the left, on the root of a tree, Adam holds out his right hand to Eve, who, almost upright, offers him the forbidden fruit. Both are represented in the chaste nudity of the Old Testament, respecting the mores of the Counter-Reformation. A snake is coiled in the tree on the right of the picture, reminding the viewer that before the Fall the snake was not forced to slide along the ground. His head is an image of Eve's face, indicating that woman is the cause of the Fall.

These figures are set against a landscape with many vegetal and animal details, crystalline, light, and meticulous in execution, reminiscent of northern European elements and rich in symbolic significance, such as the camel in the background, indicating discretion, prudence, wealth, sobriety, and temperance, and the goats in the foreground, suggesting fecundity, deceit, lasciviousness, lustfulness, and foolishness. There was no shortage of Flemish, German, or other northern European paintings and prints in Florence at the time that Santi di Tito was active. In particular I believe that this landscape can be linked to the engravings of Jan Sadeler

(see Bartsch, vol. 70, part 1, pp. 19, 44, 45), which also inspired in Poccetti's frescoes of similar themes in Santa Maria degli Angeli in Florence. However, while for Poccetti Flemish landscapes were a constant source of naturalistic inspiration, for Santi di Tito, the northern influence of this painting is unique in his *oeuvre*.

Unfortunately the identity of the original patron, which might provide an insight into Santi's combination of Tuscan and Flemish visual culture in this work, is unknown. We do know, however, that the Archbishop Giuseppe Maria Martelli (1678–1741) was an avid collector of Flemish prints as well as those by Antonio Tempesta, as documented in an inventory of 1740 in which the *Adam and Eve* appears as a "pendant" to Tito's *Annunciation* (no longer in the Museo di Casa Martelli). Together these paintings suggest that purification follows sin. Adam corresponds to the image of God as the embodiment of spirit in creation, while Eve is the mother of mankind; the model of femininity that is tainted by her is purified in Mary.

Following the recent restoration of this work, the attribution to Santi di Tito, first suggested in 1740 (Archivio di

Stato di Firenze, Fondo Martelli 476, ins.44, c.515 v.), must be accepted despite the doubts expressed by Gregori (1986) and by Civai (1990, p. 85, note 129, fig. 70). There are clear stylistic affinities with Santi's altarpiece *San Nicola da Tolentino with Santa Monica and Augustine*, executed in 1588 for the church of San Jacopo tra i fossi in Florence (now in the Pinacoteca Comunale of Sansepolcro): for example, the chained female half figure on the right of the altarpiece, representing lust, has a similar hairstyle and facial features to the snake. Other analogies can be seen with the *Immaculate Conception* in the church of San Girolamo, Volterra, also dating to the 1590s.

1. M. Gregori, "Catalogo e stima della collezione Martelli a Firenze," 1986, in the archive of the Galleria Martelli.

M. B.

40

GIUSTO UTENS
(?)Brussels–Carrara, 1609

(a) *Medici Villa and Garden at Castello*[1]
1599
tempera on canvas
147 × 233 cm

Florence, Museo Topografico "Firenze com'era"

(b) *Medici Villa and Garden Park at Pratolino*
1599
tempera on canvas
145 × 245 cm

Comune di Firenze, Museo Topografico "Firenze com'era"

These captivating lunettes are two of seventeen depictions of Medici country residences in Tuscany that Ferdinando I commissioned in 1599 from Giusto d'Utens, a Flemish painter resident in Italy, for the principal hall of his new villa at Artimino (see fig. 57 above). The idea of representing family properties in one's residence was not novel, although each cycle had its own rationale. Unusual, however, was the way in which Ferdinando wished these colorful works to stand out, not against a backdrop of competing paintings or tapestries, as was the princely norm and the case with Zucchi's

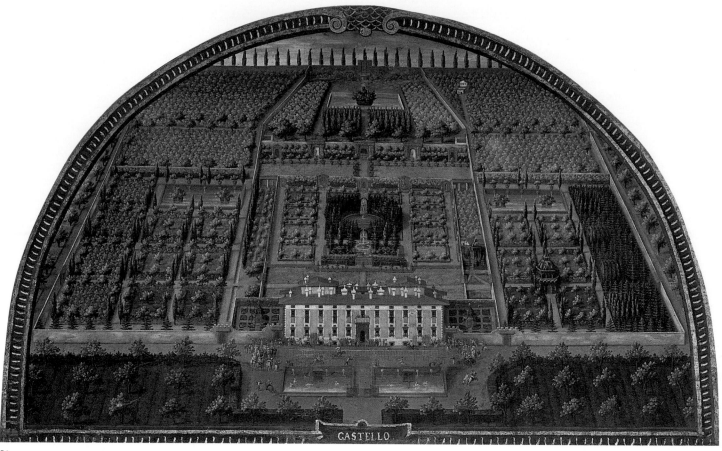

40a

topographical depictions at
Ferdinando's villa in Rome, but
against a luminous background
of plaster made with marble
dust, the surface finish that he
ordered for Artimino's interiors.
Giusto drew the Medici
properties *in situ* but each
presented complexities that
could not be captured in a
single view. Castello, begun by
Niccolò Tribolo for Cosimo I
in 1538 and continuously
elaborated throughout the
century, and Pratolino, begun by
Bernardo Buontalenti in 1569
for Francesco I and largely
completed by Francesco's
death in 1587, are good cases
in point.

Giusto's representation of
Castello manipulates the garden's
components so that its dominant
axis coincides with that of the
palace. Handy for underscoring
the opposing teams of jousters
in front of the façade and
reinforced by the nearby
fishponds, this symmetry is
physically inaccurate, however,

and the degree of unified
planning it suggests for the
historical evolution of the
complex is misleading. The
garden consisted of a series of
terraces. These were divided into
planted areas by pathways and
given axial and conceptual focus
by several grand sculptural
events, interconnected by
imagery that alluded to the
physical prosperity of Florence
within Tuscany and the political
prosperity of the Florentines
under Cosimo I. The multi-basin
forms of its two principal
fountains were inventive, and the
watery conceits devised for their
crowning figures played artfully
with classical commonplaces: the
breath that Hercules squeezes
out of Antaeus is a spectacular
jet of water, while Florence, like
Venus born from the sea, wrings
water from her hair (cat. no. 74).
Castello's wealth of marble and
bronze sculpture, which included
a colorful zoo of stone animals
in the grotto, offered sculptors
like Tribolo, Ammanati, and

Giambologna the chance to
design for a rural rather than
an urban setting. Giusto's
representation of the garden's
groves, flora, and animal habitats
is more generic than precise
but potted palms, thickets for
trapping birds, and beds of
simples can be identified, though
not the varied citruses and
mixed evergreen espaliers
extolled by the French naturalist
Pierre Belon, nor the wonderful
tree house with its aerial
fountain described by Vasari.
Located low on the slope of
an imposing peak of the
Apennines, Castello was
approached by an avenue lined
with a canopy of mulberry trees,
which Cosimo hoped to extend
to the Arno, lining the whole
length with gurgling canals
teeming with fish and crayfish.

The greater size and
complexity of Pratolino, sited on
a higher Apennine slope, posed
different problems. Although the
garden was transformed and the
residence destroyed in the early

nineteenth century, surviving
building accounts, images, and
descriptions help to indicate the
lunette's accuracy though not
to recapture the sensory impact
of Pratolino's overwhelming
population of hydraulic
automata, with sounds and
movements that can only be
imagined. The painting's format
enabled Giusto to depict only
half the complex so he chose
the half in which the palace
most commanded its
surroundings and the garden
contained a greater number and
variety of events, distributed
more ingeniously. Meandering
concatenations of irregularly
shaped pools flowed towards
geometric collecting basins,
presided over by intriguing
sculptural narratives (a laundress
with a peeing boy wrings water
from her washing, and a peasant
confronts a salamander in a
marshy pond). Water-generated
music emanated from an artificial
mount Parnassus, entertaining
those dining in the adjacent tree

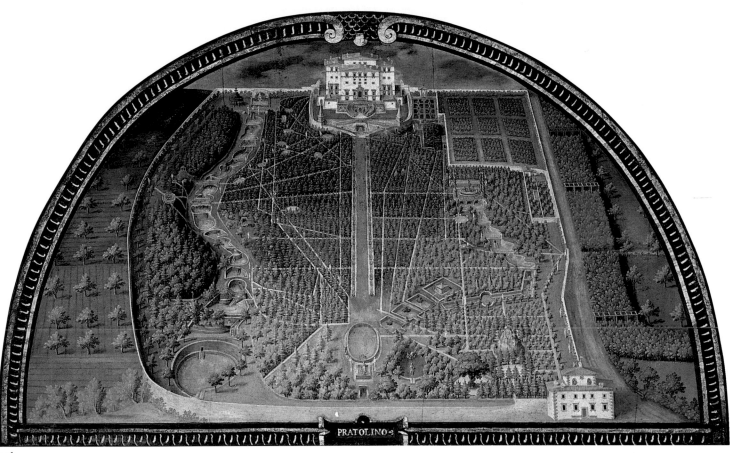

40b

house. Rainbows formed as sunlight struck the watery arcade created by jets lining the principal avenue, a diaphanous construction so lofty and well-judged that visitors could ride beneath it on horseback and remain dry. Near the palace, birds in a thickly planted aviary covered with copper mesh sang while passion drove lovers along unpredictably intersecting paths, densely shaded with evergreens, towards the distant trap of Cupid's grotto, in which a spinning statue of the god of love shot arrows of water at them.

Hidden in Giusto's image are the myriad grottoes, automata, and water jokes beneath the palace, and Giambologna's stupendous *Appennine*, still surviving in the garden's undepicted northern half. This thirty-six-foot-high personification contained three floors of grotto chambers, ornamented and plumbed to reflect the mineral substance and rivulets of a mountain's

interior. Outside the walls lay facilities for storing the ice and snow that cooled Francesco's summer drinks and foods, and beyond, an artificial lake stocked with fish, constructed under dismal conditions by peasants commandeered from the countryside. While literati and philosophers extolled art's competition with nature at Pratolino, Tuscan laborers broke into the park, cut noses off its statues and freed its birds from the aviary – an irritating reminder to Francesco that his ideal garden commonwealth was at variance with the larger rural world that contained it.

1. See Brown 1969; Vasari 1976, vol. 6, pp. 70–85, 98–99; Wright 1976; Zangheri 1979; Lazzaro 1990, pp. 161–89; Acidini Luchinat and Galletti 1992, pp. 67–77; Mignani 1993; David 1994, pp. 1–19; Wright 1996; Brunon 2000; and Butters 2001a.

S. B. B.

41

Giorgio Vasari
Arezzo, 1511–Florence, 1574

Venus at Her Toilette[1]
ca. 1558
oil on panel
154 × 124.7 cm

Stuttgart, Staatsgalerie

One of Vasari's finest paintings, this panel shows Venus attended by the Three Graces, Aglaia, Euphrosyne, and Thalia, while Cupid, hovering above, holds flowers over the head of the goddess of love. Vasari treated this subject, more common to Venetian than Florentine painting, on several occasions in his career. As a youthful painter in 1532 he made a version for his then patron, Cardinal Ippolito de' Medici (1511–35), in Rome. This large canvas is now lost but known by a long and ardent description given by Vasari in a letter written while he was still working on the

painting (Frey 1923–40, vol. 1, p. 2). According to this letter the painting showed a nude and seated figure of Venus, surrounded by the Three Graces. One was kneeling and holding a mirror, while another was plaiting a pearl necklace – recalling Venus's birth from the sea – into her hair. The third was pouring water from an emerald vase into a basin made of mother of pearl, from which doves and swans, the traditional attributes of Venus, were drinking. While this description corresponds largely with the Stuttgart composition, the painting of 1532 further included a sleeping figure of Cupid, certain *amorini*, and a hidden satyr contemplating the beauty of Venus and her attendants. The painting was a great success with both Cardinal Ippolito de' Medici and Pope Clement VII, and secured Vasari the subsequent commission for a larger canvas of a *Battle of Satyrs*, now also lost.

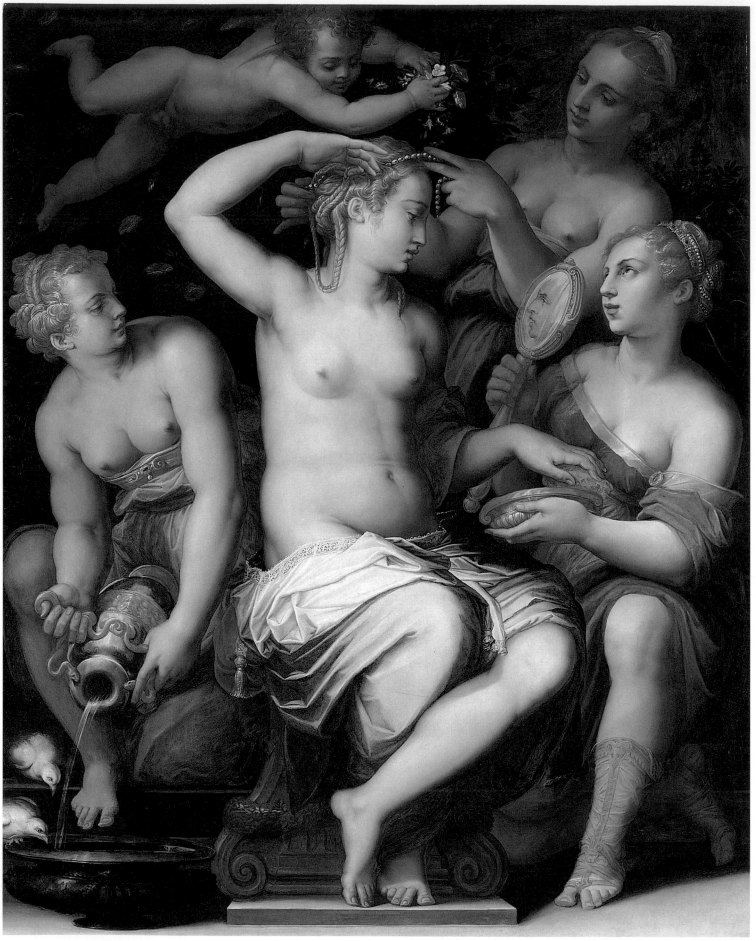

41

The Stuttgart *Venus at Her Toilette*, painted on poplar, is a mature work dating from the second half of the 1550s, yet its composition reflects almost certainly that of the 1532 painting, although simplified by the omission of the additional figures mentioned in the letter. The exact circumstances of the commission are not known but the painting is probably identical with the one Vasari executed for his friend Luca Torrigiani in Florence in 1558. Vasari mentions this painting in the *Ricordanze*, the inventory of his commissions, where it is described as a large panel of Venus adorned by the Three Graces.[2] The painting originally formed a pair with a *Bacchanal*, now in the Radiscev Museum of Fine Arts, Saratov, which, however, is accounted for neither in the *Ricordanze* nor in any other known source (Markova 1992, pp. 237ff.). Before their dispersal in a Florentine sale in 1825, both paintings belonged to the Galleria Gerini, a famous collection formed in Florence in the seventeenth and eighteenth centuries. Principally an erotic genre piece in mythological guise, the Stuttgart *Venus at her Toilette* appears also to offer some allegorical meaning: by showing an older, apparently genderless, face as Venus's mirror image, Vasari mingled a seemingly carefree depiction of female beauty with the old subject of *vanitas*, so pointedly put in Shakespeare's Seventy-Seventh sonnet: "Thy glass will show thee how thy beauty wears."

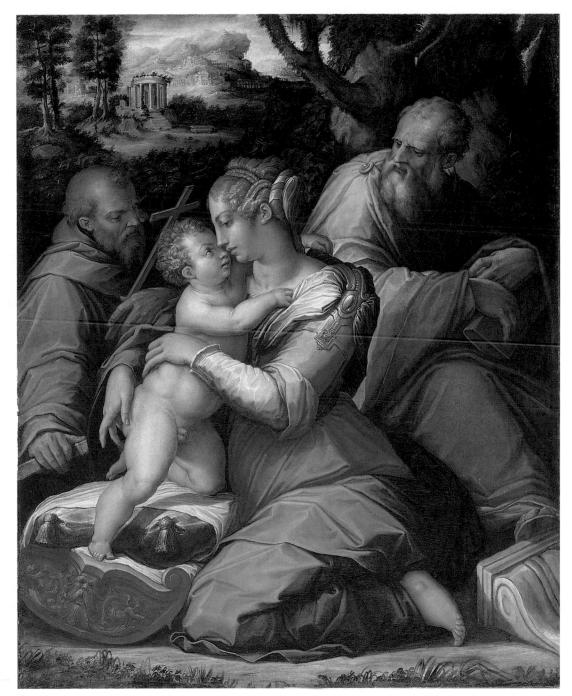

42

1. In addition to references cited within the text, see G. Ewald in Corti et al. 1981, pp. 74–75, no. 4/8.
2. "una Venere che le Gratie la fanno bella." Frey 1923–40, vol. 2, p. 874, no. 252.

F. H.

42

Giorgio Vasari
Arezzo, 1511–Florence, 1574

Holy Family with St. Francis[1]
1541–42
oil on canvas
184.2 × 125.1 cm

Los Angeles County Museum of Art. Gift of the Ahmansen Foundation

CHICAGO AND DETROIT ONLY

In October of 1541, invited by his friend, the poet Pietro Aretino, Giorgio Vasari set out for his first visit to Venice. He stayed at the house of another friend, the Florentine banker and collector Francesco Leoni. Both men belonged to the entourage of Ottaviano de' Medici, a member of a lesser branch of the family but perhaps the most important supporter of the young painter from the early 1530s. Some of Vasari's best-known works for Ottaviano are

the *Duke Alessandro de' Medici in Full Armor*, and the posthumous likeness of Lorenzo il Magnifico, both of which have been displayed in the Tribuna of the Uffizi since the later sixteenth century. Shortly before his departure for Venice, Vasari had sent Leoni four paintings, two of which were based on Michelangelo's famous cartoons of *Venus and Cupid* and *Leda*, respectively. According to his *Ricordanze*, Vasari painted for Leoni another large canvas of a

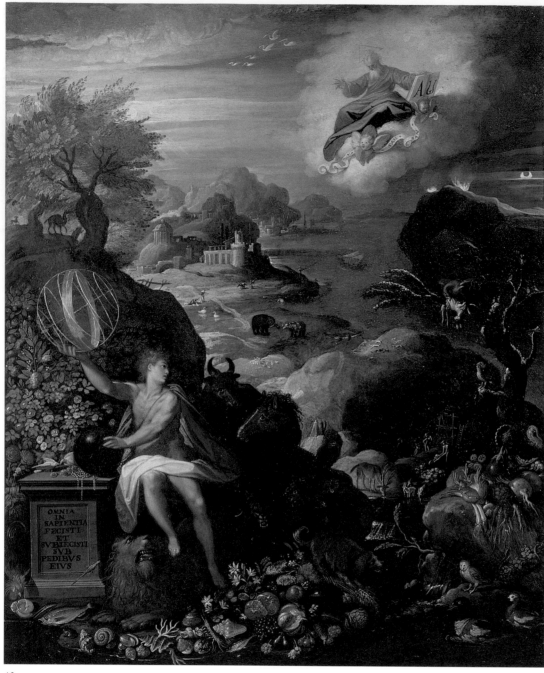

43

such as the Sybils and Prophets of the Sistine ceiling.

The importance Vasari must have attached to this painting, designed to impress his patron, is further reflected in its meticulous execution, as well as in the thorough attention given to details such as the Virgin's coiffure or the golden buckle on her left shoulder. These reveal Vasari's admiration for Parmigianino, whose work he had studied extensively during a visit to Bologna in 1539–40. The richly carved *all' antica* crib, however, is more closely modeled on works by Giulio Romano, such as his *Madonna della Gatta* (Naples, Museo di Capodimonte). On his way to Venice Vasari had paid Giulio a four-day visit in Mantua, and the exposure to the older master's work left traces in Vasari's subsequent paintings. The background with a variation on the Temple of Vesta at Tivoli symbolizing the end of paganism and the rise of the new Christian order, shows one of Vasari's finest landscapes.

Throughout the 1540s and early 1550s, and in particular prior to his appointment as court artist to Cosimo I de' Medici in 1555, Vasari made numerous variations on the theme of the Holy Family, yet the Los Angeles painting is perhaps his most successful rendering of the subject.

1. See Corti 1989, pp. 40–41, no. 23; and Conisbee 1991, pp. 173–76, no. 45.
2. ". . . et a Francesco sudetto feci un quadro grande in tela, drentovi lavorato a olio la Nostra Donna intera col figliolo in braccio et un San Giuseppe intero, a sedere, cosi un San Francesco." Frey 1923–40, vol. 2, pp. 858–59, no. 119.

F. H.

"full-length Madonna embracing her Son, with the seated figures of St. Joseph and St. Francis."[2] The Los Angeles *Holy Family with St. Francis* is certainly to be identified with this painting, and Vasari most likely painted it in Leoni's house in Venice.

Vasari's first major work made in Venice, this painting was no doubt conceived as a showpiece of the new *maniera*, or style, that he had developed in the previous years and that came to dominate central Italian painting for several decades. In 1538, the artist had visited Rome, and his extensive studies of the work of Raphael and his school resulted in a dramatic shift in style, which had previously been modeled on the manner of such Florentine artists as Andrea del Sarto and Rosso Fiorentino. He made numerous drawings after works by Raphael and his pupils, and after antique architecture and sculpture, which he subsequently used in his own compositions. It is no surprise, therefore, that Leoni's *Holy Family with St. Francis* is based on Raphael, too. More specifically, it freely paraphrases the latter's large *Holy Family* in the Louvre, a painting that Lorenzo de' Medici and Pope Leo X had sent as a present to the Queen of France in 1518. Vasari probably knew the composition from Caraglio's engraving of it, made in the early 1520s (Höper et al. 2001, p. 322, no. D39.1). Yet at the same time Vasari's figures are somewhat heavier than Raphael's, clearly reflecting his study of Michelangesque models

43

JACOPO ZUCCHI
Florence ca. 1540–1596

The Golden Age (Allegory of Creation)
ca. 1585
oil on copper
50 × 40 cm

Rome, Galleria Borghese

CHICAGO AND DETROIT ONLY

This painting is first mentioned in the inventories of the Galleria Borghese in 1693 (Della Pergola, 1959, no. 67, sup. no. 89) and was subsequently atttibuted to Jan Brueghel by Leo van Puyvelde (1950, p. 182). It escaped the notice of Voss and was given to Jacopo Zucchi by Roberto Longhi (1967, p. 346, n. 293).

There is no documentation or precise date for this commission, but, through a stylistic comparison with *The Coral Fishery* (cat. no. 45) and *The Birth of St. John* in San Giovanni Decollato, scholars agree that Zucchi executed it around 1585 for Cardinal Ferdinando de' Medici.

As is well known,[1] this is an allegorical representation of the Creation of the World, in which God the father, the alpha and the omega of the universe, descends from heaven blessing mankind and all the animate and inanimate things in the world. The inscription on the base of the pedestal, "OMNIA/IN/ SAPIENTIA/FECISTI/ET/SUBIECISTI/ SUB/PEDIBUS/ EIUS" (You made everything with your knowledge and then you placed all things at his feet) derives from two verses from Psalms: "You made everything with knowledge" (Psalm 104:24) and "You placed all things under his [mankind's] feet" (Psalm 8:7).

As well as a strong Flemish influence noticeable in the objects taken from nature and in the pictorial and chromatic treatment of the details – reminiscent of the style of the Brill brothers, particularly Paul, who was for some time active in the Torre dei Venti in the Vatican – this composition is indebted

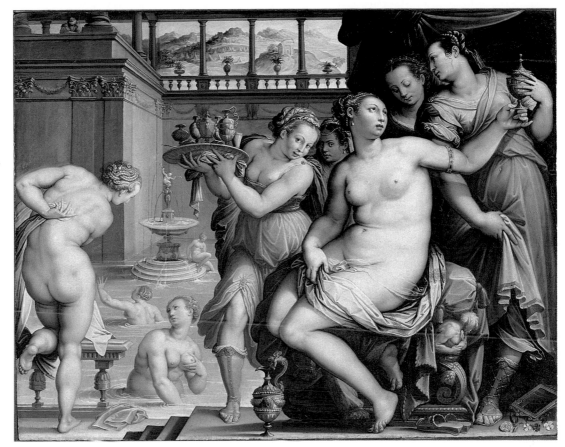

44

also to Michelangelo. The man raising the armillary sphere, the symbol of theoretical knowledge, with his right hand and resting his left on the dark sphere of the earth, dominated by mankind, evokes not only the pose of the figure of Adam from the Sistine Chapel, but also that of the figure in *The Dream of Human Life* (London, Courtauld Gallery), a drawing by Michelangelo well known at the time because of its wide circulation through prints.

At the feet of Zucchi's figure, representing Man, lie the symbols of the four elements: doves (Air), jewels (Fire), flowers, plants, and fruits (Earth), pearls, shells, and marine creatures (Water), all surrounded by a multitude of animals. Pillsbury suggested that there was a thematic difference between the left side of the painting, more orderly and peaceful, and the right side, characterized by activity and rendered in a more lively fashion (1980, pp. 215–16). As was suggested by Morel (Hochmann 1999, pp. 298–99),

the juxtaposition of these two aspects of the Universe, divided into those things that men have found in nature and preserved, and those things that they have transformed to suit their own uses, reflects the Neoplatonic interpretation of the hermetic genesis of man as it appeared in the *Pimandro*, a work that Ficino had already linked with Genesis and that was published again in 1585 with a commentary by Annibale Rosselli.

1. A. Giovannetti, in *Magnificenza* 1997, p. 201, cat. no. 155

A. B. V.

44

JACOPO ZUCCHI
Florence ca. 1540–1596

Bathsheba[1]
ca. 1573–74
oil on wood
115 × 144.7 cm

Rome, Galleria Nazionale d'arte antica, Palazzo Barberini

FLORENCE ONLY

This painting was inspired by the story told in 2 Samuel 11:2–4. King David, upon seeing Uriah the Hittite's beautiful wife, Bathsheba, at her bath, had her abducted and seduced her. The painting came to the National Gallery in Rome in 1895 from the storerooms of the municipal pawnshop, where it had been attributed to Giorgio Vasari. It was later lent to the Italian Embassy in Berlin, where it remained until 1944. It disappeared at the end of the war, then resurfaced on the international antiques market in 1965 and was bought by

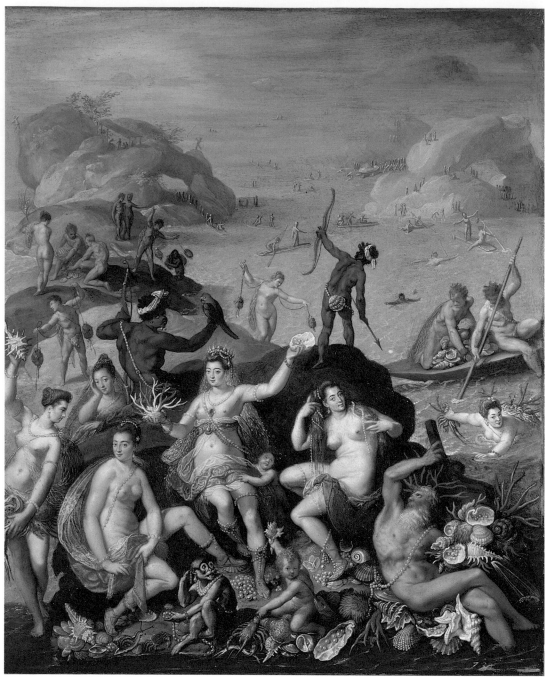

45

considers it mainly the work of Vasari, although he acknowledges that the young Jacopo had a hand in it. In my view, the *Bathsheba* has the same character of an exquisitely private work, with moderately erotic touches and a strong allegorical component, as have certain works known to have been painted by Vasari at his home in Florence, such as *Venus at Her Toilette* (cat. no. 41) and especially the *Stories of Apelles and the Painters* (1573). In this sense, the *Bathsheba* resonates perfectly with the paintings on copper that Zucchi did for Cardinal Ferdinando de' Medici's famous Studiolo, with *The Coral Fishery* and *The Death of Adonis* at the Vasari House in Arezzo, and also with other works by artists in Vasari's circle between 1569 and 1574, such as Giovan Battista Naldini's *Bathsheba* (St. Petersburg, Hermitage), Jan van der Straet's *Virtue Disarming Vanity* and the *Allegory of Sacred and Profane Love* (Paris, Louvre), and Alessandro Allori's *Susanna and the Elders* (Dijon, Musée des Beaux-Arts).

1. In addition to references cited within the text, see Giovanetti 1994–95, pp. 55–56.
2. *Gemälde alter Meister aus Berliner Besitz*, Berlin: Kaiser Friedrich Museums Verein, 1925, p. 66, no. 441.

A. B. V.

45

JACOPO ZUCCHI
Florence, ca. 1540–1596

The Coral Fishery[1]
ca. 1580
oil on copper
55 × 45 cm

Rome, Galleria Borghese

CHICAGO AND DETROIT ONLY

In 1575 Jacopo Zucchi, who had moved to Rome in 1572 and had been working ever since under the patronage of Cardinal Ferdinando de' Medici, was commissioned by the cardinal to do a set of paintings with

the Wadsworth Atheneum of Hartford, which returned it to the Barberini National Gallery in 1988.

The painting was first attributed to Zucchi in 1925, when it was displayed at an exhibition in Berlin.[2] Edmund Pillsbury dates its execution to sometime after 1573, the year in which Giambologna sculpted the *Venus Urania* (Vienna, Kunsthistorisches Museum) on which Zucchi apparently based the pose and the hair style of the female figure on the left

(Cadogan 1991, p. 259). The *post-quem* date of 1573 implies that the *Bathsheba* was painted in Rome, where Zucchi had been established since 1572 in the service of Cardinal Ferdinando de' Medici. Living in Rome, he had been able to keep in touch with Giambologna, who was working at the Vatican during those years. Even assuming that the *Bathsheba* was painted in Rome, it was still strongly influenced by Vasari and the artistic culture of Florence in the 1570s, when the painters of the

Accademia del Disegno were working on Francesco I's Studiolo and, by reinterpreting the lines and the anatomy of Michelangelo's sculpture of *Dawn* in the New Sacristy of San Lorenzo with refined inventions and touches of a new pictorial virtuosity, were opening the way to the great international heyday of Mannerism.

Not everyone agrees on the attribution of the *Bathsheba* to Zucchi. Strinati (Hochmann 1999, pp. 274–75, no. 73)

allegorical and mythological subjects to be incorporated in a *studiolo* – a walnut cabinet designed to contain *mirabilia* and comprising thirty-three drawers, twenty-four gilded bronze statuettes and nine copper doors. This piece, first described by Baglioni (1642), was identified by Edmund Pillsbury (1980) together with two other versions, one in L'vov, Ukraine, and the other in a private collection in Milan, which are similar but contain notable variations. A fourth version was described by Vannugli in 1994.

All four versions are now generally thought to have been painted by Zucchi himself, but at different times and in completely different circumstances. According to Pillsbury (1980), the oldest – the one presumably painted for the walnut cabinet – is the one now in Ukraine. This opinion was based mainly on the match between this version and Baglioni's description of the female figures in the original, among whom he noted "many portraits of various Roman ladies of that time." But as Morel rightly points out (1999), the date "159(.)" that recently came to light in the Ukraine version casts reasonable doubt on its original destination; it was probably painted in the early part of the 1590s, because Ferdinando is shown together with his wife, Cristina di Lorena, and their first two children, who were born in 1590 and 1591.

The version in the Borghese collection seems to predate the Ukranian one, because the needs of the allegorical conception clearly prevail over those of portraiture, although one notes some similarity between the model for the wife and the one Zucchi used for his better-known Flemish-style creations of the 1570s, for instance the Venus in *The Death of Adonis*. Like *The Pearl Fishery* that Alessandro Allori painted for Florentine Grand Duke Francesco I's Studiolo in the early 1570s, to which Zucchi contributed *The Mine* and other ceiling paintings, Zucchi's *Pearl Fishery* is certainly related to an allegorical representation of the sea as water, one of the four elements, and of its most valuable products, such as coral and pearls. Rare in nature and superbly enhanced by human artifice, coral and pearls doubtless received special attention from the cardinal, a refined and assiduous collector of "marvels." However, the painting also contains so many symbols alluding to femininity (such as the parrot, the snail, oysters, and seashells in general) that its interpretation (Morel, in Hochmann 1999, p. 300) as the "Realm of Amphitrite" – a subject already represented in Francesco I's Studiolo in a small bronze by Stoldo Lorenzi – seems a better fit. Coral was also the subject of a well-known drawing of Zucchi's now in the Louvre (inv. 4553), which may have been a sketch for a fountain to be erected in the gardens of Villa Medici in Rome.

1. In addition to the references cited within the text, see Vannugli 1994, pp. 161–73.

A. B. V.

following pages Detail of cat. no. 72.

SCULPTURES

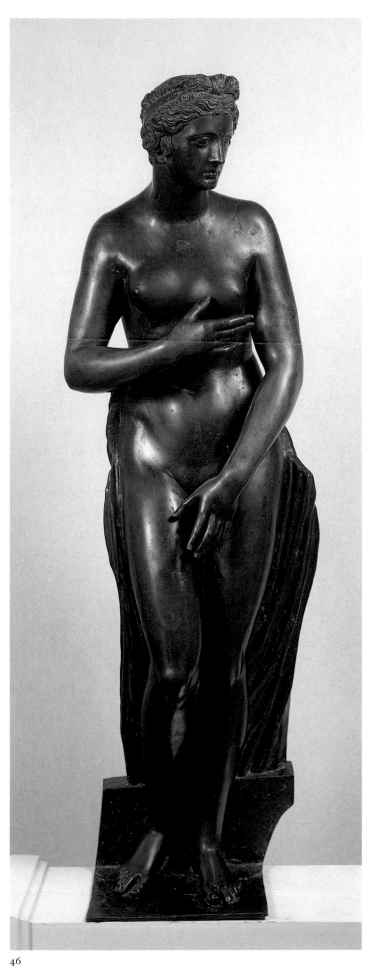

46

BARTOLOMEO AMMANATI
Settignano, 1511–Florence, 1592

Venus
ca. 1559
bronze
180 cm

Madrid, Museo del Prado

FLORENCE ONLY

This bronze figure of Venus originally stood in the Jardín de la Isla at the Royal Palace of Aranjuez, outside Madrid, together with a bronze figure of Adam/Jove (Gschwantler 1992) – part of Philip II's restoration of the palace and gardens at Aranjuez in the 1560s, which included the acquisition of sculptures and fountains to decorate its grounds (Estella 1992, pp. 71–72). Before 1574, the figure had been in the collection of Grand Duke Cosimo I de' Medici and it may have come to Spain as a result of marriage negotiations between Francesco I and Giovanna of Austria in 1562–63 (Coppel Aréizaga 1998, p. 45).

In 1586 Federico Zuccaro visited Aranjuez and described this statue and its accompanying bronze male figure as "two very fine antique bronze statues."[1] His identification of the figure as antique was understandable, since the figure is closely modeled on the *Venus Belvedere*, and even in the 1908 catalogue of the Madrid sculpture collection the bronze was cataloged as neo-attic (Barrón 1908, cited in Coppel Aréizaga 1998, p. 45).

From the document of payment to Ammanati for casting this bronze in 1558–59 Keutner (1963, pp. 84–85) has identified it as a Medici commission. The *Venus* is based on Ammanati's own stucco version of the *Venus Belvedere*, produced in 1555 as a point of departure for a possible restoration of the classical figure and acquired by Giorgio Vasari, who placed it above a fireplace in the Sala del Camino of his house in Arezzo, where it

remains today (Keutner 1963, p. 81; Coppel Aréizaga 1998, p. 45, n. 12). The Madrid bronze differs from the stucco by the addition of arms, which were added to the classical prototype only during Ercole Ferrata's restoration of the marble in 1677. During an eighteenth-century restoration of the Madrid bronze, the position of the arms was altered to place the Venus in a "pudica" pose, and in 1840 a new left arm was added to replace one lost at some date in the preceding century.

Keutner (1963, p. 82) compares the figure stylistically with Ammanati's figure of *Juno* for the fountain of the Sala dei Cinquecento in the Palazzo Vecchio (now Florence, Museo del Bargello). He has also observed that Ammanati and Vasari worked together in Rome. Ammanati's creation of a bronze figure in the antique style accords well with his (and Vasari's) documented acquaintance and support of Ludovico Lombardo, a bronze caster and restorer of classical sculpture in Rome.

1. "due statue de bronzo antiche molto bene." Coppel Aréizaga 1998, p. 45.

A. B.

47

BARTOLOMEO AMMANATI
Settignano, 1511–Florence, 1592

Hercules and Antaeus[1]
1559–60
bronze
201 cm

Florence, Museo della Villa Medicea della Petraia – Soprintendenza per i Beni Architettonici e per il Paessaggio di Firenze, Pistoia e Prato

Ammanati's *Hercules and Antaeus* was set atop a multi-basin fountain that formed the hub of Niccolò Tribolo's vast hydraulic system for the Medici villa at Castello. It was intended to exalt Cosimo I de' Medici as the

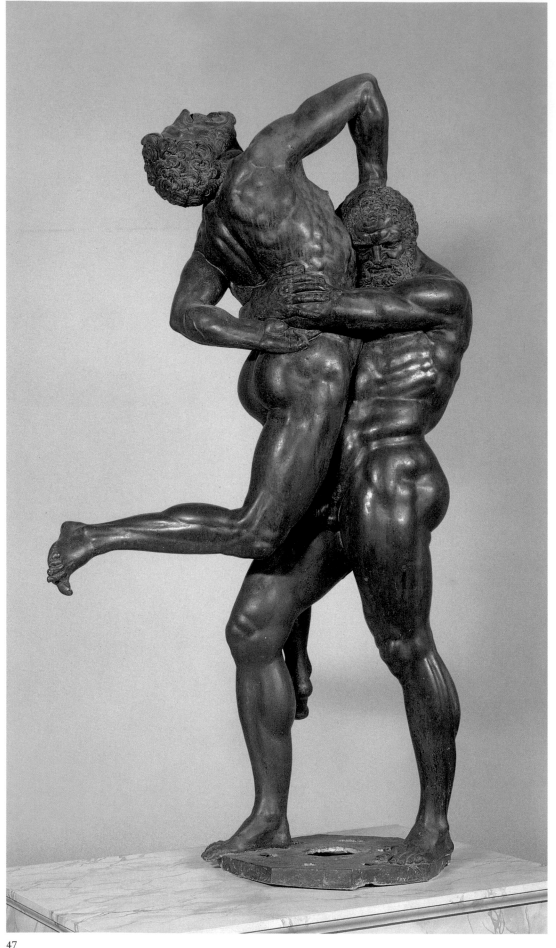

engineer of a new golden age. *Hercules* is transformed from a republican emblem into the alter ego of Cosimo: just as the mythological hero defeated evil in the figure of Antaeus, so Cosimo triumphed over his enemies, ushering in a new era of harmony and peace. The project, initiated after the victory of Montemurlo, which returned absolute power to the Medici family, was given further significance by the presence in the same garden of the fountain of *Fiorenza*, alluding to the sound government of the city.

Rising over the three basins, Ammanati's group of *Hercules and Antaeus* was produced after Giovanni Montorsoli's failed attempt to realize a similar project in 1538 with an overambitious and unrealistic work in marble. Afterwards the young Vincenzo Danti took on the commission but was also defeated by it. Perhaps originally conceived by Tribolo himself – as is suggested by Vasari's tribute to the artist on the ceiling of the Sala of Cosimo I in the Palazzo Vecchio, where he is shown holding a model of the fountain – Ammanati's version of the *Hercules and Antaeus* finally ended a gestation period of at least twenty-two years. The sculptor received the first payments in 1559 and completed the work the following year.

Remembering the Paduan examples of *gigantismo* and his study of Roman antiquities, Ammanati reinterpreted the felicitous Florentine composition of *Antaeus* by Antonio del Pollaiuolo, known both through paintings and sculptures. In following this precedent rather than the archeological example in the courtyard of the Belvedere Vaticano, Ammanati was perhaps working to a model by Tribolo, in accordance with the latter's celebration of the age of Lorenzo il Magnifico, expressed in references throughout the garden. Anticipating the more accentuated torsion of Giambologna's *Sabines*, Ammanati varied Pollaiuolo's original composition by giving the arm

47

of one of the figures a spiraling motion that indicates an interest in the study of multiple viewpoints.

1. See D. Heikamp in *Magnificenza* 1997c, p. 28; and C. Pizzorusso in Ciardi and Natali 2000, pp. 210–20.

A. G.

48

BARTOLOMEO AMMANATI
Settignano, 1511–Florence, 1592

Opi[1]
1572–75
bronze
93 cm

Florence, Museo della Villa Medicea della Petraia - Soprintendenza per i Beni Architettonici e per il Paessaggio di Firenze, Pistoia e Prato

Elegant and sensual, the enigmatically beautiful goddess, wearing a crown in the shape of a turret, represents a sophisticated example of the late Ammanati's facility with bronze sculpture. Inspired by a print by Jacopo Caraglio of around 1525 (Middeldorf 1932, p. 486), the artist here further developed his composition for the figure of *Cerere* on the fountain for the Salone dei Cinquecento, a work in marble executed ten years previously. Like the earlier *all'antica* figure, the *Opi* holds her breasts to indicate her fecundity, which she lavishes on the animal world, represented by a bull, a stag, and a she lion, to which another animal was to be added but was removed probably for reasons of space (Heikamp 1978, p. 131, n. 28). Giorgio Vasari's preparatory drawing for Francesco I's Studiolo in the Palazzo Vecchio documented Ammanati's previous idea for which the sculpture was commissioned (Rinehart 1964, pp. 74–76).

Before the fortuitous discovery in 1958 of a document that allowed Keutner to attribute the sculpture to Ammanati (Keutner 1958, p. 428, n. 10),

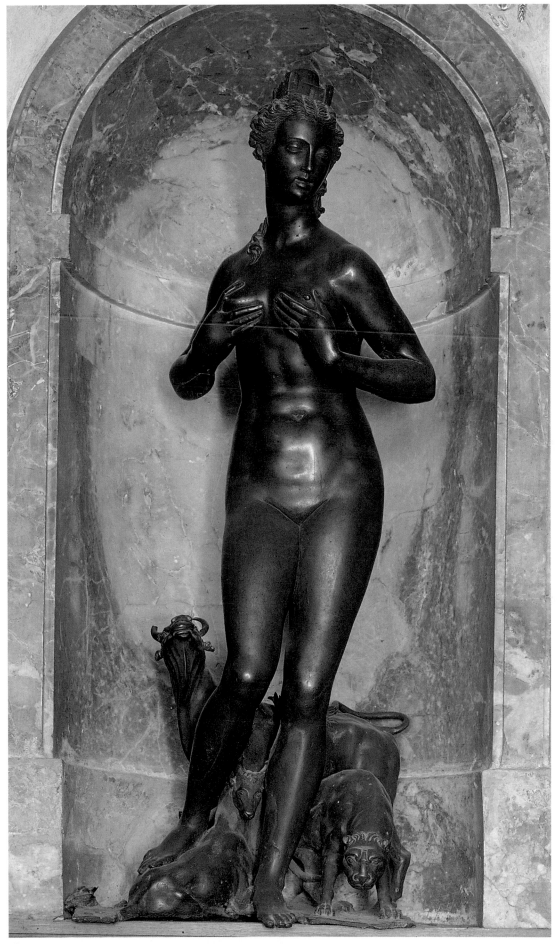

48

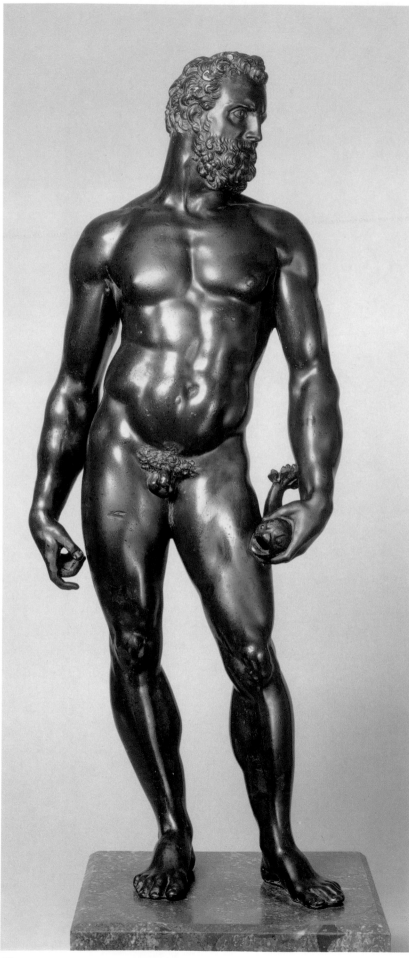

this work had been attributed to Domenico Poggini (von Bode 1980, p. 100) or Elia Candido (*Mostra del Cinquecento Toscano* 1940, p. 153). At the beginning of the twentieth century the sculpture was placed, after a long residence in the Tribuna of the Uffizi, in its original site on the upper level of the wall dedicated to the earth in the Studiolo, beside Poggini's *Plutus*. According to Vincenzo Borghini's iconographic program, *Opi* presided with her companion over the riches of the earth, signifying to Francesco and his visitors the precious porphyries, jaspers, chalcedonies, marbles, ebonies, and ivories concealed behind painted panels in the compartments of the fantastic and microcosmic cabinet. The other three elements – air, fire, and water – were under the protection of *Juno* (Bandini) and *Boreas* (Candido), *Apollo* (Giambologna) and *Vulcan* (Rossi), and *Venus* (Danti) and *Amphitrite* (Lorenzi) respectively.

1. In addition to references cited within the text, see Pope-Hennessy 1963, pp. 372–77; Berti 1967, p. 84; Schaefer 1979, pp. 441–43; Allegri and Cecchi 1980, p. 339; Avery 1996, p. 791; and D. Heikamp in *Magnificenza* 1997c, p. 355.

A. G.

49

BACCIO BANDINELLI
Florence, 1493–1560

Neptune[1]
ca. 1560
bronze
48 cm

U.S.A., Private Collection

CHICAGO AND DETROIT ONLY

This bronze statuette of *Neptune* stems from the same model as the documented example from the Galleria Colonna, made for a monumental fountain in the Piazza della Signoria in Florence. It was first published by Herbert Keutner (in *Von allen Seiten schön* 1995, pp. 288–91, no. 79) in his catalog entry to the Berlin bronze exhibition in 1995, but the sculpture itself was at the art market in London and was not shown in the exhibition. It is now being presented to the public for the first time, displayed alongside the Colonna example (not in catalog) to enable a close comparison of these two versions.

The two figures of *Neptune* are virtually identical not only in their pose, but also in their size, suggesting that their casting models (which in the case of the statuette in the Galleria Colonna included a rectangular base) where both copied after Bandinelli's original model. However, the two bronzes differ considerably from each other in their surface treatment. Where the Colonna example is chased in a very detailed and precise fashion, as is typical of Domenico Poggini, the U.S. bronze shows conspicuously less chiselwork, and such working is used primarily to smooth out the forms, not to add graphic texture: particularly telling is the diverse treatment of the hair.

Although the workmanship in the latter sculpture is indeed comparable to Bandinelli's documented bronzes, Keutner's claim that the chasing betrays the artist's own hand can hardly be endorsed. We know that Bandinelli employed various specialists in his workshop who carried out the single stages of a bronze's production (E. Schmidt in *Leonardo e mito di Leda* 2001, pp. 152–53, no. III.9): it is unlikely that the head of the workshop himself would have spent his energies in the time-consuming work of chasing. Moreover, there is no way to support an attribution of this kind by stylistic comparison, since there is not a single bronze for which we can assume that Bandinelli himself did the chasing. The sculptor's documented bronzes show notable differences of quality, implying that the workmanship after the casting must be attributed to various assistants, such as Francesco dal Prato, who worked for Bandinelli in the early 1530s. Keutner's proposition

that Bandinelli made the bronze version of his model as a gift for his benefactor, Eleonora of Toledo, is purely speculative and not founded on any documentation. It cannot even be excluded that the bronze was cast by a member of Bandinelli's workshop only after the master's death. However, because its finish is similar to other known bronzes from Bandinelli's workshop, the U.S. *Neptune* gives a better idea than the Roman bronze of how the final statue for the piazza would probably have looked.

1. For a complete discussion of this bronze, see E. Schmidt in *Leonardo e il mito di Leda* 2001, pp. 192–94, no. III. 9.

E. D. S.

50

BACCIO BANDINELLI
Florence, 1493–1560

The Flagellation of Christ[1]
1532–33
marble
63 × 81 cm

Orléans, Musée des Beaux-Arts

According to Vasari, when, in the winter of 1532/33, Pope Clement VII went to Bologna for three months to confer with Emperor Charles V, Baccio Bandinelli traveled there from Florence "to kiss the feet of His Holiness, and brought with him a picture, one *braccio* high and one-and-a-half *braccia* wide, showing Christ being beaten at the column by two nude men, and this was a half-relief which was very beautifully executed. He gave this picture to the Pope, together with a medal showing the portrait of His Holiness that his close friend Francesco dal Prato had executed; and on the reverse of this medal was shown the *Flagellation of Christ*, too."[2] The repetition of the Flagellation theme on the portrait medal makes it clear that Bandinelli intended the biblical episode to allude to Clement VII in two ways: first, in a public and

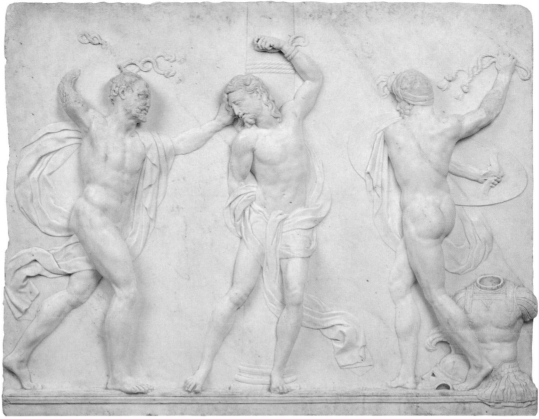

50

historical sense, the analogy between the Pope and Christ being flagellated referred to the most recent afflictions of the papacy, culminating in the looting of the Eternal City by imperial troops – the infamous "sacco di Roma" – in 1527; second, in a personal and moral sense, the analogy referred to the Pope's patience, as Christ's endurance in his suffering during the Flagellation was frequently interpreted as a model of this virtue.

In Bandinelli's marble relief, the concept of patience is expressed by Christ's head bent humbly downwards. The pose of Christ's twisted upper body, with one arm raised and the other descending along the trunk, is adopted from the antique sculpture of *Laocoön*, considered the foremost example of the visual representation of suffering. Bandinelli restored and copied this most famous of all antique statues in the first half of the 1520s, and indeed the exact posture in the *Flagellation* of the raised arm (a limb missing in the antique statue and therefore the object of controversial

proposals for completion) corresponds precisely with that realized by Bandinelli in his *Laocoön* (Florence, Uffizi).

The vigorous composition as a whole, in which the artist demonstrates his skill in representing male nude figures in action, can ultimately be traced back to a Donatellesque plaquette showing the *Flagellation*, in which the tormentor on the right is seen from the rear and the one on the left, who grasps the Savior's hair, is seen from the front. A similar compositional scheme had been adopted by Michelangelo in his designs for Sebastiano del Piombo's depiction of the same theme in the church of San Pietro in Montorio, Rome (1516). It can also be found in a panel painting by a follower of Perugino showing the *Flagellation* (Washington, D.C., National Gallery of Art), attributed to Bacchiacca and dated ca. 1512–15. In contrast to these examples, however, Bandinelli shows both flagellators with their legs crossed, enhancing the impetuosity of their aggressive movement.

If Bandinelli sought to surpass Michelangelo's version, he definitely scored a point against his rival. The Pope was so delighted with the gift, Vasari tells us, that he let Bandinelli finish the statue of *Hercules and Cacus* (Florence, Piazza della Signoria), in preference to Michelangelo, to whom the preceding republican government had assigned this block of marble.

1. See Gaborit 1994; É. Moinet in *Italies* 1996, pp. 272–75, no. 80; Schmidt 2000, especially pp. 251 and 253; and E. Schmidt in *Leonardo e il mito di Leda* 2001, pp. 128–29, no. II.10.
2. "... a baciare i piedi di Sua Santità, e portò seco un quadro, alto un braccio e largo uno e mezzo, d'un Cristo battuto alla colonna da due ignudi, il quale era di mezzo rilievo e molto ben lavorato. Donò questo quadro al Papa, insieme con una medaglia del ritratto di Sua Santità, la quale aveva fatta fare a Francesco dal Prato suo amicissimo, il rovescio della quale medaglia era Cristo flagellato." Translated after Vasari 1966–, vol. 5, p. 252.

E. D. S.

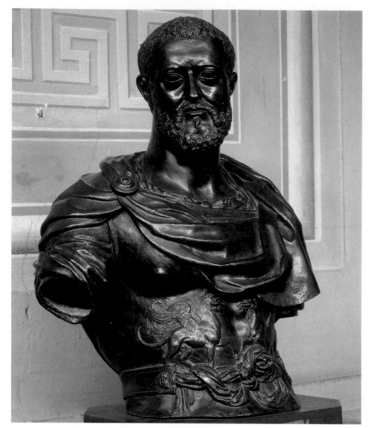

51

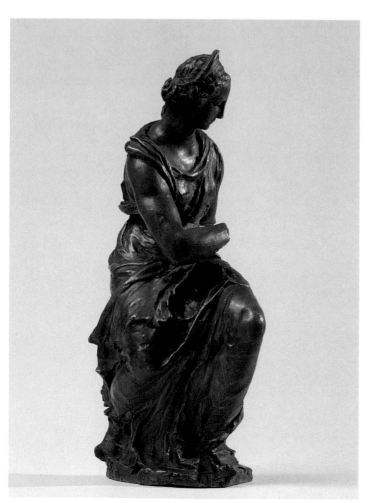

52

51

BACCIO BANDINELLI
Florence, 1493–1560

Cosimo I de' Medici[1]
ca. 1557
bronze
78.5 cm

Florence, Palazzo Pitti, Galleria
Palatina

In 1545, little more than a
decade after Michelangelo had
departed Florence for Rome,
enabling Baccio Bandinelli to
pursue his career as a sculptor in
the Medici court, Benvenuto
Cellini returned from France to
Tuscany's capital, rekindling a
long-standing rivalry between
the two master sculptors.
According to Vasari, this
situation prompted the Duke to
"commission to them a large
portrait of himself from his head
to his belt, which both should
cast in bronze, so that who did
it better would receive the
honor."[2] Cellini's bust (Florence,
Bargello), finished by 1548, tried
to surpass the marble bust of
Cosimo carved by his rival in
1544 (Florence, Bargello) by
increasing the allegorical imagery
on the sitter's armor. Bandinelli,
in a countermove, reduced the
decoration of the armor of his
bronze to two griffins, and
added a Romanizing cloak
(*paludamentum*) around the sitter's
shoulders, demonstrating his
ability to represent the softness
of textiles in solid bronze, as in
the lighter garment of the
sleeves and the even lighter
tissue of the knotted belt.
 The shape of Bandinelli's
bronze bust is highly unusual.
It does not terminate in a
symmetrically swung line,
underscoring the artificiality of
the sculpture's boundaries, nor
along the contour of some
represented object of clothing.
Instead, the sitter's body seems
to be cut off at his upper arms
and below his waist – much
lower than was usual for a bust
of that time – so that the
sculpture seems to cry out for
completion. This impression and
the peculiar form that was used
to achieve it can be explained

by a tactical move on the part
of the sculptor. In a copy of a
letter to the Duchess Eleonora of
Toledo, which may be dated to
1556–58 (Heikamp 1966, p. 58),
he envisions completing the bust
as a full statue of Cosimo in the
pose of an antique emperor
during a speech (*adlocutio*). But
Bandinelli's implicit hope, that he
would be asked to add the rest
of the body to his bust, was not
fulfilled.
 The bust, which according
to Heikamp (1966, p. 57) was
probably finished around 1557, is
first recorded in an inventory of
the Palazzo Pitti after the sitter's
death in 1574. In this entry as
well as in a later one of 1589, it
was still lacking the grand-ducal
crown, which is mentioned only
from 1597 onwards. The crown
it bears today, however, does not
correctly match the original,
because it shows only fifteen
(not seventeen) rays, and is
possibly a substitute made in
the nineteenth century.

1. See Langedijk 1981–87, vol. 1, pp.
88–89 and no. 27, 106, pp. 459–60; and
D. Gasparotto in *Magnificenza alla corte
dei Medici* 1997, pp. 227–28, no. 180.
2. ". . . fece far loro un ritratto
grande della sua testa fino alla
cintura, che l'uno e l'altro si gettassi
di bronzo, acciò che chi facesse
meglio avesse l'onore." Translated
after Vasari 1966–, vol. 5, p. 269.

E. D. S.

52

GIOVANNI BANDINI
Castello, 1540–Florence, 1599

Model for the statue of
Architecture for the tomb of
Michelangelo[1]
ca. 1568
terracotta
35.1 cm

By courtesy of the Trustees of
Sir John Soane's Museum,
London

FLORENCE ONLY

This statuette is the preparatory
terracotta model for the marble
figure of *Architecture* for the
tomb of Michelangelo in the

church of Santa Croce in Florence (see cat. no. 79 for a full discussion of the commission for the marble figures for the tomb). The figure was the first of the three allegorical marble sculptures on the tomb to be completed, being paid for in 1568. As was one of the favored sculptors in the Medici court, Bandini was responsible for carving the official portrait bust of Cosimo I, produced in a number of versions (see cat. no. 53 for Detroit version).

Pope-Hennessy (1964b) points out that although the arrangement of the legs and arms differs from the final marble, the figure is close to Bandini's finished figure and is probably an early design for the composition. Though its exact provenance is unknown, it was acquired by the architect Sir John Soane before August 1825, when it is shown in a watercolor of the Monk's Parlour in his house at Lincoln's Inn Fields (Pope Hennessy 1964b, p. 238, n. 11).

1. In addition to references cited within the text, see Thornton and Dorey 1992; and Avery 1994.

A. B.

53

GIOVANNI BANDINI
Castello, 1540–Florence, 1599

Cosimo I, Grand Duke of Tuscany *(1519–74)*[1]
ca. 1572
marble
83 × 73 × 32 cm without socle

The Detroit Institute of Arts Founders Society Purchase, Robert H. Tannahill Foundation Fund

This Carrara-marble bust depicts the aging, dignified, and authoritative Cosimo I de' Medici, Grand Duke of Tuscany. He is portrayed *all'antica*, wearing a sixteenth-century interpretation of the cuirass worn by Roman generals, over which drapes a carved cloak or *paludamentum*, fastened with a fibula.

Executed by Giovanni Bandini, the foremost portrait sculptor in Florence from 1560 until his departure for Pesaro in 1582 and one of Cosimo I's favorite portraitists, this is one of the few surviving *all'antica* busts of the Grand Duke, and probably one of the last portraits he commissioned. Comparable works are Bandini's *Bust of Cosimo I* over the entrance doorway to the Opera dell'Duomo of 1572 (Langedijk 1981–87, vol. 1, 463, n. 117), and the *Bust of Grand Duke Francesco I de' Medici* (1572) over the doorway to the Florentine Mint.

The Opera dell'Duomo bust is the only one of five recorded examples to have remained *in situ* in Florence. The sculptor's primary biographer, Raffaelo Borghini, states in his *Il Riposo* (1584, pp. 637–38), that Bandini executed four other marble busts to be placed on the exteriors, portals and interiors of the Florentine palaces of the Minerbetti, the Niccolini, the Soderini, and the Gaddi (Langedijk, 1981–87, vol. 1, 91, 463, nos. 112–16). All four of these busts, of which the Detroit example must be one, disappeared with the demise of the Medici. They were apparently dispersed until the appearance of the marble bust acquired by the Los Angeles County Museum in 1980 (Los Angeles County Museum, M. 81.39) and the bust acquired by Detroit in 1994. Two among the four busts (Minerbetti and Gaddi) were documented as being placed originally over outside doorways, while the remaining two (Niccolini and Soderini) were placed indoors. Given the excellent condition of the Detroit bust and its relative lack of surface weathering, it was probably one of those made for either the Niccolini or the Soderini.

The bust presents Cosimo with humanity and compassion, traits that began to emerge only after his appointment as Grand Duke in 1569. Bandini achieved a measure of emotion and realism through the sensitively observed balding pate, the

53

wrinkles at the eyes, the sunken cheeks, and the life-like wart. Concurrently, he subtly idealized his subject, perhaps at Cosimo's express wish, following careful study of Roman imperial portraits.

For his personal iconography Cosimo adopted the classical figures of Hercules, Apollo, Camillus, and especially Augustus as secular parallels to Old Testament heroes (Cox-Rearick 1992, p. 245; Richelson 1978, ch.2). His identification with Augustus was largely due to fortuitous circumstances and a similar astrological orientation – both had their ascendant star in Capricorn and Cosimo's first great victory, the Battle of Montemurlo, fought against exiled anti-Medicean republican families, fell on the same day that Augustus defeated Anthony and Cleopatra, 1 August (Langedijk 1981–87, 79). Moreover, Cosimo was approved by the Florentine Senate with the support of the Holy Roman Emperor, Charles V, who was also born under the sign of Capricorn and had assumed

the iconography of Augustus. Cosimo kept his Augustan allusions discreet until the Emperor died in 1558. By 1570, however, he could afford, politically, to be less subtle (Cox-Rearick 1993, p. 251). Shortly before these grand imperial busts were produced he had consolidated the Tuscan territories and abolished the remaining vestiges of republican Florence. He chose personally to be portrayed *all'antica* as Augustus in this portrait.

In the context of sixteenth-century Florentine culture, this work represents an icon of Medici rule, revealing the importance of Augustan imagery for political power and identity and epitomizing the hieratic, dignified, formal character of aristocratic portraiture in late Renaissance Florence.

1. In addition to references cited within the text, see Darr 1999, p. 6, fig. 4; Darr and Albainy 2000, p. 407, fig. 7; and Darr 2002.

A. P. D.

54

54

GIOVANNI CACCINI
Rome, 1556–Florence, 1613

Igea
last decade of the sixteenth
century
marble
220 cm

Florence, Boboli Gardens

Identified alternatively as
Temperance and Prudence
(Grünwald 1910, p. 12), this
chaste female figure, crowned
with vine leaves and represented
in the act of proffering a bunch
of herbs, should in fact be
recognized as Igea. The daughter
of Aesculapius, the god of
medicine, with whom she shared
rare healing abilities, Igea is
typically distinguished
iconographically by a serpent,
which can be seen at her feet.

This sculpture was mentioned
in 1680 by Cinelli (Schmidt
1971, p. 164), as being situated at
a crossroads in the paths of the
Boboli Garden. Next to her
stood a group, also by Caccini,
representing Aesculapius and
Hyppolitus, with whom Igea
formed a narrative unity, as
pointed out by Cambiagi (1757,
p. 44): Aesculapius is attempting
to revive young Hyppolitus with
the medicinal herbs that she
presents. The original location
of the works is not known and
they might have adorned a
fountain in one of the Medici
gardens. In mythology these
figures are closely linked to
the world of Flora, knowing
its secrets and properties and
keeping watch over it. Tribolo
therefore placed a figure of
Aesculapius as the guardian of
the garden of medicinal herbs at
the Villa Castello, while at
Pratolino the same subject
featured on a fountain within a
cave (Keutner 1965).

The two Boboli works,
especially the group of
Aesculapius and Hyppolitus,
represent a revival of the refined
archeological influences learned
by Caccini in Rome, where he
studied with Giovanni Antonio
Dosio. In fact this rare

mythography is linked to Rome:
in 1570 Pirro Ligorio had
installed in the gardens of the
Villa d'Este in Tivoli two
ancient statues of *Aesculapius* and
Igea, perhaps identical to those
found a few years earlier on the
Palatine Hill (M. Daly Davis in
Magnificenza 1997, p. 60).

Dating this work to the 1590s,
rather than to 1608 as suggested
by A. Caneva (in *Il Seicento
Fiorentino* 1986, p. 45), would
place it in Caccini's Roman
period. It shares stylistic traits
with other works executed in
Rome, such as the *Summer* and
Autumn (Florence, Santa Trinita
Bridge) realized for Alessandro
Acciaioli (Brook 1996, p. 360),
which present a similar
mannered elegance of pose and
detailed rendering of twisted
drapery to create a thick linear
pattern highlighted by a
vigorous *chiaroscuro*.

A. G.

55

GIOVANNI CACCINI
Rome, 1556–Florence, 1613

Bust of St. James
ca. 1602
marble
70 cm

ANMIG (Associazione Nazionale
fra Mutilati ed Invalidi di guerra
sezione di Firenze)

FLORENCE ONLY

Between 1592 and 1611 Don
Silvano Razzi, prior of the
Camaldolese convent of Santa
Maria degli Angeli in Florence,
proposed a vast decorative
program for the west cloister
of the complex, including the
execution of a fresco cycle and
ten marble busts to be installed
above the doors of the interior
rooms. The prior outlined a
close relationship between
the sculptural and pictorial
decorations to obtain a perfect
symbiosis between the marbles
and frescoes. The latter, executed
by Donato Mascagni, Bernardino
Poccetti, and Bernardino

55

identified as St. James, however, thanks to surviving documents that describe the exact topography of the cloister and attest to the existence of a bust of St. James over the door leading to the Nobili Chapel, honoring illustrious personages from the order and dedicated to the saint.

The sculpture, which even in its austerity draws the spectator closer by its touching humanity and intimacy, reveals Caccini's intention to pursue realism, and his adherence to the new sixteenth-century style promoted in painting by Cigoli, Pagani, and Jacopo da Empoli. Compared to early depictions of saints by the artist and to his bust of *Christ* (Amsterdam, Rijksmuseum), chilling in its formal perfection, the *St. James*, like the *St. Alexius* realized a few years later for the façade of the Florentine church of Santa Trinita, shows a greater interest in elements drawn from real life, portraying a thin face with large circled eye sockets and realistically disheveled hair.

A. G.

56

ELIAS DE WITTE,
CALLED ELIA CANDIDO
Bruges–Florence 1574 (active in Florence 1567–1574)

Wind God
1573
bronze
92 cm
inscribed: "1573. I. Fo. Elia D. Candido Fiam. di Brugia"[1]

Florence, Palazzo Vecchio

Candido's *Wind God* is one of eight bronze statuettes made for the Studiolo of Grand Duke Francesco I in the early 1570s. Like all the works in the chamber, designed to serve both as a study and as a curiosity cabinet, the piece was conceived as part of a program treating the relationship between art and nature. As a wind, it would have been located in a niche on the wall dedicated to the element of

Monaldi, represented – as was conventional in late sixteenth-century Florentine cloisters – episodes from the life of the founder, St. Romualdo, with seven stories from Genesis. Razzi integrated these images with ten marbles representing eminent monks of the Camaldolese Order and holy figures, evidently intended as exemplary models in the tradition of the "Famous Men" of Humanism (Conigliello and Vasetti 1998, pp. 39, 40, 42).

In view of Caccini's fine work on the façade of the church in

the 1580s, Razzi summoned the Tuscan–Roman master around 1598 to act as director of the scheme. With the exception of *St. Romualdo* and *Ambrogio Traversari* (both signed and dated 1599), and almost certainly *St. Pier Damiani*, all realized by Pietro Francavilla, the busts were executed by Caccini and his workshop. At least four sculptures feature his signature: *St. Benedict* (dated 1598), *St. Michael*, *St. James*, and *St. Boniface* (dated 1602), although, judging from their rather

schematic execution, *St. Michael* and *St. Boniface* must have been partially executed by one of Caccini's collaborators. However, the young *Christ* and the *Virgin* appear to be executed entirely by Caccini, as is *God the Father*, previously attributed to Francavilla.

The *St. James* (inscribed IO. CACCINUS GRATIA D. SILV. R) has been mistakenly identified as St. Alexius and St. Rocco because of similarities in the iconography characterizing the pilgrim saints. He can safely be

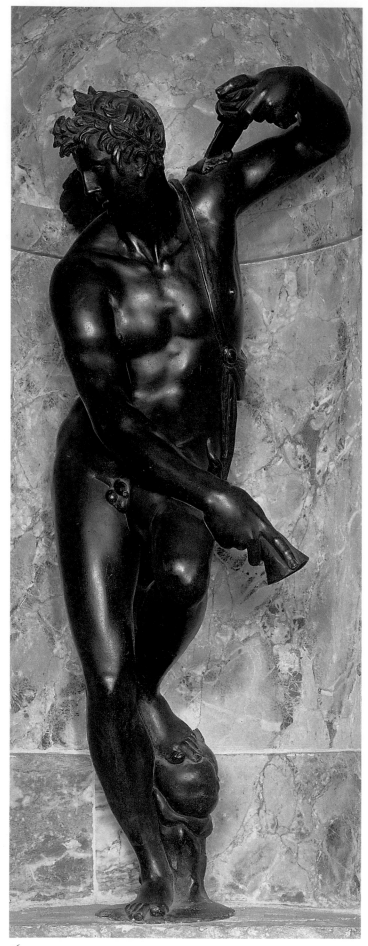

air. As an occupant of its wall's upper zone, it would have stood among the figures that Vincenzo Borghini, the Studiolo's master planner, called the "inventors or causes or . . . guardians and overseers" of the treasures of nature – these treasures themselves being held behind thematically appropriate paintings below.[2]

One of Borghini's early thoughts was to place the work above the Duke's collection of crystals This led him to think further about his designation of the god, which he had earlier called "Zephyrus." Eventually, Borghini maintained that the figure should in fact represent Boreas, "because crystals are made in the north, rather than in the sea,"[3] and because Boreas, identified with a cold northern wind, has "qualities entirely different from those of Zephyrus." These remarks, written in 1570, seem to have taken into account the ideas of earlier writers such as Vannoccio Biringuccio, who held that crystals were formed in cold mountains when waters congealed; Borghini himself specified that Boreas should hold a crystal, "which is congealed by the great coldness of which Boreas is the chief."[4]

Borghini's letters notwithstanding, Candido's bronze, completed in 1573, seems to have been situated not above a crystal collection, but rather above the door leading to another private chamber (the original disposition of the Studiolo, disassembled shortly after its completion, and reconstructed only in the last century, is still subject to debate). Rather than holding the crystal Borghini had once recommended, moreover, Candido's figure was outfitted with the more generic features of drapery and horn. In the end, no clues remained as to the wind's exact identity – unless something could be inferred from the puffy-cheeked head on which the figure treads, which, unlike Boreas and Zephyrus, would have blown from the south.

The remarkable statue is the only documented work by Candido in any medium. If the 'Fo.' before his name indicates that he was the work's caster (*fonditore*), as well as its designer, it could imply that the artist was trained as a goldsmith.

1. See Schaefer 1976; and *Magnificenza* 1997.
2. ". . . quello che furno o inventori o cagione o, come credette l'antica poesia, tutori et preposti a' tesori della Natura." See pp. 47–65 above. The Borghini texts are conveniently collected in Allegri-Cecchi 1980.
3. "Avertite ancora, che, dove è quella statua di Zephiro, ha a esser Borea; et se 'l mio scritto sta altrimenti, è per errore, perche i cristalli si fanno alla tramontana et non al marino." Letter from Borghini to Vasari, 5 October 1570.
4. ". . . et a lui darei in mano il cristallo che si congela per il gran freddo, nel quale tiene Borea il primo luogo." Letter from Borghini to Vasari.

M. W. C.

57

BENVENUTO CELLINI (workshop)
Florence, 1500–1571

Perseus and Medusa
1545–55
bronze on a marble base
75 cm

Florence, Museo Nazionale del Bargello

Virtually all recent scholarship on this curious piece follows the view of Avery (Avery and Barbaglia 1981, p. 95), who takes the work to be an early study for Cellini's monumental *Perseus and Medusa*, presuming that Cellini made it in the course of designing the statue for the Piazza della Signoria.[1] Still to be addressed, however, are the doubts raised nearly half a century ago by Ettore Camesasca (1955, p. 43), who pointed out that, with its gilding and patination, the piece must record something more than Cellini's experimentations in modeling. Restoration of the large *Perseus*

56

has revealed that it, too, originally included gilded highlights, an ornamentation that closely parallels that of this figure.

While it is possible that Cellini knew early on that he would gild the large work, it is no less plausible that a goldsmith, working on the smaller figure around or after the time of the completion of the monumental *Perseus*, would fill in details he knew from the large version.[2] Such a scenario could explain the passages that differ from Cellini's surviving earlier wax model for the piazza statues (Florence, Bargello) – the presence of the blood, the shape of the *harpe*, the pillow and base, the position and nudity of the Medusa – which seem to indicate familiarity with, but not a real understanding of, the completed figures. If, alternatively, the bronze were to date to the early 1550s, a moment at which the large *Perseus* itself was cast but not yet complete, this might explain why its author abandoned various details that were worked out in the monumental bronze – the richly ornamented helmet, the monumental wings, the large sword, and, notably, the reduced form of the *talaria* – and relied instead on the features of Cellini's earlier *bozzetto*.

The inventory made of the contents of Cellini's studio on his death in 1571 records the presence of a number of models related to the *Perseus* – a full-scale gesso model for the figures, a wooden model for the base, a bronze head of Medusa, a wax model for the *Andromeda* relief – but does not mention either the wax or the small bronze *Perseus* figures in the Bargello. (Cellini's papers, in fact, contain no reference whatsoever to the bronze.) There is also no evidence that the work, which entered the Bargello by way of the Uffizi from the house of a Florentine patrician in the early nineteenth century, ever belonged to the Medici (Barocchi 1983; Pope-Hennessy 1985, p. 306, n. 11). The fact, however, that Bernardo

Vecchietti by 1584 had a "disegno del modello del Perseo di piazza" (Borghini 1584, p. 13) in his collection, bespeaks a broad interest in Cellini's small figures that could have spurred the production of bronzes such as this.

1. Trento (1984) has referred to the piece as "un secondo modello di bronzo"; Pope-Hennessy (1985), claiming (without specific comparisons) that Cellini frequently cast his *bozzetti*, has called it a "cast after a wax model."
2. The gilding of the monumental *Perseus* in the Loggia dei Lanzi may have happened as late as May of 1559, when Cellini had scaffolding rebuilt around the statue: see Florence, Biblioteca Riccardiana, MS 2791, fol. 2v.

M. W. C.

58

Benvenuto Cellini
Florence, 1500–1571

Head of Medusa[1]
ca. 1548–49
bronze
13.8 cm

London, Victoria and Albert Museum

The case for Cellini's authorship of this small bronze head of Medusa, which was once doubted, is now fairly secure. Thermoluminescent tests conducted by the Victoria and Albert Museum in 1975 suggest that the bronze was fired sometime between 1415 and 1570,[2] and a 1571 inventory of works left in Cellini's studio after his death includes a "bronze head of Medusa," (Tassi 1829, pp. 256–58, no. 324). Though patination usually offers scant evidence for dating, the greenish patina seen here, added to create an effect of antiquity, might be compared to that used on the bronze *Perseus* from the Bargello.

Avery and Barbaglia (1981, p. 95) suggested that the piece was made as a "test" for the casting of the larger bronze *Perseus and Medusa* group the artist was making for the Piazza

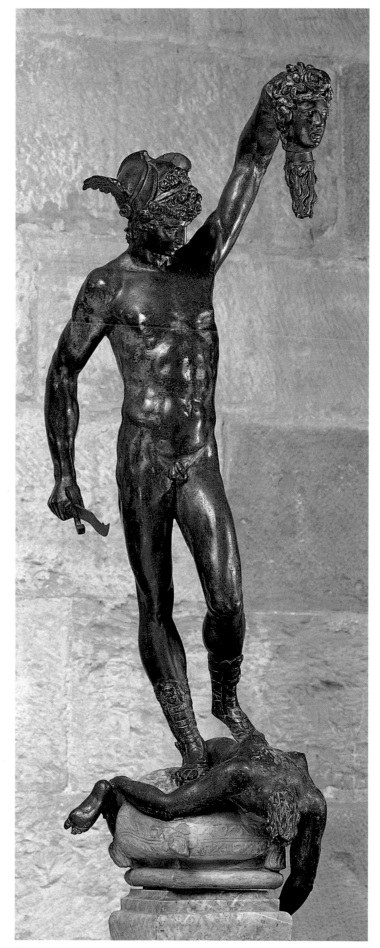

57

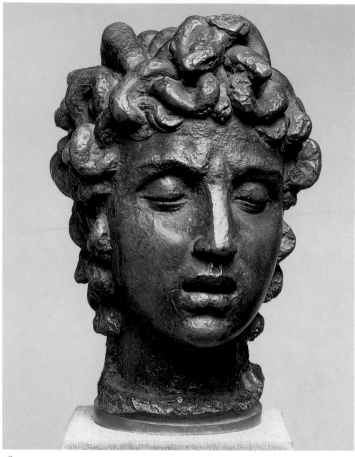

58

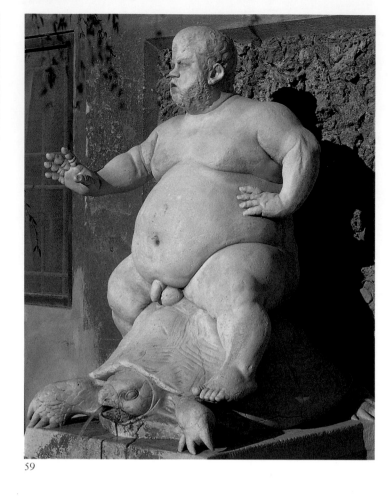

59

della Signoria. Pope-Hennessy (1985, p. 184) proposed, alternatively, that the piece was a "bronze model" for this group. The restoration of the colossal figures may offer further food for thought, for examinations have demonstrated that the alloy forming the head of Medusa is different from that forming the rest of the Perseus figure, and that the metal that went into the Medusa head was thus likely channeled independently of that which went into the body. If Cellini made a study with an awareness of how his 1549 casting arrangement would partition the large work, the result could include the details we see here: a truncated wrist, giving no indication of having ever extended an arm, and an unchased surface, suggesting that the piece was, at least initially, not intended for presentation. The treatment of the neck, where the metal has been polished to form a flat ring, may offer still more evidence. In the

monumental version, the neck of Medusa was finished in very much this manner, creating a joint into which Medusa's blood, which was cast separately, could be fitted. The attention to expression, and even the careful plotting of the snakes, suggest that the design behind the bronze was an advanced one, much closer in date to the finished work than either of the other surviving studies for the figures.

1. In addition to references cited within the text, see Pope-Hennessy 1965; and Baker and Richardson in *A Grand Design* 1998.
2. Technical documentation on the piece was generously supplied to the author by Peta Motture.

M. W. C.

59

VALERIO CIOLI
Settignano, 1529–Florence, 1599

Morgante on a Turtle[1]
1561–68
marble
130 × 86 × 95 cm

Florence, Boboli Gardens

NOT IN EXHIBITION

The dwarf Morgante (ca. 1535–after 1594) was a member of the court of Cosimo I de' Medici and served some of Cosimo's sons. He was celebrated in a number of statues, including this large marble of him on a turtle. Several bronze statuettes of Morgante by or attributed to Cioli or Giambologna display him astride a barrel, riding a dragon, or standing with crutch and horn. Either Cioli or Giambologna created a bronze nude statuette of another dwarf in Cosimo's court, Pietro

Barbino. In the late sixteenth and early seventeenth centuries dwarves were favorite figures in a ruler's retinue. Though their role was to inspire mirth and they were frequently caricatured, they also appeared in serious works of art: Velázquez's paintings of dwarves in the court of Philip IV, *El Primo* (Count Dward Diego de Acedo) and *Dwarf Sebastián de Morra* (both Madrid, Prado, ca. 1645), for instance, are moving portraits of distinct personalities.

As a garden statue, *Morgante on a Turtle* functions as a humorous diversion for those strolling garden paths, as a fountain (to which it was later converted), and as an inspiration for thoughtful speculation. The dwarf is clearly a comic figure: his flabby rolls of flesh suit sculptural caricature, and the correspondences between the bulging stomach and the dome of the turtle's shell and between Morgante's short pudgy legs and the turtle's contribute to the wit

of this portrayal. The turtle's laborious pace matches the sluggishness of his rider. This parallel suggests that the subject lampoons grand equestrian monuments, such as Giambologna's *Grand Duke Cosimo I de' Medici* in the Piazza della Signoria. That Morgante's name was ironically appropriated from a legendary giant implies that the statue may also play on antique statues in the Boboli Gardens.

Valerio Cioli devoted much of his career to the restoration of antiquities in Rome and in the collection of the Medici. Anthea Brook (1991) proposes that Renaissance knowledge of the use of genre subjects in Hellenistic gardens may be behind Cioli's garden statuary of peasants performing daily tasks, such as *Lavandaia* or the *Mower*. By the same token the corpulent Morgante would remind viewers of ancient images of the mythological figure Silenus, often seen drunk astride an ass. This grotesque sculpture, then, operated on a number of levels in Renaissance terms, from portrait of a real person to sly parody of the ruler he served and finally to commentary on the dialog between contemporary and ancient sculpture.

1. In addition to references cited within the text, see Fischer Thompson 1980.

I. W

60

SILVIO COSINI
(?)Pisa, ca. 1495–(?)Pietrasanta, post 1549

Meleager[1]
ca. 1530
marble
108 cm

Madrid, Museo del Prado

The young hunter, crowned with laurel, has conquered his prey and walks away with a litheness reminiscent of the sculptures of Polykleitos. From the front, in his languorous nudity, he has an ephebic gracefulness, controlled, elegant, and confident. But something is troubling him: he turns to one side, his body lightly arching, his shoulders and torso twisting, the marble rendering the movement modeled like wax. His eyes darken with a melancholy presentiment. He is Meleager. He has overcome the boar, the land of Calydon is safe, and he can place his arrow back in his quiver, ornamented with trophies. But ivy – symbol of constancy and transience, love and death – covers the tree stump on which his bow rests. His triumph will be fatal to him: in order to defend his love for Atalanta he takes out his arrow again and, despite his grief, slays his uncle. His life will now last no longer than the burning of the log to which the Fates linked his destiny at birth and which his mother will now, in her rage, throw on the flames.

This narrative work could be mistaken for an eighteenth-century sculpture, so delicate and elegiac appears the sculptor's interpretation of Ovid's myth. But recognizing in this marble, polished like those by Bambaia, a "straining towards ideal beauty, tempered by a sensitivity towards fantasy and dreams,"[2] it is possible to identify this as a work by Silvio Cosini. This Pisan sculptor collaborated with Michelangelo on the decorations for San Lorenzo of around 1525, and reinterpreted the master's forms in terms of his own agitated imagination, further enriched after 1530 by his closeness to Perino del Vaga at the court of Andrea Doria in Genoa. He transformed the stylized Hellenistic gracefulness of Tribolo's sculptures into a form more human and less austere, as in the sorrowful expressions and flaming hair of the candle-bearing angels in Pisa cathedral (Museo dell'Opera, 1528–30) or the archangel Raphael in the Maffei Sepulcher in Volterra (Church of San Lino, 1529–33). *Meleager* – whose presence in the Spanish collections may have been due

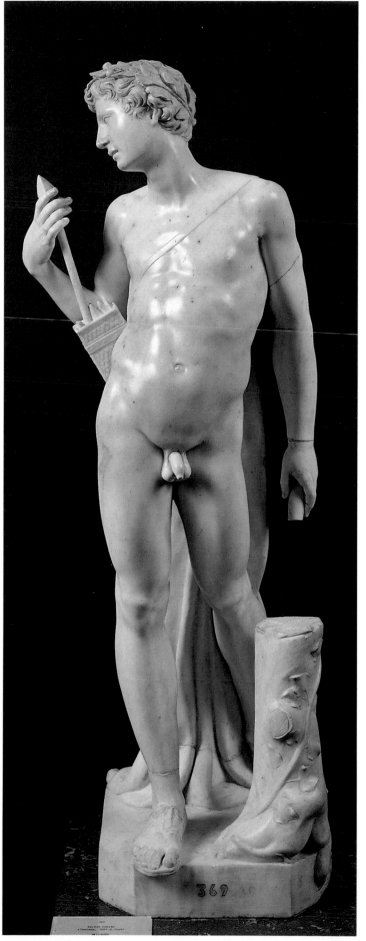

60

to the intervention of Andrea Doria, who had employed the sculptor on many occasions – must be associated with these figures.

1. In addition to references cited within the text, see del Bravo 1992, pp. 8–19; and Coppel Aréizaga 1998, pp. 58–59.

2. "tensione alla bellezza ideale, però affettuosamente comprensiva del dono di fantasie e sogni." del Bravo 1992, p. 12.

C. P.

61

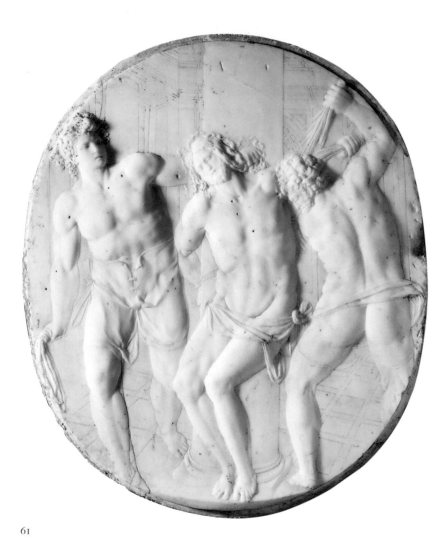

61

VINCENZO DANTI
Perugia, 1530–1576

The Flagellation of Christ[1]
ca. 1559
marble
51.4 × 43.9 cm

Kansas City, Missouri,
Nelson-Atkins Museum of Art

This oval marble relief reappeared in 1928 at an auction in Spoleto, near Danti's hometown of Perugia. It soon went to Florence (Ciardiello, 1929), then to Paris and later New York (Seligmann, ca. 1932–51), before being acquired by the present owner. Middeldorf initially connected the work "very tentatively" with those of Pierino da Vinci, subsequenty revising his analysis in favor of Danti (Middeldorf 1928, p. 53).

A *Flagellation* and a *Resurrection* are mentioned in an annotation to a sonnet written by Timoteo Bottonio in 1559 ("and around the same time . . . two marble bas reliefs, in one . . . the Resurrection . . . in the other, the Flagellation"),[2] following a reference to a bronze *Brazen Serpent* relief of the same year (Museo Nazionale del Bargello). But there is nothing to suggest that the two marble reliefs were of necessity part of a single program, or that they belonged to the same commission as the *Brazen Serpent*, made for the Medici. In the case of such a common

theme, a connection of the piece with mentions in Medici inventories of an anonymous small *Flagellation* are inconclusive. The oval format appears original, but this is not determinative for the attribution. Recent attempts to revive the attribution to Pierino da Vinci are clearly mistaken: Pope-Hennessy cogently excluded such a connection (letter, 1966).

The resurfacing of Danti's unpublished rectangular marble relief of the Resurrection (30 × 43.5 × 4.5 cm) – the same relief mentioned by Bottonio – in a Paris collection now ends the discussion, demonstrating beyond doubt Danti's authorship of the Kansas relief. The Paris relief closely resembles the *Flagellation* and is unquestionably in Danti's highly individual style. Compared to the *Flagellation*, the Paris *Resurrection* is a more complex and more densely populated composition, and it forms a revealing *trait d'union* between the divergent styles of the nearly contemporaneous *sportello* (cat. no. 62) and the *Brazen Serpent* (1559). The differences in scale and format between the two reliefs demonstrate that Bottonio's phrase, "nel medesimo tempo," is simply a general affirmation of the contemporaneity of the three works he mentions and does not imply a narrow time-frame.

No authentic relief by Pierino is remotely comparable to the Kansas *Flagellation*, which displays a somewhat orthodox and consolidated "michelangiolismo osservante" (Michelangelism), as Roman as it is Florentine and more typical of Danti, as well as bearing traces of Danti's native elegance and goldsmith's virtuosity, with barely any affinity to Bandinelli. The perspectival architectural background, carefully and incisively drawn, is found in none of Pierino's reliefs and is highly characteristic of Danti's smaller reliefs (Milan, Castello Sforzesco; Perugia cathedral, statue of Julius III; Perugia, Galleria Nazionale), many oval in format and some with

architectural drawing which might be termed "clumsy," as that of the *Flagellation* often is.

Danti was also an architect, and his one certain finished drawing, hitherto unidentified, shows the same combination of large-scale figure set into perspectival architectural context in an oval format. Classified by Byam Shaw as "(?)French, mid XVI C" (1976, no. 1447, pl. 856), this black-chalk, clearly Italian drawing of a seated female allegory is inscribed "Vinc° Purigino" (seventeenth century). It is drawn in a Michelangelesque graphic style and is recognizably by Danti in the costume and the extraordinarily long proportions. The constellation of elements is that of the Kansas *Flagellation* and Danti's other oval reliefs. The identification of the Christ Church drawing strongly suggests that a Museum of Fine Arts Boston drawing depicting Leda and other statues is drawn not by Danti but instead after his statue of Leda, now in London. In the Kansas *Flagellation*, the elegant chiseled and calligraphic treatment of the hair, for instance, in the head of Christ with its curving, angular, chain-link movement, matches perfectly the London Leda, a work certainly by Danti.

1. In addition to references cited within the text, see Summers 1969–70, pp. 68–69, 106–7, 358, 361–62, 364–65, 436–37; and Santi 1989, p. 43.
2. ". . . e nel medesimo tempo . . . due marmi di basso rilievo, nell'uno . . . la Resurezzione . . . nell'altro la Flagellazione . . ."

C. D.

62

VINCENZO DANTI
Perugia, 1530–1576

Safe door[1]
1559
bronze
99 × 65.4 cm

Florence, Museo Nazionale del Bargello

Born in 1530 into a family of artists, scientists, and writers, the sculptor Vincenzo Danti worked first in Rome and then for many years in Florence, before returning to his native Perugia. There he died in 1576 after participating in the establishment of the Perugian Accademia del Disegno, to which he donated plaster casts of Michelangelo's statues of the *Times of Day* in the Medici Chapel in San Lorenzo, Florence. Among the sculptors who passionately embraced the principles of Michelangelo's art, relief sculpture was not favored; few among these "Michelangioleschi" experimented so boldly with the form as Danti, and few achieved such distinguished results.

The dark bronze *sportello*, or safe door, closed a wall-safe in the office (*scrittoio nuovo*) of Cosimo I de' Medici in the Palazzo Vecchio in Florence, where the Duke's important papers were stored for security. The door was part of Vasari's program of renovation and decoration in the Duke's private quarters, and its geometrical framework, once emphasized through bright yellow-gold gilding, relies on the same design patterns used by Vasari throughout the ducal palace, and thus appears to have been designed by him. The central panel depicts the burning of ancient, secret books of religion, believed to contain subversive Pythagorean doctrines, discovered in the tomb of Numa Pompilius at the foot of the Janiculum in Rome. At the left is the figure of Temperance, at the right, Prudence, and below, Peace, seated with two bound captives at her sides. While the remaining figures are

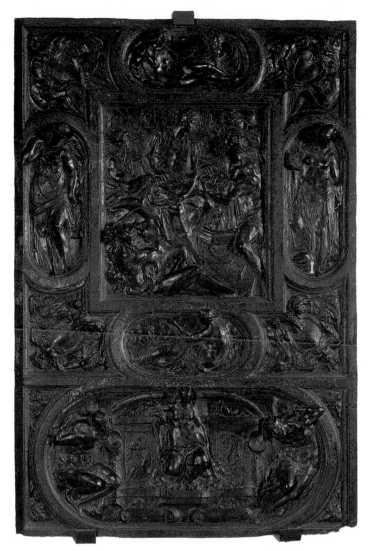

62

ambiguously characterized, the themes of the safe door carry a cautionary, moralizing implication: here are classified papers better destroyed than divulged. The iconographical program for the door seems to have been largely devised by Vasari's advisor, Cosimo Bartoli. Extensive records of payments made for the work in this ducal quarter permit progress to be followed step by step. Danti's wax model for the door was cast in bronze by the professional bronze caster, Zanobi Lastricati, shortly after November 1559.

1. In addition to references cited within the text, see Davis 1985, pp. 205–71; Fiore 1986b; Poeschke 1996, p. 233, pl. 254; and Fidanza 2000 (with bibliography).

C. D.

63

VINCENZO DANTI
Perugia, 1530–1576

St. Luke[1]
1570–71
terracotta
32.5 cm

Soprintendenza per i Beni Architettonici e per il P.S.A.E.D. di Arezzo; Museo Statale d'Arte Medievale e Moderna di Arezzo

The relatively high finish of this small terracotta statue suggests that it served as a *modello* for Danti's *St. Luke* in the Chapel of St. Luke in SS. Annunziata in Florence (1570–71) rather than as a preparatory sketch (*bozzetto*). Danti's sculpture at SS. Annunziata belonged to a series of twelve over-life-size seated

63

figures for the chapel, which served the Medicean Accademia del Disegno. Danti was the author of numerous Medici commissions (for example, the brilliant Michelangelesque *Brazen Serpent* with a Medici dwarf in the lower right corner, and the bronze *sportello*, cat. no. 62), and his outstanding talents were recognized in the award of this prestigious commission to execute the statue of St. Luke, the patron of painters and the titular saint of the painters' chapel.

Despite the careful working of its surface, the terracotta is endowed with a notable expressive force. It is Michelangelesque in character, not only in the physiognomy of the head and forceful anatomical treatment of the nude, but also in the organization of the drapery, characteristic of the mature Michelangelo, with emphatically formed folds framing the ample forms in large arcs. In the invention of his figure, Danti has ingeniously transformed his model, Michelangelo's reclining marble statue of *Day* in the New Sacristy of San Lorenzo, into a seated figure, possibly making drawings after a small model, as did Tintoretto in his multiple views of Michelangelo's statuary (e.g. Byam Shaw 1976, no. 762). Even more closely analogous is El Greco's famous drawing of *Il Giorno* (Munich, Graphische Sammlung) – almost exactly contemporaneous with Danti's statue – which represents the figure as seen from above, turned upright, and thereby transformed into a near-seated pose. Thus Danti shows himself still to be a pure "michelangiolesco" in this, one of his last Florentine works.

1. In addition to references cited within the text, see Davis 1981, pp. 301–2; Santi 1989, pp. 55–56; and Casciu 1994, p. 12.

C. D.

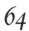
64

FOLLOWER OF MICHELANGELO
Florentine

Leda and the Swan[1]
ca. 1550–75
marble
138.3 cm

London, Victoria and Albert Museum

This marble was bought as a Michelangelo in 1865 by the celebrated painter Sir John Everett Millais from the collection of Count Angelo Galli-Tassi (1792–1863) in Florence, and was said to have been in the Galli family's possession for over three hundred years. On acquisition by the Victoria and Albert Museum it was associated with Vincenzo Danti (1530–76) through comparison with the figures on his *sportello* of 1559 (cat. no. 62). This attribution was later firmly expounded by Keutner (1958) who dated it to 1572–73, proposing a stylistic relationship with the bronze *Venus* (Florence, Palazzo Vecchio) also attributed to Danti, and the *Salome* of 1570 from the monumental bronze group of *The Beheading of St John the Baptist* (Florence, Baptistery). Pope-Hennessy (1964a, vol. 2, pp. 457–58, no. 484) followed suit, suggesting that Danti left the marble unfinished when he departed from Florence in 1573.

Kinney (1976, pp. 25–33), however, identified the marble as "una Leda alta due braccia" by the Florentine sculptor Bartolomeo Ammanati, recorded by Raffaelo Borghini (*Il Riposo*) as being in the possession of the Duke of Urbino and datable to about 1535. A drawing now in the Museum of Fine Arts, Boston, was seen as a preliminary sketch by Kinney, who rejected the inscribed attribution to Giuliano Dandi, sculptor of San Gimignano, said to have originated from Vasari, the one-time owner. This suggestion has since been rejected (Davis 1985, p. 270; Macandrew 1983,

pp. 24–25, no. 16), and the nature of the sketch indicates it is a study after the marble, or possibly after a small-scale model (verbal suggestion by Hugo Chapman) – a potential explanation for the differences with the sculpture.

Although theoretically this would not rule out association with Ammanati's documented *Leda*, generally identified with a Michelangelesque example in the Bargello, the style of the London group is quite distinct from the sculptor's secure works. Similarly, despite certain affinities, Danti's marbles are not sufficiently close to the overall treatment of the *Leda* to warrant firm attribution to him. Comparisons have equally been made with other sculptors, including Benvenuto Cellini, who in 1559 carved a (lost) marble *Leda* "one *braccia* tall" (about 59 centimeters; Summers 1979, pp. 374–77, no. 11). The composition, influenced by both classical and contemporary sources, would have made an appropriate pendant to the antique *Ganymede* (1548–50) restored by Cellini and placed alongside Jacopo Sansovino's *Bacchus* in Cosimo I's apartments (both now Florence, Bargello; Pope-Hennessy 1985, pp. 227–29). The marble can therefore be placed in the general orbit of Michelangelo's followers in the third quarter of the sixteenth century.

The *Leda and the Swan* is a powerful yet subtle work, with its lyrical movement and sensitive interrelationship of the protagonists. Like Cellini's Ganymede, Leda fondles the delicately carved feathers of the bird's neck but, in contrast to Cellini's work, some areas of the marble are confused and poorly carved, possibly indicating a later reworking. Unusually, the Leda is shown draped, her diaphanous, scalloped robe belted at the waist and supported at the shoulders by straps and clips created from rodent (possibly weasel) heads, which perhaps held some significance. This differs markedly from the typical classical drapery on similar

64

65

contemporary sculpted females. Pope-Hennessy's suggestion that the marble may have been intended as a fountain figure is plausible, but cannot be supported by evidence, and the original setting remains unknown.

1. In addition to references cited within the text, see Santi 1989, pp. 57–58; Fidanza 1996, pp. 36–37, 38, 39; and Eisler, no. 9.

P. M.

65

MATTIAS FERRUCCI
(?)Florence, second half of the sixteenth century–(?)Florence, after 1653

Grand Duke Cosimo II[1]
1621
porphyry
64.5 cm without the base
inscribed: "MATT[HIAS] FERR[UCCE]US FE[CI]T"

Florence, Palazzo Pitti

FLORENCE ONLY

The skill and technology that went into the execution of this bust, and indeed the very idea that Cosimo II's portrait be realized in porphyry – the purple stone associated with Roman and Byzantine emperors – has a remarkable history in grand-ducal Florence and in the Ferrucci family. Mattias di Giovan Battista Ferrucci was the grandson of Francesco Ferrucci, called Il Tadda (1497–1585), the most significant craftsman associated with working porphyry at the sixteenth-century Medici court. Member of a famous clan of stoneworkers and trained as a stonecutter and ornamental carver in the stoneyards of Fiesole, Tadda took up the challenge posed by a stone harder than ordinary steel stoneworking tools when, in 1555, Cosimo I commissioned a porphyry fountain for the center of his palace courtyard. Soon after, Tadda began to carve relief heads in porphyry, of Christ and of Cosimo I, his wife, and progenitors, and eventually he executed an over-life-size *Justice* in porphyry (see cat. no. 98e), with the help of two of his sons, Romolo and Giovan Battista, Mattias's father.

Widely acclaimed, these feats were made possible by the novelty of his tools, which relied for their effectiveness, according to contemporaries, on the herbal distillate used to harden or "temper" their steel. Although Cosimo I's practical knowledge of plants and distillation, as well as Medici experimentation in hardening steel armor, lend plausibility to Vasari's claim that Cosimo provided the original temper, this was not the agent of Tadda's success. The temper worked because of the size and shape of the new steel tools that Tadda designed, his metallurgical skill in forging and maintaining them, and his dogged patience (Tadda took a month to execute the eye of a *Savonarola* and thirteen years to execute the *Justice*). Cutting inscriptions was one of the skills of the good stoneworker, so the signature, MATT[HIAS] FERR[UCCE]US FE[CI]T, on the back of this bust's left shoulder was meant to be appreciated for its technique. Michelangelo, who had tried and failed to repair an ancient porphyry basin, was impressed when shown Tadda's *Head of Christ*, but his preference for white over colored stone, and the rapidity of his carving technique, meant that he had little interest in carving porphyry himself.

As a dynastic portrait in porphyry, this image of Cosimo II belongs to Tadda's series of Medici portraits and to the related reliefs, probably carved by Mattias, of Christine of Lorraine (begun in 1601) and Ferdinando I. As a bust in the imperial stone, it just precedes the larger and far more elegantly carved busts by Tommaso Fedeli da Urbino of Ferdinando I, Cosimo II, and Ferdinando II. Valued for its rarity, durability, and imperial associations, the purple–red stone flecked with white was usually better suited to portraying authority than character. Maria Maddalena of Austria, when given this weak-shouldered and coarsely carved bust of her husband, declaimed that it was a "rare thing, but not very much like him."[2] Fedeli rather than Mattias was asked to execute the next porphyry bust of Cosimo II.

1. See Langedijk in *Palazzo Vecchio* 1980, pp. 346–48; Langedijk 1983, vol. 1, pp. 112–14, 167, 191–92, 563, 669–70, vol. 2, pp. 751, 800–1; Castro Moscati 1987; Butters 1996; and Zangheri 2000, p. 130.
2. "cosa rara, ma non troppo somigliante." Tinghi 1600–15, fol. 261.

S. B. B.

66

MATTIAS FERRUCCI
(?)Florence, second half of the sixteenth century–(?)Florence, after 1653

Head of the Virgin of the Annunciation, after the Miraculous Image of the Annunciation in Santissima Annunziata, Florence[1]
first half of the seventeenth century
porphyry
31 cm
signed lower edge: "MATTHIAS FERVCCEVS FLOR. F"

Detroit, Private Collection

The protagonists of empires earthly and heavenly have long

been associated with porphyry, which in color suggests the purple of kingship and the red of martyrs' blood, and in its substance, formed by fire, is so indestructible that, unlike marble, it remains intact when burned. Mattias's pious grandfather, Tadda, whose miraculous cure by the spirit of Savonarola was recorded in 1578, had often been moved to devote his unusual skill in porphyry carving to the glory of God. Personal devotion rather than a commission probably prompted Tadda to carve the porphyry *Head of Christ*, now in the Prague National Gallery, and that of "the Mother of God," now lost, although both soon fell into Medici hands. His two heads of Savonarola in porphyry, also lost, were certainly personal declarations of spiritual love and gratitude.

The fine relief by Mattias Ferrucci displayed here, undocumented and incorrectly identified as a young Christ since its appearance at auction, could not be a more eloquent heir to this family tradition of personal piety and technical bravura. The sweet, full-faced figure, whose upward gaze to the left suggests inspiration from a painted or sculpted narrative, depicts the youthful Virgin Annunciate from the fourteenth-century fresco of the *Annunciation* in the Annunciate's Chapel within the Servite church of Santissima Annunziata, a work that owed its great fame and veneration to the fact that the Virgin's head had been miraculously executed. Despite its unified color, unnatural but shining by virtue of its splendid finish, the depiction in the relief is extremely accurate in its physiognomy and features, pose and glance, dress and overmantle, and hair, curling over the ear and falling naturally over the shoulder, so simple and pure "as to outstrip the most exquisite ornaments and the delicacy of all the hair clasps that women hold in such high regard."[2] Her gentle beauty not only exemplifies the paradigmatic qualities of Mary but testifies

to the quality that Bocchi, in the treatise he dedicated to the fresco in 1592, called "costume," in which the soul's nature suffuses the face, a quality all painters tried to portray but which the divine painter, portraying a divine subject, had realized consummately.

To Florentines of the time, and to the visiting pilgrims who had enjoyed the favor of having the fresco revealed to them, the subject of Mattias's relief would have been immediately recognizable. Obvious too would have been the special privilege implicit in such a depiction, for only recently had the Medici Grand Dukes, whose family had been the fresco's particular patrons and protectors for more than a century, permitted any copies of it to be made. Typically, the one that Allori painted in 1580 was for a person both pious and well connected, Cardinal Charles Borromeo. What motives lay behind its emulation in porphyry rather than paint are not known, but Mattias would not have proceeded without grand-ducal and Servite permission. It may well be significant that he was a priest as well as a sculptor, however, and if Mattias was a Servite, this would help to explain the origins of such an unusual work.

Although its intended recipient remains a mystery, Ferdinando I and Cosimo II commissioned works for the Annunciate's Chapel, and their wives, like other women, were particularly devoted to Florence's most venerated image; Medici versions of it in *pietre dure* continued to be made into the eighteenth century. Fortuitously but conveniently, from the tenth century to 1749, the Florentine calendar began on 25 March, the Feast of the Annunciation.

1. See Bocchi 1852; Cappelli 1978, p. 13; Baldini, Giusti, and Martelli 1979, pp. 313–14; *Splendori di Pietre Dure* 1988–89, pp. 170–71, 178–79; Lecchini Giovannoni 1991, p. 256 and fig. 190; Butters 1996; *European Sculpture and Works of Art 900–1900*, Sotheby's sales catalogue, London,

66

13 December 2000, pp. 28–29; and Zangheri 2000, p. 130.
2. "Non è la capellatura ornata in alcuna parte, ma così semplice, come si vede, e così pura, mentre che cade sopra le spalle, che vince ogni isquisito ornamento e tutta la dilicatezza di tutti i fermagli, che sono alle donne cotanto in pregio." (Bocchi, p. 62).

S. B. B.

67

PIETRO FRANCAVILLA
Cambrai, 1548–Paris, 1615

Meleager
1590–95
bronze
76.5 cm

Dresden, Skulpturensammlung, Staatliche Kunstsammlungen

This sophisticated sculpture representing the mythical figure who slew the boar of Calydon is one of the few bronzes attributed to Pietro Francavilla. It is mentioned in the

inventories of the Dresden Museum from 1747, listed as an object of Roman provenance and the pendant to another small statue of a hunting *Diana*. The bronze has been the subject of in-depth research by Raumschüssel, who initially (in *Barock in Dresden* 1986, p. 209, n. 232) considered the work to be the product of an Italian–Flemish master, as suggested by Weirauch (1956, p. 84, n. 109), adding that the artist might have been from the circle of Giambologna, stylistically close to Francavilla. On the occasion of the great Berlin exhibition of 1996 dedicated to Renaissance and Baroque European bronzes, the same scholar attributed the work to Francavilla on the basis of comparisons with other works by this artist, suggesting a date around 1590–95 (in *Von Allen Seiten Schon* 1995, p. 330, n. 100).

The possibility of attributing the *Meleager* to Francavilla had already been suggested by Pope-

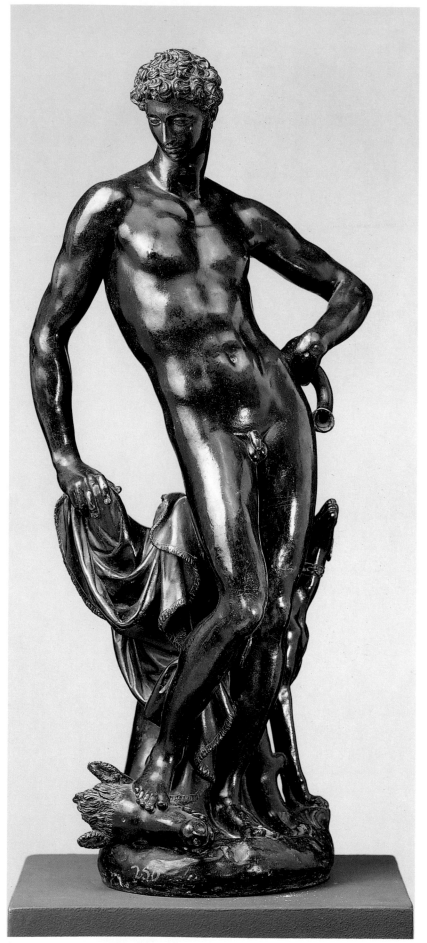

Hennessy (1970), who noted significant formal similarities with the wonderful terracotta representing a semi-reclining youth at the Victoria and Albert Museum in London, rightly considered by the scholar to be the work of the Flemish artist. The most accentuated similarity between the figures lies in their heads and long arched necks, a recurrent characteristic in Francavilla's work, deriving from Michelangelo's statue in the New Sacristy of San Lorenzo of Giuliano de' Medici, whose proud, controlled energy is here transformed into an attenuated elegance.

The comparisons offered by Raumschüssel in support of the Francavilla attribution – with the sculptor's *Jason* for the Palazzo Zanchini (Florence, Museo Nazionale del Bargello) and especially with his *Apollo* for Averardo Salviati, signed and dated 1591 (Baltimore, Walters Art Museum) – are particularly convincing. The two figures show a strong similarity of pose to the Dresden bronze, as well as a Hellenistic softness in the treatment of the body, the sinuous outlines, and the pure features of the face, that seem to derive from a common model. Raumschüssel has also pointed out several other formal and iconographic influences: the evident reference to the antique, particularly the Belvedere *Antinous* and an antique torso at the Uffizi Gallery "restored" as a *Meleager* in the sixteenth century; and an allusion to Raphael's fresco of *Apollo* in one of the niches of the *School of Athens*.

The inclusion of the *Meleager* in the tiny corpus of Francavilla's small bronzes might be an important step towards the reconstruction of the sculptor's activity in this field, which was, however, infrequent, as he enjoyed a different role within the tightly structured workshop of Giambologna: the essential position of first assistant in the production of monumental marble sculptures. A new evaluation of this side of his work may lead to a thorough reconsideration of his bronze output, which, not coincidentally, reached its artistic peak away from Florence and Giambologna, in the four superb *Slaves* of his monument for Henry IV of France (Paris, Musée du Louvre).

D. P.

68

PIETRO FRANCAVILLA
Cambrai, 1548–Paris, 1615

St. Romualdo[1]
1599
marble
ca. 70 cm high

ANMIG (Associazione Nazionale fra Mutilati ed Invalidi di guerra sezione di Firenze

This sculpture, signed and dated (PET.FRANC.IN GRATIAM D.SILVANI K [sic] AC.F. A.D. 1599), is situated above one of the doors in the southern wall of the cloister of the convent of Santa Maria degli Angeli in Florence and belongs to a series of ten busts representing the Virgin, the Saviour, and saints and beatified persons from the Camaldolese order. The busts, placed in the middle of the split timpani surmounting the doors to the interior rooms, are an integral part of a rich ornamentation that includes lunettes frescoed by Donato Mascagni, Bernardino Poccetti, and Bernardino Monaldi, and depicting stories FROM GENESIS AND stories of St. Romualdo. The initiative of redecorating several areas of the convent and of the cloister dated back to Don Silvano Razzi, the abbot from 1592 until 1611, who lavished on this enterprise a generous amount of money and uncommon artistic taste. The abbot entrusted Giovanni Caccini with the principal responsibility for this series of busts, and the majority were executed by him, whereas Francavilla sculpted only the *St. Romualdo* and the *Ambrogio Traversari* (also signed and dated). On stylistic grounds the bust for *St. Pier Damiani* can also be (partly) attributed to him (Conigliello 1998, p. 78).

67

The portrait busts of saints for this cloister were executed at the end of a particularly prolific decade for Francavilla, rich in significant events and commissions, which had firmly established him as an artist in Florentine and Pisan circles. In the same year, 1599, according to eighteenth-century documents from the convent, the sculptor had portrayed Ambrogio Traversari for the second time in an oval bas-relief placed above one of the doors of the Chiostrino dei Morti (Little Cloister of the Dead). Also by him is a second bust representing *St. Romuald*, signed and dated 1600 (Florence, Ospedale di Santa Maria Nuova) and of large dimensions. This was made for an unspecified room in the Convento di Santa Maria degli Angeli.

The *St. Romuald* exhibited here reveals Francavilla's specific intent to render the moral nobility of his subject and his importance as the founder of the Camaldolese order. In some formal aspects, such his representation of the folds of his habit, Francavilla seems to be influenced by Caccini, who on other occasions too was engaged on the same artistic commissions as the Flemish sculptor. A comparison between the two artists, however, does not prove favorable to Francavilla: the gaunt face of the *St. Romualdo*, with its flowing beard, has a fixed gaze and an immobility that render the saint less attractive and expressive than the softly intent faces of Caccini's neighboring saints. It is no coincidence that Caccini, perhaps owing to a more modern sensibility, was entrusted with the majority of these sculptures.

1. See Conigliello 1998, pp. 74–78, 95–96 (with preceding bibliography).

D. P.

68

69

GIOVANNI BOLOGNA, CALLED GIAMBOLOGNA
Douai, 1529–Florence, 1608

Rape of a Sabine[1]
1579
bronze
99.5 cm

Naples, Museo di Capodimonte

FLORENCE ONLY

A letter from Giambologna to his patron Ottavio Farnese, Duke of Parma, dated 13 June 1579, cites the completion of this statue and its readiness for shipment. The letter offers multiple interpretations of its theme as the rape of Helen, Proserpina, or one of the Sabines, since "the subject was chosen to give an opportunity for the knowledge and study of art."[2] Clearly what concerned the sculptor foremost was the artistic problem of how to represent one figure lifting another. Scholars have noted that the muscular, striding man depends on a motif from a famous ancient statuary group then owned by the patron's family, the *Farnese Bull* (Naples, Museo Archaeologico). The sculptor devised the graceful torso and gesticulating arms of the woman to contrast with her sturdy assailant, yet interlocked their figures in a way that is anatomically plausible and artistically satisfying. Following

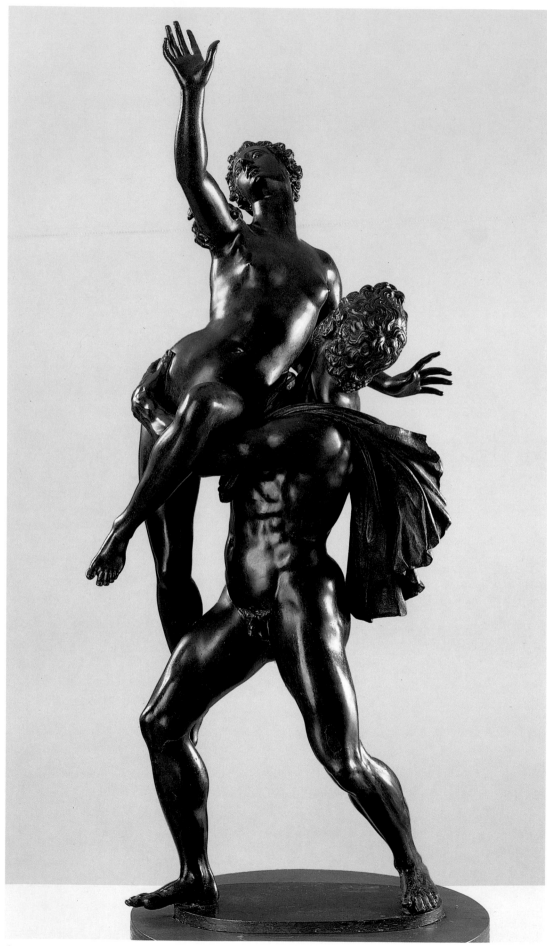

this work the sculptor proceeded to amplify the composition by adding a Sabine man crouching at the base. This complex and dramatic work became one of his best-known marble groups, *Rape of the Sabines*, in the Loggia dei Lanzi in Florence.

The over-three-foot-high bronze in Naples was intended as an important interior decoration, as we know that Giambologna made an ebony base set with stones for it to stand on in Parma. Two other versions may be contemporary with Giambologna (New York, Metropolitan Museum of Art, and Vienna, Kunsthistorisches Museum). The professional finish of these two bronzes suggests that Giambologna handed the model over to his assistant Antonio Susini after making the prime version.

1. See Ambrosio 1995, p. 24, no. 9.
2. ". . . *eletto per dar campo alla sagezza e studio dell'arte.*"

I. W.

70

GIOVANNI BOLOGNA,
CALLED GIAMBOLOGNA
Douai, 1529–Florence, 1608

The Rape of Deianira[1]
1575–80
bronze
42.1 cm
inscribed on fillet binding
Nessus's head: "IOA BOLONGIE"

Paris, Musée du Louvre,
Département des objets d'art

FLORENCE ONLY

The centaur Nessus clutches Hercules' wife Deianira to his back and rears to gallop away with her. Hercules had entrusted the centaur with the task of carrying his wife across the river Evenus, but was betrayed when Nessus rode off with her. The model for this composition proved to be immensely desirable to contemporary connoisseurs. Its attraction lies in the successful integration of two struggling figures into one

69

composition, combined with the popular mythological theme of abduction. Giambologna had sought solutions to the problem of the interaction of two figures since the *Samson and the Philistine*, 1560–62, once in the Medici Casino di San Marco in Florence and now in the Victoria and Albert Museum, London. Michelangelo's exercises in balancing struggling figures, as in his *Samson and the Philistines*, known through various models, inspired followers to attempt to solve this compositional challenge. Furthermore Michelangelo's composition initiated a series of abduction groups that found fullest expression in the *Rape of the Sabines* in the Loggia dei Lanzi (see cat. 69). The half-horse, half-man nature of the centaur added equestrian complexity to the figural composition and a bestial element to the subject.

First mention of the commission appears in documents of the Salviati family. The resulting bronze has been identified by Keutner (*Catologo della Galleria Colonna* 1990, p. 285, no. III) as that mounted on a seventeenth-century bureau in the Galleria Colonna in Rome. While this location would have been adopted only when the bronze passed from the Salviati to the Colonna, the mounting of the composition on furniture indicates the kind of placement such a bronze would have had in interior decor. The composition also appealed to the Medici. Another model was given by the Duke of Tuscany to Duke Christian I of Saxony before 1587 and is still in Dresden (Staatliche Kunstsammlungen). The Louvre model in this exhibition – now regarded as the earliest signed version – was probably given by André Le Nôtre, famed garden designer and notable collector of bronzes, to Louis XIV of France in 1693. A third signed example is in the Huntington Library, San Marino, California. Bronze specialist and sculptor Antonio Susini varied the composition, particularly the pose of Deianira,

in a work of which replicas can now be found in the Louvre and in the Robert H. Smith Collection, Washington, D.C. Numerous casts and variations of Giambologna's and Susini's models testify to their enduring popularity and make them prime examples of the refinement of bronze casting in late-sixteenth-century Florence and of the dissemination by gift of bronze statuettes throughout Europe.

1. In addition to references cited within the text, see *Les bronzes de la Couronne* 1999, cat.176, pp. 128–29; and Radcliffe 1994, pp. 46–52, no. 7.

I. W.

71

GIOVANNI BOLOGNA, CALLED GIAMBOLOGNA
Douai, 1529–Florence, 1608

Fata Morgana[1]
ca. 1572
white Carrara marble
99 cm

Private Collection

Since its discovery at auction in 1989 (Christie's South Kensington at Wrotham Park, 13 September 1989), this sculpture has been the subject of debate over its identification as the lost marble figure of Fata Morgana (Morgan le Fay), which Giambologna is recorded to have carved for the grotto at the Villa Il Riposo near Florence belonging to his first patron and benefactor Bernardo Vecchietti. Raffaello Borghini's account in his book *Il Riposo* (1584, pp. 250–51) is the basis for this identification: "Above the basin that receives the water a most beautiful woman made out of marble by Giambologna in the act of leaving a cave . . . and this woman represents the *Fata Morgana* (after which in ancient times the spring was named)."[2] On the basis of two inscriptions of 1572 and 1574, formerly within the grotto, and on stylistic grounds, the sculpture

70

71

has been dated to between 1571 and 1574.

Early photographs and the present remains of the grotto, in which Vecchietti dined and entertained visitors, make clear that the figure was placed on a rustic fountain as if emerging from a cave. The choice of subject may have been derived from Boiardo's *Orlando Inammorata* (II, VIII, 5) or Ariosto's *Orlando Furioso* (VI, 44), though it has also been suggested that following Arthurian legend and French and Italian chivalric romances, she functions in her benign interpretation as the fount of youth, with the implication that her own youth had been restored by Vecchietti. This was a pun on his name and reference to the rejuvenating source of water at the grotto (Heikamp 1981, pp. 25–27; Bury 1990, p. 100; Heikamp in *Magnificenza* 1997, pp. 51, 52).

By 1753 the figure (described as a "Busto di Venere") had been moved to a different location in the grotto, and she figures in the 1755 inventory of the villa itself. Her identification as the *Fata Morgana* seems always to have been ambiguous, for the English painter and dealer Thomas Patch, who had acquired her from Vecchietti's descendants by 1768, describes her as Venus in his letter of October that year offering her to Charles Townley (Bury 1990, p. 97). In 1773 she is again described as a Venus while in Patch's collection, and in Giuseppe Pelli's report to the Grand Duke, Pietro Leopoldo, recording Patch's application to export her from the Grand Duchy of Tuscany in October 1775, she is referred to as "Venus in the Bath," though Pelli also refers to Borghini's identification of her as the *Fata Morgana* (Avery 1990, p. 392).

Scholarly opinion differs as to whether this newly discovered figure can be associated with the figure exported by Patch and sold to a "vecchio inglese," apparently the Second Earl of Hopetoun (1704–1781, passing thereafter by descent and purchase to the present owner).

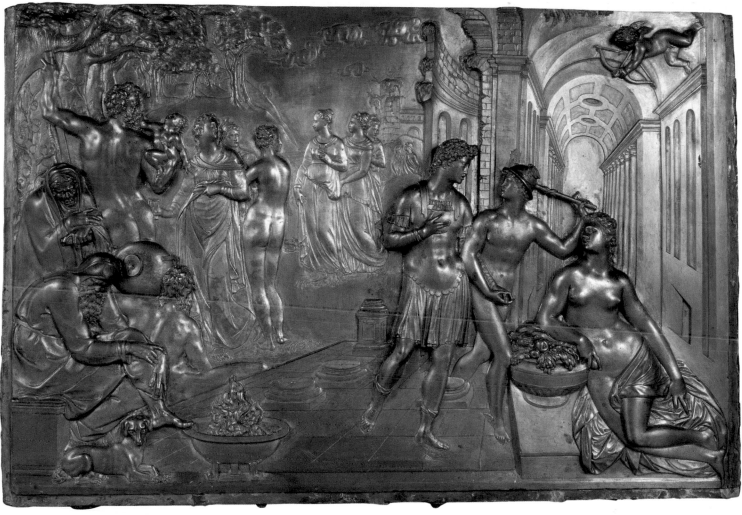

72

Bury has argued that its style can be approximated with other works by Giambologna of the early 1570s, such as the marble version of *Florence Triumphant over Pisa*, completed 1570–72, a view shared by Heikamp (in *Magnificenza* 1997, p. 52). Even accounting for its weathered state, Avery (1990, p. 399) considers the sculpture to be of insufficient sculptural quality to be by Giambologna's hand, referring to the *Venus* of the Grotticella as the qualitative benchmark for the present figure, and citing Pelli's disparaging report of it by two other artists as "not a first rate work, but of squat design."[3] Wengraf (1990, p. 439), however, has also pointed out Pelli's statement that he knew of "no [other] marble statue in the Royal Gallery, which is definitely by Giovanni Bologna, and therefore it might be an

occasion to purchase this example,"[4] as support of its attribution. Brook (2000) has identified a graphic source for Giambologna's composition in a print of *Venus and the Rose* by Giorgio Ghisi after Luca Penni, dated 1556.

1. In addition to references cited within the text, see Avery 1987, p. 100.
2. "Sopra il vaso, che l'acqua riceve è una bellissima donzella ignuda di marmo fatta da Giambologna in atto di uscir d'un'antro . . . e questa bella donna per la Fata Morgana (da cui anticamente fu appellata questa fonte) è figurata." Borghini 1584, pp. 250–51.
3. "non è opera di primo rango, ma di disegno tozza." Archivio delle Gallerie Fiorentine, filza 8, no. 64, 14 October 1775, cited in Bury 1990, p. 143, n. 17.
4. "non conosco nella R. Galleria Statua in marmo che sia sicuramente di Giovanni Bologna e perciò

potrebbe esser opportuno l'acquisto di questa." Archivio delle Gallerie Fiorentine, filza 8, no. 64, 14 October 1775, cited in Bury 1990, p. 143, n. 17.

A. B.

72

GIOVANNI BOLOGNA, CALLED GIAMBOLOGNA
Douai, 1529–Florence, 1608

Allegory of Prince Francesco de' Medici
ca. 1561–62
bronze with light red–brown patina
30.7 × 45.6 cm

Vienna, Kunsthistorisches Museum

CHICAGO AND DETROIT ONLY

Giambologna is better known for his statues than for his reliefs,

and within the latter category, his religious works, such as the cycles in the Grimaldi and Salviati chapels, are more famous than secular ones. The secular reliefs mainly provide commentary for large-scale sculpture as predellas do for altarpieces. While the reliefs on the *Oceanus* fountain, the equestrian statue of *Grand Duke Cosimo I de' Medici*, and the *Rape of the Sabines* are superb works of art, they are all incorporated into a larger complex. Eight gold reliefs of the life of Francesco I were similarly part of the decoration of an ebony cabinet. What is interesting about the *Allegory of Prince Francesco de' Medici* is its rarity as an independent relief within the Giambologna *oeuvre*.

Apparently an early work – predating Francesco's growing a beard by 1564 and thought by Manfred Leithe-Jasper (1986,

209

73

pp. 210–13, no. 53) to date around 1560–61 – this relief is one of four versions. The alabaster relief in the Prado in Madrid is likely to be the prime version, and it may be that Francesco presented it to Philip II at the time when he was staying at the Spanish court in 1562–63. Artists in Giambologna's native Flanders such as his teacher Jacques Dubroeucq favored alabaster, and the sculptor occasionally used it in early works in Italy. It is possible that the Kunsthistorisches bronze and another version in the Bargello were cast directly from the alabaster, but Leithe-Jasper cautions against this assumption. There is also a silver version in Vienna. Cosimo may have sent the Vienna bronze to Emperor Maximilian II in 1565, but its certain pedigree begins only in 1604, when Cesare d'Este gave it to Rudolf II.

A precise interpretation of the relief's subject continues to be elusive. E. Tietze-Conrat (1918) considered it to be a courtly allegory of Francesco I de' Medici being led by Mercury towards his bride. Cosimo sought the hand of Barbara, eldest daughter of Maximilian II, for his son Francesco and is known to have sent statues by Giambologna to promote the match; but Barbara was given as wife to the Duke of Ferrara, and her sister Giovanna wed Francesco. Keutner (1978–79) countered that the relief represents the theme of Francesco as future ruler of Tuscany. In this view Francesco approaches the personification of Florence, a subject the sculptor treated as an independent fountain motif (cat. no. 74). Flying Cupid encourages the mutual attraction of the couple with his arrow. On the left side

a queue of figures including a river god, Saturn (Chronos), and the Hours symbolizes, for Keutner, time and the cycles of nature. The complexity of this allegory is not unlike that of Pierino da Vinci's marble relief *Pisa Restored* of around 1552 (cat. no. 95), in which the Duke is shown among personifications of his virtues expelling the vices of Pisa. While the bronze relief's crowded composition may reflect Giambologna's inexperience in combining various northern European print sources, the suave poses of the figures nonetheless make this a seductive image.

I. W.

73

GIOVANNI BOLOGNA,
CALLED GIAMBOLOGNA
Douai, 1529–Florence, 1608

Monkey[1]
ca. 1567–70
bronze with brown patina
41 × 35 × 28 cm

Paris, Musée du Louvre,
Département des objets d'art

DETROIT ONLY

The *Monkey* has been closely associated with the four bronze monkeys originally placed in niches on the plinth supporting Giambologna's marble fountain group of *Samson and a Philistine* (London, Victoria and Albert Museum). The fountain was commissioned by Francesco de' Medici for the *casino* built by Buontalenti between 1568–67 for the garden at San Marco, and was placed in the garden of simples. In the preparatory drawing for the fountain (Galleria degli Uffizi 1416s), monkeys can be seen in the niches on the pedestal supporting the marble basin.

The fountain remained in Florence until 1601 when it was sent to Spain as a diplomatic gift and placed in the gardens of the Royal Palace at Valladolid. In 1623 the surmounting sculpture was sent as a diplomatic gift to

England to the Prince of Wales, Charles Stuart, the future King Charles I, who in turn gave it to George Villiers, the Duke of Buckingham. After several further vicissitudes, the sculpture came to the Victoria and Albert Museum (see Pope-Hennessy 1964a, pp. 460–65, no. 486 for full history). Its base was sent to the Jardín de la Isla, at the Royal Palace of Aranjuez, where it presently supports a bronze figure of Bacchus by the Flemish sculptor Jacques Jonghelinck. It appears that the bronze monkeys were separated from the rest of the fountain, either when it was originally sent to Spain in 1601 or by 1665, the date of an engraving of the fountain that does not include the monkeys in the niches.

Lefébure (1984) and Avery (1987, p. 154) characterize the monkeys on the pedestal as representing the baser instinct of man and connect them with the figure of the Philistine in the sculptural group surmounting the fountain. Monkeys have also been associated with taste – which, as, Lefébure points out, is appropriate for a fountain situated in the center of a garden of simples – and with the sanguine humor, one of the four temperaments of man, a link that concurs with Francesco de' Medici's interest in the esoteric and alchemic. A further relationship is with the Medici family's fascination with exotic and domesticated animals, as witnessed by the menagerie kept in a courtyard at the Palazzo della Signoria, and by the bronze birds Giambologna cast for the Grotta Grande at the Medici Villa at Castello in 1567. The verisimilitude of some of these, especially the *Eagle* and the *Turkey* (both Florence, Bargello; Avery 1987, figs. 156, 158), suggest that Giambologna took life casts. Given the stylistic similarities between Giambologna's treatment of the birds' feathers and the lively surface treatment of this monkey, which is worked freely in the wax and the finished bronze, it is likely that the latter was cast soon after the birds, perhaps

between 1567 and 1570, and we know that the marble for the base was quarried in 1569. Scientific examination of this bronze shows that the monkey's left paw was cast separately from the rest of the figure. The composition of the metal is similar to a bronze *Pigeon* (inv. no. OA9138) also in the Louvre.

1. In addition to references cited within the text, see *Nouvelles acquisitions du département des objets d'art 1980–1984*, Musée du Louvre, Paris, 1985, no. 19; and Avery 1987, pp. 47, 56, 154, no. 129, pls. 44, 157.

A. B.

74

GIOVANNI BOLOGNA,
CALLED GIAMBOLOGNA
Douai, 1529–Florence, 1608

Venus (Fiorenza)
after 1565, probably ca. 1571–72
bronze
125 cm

Florence, Museo della Villa Medicea - Soprintendenza per i Beni Architettonici e per il Paessaggio di Firenze, Pistoia e Prato

This bronze, which originally topped Tribolo's fountain of *The Labyrinth* at the Medici Villa at Castello, is usually reproduced under the name "Florence." The identification depends in large part on the assumption that Giambologna knew, and perhaps even completed, the statue Tribolo projected but never cast for the fountain. Boström (1997), however, has recently demonstrated that Tribolo's model had in fact been cast well before Giambologna's time by Zanobi Lastricati; Giambologna was commissioned to replace, not to complete, the statue Tribolo designed.[1] The earliest writer to mention Giambologna's statue *per se*, moreover, was Baldinucci, who referred to it not as "Florence," but simply as "a woman combing her hair," perhaps seeing something more akin to Venus at her toilette.[2]

Though the woman in fact holds no comb, the idea raised by Baldinucci merits attention: Avery (Avery and Radcliffe 1978) suggested that the statue is based on an engraving by Marcantonio Raimondi showing Venus wringing water from her hair, and Keutner noted that this gesture would identify the statue as a Venus Anadyomene, the goddess born from the sea, who presses brine from her locks (Avery and Radcliffe 1978, p. 80). Though Keutner himself, in the end, also sustained the identification of the figure as "Fiorenza" – largely on the basis of the socle ring, which includes emblems of conquered Tuscan cities – his demonstration that these emblems were themselves complete by 1555, and thus not by Giambologna, leaves open the possibility that Giambologna intended the statue to be a Venus (*Von Allen Seiten Schön* 1995, pp. 358–61). That the base of Giambologna's statue does not fit snugly into the ring (which must have been left by Lastricati) raises doubts about whether Giambologna had it before him when making the work. What's more, the attributes on Lastricati's figure that most clearly identify it as "Florence" – a diadem with Medici *palle* and a fleur-de-lis – are absent from Giambologna's.

If Tribolo's figure already represented Florence as Venus, or if Giambologna, not attending to the existing socle, transformed Tribolo's figure of Florence into Venus, the resulting ambiguities would have been intensified by the height and distance at which the work was originally displayed. The work's original viewers, moreover, may even have appreciated the conflation of the two figures, which could have served to suggest various aspects of Florence. With fertile waters pouring from her hair, the statue could suggest Venus's role as genetrix, or even as the *dea hortorum*, governing the garden and the liquids over which she presided, and more specifically, the flowers that gave Florence its name.[3]

74

75

The earliest evidence of Giambologna's work on the figure is its appearance in a contemporary portrait of the artist, one that also shows Giambologna's 1565 design for the Bologna *Neptune*. Giambologna must have completed the statue around 1571, the year Lastricati's bronze was removed from the fountain and exported to Spain.[4]

1. Lastricati's bronze currently stands in the gardens at Aranjuez in Spain.
2. "Gettò dipoi a Firenze una femmina in atto di pettinarsi le chiome, per l'altre volte nominata villa di Castello." Baldinucci 1845–47, vol. 2, p. 568.
3. On the Venus Genetrix as the goddess of flowers, and more generally on the Venus Hortorum, protectress of gardens, see Dempsey

1992, pp. 41–49. For the origins of Florence's name see Villani 1802, vol. 1, book 1, ch. 38, p. 58.
4. The authorship of the portrait remains disputed: Avery suggests Pietro Francavilla; Keutner, Hans Van Aachen; Laschke, Paserotti.

M. W. C.

75

GIOVANNI BOLOGNA, CALLED GIAMBOLOGNA
Douai, 1529–Florence, 1608

Morgante on a Barrel[1]
before 1582
bronze
41 × 17 cm

Paris, Musée du Louvre, Département des objets d'art

DETROIT ONLY

There were two dwarves at the sixteenth-century Medici court, Barbino and Morgante (ca. 1535–after 1594), the latter named after the giant in Luigi Pulci's epic poem, *Morgante* (1483). The dwarf Morgante is the subject of this and a number of related bronzes and he was also painted as Bacchus in the mid-1550s by the court artist Bronzino.

He is shown here in the same guise, perched uncertainly on a wine cask with the base of a glass (its bowl missing) in his left hand and a spigot in his right. On the cask below is a covered vent. The modeling of the sculpture is superb, with all the details well defined and clearly legible, and it is cast in one piece, with four integrally cast lugs on the underside, presumably for fixing. The dark patina is of the highest quality.

A few sculptures replicate the prototype bronze: a terracotta example (a copy?) exists in the Museo Stibbert in Florence; H. R. Weihrauch (1967, p. 223) refers to an example in the Binder Collection in Düsseldorf; another example, presumably following closely the *Morgante on a Barrel* and made in sugar paste for the wedding celebrations of the future Grand Duke Cosimo II and Maria Maddalena of Austria (1608), has not survived.

In *Morgante on a Barrel* the figure of the dwarf is identical to that of the *Morgante on a Dragon (or Sea Serpent)* from the sixteenth-century Medici collections, today in the Museo Nazionale del Bargello, Florence (Supino 1898, p. 390, no. 36). The Bargello bronze, in which the dwarf holds a fishing rod and fish, was made as a fountain to be placed in a basin in the hanging garden of the Uffizi created for Francesco de' Medici. The figure itself is by Giambologna and the dragon by the goldsmith Cencio della Nera, and the two components can be securely dated to 1582–83. The date of the *Morgante on a Barrel* is less certain. The superiority of its facture has suggested to some scholars that it preceded the

Morgante on a Dragon and already existed when a fountain figure was requested from Giambologna in 1582 (Jestaz 1979, pp. 78–79). It has also been noted that the pose of the arms, the same in both statues, is more suited to a wine glass and spigot (Jestaz) than a fishing rod and fish, although this too has been disputed (Anthony Radcliffe, written communication). The two sculptures may, however, be based on a common model, made before 1582 (Herbert Keutner 1956, pp. 244–51). It is likewise possible that the *Morgante on a Barrel* may have been based on the *Morgante on a Dragon* but executed some time after 1582, and in that case a probable candidate for its maker would be Giambologna's long-time assistant and caster, Antonio Susini.

While the original purpose of the *Morgante on a Dragon* is obvious, it is not clear how the *Morgante on a Barrel* was meant to be displayed and it is not possible to determine if it is piped and if its use as a fountain was ever intended.

1. In addition to references cited within the text, see Dhanes 1956, pp. 213–14, pl. 103; Avery and Radcliffe 1978, no. 51; and Watson 1978, p. 25.

M. M.

76

GIOVANNI BOLOGNA, CALLED GIAMBOLOGNA
(after a model by)
Douai, 1529–Florence, 1608

ANTONIO SUSINI
(probably cast by)
active Florence, 1572–1624

The Fowler or *The Bird Catcher*[1]
ca. 1575–1600
bronze with dark copper-colored patina
35.4 × 27.3 × 17.8 cm

The Detroit Institute of Arts. Gift of Mr. Robert H. Tannahill

The Fowler, or *The Bird Catcher*, is the largest and most impressive among a group of bronze genre figures produced by

Giambologna and his workshop in Florence between 1575 and the sculptor's death. The figure is identified by instruments of the hunt at night: in some examples a lantern or oil lamp is held high in the left hand; in others the right hand holds a club, stick, or racket-shaped net – all weapons used to strike the bird as it is drawn to the light.

The theme of a peasant holding a fowling lantern appears in early seventeenth-century lists by Markus Zeh (1611) and Baldinucci (1688) of documented authentic bronze works by Giambologna (Avery and Radcliffe 1978, pp. 160–63, nos. 130–34). In late sixteenth-century Medicean Tuscany the widespread interest in nature, agriculture, and the rustic life led to the creation of statues at work or play, which were placed in natural settings or gardens such as the Villa Pratolino, or the Boboli Gardens (see Avery and Radcliffe 1978, pp. 160–61). In his contemporary account, *Il Riposo*, Raffaello Borghini discusses a splendid hunting lodge and a nearby grotto, and describes the experience of hunting for birds with lamps at night and in early morning. The forward-leaning pose of *The Fowler* was possibly inspired by the Graeco-Roman marble *Pedagogue* (Florence, Uffizi Gallery) from the antique marble group of *Niobe and Her Sons* (Avery 1987, p. 46), which Cardinal Ferdinando de Medici acquired in Rome and transferred to Florence when he became Grand Duke in 1587.

This is the largest of three primary genre figures by Giambologna, and its highly finished casting compares closely to related versions in museums in Florence, Stockholm, Paris, Milan, St. Louis, and formerly on the art market (Newhouse Galleries, New York, 1994, Trinity Fine Arts, cat. no. 55). Avery (1987, pp. 46, 266, no. 112) groups these and the Detroit composition as "Type 1," arguing that Giambologna modeled the figure and drapery, while the high-quality facture and patination of the finest examples

can be associated with the hand of Antonio Susini, Giambologna's specialist for small-scale bronzes, renowned for the quality of his casts, patination, and finish. Although the patination differs between these casts, each has been sharply chiseled. However, the Detroit bronze's tall, elaborately molded base with dead birds cast on the upper surface is a later seventeenth-century addition or replacement. It is normally found on the slightly later ("Type 2") *Fowler*, probably also cast by Antonio Susini or a northern European associate and inspired by Michelangelo's pedestal design for the monument to *Marcus Aurelius*, Rome (Avery 1987, p. 266, no. 113).

Only the superb Louvre *Fowler*, the Stockholm version (Stockholm, National Museum; see Avery and Radcliffe 1978, no. 132), and the Detroit bronze, which most closely resemble each other, represent the fowler with a fowling lantern in his left hand and only the Detroit and Louvre bronzes have such a precisely rendered thin moustache; both also have sharp chiseling and lack the feather in the cap (Darr 2002, cat. no. 109 and Darr 1986, pp. 481, 484).

1. In addition to references cited within the text, see Darr in *Masterpieces from the Detroit Institute of Arts* 1989, pp. 45, 151, 200, no. 12.

A. P. D.

77

GIOVANNI BOLOGNA, CALLED GIAMBOLOGNA
Douai, 1529–Florence, 1608

Grand Duke Francesco I de' Medici[1]
1585–87
bronze
77.5 cm
inscribed on the base: "FR MM DE II" (Franciscus Medici Magnus Dux Etruriae Secundus)

New York, The Metropolitan Museum of Art, Purchase, Gift of Irwin Untermyer and Bequest of

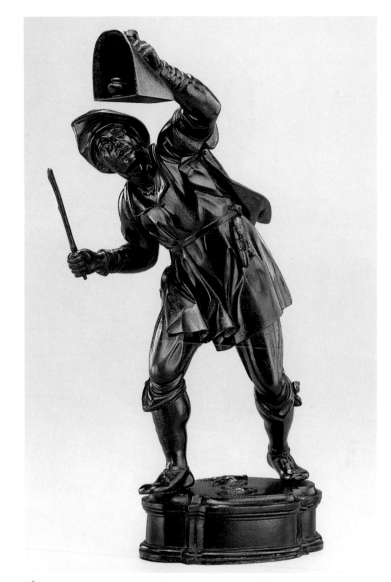

76

Ella Morris de Peyster, by exchange; Edith Perry Chapman Fund; Robert Lehman Foundation, Inc. Gift; Edward J. Gallagher Jr. Bequest, in memory of his father Edward Joseph Gallagher, his mother Ann Hay Gallagher, and his son Edward Joseph Gallager III; and Harris Brisbane Dick Pfeiffer, Louis V. Bell and Dodge Funds, 1983

Francesco wears contemporary armor, a ceremonial sash, and, most prominently, the chain of the Order of the Golden Fleece, which he received in August 1585. As Ferdinando died in 1587 the bust must have been modeled at some time during these two years, when the Duke was between forty-four and forty-six years old.

Portrait busts by Giambologna are rare; this one relates to a bronze bust of Francesco's father, Cosimo I (Florence, Galleria degli Uffizi), with the same elements of armor, sash, and chain, usually dated to 1560, although Charles Avery has proposed a date of around 1574. Francesco's face is fleshier than it appears in painted likenesses from his more youthful days or in the physiognomy of a related bust by the studio of Giambologna. The sculptor represents his favorite Medici patron with the commanding presence and aloof tilt of the head that he devised for such grand-ducal portraits as the equestrian monument of Cosimo I. He idealizes Francesco's features by reducing specific

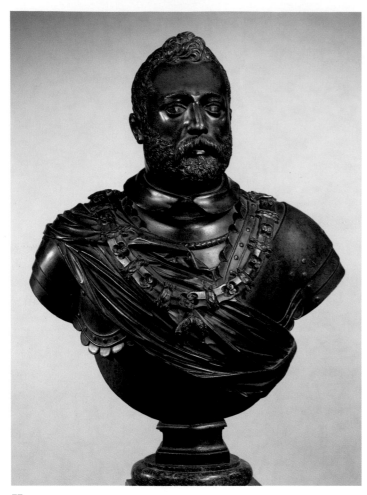

77

details to abstractions; for example, the eyes are entirely blank. As a result, the Grand Duke appears noble but unapproachable.

The quality of the facture of this bronze, with its broadly handled chasing and well-preserved reddish–brown lacquer patina, suggests that it may have been cast by Giambologna's principal assistant, an assured sculptor in his own right, Pietro Tacca. It in fact appears to be a bust that documents record being shipped from Florence to Paris in 1611 alongside the equestrian monument of Henry IV, begun by Giambologna but finished by Tacca. Tacca was paid 300 *scudi* for this bust by Marie de' Medici, daughter of Francesco and widow of Henry IV of France.

1. See Raggio 1984, pp. 29–30.

I. W.

78

ZANOBI (DI BERNARDO) LASTRICATI
Florence, 1508–1590

Mercury[1]
1549–51
bronze
183.1 cm, base 13.7 cm
inscribed: "ZANOBI LASTRICATI CIANO COMPAGNI, FIORENTINI AMICI FACIEVANO PER INPARARE"

Baltimore, Maryland, The Walters Art Museum

Marco Spallanzani (1978, pp. 13–17) has published the prolific documentation for the commission and execution of Zanobi Lastricati's bronze *Mercury*, produced for Lorenzo di Piero Ridolfi's courtyard in his palace on via Tornabuoni in Florence, now the Palazzo Ridolfi-Tornabuoni. The resulting statue has been identified as the signed,

over-life-size bronze statue in the Walters Art Museum in Baltimore. The *Mercury* is the only identifiable sculpture included in the 1568 and 1574 inventories of the Palazzo Ridolfi, where it is described as standing in the middle of the courtyard (Boström 1995a, Appendix 7, pp. 152–53, 157–58). The record of payments reveals that it was executed between 1549 and 1551, the years when the Palazzo Ridolfi was being reconstructed and decorated by Lorenzo Ridolfi and his wife Maria Strozzi Ridolfi (Spallanzani 1978, pp. 8–21).

The round integral base of the sculpture is inscribed: "ZANOBI LASTRICATI CIANO COMPAGNI, FIORENTINI AMICI FACIEVANO PER INPARARE" (Zanobi Lastricati Ciano Compagni, Florentine friends did this to learn.) Ciano is identifiable with Ciano Compagni (Vasari–Milanesi 1878–85, vol. 5, p. 199, n. 2), the Medici perfumerer for whose Florentine palace courtyard Lastricati executed much sculptural decoration, extensively described in a published letter of 1546 by Niccolò Martelli (Martelli 1916, pp. 71–73). Though Vasari claimed that Lastricati cast the *Mercury* after a preparatory model by Ciano, Spallanzani (1978, pp. 15, 19, doc. 5) has shown that Ciano only served as guarantor, ensuring that the work would be completed as agreed. By this date Lastricati already had some experience in bronze casting for several Medici commissions, assisting, together with his brother Alessandro, in the casting of the head of *Medusa* for Cellini's *Perseus and Medusa*, as well as a bronze figure of *Fiorenza* of around 1543 (Boström 1997; cat. no. 74), bronze door-handles for the Sala degli Elementi in the Palazzo Vecchio (1557; Boström 1994), and Vincenzo Danti's *sportello* or safe door (1559) for Cosimo I's *stanzino* (cat. no. 62).

Ridolfi's patronage of Lastricati – after all a Medici sculptor – was curious given Ridolfi's allegiance to Florentine

political exiles in Rome who opposed the Medici family, but this illustrates the pragmatism of Florentine artistic commissions. Spallanzani has suggested that the classical "full figure of Mercury wearing a hat"[2] described by the writer Ulisse Aldrovandi in the Roman collection of Lorenzo's brother, Cardinal Niccolò Ridolfi (d. 1550), was the model for Lastricati's *Mercury*. The sculpture had arrived in Florence by July 1549, just before Lastricati's version was cast, and is probably the version now in the Uffizi Gallery (Spallanzani 1978, pp. 13–17, caption for fig. 4; Mansuelli 1958, vol. 1, n. 27, pp. 50–51). It is interesting that Lorenzo should desire a version of the classical marble *Mercury*, for it is possible that in commissioning a modern bronze cast he was proposing a *paragone*, not only between the materials used, but between the classical and modern interpretation of the subject. The comparison is not a happy one, for the grace of the classical version clearly surpasses Lastricati's rather lumpen figure. Thus the reference to "learning" in the ingenuous inscription suggests that this was an academic exercise in classical reproduction, not one of technical self-improvement.

1. In addition to references cited within the text, see Spicer 1995, p. 21.
2. "Mercurio intiero col suo cappello in testa." Aldrovandi 1556, p. 292.

A. B.

79

BATTISTA LORENZI
Florence, 1527–1594

Model for the statue of *Sculpture* for the tomb of Michelangelo[1]
ca. 1570
terracotta
34.1 cm

London, Victoria and Albert Museum

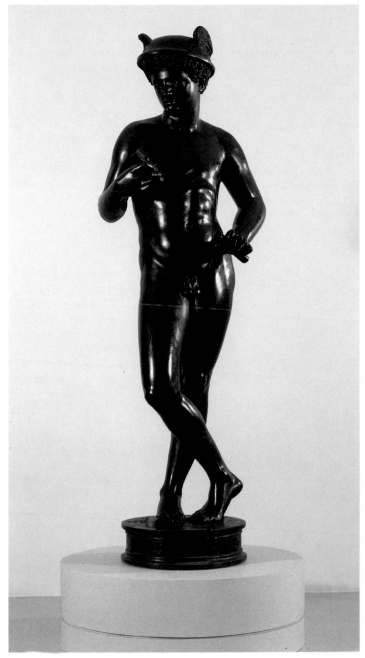

78

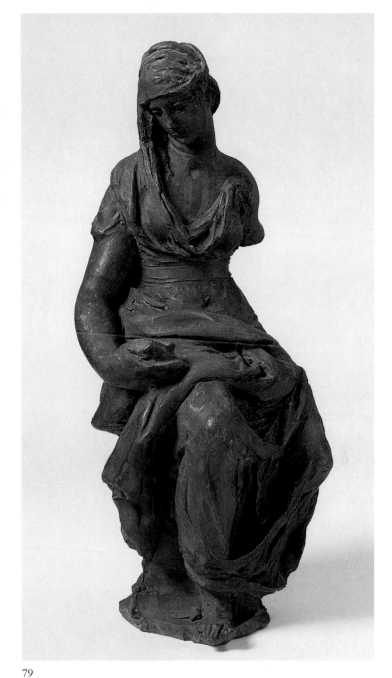

79

This terracotta statuette is the sketch-model for one of the marble allegorical figures placed on the left side of the tomb of Michelangelo in the church of Santa Croce in Florence. The tomb was planned by Vincenzo Borghini, the *luogotenente* (lieutenant) of the Accademia del Disegno, and designed by Giorgio Vasari shortly after Michelangelo's death in 1564. Marble figures of *Sculpture*, *Architecture*, and *Painting* were to be placed on the ledge supporting the sarcophagus, and each was assigned to a different

sculptor. According to Raffaello Borghini's account of the emblems held by each figure in *Il Riposo* (1584, pp. 108–9), the lateral figures of *Sculpture* and *Architecture* flanked a central figure of *Painting*. *Sculpture* on the left was assigned to Battista Lorenzi, *Architecture* to Giovanni Bandini (for a terracotta sketch in the Sir John Soane Museum, London, see cat. no. 52), and *Painting* to Valerio Cioli.

Lorenzi's figure was already partially carved when Michelangelo's heirs asked for

Sculpture to occupy the central position on the tomb. Thus Lorenzi's figure was altered to represent *Painting*. However, as Pope-Hennessy observes (1964b), the final marble figure nonetheless holds a torso, since it was originally intended to represent sculpture. The Victoria and Albert figure wears a veil, like Cioli's marble *Sculpture*, suggesting that this model relates to Lorenzi's initial commission for *Sculpture*, before its change of iconography. The marble was completed only in 1573, and paid for in 1575.

1. In addition to references cited within the text, see Avery 1994, esp. pp. 16–17.

A. B.

215

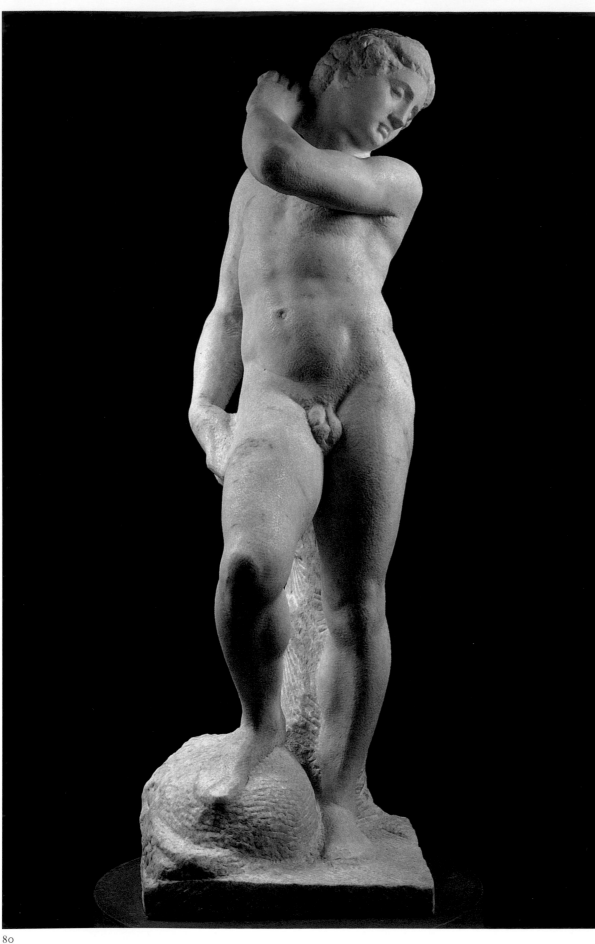

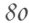

MICHELANGELO
BUONARROTI
Florence, 1475–Rome, 1564

David–Apollo[1]
ca. 1525–30
marble
146 cm

Florence, Museo Nazionale del
Bargello

This is one of Michelangelo's
most mysterious sculptures, not
least because of its subject. We
know from Giorgio Vasari (1962,
p. 66) that it was "begun" for
the Medici governor of
Florence, Baccio Valori.
According to Vasari's account,
the date that work began on the
statue cannot be before August
1530, after Michelangelo's return
to Florence following the
restoration of the Medici. As
concerns the subject, Vasari
believed it was an Apollo
"extracting an arrow from his
quiver," and that, through this
statue, and with the mediation
of Valori, Michelangelo intended
to "make peace with the Pope
[Clement VII de' Medici] and
with the Medici."[2] The sculpture
is mentioned, without any
indication of its subject, in a
letter from Valori to
Michelangelo dated 1531 or
1532, where he writes that he
does not intend to press him
"for my sculpture, as I know for
certain, from the affection you
bear me, [that it] does not need
to be demanded."[3] The work is
also listed in an inventory of
the Palazzo Vecchio of 1553
as an "unfinished *David* by
Buonarroti,"[4] located in Cosimo
I's quarters together with two
representations of *Bacchus* by
Andrea Sansovino and Baccio
Bandinelli. From there it was
transported to the amphitheater
of the Boboli Gardens, where it
remained until 1824, when it
was brought back to the Uffizi
and subsequently to its current
location.
 A drawing in the Pierpont
Morgan Library in New York
(previously in the Janos Scholz
Collection) is an obvious copy

of the statue, clearly interpreting it as an Apollo (the "quiver" mentioned by Vasari is recognizable). The drawing was attributed to Rosso Fiorentino by E. A. Carroll (in *Rosso Fiorentino* 1987, pp. 146–48, n. 49). This bears consequences for its date, which – on the basis of events in Rosso's life – can be placed at the end of 1527. Michelangelo would therefore have begun his sculpture before he decided to give it to Baccio Valori, in which case we may accept that the work was originally a David, a recognizable republican emblem too blatant to be maintained after the return of the Medici to Florence, hence its transformation into an Apollo. Alternatively we may conjecture that the description of this work as a David – given only in the 1553 inventory – was simply a mistake and that Michelangelo intended to represent Apollo from the start.

The work, which enjoyed only a modest success, is one of Michelangelo's most intriguing creations. It shows the spatially experimental approach of the *Christ* in Santa Maria sopra Minerva, but its unfinished state conceals its form, so that the figure appears to be expanding in every direction. The relationship between the legs, torso, head, and left arm, which all follow subtly different trajectories, seems to foreshadow the spatial concepts of Mannerist sculpture, with its deliberate complexity of movement. But the nebulous definition of Apollo's form renders it – at least in its present state – almost an antithesis, an example in negative of the Mannerist type.

Regarding the sense of intimacy conveyed by the sculpture, we can conclude with Tolnay's observation that "it is conceived not as an animated body, but as the incarnation of a psychic state . . . the position here is of one tossing in his sleep. The gestures seem to be unconscious reflexes, like those of a dreamer trying to drive away a nightmare."[5]

1. In addition to references cited within the text, see Tolnay 1970, pp. 96–97, 181–82; and Barocchi 1982b, pp. 14–20.
2. "si cavava una freccia dal turcasso"; "fare la pace col papa [Clemente VII de' Medici] e con la Casa de'Medici." Vasari 1962, p. 66.
3. "della mia figura, perché mi rendo certissimo, per l'affezione che conosco mi portate, [ch'essa] non ha bisogno di sollecitudine." Quoted in Barocchi 1982b, p. 1095.
4. "David del Buonarroto imperfetto." Quoted in Conti 1893, vol. 1, p. 35.
5. Tolnay 1970, vol. 3, pp. 96–97.

G. B.

81

MICHELANGELO
BUONARROTI
(circle of)
Florence, 1475–Rome, 1564

Torso[1]
1530–40
terracotta
23 cm

Florence, Ente Casa Buonarroti

"Sculptors, when they want to produce a marble figure, have the custom of making a *bozzetto* . . . or a model . . . either in clay or in wax or in plaster, so that they can show the pose and the proportions that must be obtained in the figure they intend to represent."[2] Thus Giorgio Vasari described *bozzetti*. He returned to the subject when he wrote about the foreshortening of figures, stating that painters employed three-dimensional models for such work. Michelangelo himself "made models in clay or wax to this end; and from these . . . he would derive the contours, the light, and the shadow."[3]

A series of *bozzetti* produced in Michelangelo's circle, variously attributed, are now in the Casa Buonarroti in Florence. Some were probably left in Michelangelo's workshop in via Mozza in Florence and given to the Medici after his death by his nephew Leonardo, becoming incorporated into the Buonarroti collections; others presumably

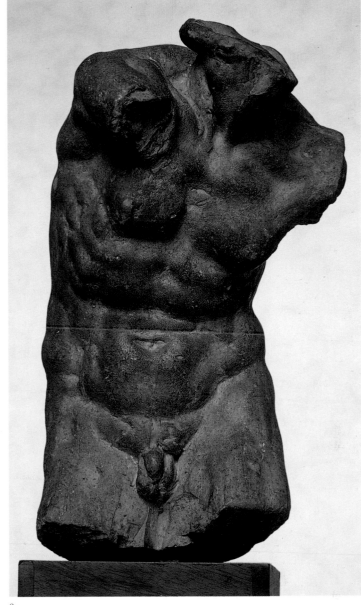

81

returned to Florence from Rome; and we cannot exclude the possibility that some came to the Buonarroti collections in other ways. This indicates the difficulties encountered in basing an analysis of the historical and artistic merits of these pieces on their respective provenances, "rediscovered" in a secret armoire in the Casa Buonarroti, where they had remained since the end of the eighteenth century, by Rosina Vendramin, who married Cosimo Buonarroti in 1846.

From Vasari's observations as well as those of other sources and from a general knowledge of artistic techniques that have

passed unchanged through the centuries we know that preparatory sketches were realized in malleable materials and that, because of their function as a transitional stage in the creation of monumental sculpture or decorative painting, they would rarely have been made permanent through firing. (In the case of clay it is prudent to treat the technical information provided by modern scholars with caution, as it is quite common to find raw clay that has never been fired defined as "terracotta.") On this basis a certain scepticism must arise regarding the direct attribution of terracotta models to Michelangelo.

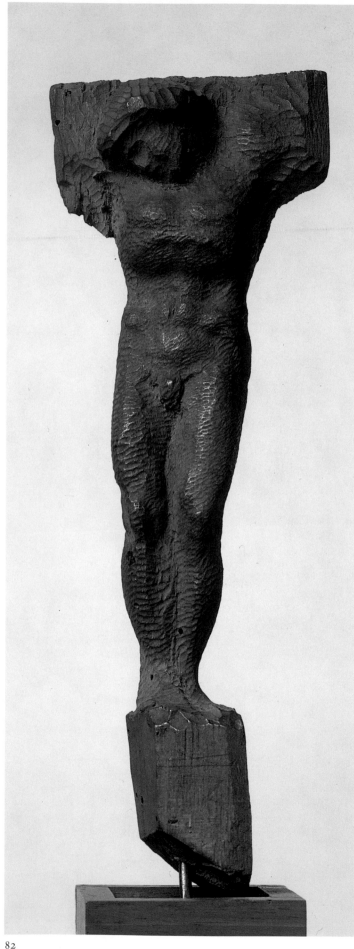

The present male torso cannot be directly connected with any specific work by Michelangelo (J. Shell in *The Genius* 1992, p. 220, has already rightly denied a direct link between this figure and the *Slaves* in the tomb of Julius II). Although powerful in its modeling, the sketch does not suggest a direct transposition of Michelangelo's style, the quality declining markedly particularly on the back, where the anatomy is treated conventionally and schematically. The torso does, however, show stylistic traits typical of Michelangelo at the time he was working on the tomb of Julius II starting around 1516, where elaborations and developments from the antique are evident (for example *Laocoön*, and the *Belvedere Torso*).

Technical analysis by Jeannine A. O'Grody (1999, pp. 270–72) suggesting that the vertical grooves visible throughout the sketch are left over from a process of bronze casting confirms that the origin and function of the piece were not the same as those of a *bozzetto* in the sense given above by Vasari. Like all recent scholars, therefore, I believe that a direct authorship by Michelangelo must be excluded, and that this sketch was produced by one of the master's Florentine followers, probably in the 1520s or 1530s.

1. In addition to references cited within the text, see E. Lombardi in *I bozzetti michelangioleschi* 2000, pp. 54–59.
2. "Sogliono gli scultori, quando vogliono lavorare una figura di marmo, fare per quella un modello . . . cioè uno esempio . . . o di terra o di cera o di stucco, perché e' possan mostrare in quella l'attitudine e la proporzione che ha da essere nella figura che e' voglion fare." Vasari 1966–, p. 87.
3. "prima di terra o cera ha per questo uso fatti i modelli; e da quegli . . . ha cavato i contorni, i lumi e l'ombre." Vasari 1966–, p. 122.

G. B.

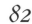

MICHELANGELO BUONARROTI
Florence, 1475–Rome, 1564

Crucifix[1]
ca. 1562
wood (?linden)
27 cm

Florence, Ente Casa Buonarroti

CHICAGO AND DETROIT ONLY

The first mention of this small unfinished *Crucifix* was made by Thode (1913), who expressed serious doubts about its attribution to Michelangelo and erroneously indicated that it is made of wax. The work was not directly attributed to Michelangelo until Tolnay (1965; 1967, vol. 2, pp. 71–73) linked it with documentary evidence about the artist and with a well-known series of drawings of crucifixes undoubtedly by Michelangelo.

The documentary information is contained in four letters from Lorenzo Mariottini in Rome to Michelangelo's nephew, Leonardo, in Florence, between August and October 1562, and in another letter also to Leonardo from the sculptor Tiberio Calcagni, also from Rome. Mariottini mentions that Michelangelo "would like to make a wooden crucifix" and that "he wishes you to send him all the tools necessary for such a work, and to ask someone in the trade there about this, such as a carver of wooden figures. And have them made properly and well, and send them as soon as possible."[2] It is still unclear why it was deemed necessary to seek the tools in Florence rather than in Rome, and it seems odd that they would have to be specially made for the purpose.

From Calcagni's letter we learn that in July 1563 Michelangelo was working "at your [Leonardo's] wooden Christ."[3] This verifies that a few months before his death Michelangelo was working on a wooden crucifix, having executed a similar work some seventy years earlier for the

82

218

prior of the church of Santo Spirito in Florence, where it remains today, and that the artist intended to give the crucifix to his nephew. Tolnay therefore believed that the present wooden sketch in the Casa Buonarroti was created as a study for Leonardo's larger crucifix, begun but probably never completed and now lost.

The drawings to which Tolnay refers (now in Paris, London, Windsor, and Oxford) were conceived for a group that included the Virgin and St. John, and the outline of a triangular block on the verso of one of the drawings suggests that Michelangelo was planning a marble group. The relationship of the drawings to the wooden crucifix mentioned in Calcagni's letter is, therefore, a mere comparison rather than a direct reference. We cannot certainly demonstrate that originally there was a specific correspondence between the drawings of crucifixes, the lost wooden *Crucifix* destined for Leonardo on which Michelangelo was working in 1563, and the sketch in the Casa Buonarroti. What we can, however, recognize is the extraordinary spiritual affinity between the Casa Buonarroti sketch and the drawings, especially that in the British Museum, London (Wilde, no. 82, 1953).

The wooden sketch, which must be attributed to Michelangelo if only for a complete lack of alternative and which must have returned to Florence from Rome with the rest of the artist's legacy, constitutes a touching example of his notion of artistic creation as interior monologue. In fact a constant of Michelangelo's thought is his lack of interest in finalizing the work of art for an audience. The rough surface of the crucifix, on which the marks left by the gouge are clearly evident, recalls the late paintings of Titian, or, a century later, of Rembrandt. Its rarefied form, devoid of any earthly connotations, evokes the late quartets of Beethoven (for example the "Canzona" of opus

132). Putting aside its dimensions and material, this crucifix could be seen as a smaller-scale *Pietà Rondanini*, a solitary meditation by the artist as he approached his death.

1. In addition to references cited within the text, see J. Shell in *The Genius* 1992, p. 270; and J. A. O'Grody in *I bozzetti michelangioleschi* 2000, pp. 64–67.
2. "vorrebbe fare uno Crocifisso di legno"; "vorrebbe che voi gli mandassi tutti quelli ferri che per simile opera occorrono, e che domandiate costì a qualcuno del mestiere, cioè intagliatore di figure di legname. E fateli fare belli e buoni, e mandateli quanto prima." *Il carteggio indiretto* 1995, p. 126.
3. "al vostro [di Leonardo] Cristo di legname." *Il carteggio indiretto* 1995, p. 154.

G. B.

83

VINCENZO DE' ROSSI
Florence, 1525–1587

Vulcan Forging an Arrow for Cupid[1]
1571–72
bronze
90 cm

Florence, Palazzo Vecchio, Studiolo of Francesco I

This bronze figure of *Vulcan* by Vincenzo de' Rossi was one of eight bronze statuettes commissioned by Francesco I de' Medici in around 1570 to decorate the niches of his Studiolo in the Palazzo Vecchio (see also cat. nos. 48 and 56). De' Rossi was paid for the bronze statuette between July and September 1572 (Florence, Archivio di Stato, *Scrittoio delle Fabbriche Medicee*, filza 5, c. 31r, cited in Keutner 1958).

According to a letter of 3 October 1570, Vincenzo Borghini planned to display the statuette on the Fire Wall (see p. 56 above), where objects associated with fire, such as iron, steel, and glass, were to be displayed in cupboards. Casini's painting *The Forge of Vulcan* would have made a direct

reference to de' Rossi's bronze.

Vulcan is characterized as a muscular male figure, holding up his hammer and about to strike the metal arrow he is forging on his anvil. His bulging brow is recognizable in other bronzes cast by de' Rossi just a few years earlier: the two satyrs on Ammanati's *Neptune Fountain* in the Piazza della Signoria, dating from around 1565; and Pluto from the bronze *Rape of Proserpina* group attributed to de' Rossi, now on loan from the National Trust to the Victoria and Albert Museum, London (see Boström 1990, p. 838, figs. 11, 13, 12, 16; and Mandel 1995). Unlike the more sinuous and elegant Mannerist bronze figures cast by other sculptors for the Studiolo, such as the *Opi* or the *Boreas* (see cat. nos. 48 and 56), de' Rossi's figure is rooted to the spot as he strains down to forge the arrow. His torso is vigorously modeled and the leg muscles clearly delineated, as in a Hercules figure. As Vossilla has observed (*Magnificenza* 1997, p. 230, no. 182), the models of de' Rossi's teacher, Baccio Bandinelli, are evident in this composition, especially Bandinelli's marble group of *Hercules and Cacus* for the Palazzo della Signoria.

1. In addition to references cited within the text, see Cecchi and Allegri 1980, pp. 338–39.

A. B.

84

RIDOLFO SIRIGATTI
Florence, 1553–1608

Cassandra del Ghirlandaio
1578
marble
102.2 cm

London, Victoria and Albert Museum

FLORENCE ONLY

This bust portrays Cassandra del Ghirlandaio, the daughter of the Florentine painter Ridolfo, who in 1547 married the rich textile

merchant Niccolò Sirigatti. The latter, who belonged to an ancient Florentine family, was also immortalized in a marble bust (London, Victoria and Albert Museum), the companion piece to Cassandra's. Their first child was Ridolfo Sirigatti, born in 1553. As well as continuing his father's mercantile activity, he brought fame to his family by becoming one of the Knights of Santo Stefano in 1581. He was also very interested in the arts and was an amateur sculptor who, as these two busts prove, produced work of high quality. His artistic inclination led him to collect ancient and modern art, as did his brother Lorenzo, who was also an amateur architect.[1] Ridolfo probably owed his artistic education to the fact that his mother came from a well-known and respected dynasty of painters – the name Ridolfo was given to him in honour of his maternal grandfather (Borghini 1584, p. 489) – and it is likely that he and Lorenzo frequented the workshop of Michele Tosini, the artistic heir of Ridolfo del Ghirlandaio (Pegazzano, 1998, p. 148). As an expert and collector, Ridolfo Sirigatti features as one of the four protagonists in *Il Riposo* by his friend Raffaele Borghini (1584). The first mention of the two busts occurs in this treatise (Borghini 1584, pp. 21–22).

Sir John Pope-Hennessy identified the two sculptures as Ridolfo's parents (1965, pp. 33–36), and he recommended their acquisition to the Victoria and Albert Museum in 1961 (in the same year a photograph of the two marbles, available on the Roman art market, had reached the London museum, with an attribution to Alessandro Vittoria). To this scholar, furthermore, we owe the only essay published so far on this subject.

Like the bust portraying Niccolò, the one of Cassandra carries the date of execution and an inscription that identifies its subject: CASSANDRA GRILLANDARIA/NICOLAU SIRIGATTO NUPTA/M.D.LXXVIII

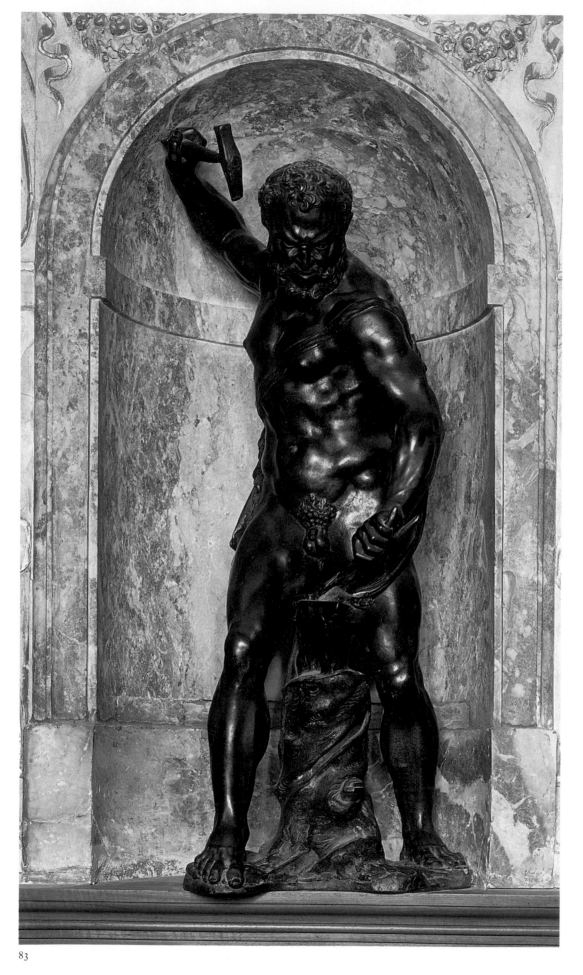

(Cassandra del Ghirlandaio, married to Niccolò Sirigatti in 1578). On the back of both sculptures there is another Latin inscription, a dedication in which the name of Ridolfo appears and in which the busts are presented as a tribute from Sirigatti to his parents: QUEM GENUI/RODULPHUS/ANIMI CAUSA/CAELAVIT (Ridolfo sculpted [the portrait of] his parents with his affection). The bust of Niccolò is dated 1576, two years prior to the merchant's death, whereas his wife's was finished in 1578. Borghini praised the two portraits both for their likeness to the subjects and also for a detail in Cassandra's bust which he noted with admiration: "a very thin veil that he sculpted on her head, which hangs around her shoulders, detached from her neck, and rendered with such ability that it looks translucent" (Borghini 1584, pp. 21-22). The same detail impressed Pope-Hennessy, who noticed in the two sculptures a high technical skill and an unusual and original style in comparison with other, contemporary sculpture. The particular disposition of the shoulders in the two busts, with the right one pulled slightly back from the rest of the figure, and the left pushed slightly forward, shows the artist's precise intention to give an impression of movement. The optical expedients are combined with a technical virtuosity that can be appreciated especially in the draping of the cloths: Cassandra's veil, forming deeps hollows on the sides of her neck, almost creating a niche for the woman's head (with effects that anticipate those by Nicolas Cordier in his portrait of Luisa Aldobrandini Deti in the Roman church of Santa Maria sopra Minerva); the folds of her dress below her breast; the prominent buffs of the shirt coming out of the sleeves. In these respects, according to Pope-Hennessy, the busts foreshadow the taste of the seventeenth century, especially in Rome. Analyzing their characteristics, in fact, it is possible to identify some

83

elements that would appear in the sculptures by Pietro Bernini, who received his first artistic training from Ridolfo Sirigatti (Baglione 1642, p. 304).

1. On Lorenzo Sirigatti, see. Pegazzano 1998, pp. 144–75.

D. P.

85

ANTONIO SUSINI
active Florence, 1572–1624

GIAMBOLOGNA
(probably after a concept by)
Douai, 1529–Florence, 1608

(a) *Lion Attacking a Horse*[1]
ca. 1580–90
bronze with a golden chocolate–brown patina and remains of red lacquer
23.5 × 30.5 cm
inscribed on the underside of the right rear paw of the lion: "ANT° SVSINI/FLORE. OPVS"

The Detroit Institute of Arts. City of Detroit Purchase

(b) *Lion Attacking a Bull*
ca. 1580–90
bronze with brown–red patina
21 × 28.5 cm
inscribed under right front hoof, "ANT°-/SVSI/NI.F"; on the left haunch of the bull: "N° 19"

Paris, Musée du Louvre

(b) CHICAGO ONLY

The Louvre *Lion Attacking a Bull* was probably the pendant to the *Lion Attacking a Horse* in the Detroit Institute of Arts: both have similar patinas and engraved signatures, and are one of only two pairs of surviving bronzes of these groups signed by Antonio Susini, Giambologna's principal bronze caster until 1600 and an heir to a number of Giambologna's working models. The other signed pair of bronzes, once shown together in the Museo di Palazzo Venezia, is in the Corsini Collection, Rome, in the Palazzo Corsini (see Darr 2002, cat. no. 110). The importance and influence of the pair of bronzes is shown by their

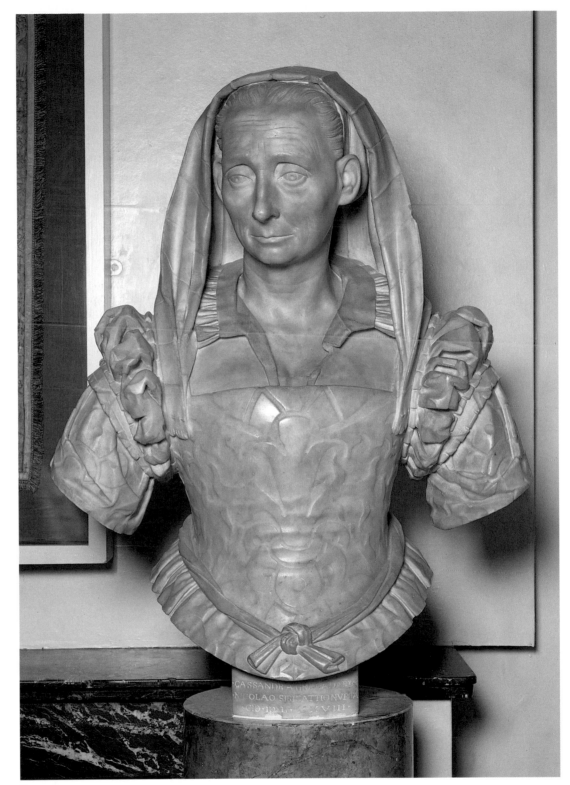

84

appearance in a contemporary painting, *The Allegory of Sight*, by Jan Bruegel the Younger (Philadelphia, Museum of Art).

No examples signed by Giambologna are known but as both compositions are recorded among his authentic models, Giambologna is credited with

the concept for the pair (Avery 1987, p. 269, no. 139; Radcliffe 1994, pp. 66–69). In 1611 Philipp Hainhofer reported to the Duke of Pomerania that the Augsburg councillor Markus Zeh possessed, among other works by Giambologna, a group of a *Lion Attacking a Horse* and of a *Lion*

Attacking a Bull.[2] In his *Life of Giambologna* (1688), Baldinucci mentions these as works cast during Giambologna's lifetime after his models; and in the *Life of Antonio Susini*, Baldinucci remarks that Antonio's nephew Gianfrancesco made aftercasts of the same models by

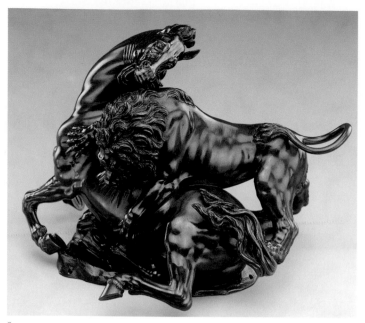

85a

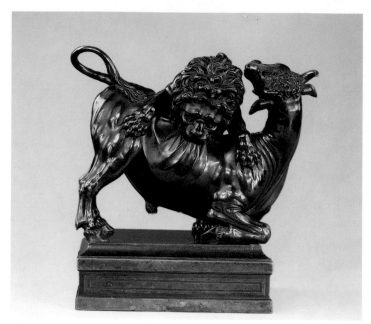

85b

Giambologna (Draper in *Liechtenstein* 1985, 71–72, nos. 40–41; see Radcliffe 1994, p. 68 for a record of later unsigned casts of this composition). However, none of the surviving examples can be attributed to Giambologna with certainty and study of the various versions must be based on the superb examples signed by Antonio Susini.

The refined surface of the *Lion Attacking a Horse* displays evidence of work with chisel, file, and hammer and of polishing with a wire brush following the direction of the animals' hair before the application of a golden–brown surface coating and Florentine lacquer. The subject itself is freely inspired by a monumental Graeco–Roman marble sculpture admired by Michelangelo, now in the garden of the Palazzo dei Conservatori on the Capitoline Hill in Rome. Baldinucci (1845–47, vol. 4, p. 110) records that Giambologna took Antonio Susini with him to Rome, where he made Susini copy the most marvelous statues in the city. An engraving of 1584 by Cavalleri shows the poor condition of the Capitoline Hill marble, which consisted only of a torso until the sculptor Ruggero Bescapé restored the original in 1594 (Darr 2002, no. 110), with a design that

may have been inspired by a northern engraving of a *Lion Hunt* (ca. 1540–50) by Jan Ewoutsz Muller, possibly after a painting by Jan van Scorel (Radcliffe 1994, p. 66). Susini's bronze adopts a different approach to Bescapé's restoration and, as Avery (1987, p. 60) has demonstrated, this difference gives 1594 as the date *ante quem*, suggesting that the bronze was designed around 1580–90 and cast then or perhaps slightly later, around 1600.

Susini's composition, in which the horse's head turns backward to attack and bite the lion, provides a greater sense of violent drama and is considerably more animated than either the antique prototype or Bescapé's restoration. From the prominently engraved signature indicating that this model is Antonio Susini's OPVS (or "work") – whereas the *Lion Attacking a Bull* group uses only the weaker F[ecit] (or "made") – Avery (1987, p. 60) and Radcliffe (1994, pp. 66–68) have made a convincing argument that Susini had a greater role in the design and creation of the composition and was also responsible for the casting. Avery has also proposed that the partial form of signature on the *Lion Attacking a Bull* group suggests that it was not based on a specific antique

prototype but was freely invented and modeled by Giambologna, inspired by classical coins and Hellenistic sources, then cast or made (*fecit*) by Antonio Susini.

1. In addition to references cited within the text, see Avery and Radcliffe 1978, pp. 186–88, nos. 170 and 171; Darr 1986, pp. 481, 484, n. 21; Darr in *Masterpieces from the Detroit Institute of Arts* 1989, pp. 46, 151–52, 200–1; *Les Bronzes de la Couronne* 2001, p. 78, no. 19.
2. "Un gruppo d'un lione ch'ammaza un cavallo" and "Un gruppo d'un lione ch'uccide un toro." Leithe-Jasper 1986, pp. 226–28, no. 58.

A. P. D.

86

GIANFRANCESCO SUSINI
Florence, 1585–ca. 1653

Arrias and Paetus (The Gaul and His Wife)[1]
ca. 1630
bronze
42.4 cm

Rome, Galleria Colonna

FLORENCE ONLY

Gianfrancesco Susini was the nephew and artistic heir to Antonio Susini, Giambologna's most important follower and assistant, and he took over his uncle's workshop in the via dei Pilastri in Florence after Antonio's death in 1624. He produced for the Medici family and other local sculpture collectors small-scale bronze versions of antique sculptures after models by Giambologna and Antonio Susini, and from his own inventions.

In his life of the artist, Filippo Baldinucci (Baldinucci–Ranalli, vol. 4, p. 118) states that Susini spent time in Rome, probably around 1625, and lists Gianfrancesco's small-scale copies after the antique, which include the present bronze and other copies of such canonical works of antique sculpture as the *Seated Mars*, the *Hermaphrodite* in the

Borghese collection, the *Farnese Hercules*, the *Farnese Bull*, the *Wild Boar* in the Medici Collection, and the so-called *Dioscuri* on the Quirinal Hill. His bronze statuette group of the *Abduction of Helen* in the Staatliche Kunstsammlungen in Dresden, dated 1626, is his own invention.

This bronze was made to the commission of the Florentine patrician Jacopo di Lorenzo Salviati (1607–72), who made a final payment to Susini on 13 September 1632. The group is based on the marble group now in the Collezione Ludovisi, Museo Nazionale Romano, Rome, which was probably found between 1621 and 1623 during excavations at the Villa Ludovisi (on the site of the ancient Gardens of Sallust), and restored by Ippolito Buzio in 1624 (Haskell and Penny 1981, pp. 282–84). The identity of the group has been the subject of debate. Though in the Salviati payment document it is identified as "the gladiator who kills himself with a woman beside, in bronze,"[2] in his life of the sculptor, Baldinucci describes it as "a male figure who, holding in his arms a gravely injured woman, kills himself out of sadness and compassion."[3] As Haskell and Penny state, alternative identifications include the Gaul and his wife and Pyramus and Thisbe, but the present identification of Arrias and Paetus has been current since the mid seventeenth century.

In his reduction from the original marble Susini has altered certain details of the drapery, hair and physiognomy. A second version of this bronze in the Musée du Louvre in Paris was thought until now to have been cast by Le Pileur after a model by Pierre Garnier (Landais 1958).

1. In addition to references cited within the text, see *Die Bronzen der Fürstlichen Sammlung Liechtenstein* 1986, pp. 74–86, 168–201; E. A. Safarik, "Introduction," *Catalogo della Galleria Colonna in Roma* 1990, cat. no. 12, p. 297 (and for archival references).

2. "un gladiatore che si amaza chon una femina acchanto di bronzo."
3. "una figura di maschio, che tenendo in braccio una femmina gravemente ferita, per dolore e compassione da la morte a se stesso . . ."

A. B.

87

FERDINANDO TACCA
1619–1686

Bireno and Olimpia[1]
1540–45
bronze with light brown patina and traces of red–gold lacquer
37.9 cm

The Art Institute of Chicago Major Acquisitions Centennial Endowment through prior gift of The George F. Harding Collection

Ariosto's epic poem *Orlando Furioso* enjoyed continuous popularity from its first publication in 1516 through the seventeenth century. Dramatic stories of its principal heroes, Angelica, Ruggero, and Medoro were featured in numerous Florentine paintings commissioned by the Medici. Cardinal Carlo de' Medici owned Giovanni Bilivert's *Ruggero Disarming Before Angelica* (1624; Florence, Gallerie Fiorentine), and Carlo's brother Don Lorenzo displayed paintings of various scenes from the poem by Cesare Dandini, Orazio Fidani, and Vincenzo Mannozzi at his villa at Petraia (see Bellesi and Romei, pp. 11, 19). Sculptural representations of this literary masterwork were favorite subjects of Ferdinando Tacca, first sculptor to dukes Ferdinando II and Cosimo III. He executed two-figure dramatic tableaux in bronze of *Ruggero and Angelica* (Louvre) and *Angelica and Medoro* (formerly London, Heim Gallery), as well as the more rarely depicted *Bireno and Olimpia*. This last story (canto X, v. 19) depicts the false lover Count Bireno gathering his clothes to sneak out of the tent he shares with Olimpia. *Olimpia abbandonata da*

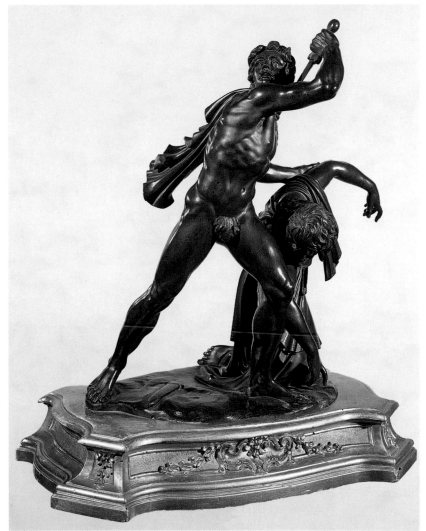

86

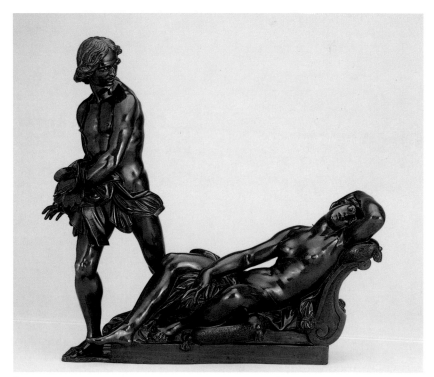

87

223

Bireno was also the subject of a painting by Vincenzo Mannozzi in the collection of Cardinal Giovan Carlo de' Medici, now in a private collection (Bellesi and Romei, p. 17).

The sculpture focuses on the contrast between Bireno's stealthy exit and Olimpia's languorous sleeping figure. Glancing back, Bireno ogles (as does the viewer) the beautiful woman he abandons. In a larger sense the composition is also a dialog between a contemporary sculptor and a revered master of the previous century: the figure of Olimpia exactly reproduces that of a composition of *Sleeping Nymph and Satyr* (Dresden, Grünes Gewölbe) executed by Giambologna around 1586. Its model must have passed, along with other studio models, from Giambologna to his long-time assistant Pietro Tacca and thence to Pietro's son Ferdinando. In the Chicago group the angular, abstract style of the late sixteenth-century confronts the more relaxed, naturalistic bent of the mid-seventeenth. It has been suggested that Tacca adapted Giambologna's figure of *Mars* for Bireno, but if so, he successfully balances borrowed elements in a new concept. Bireno's luxurious hair, sharp features, and slight build are so close to such figures as Ruggero in Ferdinando's Louvre group that his authorship of this sculpture seems assured. The fine casting, precise chasing, and rich patination of the group, however, are so close to the craftsmanship of Gianfrancesco Susini that some authors have suggested a collaboration between Tacca and Susini.

1. In addition to references cited within the text, see Avery and Radcliffe 1978, cat. no. 73, p. 121; *Il Seicento Fiorentino* 1986, vol. 1, no. 4.37, p. 459, vol. 2, p. 74; and Pratesi 1993, vol. 1, p. 105 (as collection Daniel Katz), vol. 2, p. 651.

I. W.

88

WILLEM TETRODE, CALLED GUGLIELMO FIAMMINGO
(attributed to)
Delft, ca. 1525–1574/1575

Mercury[1]
1550–62
bronze
44.9 cm

Florence, Museo Nazionale del Bargello

Previously attributed to Elia Candido, this Florentine bronze, known also from other versions, was recently identified by Radcliffe (1985, pp. 104–7) as a work by the Flemish sculptor Willem Tetrode. This new attribution is supported by an existing theory of Supino's (1898, p. 397), as well as by convincing stylistic analogies with other works by the Dutch artist. In addition, the engraver Jacob Matham made a popular print of the sculpture from a drawing by Hendrick Goltzius, an artist who carefully followed the output of Tetrode and who documented the activity of the sculptor in his drawings on several occasions.

There are many imperfections in the casting of the piece, a feature that also characterizes the bronze series realized by Guglielmo Fiammingo for the cabinet that housed Cosimo de' Medici's coin collection. The *Mercury* shares with these bronzes, now divided between the Bargello and the Uffizi (see Massinelli 1987), a vigorous Michelangelesque modeling and a certain nervousness, as can be seen in the powerful muscles of the torso and of the thighs tensed in the action of flying. It is therefore legitimate to include the athletic messenger in the group of sculptures *all'antica* that Tetrode executed for the famous Florentine coin cabinet following his departure from Florence, a project completed by 1562 at the latest. This date, in fact, marked the confiscation of the cabinet from Niccolò IV Orsini, Count of Pitigliano, and its subsequent inclusion in the

Medici collections. *Mercury* could then be one of those small sculptures mentioned in inventory descriptions that are missing from the monumental cabinet.

It is striking that the sculpture is not in any way indebted to the more celebrated *Flying Mercury* by Giambologna, which was under way from 1562, nor does it share any similarities with the *Mercury Running on Clouds* executed in 1551 by Leone Leoni on the verso of a famous medal. Tetrode is also indifferent to the image frescoed by Raphael and his workshop on the walls of the Villa Farnesina in Rome, made famous by diffusion through the prints of Marcantonio Raimondi in 1518. Remaining detached from both recent models and those from the past by Verrocchio and Rustici and the circle of Donatello, the Flemish artist preferred to follow the ideas of his first Florentine teacher, Cellini, with whom he had worked since the latter's period in France, and whom he had followed to Florence between 1548 and 1550. Tetrode returned for inspiration to the key projects of those years, reviving Cellini's slender and muscular *Mercury* for the base of the monumental *Perseus* in the Piazza della Signoria. It was not, however, Cellini's sensual and affected elegance that Tetrode recalled in his own *Mercury*, but rather, perhaps echoing Ammanati, he sought to recreate the compressed power of Michelangelo's figures, achieving a highly personal style that he actively promoted in his letters to the ducal administration, wishing to be recognized as an autonomous artist and not a mere collaborator of Cellini.

1. In addition to references cited within the text, see Pope Hennessy and Radcliffe 1970, p. 217; and Giannotti 1999, pp. 175–76, 181.

A. G.

89

NICCOLÒ TRIBOLO
Florence, 1500–1550

Drum from the fountain of *Hercules and Antaeus,* with *putti* and geese[1]
marble
113 cm

Florence, Museo del Castello - Soprintendenza per i Beni Architettonici e per il Paessaggio di Firenze, Pistoia e Prato

This fragment constitutes the section between the two upper circular basins of the fountain of *Hercules and Antaeus*, designed by Tribolo for the lower level of the garden of the Medici Villa of Castello and executed between 1538 and 1548 by Tribolo with the collaboration of Pierino da Vinci and other assistants, including Stoldo and Antonio Lorenzi, Valerio Cioli, and Francesco Ferrucci del Tadda. While the sculpture set on top of the fountain – the group of *Hercules and Antaeus* cast later by Bartolomeo Ammanati – confers on the work a political symbolism linked with the government of Cosimo I, the decoration of the basins is suited to the playful context of the garden, with arrangements of playing children in marble and bronze.

The entire fountain is structured using octagonal and circular shapes, as though Tribolo wished to raise the issue – highly pertinent in the context of the debate on the supremacy of the arts – of the "view" in sculpture: whether there should be one, four, eight, or an infinite number of viewpoints. Like his friends Benvenuto Cellini and Agnolo Bronzino, Tribolo seems to have vacillated between the two latter options, expressing the alternatives in the lowest basin, which is octagonal on the outside and circular on the inside. Thus eight *putti* stand on lions' feet on the corners of the faces of the octagon, creating a continuous, circular effect. Conversely, the circular basins are segmented by the marking of the cardinal points, with

frolicking bronze *putti* on the larger one and goat heads on the smaller one.

The central element of the trunk, exhibited here, is entirely the work of Tribolo and features two pairs of young children, each bearing a goose with water pouring from its beak. Their intertwining arms and the overlapping wings of the geese form a kind of dancing circle that conceals the octagonal section of the trunk. Nevertheless it must be noted that this "ring-a-ring-a-roses" movement, explicitly reminiscent of Hellenistic elements in formal and thematic terms, is dissected into a sequence of frozen individual images (I would suggest that there are four principal and four secondary images), each – the groups of *putti*, of geese, and of masks below the triglyphs – showing a momentary but complete balance. Such a conception is analogous to that applied by Tribolo throughout the garden, where the individuality and transience of each single element can be gathered in an overall unitary and static perspective.

1. See C. Acidini Luchinat in Acidini Luchinat and Galletti 1992, pp. 93–99.

C. P.

90

NICCOLÒ TRIBOLO
(circle of)
(?)Florence, 1500–1550

Boy with Two Geese
ca. 1550–60
marble
73.66 cm

The Detroit Institute of Arts
City of Detroit Purchase

On its accession by the Detroit Institute of Arts from the Florentine dealer Salvatore Romano, this marble group was attributed to Domenico Poggini (DIA museum archives, VAL5/18, letters dating between 30 July and 2 November 1925). However, Valentiner (1932)

related the group stylistically to the *Fountain of Hercules* designed by Niccolò Tribolo for the Medici Villa at Castello and probably completed after his death by several assistants, including Pierino da Vinci, Antonio di Gino Lorenzi and his brother Stoldo di Gino Lorenzi, Valerio di Simone Cioli, and others (Wright 1976, pp. 176–89; del Bravo 1978, pl. 40; Acidini Luchinat and Galletti 1992, passim). The Detroit group can be closely paralleled with the marble *putti* on the upper shafts of the fountain, some of which were probably carved by Pierino (see Cianchi 1995, fig. 23.) Holes, presumably for water spouts, are drilled in the Detroit boy's belly and in the base, evidence that the group originally served as a small fountain.

The Detroit marble is also closely similar in conception and classicizing subject matter to the marble group of *Putto and Goose* placed on a fifteenth-century Medici fountain outside the Galleria Palatina on the landing of the first floor of the Palazzo Pitti (Wiles 1933, pp. 13–14, fig. 23), which once stood in the center of the grotto at Castello. Gramberg (1932, p. 223) and del Bravo considered the group to be by Pierino, though Holderbaum (1995, p. 18, fig. 18) has attributed it to a pupil of Tribolo. The Detroit and Pitti sculptures share a similar treatment of the hair, the rocky base, and the *putto's* squared-off toes, and the geese's furrowed brows are also comparable. Other anatomical details differ, however, and relate to works produced in the Tribolo workshop, such as the *Boy Sitting on a Pitcher*, now in the Thyssen-Bornemisza Collection and said to have come from the Palazzo Grifoni on via de' Servi in Florence (Radcliffe, Baker and Maek-Gérard 1992, pp. 126–31), which Radcliffe associates with the "style of Tribolo."

Because Pierino died at a very young age, his documented *oeuvre* is small, and current scholarship has been reconsidering many pieces

traditionally attributed to him, which may now be attributable to Tribolo or to the latter's workshop. Holderbaum (1995, p. 18) points out that Tribolo's designs and their adaptations by Pierino proved so successful among contemporary and later copyists and imitators that secure attributions are often impossible to make. We should look, therefore, to Tribolo's immediate followers of the 1550s or slightly later for the possible author of the Detroit *Putto*, although the conceptual invention appears to be Tribolo's.

A. B.

91

Niccolò Tribolo
(circle of)
Florence, 1500–1550

Putto with Goose
ca. 1550
marble
85 cm

Florence, Palazzo Pitti, Galleria Palatina

FLORENCE ONLY

This group currently crowns the marble fountain situated on the landing of the staircase of Luigi Del Moro in the Palazzo Pitti and recently recognized as a work of around 1460 made by Antonio Rossellino, perhaps with the collaboration of Benedetto da Maiano, for the garden of the Palazzo Medici in via Larga (Caglioti 2000, vol. 1, pp. 359–79). In the context of the fifteenth-century multi-basin fountain, both the *putto* and the smaller basin on which it rests are stylistically anomalous; but there is also disharmony between the figure and the basin itself, as the latter was arranged centrally to support a circular element while the rocky base of the *putto* is rectangular. Already assembled in this manner, the fountain arrived in Florence in 1889 from the Medici villa of Castello, where it was located in the Grotta degli Animali according to records of 1885, while before 1878 it was situated

in the meadow to the right of the villa. It was probably here that, at a date that cannot be confirmed but certainly after 1576, the various heterogeneous elements were combined. It is possible, as suggested by Acidini Luchinat (Acidini Luchinat and Galletti 1992, p. 120), that the *putto* had always been at the Villa Castello, serving as a decorative fountain element. Undoubtedly its iconographic and stylistic traits include it in the sculptural apparatus conceived, coordinated, and partly executed by Tribolo between 1538 and 1550 for the ducal villa.

The theme of the *putto* who playfully torments an animal, evoking Hellenistic figures, appears to be linked to the circle of *putti* decorating the middle section of the fountain of *Hercules and Antaeus* at Castello, and the *putto* has therefore always been seen as a work by Tribolo or by his main collaborator at Castello, Pierino da Vinci (see Caglioti 2000, vol. 1, pp. 363–64, n. 27). This author is convinced that the latter was not involved in the manufacture of this *putto*, as he tended to be more delicate in expression and form. Excluding the possibility that this was a figure realized exclusively by Tribolo, this author believes that the *putto* must be attributed to one of the sculptors involved in the Castello project under his strict supervision.

C. P.

90

91

92

92

NICCOLÒ TRIBOLO
Florence, 1500–1550

Harpy on the Back of a Toad[1]
1530–40
Gonfolina sandstone
90 cm

Private Collection

FLORENCE ONLY

This work was designed as the ornamentation for a fountain in the Palazzo Lanfranchi–Toscanelli in Pisa. It represents a young woman with a sorrowful

expression, her femininity forcefully displayed in her swollen breasts and visible sex. But she is imprisoned in a leonine body and her zoomorphic extremities appear almost amputated. She belongs to the category of metamorphic and monstrous creatures – harpies, sphynxes, and sirens – often freely interchanged with one another.

The harpy and the toad are traditionally associated with negative elements and they are sometimes combined to signify avarice or greed. A sorrowful, pleading, or defeated harpy

might suggest – as in the emblem of Andrea Alciati (1531) – the principle that "from honest riches there is nothing to fear."[2] Such an interpretation, appropriate to the sculpture's location within the sumptuous and undoubtedly coveted palace of the rich merchant family of the Lanfranchi, is, however, problematic due to the unusual appearance of this harpy who, instead of featuring the feet of a lion or of a predatory bird, displays aquatic elements similar to fins. This peculiar image is known in only one other example, similar in its strongly

outlined anatomy, contracted pose, and expressiveness: this is the figure sculpted on the shield of one of the two trophies destined for the Medici tombs in the New Sacristy of San Lorenzo. According to Vasari, the execution of the figure was entrusted to Michelangelo and his collaborator Silvio Cosini around 1530.

The existence of this motif in the work of Michelangelo supports the theory that the author of the harpy may be one of the masters involved with the San Lorenzo project. One credible possibility is Cosini

228

93a

93b

himself, a sculptor originally from Pisa where he was intensively active, who was inclined to foster bizarre and frightening fancies. But it is also worth considering Niccolò Tribolo, who was more involved than Cosini in Michelangelo's projects, who specialized in fountains and statues in stone, and who on many occasions worked in Pisa. The original and vigorous composition, more terrible than grotesque and not yet developed into a decorative formula, its emotional expression, recalling Hellenistic models, and the synthesis in the articulation

of the various parts of the group – the strong realism of the tensed leonine body juxtaposed with the soft, wrinkled skin of the toad – are all typical of the formal characteristics of Tribolo's sculptures. Furthermore the similarities to both the face of his *Nature* (Castle of Fontainebleau, around 1530) and the vigorous anatomy of *Fiesole* (Florence, Museo del Bargello, 1538–43) suggest that this intense work is one of the Florentine master's most characteristic works.

1. See C. Pizzorusso in *L'officina della maniera* 1996, pp. 394–95.
2. "dalle ricchezze oneste non vi è nulla da temere."

C. P.

93

PIERINO DA VINCI
Vinci, ca. 1529–Pisa, 1553

(a) *Bacchus*
1547
bronze,
13 cm

(b) *Pomona*
1547
bronze
17 cm
inscribed: "1547, Opera di Piero da Vinci, with the arms of Luca Martini"

Venice, Ca' d'Oro

Unmentioned by early sources, Pierino's signed base in the Ca' d'Oro and the statuettes of *Bacchus* and *Pomona* – already separated from the base in the eighteenth century – were reunited only in 1974 by Peter Meller. The base – inspired by Michelangelo's base for the *Marcus Aurelius*, which had been recently erected on the Capitoline Hill – bears the date 1547, the signature "Opera di Piero [= Pierino] da Vinci," and the arms of Luca Martini, Pierino's most important patron and Cosimo I's *provveditore dei fossi* for Pisa. Martini had assumed his Pisan governorship in April of 1547, and Pierino joined him there the same year.

The identification of Pierino's male figure as *Bacchus* is beyond question; that of his counterpart has proved more elusive. A 1784 inventory improbably refers to the statuette as *Venus* (the same source also attributes her and the *Bacchus* to Michelangelo!). Traditionally, however, Venus holds only the apple awarded by Paris; Pierino's figure holds a fruit in each hand. Meller (1974) has suggested that she might represent Venus or Eve or the orchard nymph Pomona (whose name derives from the Latin name of the fruit, *pomus*). Most scholars have followed Meller in leaving the identification open, but Nelson (1995) has observed that, as a symbol of the fecundity of the earth, Pomona fits with the iconography of Martini's other commissions, such as Pierino's statue of *Dovizia* (Abundance) and Bronzino's lost *Madonna*, in which the *provveditore* was shown as donor holding a basket of produce – which to Vasari symbolized Martini's transformation of the Pisan plain from malarial marsh to productive farmland. As tutelary spirits of the natural world, Bacchus and Pomona were paired in Renaissance literature, as in Ariosto's sonnet of 1519 on the illness of Duke Lorenzo de' Medici (Cox-Rearick 1984, p. 128).

Though Pierino's group celebrates Martini's achievement

as overseer of Pisa, it may well have been intended as a gift for Duke Cosimo I, perhaps for the latter's residence in Pisa. Cosimo's interest in Bacchic symbolism is demonstrated by his installation of Jacopo Sansovino's *Bacchus* in his quarters in the Palazzo Vecchio, as well as his 1549 commission to Bandinelli to convert the first version of *Adam* for the cathedral choir into a *Bacchus* (now Florence, Palazzo Pitti). Bandinelli was Pierino's erstwhile teacher and a frequent visitor to the court at Pisa and the *Bacchus and Pomona* group apparently caught his eye. Bandinelli's final *Adam and Eve* for the choir (1551, now Florence, Museo Nazionale del Bargello) reflects aspects of its composition, the pose of the *Adam* being nearly a mirror image of Pierino's *Bacchus*.

In a lunette at Poggio a Caiano Pontormo had already employed the orchard nymph Pomona to symbolize a fruitful golden age under Medici domination. Bacchus was the harvest deity of the summer, Pomona of the springtime (see Cox-Rearick 1984, pp. 126–27) and their juxtaposition in Pierino's elegant bronze group combined a timely celebration of Pisa's new fruitfulness with a venerable Medicean theme – the recurrent cycles of time.

1. In addition to references cited within the text, see Cianchi 1995; and Fenton 1998, pp. 74, 78.

L. A. W.

94

PIERINO DA VINCI
Vinci, ca. 1529–Pisa, 1553

River God[1]
1547–48
Carrara marble
135 cm

Paris, Musée du Louvre, Département des sculptures

Vasari's 1568 biography of Pierino da Vinci relates how, soon after Duke Cosimo I named his

secretary Luca Martini as superintendent (*provveditore*) of Pisa in April 1547, with orders to drain the malarial swamps infesting the city's plain, the learned official invited his protégé Pierino da Vinci to join him in his new residence. Martini's office also involved overseeing marble shipments passing through Pisa on their way from Carrara to Florence, and he was able to entice his friend Pierino to leave Rome with the gift of a marble block 3 *braccia* (175.1 cm) in height. When Pierino came to Pisa and began to carve the block, he found a crack that reduced the workable area of the piece to 2 *braccia* (116.7 cm), and so – according to Vasari's account – he changed the design from a standing to a recumbent figure. Middeldorf (1928) identified the statue now in the Louvre with the "young river god" described in the *Lives*, on the basis of its subject, dimensions, provenance, and close stylistic relationship to Pierino's other works, in spite of a discrepancy with Vasari's reference to a reclining pose and his description of three *putti* rather than two helping to hold the vase.

Vasari (whose *Life* of Pierino is riddled with factual inaccuracies) probably only knew the *River God* through hearsay. According to a letter written by Martini on 8 January 1549, the work was already completed by that date. Soon after receiving the statue from Pierino, Martini presented it to Duchess Eleonora, who donated it to her brother Don Garcia when he was on a visit to Pisa. Don Garcia, in turn, installed the sculpture in the garden of his Villa di Chiaia in Naples – the city where the statue was rediscovered prior to its acquisition by the Louvre in 1915.

There is no evidence that Pierino's *River God* was meant to represent a specific river, though there can be little doubt that the sculptor and his patron intended the work to celebrate Martini's achievements as *provveditore* – from draining the

marshes of the Pisan plain to overseeing shipping along the Arno route to Florence. The unusually young age of the river god belongs to a trend in sixteenth-century Florentine art favoring youthful depictions of deities traditionally portrayed as old men (Waldman 1998).

The composition's *figura serpentina* poses attest to the impact of Michelangelo's art on Pierino (the same was true of Pierino's master Tribolo). Yet the younger artist goes beyond either of these masters in the undulating sinuosity of his figures, rhythmically emphasized in each of the work's ingeniously varied profile views. The liquescent quality of the poses is echoed in the sensuously organic treatment of musculature and in the fluid rendering of such details as the figures' hair, the grass between their feet, and the swan with his undulating neck. Characterized by Middeldorf as "one of the happiest, most harmonious and vital works that Florentine sculpture of the sixteenth century has produced," the Louvre *River God* reminds us that contemporary views of Pierino as a "second Leonardo" were more than a rhetorical commonplace; in works such as this it seems as though Pierino was consciously trying to evoke the grace, delicacy, and harmony that characterized the art of his famous uncle.

1. In addition to references cited within the text, see Vasari 1966–, vol. 5, p. 233; Utz 1972; Cianchi 1995; and Fenton 1998, p. 77.

L. A. W.

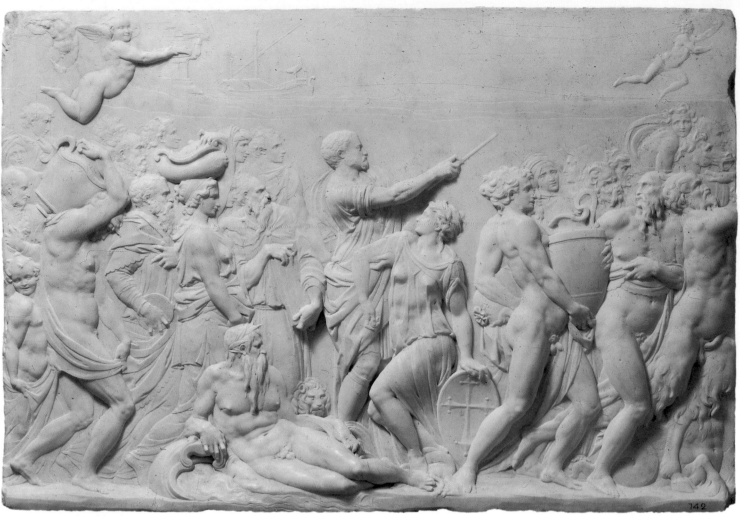

95

95

PIERINO DA VINCI
Vinci, ca. 1529–Pisa, 1553

Pisa Restored[1]
ca. 1552
Carrara marble
74 × 108 cm

Vatican City State, Musei
Vaticani

The elegance and virtuosity of this well-preserved marble, Pierino da Vinci's most famous work, justify its reputation as one of the most important sixteenth-century reliefs, and perhaps the finest executed in an assertively Michelangelesque style. In his long, admiring description (1568), Vasari noted that Pierino "represented Pisa restored by the Duke [Cosimo I de' Medici], who is in the work present in the city and at its restoration, which is being urged on by his presence. Surrounding the Duke his virtues are portrayed, particularly a Minerva, represented because of the Wisdom and the Arts which had been revived by him in the city of Pisa. And she [Pisa] is surrounded by many evils and natural deficiencies of the place, which in the manner of enemies besiege her all round and afflict her. From all these the city has since been liberated by the above-mentioned virtues of the Duke."[2]

Standing in the center of the composition, behind the river god representing the Arno, Cosimo literally raises up a female personification of Pisa. With his scepter held out before him, the Duke emphatically banishes from the city the various vices depicted on the right, and leads in the dignified company on the left. Though Minerva cannot be securely identified, the attributes held by other figures – an urn, armillary sphere, and tablet – refer to the improvements introduced in Pisa under Cosimo's reign, specifically the reopening of the university in 1542, and the establishment of the office of canals in 1547. The latter position was held by Luca Martini, who not only supervised the draining of pestiferous marshes and the rebuilding of the local fleet (perhaps reflected in the distant ship) but also served as Cosimo's principal representative in the city.

In Pisa Martini helped to create a small court with fellow humanists and artists, including Pierino, whom he "discovered" in Tribolo's workshop. Most of Pierino's commissions were for or facilitated by Martini, and many of these, including the *River God* (cat. no. 94), *Bacchus and Pomona* (cat. nos. 93 a and b), and *Abundance* refer to the prosperity Cosimo's learned agent brought to Pisa. This theme also dominates several paintings commissioned by Martini, including the celebrated portrait by Bronzino (cat. no. 16). Even the present relief, undocumented, must have been made for Martini, who appears in the center of the left-hand group, holding his compass and astrolabe. These instruments probably refer to the patron's work in measuring the Pisan countryside – also referenced in Bronzino's painting – and to his research, praised by his contemporaries, into the size and dimensions of Dante's *Inferno*. Martini's literary activity also included a sonnet about Pisa that could describe his role in the relief: the Duke "shows me everything, and teaches / How much one must do, and how, and when / In order to bring a

facing page Detail of cat. no. 95.

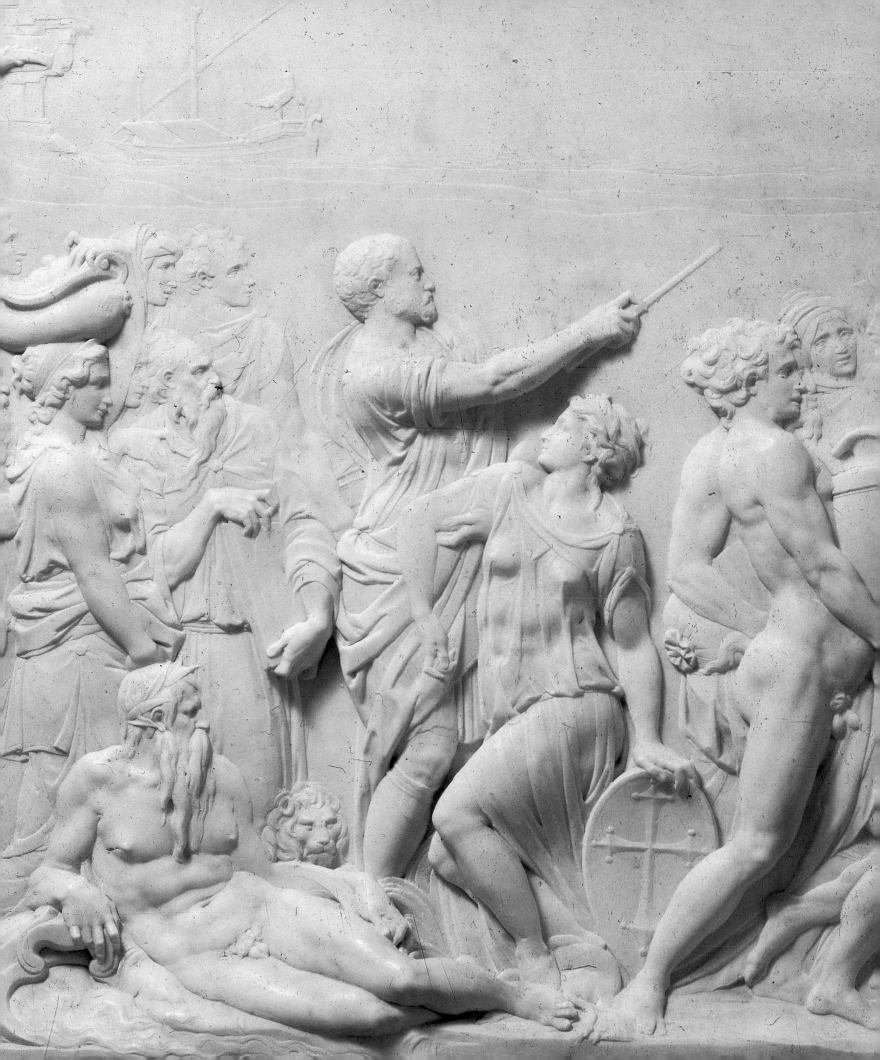

work to its proper end."[3] Among the other portraits in the relief there is a witty image of the young artist himself: on the far left, behind an image of his teacher, Pierino looks at us and holds a relief – this very sculpture – covered by a cloth.

1. See Ciardi 1991; Chianci 1995; Nelson 1995.
2. "figurava Pisa restaurata dal duca, il quale è nell'opera presente alla città et alla restaurazione di essa sollecitata dalla sua presenza. Intorno al duca sono le sue virtú ritratte e particolarmente una Minerva figurata per la Sapienza e per l'arti risusciate da lui nella città di Pisa: et ella è cinta intorno da molti mali e difetti naturali del luogo i quali, a guisa di nimici, l'assediavano per tutto e l'affliggevano. Da tutti questi è stata poi liberata quella città dalle sopredette virtú del duca." Vasari 1967, vol. 5, pp. 498–99.
3. "mi mostra ogni cosa, e isegna / Quanto si debba fare, e come, e quando / Per condurre alla fin opera si degna." Luca Martini, "Capitolo à Visino Mercaiaio," in *Il secondo libro dell'opere burlesche, di Messer Francesco Berni et di diversi autori*, Florence, 1555, pp. 130–31.

J. K. N.

96

DANIELE RICCIARELLI DA VOLTERRA
Volterra, 1509–Rome, 1566

Michelangelo Buonarroti[1]
ca. 1564–66
bronze with dark brown patina
28 cm

Visitors of the Ashmolean Museum, Oxford. Given by William Woodburn 1845

When Michelangelo died on 18 February 1564 his assistant and collaborator in Rome, the sculptor and painter Daniele da Volterra, made a portrait of his close friend, probably based on a death mask. Born Daniele Ricciarelli, Daniele da Volterra had trained in Volterra and Siena before, in around 1535, moving to Rome, where he worked with Michelangelo, Pierino del Vaga, and others. According to Vasari, Daniele had made molds

of Michelangelo's sculptures in the Medici Chapel in San Lorenzo, Florence, and had worked with Michelangelo on paintings in Rome and on the bronze equestrian statue of Henry II of France, which Daniele modeled with Michelangelo's assistance after the king's death in 1559, although he left the bronze cast incomplete upon his own death (see Boström 1995b; Treves 2001, pp. 36–45; and Thomas 2001, pp. 46–53).

In 1563–64 the Council of Trent proposed action against Michelangelo's painted nudes in *The Last Judgment* in the Sistine Chapel. Pope Paul IV commissioned Daniele to overpaint the genitalia of his master's nudes, a commission that adversely affected the artist's reputation and earned him the unfortunate nickname "braghettone," meaning undergarments (Treves 2001, p. 43). Ironically, this occurred at the same time that Daniele was producing bronze portrait heads of Michelangelo, such as the Oxford cast. Although J. C. Robinson (1870, p. 101, no. 90) proposed that this portrait was perhaps made earlier, around the 1550s, the majority opinion (Penny, Ragionieri, following Fortnum and others; see Penny 1992, vol. 1, p. 160) has accepted that Daniele modeled this head to honor and memorialize Michelangelo. The mask was probably created just before the body was clandestinely removed and taken to Florence.

When Daniele died on 4 April 1566, an inventory of his house (formerly Michelangelo's) listed at least six bronze heads of Michelangelo, of which three appear to be heads alone, and three or four were heads with a portion of the chest or collar (see Penny 1992, vol. 1, p. 159). Two heads were recorded as unfinished and sent in late 1565 or early 1566 to Leonardo Buonarroti, Michelangelo's nephew in Florence, although the heads were somewhat delayed due to Daniele's work on the Henry II horse (see Penny 1992, vol. 1, p. 159; and

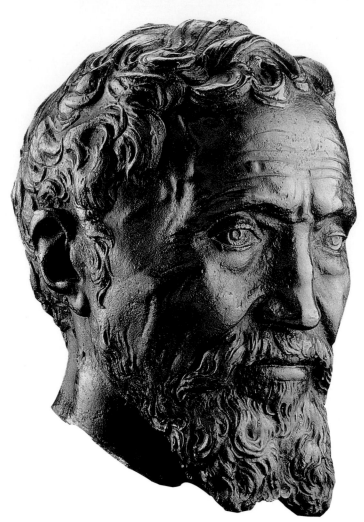

96

Bostrom 1985, p. 816, n. 47). One of these bronze heads disappeared, and the other was finished and supplemented with the addition of a draped classical bronze torso, cast by Giambologna, and has remained in the Casa Buonarroti, Florence, since the sixteenth century (Ragionieri 2001, pp. 40–41, no. 2).

Daniele, who was old and ill when he died, had apparently not cleaned, chiseled, or finished most or any of the other bronze portraits. The Ashmolean portrait is itself unfinished and is a head alone. The various casts (e.g., Paris, Musée du Louvre; Paris, Musée Jacquemart-André; and Milan, Castello Sforzesco), display differences in the length of the beard, and in the definition of the eyes, beard, and wrinkles, and some are less sharply defined than others, suggesting that they may be

aftercasts (Penny 1992, vol. 1, p. 160). The production of an exceptionally large edition for a sixteenth-century bronze portrait indicates that the piece was revered by owners as a death mask of the great artist. Michelangelo is presented modestly and unheroically as a beloved friend to Daniele da Volterra and to other artists and admirers in Rome, Florence, and elsewhere.

1. In addition to references cited within the text, see Fortnum 1876; and Barolsky 1979, p. 112, no. 27.

A. P. D.

97a

97b

97

GUILLAUME DUPRÉ
probably Sissonne, near Laon,
ca. 1579–1640

(a) *Cosimo II*[1]
1613
bronze
9.5 cm diameter

London, The British Museum

CHICAGO AND DETROIT ONLY

(b) *Francesco de' Medici*
1613
bronze
9.4 cm diameter

The Detroit Institute of Arts,
Founders Society Purchase,
Honorarium and Memorial Gifts

CHICAGO AND DETROIT ONLY

The French sculptor and metal
founder Guillaume Dupré
executed these medals of
Cosimo II and his younger
brother Francesco in 1613 during
a visit to Florence.[1] Dupré, who
probably trained as a sculptor
under Barthélemy Prieur, began
to produce medals in earnest in
1600, a development in which
he may have been encouraged
by the arrival in France late that
year of Maria, Henry IV's new
queen and the daughter of
Francesco I. The large format of
Dupré's medals, their imperious
portraits, and the elaborate

pictorial reverses that he gave to
many of them show that he was
familiar with the cast medals of
such sixteenth-century Italian
artists as Leone Leoni and
Jacopo da Trezzo, which are
known to have circulated in
France. His skill as a relief
portraitist was recognized
officially in 1604, when he was
appointed contoller-general of
punches and effigies for the
French coinage, a role that
involved the provision of wax
portraits of the King to serve as
models for coins.

Dupré's Italian visit lasted
from 1612 to 1613. His itinerary
was almost certainly planned
according to the wishes of Maria
de' Medici, who acted as regent
of France after her husband's
assassination in 1610, and under
whose rule Dupré was granted
the position of first sculptor to
the King. His first stop was
Mantua, where he executed
a medal of Maria's nephew,
Francesco IV Gonzaga, Duke
of Mantua, whose rule, begun
in 1612, was to be abruptly
terminated the following year.
He then traveled to Florence,
where he made the two medals
of Maria's cousins exhibited
here, along with medals of their
mother Christine of Lorraine,
Maria's aunt, and of Cosimo's
wife Maria Magdalena of
Austria. While in Florence,
he may also have helped to

expedite the dispatch to France
of an equestrian statue of Henri
IV commissioned by Maria in
1605 and completed by 1612 but
not sent from Italy until 1613.

The stern profiles of the two
male portraits are offset by the
vigorously depicted hair and the
strong emphasis placed on the
ruff in the case of Cosimo, and
the collar worn by Francesco.
The ceremonial armor and
mantle worn by the Grand
Duke provides associations with
the great military figures of
the ancient world, whilst the
Prince's contemporary armor
links directly to his role as
commander of the Tuscan forces,
which in 1613 supported Mantua
against Savoy. Dupré's medals,
designed to impress by means
of both their grand scale and
faultless execution, were intended
to demonstrate to the Italians
that a French sculptor in the
service of the French court
could outdo the great Italian
medalists of the previous century.
They were also a convenient
medium in which Maria could
obtain up-to-date portraits of
members of her Italian family.

1. See Langedijk 1981–87, vol. 1,
pp. 575–77; vol. 2, p. 927; Pollard
1984–85, vol. 2, pp. 880–85, 890–94,
nos. 476, 478; Jones 1988, vol. 2, pp.
82–85, nos. 42–43.

P. A.

98

PIETRO PAOLO GALEOTTI
Monterotondo, near Rome,
ca. 1520–1584

A group of medals celebrating
the achievements of Cosimo I
de' Medici[1]
ca. 1567
silver and bronze
4–4.4 cm diameter

London, The British Museum

CHICAGO AND DETROIT ONLY

These medals were executed as
celebrations of various military
and civil projects undertaken by
Cosimo during the first thirty
years of his reign. The military
actions commemorated by the
medals were the construction
of fortifications on the island of
Elba from 1548; the taking of
Siena in 1555, and ratification
of its annexation in 1559; the
foundation in 1562 of the
military Order of St. Stephen to
protect the Tuscan coast from
Turkish raiders; the construction
of fortresses throughout Tuscany;
and the organization of the
Tuscan militia. The civil projects
were the draining of the swamps
around Pisa in the 1540s; the
channeling of the Arno,
following the flood of 1557; the
construction of aqueducts to
provide Florence and Pisa with
water; and a number of building

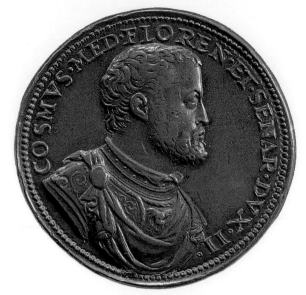

98a obverse

98a reverse

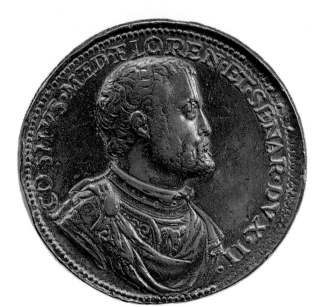

98b obverse

98b reverse

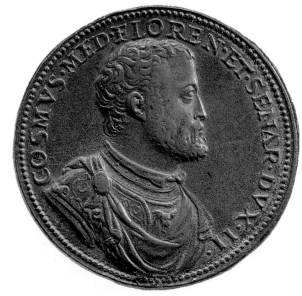

98c obverse

98c reverse

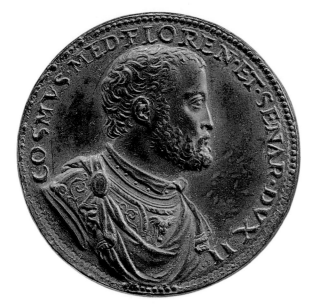

98d obverse

98d reverse

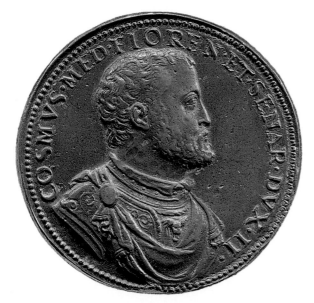

98e obverse

98e reverse

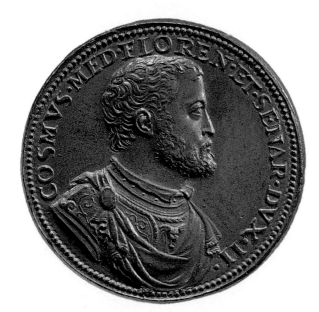

98f obverse

98f reverse

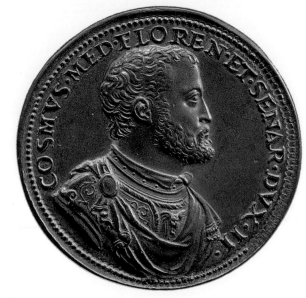

98g obverse

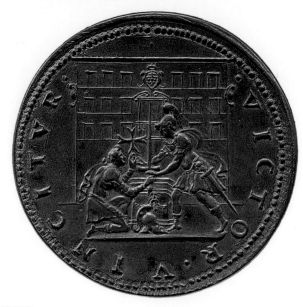

98g reverse

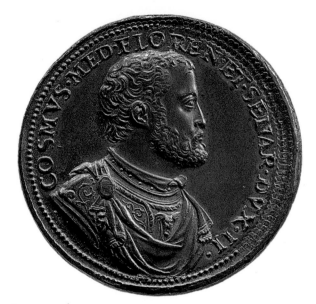

98h obverse

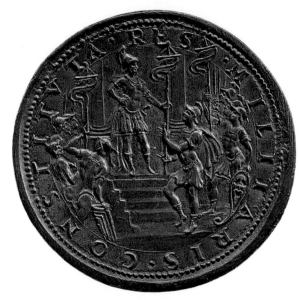

98h reverse

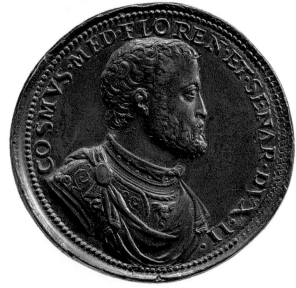

98i obverse

98i reverse

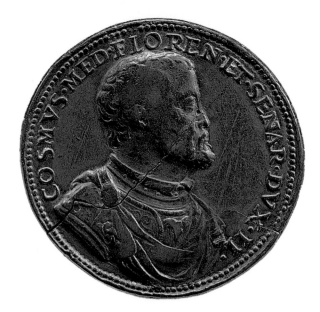

98j obverse

98j reverse

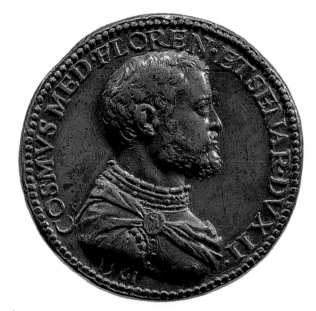

98k obverse

98k reverse

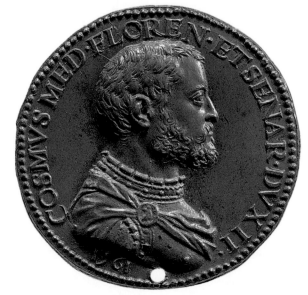

98l obverse

98l reverse

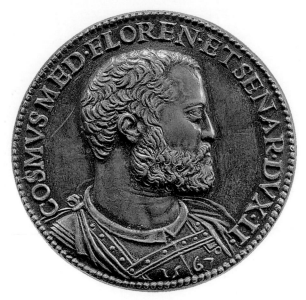

98m obverse

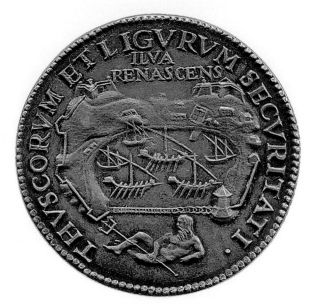

98m reverse

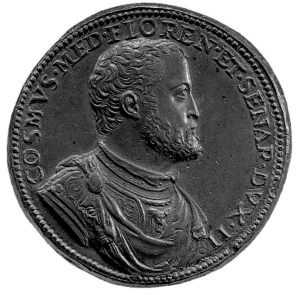

98n obverse

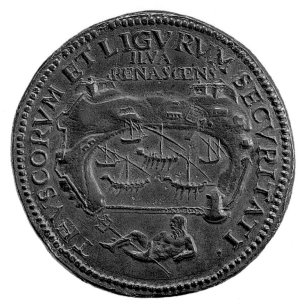

98n reverse

projects within Florence itself. These were: the reconstruction of the Palazzo Pitti, the official Medici residence, begun in 1557; the erection in the Piazza Santa Trinita of the Column of Justice, a gift from Pope Pius IV of 1561; the building of the Laurentian Library, work on which continued throughout the 1560s; and the building of the Palazzo degli Uffizi government offices, begun in 1560. Another medal commemorated Cosimo's delegation of duties to his son Francesco in 1564.

These reverses were based on painted medallions which decorated the courtyard of the Palazzo Vecchio for the entry into Florence in 1565 of Giovanna of Austria prior to her marriage to Francesco. The program for these was devised by Vincenzo Borghini, who worked from an initial list of subjects drawn up by Cosimo himself. Some designs were supplied by Vasari, and some were derived from earlier medals by Domenico Poggini. By March 1566 Galeotti and Borghini were discussing inscriptions for the medals, and later that year the artist took charge of a quantity of gold, from which the first medals were to be struck. At the same time he set about creating a new medalic portrait of Cosimo, whom he portrayed as an ancient

Roman general wearing an *all'antica* cuirass; dated 1567, this portrait was to serve as a common obverse for the various reverses.

Ancient coins were used as design sources for several of the medals: the Elba reverse was copied from Poggini's medal of 1549–50, which in turn was closely based on a coin of Nero; the composition of the Tuscan militia medal was suggested by *adlocutio* scenes on Roman imperial coins, in which a general addresses his troops; and on the medal commemorating the channeling of the Arno, the bull, a common metaphor for a flood, derives from a coin

of Augustus, its cut horns symbolizing the pacification of the river. A further allusion to antiquity was made: the number of medallic reverses produced by Galeotti was thirteen, but in his *Lives*, published in 1568, Vasari omitted the medal of the channeling of the Arno, and described only twelve, thereby inviting a parallel to be drawn between Cosimo's achievements and the labors of Hercules, the legendary hero with whom Cosimo had long identified himself. Vasari's close involvement with Medici iconography would suggest that in thus reducing the number of medals he was following an

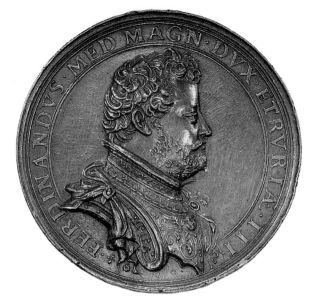

99a obverse

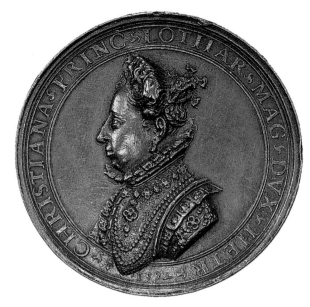

99a reverse

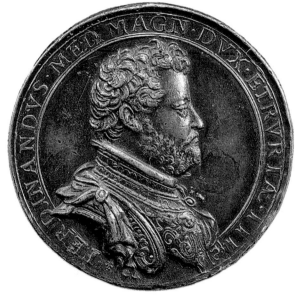

99b obverse

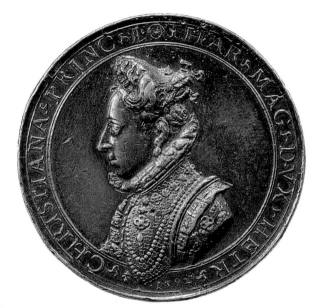

99b reverse

official policy adopted soon after the medals were produced.

Their designs came to be a vital part of the imagery associated with Cosimo. They were used as the basis for decorative *tondi* on a group of carved marble cornerstones now in the Palazzo Pitti, Florence; again, twelve were selected, with on this occasion the commemoration of the building of fortresses in Tuscany omitted from the program. They were also reproduced as grisailles in the nave of the church of San Lorenzo for Cosimo's funeral. But the influence of these medals continued to be felt long

after this: the notion of a finite series of struck medals created for political ends, something quite new in the history of the medal, was to be taken up again in succeeding centuries by absolutist rulers across Europe.

1. See Vasari–Milanesi 1878–85, vol. 7, pp. 542–43; Borsook 1965–66, esp. pp. 44–45; Forster 1971, esp. pp. 80–81; Johnson 1976; Langedijk 1981–87, vol. 1, pp. 485–94; Pollard 1984–85, vol. 2, pp. 774–96, nos. 411–26; Scorza 1988; Toderi 2000, vol. 2, pp. 520–27, nos. 1562–83; and Attwood 2002, nos. 853–65.

P. A.

99

MICHELE MAZZAFIRRI
unknown location, ca. 1530–1597

(a) *Ferdinando de' Medici and Christine of Lorraine*[1]
1593
gold and silver
3.9 cm diameter

(b) *Ferdinando de' Medici and Christine of Lorraine*
1593
silver
3.8 cm diameter

London, The British Museum

CHICAGO AND DETROIT ONLY

These medals, showing Ferdinando on one side and Christine on the other, were produced three years after their marriage. They are among several medals produced for the Grand Dukes Francesco and Ferdinando by Mazzafirri, who is documented as a goldsmith in the service of the Medici from the late 1570s until 1594. Among his many tasks was the casting of sculptural models executed by Giambologna, including silver versions of that artist's *Labors of Hercules*, which were set up in the Tribuna of the Uffizi. He is known to have executed a seal for Francesco de' Medici, and

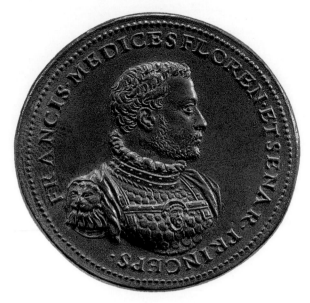

100a obverse

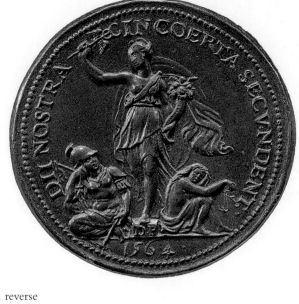

100a reverse

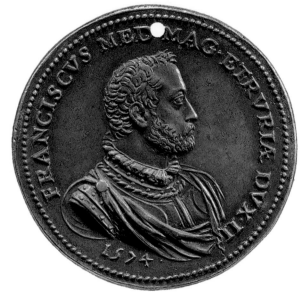

100b obverse

100b reverse

he probably also worked in the Florentine mint: a group of wax models for coins attributed to the artist, including portraits of the Grand Dukes Francesco and Ferdinando, was formerly in the British Museum.

Mazzafirri's medals of Francesco are dated 1576–77; the sign of Aries that appears as a reverse was chosen by Francesco himself, who must have had in mind his father's similar use of Capricorn. Mazzafirri's first medal of Ferdinando was executed in 1587, the year of the Duke's accession; unsigned versions of the bust were also used for coins of the same year.

The following year Mazzafirri made another medalic portrait of Ferdinando, for which he created a number of reverses. Like those produced for Cosimo I by Poggini, these are a mixture of personal devices and achievements memorialized: one bears a device invented for Ferdinando by Scipione Bargagli in 1588 showing a swarm of bees emerging from a hive, with the queen (then thought to be a king) in the center and a legend that translates "Through majesty alone" (MAIESTATE TANTVM); another has the cross of St. Stephen, a reference to the Order of St. Stephen founded by

Cosimo I in 1561; and another, produced in 1590, carries a plan of the new fortified port of Livorno, commenced under Cosimo and continued under Ferdinando. A medal by Mazzafirri of Christine of Lorraine, probably made around the time of her marriage, has a reverse legend describing her as "The fruit and light of modesty" (FRVCTVM LVMENQVE PVDORIS), a sentiment reminiscent of that on Poggini's medal of Cosimo's duchess, Eleonora.

Medals of the type exhibited here were first issued in 1592, the date that appears on the

reverse, but an inscription on the edge of the gold example reveals that this piece was struck in 1593. Marks on the edge of the gold medal indicate that chains were originally attached to it, and other gold medals of Ferdinando and Christine by Mazzafirri now in the Museo del Bargello, Florence, still retain their chains. This made it possible for those to whom the medals were presented to wear them, and when Ferdinando and Christina were buried, in 1609 and 1637 respectively, they too wore gold medals of themselves by Mazzafirri suspended from gold chains around their necks.

1. See Langedijk 1981–87, vol. 1, p. 672; vol. 2, p. 762; Pollard 1984–85, pp. 824–26, nos.446–47; Toderi 2000, vol. 2, p. 537, no. 1625; and Attwood 2002, no. 883.

P. A.

100

DOMENICO POGGINI
Florence, 1520–1590

(a) *Francesco de' Medici as Prince*[1]
1564
bronze
4.3 cm diameter

(b) *Francesco de' Medici as Grand Duke*
1574
bronze
4.2 cm diameter

London, The British Museum

CHICAGO AND DETROIT ONLY

The legends on the obverses of these two medals indicate the changing status of Francesco: described as "prince of Florence and Siena" (FLOREN ET SENAR PRINCEPS) in 1564 following his father's death ten years later he has the title, "the second Grand Duke of Tuscany" (MAG ETRVRIAE DVX II), underlining the dynastic succession of the Medici. The same reverse was used for both medals. On it a figure of Peace holding a caduceus and a cornucopia is raised above two conquered figures, whilst the accompanying legend implores: "May the gods favor our undertakings."[2] The artist's initials appear on the block on which Peace stands.

Domenico Poggini and his brother Gianpaolo were employed as goldsmiths in the service of Cosimo de' Medici from the mid-1540s, working in the Guardaroba under Cellini. Domenico Poggini's earliest known medals were also produced for the Medici: a medal of 1549–50 commemorated the fortification of Elba by Cosimo I, and another associated the Duke with Apollo, while a medal of Eleonora of Toledo of 1551 – almost certainly by Poggini – celebrated the Duchess for her "joyful fecundity with modesty" (CVM PVDORE LAETA FOECVNDITAS) in a reverse devised by Paolo Giovio. From the mid-1550s Poggini served as a die-engraver at the Florence mint, and in 1561 he produced two further medals of Cosimo, commemorating the capture and annexation of Siena and the commencement of the building of the Uffizi. The reverse designs of the Elba, Siena, and Uffizi medals were later reused in Galeotti's series of propaganda medals.

From the mid-1550s Poggini also worked on a larger scale. Following the example of Cellini, to whose *Perseus* he wrote a laudatory sonnet, he progressed from goldsmithing to the more prestigious medium of large-scale sculpture. His works in marble include a *Bacchus* (New York, Metropolitan Museum), signed "Domenico Poggini, Florentine goldsmith, made [it], 1554" (DOMENICVS POGINVS FLORENT AVRIFEX FACIEBAT MDLI III), and an *Apollo*, also signed by Poggini as a goldsmith and dated 1559, which stands in the Boboli Gardens, Florence. Having resigned from the goldsmiths' guild, he was received into the Accademia del Disegno on 12 March 1564, "for having made more sculptures of marble and no longer practicing as a goldsmith."[3]

His output remained diverse. In 1564 he created a terracotta statue of *Poetry* for the funeral of Michelangelo, and also a marble bust of Francesco de' Medici, now in the Uffizi; the following year he provided decorations for the wedding celebrations of Francesco de' Medici and Giovanna of Austria; and in 1571 he executed a bronze statuette of *Plutus* for one of the eight niches in the Studiolo created by Vasari for Francesco in the Palazzo Vecchio. Two busts of Francesco and Giovanna's baby son, Filippo, born in 1577 but dying five years later, have also been attributed to him. He continued to work at the Florence mint, and not only made the present two medals but was probably the author of an unsigned medal of Francesco's wife, Giovanna. He also had a reputation as an antiquarian and was, like Michelangelo, a poet as well as a sculptor.

1. See Langedijk 1981–87, vol. 2, pp. 893–94; Pollard 1984–85, vol. 2, pp. 747–79, nos.393–94; Toderi 2000, vol. 2, pp. 496, 498, nos.1469, 1477; and Attwood 2002, nos.815, 820.
2. DII NOSTRA INCOEPTA SECVNDENT
3. "per aver facto di scultura piu cose di marmo e non esercjtando piu al orafo." Frey 1923–40, vol. 3, p. 208.

P. A.

DECORATIVE ARTS

MEDICI PORCELAIN WORKS
Florence, ca. 1575–87

BERNARDO BUONTALENTI
(design and modeling
attributed to)
Florence, 1536–1608

Ewer[1]
ca. 1575–78
soft-paste porcelain with
underglaze blue and manganese
decoration
36.8 × 23 cm diameter
inscribed: "F. M. M. E. D. II"

The Detroit Institute of Arts
Founders Society Purchase,
Robert H. Tannahill Foundation
Fund, New Endowment Fund,
Henry Ford II Fund, Benson
and Edith Ford Fund, Mr. and
Mrs. Walter Buhl Ford II Fund,
Mr. and Mrs. Horace E. Dodge
Memorial Fund, Josephine and
Ernest Kanzler Fund; gifts from
Mrs. Horace E. Dodge, Mrs.
Russell A. Alger, Mr. and Mrs.
Edgar B. Whitcomb, Robert H.
Tannahill, Julie E. Peck, Ralph
Harman Booth, Mrs. Alvin
Macauley, Sr., Albert Kahn, Mr.
and Mrs. Trent McMath, K. T.
Keller, Arnold Seligman, William
Buck and Mary Chase Stratton,
Mrs. Sydney D. Waldon, Mr. and
Mrs. William E. Scripps, Ernest
and Josephine Kanzler, Dr. and
Mrs. Reginald Harnett, Elizabeth
Parke Firestone, and City of
Detroit Purchase, by exchange.

This large and lavishly decorated
ewer (brocca) is among the most
important of some fifty-nine
known pieces of Medici
porcelain produced in Florence
from around 1575. This was the
first porcelain to be produced
anywhere in Europe, being
manufactured at least one
hundred years before the
medium was reinvented in
France and Meissen.

The coats of arms that appear
twice celebrate the union of
the Medici with the imperial
Hapsburg family through the
marriage in 1565 of Francesco
I de' Medici and Giovanna of
Austria, daughter of Ferdinand I
and niece of the Holy Roman
Emperor, Charles V. The symbols

also date the ewer to between
Francesco's accession to the title
of Grand Duke in 1574 and
Giovanna's death in childbirth
in 1578 (Liverani 1936, p. 18;
Spallanzani 1994, p. 71). The
mark of F. M. M. E. D. II, for
Franciscus Medicis Magnus
Etruriae Dux Secundus, on the
underside of the ewer inside the
Medici symbol of six palle (red
balls) appears on only one other
surviving piece, a much smaller
ewer in the Musée du Louvre in
Paris. Before its acquisition, the
Detroit ewer was accidentally
damaged, but it has been
excellently and expertly repaired:
only the tip of the spout appears
to be a nineteenth-century
intervention, following the
original design as seen in an
1859 illustration in the Gazette
des Beaux-Arts (Jacquemart 1859,
p. 284).

Plates and chargers constitute
the largest group of surviving
wares from the Medici Porcelain
Works: ewers are comparatively
rare. Given the difficulties in
modeling and firing the paste,
an object of this size represents
an important achievement and
its survival is remarkable. Its
elaborate handle comprises two
contrasting volutes, joining at the
top and attached to the ewer
with winged grotesque masks.
Despite the presence of a spout
and handle, the ewer was not
intended for daily use but rather
as a precious object for display.
Radiating around the spout are
applied gadroons, derived from
contemporary metalwork and
highlighted with cobalt blue.

The impressive scale,
distinctive armorials, and high
quality of the sculptural and
pictorial designs strongly suggest
that Bernardo Buontalenti was
responsible for the overall design
of the ewer and the modeling of
the masks at least. Buontalenti
was the artistic mentor to the
young Francesco and was in
charge of many court projects,
including the Medici Porcelain
Works. One of his designs for
metalwork in the Uffizi shows a
tall ewer with gadroons around
the neck of the vessel and masks
at the junction of the handle
and body that are remarkably

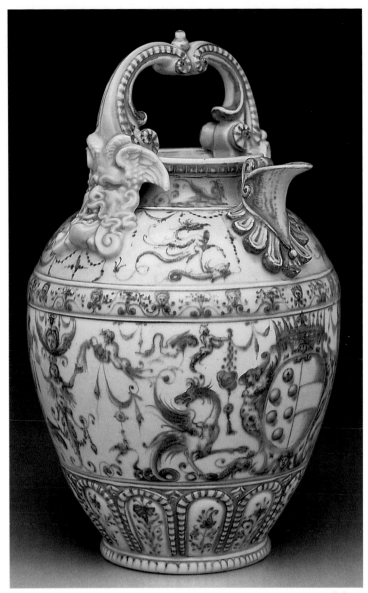

101

close to those on the Detroit
piece (see Magnificenza 1997,
p. 263, cat. no. 203). Moreover,
González-Palacios has
demonstrated (1986, vol. 2,
p. 214, fig. 409) that the carved
grotesque masks Buontalenti
produced elsewhere directly
compare to those featured here.

The painted decoration
consists mainly of Raphaelesque
grotesque motifs in underglaze
blue, reflecting the interest
in grotesque decoration in
sixteenth-century Italy. The
grotesques are also quotations
from the refined maiolica wares
produced by the Fontana and
Patanazzi workshops of Urbino,
and are extremely rare on
Medici porcelain. Spallanzani
(1994, p. 71) following Liverani,

has attributed the painting on
the ewer to Flaminio Fontana of
Urbino, who was active in the
grand-ducal workshops from
1573 to 1578. The most potent
influence on Medici porcelain
decoration, however, was the
Chinese blue-and-white
porcelain of the Ming Dynasty,
and at the ewer's base are
applied lappets of Chinese
inspiration, each containing
stylized blue flowers.

The history of the ewer is
fully documented. Prominently
listed in grand-ducal inventories
of 1691 and 1721 as "a large
porcelain jug with stirrup-shaped
handles and with the Medici
and Austrian coat-of-arms,"[2] it
was sold from the Florentine
grand-ducal collections at an

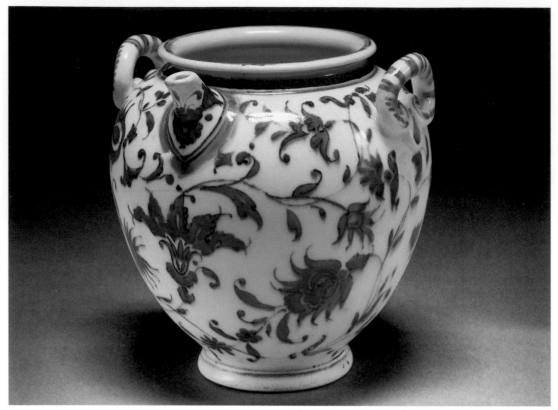

102

auction in the Palazzo Vecchio in 1772 (Spallanzani 1990; Darr 2002), and was in the Rothschild family collections for nearly 150 years before it was acquired by the Detroit Institute of Arts in 2000 (see Jacquemart 1859, p. 284; Liverani 1936, pp. 18–19; Spallanzani 1994, p. 71, pl. 26).

1. In addition to references cited within the text, see Archivio di Stato di Firenze, Guardaroba Medicea, 1301 bis, fol.175r, 1691; 1326, fol.376r, 1721; Darcel 1878; Liverani 1956; Cora and Fanfani 1986, pp. 23, 98–99; and Garnier 1889, fig. 1.
2. "una mezzina di porcellana grossa, con manichi a staffa con arme de' Medici et Austria."

A. P. D.

102

MEDICI PORCELAIN WORKS
Florence, ca. 1575–87

Flask[1]
ca. 1575–87
soft-paste porcelain with underglaze blue decoration
12.7 cm
inscribed with the dome of Florence cathedral and "F" beneath the foot

Washington, D.C., National Gallery of Art, Widener Collection, 1942

This small, precious, oval-shaped porcelain flask is painted at the neck with a band of circles, lines and dots and on the body with tendrils and lotus flowers. This follows the style of Chinese Ming porcelain and also of the blue-and-white Islamic ware that copied the Chinese (then known in Italy as "stile turchesco"): over four hundred examples of Chinese blue-and-white, and possibly also of Islamic wares, were in the Medici collections of Duke Cosimo by 1553 (see Spallanzani 1994; T. Wilson in

Western Decorative Arts 1993, p. 238). However, much of the refined design stems from the inspiration of the porcelain painters in the Medici grand-ducal workshops.

Beginning in the fifteenth century, considerable quantities of Chinese porcelain entered Europe through Venice, prompting experiments in the manufacture of high-fire translucent white ware. Despite numerous attempts throughout Italy and elsewhere, the secret of making porcelain eluded ceramists for more than a century. However, Duke Francesco I de' Medici established a ceramics workshop in Florence in the 1560s for the purpose of replicating Chinese blue-and-white porcelains and in the 1568 edition of his *Lives* Vasari wrote that his talented pupil Bernardo Buontalenti was working for Francesco in Florence and would shortly be able to produce vessels of porcelain (Vasari–Milanesi 1878–85, vol. 7, p. 615). In 1575 Andrea Gussoni, the Venetian ambassador to Florence, recorded that "Francesco has found the

way to produce 'Indian' porcelain and in his experiments has equaled its quality – its transparency, hardness, lightness, and delicacy; it has taken him ten years to discover the secret, but a Levantine showed him the way to success."[2] From these experiments the Medici workshops produced what is generally considered to be the first European porcelain, though it is technically soft-paste, having the translucency, whiteness, and hardness of hard-paste porcelain, but not containing kaolin or petuntse. The relatively low clay content made the body difficult to form and the paste had a high firing range at 1100 degrees Centigrade, all of which strained sixteenth-century technology and resulted in a prohibitively high cost. Production is documented from 1575 until Francesco's death in 1587, though it probably continued until about 1620. There are, however, no surviving examples of Medici porcelain datable after 1587.

The Washington flask, painted a deep cobalt blue underglaze, relates most closely in color and decoration to a pilgrim flask in the J. Paul Getty Museum, Los Angeles; a flask in the Musée Jacquemart-André, Paris; and a similarly small jug in the Museo Nazionale di San Martino, Naples (Cora and Fanfani 1986, pp. 118–19, 148–49). Each of these four related pieces has the same inscription, showing Brunelleschi's dome and the initial F under the foot. Although the Washington flask's date of manufacture is not certain, Spallanzani has proposed that it might be identified with a precise description from an inventory of 1588 recording "a tiny 'dwarf-like' porcelain vase with two little handles and a delicate spout and cover."[3] This inventory lists Medici and Chinese porcelain brought from the Villa Medici in Rome to Florence by Cardinal Ferdinando de Medici upon his brother Francesco's death, demonstrating how the rare porcelain was already greatly valued. This same small flask is also probably one of those recorded in the Medici

grand-ducal *spezieria* inventory of 1732 as "two [small vases for oil] one-fifth of a Florentine *braccia* tall, with a spout and two stirrup handles," but it appears by then to have lost its cover.[4]

1. In addition to references cited within the text, see *Palazzo Vecchio* 1980, no. 403.
2. "Il Granduca Francesco de' Medici ha ritrovato il modo di fare la porcellana dell'India, e nella sua prova è riuscito ad eguagliarne la qualita cioè la trasparenza, la cottura, la leggerezza, e la delicatezza; che seppe da lui essergli occorsi piu di dieci anni prima di scoprire il segreto, ma che un levantino gli aveva indicato il mezzo per riuscire." T. Wilson in *Western Decorative Arts* 1993, p. 235.
3. "un vasetto nano di porcellana con dua manichetti e bocchuccio a coperchio." Spallanzani 1994, pp. 97, 188, doc. 42.
4. "due [vasetti ad uso di vettine] alti 1/5 con boccuccio e due manichi a staffa." See Spallanzani 1990, pp. 318–320, and T. Wilson in *Western Decorative Arts* 1993, p. 240.

A. P. D.

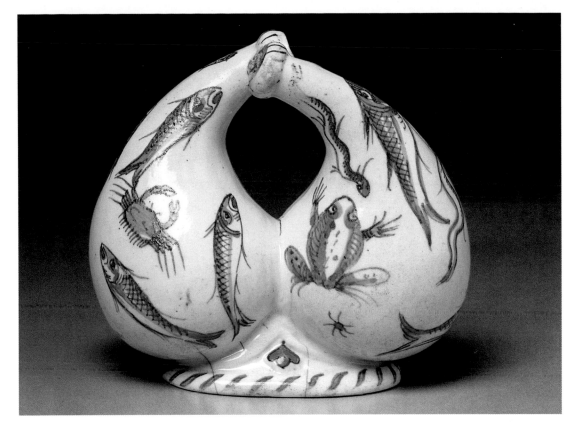

103

103

MEDICI PORCELAIN WORKS
Florence, ca. 1575–87

Cruet[1]
ca. 1575–87
soft-paste porcelain with underglaze blue-and-manganese decoration
12 cm

Boston, Museum of Fine Arts, Gift of the Estate of Professor Henry Williamson through Miss Sarah H. Blanchard

CHICAGO AND DETROIT ONLY

Among four known cruets made of Medici porcelain, the Boston cruet, uniquely decorated with an array of playful sea creatures, is the most charming. Seventeen different sea animals – a crab, a frog, a spider, eels, and a variety of fish – are painted in a pale cobalt blue outlined in darker manganese purple. The design was perhaps inspired by earlier drawings and prints of nature by Albrecht Dürer or by the

contemporary glazed ceramics of Bernard Palissy for the court of Henry II and Catherine de Medici in France, but it is most likely to have been made by Jacopo Ligozzi from Verona (1543–1627), who produced superb drawings and paintings of animals, plants, and nature at the court of Francesco de' Medici and the later grand-ducal courts in Florence.

The bi-lobed, pear-shaped vessel for oil and vinegar (*ampolle* or *ampolline*) sits on a single base with a cream-colored ceramic body. It is not inscribed with the Medici porcelain manufactory's mark (the dome of Florence cathedral and the letter F in underglaze blue, or the six Medici *palle*). It is made from the same mold as a closely related cruet formerly in the collection of Barons Nathaniel and Albert von Rothschild (Christie's, London, 8 July 1999, cat. no. 140): each has a similar vertical seam down the sides of the flask; the two are similar in scale, form, and in their faint pink–orange glaze (Lane 1955, p. 81); and each lack marks, although the Rothschild cruet

is decorated with stylized grotesques and a somewhat later northern silver-gilt mount of a two-tailed mermaid astride the spouts. (Timothy Wilson and John Mallet accept both as made by the Medici manufactory despite the absence of marks, according to curatorial files at the Boston Museum of Art.) Two other Medici porcelain cruets of different form, both also unmarked, are in England (Victoria and Albert Museum, London, and the Duke of Devonshire Collection, Chatsworth, on permanent loan to the Fitzwilliam Museum, Cambridge).

Spallanzani (1994, pp. 98, 104–5) has identified inventories suggesting that this cruet was probably one of four sent in early 1583 to Cardinal Ferdinando de' Medici's Villa Medici in Rome, and returned 1589–90 to the Medici Guardaroba in Florence shortly after Ferdinando became Grand Duke. Spallanzani (1990, pp. 317, 320) has also published inventories that record cruets of various types: the 1721 Guardaroba Medicea in the

Palazzo Vecchio – "two similar porcelain cruets, each joined together"; and the 1735 inventory of the Medici Villa at Artiminio – "two small porcelain cruets with similar spouts and handles, each one-fifth of a *braccia* high." The height in the latter inventory equates to 12 centimeters, strongly suggesting that this document references the Boston and Vienna cruets. Cora and Fanfani (1986, p. 79) have proposed that Gioacchino di Guido, a ceramics painter active in Florence between 1558 and 1612, may have painted the Boston cruet, but this attribution has not yet been confirmed.

1. In addition to references cited within the text, see *Works of Art from the Collection of Barons Nathaniel and Albert von Rothschild*, Christies, London, sales catalog, 8 July 1999, no. 140.
2. "due Ampolle di porcellane simile, attaccate asieme" and "due ampolline di porcellane con sua boccucci e manichetti, simile, alti 1/5 per ciascuno."

A. P. D.

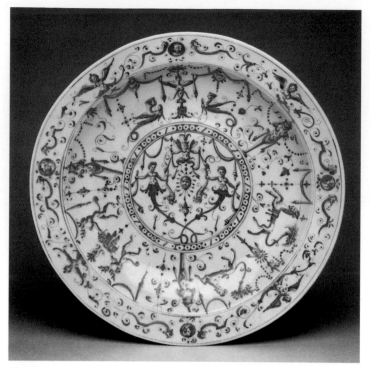

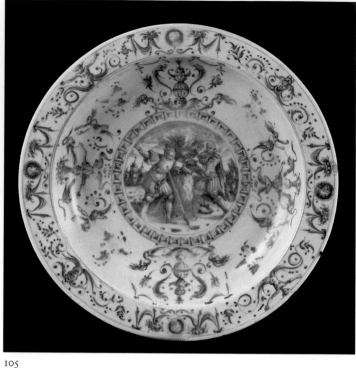

104

105

104

MEDICI PORCELAIN WORKS
Florence, ca. 1575–87

Charger[1]
ca. 1575–78
soft-paste porcelain with
underglaze blue decoration
37 cm diameter, 5.5 cm deep
inscribed with the dome of
Florence cathedral and "F"

Private Collection

This is among the largest and
most beautifully decorated
chargers (or large plates)
made at the Medici porcelain
manufactory. Like the Medici
ewer in Detroit (cat. no. 101),
the charger (which was on loan
from William R. Hearst and
French and Company to the
Detroit Institute of Arts during
the 1930s), is also painted in
soft cobalt blue with delicate
Raphaelesque grotesque
decorations. In the center is a
human mask surrounded by a
pair of griffins and a winged
and crowned small beast, all
holding swirling draperies inside
the pearl-decorated central
medallion. The sides and the
outer bowl of the charger
surrounding the central *tondo* are
painted with an interlocking

group of refined *putti, atlantid
terme* figures, centaurs with
cornucopias blossoming from
their tails, playful beasts, cameo
medallions with busts, and other
fantasy figures entwined with
garlands, volutes, and tendrils.
The back of the charger is also
decorated to the rim of the
foot, which contains the mark
of the dome of the Florentine
cathedral and the initial F for
Florence or perhaps Francesco.

Only a few of the highest
quality pieces of Medici
porcelain are decorated with this
refined Raphaelesque grotesque
decoration: a flask in the Victoria
and Albert Museum, London; a
ewer in the Museo Nacional de
Arte Antiqua, Lisbon; a superb
small polychromed ewer in a
private collection; the large
Detroit ewer; and this large
charger (Cora and Fanfani 1986,
pp. 64–65, 82–83, 96–98, 146–47).
Of all the Medici plates and
chargers, as distinguished from
basins, this is the largest in
diameter. It may have been
created in the same years as the
similarly decorated Medici ewer
in Detroit of around 1575–78,
after a design by Bernardo
Buontalenti, who was in charge
of Francesco's artistic, alchemical,
and scientific workshop at the

Casino di San Marco, which he
built in 1574. Francesco himself
also worked alongside
ceramicists, goldsmiths, hard-
stone workers, glass-makers, and
others from morning until night,
pausing only for dinner.

In 1576 the Ferrarese
ambassador in Florence wrote
that Francesco had shown him
several large works of porcelain
"which gave him much pleasure,
because he had not expected
that this porcelain of his would
succeed for large pieces" (T.
Wilson in *Western Decorative Arts*
1993, p. 235). Because of the
similar scale and quality of the
charger and the Detroit ewer, it
seems likely that the ambassador
was referring to these two
related pieces – thereby giving
the charger a date of around
1575–78 – as well as the
Metropolitan plate (cat. no. 105).
As Spallanzani (1994, p. 71) and
Liverani have proposed that
Flaminio Fontana of Urbino,
who was the grandson of
Guido Durantino and active
in Florence supervising
porcelain firings between 1573
and 1578, may have been the
painter of the Detroit ewer,
this equally impressive charger
may be similarly ascribed to
Fontana.

1. In addition to references cited
within the text, see *The Detroit
Institute of Arts* 1937; Liverani 1956;
and *Ceramics*, Drouot Richelieu,
Marc Ferri, Paris, sales catalog, 6
May 1994, pp. 9–11, no. 37.

A. P. D.

105

MEDICI PORCELAIN WORKS
Florence, ca. 1575–87

Plate representing the *Death of
King Saul*[1]
ca. 1575–78
soft-paste porcelain with
underglaze blue-and-manganese
decoration
33.3 cm diameter, 5.7 cm deep
inscribed with a coronet and the
six *palle* of the Medici arms, the
upper ones with initials "F. M.
M.," the lower ones with
indistinct marks, one at left
possibly "E." (outside bottom)

New York, The Metropolitan
Museum of Art, Samuel D. Lee
Fund, 1941

This delicately painted plate
represents at its center the *Death
of King Saul*. The medallion is
surrounded by Raphaelesque
grotesque decoration and

ornaments and cameos painted in blue underglaze.

The narrative scene may well have been intended to allude to Grand Duke Cosimo, who died in 1574 and who had often chosen to be represented with the identities and attributes of Old Testament and classical heroes. Just as Cosimo had united Tuscany and was its first Grand Duke, so King Saul was the first king of Israel, reigning from 1020–1000 BC; like Cosimo, he was a leader known for his personal bravery and military prowess who also organized various tribes against outside military threats; and just as Cosimo had united the Tuscan towns and territories, Saul was successful in developing a strong cohesive Hebrew nation and creating a powerful monarchy against the Philistines and other tribes. However, Saul eventually became envious of David, his brilliant young military commander, and because of this personal preoccupation, he ignored the encroaching Philistine army who inflicted a disastrous defeat on Mount Gilboa. Rather than accept capture, Saul along with another commander killed themselves by falling on their swords, as represented here. The scene itself derives from the Frankfurt Bible (*Biblicae Historiae*), engraved by Hans Sebald Beham (see Cora and Fanfani 1986, p. 113).

The back also connects this plate closely and directly with the Medici: like only two or three other distinguished examples (the Detroit ewer and a small ewer in the Musée du Louvre, Paris), it is decorated with the six Medici *palle* inscribed with what appear to be Francesco's initials "F. M. M. E. D. II." It is unique, however, in featuring above this mark the Medici grand-ducal coronet that Cosimo was granted in 1569.

Four less elaborately painted large Medici porcelain basins depicting the Evangelists in the center are known (Lisbon, Arezzo, Florence, and unknown location), and they relate in size to this plate. However, the grand-ducal marks and the

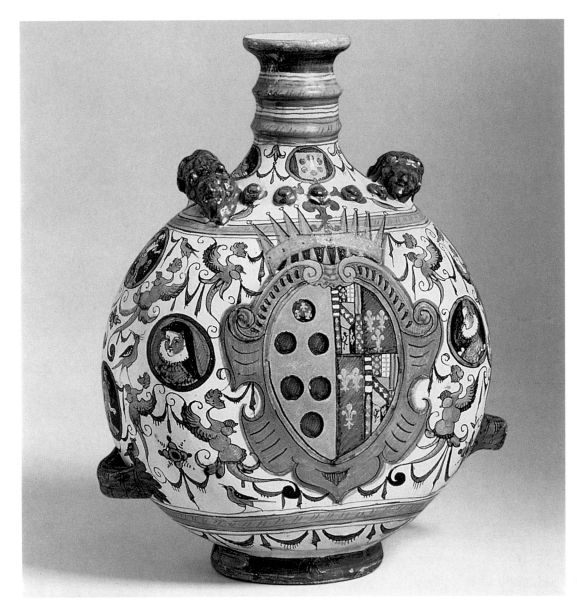

106

particularly refined decoration of this large plate draw a closer comparison with the Detroit ewer, suggesting that the plate too may be tentatively dated between around 1575 and 1578 and may also have been painted by Flaminio Fontana of Urbino.

Spallanzani (1990, p. 319, n. 26–27) identified at least one other large plate with a narrative battle scene at its center and the Medici coat of arms with a coronet and initialed *palle* on the reverse (current location unknown). In 1825 this plate was owned by Ottaviano Targioni Tozzetti, one of the nineteenth-century specialists and collectors, along with Foresi and acquemart, responsible for the revival of interest in Medici

porcelain. Because of the large number of plates known, it has been impossible to identify specific references to the New York plate in the various Medici inventories, which identify specific forms, rather than describing images. The New York plate is, however, doubly unique in being the only known plate with a two-figure narrative scene, and the only extant porcelain with the elaborate grand-ducal coronet and initialed Medici *palle* represented together underneath.

1. In addition to references cited within the text, see Liverani 1936, pp. 12–13, no. 10.

A. P. D.

106

MONTELUPO

Flask[1]
1590–96
maiolica
35.7 cm (base 13.7 cm)

Faenza, Museo Internazionale delle Ceramiche

FLORENCE ONLY

Perhaps identifiable as one of nine Montelupo flasks mentioned in an inventory of 1596 and in another inventory compiled on the death of Grand Duke Ferdinando I in 1609, this sophisticated flask "da pellegrino" (with lateral handles and a pierced base to

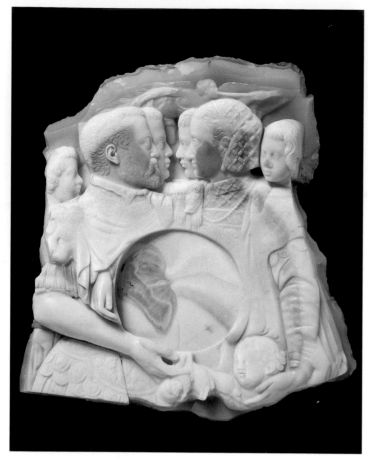

107

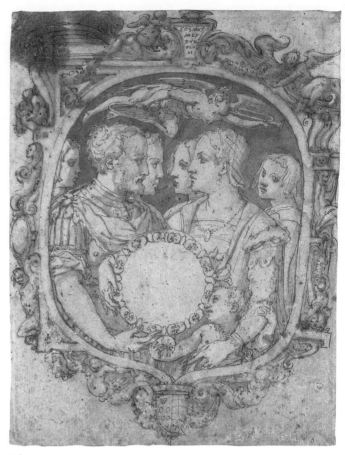

108

accommodate a rope) belongs to a series of ceramics featuring the grand-ducal coat of arms. The Medici–Lorraine arms are prominent on both faces of the vase, which has a flat belly and features a collar and a string of pearls in relief on the shoulders. On each side of the vase, where the heraldic emblem with three "ailerons" (birds in flight) is repeated on a smaller scale, are painted two small portraits within medallions, flanked by a pair of cameo images. Two of the portraits probably represent Christine of Lorraine and her grandmother Catherine de' Medici, who played an active part in orchestrating Christine's marriage to Ferdinando I; the cameo pairs represent Marco Curzio and Lucrezia, and Charity with a crowned figure. The formal typology and the chromatic range – orange, blue, yellow, black, and green on a white maiolica ground – indicate the influence of the Medici ceramic workshop, established in Florence in the

Casino di San Marco in the 1560s in order to manufacture objects in imitation of Oriental porcelain. This in turn prompted the foundation of workshops in Montelupo, where in 1590 twenty kilns were active, while Cafaggiolo and Pisa inaugurated ceramic workshops in 1593–94.

The evolution of grotesque decoration in ceramics, realized with swift and sophisticated lines and originated by Raphael among others, reviving examples from antiquity, ran parallel to the development of decorative themes in other crafts, particularly tapestry, which were the focus of a technical and stylistic renaissance fostered by grand-ducal patronage, despite the controversy of the *Paragone*. The quality of this object dates it to the 1590s, when Tuscan maiolica production reached its stylistic maturity, as yet unaffected by Mannerist influences.

The body of Medici porcelain, of which some sixty examples are known, also includes a pair of vases with

handles in painted maiolica that have not previously been published, parted from the Medici collection at an unknown date and acquired by Sir Harold Acton for his Florentine collection (now New York University, Florence, inv. 1984 Nos. 2 and 5). Differing from the flask in formal terms – the Acton maiolicas appear to be pharmacy vases – the pair are similar to the flask in their decoration, which features the Medici–Lorraine arms, and in their color range. The inscriptions on the bellies of the vases, "Mitridato Ro.no" and "Theriaca di An.co," reveal antiquarian influences that mark the objects as the products of grand-ducal patronage.

1. See Spallanzani 1994; and C. Ravanelli Guidotti in *Magnificenza* 1997, n. 109, p. 144.

C. G.

107

GIOVANNI ANTONIO
DE' ROSSI
Milan, 1517–Rome, after 1575

Cameo with portraits of Duke Cosimo I de' Medici and his family[1]
ca. 1559–62
onyx
18.5 × 16.5 cm

Florence, Museo degli Argenti

This cameo portrays the Duke, his consort, Duchess Eleonora of Toledo, and five of their children in what at the time was one of the largest cameos carved since classical antiquity. Giorgio Vasari describes it as a "cameo grandissimo," stating that, in addition to Cosimo's sons, his two daughters, Isabella and Lucrezia, were included in the composition (Vasari–Milanesi 1878–85, vol. 5, p. 387). They are, in fact, missing, and it appears a decision was taken to include only male children. However, the sides of the cameo seem

to have been broken, so it is possible that portraits of the two daughters were originally included. What is more likely, though, is that the missing parts showed the bodies of Garzia and Ferdinando, who are depicted on each side. Above the ducal family Fame blows her trumpet, and at the bottom of the scene little Pietro plays with the Toson d'Or (Order of the Golden Fleece). In a drawing by Vasari that completes the cameo with a frame (cat. no. 108), the Toson d'Or is shown hanging from a collar, now missing.

The artist who carved this important work, Giovanni Antonio de' Rossi, was a salaried employee of the Medici court from 1556 to 1562, and worked on this cameo from 1559 through the first half of 1562. Letters attesting to his authorship and the evolution of the work were exchanged in these years among the artist, various members of the court, and the Duke (Poggi 1916). By 1560 Giovanni Antonio had returned to Rome, never again to reside in Florence, although he continued to work on the cameo. The remainder of his life was spent in the service of the papacy and as a dealer in antiquities.

The cameo was never finished, however. It lacks the frame projected by Vasari, which is not mentioned in any inventory entries, and the large central recess remains empty. The letters documenting the cameo mention a *medaglia* intended for this space and recent discoveries (McCrory 1998) show that this was to be a cameo representing the personification of Tuscany, or Florence as Vasari states, as mentioned in the letters. The cameo possibly copied the reverse of a medal of Cosimo I by Domenico di Polo de' Vetri showing the personification of Florence.

According to Vasari's drawing the collar of the Golden Fleece was to have been placed at the outer edge of the central recess, where it would have surrounded the cameo of Tuscany or Florence. The central recess

measures 6.21 by 6.54 centimeters, allowing space for both a cameo of the same size as the prototype medal and the miniature collar of the Toson d'Or.

From 1562 the large cameo was placed in the Guardaroba of the Palazzo Vecchio, where it was kept in a white box with thirteen other cameos, until on the completion of the Tribuna of the Uffizi it was displayed in one of the room's recessed wall cupboards, paired with a large (14.2-centimeter diameter) antique cameo of *Antoninus Pius Sacrificing to Spes*. Both cameos are listed in the first inventory of the Tribuna of 1589 (Gaeta Bertelà 1997, p. 58, nos. 671 and 673). The juxtaposition of the two can convincingly be construed as a demonstration of the *paragone* between the ancients and moderns. The later cameo remained in the Tribuna through the eighteenth century and was still in the Uffizi in the nineteenth century, although for much of the time it was not on view. In 1907 it was transferred to the Bargello and finally to its current location, the Museo degli Argenti.

1. In addition to references cited within the text, see Piacenti 1967, p. 144, no. 306; M. McCrory in *Palazzo Vecchio* 1980, vol. 3, pp. 147–48, no. 277; M. Sframeli in *Splendori di Pietre Dure* 1988–89, pp. 76–77, no. 2; and McCrory 1998, pp. 48–49.

M. M.

108

GIORGIO VASARI
Arezzo, 1511–Florence, 1574

Drawing of the cameo with portraits of Duke Cosimo I de' Medici and his family[1]
ca. 1559
pen and brown wash
28.3 × 21 cm

Oxford, Christ Church College

DETROIT ONLY

As well as being an artist and architect, Giorgio Vasari was the artistic impresario at the court of

Cosimo I de' Medici. Court artists frequently supplied drawings for decorative art objects, as was the case with this drawing for the large cameo of Cosimo I de' Medici and his family (cat. no. 107). The drawing is interesting for a number of reasons, most of all for the understanding it provides of the intended appearance of the cameo. It is clear that a sumptuous frame, which would have been in gold or gilt metal, was meant to complete the gem. Vasari provided a different ornament for the frame on the right and left sides of the cameo, furnishing alternative solutions from which his patron might choose. This follows customary practice, as is evident in architectural drawings and those made for ornament. The frame includes a cartouche at the top with the inscription COSMUS/MED/DUX/FLO/II and at the bottom the Medici and Toledo arms surmounted by the ducal crown. At the outer edge of the central recess is drawn the collar of the Toson d'Or (not included in the cameo). In all other details the drawing corresponds closely, if not exactly, to the extant cameo. However, Vasari's description differs both from his own drawing, which he does not mention, and from the cameo itself: "Giovanni Antonio de' Rossi . . . has executed for the most illustrious Duke Cosimo de' Medici a very large cameo, one-third of a *braccio* in height and the same in width, in which he has cut two figures – namely His Excellency, and the most illustrious Duchess Leonora, his consort, who both hold with their hands a roundel in which is [a medallion] containing a Florence [*Fiorenza*], and beside them are portraits from life of the Prince Don Francesco, with Cardinal Don Giovanni, Don Garzia, Don Ferdinando, and Don Pietro, together with Donna Isabella, and Donna Lucrezia, all their children . . ."[2]

1. In addition to references cited within the text, see Byam Shaw

1976, pp. 75–76, no. 161; and M. McCrory in *Palazzo Vecchio* 1980, vol. 3, p. 148, no. 278.

2. "Giovanantonio de' Rossi . . . ha per lo illustrissimo duca Cosimo de' Medici condotto un cammeo grandissimo, cioè un terzo di braccio alto e largo parimente, nel quale ha cavato dal mezzo in su due figure; cioè Sua Eccelllenzia e la illustrissima duchessa Leonora sua consorte, che ambidue tengano un tondo con le mani, dentrovi una Fiorenza. Sono, appresso a questi, ritratti di naturale il principe don Francesco con don Giovanni cardinale, don Grazia [Garzia], e don Arnando [Ferdinando], e don Pietro insieme con donna Isabella e donna Lucrezia, tutti lor figliuoli . . ." Vasari–Milanesi, Florence, 1878–85, vol. 5, p. 387.

M. M.

109

ANONYMOUS

Cameo with portrait of Duke Cosimo I de' Medici[1]
ca. 1567–1588
lapis lazuli
5.6 × 4.7 cm

New York, The Metropolitan Museum of Art, The Milton Weil Collection, 1938

Lapis lazuli cameos, both ancient and modern, are rare, perhaps due in part to their uniform tone, which does not provide the contrasting layers of color found in agates and onyxes that are preferred by cameo carvers.

109

253

110

Pliny the Elder in his *Natural History* remarks on the difficulty of carving lapis lazuli, and it was the challenge of surpassing the ancients, together with a predilection for this particular stone (see p. 103 above), that must have made its choice particularly appealing to the sixteenth-century Medici court, where this cameo was engraved. The only engraved gem in lapis lazuli comparable in size to this piece is a cameo with a portrait bust of the Genoese Admiral Andrea Doria (1466–1560) surrounded by a frame of enameled gold, in the Cabinet des Médailles of the Bibliothèque Nationale de France in Paris.

The anonymous carver of this cameo of Cosimo I based his portrait on a bronze medal by Pietro Paolo Galeotti, whose prototype seems, in turn, to be the portrait of Cosimo I de' Medici in the cameo with portraits of Duke Cosimo I de' Medici and his family (cat. no. 107). Galeotti produced a number of medals with portraits of Cosimo, but it is the one dated to around 1567 that is considered the prototype for the New York cameo, for which the date of the medal provides a *terminus post quem* (Pollard 1985, vol. 2, p. 774, nos. 98, 411).

A cameo is listed among the possessions of Don Antonio de' Medici — the son, probably illegitimate, of Cosimo's son Francesco I and Bianca Capello — in an inventory drawn up at the Casino di San Marco dated 1588, where it is described as "A small picture in which [is] a head of the Duke Cosimo in low relief, of lapis lazuli, with an ornament [frame] of ebony, about one-eighth of a [*braccio*] high."[2] Equating to 7.25 centimeters, this measurement presumably included the frame, which would have been narrow, and thus closely corresponds to the size of the New York cameo. Narrow ebony frames were often used to encompass cameos, medals, and ancient coins, so the presentation of the cameo closely matched sixteenth-century practice. It has been suggested (Langedijk 1979, pp. 78, 76) that the cameo was carved at the Casino di San Marco, where from 1572 hard-stone vases and other *objets d'art* were created, and that it remained there until 1588. It is last mentioned in 1628, after the death of Don Antonio, in an inventory of the Guardaroba, whence it passed to the Tribuna of the Uffizi. When it left Florence is not known. It is next found in the Milton Weil

Collection, whose owner gave it to the Metropolitan Museum of Art in 1938.

1. In addition to references cited within the text, see Kris 1932, pp. 18–19.
2. "Un quadrettino entrovi una testa del Duca Cosimo di basso rilievo di lapis lazzeri, con ornamento d'ebano alto un ottavo incirca." Archivio di Stato di Firenze, Guardaroba Medicea, 399, f. 267 recto.

M. M.

110

STEFANO CARONI
(?)Milan, before 1572 (date of arrival in Florence)–Florence, 1611

Tazza[1]
1610
prasma, enameled gold
7.5 × 12.5 × 12.5 cm

Florence, Museo degli Argenti

This small prasma *tazza* (shell-shaped vase) was created in 1610, one year before the death of its author, Stefano Caroni, and in the first year of the reign of Grand Duke Cosimo II (Fock 1974, p. 110). Immediately below the prasma bowl of the vase is an enameled gold knop and the whole vase is supported on a footed prasma base. Prasma is a type of jasper, leek-green in color that was in use for vases at the Medici court, although vases of deep blue lapis lazuli and transparent rock crystal were the overwhelming preference of the sixteenth-century Grand Dukes.

The Caroni brothers, Stefano and Ambrogio, arrived in Florence in 1572 from Milan, the pre-eminent center for the carving of hard stone (*pietre dure*) and for the creation of important quartz vases. Brought to Florence by Prince Francesco (later Grand Duke Francesco I), they were soon followed by other Milanese hard-stone carvers, all of whom were established in a workshop in the Casino di San Marco, and from there moved to the Galleria dei Lavori in the Uffizi, a transfer

sanctified by Francesco's successor, Ferdinando I, in his "lettera patente" of 3 September 1588 (see pp. 108–09 above).

The Caroni brothers were well known before their arrival in Florence and were among the important gem engravers from whom an estimate was requested in 1572 when a rock-crystal vase was to be made for Duke Wilhelm of Bavaria. Of the hard-stone vases commissioned by Francesco after the Caroni's arrival in Florence only a few survive: a lapis lazuli vase in the collection of the Museo degli Argenti in Florence, with a partial mount by the great Dutch goldsmith Jaques Bylivelt, has been attributed to them (Fock 1980, p. 323).

Francesco's successor, Grand Duke Ferdinando I, was, on the whole, interested in commissions of a different order. His major artistic concern was the completion of the Chapel of the Princes, the great Medici mausoleum in the church of San Lorenzo in Florence. This involved intense activity in the workshops to produce hard-stone mosaics (*commessi di pietre dure*), and Ambrogio Caroni was specially dedicated to this task, although Stefano Caroni, while concentrating on *pietre dure* vases, was not completely excluded from commissions for the chapel; his contribution to the splendid rock-crystal columns prepared for the chapel's tabernacle is well-known (*Splendori di pietre dure* 1988–89, pp. 128–29). The conclusion, based on contemporary documentation, is that Ferdinando ceased the fervent patronage of *pietre dure* vases that marked his brother's reign, and this lack of interest was felt by the specialists in the field, the Caroni included (Fock 1980, p. 357). Stefano Caroni's late shell-shaped *tazza*, exquisite but small, is therefore indicative of the new patronage of Ferdinando, which moved away from the large and splendid lapis lazuli and rock-crystal vases ordered by Francesco I.

III

documented carving important vases of lapis lazuli for the court in Florence (Fock 1980, p. 321).

1. In addition to references cited within the text, see Piacenti 1967, p. 134, no. 79; C. W. Fock, pp. 97–101; C. W. Fock 1980, pp. 322–23; and C. W. Fock in *Palazzo Vecchio* 1980, vol. 3, p. 226. no. 429.
2. "Un vaso di lapis a uso di naviciello con suo piede del simile guarnita d'oro con do manichi a use di serpente, duo anelli tutto d'oro smaltato che detti anelli v'è 18 rubini e 20 diamenti e dua rubini a detti manichi e nel piede 2 cerchietti d'oro smaltato." Quoted in Fock 1974, pp. 98–99.

M. M.

112

GASPARO MISERONI
Milan, ca. 1518–Milan, ca. 1573

Tazza[1]
ca. 1550–56
lapis lazuli
8.5 × 23.5 × 13.2 cm

Florence, Museo degli Argenti

This lapis lazuli *tazza* (shell-shaped vase) is composed of a shell enwrapped by a monster, its head and fin carved on one side. The *tazza* is dated to around 1550–56 and attributed to the Miseroni workshop because it is similar to another *tazza*, also in the Museo degli Argenti, carved from heliotrope, which has nearly identical measurements and is dated to 1556–57 on the basis of a payment of 300 scudi made in 1557 by Cosimo I de' Medici to Gasparo Miseroni for a large vase in heliotrope (for a full discussion of the *tazza* and the original documents see Fock 1976, pp. 123–24). This is almost certainly the heliotrope vase mentioned in Cosimo I de' Medici's Guardaroba inventory of 1560 and a drawing of this *tazza* is among those by Giovanni Grisoni in the Department of Prints and Drawings of the Art Institute of Chicago.

The lapis lazuli *tazza* once had a gold cover. It is listed in

1. In addition to references cited within the text, see Piacenti 1967, p. 135, no. 96; and C. W. Fock in *Palazzo Vecchio* 1980, vol. 3, p. 225, no. 426.

M. M.

111

STEFANO CARONI
(?)Milan, before 1572 (date of arrival in Florence)–Florence, 1611

and/or AMBROGIO CARONI
(?)Milan, before 1572 (date of arrival in Florence)–Florence, 1611

and JAQUES BYLIVELT
Delft, 1550–Florence, 1603

Navicella[1]
1575
lapis lazuli, enameled gold
10.5 × 13.5 × 26 cm

Florence, Museo degli Argenti

This *navicella* (boat-shaped vase) was the first vase mounted for Prince Francesco de' Medici by Jaques Bylivelt, who arrived in Florence in 1573, summoned from Augsburg, where he had traveled from his native city, Delft. Bylivelt was both a jeweler and goldsmith, and thus well prepared to furnish the

sumptuous mounts required for the *pietre dure* vases carved at the Florence court. The complex and elaborate form of the mounts for this vase can be recreated only through recourse to contemporary and later documents.

The account book kept by Bylivelt during his tenure at the Medici court documents this commission, first mentioned in 1575. The vase then appears in the first inventory of the Tribuna of the Uffizi in 1589 and is there described as "A vase of lapis in the guise of [a] *navicella* with a like foot, adorned with two handles in the guise of serpents, two rings, all of enameled gold [and] in those rings there are eighteen rubies, twenty diamonds and two rubies in the handles with two small circles on the foot of enameled gold."[2] Of the several original mounts only the two circular enameled gold mounts remain – one, predominantly white, immediately below the bowl; and a second, mainly dark blue in color, terminating the lapis foot – and even these may have been damaged. An early nineteenth-century inventory, the "Inventario delle Gemme del 1825," fully describes the original mounts and adds such information as that each side

showed a monster with the claws of an eagle and the tail of a dolphin. The original appearance of the vase can be compared to a drawing of around 1576 by Bernardo Buontalenti, who as court artist often furnished designs for hard-stone vases (Fock 1974, fig. 79).

Except for the two enameled circles on the foot, after 1825 the splendid vase was deprived of its fabulous mounts – by this stage already damaged. The lapis lazuli vessel, however, remains in its original state. The stone is similar to that of the well-known large lapis vase designed by Buontalenti with mounts by Bylivelt in 1581–84 (Florence, Museo degli Argenti), and to that of several other important lapis lazuli vases from the Medici collections now in the Museo degli Argenti. It has been suggested (M. Scalini in *Magnificenza* 1997, p. 162, no. 123) that the stone of these vases came from the same piece or at the very least from the same quarry as the present vase. The stone's beautiful veins of pyrite would have harmonized with the elaborate enameled gold mounts.

The *navicella* has been attributed to Stefano Caroni on the basis of its date of 1575, at which date Caroni is

255

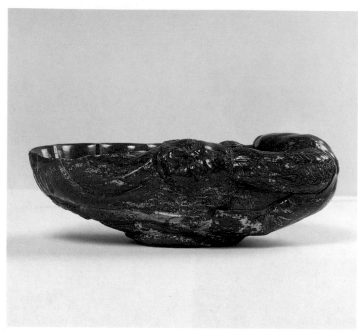

112

the 1589 inventory of objects inherited by Grand Duchess Christine of Lorraine, consort of Grand Duke Ferdinando I de' Medici, from her grandmother, Catherine de' Medici, dowager queen of France, in the year of her marriage to the Grand Duke, where it is described as "A *tazza* in the form of a long shell, lobed, of lapis lazuli all of one piece, with a serpent that encompasses [it], and with the tail that serves as a foot but without ornament."[2] A later inventory of 1704 describes "A separate cover, all of pierced gold [with a design] of leaves and flames of fire with the cipher of the Queen Mother and King Harry [Henry II] with an enameled legend above that says: *Talis Flamme Mihi Sic Ardeo Matris Amore.*"[3]

In the year of its arrival in Florence, 1589, the *tazza* was placed in the Gabinetto di Madama of the Uffizi Gallery, where Christine kept her precious works of art, including many inherited *pietre dure* vases. A 1589 inventory of the Gabinetto di Madama describes the cover "with flames enameled in fire red." The *tazza* was soon moved to the Tribuna of the Uffizi, but in a 1769 inventory the cover is mentioned as damaged, and by 1782 it

had been removed to the Guardaroba. The cover is no longer extant; presumably it was destroyed some time between 1782 and 1825, the year in which an inventory of the Uffizi describes the *tazza* in its actual state. Some idea of the cover's original aspect is conveyed by the cover of the so-called "Tazza of Diane di Poitiers" in rock crystal in the Museo degli Argenti, which has a sumptuous gold-enameled cover showing Moresque ornament and the cipher of Catherine de' Medici and Henry II. This cover was created in the French royal workshops and added to the Milanese rock-crystal *tazza*, and the cover of the lapis *tazza* was undoubtedly created in the same way. Both the comparison with the heliotrope *tazza* (1556–57) and the date of the death of King Henry II (1559), whose cipher is on the cover, confirm that the lapis lazuli *tazza*, both vessel and cover, was created in the years 1556–59.

1. In addition to references cited within the text, see Piacenti 1967, p. 140, no. 237; Fock 1976, pp. 124–26; Distelberger 1978, p. 83; and C. W. Fock in *Palazzo Vecchio* 1980, vol. 3, p. 220, n. 414.
2. "Una tazza a spicchi in forma di nichia lunga di lapis con un serpente

che la cinge intorno et con la coda fa il piede, con suo coperchio d'oro straforato a fogliami et fiamme, con la cifra della regina madre et del re Arrigo, et lettere smaltate." Archivio di Stato di Firenze, Mediceo del Principato, 6354A, f. 365v, n. 38, quoted in Fock 1976, p. 124.
3. "Con coperchio sopra d'oro intagliatori una cifra e rabeschi straforati con flamme sopra d'oro di getto simile tutte smaltate di rosso con una fascia scritovi: *Talis Flamme Mihi Sic Ardeo Matris Amore.*" Quoted in Fock 1976, p. 125.

M. M.

113

Anonymous

Jasper ewer[1]
Last half of the sixteenth century
jasper, gilt bronze, enameled
gold, emerald, ruby
26 cm

Florence, Museo degli Argenti

The jasper ewer was probably created to form a pair with a footed basin, also in the Museo degli Argenti, for which a dark brown jasper, veined in white and similar in appearance to that of the ewer, was used. The ewer is of an oval shape with a smooth surface. It has a carved lobed mouth. The handle has been replaced and the mounts altered.

The ewer appears for the first time in a Medici inventory of 1704 and is listed consistently in the inventories of the eighteenth and nineteenth centuries. Early eighteenth-century inventories (1704 and 1753) describe "A ewer of red jasper with a cast gold handle composed of a dragon enameled in many colors, which terminates in a 'mascherone' in the same technique; both dragon and 'mascherone' have tongues set with a ruby. The 'mascherone' is decorated with five sapphires, six emeralds, and six diamonds, with pearls hanging from the dragon's ears. In the middle is a circular element set with small rubies; [below] is a foot of a similar jasper with a knop and a circular mount of gold enameled with arabesques in many colors,

surrounded by eight blister pearls and eight gold mounts in a similar [style] set with four rubies and four table-cut emeralds, two-fifths [of a *braccio*] high."[2] By 1769 only the head of the dragon remained, and in 1780 it was placed in the Guardaroba (ASBASF, MS 98, 1769, n. 1821). After the removal of the elaborate enameled-gold handle a gilt bronze handle was substituted – vessels in the Medici collection frequently suffered the substitution or elimination of their precious gold and gem-set mounts in the centuries after their creation.

The absence of contemporary documentation makes it difficult to identify the workshop where the jasper ewer, and probably its companion basin, were created. On the basis of its shape – similar to examples in the Schatzkammer in Munich – as well as its mount, the ewer has been attributed to the Saracchi workshop, supplier of many *pietre dure* vessels to the Medici, but it is possible that it may have been created in the Medici glyptic workshops of the later sixteenth century and, if so, most probably during the reign of Francesco I de' Medici.

1. In addition to references cited within the text, see Piacenti 1967, p. 139, no. 208; and Heinzl-Wied 1973, p. 48.
2. "Una Mesciroba di diaspro rosso con manico d'oro di getto di un drago smaltato di più colori, che fa termine sopra di un mascherone simile, con lingue, tanto al drago che al mascherone, d'un rubino, ornato da cinque zaffiri, sei smeraldi, e sei diamanti, con perle pendenti all'orecchio del drago, con un bottone in mezzo di rubini piccoli, con suo piede sotto di diaspro simile con un bottone e cerchio d'oro smaltato à rabeschi di più colori, contomati da otto perle scaramazze e da otto castoni d'oro simile legatovi quattro rubini e quattro smeraldi in tavola, altro 2/5." Archive of the Soprintendenza ai Beni Artistici e Storici di Firenze [ASBASF] MS 82, 1704, n. 2613; MS 95, 1753, n. 1952.

M. M.

114

Bernardino Gaffurri
(?)Milan–Florence, 1606

Jaques Bylivelt
Delft, 1550–Florence, 1603

Oval plaque showing the Piazza Granducale[1]
1599–1600
chalcedony, lapis lazuli, cornelian, heliotrope, rock crystal, gold, gilt metal
18 × 25.5 cm

Florence, Museo degli Argenti

This oval plaque was made for the large and important *studiolo* or cabinet ordered by Grand Duke Ferdinando I in 1593 to adorn a niche directly opposite the entrance of the Tribuna in the Uffizi Gallery. The so-called "Studiolo Grande" was made of precious ebony, inset with hard stones and adorned with gems such as topaz, sapphire, emerald, aquamarine, ruby, and pearls and decorated with gilded *bas-reliefs* of events from the reign of Ferdinando's predecessor, Grand Duke Francesco I. The cabinet displayed Ferdinando's name on its façade and his mosaic portrait was placed at the apex of the arch of the Tribuna directly overhead. The oval plaque was situated high within a central recessed niche of the *studiolo* itself. The portrait in immutable mosaic, the name of Ferdinando affixed to the *studiolo*, and the plaque showing the seat of Medici power, also rendered in the enduring medium of hard stone, were thus employed at the focal point of the Medici collections to proclaim the splendor and power of the Grand Duke and his rule.

The plaque combines hard stones and precious metal in an astounding and virtuoso assembly, and it is not surprising that two skilled craftsmen in the employ of the court were required to execute it. Bernardino Gaffurri, the Milanese expert in the creation of hard-stone mosaics (the famed *commessi di pietre dure*), set the stones, while the court jeweler and goldsmith, Jaques Bylivelt,

was responsible for the goldsmith work required for the statues, cornices, and narrow strips separating the checkerboard pavement. The architectural elements are covered by a thin sheet of rock crystal, fixed in place by the cornices of the buildings.

The view of the Piazza Granducale – in actuality the Piazza della Signoria – from the north renders the square with great accuracy, showing its many sculptures, including the equestrian statue of Grand Duke Cosimo I by Giambologna, Michelangelo's *David* and Cellini's *Perseus*, to name only a few. The representation is based on an anonymous woodcut that established a strongly perspectival view with a single vanishing point, regularizing the architecture to conform to this uniform vision.

In 1776 the *studiolo* was still whole but it progressively lost important parts of its decoration and by 1825 the plaque was in the Guardaroba of the Lorraine dynasty, then the rulers of Tuscany. In the mid-nineteenth century it was displayed in the Gabinetto delle Gemme of the Uffizi Gallery.

1. See Zobi 1853, p. 197; Heikamp 1963, pp. 57–61; Piacenti 1967, pp. 226, 251–52, docs. 46, 254, doc. 57; Fock 1974, p. 142, no. 271; C. W. Fock in *Palazzo Vecchio* 1980, vol. 3, p. 236, no. 449; Heikamp 1988, pp. 134–35, 176; Massinelli 1990, pp. 118, 120; and S. Blasio in *Magnificenza* 1997, pp. 78–79, no. 40.

M. M.

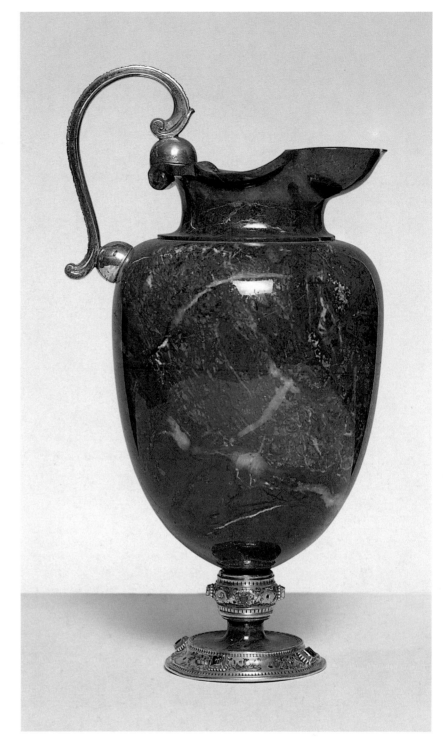

113

paliotto simile a quello che va a San Carlo a Milano finito di oro con gioie." Sframeli 1988, p. 158.

A. M. G.

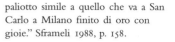

116

MICHELE CASTRUCCI,
GUALTIERI CECCHI, AND
THE GRAND-DUCAL
WORKSHOP

GIULIO PARIGI
(after a design by)
Florence, 1571–1635

Ex-voto of Cosimo II de'
Medici[1]
1617–24
pietre dure relief and inlay with
gems and enamels within a
gilded bronze frame
54.5 × 64.5 cm

Florence, Museo degli Argenti

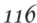

This panel featuring Cosimo II de' Medici kneeling against a background view of Florence cathedral was conceived as an ex-voto for the altar of San Carlo Borromeo in Milan to give thanks to the saint – canonized in 1610 and immediately the object of a fervent cult – for healing the Grand Duke from ill health. Originally set within a gold altar frontal, the panel was never sent to Milan because Cosimo died in 1621, three years before the completion of the extraordinary offering, which kept several artists from the grand-ducal workshops busy for seven years.

Secure information on the work comes from a document dated 1624, where it is stated that "The altar frontal was executed by the goldsmith Cosimo Merlini of the Galleria after a design by Giulio Parigi, and the background and the figure of the middle panel are by Michele Castrucci and Gualtieri Cecchi, stonecutters of the Galleria, and by the goldsmith Jona Falchi."[2] Although it is certain that Giulio Parigi designed the altar frontal, his drawing in the Biblioteca Marucelliana (see cat. no. 117), previously identified as a preparatory sketch, seems to

114

115

GRAND-DUCAL WORKSHOPS

Copy of an ex-voto of Cosimo
II[1]
1624
relief in polychrome papier
mâché
35 × 48 cm

Florence, Museo dell' Opificio
delle Pietre Dure

Enclosed within a modern frame, this relief in painted papier mâché is a faithful copy in modest materials of the sumptuous ex-voto in *pietre dure*, gems, and enamels commissioned by Grand Duke Cosimo II in 1617, today in the Museo degli Argenti (see cat. no. 116). Formerly considered to be a preparatory model for the precious ex-voto, the papier mâché version should in fact be identified as one of four replicas documented in a payment to the painter Francesco Bianchi Bonavita dated 31 May 1624 for executing "four papier mâché

models of the ex-voto of the happy memory of the Most Serene Cosimo II copied from the *pietre dure* model."[2]

It is possible that at the time the replica was made, plans to send the original ex-voto, conceived as part of a dazzling altar frontal, to its intended destination at San Carlo Borromeo in Milan had not been abandoned, even though the Duke had already died. This is suggested by an earlier document dated 22 March 1624 for the payment of an otherwise obscure painter named Virginio Lotti "for coloring a drawing of an altar frontal similar to the one destined for San Carlo in Milan, finished with gold and gems."[3]

The copies were therefore indended to document the prestigious work produced by the grand-ducal workshops, in keeping with a tradition recorded on other occasions. For example, in 1597, before delivering an elaborate and celebrated inlaid table to Rudolph II of Hapsburg, the miniaturist Daniel Froschl was

given the task of painting a copy on paper of the design of the table top, to be kept in the Guardaroba.

Another polychrome plaster relief of the ex-voto is in the Victoria and Albert Museum in London and is probably also a copy of the original *pietre dure* model. While it is true that it was customary in the grand-ducal workshops to produce full-scale plastic models for works in *pietre dure* relief or sculpture, it must also be noted that these models were made exclusively of polychrome wax, and were given by the sculptor directly to the inlay craftsmen for the realization of the final object.

1. See Piacenti 1965, pp. 115–20; A. Giusti in Giusti, Mazzoni, and Pampaloni Martelli 1978, pp. 317–18; and M. Sframeli in *Splendori di pietre dure* 1988, pp. 158–60; Giusti 1978, p. 318.
2. "li quattro modelli di cartapesta del voto della felice memoria del Ser.mo Cosimo Secondo cavati al naturale da quel di pietre."
3. "per aver colorito il disegno del

refer to a project for a voto that Christine of Lorraine intended to give to the Basilica of Loreto. The drawing in fact reveals several differences from the present work, and above all it bears the emblem of the Lorraine dynasty.

Of the gold altar frontal, separated in 1789 from the hardstone relief and most likely melted down, as was the destiny of many precious metal items during the Lorraine period, it is known that it formed a sumptuous frame around the central relief with *putti* on the sides. A succinct description by Charles De Brosses in 1739 mentioned that it was six feet long and made of chiseled solid gold with an inscription in rubies.

The dazzling central panel survived, and was given the eighteenth-century frame in gilded bronze that it retains today. The panel features a superb and eloquent celebration of the Grand Duke, realized in mosaic relief and *pietre dure* inlay, the pride and joy of the Medicean workshops, each here competing for attention. Clothed in regal robes studded with rubies and diamonds and colored with polychrome enamels, Cosimo II points to the crown and scepter, the symbols of his power, against an unmistakably Florentine background that, in its Milanese location, was intended to assert unequivically the identity of the sovereign and the magnificence of his artistic patronage.

It is likely that the Scandinavian goldsmith Jonas Falck executed the precious robes with their gems and enamels, while the altar frontal was produced by the goldsmith Cosimo Merlini, who received supplies of gold for this project on many occasions. The mosaic relief of the figure and the inlay background were realized by two experienced stonecutters ("pietristi"), Gualtieri Cecchi and Michele Castrucci, the latter perhaps a relative of the Castrucci family that in the same period worked in the inlay workshops founded in Prague by Rudolph II of Hapsburg.

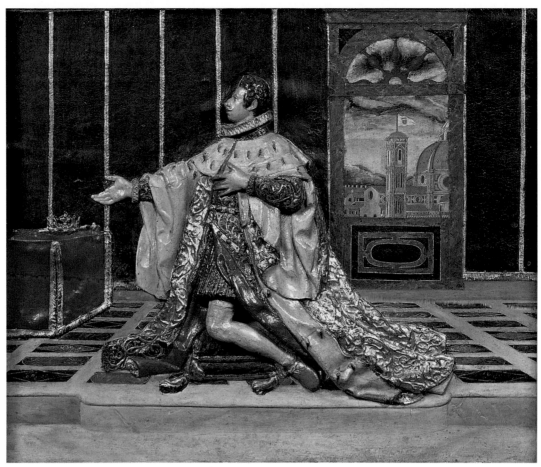

115

116

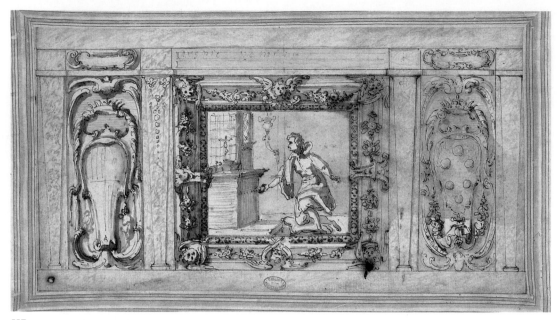

117

1. See K. Aschengreen Piacenti in
Artisti alla corte granducale 1969, p.
150, cat. 145; M. Sframeli in *Splendori
di pietre dure* 1988, pp. 158–60; and A.
Giusti in *Tesori dalle collezioni medicee*
1997, p. 138.
2. "Detto paliotto è stato lavorato
dall' orefice Cosimo Merlini della R.
Galleria; con disegno di Giulio
Parigi architetto e lo sfondo della
formella di mezzo, e figura, da
Michele Castrucci e Gualtieri
Cecchi pietristi di Galleria e dall'
orefice Jona Falchi."

A. M. G.

117

GIULIO PARIGI
Florence, 1571–1635

Sketch for an ex-voto of
Cosimo II de' Medici[1]
1620–40
pen, bister, and watercolor on
paper
14.3 × 25.3 cm

Florence, Biblioteca Marucelliana

FLORENCE ONLY

This lively sketch drawing, easily
legible and pleasing to the eye,
features a design for an altar
frontal with three vertical panels:
in the center, bordered by a
lavish frame, Grand Duke
Cosimo II is seen kneeling in
front of an altar, while in the
two lateral spaces, within

elaborate scrolls, are the Lorraine
arms on the left and the Medici
arms on the right. On the verso
a historical inscription reads:
"Drawing for an unknown altar
frontal in the Medici
Guardaroba."[2] Another, more
recent inscription, dating from
the nineteenth or twentieth
century, suggests: "By Bella or
Poccetti?" (Piacenti 1965),
linking this drawing with the
frontal commissioned by Cosimo
II for the altar of San Carlo
Borromeo in Milan, has
suggested that its author was
Giulio Parigi, to whom a
document of 1624 attributes the
design of a gold and *pietre dure*
altar frontal completed that year
(see cat. no. 116).

Parigi, who was engaged on
Medicean commissions on many
occasions, seems the most likely
among those proposed as the
author of this drawing,
particularly in light of the
animation and dynamism of
the figure of the Grand Duke,
which seems to anticipate the
work of Jacques Callot, and the
lively tracing of the heraldic
emblems. However, some
authors, such as Brunetti (in
I disegni e le incisioni 1984, pp.
78–79), doubt that the drawing
was linked to the ex-voto for
San Carlo Borromeo. During
the reign of Cosimo II several
altar frontals were executed and
sent to celebrated sanctuaries as

invocations for the cure of the
poor health that eventually led
to his early death. Notable
among these was a silver altar
frontal donated by his mother,
Christine of Lorraine, to the
Sanctuary of Loreto. Of this it
is known that the Grand Duke
was represented kneeling in front
of the holy house of Loreto,
identifiable perhaps as the ashlar
structure with an open window
that appears in the drawing. In
addition to this difference in the
background of the central panel
the present drawing features
other anomalies in comparison
with the Milan altar frontal; for
example, where the sides of the
Milan altar frontal featured two
putti, those in the drawing show
coats of arms. Finally, the
presence of the Lorraine arms
coupled with those of the
Medici seems to point to a
commission by Christine of
Lorraine not Cosimo II.

1. In addition to references cited
within the text, see M. Sframeli in
Il Seicento fiorentino 1986, vol. 2, pp.
476–77.
2. "Disegno del paliotto di
guardaroba ignoto."

A. M. G.

PRAGUE WORKSHOPS
after a design by
BERNARDINO POCCETTI
San Gimignano, 1548–Florence,
1612

Abraham and the Three Angels[1]
1610–22
pietre dure mosaic
16 × 44 cm

Florence, Museo dell' Opificio
delle Pietre Dure

This panel showing the story of
Abraham inviting to his table
the three angels sent by God in
the guise of travelers, belongs
to a series of Old and New
Testament scenes destined for
the altar of Ferdinando I's
Chapel of the Princes. The
glittering altar, decorated with
pietre dure and finished with
precious metals, was begun in
the second half of the sixteenth
century at the grand-ducal
workshops but was never
completed, although it is known
that in the early part of the
seventeenth century the *pietre
dure* workshops were laboring
intensively on inlay and *intaglio*
elements for it.

Such was the intensity
of work on the chapel that
Ferdinando's successor, Cosimo
II, had to seek the help of the
pietre dure mosaic workshops
created at the end of the
sixteenth century by Rudolf II
of Hapsburg in Prague, where
the craftsman Giovanni Castrucci
was transferred from Florence.
Documents show that a
preparatory drawing for the
Abraham and the Three Angels
was completed in 1610 by
Bernardino Poccetti, who had
received the commission four
years earlier from Ferdinando
I. To lighten the load of the
Florentine workshops, or perhaps
to gain an example of the
Prague manufactory for his altar,
Cosimo entrusted its execution
to Giovanni Castrucci. After
Castrucci's death in 1615, the
mosaic was completed by his
relatives Cosimo Castrucci
and Giovanni Pandolfini, and
delivered by the latter to
Florence in 1620.

It is likely that Poccetti's design was altered in Prague during the execution of the work, as is suggested by the fur busby worn by Abraham, which was typical of contemporary Bohemian fashion. The piece is refined in its execution and chromatic range, in no way inferior to *pietre dure* works produced in Florence. As usual for works made in Prague, the piece consists exclusively of jaspers and agates from the Bohemian regions, exploiting the streaks and the markings that characterize these materials with a fine painterly sensibility. Also typical of Castrucci's workshop is the emphasis given to the treatment of the landscape, which – as with landscape painting – was one of the most favored themes at the Prague court and featured in many examples from Rudolf II's workshops, which were active for twenty-five years.

1. In addition to references cited within the text, see C. Przyborowsky in *Splendori di pietre dure* 1988, p. 188; Giusti 1992, p. 169; and B. Bukovinska in *Rudolf II and Prague* 1997, p. 486.

A. M. G.

119

DOMENICO DEL TASSO
active Florence, 1563–85

Commesso table top[1]
ca. 1593
wood with *intarsia* in *pietre dure*
and gilded copper
68 × 147 cm

Florence, Museo di storia Naturale, sezzione Mineralogia - università di Firenze

This piece comprises a panel of elmwood veneered with granadilla, a warm reddish–brown wood, and inlaid with hard-stone slabs cut in regular geometrical patterns, combining Sicilian and Barga jaspers, lapis lazuli, agates, and cornelians. The hard stones are edged and linked in a geometrical web of gilded copper, also inlaid into the wooden panel.

Transformed into a table top in the nineteenth century, the panel originally belonged to Ferdinando I de' Medici's Studiolo Grande, of which it is the only surviving work in wood, and then was placed in the Tribuna in the Uffizi. The monumental cabinet was executed between 1593 and 1599 by Domenico del Tasso and completed by Cristoph Paur, active as a "master of ebony" in the grand-ducal workshops since 1589. In 1780 it was transferred from the Uffizi to the new Museo di Fisica e Storia Naturale, where – appreciated

only as a precious stone and not as an artistic masterpiece – it was stripped of all its components and dismembered.

The panel, which functioned as a retractable surface on which the precious objects contained in the cabinet could be displayed and viewed, was originally placed between the base and the first level of the cabinet's façade. A document of 20 March 1593 reveals that it was designed and executed by Domenico di Battista del Tasso, who already in 1563 was in the service of Cosimo I de' Medici. Although geometrical *pietre dure* patterns inlaid on wooden panels were created at the end of the sixteenth century, they are most typical of the taste of the first two Grand Dukes, Cosimo and Francesco. This is also reflected in the early table top with jaspers edged with ivory designed by Vasari before 1557 and today in the collection of the Banca di Roma, and in the desk with hard stones edged in copper, today in the Museo degli Argenti – a rare and priceless relic of the lost Studiolo of Francesco I.

1. In addition to references cited within the text, see A. Giusti in Giusti, Mazzoni, and Pampaloni Martelli 1978, pp. 299–300; A. M. Massinelli in *Splendori di pietre dure* 1988, p. 106; and D. Heikamp in *Magnificenza* 1997, p. 83.

A. M. G.

120

GRAND-DUCAL WORKSHOPS
after a design by
IACOPO LIGOZZI
Verona, ca. 1547–Florence, 1627

Chessboard[1]
1619
pietre dure mosaic in an ebony frame
57 × 54 cm

Florence, Museo degli Argenti

This chessboard is mounted within an ebony structure that also functions as its frame, the board itself featuring jaspers and lapis lazuli, while the surrounding moulding is inlaid with *pietre dure* flowers and butterflies. We know from documents that in November 1617 the painter Iacopo Ligozzi had completed a design "minutely painted to the same scale"[2] for a chessboard with flowers. Like most designs on paper for objects in inlay this drawing has now been lost, but a watercolored sheet with butterflies and flowers survives in the Galleria degli Uffizi (GDSU n. 1956) and is perhaps related to the project.

The execution of the chessboard was entrusted to the workshop of Giovan Battista Sassi, a skilled master of inlay in the employ of the Medici who was also the nephew of Cristofano Gaffurri, one of the Milanese artists that Francesco I de' Medici brought to Florence,

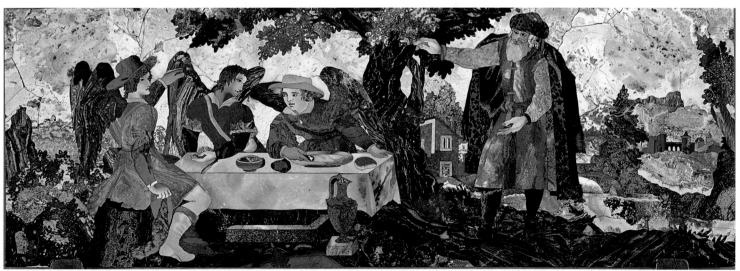

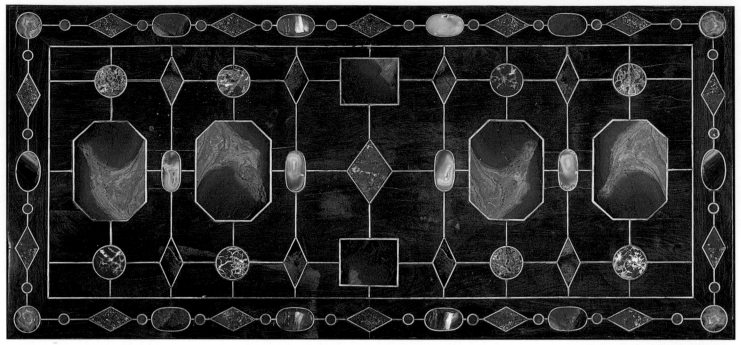

119

who was responsible for establishing the city as a center of excellence for *pietre dure* production. Following two years of work, with the collaboration of Ligozzi, Sassi delivered the chessboard to the Medici Guardaroba in 1619. As was often the case with painters who designed works in *pietre dure* inlay, Ligozzi chose the stones for the piece, selecting those with chromatic nuances most suited to the image from the extensive collection the Medici made available to the workshops.

Ligozzi must be credited not only for his keen pictorial sensibility in bringing out the beauty of the colors of the stones, but also for making a naturalistic theme the main subject of a mosaic, an innovation that would be influential and distinctive in later Florentine *pietre dure* production. An avid observer of botanical and zoological subjects since the time of Francesco I, for whom he created an extraordinary series of watercolors (now in the Galleria degli Uffizi), Ligozzi translated his scientific and naturalistic vocation into an inexaustible and brilliant decorative creative output during the first decade of the seventeenth century.

In its small dimensions and its rigorously simple composition, typical of Florentine taste, this chessboard is exquisite proof that the genre of *pietre dure* inlay, in spite of the innumerable objects produced, avoided repetitiveness and banality thanks to the artists' fresh approach to technique and color.

1. See Piacenti 1967, p. 174; and A. Giusti in Baldini, Giusti, and Pampaloni Martelli 1979, p. 258.
2. "miniato al naturale."

A. M. G.

121

GRAND-DUCAL WORKSHOPS
from a model attributed to
MATTEO NIGETTI
1560/70–1648

Panel with vase of flowers[1]
early seventeenth century
pietre dure mosaic on white
marble ground
133 × 77 cm

Florence, Museo dell' Opificio delle Pietre Dure

This panel, for which the Museo dell' Opificio possesses an identical pendant, offers a striking decorative version of the theme of a vase of flowers – one of the earliest and most favored subjects of grand-ducal inlay work. The motif is repeated in similar panels for the monumental altar of Santo Spirito, executed between 1599 and 1607 for the Michelozzi family with the collaboration of inlay craftsmen provided by Ferdinando I from the grand-ducal workshops. Among these craftsmen was Urbano Ferrucci – probably related to the family of the famed porphyry carver Francesco Ferrucci – a skilled master of inlay active from the end of the sixteenth century in the Galleria dei Lavori (which later became the Opificio delle Pietre Dure). In the early seventeenth century "vases made in inlay, on a ground of black marble,"[2] were recorded in his workshop and these are perhaps identifiable as the two present examples.

The bodies of the two grandiose vases are in lapis lazuli, with chalcedony volutes and festoons reminiscent of the gold mounts made for *pietre dure* objects in the contemporary Medicean collections. The Mannerist silhouette of the vases and their mounts is echoed in a drawing by Matteo Nigetti for some vases destined for the basilica of Santissima Annunziata. At the time that the drawing was made Nigetti was working on the Chapel of the Princes and it has been suggested that the present panels – surviving from a more numerous series (see cat. no. 122) – were destined for the chapel. Documentation and the surviving drawings for the oft-modified chapel and its ciborium do not, however, support a link between the series of panels for the chapel and the Opificio vases. It is certain, though, that in 1691 – long after these panels were made – inlaid panels showing vases of flowers alternating with orange trees decorated the walls of an oratory within the Medici Villa del Poggio Imperiale, later dismantled when the building was restructured in a neoclassical style.

1. See A. Giusti in *Splendori di pietre dure* 1988, p. 26; and Giusti 1995, p. 25.
2. "vasi a commesso in fondo di paragone."

A. M. G.

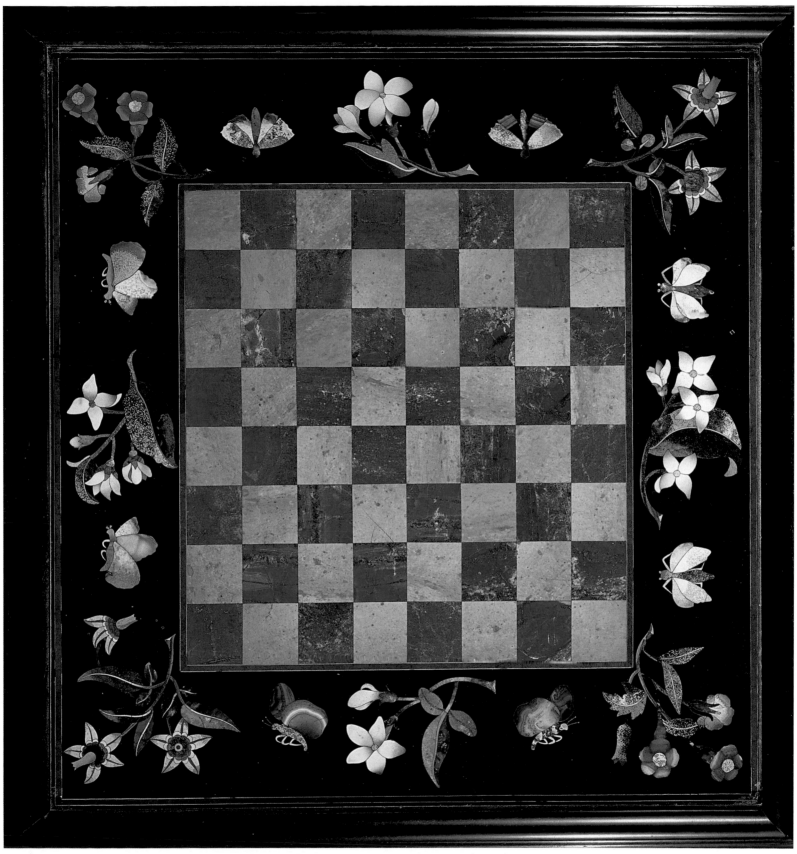

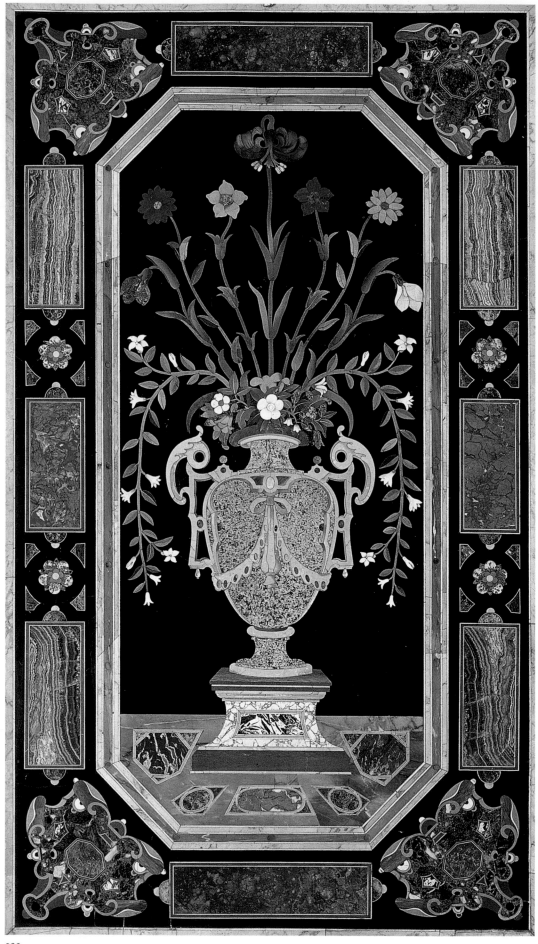

121

GRAND-DUCAL WORKSHOPS

Panel with vase and orange tree[1]
early seventeenth century
pietre dure on alabaster ground
133 × 77 cm

London, Victoria and Albert
Museum

One of two identical panels
featuring orange trees framed
with scrolls, this piece belongs
to the same series as the pair of
panels with vases of flowers in
the Museo dell' Opificio delle
Pietre Dure in Florence (see cat.
no. 121). The frames, identical for
both pairs of panels, feature
Aquitaine marble in the angular
scrolls of the London pair, while
in the Florence panels these
elements are rendered in green,
with Sicilian jasper and Sienese
agate alternating along the long
sides. These intentional
differences within the series
were created to highlight by
contrast the broad range of the
hard stones employed. Such an
effect is obtained most strikingly
in the central area of the
Florentine panel, where the
velvet black of the ground
intensifies the brightness of the
orange trees' springtime blooms
while the surrounding alabaster
gives the London one an
opalescent luminosity.

Executed in the early
seventeenth century, when
naturalistic themes were the
most popular subject for grand-
ducal *pietre dure* inlay work –
such themes remained the
principal motif throughout the
century – the panels were used
to cover the walls of an oratory
within the Villa del Poggio
Imperiale. They were completed
by a wainscoting of black marble
framed with inlayed *pietre dure*
enclosing *pietra paesina* of aquatic
creatures, also in *intarsio*. Two
sections of this decorative base,
featuring swans and fishes,
survive today at the Museo dell'
Opificio.

Following the dismantling of
the oratory when the villa was
rebuilt in a neoclassical style,
the inlaid panels and slabs were

returned to the Opificio, which had executed them two centuries earlier. There, in 1789, they are mentioned as eleven "large panels" ("formelloni"), although only two now remain because of the donation and sale of works from the Opificio's ancient collection during the nineteenth century. The two panels now at the Victoria and Albert Museum were acquired by the then South Kensington Museum in 1867, at the Universal Exhibition in Paris.

1. See A. Pampaloni Martelli in Giusti, Mazzoni, and Pampaloni Martelli 1978, pp. 287–89; Gonzàlez Palacios 1981, vol. 2, p. 23; A. Giusti in *Splendori di pietre dure* 1988, p. 138.

A. M. G.

123

GRAND-DUCAL WORKSHOPS

Medici–Lorraine coat of arms[1]
late sixteenth century
marble mosaic on white marble ground
39 × 28 cm

Florence, Museo dell' Opificio delle Pietre Dure

Against the white marble ground of this oval panel the Medici–Lorraine arms stand out, surmounted by the crown of the Grand Duchy of Tuscany, executed in polychrome marble inlay with mother-of-pearl inserts. The work was probably made for the wedding of Grand Duke Ferdinando I de' Medici to Christine of Lorraine in 1589: an auspicious celebration such as this is suggested by the two cornucopias in the frame of the panel, which have a stylized elegance typical of Bernardo Buontalenti, who at the time was permanently employed in the production of works of art for the court and the grand-ducal workshops.

The dating of the coat of arms to the late sixteenth century is supported by comparison with the emblems of the cities of the Grand

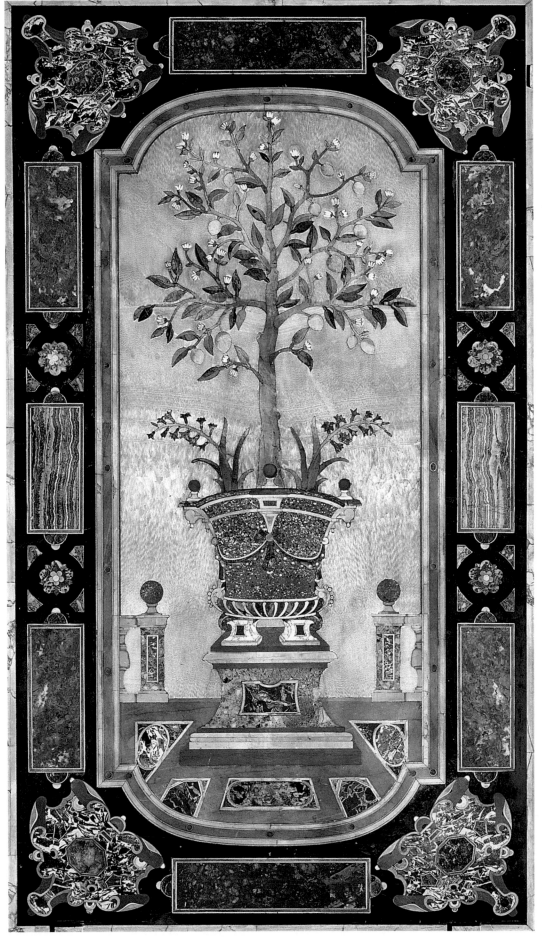

122

123

Duchy of Tuscany, produced at the same time for the interior of the Chapel of the Princes and also executed on a white ground, in a vivid range of polychrome marbles with luminous details in mother-of-pearl. Heraldry had been a favorite subject for inlay work made by the *pietre dure* workshops from the time of their foundation in 1588. For example, coats of arms appeared in the celebrated table delivered in 1597 to Rudolf II of Hapsburg, (subsequently destroyed), and also in a table made during the reign of Ferdinando I, now at the Museo degli Argenti.

In 1610 a proposal was made to insert the Medici–Lorraine arms, together with a similar *intarsia* bearing the insignia of Paul V, within a panel featuring an epigraph to the memory of Ferdinando I, who had died the previous year, which was to be located above the altar of the New Sacristy in San Lorenzo. This project was not realized, however, and both coats of arms were left without a home until they were incorporated into the Museo dell' Opificio's collection.

1. See A. Giusti in Giusti, Mazzoni, and Pampaloni Martelli 1978, p. 286; C. Przyborowski in *Splendori di pietre dure* 1988, p. 124; and A. Giusti in *Magnificenza* 1997, p. 181.

A. M. G

124

GRAND-DUCAL WORKSHOPS

Table top with scrolls and trophies[1]
late sixteenth century
polychrome marble *intarsia*
90 × 115 cm

Florence, Palazzo Vecchio

This table top is composed of soft stones and mottled marbles, many of these – for example, the central oval of alabaster with amber tones – being of archeological origin. The center is decorated with the alabaster oval surrounded by a scrolled design and framed by four military trophies and stylized stems of flowers, the whole bordered with a large band representing a sequence of scrolls.

Documents record the table as being present in the Villa del Poggio Imperiale, where it was mounted on a wooden support in white and gold, different from that used today. The table dates back, however, to the first intensive phase of activity in the workshops founded by Ferdinando I in 1588. During his long stay in Rome as a cardinal, Ferdinando had acquired for his unfailingly tasteful and eclectic collection, tables made by the renowned Roman *pietre dure* workshops, inlayed with ancient marbles and imitating the techniques and materials of the *opus sectile* of Imperial Rome. It is no accident, therefore, that many of the creations of the Florentine workshops were inspired partly by contemporary Roman models, which had been admired since the time of Cosimo I.

A feature typical of these Roman tables was the presence of a central panel in a precious and variegated stone focusing on motifs such as scrolls and shields, with some figurative elements such as military trophies, similar to those adopted in the example from the Palazzo Vecchio. Here, however, these elements acquire a visual prominence and structural complexity that suggest that the object was made in Florence. A table top similar to this in its motifs and date is kept today in the Villa del Poggio Imperiale.

1. See A. Giusti in Baldini, Giusti, and Pampaloni Martelli, 1979, p. 290.

A. M. G.

125

GRAND-DUCAL WORKSHOPS

Table top for the Duke of Osuna[1]
1614
polychrome marble mosaic
118 × 118 cm

Madrid, Museo del Prado

FLORENCE ONLY

A large band of scrolls and shields defines a square enclosing an octagon that in turn surrounds a smaller central octagon. The spaces within this rigorous and elegant geometric framework set against a black ground accommodate trophies and vases of flowers, while the central octagon combines the arms of the Giròn family with the royal arms of Spain and Portugal. This has made it possible to identify the table as a possession of the Spanish gentleman Pedro Téllez Giròn, the Duke of Osuna, who was viceroy of Sicily and then Naples between 1611 and 1620. The inclusion of the royal arms next to those of the gentleman's family was a privilege occasionally conceded to viceroys by the sovereign and the arms are surrounded by the collar of the golden fleece, the highest decoration conferred by Spain.

The table top was probably offered as a gift to the viceroy by Cosimo II, according to the habitual munificence of the Grand Dukes, who charmed illustrious personages with sophisticated and lavish creations from the Florentine workshops as tokens to establish the prestige of the small Grand Duchy with the potentates of Italy and Europe. A detailed documentation records the transferral and shipping in Livorno of the "small mosaic table made for the Duke of Osuna"[2] in July 1614. Only two years later Jacopo of Jan Flach, a craftsman from northern Europe, was given full payment for his work on the object. His involvement in inlay work is proved also by the coats of arms

of Tuscan cities designed for the sheathing of the Chapel of the Princes.

Although the table was made during the reign of Cosimo II, when Florentine inlay work typically focused on naturalistic themes inspired by the designs of Iacopo Ligozzi (see cat. no. 120), this object reflects the "Roman" taste popular during the reign of Ferdinando I, both in the use of ancient marbles and in the design of the frame with scrolls. The theme of military trophies was common to both Roman and Florentine table tops at the end of the sixteenth century, while the four two-handled vases of flowers that elegantly "force" the perimeter of the central octagon reflect a more typically Florentine style.

1. See A. Gonzàlez Palacios in *Civiltà del Seicento a Napoli*, 1984, vol. 2, p. 394; R. Valeriani in *Splendori di pietre dure* 1988, p. 150; and Gonzàlez Palacios 2001, pp. 85–88.
2. "tavolino di Commesso provisto per il sig. Duca di Ossuna."

A. M. G.

126

GRAND-DUCAL WORKSHOPS

Cabinet
ca. 1620
wood with soft-stone inlay
61 × 105.5 × 35 cm

The Detroit Institute of Arts Founders Society Purchase, Robert H. Tannahill Foundation Fund; gifts from Mr. and Mrs. Trent McMath, Mrs. Allan Shelden, Mrs. William Clay Ford, Robert H. Tannahill, Mrs. Ralph Harman Booth, John Lord Booth, Mr. and Mrs. Edgar B. Whitcomb, Mr. and Mrs. James S. Whitcomb, K. T. Keller, Virginia Booth Vogel, and City of Detroit purchase, by exchange

The structure of this cabinet is common among the few surviving table cabinets produced as part of the abundant output of the grand-ducal workshops during the first twenty years of

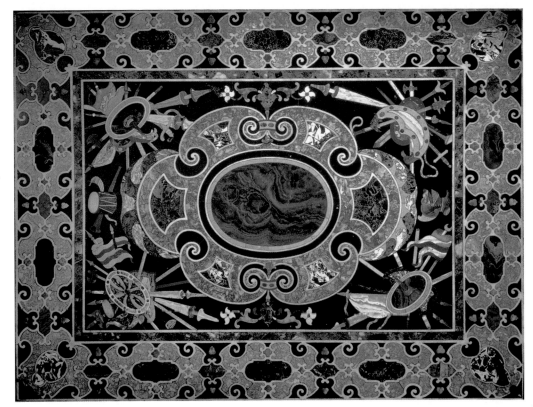

124

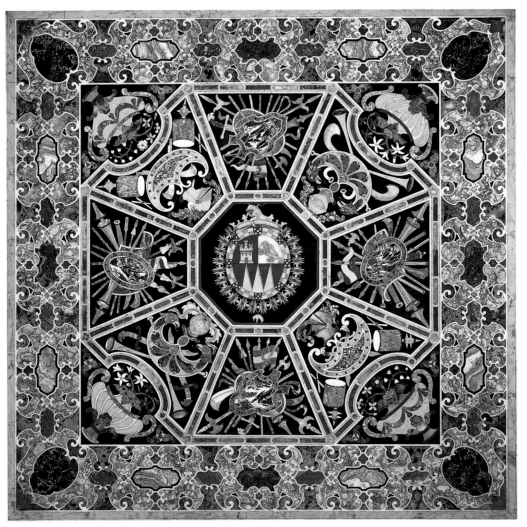

125

267

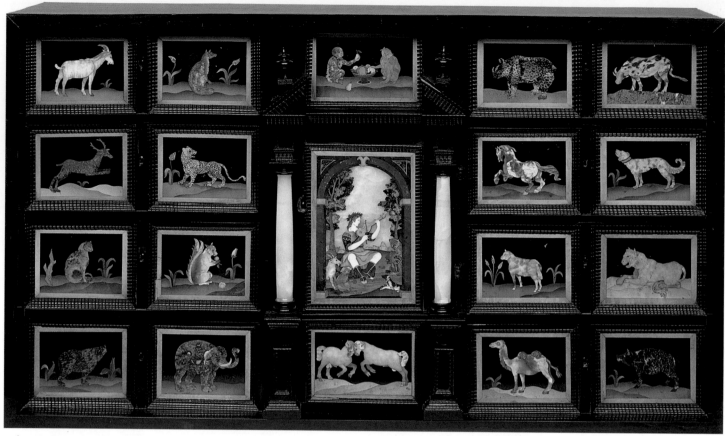

126

the seventeenth century. Later, during the reign of Ferdinando II, this type of furnishing, fashionable in Florence among illustrious patrons, took on architectural shapes and embellishments, eventually developing into the outstanding creations of the Baroque era during the reign of the last generation of the Medici.

This cabinet comprises similar materials to other Florentine examples: pear wood varnished with black for the structure; precious ebony for the façade, with a pattern of interlacing framing the central inlay panels; and soft stones selected in a suitable range of colors for the inlay. This features animals on a black marble ground, for whom Orpheus on the central door plays his music. The theme of Orpheus recurs throughout grand-ducal inlay production, lending itself to a marriage of popular mythological themes – popular also in contemporary painting – and animal themes, which reflected the naturalistic taste predominant in Florentine

pietre dure mosaic during the reign of Cosimo II.

A single pictorial model appears to have inspired the Orpheus in the Detroit cabinet as well as the Orpheus on a cabinet in the Metropolitan Museum in New York, previously in the Barberini Collection, and a humbler mosaic Orpheus in Chirk Castle in the United Kingdom. A similar figure, but with variants that exclude its derivation from the same cartoon, can be recognized in the panel of Orpheus – certainly of Florentine origin – that decorates the *baldacchino* for the throne in the Red Fort of Delhi.

The New York cabinet, dated by Gonzàlez Palacios (1993) to around 1620 on stylistic and historical grounds, offers a useful point of reference for the present cabinet, which displays a more refined and skilled execution in the central panel featuring Orpheus, with a better rendition of its pictorial model. It is tempting to attribute it to

Jaques Bylivelt, known to have designed inlay works for the grand-ducal workshops in the second decade of the seventeenth century. The animals on the eighteen drawers of the façade and the three drawers hidden behind the Orpheus panel, are rendered with great accuracy and with sensitivity to the markings of the stones, reflecting the great pride taken by the workshops not only in the intrinsic value of the materials, but also in the natural chromatic range of the stones and gems, highlighted with boundless imagination.

The menagerie of domestic and exotic animals appears in numerous creations made by the workshops during the seventeenth century, not only in connection with the theme of Orpheus but also as an autonomous subject on a table top now in Versailles and on a cabinet in the Hofburg in Vienna, perhaps created by a later assembly of its component parts.

A. M. G.

127

GASPARO MOLA
Como, ca. 1570–Rome, 1640

or MASTER GUGLIELMO, "THE FRENCHMAN" ("FRANCESE")

The Medici Casket[1]
ca. 1610–20
chiseled and pierced steel
25 × 18 × 18 cm

London, Victoria and Albert Museum

FLORENCE ONLY

This item is documented as being present in the Debruge–Duménil Collection, formed between about 1830 and 1840. It was sold at auction in Paris on 12 March 1850 and acquired by Lord Cadogan, who exhibited it in 1857 at the Manchester Art Treasures Exhibition. In 1865 it was put on the market again at Christie's (3–7 April), and it continued to be transferred from one owner to another at an ever-increasing price. In the collection of J. Malcom of

Poltalloch it was loaned to an exhibition in Leeds in 1868 and to the exhibitions organized by the Burlington Fine Arts Club in 1878 and 1900. Before it was forgotten, it was again sold at Christie's in 1913, with other items from the Malcom Collection, cataloged as a French work executed in the 1550s for a Grand Duke of Tuscany.

These vicissitudes were precisely reconstructed in 1967 by R. W. Lightbown, who provides an enthusiastic description of the object, undoubtedly one of the most sophisticated items ever included in the Medicean collections, and laments the losses and alterations it has suffered:

The interior is unfortunately considerably restored . . . The inside of the dome of the lid is lined with red velvet, edged with gold braid, and kept in place by a rectangular frame containing a stud formed as a flower and four broad leaves. The base of the small upper casket is formed by a square plate that is also the lid of the main casket. To this plate are applied two richly molded circular frames, the inner one containing a plate pierced with the arms of the Medici under a grand-ducal crown. Between the two circles pierced plates form a design of plain gadroons connected by scrolls and twisting baluster shapes in a skilful alternation of movement and repose. Through the piercing of these plates and those of the spandrels can be seen the blue undersurface contrasting with the silvery shimmer of the plates themselves. It is a pity that the original key of the casket is lost: the present key, though well designed and dating from the second half of the seventeenth century, is a replacement. The key of the small upper casket is modern.

Lightbown also analyzed the architectural structure of the object, recalling the inventions of Bernardo Buontalenti, whose influence is particularly evident in the pilaster strips with volutes

featuring ram's heads. The figures of Athena and Mars are exquisite, as is the heraldic crown with fantastic griffins with large breasts, alluding to fecundity. The scholar acknowledged Piacenti's suggestion to refer to Master Guglielmo, "the Frenchman," active in Florence between around 1592 and 1633 and perhaps a member of the same family as Francois Lemaistre (1617–?1624), known to be working for the French. He concluded, however, that despite the praises of this master voiced by Antonio Petrini, who in 1642 wrote a treatise on craftsmanship, dedicated to Don Lorenzo de' Medici (now at the Biblioteca Riccardiana in Florence), the style of the figures is so close to that of certain works by Gasparo Mola that any other attribution is unlikely.

Lightbown supported his theory with a comparison with the representation of Faith on Cosimo II's shield at the Museo Nazionale del Bargello (inv. M 760) matching the burgonet. However, it was common in the Medicean Galleria dei Lavori for particularly intricate works, including objects made with precious metals, to be executed by several craftsmen. The same rule applied in armorers' workshops, although some authors, by treating separately pieces obviously linked by structure or style, deny that there was ever a specific authorship in this type of manufacture. We do not know of any signed work by Guglielmo.

It must be pointed out, however, that the spectacular sword hilt and scabbard mounts from the early seventeenth century, now at the Museo Nazionale del Bargello (M 265), bears a partly erased signature: "Lambart . . . A Paris." The fish-shaped heads and the dolphins featured there, perhaps alluding to the French dynasty, also display female breasts, and the treatment of the animals' faces reveals the soft sculptural touch visible in some of the details of the present desk casket.

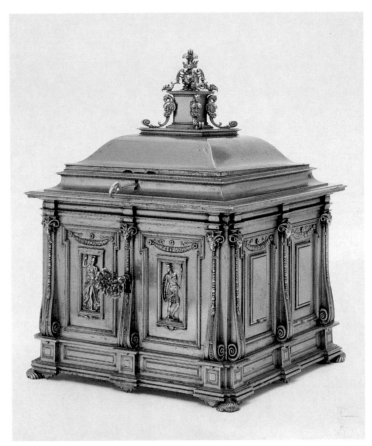

127

The Bargello casket has been attributed by Alvar Gonzàles Palacios (1996, especially pp. 34–35) to Guglielmo Lemaitre.

1. In addition to references cited within the text, see Labarte 1847, pp. 721–22, no. 1433; and *Die Pracht der Medici* 1998, n. 89, p. 156.

M. S.

128

SIMONE PIGNONI
active Florence, 1593–1614

Reliquary of St. Sixtus[1]
1614
embossed silver, chiseled and carved, partially cast
36 × 43 × 19 cm
inscribed on the lid: "S.TI XISTI" and "BARTHOLOMEUS LANFREDINUS EPISCOPUS FESOLANUS DIVO ROMOLO ANNO DM MDCXIIII"; on the bottom: "SIMON PIGN SCULPSIT"

Basilica si Santa Maria all'Impruneta

The lid of this reliquary shows the Medici–Lorraine arms. The inscriptions attest that the object was executed by Simone Pignoni, a goldsmith active between 1593 and 1614, whose earliest known work a reliquary bust for one of the virgin companions of St. Ursula for the church dedicated to the saint in Montevarchi. Documents dated 30 November 1603 show that he was registered to the trade association of "Arte della Seta," and in 1607 he restored a crucifix by Spigliati (Museo di Montevarchi), and realized a challis for the church of San Giuseppe in Florence.

The inscriptions also indicate that the reliquary was commissioned to contain the remains of the first bishop of Fiesole, according to the will of the local bishop Bartolomeo Lanfredini in 1614. At a slightly later date it must have become the property of the Medici, who added their arms beside the figure of St. Sixtus on the top of the casket and donated it to the Basilica dell' Impruneta. The

269

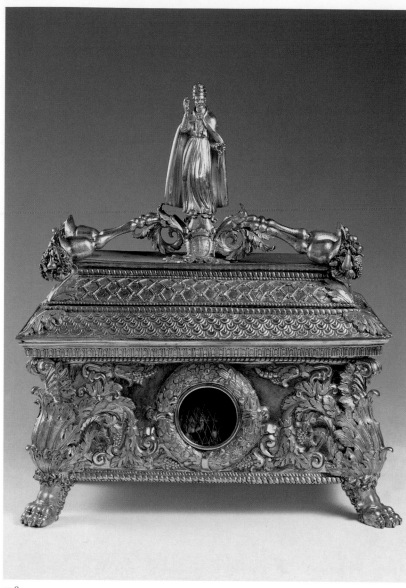

128

reliquary was delivered with great pomp in 1633, as a token of gratitude for surviving the plague, as recorded by Rondinelli: "from the Grand Duke . . . and Madame [Christine of Lorraine] . . . a beautiful silver reliquary, within which is the head of St. Sixtus first pope and martyr."[3]

From a structural point of view this particular type of casket derives from the model of the sarcophagus that Andrea del Verrocchio placed on the eastern side of the Old Sacristy in San Lorenzo in 1472. It bears some interesting affinities with a reliquary belonging to a group of similar architecturally conceived objects in the Tesoro of the Museo dell' Opera del Duomo in Florence, today recognized as a product of the last twenty-five years of the fifteenth century. The St. Sixtus reliquary is, however, closer to Verrocchio's model, imitating with minimal variation all its decorative aspects, including the cornucopias at the top of the casket.

1. In addition to references cited within the text, see E. Nardinocchi in *Gli argenti fiorentini* 1992–93, vol. 2, pp. 1122–24, n. 78; vol. 1, p. 114; and R. C. Proto Pisani in *Il museo di Santa Maria all'Impruneta* 1996, pp. 68–69.
2. Archivio di Stato in Florence, Arte della Seta, 14, c. 50b.
3. "dal Granduca . . . e da Madama . . . un bellissimo sepolcro d'argento, dentro al quale e la testa di San Sisto primo papa e martire." Rondinelli 1634.

M. S.

129

ANDREA TARCHIANI
died 1647

Reliquary of St. William, Duke of Aquitaine[1]
1619
silver embossed, chiseled and engraved, partially cast, and gilded and rock crystal cut and carved
54 cm

Florence, Tesoro della Basilica di San Lorenzo

This reliquary rests on a square-sectioned base with lions' feet at each corner, narrowing both below and above the first register to terminate in an octagonal-shaped support. On this structure, its sides pierced by eyelets to display the remains within, and with four angels seated on the corners, rises a cylindrical case. Its body, smooth and ornamented with festoons and carved masks, is linked at the bottom with a reduced and molded cup through a metal ring, and a cornice, also molded and indented, holds the cupola with a metallic angel, with a scroll at the top.

Commissioned in 1619 with a similar piece intended to house the remains of one of St. Ursula's companions, it was given by Cosimo II de' Medici to his wife Maria Maddalena of Austria to decorate the Chapel of Relics in the Palazzo Pitti. Its maker, Andrea Tarchiani, was active in the grand-ducal workshops for at least forty years, and he was one of the most highly skilled artists of his time. The object's unusual typology probably stems from a desire to relate the reliquary to the ornamentation of the altar, where the candelabra would have echoed the swollen and rounded base on lions' feet, deriving from classical sarcophagi.

The cylindrical case, which follows the Mannerist approach of eliminating the foot from the shaft, which is rounded like a baluster, was probably mass produced in bulk by one of the workshops specializing in the production of rock crystal in Milan. The reliquary has a clumsy monumentality due to a lack of slenderness and proportion between the two parts, which, however, reveal the ingenious experimental skills of the Florentine masters.

1. See E. Nardinocchi in *Gli argenti fiorentini* 1992–93, vol. 2, pp. 134–36; and E. Nardinocchi in Bertoni and Nardinocchi 1995, p. 50.

M. S.

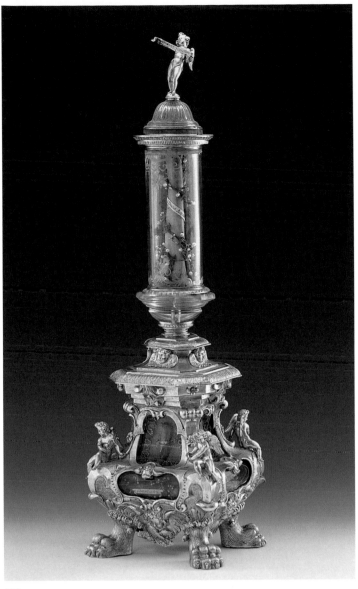

129

130

130

FLORENTINE

Cross for Christine of Lorraine[1]
seventeenth century, with
eighteenth-century base
silver, gilded bronze, and coral
47.5 × 18.6 cm
base 15.6 × 15.4 cm

Florence, Tesoro della Basilica di
San Lorenzo

The support is constituted by a
thin silver plate (which was
recently reinforced by a
semicircular strip of the same
material placed on the back); the
extremities of the cross feature
triangular ornamentations set
into the cross, in recess, cast and
roughly polished, while the

trunk and the arms of the cross
feature pierced decoration with
generic rounded shapes. In the
same technique are decorated
the crossed tibiae, in the center
of which should be found the
skull of Adam, previously
situated there, and made of
coral, but now missing. Also
made of coral is the scroll,
recognizably the work of the
end of the sixteenth century and
early seventeenth century, and
the Christ with the crown of
thorns. The top of the cross
features a ring cast at the same
time as the rest of the cross and
used to suspend it, indicating
that the pyramid-shaped base
was a later addition: indeed, it
has features typical of the
eighteenth century such as the

plain and reduced mirroring in
silvered copper, with the rest in
gilded bronze.

The cross was evidently
manufactured in southern Italy,
and it was not a particularly
prestigious object, although
the quality of the Christ and
the scroll is good. Previously
unpublished, it probably comes
from the Palatine Chapel in the
Palazzo Pitti, as a result of the
exchanges made during the
Lorraine dynasty with the aim
of gathering in state collections
the precious *pietre dure* vases
made for the Medici during the
Renaissance. We cannot certainly
retrace its provenance, as such
crosses were common gifts in
the years of its execution.
Furthermore, the legacy of the

Marquis Botti, which passed to
the Medici in the seventeenth
century when the Botti family
line was extinguished, cites
several coral crucifixes. The
present object was only cursorily
described in an inventory by
Elisabetta Nardinocchi.

1. See E. Nardinocchi in Bertani
and Nardinocchi 1995, p. 74.

M. S.

271

131

131

FLORENTINE

Temple, known as the Reliquary of the Passion[1]
seventeenth century
silver, partially gilded, chalcedony, agate, rock crystal
53.5 cm

Florence, Tesoro della Basilica di San Lorenzo

This reliquary, made in the shape of a temple with a hexagonal floor, currently rests on a base of gilded wood, which replaces the original in ebony with drawers, documented in a drawing at the Gabinetto dei Disegni e Stampe at the Uffizi. The temple comprises a metallic base on which a tall mirrored pedestal rises, partly ornamented with rock crystal, and with mouldings, in the corners of which are cubes, on which Corinthian columns are erected, with a chalcedony shaft, supported by plinths. All is surmounted by a trabeation with an attic ornamented by a balustrade interrupted by six cubes supporting obelisks (only two are left undamaged and one is splintered). The cover is made in the shape of a vaulted dome, with eighteen segments ordered by groups of three on each face, all decorated with four-faced pyramids in rock crystal. The whole is surmounted by a lantern with buttresses supporting the crossed orb.

Beneath this structure a podium of four steps with compasses plan: on this stand two flagellators wearing silver turbans beside a figure of Christ made in pink agate marked with red, who is tied to the shaft of a column made of plasm. The remains, situated in the basement, bear the inscriptions: "Columna Flagellationis D. N. Jesu Christi quae extat Romae in Templio S. Praxedis"; "Ex altera Columna ad quam Christus Dom. Ligatus, e caesus fuit, quae colitur Hierosolymi"; "Ex Petra Hostii Monumenti Domini N. Jesu Christi."

The reliquary has been linked with Giovanni Antonio Dosio but such a reference is based exclusively on stylistic grounds, particularly the comparison of proportions and decorative elements with real architecture and with drawings. The object was purchased by Christine of Lorraine in February 1609 and is first mentioned as being present in Florence in the inventory of her chapel in the Palazzo Pitti in 1621.

Since 1980, publications have followed the information given in the catalog entry for this object in the Medici exhibition of that year, *Palazzo Vecchio: committenza e collezionismo medicei* (catalog entry 454, pp. 238–39), which recognized this object as one mentioned in the inventory of the jewels of Christine of Lorraine.[2] The quality of the figures, in terms of innovation and execution, is not excellent, although the stone utilized for the Christ is very unusual.

Another extraordinary Christ tied to a column, made in Italy, almost certainly in Milan, has been published by Daniel Alcouffe (2001, pp. 40–41): it was executed with greater subtlety and in bloodstone, but it constitutes a good point of comparison with the Florentine example.

1. In addition to references cited within the text, see Massinelli and Tuena 1992, p. 118; and E. Nardinocchi in Bertoni and Nardinocchi 1995, p. 46.

2. Archivio di Stato in Florence, Guardaroba Medicea 152, p. 47; another copy is in the Archivio Soprintendenza "alle Gallerie" Fiorentine, 71, c.147.

M. S.

132

GASPARO MOLA
Coldrerio, ca. 1580–Rome, 1640

Ceremonial helmet for Cosimo II
ca. 1609
burnished and blue-colored steel, with decorations in silver and gold
28 cm

Florence, Museo Nazionale del Bargello

When the Medici armory was dispersed this helmet was among the most important pieces rescued by Giuseppe Bencivenni-Pelli, who thought it an extraordinary example for the uniqueness of the work, and for its historical value. Fashioned as an ordinary late-sixteenth-century peaked burgonet, the helmet was graced with elegant applied decorations, made by the grand-ducal goldsmith and minter to correspond perfectly with those of a matching buckler (a circular shield, Florence, Museo Nazionale del Bargello, M 760). The overall decorative program includes the virtues and the figure of Fame, who appears on the helmet with Charity, set in silver ovals framed by grotesque ornamentation. On the inner border of the shield appear the signs of the zodiac.

The piece can be identified as the work of Gasparo Mola from Antonio Petrini's 1642 description, which cited this helmet, made for Cosimo II, praising its author as the best decorator of armory of the time.

Two double portraits – one previously at the Luzzetti Collection in Florence and the other also in Florence in a private collection – provide further information on the helmet. Both represent a young boy who could be Giancarlo de'

Medici (1611–63), wearing the helmet and displaying a gold medallion executed by Mola for Carlo Emanuele I of Savoy in 1606. The other figure, who wears a feathered hat, points in the Luzzetti painting to the pistol he holds, while in the other canvas – similar in composition – he holds out towards the viewer a map representing a bastioned fortress. He may be identified as Mattias de' Medici (1613–67), which would date the canvases, possibly by Cesare Dandini, to about 1625–30. While the second painting was probably a Medici commission, since the youth in the foreground points to the fortified architecture – architecture being considered to be one of the most suitable occupations for a prince – the first may have been commissioned by Mola himself, perhaps already absent from Florence (which would date the canvas slightly later), to record or to celebrate his work as an armorer and minter before his Roman activity.

This burgonet was used as a model by Vincenzo Mannozzi (1600–58) for the helmet worn by Orlando in the cave of the brigands in a painting that belonged to Don Lorenzo de' Medici (now in the Soprintendenza Speciale il Polo Museale Fiorentino), intended to identify the Grand Duke with the celebrated knight Charles the Great, the defender of Christianity. The burgonet was still greatly appreciated during the Enlightenment, and later it was used in the depiction of Radamisto in the act of killing Zenobia by Luigi Sabatelli, previously in the Tommaso Puccini Collection, and now in the Museo Civico in Pistoia.

M. S.

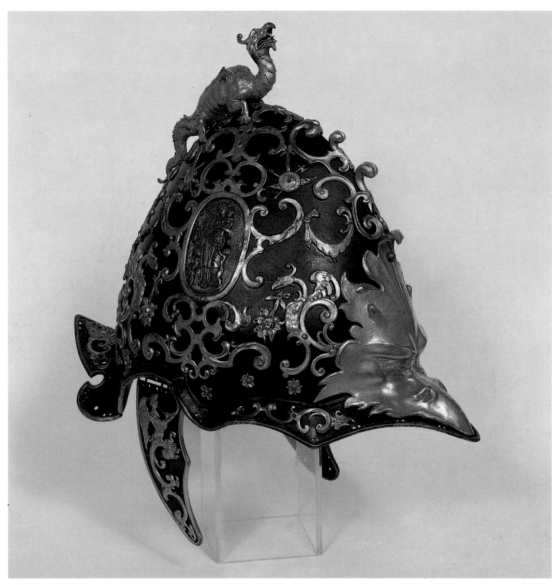

132

133

ITALIAN

Cuirass for Cosimo I[1]
ca. 1550–60
steel, brass rivets, and leather
186 cm

Vienna, Kunsthistorisches Museum, Hofjagd- und Rüskammer

FLORENCE AND CHICAGO ONLY

The cuirass, which was sent from Florence to represent Cosimo I in Archduke Ferdinando II of Tyrol's "gallery of heroes" (Heldenruestkammer), where it appears for the first time in an inventory of 1593, is designed to be worn on horseback. It has large Pauldrons but lacks the projecting *buffe* that in the past had been a feature of armor decoration, and that in the period in question was commonly used only in armor for tournaments. Another traditional element is the helmet with lames protecting the gorget and with ribbed borders on the ventail, which was frequent on luxury armor. The only anomaly is the articulated blade for the skirt of tasses, which were normally found in half armors (corselet) for foot soldiers, like those that Cosimo himself commissioned from Pietro Gandino di Brescia in 1549–50 during the war against Siena.

The armor is faithfully reproduced (although the lance rest is omitted) in a *tondo* by Bronzino representing Cosimo for the Studiolo of Francesco I de' Medici in the Palazzo Vecchio, where the leather straps lined in red velvet, now lost, are clearly visible, as is the belt with sheaths for sword and dagger. In view of the fact that the reproduction of some details in the Studiolo painting is not entirely accurate, this latter weapon can probably be identified as the belt kept in the Museo Nazionale del Bargello (M 1353).

A painting by Francesco Furini, *Gloria di casa Salviati* (ca. 1628), still in the possession of the Florentine family, shows next to the young Cosimo (seen in the act of receiving the

273

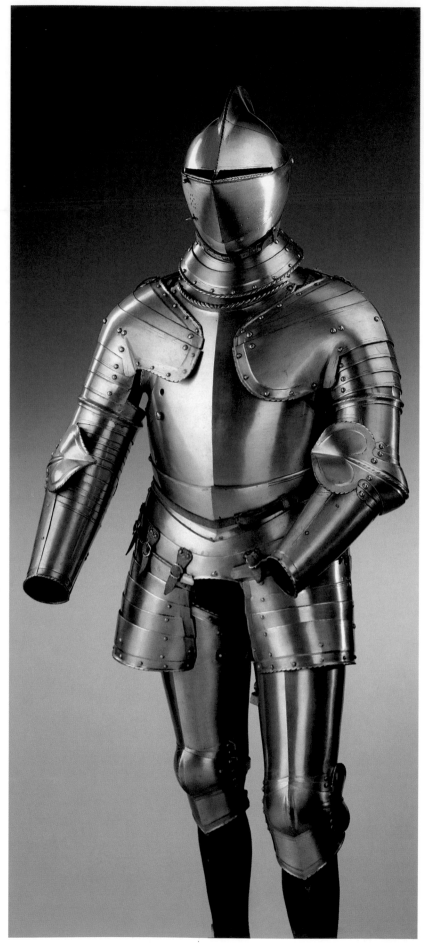

regent's scepter while an angel crowns him Grand Duke), a cuirass similar to this one. Its arm pieces, however, do not have lames inside the elbow joints, although the armor is completed by a helmet apparently identical to the one from Vienna, decorated with white feathers.

In choosing this armor to be sent to the Archduke, Ferdinando I evidently wished to emphasize his father's strong opposition to the French, attested to by other Florentine armors, including the one that served as a model for Furini's painting.

1. See Scalini 1988–90, especially p. 16; Gamber and Beaufort 1990, p. 125; Scalini 1992; Beaufort in *Die Pracht der Medici* 1999; *Ergaenzungen aus Muenchner und Wiener Museen und Sammlungen sowie Privatsammlungen*, ed. Wilfried Seipel, p. 83; Salvatici 1999, p. 44, n. 29.

M. S.

134

MASTER MARIANO, "THE ARMORER"
active ca. 1600–1610

(a) Boy's suit of half-armor for Cosimo II[1]
ca. 1605

The Detroit Institute of Arts, Gift of the William Randolf Hearst Foundation

(b) Gloves for boy's suit of half-armor for Cosimo II
ca. 1605

Lent by the Board of Trustees of the Royal Armouries

(c) Shield for boy's suit of half-armor for Cosimo II
ca. 1605

Florence, Museo Nazionale del Bargello

Steel embossed and engraved, purple-tinted with gold finishes

The corselet appears in the Medici state iconography, worn by Don Lorenzo de' Medici (inv. Poggio Imperiale n. 791r). There it is completed by two

tassels and pauldrons, different from what we see in the Detroit example. The portrait does not show the gauntlets, which, in order to match the rest of the corselet, should have shelled and polished rectilinear listels instead of the undulating ones that appear in the gloves in the Leeds Collection. Iconographic and documentary sources link the corselet to Cosimo II, but the composition of the present pieces (with the exception of the round shield, which never left Florence, and which matches the Detroit pieces, but which might not be part of the original ensemble) was already present in the castle of Erbach, Germany (where it is listed in an inventory of 1808), as has been pointed out by Boccia (1983). Comparison with other Florentine works featuring similar decoration reveals, however, that the Leeds gauntlets belong to a different set of armor and at a recent auction (Christie's 20 October 1996, lot. 121) a pair of gauntlets appeared that fit better with the Detroit corselet, which features only rectilinear fluting, corresponding with the central ribs of the glove and which mark its border, in perfect analogy with the rest of the gauntlet and the back plate in the Museo Nazionale del Bargello (M 1300, M 1330), undoubtedly related, and probably a possession of Don Lorenzo de' Medici (1599–1648).

A left gauntlet for a cuirass is now at the Museo Stibbert in Florence (inv. 2561), previously cataloged as a French object (ca. 1600–10). Donald J. La Rocca and J. P. Puype drew my attention to some remains of an interesting corselet (Legermuseum, Delft, Reg. 058424), mixed up with parts for use in the field. This was almost certainly manufactured by the same armorer that produced the present pieces, although it was a less sophisticated commission within the Medici court.

The corselet could be identified as one described in the inventory of the armory compiled in 1631 as follows:

133

1. In addition to references cited
within the text, see L. G. Boccia in
Palazzo Vecchio 1980, p. 403; Boccia
1983; Scalini 1987, passim, especially
pp. 80–91; Scalini 1990, passim.
2. "Una Armadura da Barriera del
Colore della Viola mamola scanellata
a strisce di lustro bianco e lavorata
di Gar.e [guarniture] o strisce doro a
fogliami cioe petto stiena bracciali
goletta elmo e buffa e guanti o
manopole con uno scudo simile la
quale fu fatta per la Gloriosa
memoria del Ser.o Cosimo
Secondo." Archivio di Stato di
Firenze, Guardaroba Medicea, n. 513,
c.11 verso.

M. S.

135

ELISEUS LIBAERTS
documented 1557–69
after a design by
ETIENNE DELAUNE
documented 1551–83

Helmet (burgonet) with buffe[1]
ca. 1550
Steel embossed and engraved,
blue-tinted, ornamented with
silver and gold
35.5 cm

New York, The Metropolitan
Museum of Art, Rogers Fund,
1904, and Joseph Pulitzer Fund,
1922.

CHICAGO AND DETROIT ONLY

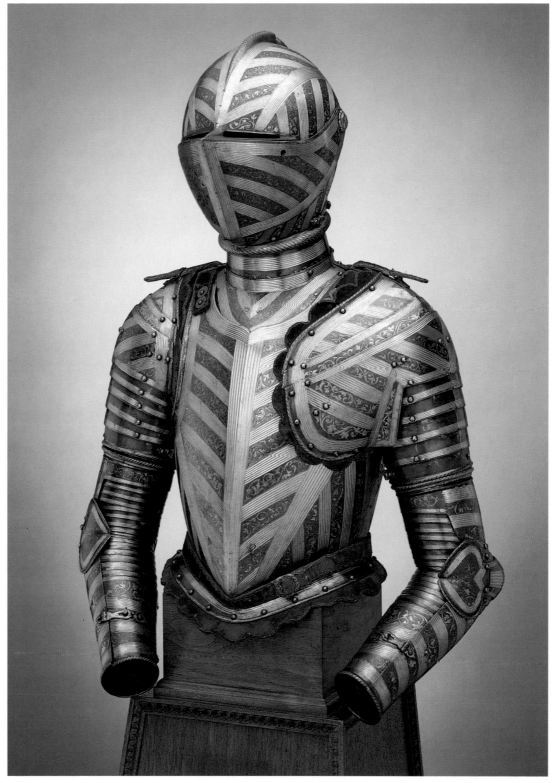

134a

The "Medici burgonet" has been
known to scholars for a long
time and features the battle
between the centaurs and the
Lapiths. Its place within the
great body of garniture executed
in the royal atéliers of France for
Henry II of Valois has never
been questioned, and was
confirmed by Boccia in *Palazzo*
Vecchio 1980, p. 402). Examples of
this type of headpiece are
recorded in Medici documents.
This one was certainly in
Florence when Ferdinando I
became Grand Duke, as it
appears in his
portrait by Scipione Pulzone,
one of a series of court
paintings conceived for the
Galleria degli Uffizi.

The helmet evidently
had a fundamental political
significance, as it appears again
in the official portraits of
Cosimo II de' Medici on his
succession. Undoubtedly it was
selected for its allusion to the
dynastic claims of the Medici
to the French crown through
the marriage of Christine of
Lorraine to Ferdinando I, as
has been noted by the present
author (M. Scalini in *Die Pracht
der Medici* 1998). The suggestion
by Boccia that this was an
"antiquarian" gift or a "sign of

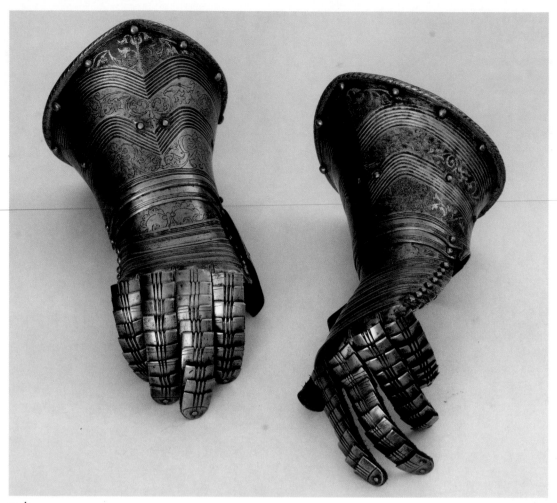

134b

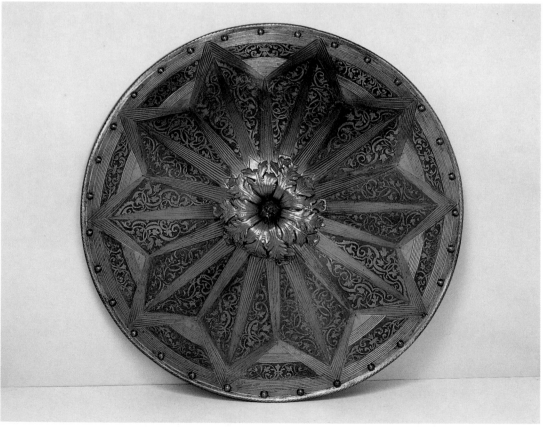

134c

respect"[2] from an unidentified member of the French household, who presumably would have been unaware of the highly symbolic value of the object, is improbable and goes against the mentality of the time. The helmet is one of the most sophisticated works produced by the so-called "atélier de la Couronne" (royal workshop), which created armor comparable with the most exquisite contemporary goldsmith works.

The French origin of the object and its iconography indicate that it reached Florence at the time of the marriage of Ferdinando to Christine of Lorraine and not before.

As the present author has noted, there are a number of pieces alluding to dynastic and political relationships among the Florentine armor once displayed in the armory in the Uffizi, and the precise political significance of these objects can be linked to spectacular chivalric events during which music and songs composed for the occasion underlined the visual message deployed by the arms and the costumes.

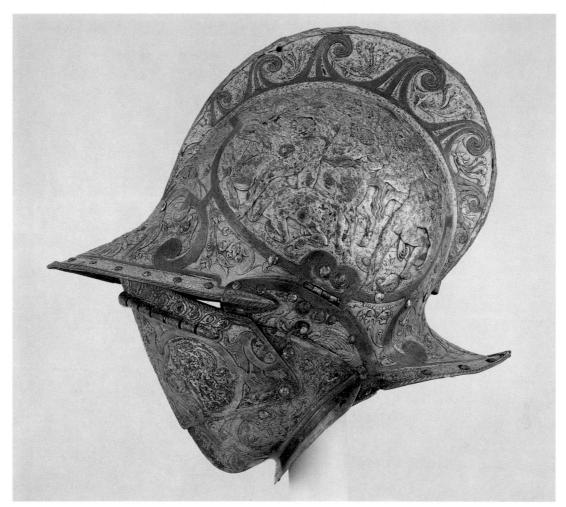

135

1. In addition to references cited within the text, see L. G. Boccia in *Palazzo Vecchio* 1980, p. 402; Scalini 1997; and Scalini 1998–99.
2. "antiquario"; "attestato di stima."

M. S.

136

ALESSANDRO ALLORI
and workshop
(drawing and cartoon)
Florence, 1535–1607

GUASPARRI PAPINI
(textile)
active Florence, 1588–1621

Portiera with the Medici–Lorraine arms[1]
1597–1602
tapestry in wool, 5 warps per cm
270 × 192 cm

Florence, Palazzo Pitti, Depositi Arazzi

FLORENCE ONLY

This *portiera*, or door hanging represents the coats of arms of Ferdinando I de' Medici and his wife, Christine of Lorraine, with the grand-ducal crown. These are set within an architectural frame decorated internally with two small heads and two masks in *camaïeu* (monochrome), while on the external pediment a small head in the grotesque style appears surrounded by four volutes, two of which are surmounted by *pots au feu*. Below these coats of arms a drape hangs from two herms. With the exception of the use of *camaïeu*, the figurative and ornamental motifs are typical of Allori's repertoire in door hangings between 1589 and 1597 (Meoni 1998, pp. 362–63, n. 135 and 136; pp. 366–67, n. 138).

The borders with their great scrolls and volutes, although featuring branches and natural elements within their structure, repeat the same motifs that appear between *putti* and festoons in other slightly earlier door hangings showing the Medici–Lorraine arms, dated between 1593 and 1597 (Meoni 1998, pp. 366–69, n. 138–40). The decoration here is primarily architectural, however, the scrolls and volutes being similar to the ornamentation of four types of frieze that appear in above-door hangings of New Testament scenes executed between 1598 and 1600 from cartoons by Allori (Meoni 1998, pp. 412–29, nn. 172–82).

Some fifteen door hangings featuring the Medici–Lorraine arms were made between 1597 and 1602 and these may have included an example showing the same design as the present tapestry but on a red background (Meoni 1998, p. 373 n. 143), as well as the present tapestry itself, which is on a blue background. The borders of these two pieces are identical to a *portiera* showing the Medici coat of arms between allegories

of Florence and Siena that appeared on the market in 1995, with a provenance from the Cyril Humphris Collection. This tapestry is clearly recognizable as one of eight delivered to the Medici Guardaroba between 1597 and 1604 in which the central iconography derives from a slightly earlier tapestry. One version survives of the earlier work (Rome, Palazzo Madama), which came to be almost a manifesto for the politics of Ferdinando I (Meoni 1998, p. 361 n. 134).

Adelson (in *Palazzo Vecchio* 1980, p. 114, n. 208) has suggested that this door hanging was made by an anonymous tapestry-weaver and cartoonist some time between the wedding of Ferdinando I and Christine of Lorraine in 1589 and the Grand Duke's death in 1609. This dating is correct, but the door hanging was undoubtedly woven by Papini and the execution of the cartoons was entrusted to

277

136

Alessandro Allori and his workshop, which worked exclusively for the Medici.

1. In addition to references cited within the text, see Meoni 1998, p. 372, n. 142.

L. M.

137

ALESSANDRO ALLORI
(drawing)
Florence, 1535–1607

MICHELANGELO CINGANELLI
(drawing and cartoon)
Settignano, ca. 1558–Florence, 1635

GUASPARRI PAPINI
(textile)
active Florence, 1588–1621

Portiera with the arms of the Medici and Austria[1]
1614
tapestry in wool, silk, silver, and gilded silver, 6–7 warps per cm
263 × 204 cm

Florence, Palazzo Pitti, Depositi Arazzi

FLORENCE ONLY

This *portiera,* or door hanging, identified by Frezza (in *Palazzo Vecchio* 1980, pp. 101, 103 n. 180), is a version of an identical tapestry (Florence, Palazzo Pitti) exhibited in 1882 in the former Regia Galleria degli Arazzi in Florence by Cosimo Rigoni, who linked the double coat of arms of the Medici and Austria to Francesco I and his wife, Giovanna of Austria (Rigoni 1884, n. 1). This identification was accepted by Göbel, who dated the work to between 1574 and 1578 (Göbel 1923–34, vol. 2.1, p. 383). Frezza, however, has noted that the style of the border suggests a later date, and has associated the coat of arms with Cosimo II and Maria Maddalena of Austria, who reigned between 1609 and 1621. Payments were made to Michelangelo Cinganelli for the execution of the cartoons from 1614 and Frezza has attributed the design of the border to him

suggested that a design or cartoon by Alessandro Allori was used for the central scene, based on similarities between the two allegories of Abundance and the figure of Vigilance in a Uffizi drawing attributed to the artist, the *Distribution of Grain* (Florence, Gabinetto Disegni e Stampe degli Uffizi, n. 739 F), made for a tapestry executed in 1597, now lost.

Although the idea that the design for the two allegories is inspired by a single model by Allori appears convincing, the compositional structure of the central part of the tapestry and some of its decorative elements – for example, the perfect symmetry of the shield featuring two *putti* and Abundance above a pedestal ornamented by grotesque motifs – are instead reminiscent of the style of Cinganelli as seen in his three above-door hangings representing the Stories of Phaeton (1617–18). The border is similar to the same series, featuring squares with decorative grotesque motifs (Meoni 1998, pp. 342–59, n. 125–33).

Although there are no known documents referring to the present door hanging and its companion, both woven with gold and silver, they could be identified as two examples delivered by Papini on 13 October 1614 and executed in the same precious materials but featuring only the Medici arms (Frezza in *Palazzo Vecchio* 1980, p. 103, n. 180). These were probably later modified to accommodate the Austrian arms, since in 1637–38 one of the two examples is described in detail among the decorations of the Sala della Carità in the Palazzo Pitti as representing two allegories of Abundance flanking the Medici–Austrian arms (Meoni 1998, p. 388, n. 153).

1. In addition to references cited within the text, see L. Meoni 1998, pp. 388–90, n. 154.

L. M.

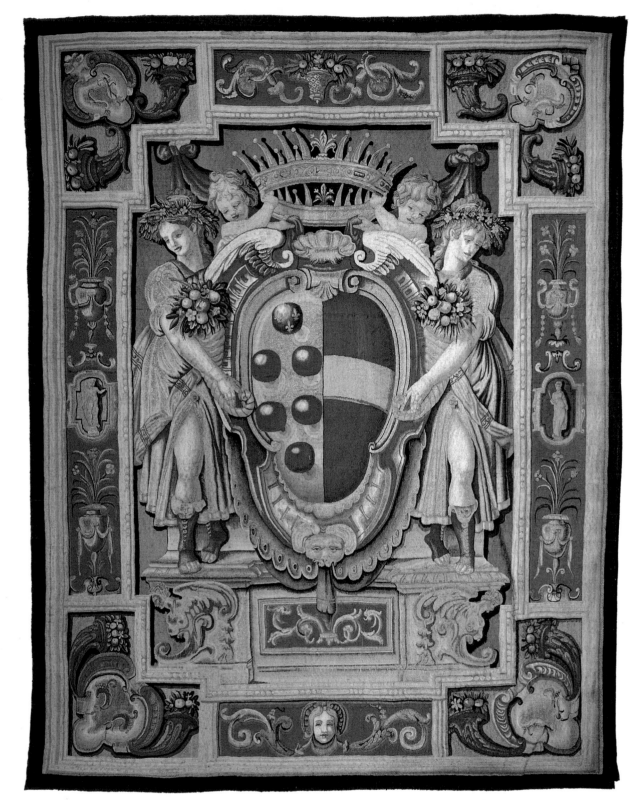

137

AGNOLO BRONZINO
(drawing and cartoon)
Florence, 1503–1572

JAN ROST
(textile)
active Brussels, 1536–Florence,
1564

Portiera of *Abundance*[1]
1545
tapestry in wool, silk, gold, and
gilded silver, 8–10 warps per cm
242 × 146 cm

Florence, Palazzo Pitti, Depositi
Arazzi

This *portiera*, or door hanging,
has received enormous critical
attention because of its
importance in the chronology of
the Medicean workshops, having
been recognized as the first
tapestry woven in Florence. Jan
Rost, arrived in Florence in
August 1545 and began work on
it probably slightly after 16
September, the date when
Bronzino appears to have
completed the cartoon (Adelson
1990, pp. 88–112, 348–49, n. 1).

Smyth (1971, pp. 25–26, 67,
n. 131, 87–91, 98–100, fig. 21),
analyzing known documents,
has demonstrated that the door
hanging is the test sample sent
by Rost on 8 December 1545
to Pisa, where Cosimo I was
staying. Smyth has also accepted
Heikamp's (1968, pp. 23, 25, 30,
fig. 4) attribution of the cartoon
to Bronzino rather than Salviati,
who had previously been
considered the designer, and
recognized in this door hanging
a perspective construction of a
space similar to that in *Joseph in
Prison and the Pharaoh's Banquet*
also by Bronzino and considered
to be the first tapestry executed
for the *Joseph* series.

The subject, not mentioned at
all in documents of 1545 and
known as *Springtime* in later
documents, is identified as
Abundance ("abundance with
landscape")[2] only from an
inventory of 1553. The theme of
abundance and fertility seems to
be linked to Cosimo, whose
emblem, a tortoise, appears here,
and to the new Augustan golden

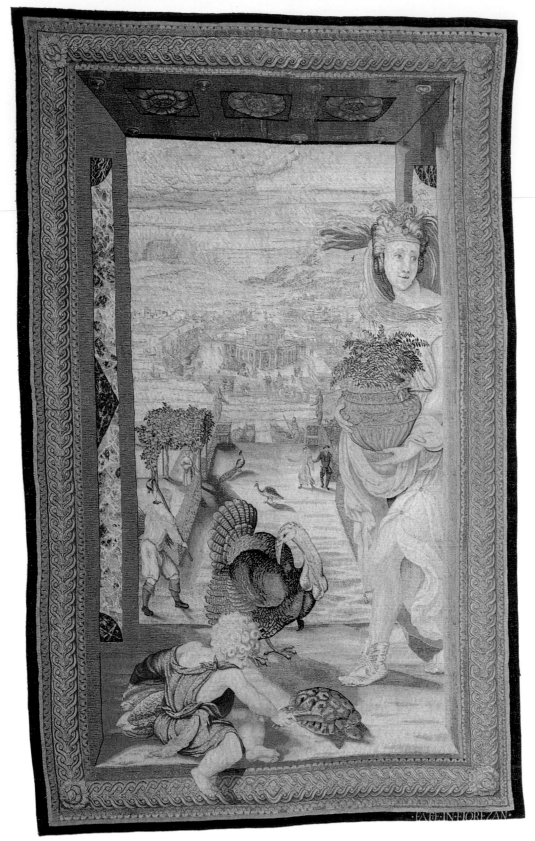

138

age inaugurated by him, as well as perhaps referring to the foundation of the Medicean tapestry workshops.

Stylistic differences between *Abundance* and other contemporary works by Bronzino may derive from initial difficulties in the medium of textiles, which was new to him, or perhaps from an awareness that Cosimo intended to have this door hanging evaluated in Flanders and that it would be compared to the work of the Flemish workshops, by which the budding Medicean tapestry manufactory was inspired (Adelson 1990, pp. 96–99). This may explain why the painter here used non-Florentine models that rarely appear again in his later work, with the foregrounds dominated by compact masses of the bodies. The perspective view of the garden and the borders similar to the carved and gilded frames reflect Brussels tapestries such as the *Conquest of Tunisi* series from cartoons by Jan Cornelisz Vermeyen and the *Vertumnus and Pomona* series from models by Vermeyen and Pieter Coeck van Aelst (Meoni 1998, p. 161).

1. In addition to references cited within the text, see Meoni 1998, pp. 158–61, n. 19, with previous bibliography.
2. "dovitia à paesi." Adelson 1990, pp. 349, 664, doc.259.

L. M.

139

Agnolo Bronzino
(drawing and cartoon)
Florence, 1503–1572

Nicholas Karcher
(textile)
active Brussels, 1517–Mantua, 1562

Benjamin Received by Joseph[1]
1549–1553
tapestry in wool, silk, gold, and gilded silver, 7–9 warps per cm
570 × 297 cm

Florence, Palazzo Vecchio

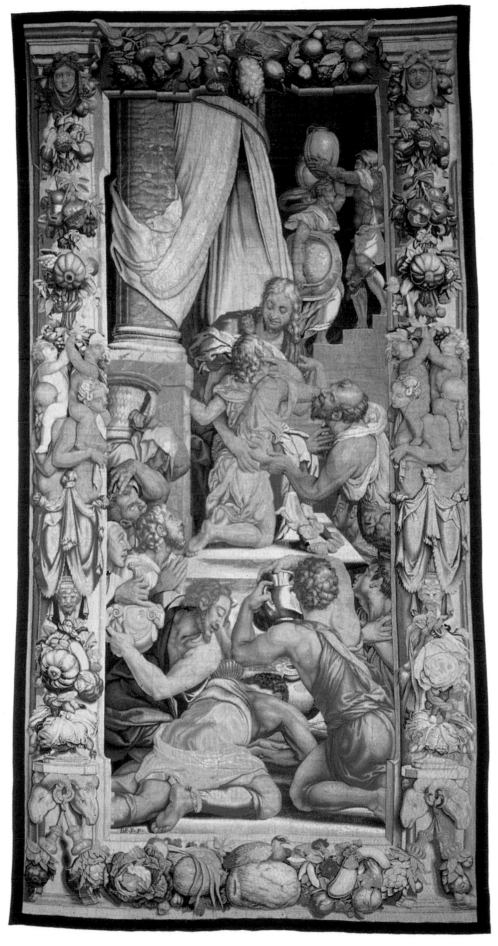

139

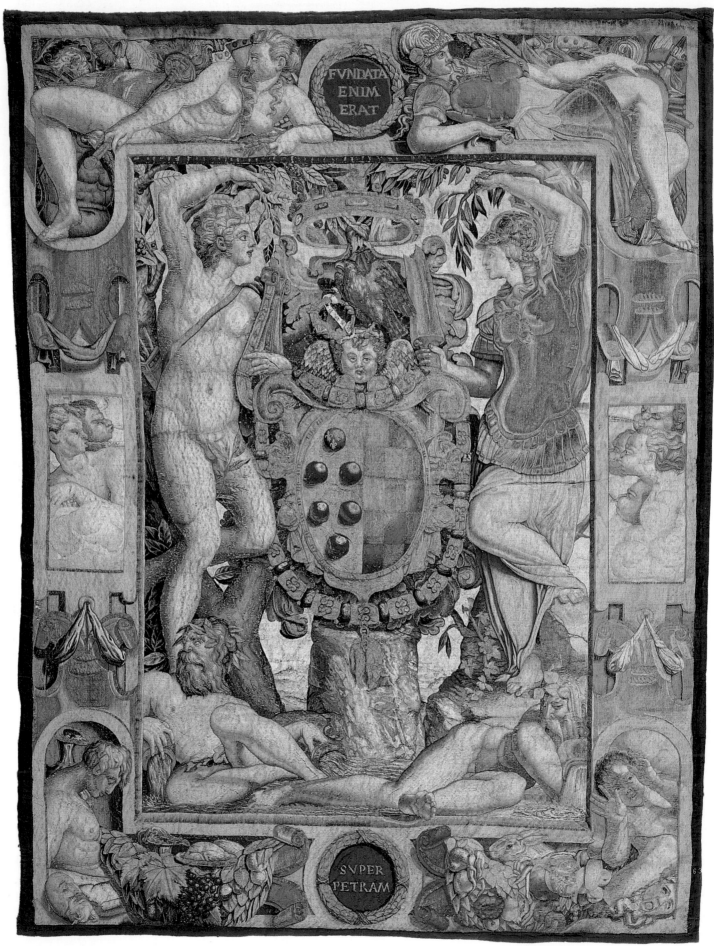

This tapestry belongs to a series of twenty works representing the *Story of Joseph*, considered to be among the masterpieces of Italian tapestry and the object of numerous scholarly studies. The biblical theme of Joseph, betrayed by his brothers and by his benefactor (Genesis 37–50) is a transparent metaphor for the Medici, chased out of Florence and subsequently returning in triumph.

Designed for the Salone dei Dugento in the Palazzo Vecchio, this was one of the first two series produced in the new Florentine tapestry workshops by the Flemish masters Jan Rost and Nicolas Karcher. Three of the cartoons were painted by Jacopo Pontormo, one by Francesco Salviati (see fig. 45 above), and the remaining sixteen by Bronzino, who was assisted by Raffaellino dal Colle on the central scenes from 1548, and by Lorenzo Zucchetti and Alessandro Allori on the borders from at least 1549.

The painters were already working on the cartoons by 26 October 1545, but the entire series was not completed before 21 August 1553, when the last three tapestries were delivered by Rost. In a list of the pieces woven by the two Flemish masters, compiled only one month later, on 27 September, the tapestries are numbered from one to twenty, providing a key to identify the order in which they were displayed in the Salone dei Dugento (Adelson 1990, pp. 149–204, 378–80, n. 20).

An erroneous theory previously suggested that only half of the tapestries were destined to be displayed at one time, which created an artificial division of the series (Conti 1875, p. 12; Geisenheimer 1909, pp. 137–47). Around 1865, when Florence was capital of Italy, ten pieces were given to the Palazzo Pitti as a crown endowment, and from 14 July 1882 they were transferred to the Palazzo del Quirinale in Rome, where they are today.

The present tapestry, the eleventh in the series, opened the narrative sequence on the western wall, starting from the left. Through reports of 1549–50 and September 1553 by the tapestry-weaver for the Medicean Guardaroba we can date the work, which was probably already being produced when the first list was compiled, as it is stylistically comparable to *Joseph Holds Simon Prisoner* (now in Rome) delivered by Karcher on 15 September 1547.

A large drawing in reverse of the scene is in the Galleria degli Uffizi (GDSU 10311 F). It is still debated whether this is by Bronzino. Geisenheimer (1909, p. 147, n. 2) believes it to be a copy by Alessandro Allori, while Smyth (1971, pp. 32–35, 72–73, n. 158–72) attributes it to Bronzino, considering it to be a model for the cartoon, completed – according to Janet Cox-Rearick (1971, p. 7, n 3) – by Raffaellino dal Colle. Smith (in Petrioli Tofani and Smith 1988, p. 76) considers it to be a model by Salviati, re-elaborated by Bronzino.

1. In addition to references cited within the text, see Meoni 1998, pp. 124–27, 135–36, n. 6, with previous bibliography.

L. M.

140

BENEDETTO PAGNI DA PESCIA
(cartoon)

FRANCESCO DI PACINO
(textile)
(?)Florence

NICHOLAS KARCHER
(textile)
active Brussels, 1517–Mantua, 1562

Allegorical *portiera* with the Medici–Toledo arms
1547–49
tapestry in silk, gold, and gilded silver with traces of wool; warp in wool, 8–10 threads per cm
253 × 190 cm

Florence, Palazzo Pitti, Depositi Arazzi

The allegory illustrated in this door hanging serves as a manifesto of the foundation of a prestigious and sound dynasty by Cosimo I de' Medici and Eleonora of Toledo, whose arms are represented in the bipartite crest in the center. Iconographic and iconological analysis of this allegory was tackled first by Viale (1952, p. 83 n. 78) and more recently by Adelson (1992), who has linked the inscription in the two borders "Fundata Enim Erat / Super Petram" to a passage from the Precepts in the Gospel of St. Matthew.

There are two versions of this door hanging, one realized by "Francesco di Pacino, weaver of cloths,"[1] the first independent tapestry weaver documented in Florence, and the present version, completed by Karcher some time before 24 October 1549 (Meoni 1998, pp. 168–71, n. 23). Adelson (1992) was responsible for finding the first door hanging and distinguishing the two versions on the basis that the present tapestry features a softer shaping of the images, comparable with Karcher's *Banquet of Joseph* for the series of the *Story of Joseph*.

Based on letters from Cristiano Pagni, one of Cosimo I's secretaries, to the Duke's major-domo, Pierfrancesco Riccio, Adelson has attributed the cartoon for the two door hangings to Benedetto Pagni da Pescia, who worked in Raphael's workshop in Rome and in that of Giulio Romano in Mantua. Stylistic comparison with the few known works by the artist – particularly the *Madonna Medici* (Sarasota, Ringling Museum of Art), or the *St. Sebastian* (Mantua, Museo Diocesano) – is convincing.

The composition seems to derive from a drawing by Francesco Salviati, now in Oxford. In Pagni's cartoon, however, even though the figures were inspired by Michelangelo, they show the clear influence of Giulio Romano's work in Mantua, particularly the "sotto in su" effect of the river gods. The figures also refer to the School of Fontainbleau in the images

of *Apollo* and *Minerva*, and to Agnolo Bronzino, to whom this cartoon was originally attributed (Adelson 1992; Meoni 1998).

1. "Francesco di Pacino tessitore di drappi." ASF, FABBRICHE MEDICEE I, ca. 17s; Adelson 1990, p. 567, doc. 125.

L. M.

141

FLORENTINE

Miter[1]
second quarter of the sixteenth century

velvet, silk, and gold thread

Pienza, Museo Diocesano d'Arte Sacra

This miter, part of a set of liturgical vestments which between 1528 and 1563 belonged to Alessandro Piccolomini, bishop of Pienza, was worn at the Council of Trent in 1545 (Mannucci 1915, pp. 34–35). The chasuble, cope, and stole from the set also survive. The cope was made from one of the most beautiful fabrics produced in Florence, woven with golden weft loops ("ricci d'oro"), replicating that of the most sumptuous damask produced in Florence (cat. no. 144). A key feature of Florentine textile production was experimentation with the weaving process to obtain plastic and linear effects that would highlight both the sumptuous composition and the complexity of the details. The quality of design and finesse of execution of the embroidery applied on the red velvet of the stole, the pluvial's hood, and the miter appears to be the work of professional masters, probably also Florentine.

1. In addition to references cited within the text, see *Drappi, Velluti* 1994, cat.22, p. 118.

R. O. L.

142

FLORENTINE

Antependium[1]
second quarter of the sixteenth century
single-pile ciselé velvet, lancé, silk, gold lamella.
86 × 222 cm

Florence, Museo Stibbert

Many Tuscan liturgical vestments were made from this type of velvet, usually produced with a red pile on a white and silver ground, rather than yellow and red with gold. Throughout the sixteenth century the cone or pomegranate, key motifs in fifteenth-century production, were still favored in fabrics used for liturgical vestments or ceremonial clothes. These motifs, set within the symmetrical structures of medium or large patterns, recur throughout the history of textile production to the present day, adapting to variations of taste and gradually losing their original religious significance.

The great success of this type of sixteenth-century velvet is probably due to the fact that it combined compositional elegance with a luxurious and splendid effect achieved through a system more economical than that of the previous century: by employing gold lamella instead of gold filé a large amount of the precious material was saved, and the brocade technique, which slowed down the production of this sort of textile, was eliminated. An innovative new velvet was also invented during this period that combined two kinds of pile, cut and uncut, expanding the possibilities for subtler gradations and nuances of color. At the same time, the practice of filling some areas with small checks or triangles was adopted as a new decorative expedient to yield a lighter design, a technique that was enormously successful for over a century.

The slight technical discrepancies between different examples of this type of velvet suggest that it was produced over many decades (it is represented in Jaques Bylivelt's *The Emperor Constantine Brings Back the Cross to Jerusalem* in the church of San Gaetano in Florence, dated 1641), and by many different looms. For the use of this motif see Boccherini and Marabelli 1993, pp. 37–40, 57–58 and 97–99.

1. In addition to references cited within the text, see *Il Museo Stibbert* 1974, vol. 2, cat.1966, p. 169.

R. O. L.

143

FLORENTINE

Dalmatic[1]
1600–20
double-pile ciselé velvet, brocade, silk
121 × 133 cm

San Gimignano, Museo d'Arte Sacra

FLORENCE ONLY

This velvet is one of the most refined clothing textiles produced in sixteenth-century Florence. From the middle of the century, silk producers, spurred by the need for constant renewal of their decorative repertoires to cater to the demands of fashion, differentiated the production of textiles for clothes from that of textiles for furnishings and liturgical vestments, which until then had been distinguished by technical qualities rather than design. Motifs, deriving from those typical in the fifteenth century, became smaller: for example, the blossoming trunk was transformed into a small branch from which sprung stylized flowers, usually pomegranates, lilies, or tulips (see Landini 1999, p. 59). In contrast to the textiles produced in other important cities, Florentine clothing silks incorporated symbolically significant animals, a theme previously more common in borders and in grotesque designs for furnishing and decorative textiles.

142 *(facing page)*

143

The present example features a peacock and dragon opposed as the forces of good and evil. The execution of the piece is particularly sophisticated: on a white satin background with piles of two contrasting colors are inserted brocade wefts in polychrome silk, a technique that was unique to this type of velvet and that must have made it one of the most expensive clothing textiles even though it included no precious metals. The dress of St. Lucy in Pompeo Caccini's *Martyrdom of St. Lucy* in the church of Santa Trinita in Florence is painted in the same colors, and with a similar motif. A color variant is found at the Galleria del Costume in Florence (Inv. Tessuti Antichi, n. 384).

1. In addition to references cited within the text, see Santangelo 1959, table 67; and *Drappi, velluti* 1994, cat. no. 61, p. 146.

R. O. L.

144

144

FLORENTINE

Cope[1]
mid-sixteenth century
classic damask silk
142 × 268 cm

Siena, Basilica di san Clemente
ai Servi

FLORENCE ONLY

This cope was made from one
of Florence's most successful
fabrics on the national and
international market.
Documented in paintings from
the 1520s and 1530s – Marcello
Fogolino's *Banquet of King*

Christian of Denmark (Bergamo,
Castle of Malpaga) and Hans
Holbein's *French Ambassadors at
the English Court* (London,
National Gallery) show different
ways the fabric was used in
furnishing – damask was also
often used in clothing from this
period until the seventeenth
century, as in, for example,
Cristofano Allori's *Giuditta with
the Head of Holofernes* (Florence,
Palazzo Pitti). The value of this
damask lay in both the design
– an unusually large and long
pattern – and the perfection of
its execution.

Damask was one of the most
frequently purchased fabrics at
the court of Cosimo I de'

Medici, where it was employed
for the clothes of the ducal
family: Don Garcia was buried
in a black damask cloak
("cappotto") in 1562; Cosimo
wears black damask
overgarments in Bronzino's
portrait in the National Gallery
of Canada, Ottawa, and similar
garments in blue in Vasari's
representation in the Palazzo
Vecchio, Florence, where he is
shown planning the conquest of
Siena. Bronzino also painted
with great accuracy a crimson
damask, similar to that of the
present cope, worn in a rich
coat dress ("zimarra") by
Eleonora or Toledo (Turin,
Pinacoteca Sabauda). In the

drawing intertwined trunks with
heart-shaped leaves enclose two
different types of pine cone; at
the point where the trunks cross
is a diamond ring – the Medici
emblem – and a crown
(Bulgarella 1996–97). On the
significance of this damask, see
Boccherini and Marabelli 1993,
pp. 48–49, 102.

1. In addition to references cited
within the text, see *Drappi, velluti*
1994, cat.31, p. 125.

R. O. L.

following pages Detail of cat. no. 215.

WORKS ON PAPER

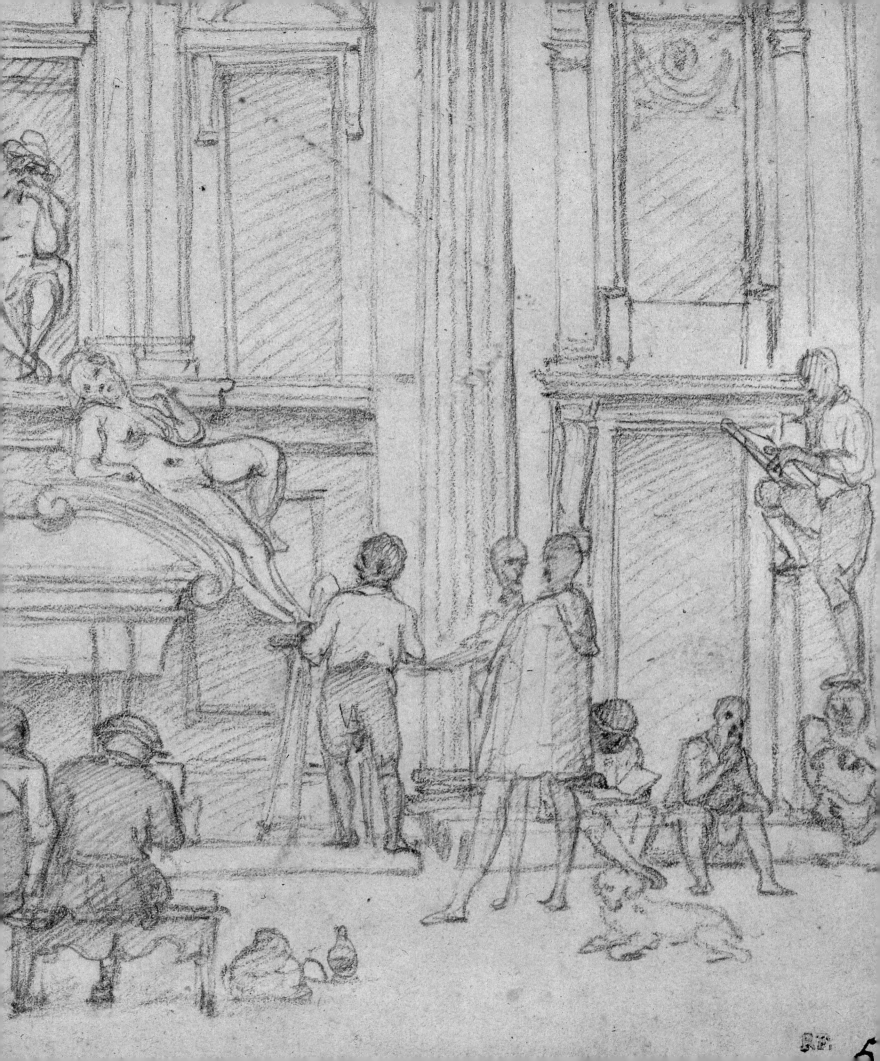

145

ALESSANDRO ALLORI
Florence, 1535–1607

Animated Skeleton[1]
ca. 1560–65
black chalk on white paper
4.23 × 2.94 cm

Florence, Gabinetto Disegni e
Stampe degli Uffizi

CHICAGO ONLY

Previously cataloged as a work
by Jacopo Pontormo, this and
three other studies from the
same collection with similar
subjects and techniques (6700
F, 6709 F, and 6710 F) were
reattributed to Alessandro Allori
by Forlani Tempesti for the 1963
Uffizi exhibition, *I fondatori
dell'Accademia delle Arti del
Disegno*. Allori is associated with
a number of drawings divided
between Florence, Paris, and
Edinburgh that show life studies
of skeletons and *écorchés* and
details of muscles and bones,
revealing the interest in anatomy
developed by the young painter
in the workshop of his master,
Agnolo Bronzino, and in the
atelier of Baccio Bandinelli,
which he also frequented.

Allori himself, in his treatise
*The Rules of Design (Delle Regole
del Disegno)*, first compiled
around 1560, mentioned that
he had carried out anatomical
research by dissecting corpses
at the Ospedale di Santa Maria
Nuova under the supervision of
Alessandro Menchi, the first
physician of the Accademia del
Disegno. Undoubtedly another
source of inspiration were the
anatomical plates included in
Andrea Vesalio's treatise *De
Humani Corporis Fabrica*,
published in Basle in 1543.
However, as Lecchini
Giovannoni (1991, pp. 223, 311)
has pointed out, Allori was
probably equally struck by the
illustrations for Jan di Valverde's
*Historia de la Composición del
cuerpo humano*, published in
Italian in 1559 and mentioned
by the painter in his own
anatomical treatise. Lecchini
Giovannoni has also noted in
Allori's painting of *Christ between*

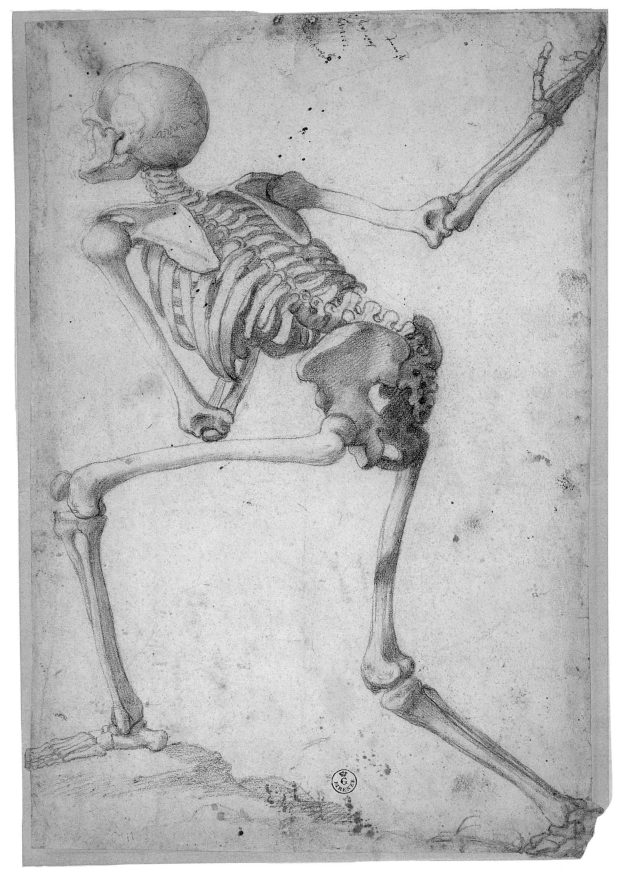

145

facing page Detail of cat. no. 186.

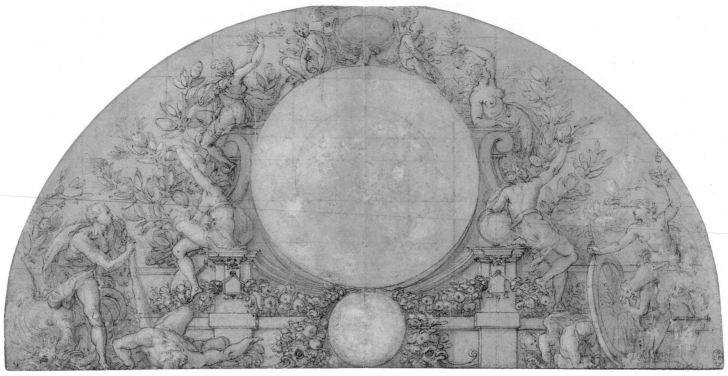

146

Saints Cosmas and Damian (1559;
Brussels, Musées Royaux des
Beaux Arts) references to the
study of anatomy in the open
book exhibited by one of the
saints which shows a skeleton
and an écorché.

The four Uffizi drawings,
which can be linked with a
drawing in the Louvre (inv.
no. 13) as part of a homogeneous
group featuring skeletons in
casual poses stepping up or
down, were not executed as
preparatory works but as
research on the theme of
balance in the standing position
and in motion. The skeleton
seen from the back in the
present drawing is similar in
pose to that of drawing 6700 F
in the Uffizi, seen climbing
upwards, pushing on the left
foot. The dense and measured
chalk hatching defining the figure
attests to Allori's full mastery of
the technique, the result of
assiduous study from life.

1. In addition to references cited
within the text, see A. M. Petrioli
Tofani in Il potere e lo spazio 1980,
p. 388, n. 8.4; S. Lecchini Giovannoni
in Immagini anatomiche 1984, p. 84,
n. 25, fig. 32; and Viatte 1988, p. 28.

M. C. F.

146

ALESSANDRO ALLORI
Florence, 1535–1607

Design for a lunette with
Hercules and Fortune in the Garden
of the Hesperides[1]
ca. 1578
pen and ink, brown wash with
white chalk highlights on white
paper squared with black chalk
18.4 × 36.4 cm

Lent by Her Majesty Queen
Elizabeth II

DETROIT ONLY

The putti and the head of a
bearded man, visible respectively
in the central space and the
small tondo below, were executed
in pen on cut paper and glued
to Allori's drawing in the
seventeenth century. These
elements aside, the drawing
shows a compositional study for
the lunette frescoes made by
Allori in 1578 in the Villa del
Poggio a Caiano as part of a
vast commission from Francesco
I de' Medici that included the
completion of the paintings in
the Sala di Leone X, already
largely decorated by Andrea del
Sarto, Francesco Franciabigio,
and Jacopo Pontormo.

Although the squaring
indicates that the design is
shown at an advanced stage, and
although the Hesperides and the
putti are already definitively
placed in relation to the
circular window, the drawing
nevertheless reveals some
differences from the final fresco.
These are, I believe, not the
result of any decision on the
part of the artist, but are rather
due to small modifications made
to the iconography at a later
stage by the author of the
program, Vincenzo Borghini.
The scene created by Borghini,
complementing Pontormo's
lunette of Vertumnus and Pomona,
takes up the theme of the return
of the Medici family to the
government of Florence under
Cosimo I, who by this stage was
dead. He is shown in Allori's
fresco in the heroic guise of
Hercules, champion of virtue
(see Schwarzenberg and Paolozzi
Strozzi 1992), who after defeating
the serpent takes on the task of
defending the golden apples in
the luxuriant garden of the
Hesperides, an allusion to the
grand-ducal gardens where citrus
fruit was grown. In his role as
defender Cosimo–Hercules is
assisted by Fortune, represented
on the right of the composition,

who – as indicated in the Latin
motto VIRTUTEM FORTUNA
SEQUETUR – protects the virtuous
and subjugates under her wheel
Envy and Debt, previously
identified as Vice (Cox-Rearick
1984, p. 145, n. 8) and Fury
(Schwarzenberg and Paolozzi
Strozzi).

In the transition from the
exhibited drawing to the final
version, Allori, undoubtedly at
Borghini's recommendation,
eliminated the male nude
reclining on the ground at the
feet of Hercules in the Windsor
drawing. This figure, variously
interpreted as Vice by Cox-
Rearick and more generically
as an enemy by Lecchini
Giovannoni, may in fact represent
the lifeless body of Antaeus, the
personification of pure instinct
and irrationality, whose myth –
often used in the iconography of
Cosimo – is linked to that of the
Hesperides, as Hercules killed the
giant on his return from winning
the golden apples.

1. In addition to references cited
within the text, see Popham and
Wilde 1949, pp. 185–86, n. 58; and
Lecchini Giovannoni 1991, p. 249,
fig. 150.

M. C. F.

147

ALESSANDRO ALLORI
Florence, 1535–1607

Study for the Virgin in the Santa
Croce *Deposition*[1]
ca. 1568–71
black chalk with white
heightening on paper tinted gray
39.6 × 25.6 cm

Paris, Musée du Louvre,
Département des Arts
Graphiques

DETROIT ONLY

This compelling study of the
Virgin served Allori in the
execution of one of his major
commissions – the *Deposition*
altarpiece for the Compagnia
del Gesù, installed in 1571 in
the church of Santa Croce in
Florence (see Pilliod 1992 and
Pilliod 2001, pp. 114–19 and
146–48). Closely related,
particularly in the pose of
Christ, to the fresco *Trinity*
(1571, Santissima Annunziata)
that Allori completed for
Bronzino, the *Deposition* also
displays the influence of
Michelangelo: echoes of the
Slaves for the tomb of Julius II
and of the *Last Judgment* can be
seen in the muscular figures
struggling to lower Christ from
the cross. Viatte (1988, p. 23) has
suggested that the slumped
attitude of Allori's Virgin reflects
that of a sleeping apostle in
Michelangelo's (lost) composition
depicting the *Agony in the
Garden*, realized in paint by
Marcello Venusti around 1550–63
(Rome, Galleria Doria-
Pamphili). Certainly, a debt to
Michelangelo can be seen in the
expansiveness and gravity of
Allori's figure, intended in its
pose to recall poignantly an
earlier time when the Virgin
embraced the infant Christ on
her lap.

Several other preliminary
drawings for the Santa Croce
Deposition survive, including a
beautiful, black-chalk study for
the dead Christ (Uffizi 10263F)
and a dynamic sketch for the
entire composition (Uffizi,
10318F; see Lecchini Giovannoni
1970, nos. 7 and 8, pp. 22–23,
figs. 7 and 8).

1. In addition to references cited
within the text, see Lecchini
Giovannoni 1991, p. 219, under no.
12, fig. 18.

L. J. F.

148

ALESSANDRO ALLORI
Florence, 1535–1607

Study for the *Banquet of
Cleopatra*
ca. 1570–71
pen and brown ink with ink
washes, black chalk, white
heightening on cream-colored
paper, and a 4 cm strip of paper
added at top to complete the
oval
30.6 × 44.4 cm

London, The Courtauld Institute
Gallery, Witt Collection

FLORENCE ONLY

This highly finished drawing was
among the final studies – and
perhaps the *modello* – for the
Banquet of Cleopatra, one of two
paintings (the other being the
Gathering of Pearls) that Allori
contributed to the decoration
of Francesco I's Studiolo in the
Palazzo Vecchio (see pp. 47–65
above). Allori's darkly evocative
and exquisite painting represents
an episode from the life of
Cleopatra recounted in Pliny's
first-century AD *Natural History*
(IX, 57). According to the
ancient author, Marc Antony
made a wager with Cleopatra
that she could not spend ten
million sesterces on a single
feast. Cleopatra won the bet at a
grand banquet, where she
dissolved a very large pearl in
vinegar and drank the solution.
In the painting, Cleopatra has
dropped one pearl in her glass
and is reaching for another, as
Marc Antony quickly extends his
arm to restrain her.

Allori's oval painting would
have been installed in the
Studiolo concealing a cupboard
containing Francesco's holding of
pearls and objects crafted from
them and just beneath his
painting of the *Gathering of
Pearls*, a subject also derived
from Pliny (IX, 108). The
Courtauld study differs from the

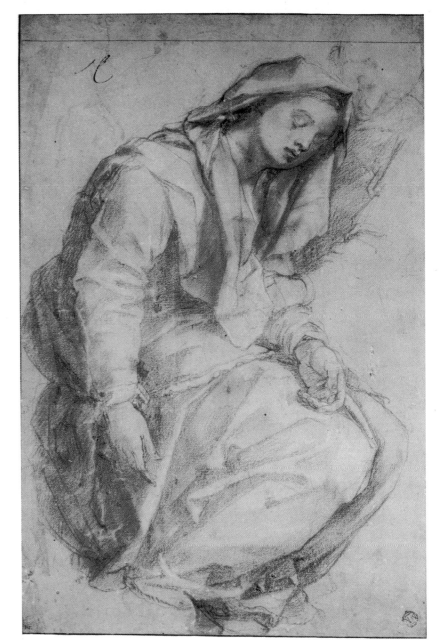

147

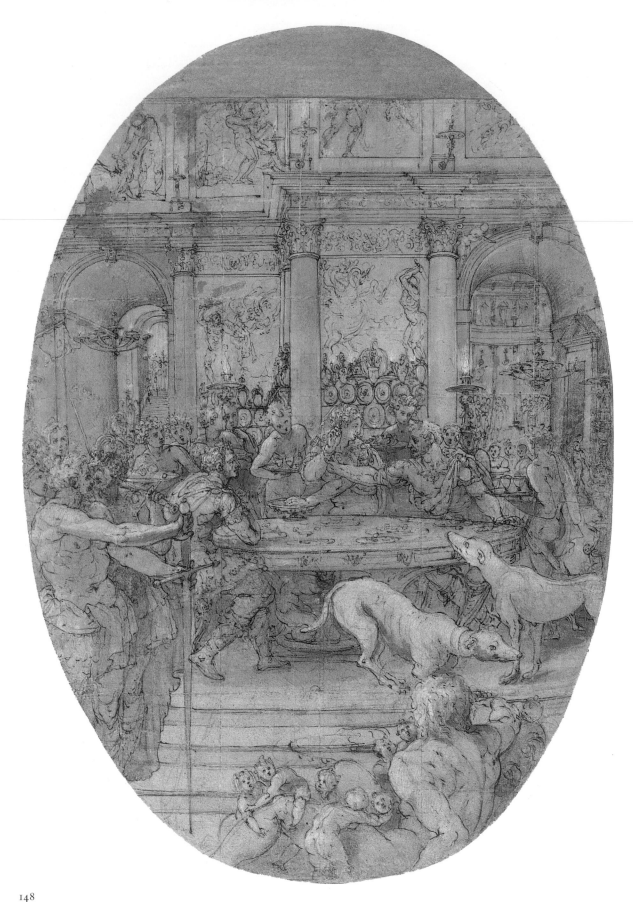

final composition in the gesture of the figure in the far left foreground and in the rendering of the back walls of the palatial setting. Whereas the painting presents statues of Venus and Juno in niches – corresponding to actual statues of those deities in a nearby corner of the Studiolo – in the drawing, the back walls of the banquet room are adorned with tapestries depicting the Labors of Hercules. Had this preliminary idea been realized, Allori's painting would have been more closely connected iconographically to Santi di Tito's adjacent Studiolo picture of *Hercules and the Discovery of Tyrian Purple*.

Another preparatory drawing for the *Banquet of Cleopatra*, for one of the hounds, is preserved in the Uffizi (see Schaefer 1982, p. 127).

1. In addition to references cited within the text, see Schaefer 1976, vol. 1, p. 81; and Lecchini Giovannoni 1991, pp. 227–28, under no. 28, fig. 58.

L. J. F.

149

ALESSANDRO ALLORI
Florence, 1535–1607

Study for the *Display of the Remains of St. Antonino*[1]
ca. 1588
black chalk, pen and grey–brownish washes on brown colored paper, squared with black chalk
61.4 × 37.6 cm

Florence, Gabinetto Disegni e Stampe degli Uffizi

CHICAGO ONLY

This drawing, published in 1970 and in 1991 by Lecchini Giovannoni (1970, pp. 41–42, n. 46; 1991, p. 271, fig. 262), is a preparatory study for one of four frescoes painted by Alessandro Allori on the larger sections of the dome in the Salviati Chapel in the church of San Marco in Florence. Acquired

148

by the brothers Averardo and
Antonio Salviati in 1578 to
give honorific burial to the
uncorrupted remains of St.
Antonino Pierozzi, the chapel
was restructured architecturally
by Giambologna, who also
executed the marble statues and
the bronze reliefs on the walls.
Allori's frescoes for the dome,
one of which is signed and
dated 1588, dedicated to the
popular Florentine saint,
alternated with eight virtues
in the pendentives and in the
smaller vaults of the dome, and
with the figures of prophets and
sybils between the windows. In
the spaces under the arches
Allori illustrated six episodes
from the life of St. Antonino in
small monochrome scenes set
against a gold background. The
four larger segments of the
dome showed two episodes
relating to the death of the
saint, which took place on the
day of the Ascension of Christ,
and the two apparitions after his
death. The drawing presented
here refers to the scene frescoed
in the segment facing the altar
of the chapel, displaying the
*Display of the Remains of St.
Antonino* to a worshipful
congregation.

As Lecchini Giovannoni has
already pointed out, this Uffizi
study, squared for reproduction
on a larger scale, presents some
variations from the final painted
version, in the number and
poses of the spectators in the
foreground beside the fresco's
explicative Latin inscription.
Nevertheless, the drawing, which
was produced at a late stage in
the development of the work,
reveals that the artist had already
overcome the difficulties caused
by the elongated and trapezoidal
shape of the space destined for
the painting by inserting a large
baldacchino, seen from below,
in the narrow top part of the
composition. Furthermore, the
delicate but precise drawing
indicates the painter's concern
to make the episode clearly
legible, according to the
recommendations of the Council
of Trent on the subject of sacred
images. In this respect the
Salviati Chapel can be

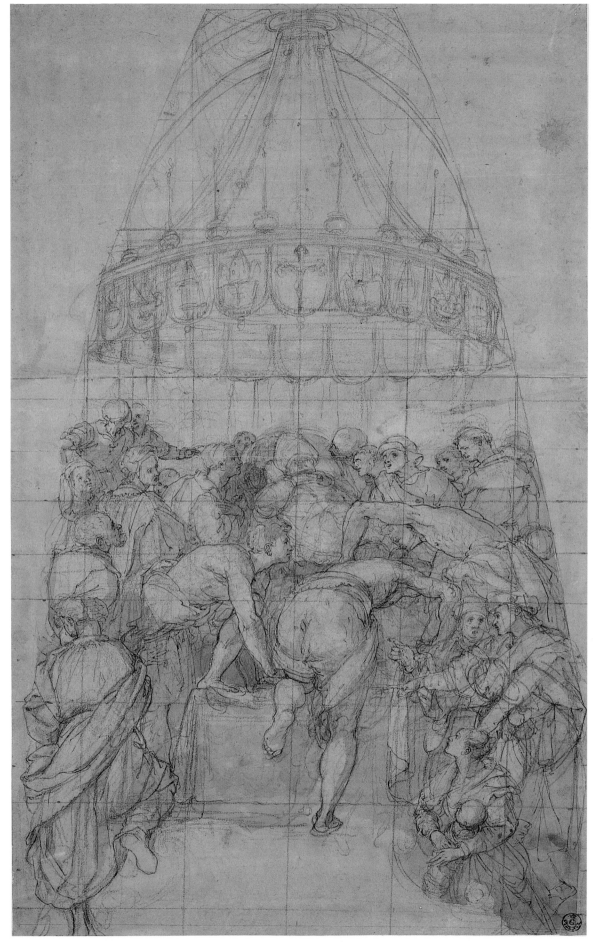

149

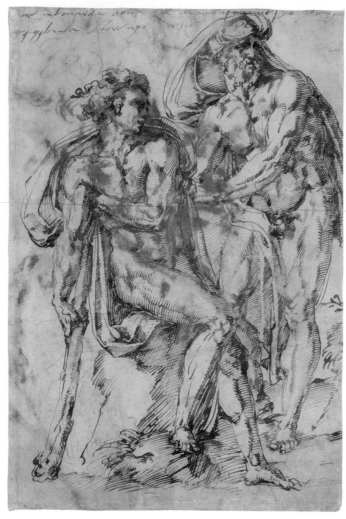

150

academic studies of the male nude standing and seated in highly artificial postures of extreme *contrapposto*, and arranged in tightly knit groups of two or three figures. The poses are conventional and were repeated by the artist from one composition to the next. As in this case, the figures are sometimes partially draped or have props, but these accessories are seldom meaningful. With very slight adaptations for iconographic reasons, nudes in these attitudes were easily incorporated as Mercury (the standing figure) and Zeus (the seated man) into the large *Combat of the Gods: the Battle between Reason and Passion* (Bartsch, vol. 15, 262.44; Ward 1988, fig. 29) designed by Bandinelli, engraved by Nicholas Beatrizet, and published in 1545.

The large portrait drawing on the verso is exactly the kind described in cat. no. 152. Except that it was executed in brown ink instead of black chalk, the Windsor drawing is identical in character to a magnificent *Head of a Bearded Man* (Turin, Royal Library) reproduced (in reverse) by Pope-Hennessy (1985, fig. 102) with a speculative attribution to Benvenuto Cellini. The model for that drawing was again depicted by Bandinelli in the *Head of a Turbaned Man* (Harvard University, Fogg Art Museum; see Ward 1988, under nos. 33, 36, fig. 23), made around 1539–40 in connection with the relief representing *The Meeting of Leo X and Francis I at Bologna, 1515* on the tomb of Pope Leo X in the Roman church of Santa Maria sopra Minerva (Ward 1988, fig. 22).

1. In addition to references cited within the text, see Popham 1949, no. 74; and Ward 1982. no. 420.

R. B. W.

considered one of the most significant examples in Florence of the Counter-Reformation (see F. De Luca in *Altari e committenza* 1996, pp. 114–29).

1. In addition to references cited within the text, see Petrioli Tofani 1991, pp. 311–12, n. 734 F.

M. C. F.

150

BACCIO BANDINELLI
Florence, 1493–1560

recto: Two male nudes[1]
verso: Bust of a man, turned three-quarters to the left
(?)early 1540s
pen and brown ink
40 × 26.5 cm
inscribed recto, above: "nena lionarda dona . . . / figliuola di lorenzo . . ." (partly cut away), in a sixteenth-century hand; recto, below: "Bandinelli" (mostly cut away), in an eighteenth-century hand

Lent by Her Majesty Queen Elizabeth II

DETROIT ONLY

There are well over one hundred extant drawings by Bandinelli that are identical in type to the recto of this sheet:

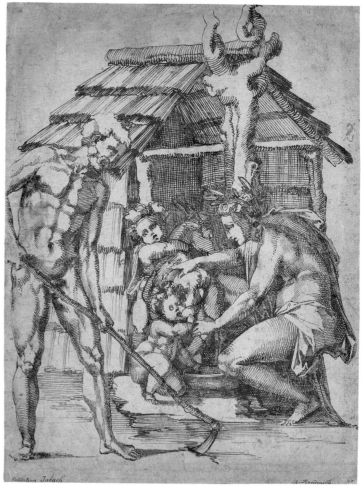

151

151

BACCIO BANDINELLI
Florence, 1493–1560

The Labors of Adam and Eve[1]
1547–48
pen and dark brown ink
37.9 × 27.8 cm
inscribed recto, lower left:
"Collection Jabach"; recto, lower
right: "B. Bandinello," both in
pen and brown ink

The Art Institute of Chicago
Restricted Gift of Anne Searle
Bent

CHICAGO AND DETROIT ONLY

Until 1983, when this excellent
drawing appeared at auction, it
had passed without reference
through numerous distinguished
collections. Its existence was
suggested, however, when a
good, old copy came up for sale
in London (Sotheby's, 17 April
1980, lot 101). The subject
matter and composition were
evidently inspired by the fresco
usually ascribed to Dello Delli
in the Chiostro Verde at Santa
Maria Novella, Florence (Pope-
Hennessy 1969, fig. 19), which
similarly shows Adam tilling the
soil with a long hoe before the
First Family's thatched shelter.
The subject has no specific
textual source, though it was
inventively conjured from
Genesis 3–4, where the
expulsion of Adam and Eve
from Paradise is recorded. Like
the parents of any species, they
are preoccupied with the care
and feeding of the younger
generation. Bandinelli's
representation of the episode is
iconographically eccentric, for
the depiction of the baby Abel
suckling from a goat, assisted by
Eve who wears a wreath, is
reminiscent of antique and
all'antica depictions of the infant
Jupiter being fed by the goat
Amalthea.

This *modello* drawing was
made between September 1547
and March 1548, when
Bandinelli designed, and then
completely redesigned, a new
marble choir for Florence
cathedral. Among its decorative
components was a series of

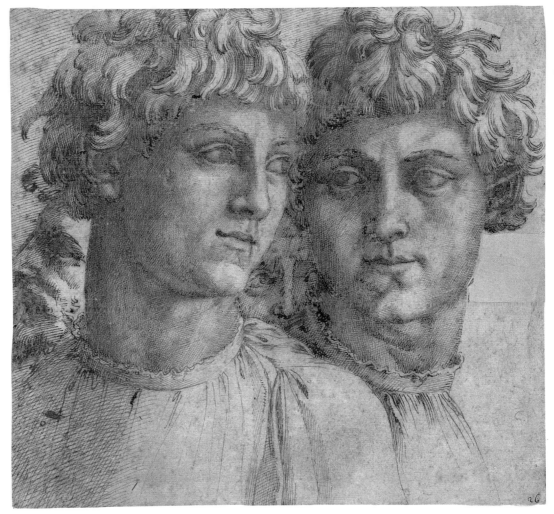

152

twenty-one bronze reliefs with
scenes from the Old Testament.
Duke Cosimo greatly admired
Baccio's highly finished drawings
for the narrative bronzes "both
for their variety and quantity, as
well as for their beauty,"[2] and
Vasari had at least one of them
in his famous Libro dei Disegni.
Fourteen drawings still exist, but
the reliefs were never cast.[3]

1. In addition to references cited
within the text, see *Old Master
Drawings* 1992, pp. 18–19; Folds
McCullagh and Giles 1997, no. 11,
pp. 12–13.
2. "i quali sì per la varietà e
quantità, come ancora per la loro
bellezza." Vasari–Milanesi 1878–85,
vol. 6, p. 179.
3. See Ward 1988, nos. 39–41 for a
comprehensive summary of the
project, its chronology, related
drawings, and bibliography.

R. B. W.

152

BACCIO BANDINELLI
Florence, 1493–1560

Two studies of the head of a
youth[1]
(?)ca. 1550
pen and brown ink on tan paper
23.8 × 25.5 cm
inscribed recto: "26" in pen and
brown ink

The Art Institute of Chicago
Helen Regenstein and Samuel
A. Marx Endowments

FLORENCE AND CHICAGO ONLY

Throughout his long career
Bandinelli made portrait studies
of workshop assistants or female
members of his household who
served as anonymous models for
his relief sculptures (see Ward
1988, nos. 18 and 19, and fig.
23). These studies are
surprisingly large and highly
finished. Only a few sitters are
identifiable, such as Jacopa Doni
(the artist's wife) or Duke
Cosimo (Ward 1988, figs. 4, 27).
His own distinctive physiognomy
is usually idealized in the service
of some allegorical concept such
as *The Three Ages of Man* (see
Bean 1982, no. 18).

Published by this writer in
1993, the present drawing was
later acquired by the Art
Institute of Chicago and
meticulously cataloged by
Suzanne Folds McCullagh. She
duly recounted that Bandinelli
reserved the highly refined pen-
and-ink technique of the two
studies for the head of a youth
for drawings of importance to
him as keepsakes – the copy of
Leonardo's *Annunciate Angel*, for
example, or the competition
drawing of *Andrea Doria in the
Guise of Neptune* (Ward 1988, fig.
5 and no. 29 respectively) – from

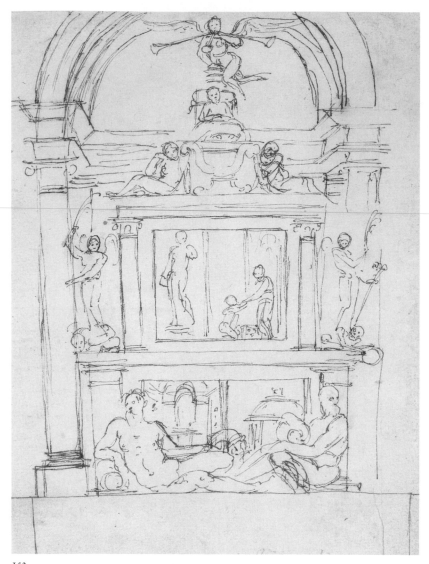

153

which it may be inferred that his emotional attachment to this sheet was strong. On this basis it was suggested that the twice-depicted youth might have been Bandinelli's beloved natural son, Clemente (1534–54), at about age sixteen. The hypothesis gains credibility from a comparison of these faces with the features of the dead Christ held by Nicodemus in the *Pietà* surmounting the Bandinelli sepulcher in the Florentine church of Santissima Annunziata (Ward 1988, fig. 26). The comparison is persuasive only when one looks at the sculpture from the floor of the church, not from the level perspective of photographs. Nicodemus is an obvious self-portrait by Baccio, and the lifeless Son of God is, surely, an idealized portrait of Clemente at the time of his early death (Weil-Garris 1981, pp. 241–42).

1. In addition to references cited within the text, see Ward 1993; and Folds McCullagh and Giles 1997, no. 703, p. 398, and frontispiece.

R. B. W.

153

VINCENZO (MARIA)
BORGHINI
(attributed to)
Florence, 1515–1580

Sketch for the catafalque of
Michelangelo
ca. 1564
pen and brown ink on paper
19.6 × 14.6 cm

Private Collection

Michelangelo's death in Rome on 18 February 1564 prompted Cosimo I and the Accademia del Disegno to consider an appropriately magnificent homage in the Medici church of San Lorenzo in Florence. In a letter of 21 February Vincenzo Borghini, the lieutenant (*luogotenente*) of the Accademia, suggested to Vasari that they arrange the funeral (Wittkower 1964, pp. 10–11). Michelangelo had always wished to be buried

in Florence, and at the instigation of his nephew Lionardo Buonarroti, the artist's body was transported there, arriving at the customs house "in a bale – as if it were some merchandise."[1] The coffin was transported by the academicians to the sacristy of Santa Croce, where it was opened and the body revealed to be intact – "a divine sign" according to Borghini (quoted in Wittkower 1964, p. 16).

Michelangelo's apotheosis pervades the artistic imagery for his obsequies in a program probably drawn up by Vasari and Borghini. Vasari's account of the catafalque (Vasari–Milanesi 1878–85, vol. 7, pp. 296–306) states that it was positioned in the central nave of San Lorenzo and details the complex iconography of the artistic arrangements. These were organized by Bronzino, Ammanati, and Cellini in addition to Vasari, while Zanobi Lastricati was appointed *proveditore* (comptroller) for all the material and financial arrangements (Wittkower 1964, p. 19).

The present drawing relates closely to the first design for Michelangelo's catafalque in pen, ink, and wash, bound into the Codex Resta in the Ambrosiana Library, Milan (Bora 1976, p. 65). However, the Milan drawing differs from the present version in its much more polished hand. Both drawings show an elaborate structure, with the effigy of Michelangelo reclining on a sarcophagus and Fame, blowing her trumpets, flying above. In the present drawing the Medici Chapel and the dome of St. Peter's are depicted in the lowest tier; on the second is an allegory of Sculpture guiding the young Michelangelo, with figures of Art triumphing over Death in one corner and Eternity triumphing over Time in the other. Bora (1976, p. 65) has pointed out that the Milan drawing is close to a tomb design, with the catafalque seeming to project from a wall, rather than being placed in the nave as Vasari stated: Wittkower suggests that it was intended to

evoke the tomb of Julius II or the Medici Chapel (Wittkower 1964, p. 22).

Both the London and Milan drawings relate to the sketch of Michelangelo's catafalque in the Staatliche Graphische Sammlung, Munich (Wittkower 1964, pp. 19, 89, 105–6, 154, 156, 160–61), which Wittkower suggests is the final design. Its free graphic style bears no similarities to the Milan or the present drawing, however. Since Vasari stated that the figure of Fame was by Lastricati ("which Fame was by Zanobi Lastricati"[2]), scholars have attributed this group of drawings to him. Yet we know nothing of Lastricati's graphic style – he was principally a sculptor (see cat. no. 78) – and his administrative role does not favor this attribution. It is more likely that the drawings were sketched by Vincenzo Borghini, the chief designer of the catafalque. Examples of Borghini's drawing style are numerous: his sketches for the decorations for Francesco de' Medici's marriage to Giovanna of Austria, for instance, compare favorably with this sketch (see Ginori-Conti 1936, figs. 4, 5, 11, 17).

The present drawing was probably bought by Sir William Roscoe at the Ottley Sale in 1814, and sold in 1816 to a Manchester bookseller (Wittkower 1964, pp. 154–55, n. 5). Until its recent appearance on the Belgian art market the drawing had gone untraced.

1. "e come fussi una mercatantia inviatolo alla patria in una bala." Wittkower 1964, pp. 14, 16. See also Acidini Luchinat's essay in this catalog.
2. "la quale Fama fu di Zanobi Lastricati." Vasari–Milanesi, vol. 7, p. 306.

A. B.

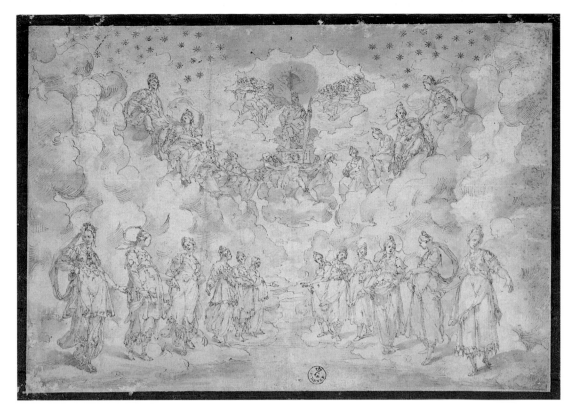

154

154

ANDREA BOSCOLI
(?)Florence, ca. 1560–Rome, 1608

Harmony of the Spheres, design for the first *intermezzo* of
La Pellegrina[1]
1589
pen and brown wash on traces of black chalk
26.6 × 37.6 cm

Florence, Gabinetto Disegni e Stampe degli Uffizi

DETROIT ONLY

The drawing illustrates the first of six *intermezzi* for the comedy *La Pellegrina* by Girolamo Bargagli, performed in the Uffizi Theater on 2 May 1589 to celebrate the marriage of Grand Duke Ferdinando I to Christine of Lorraine. All of the renowned *intermezzi* were created by Giovanni dei Bardi and staged with groundbreaking new scenography by the court architect Bernardo Buontalenti. The first *intermezzo* presented the descent to earth of the celestial spheres, guided by the expression of universal harmony,

Harmony Doria, who sang a madrigal by Bardi with music by Emilio dei Cavalieri as she played the lute. The action included the entrance onto the stage of seven cloud machines with vertical and horizontal traction, operated by teams of technicians standing on the galleries behind the stage.

This drawing documents the scenographic complexity of the *intermezzo*, a typology that had lost its original function as mediator between the acts of a play, and in which the dramatic script was eclipsed by the astonishing machinery and large number of characters brought onto the stage. According to the most recent theories, the drawing was executed by Andrea Boscoli and used as a model for a series of etchings produced by Agostino Carracci. It is possible that in 1589, Boscoli was commissioned to execute, on the basis of sketches by Buontalenti, a series of drawings illustrating all the stage sets of the *intermezzi* for *La Pellegrina*, to be reproduced in prints illustrating the official *Descrizione* of the celebrations compiled by Raffaello Gualterotti. Recent studies

confirm the propograndistic intentions of Ferdinando I's government, which aimed to disseminate striking images of the Grand Duchy through illustrations of the new scenic art promoted by the Florentine court.

1. See *Il luogo teatrale a Firenze* 1975, p. 113, n. 8.11; DeGrazia 1984; Albrecht 1991; Saslow 1996, pp. 198–99, n. 9; and *Magnificenza* 1997, p. 297, n. 244.

A. M. T.

155

AGNOLO BRONZINO
Florence, 1503–1572

Head of a Young Man[1]
ca. 1550–55
black chalk
13.8 × 10.4 cm

Los Angeles, J. Paul Getty Museum

DETROIT ONLY

This life study, the only known drawing by Bronzino for the head of a surviving portrait, was

155

made in preparation for the *Portrait of a Young Man* (Kansas City, Nelson-Atkins Museum of Art; Rolands 1996, no. 22). As such, it gives valuable information about Bronzino's working procedure as a court portraitist, which involved executing a drawing of the head for the approval of his aristocratic sitter, and then using studio models for the rest of the portrait. Two examples of this type of portrait from Bronzino's circle are those of Duke Cosimo I de' Medici made by Pontormo in around 1537 (Florence, Uffizi 6528Fv; Cox-Rearick 1981, cat. 334) and by Bandinelli in around 1540 (Florence, Uffizi 15010F; Ward 1988, fig. 27).

Technical examination reveals that in a first version of the Kansas City painting the man was bareheaded, his face closely resembling the Getty drawing. But in the final painting Bronzino made the face thinner and covered most of the curly

hair with a plumed beret. The sitter is unknown but the costume and accessories in the three versions of the composition that Bronzino painted successively on the panel (armor in the first; rich dress and sword in the second and third) make it clear that he was a member of the ruling elite. His face also has a distant and mask-like quality typical of Bronzino's court portraits, such as those of Duke Cosimo I de' Medici. As in the Cosimo portraits, the slightly wall-eyed treatment of the eyes inhibits any sense of communication with the spectator.

The portrait, and hence the drawing, have rightly been dated to the early 1550s, when Bronzino abandoned the elaborate architectural backgrounds he had previously favored in portraiture (see cat. no. 14) and concentrated on the monumentality of his subjects (see cat. nos. 13 and 16). The

technique of the drawing, delicately and precisely executed in a silvery black chalk, also points to the early 1550s, when Bronzino abandoned the broader handling he used in some of his earlier drawings.

1. In addition to references cited within the text, see Turner and Plazzotta 1997, no. 7.

J. C.-R.

156

AGNOLO BRONZINO
Florence, 1503–1572

Study for a dead Christ
1529
black chalk, squared in black chalk on the verso
31.4 × 21.9 cm

New York, Private Collection

FLORENCE ONLY

This magnificent large drawing of a dead Christ for a *Pietà* was recently sold in Paris as "attributed to Bronzino" and resold shortly thereafter in London as Bronzino's study for the Christ in his signed altarpiece, *Pietà with the Virgin and Magdalene* (Florence, Galleria degli Uffizi). Contemporary documents (Florence, State Archives and Biblioteca Nazionale) establish that the painting was executed in 1529 for the Florentine banker Lorenzo Cambi for his chapel in Santa Trinita (Waldman 1997) and Vasari also mentions it in the same church in his *Life* of Bronzino (Vasari–Milanesi, 1878–85, vol. 7, p. 594). The present author is quoted in the catalog for the Paris sale (Drouot, Paris, sales catalog, 20 November 2000, lot 21) as supporting the attribution of the drawing to Bronzino and in a catalog for an exhibition at the Colnaghi Gallery, London, (*An Exhibition of Master Drawings*, Adam Williams Fine Art Ltd. and Colnaghi, New York and London, 2001, no. 3) as proposing the association with the Uffizi painting; the drawing

has since been studied in depth (Monbeig Goguel 2001).

Bronzino's treatment of the motif of the dead Christ held by the Virgin (and sometimes others) is in the Florentine tradition of Perugino, Fra Bartolommeo, Andrea del Sarto, and – most notably – his master Pontormo, whose dead Christ in the *Lamentation* (Capponi Chapel, Santa Felicita, 1526–28) was Bronzino's immediate prototype (but note also Pontormo's *Christ of the Lamentation* fresco at the Certosa di Galluzzo near Florence of around 1525). Indeed, Pontormo supplied his pupil with a red-chalk drawing for the lower legs of Christ in the *Pietà with the Virgin and Magdalene* (Florence, Uffizi 6527F; Pilliod 1995, p. 154). Bronzino's pupil, Alessandro Allori, in turn continued to explore this dead Christ composition in a number of paintings, for which he may have made use of a Bronzino drawing such as this (Monbeig Goguel 2001).

The Michelangelesque monumentality of the nude, as well as Bronzino's characteristic plasticity and the refined delicacy of handling of the black chalk may be compared with his study for *St. Michael Fighting the Devil* for the vault of the Chapel of Eleonora of 1540–41 (see cat. no. 157), although the less fluid dead Christ drawing is not so obviously studied from a live model. Indeed, it has been suggested that this study is a synthesis based on several drawings rather than drawn from life. This hypothesis is supported by the presence of three disembodied hands – one holding Christ's head, one supporting his right hand (both presumably the Virgin's), and one resting across his thighs, which is the right hand of the Magdalene (Monbeig Goguel 2001).

Bronzino made significant changes in the painted figure in the *Pietà*, which must have required further preparatory studies: in the painting Christ's head is thrown back rather than inclined, the legs are bent, the right arm is bent and the hand

aligned with the hips, the left arm is no longer raised, and the Virgin docs not hold his right hand.

About three years after he painted the Uffizi *Pietà* Bronzino reused this drawing in almost all its details in another *Pietà*, a fresco in a country tabernacle near Florence (San Casciano, Mercatale Val di Pesa), which Vasari records as being painted by Bronzino for the Strozzi after Bronzino's return from Pesaro in 1532 (Vasari–Milanesi 1878–85, vol. 7, pp. 595–96). The fresco, now ruined and overpainted, is a reprise of the Uffizi *Pietà* composition in a more vertical format, with the Virgin standing and Christ's body seated and a fourth figure added to the left (see Cox-Rearick 1993, p. 96).

J. C.-R.

157

A GNOLO B RONZINO
Florence, 1503–1572

Study for *St. Michael Fighting the Devil*[1]
1540–41
black chalk on blue–gray prepared paper
38.5 × 22.5 cm

Paris, Musée du Louvre Département des Arts Graphiques

CHICAGO ONLY

This nude study was made in preparation for *St. Michael Fighting the Devil*, painted by Bronzino in 1540 on the vault of the Chapel of Eleonora in the Palazzo Vecchio. The chapel, decorated with *Stories of Moses* on the walls, four saints on the vault, and an altarpiece of the *Lamentation with Saints John the Baptist and Cosmas*, was Bronzino's first major commission from Duke Cosimo I de' Medici.

Bronzino's preparation for the St. Michael began with a compositional study for the whole vault in black chalk and wash, heightened with white (Frankfurt, Städelsches Kunstinstitut), in which the saint is depicted in a spirited and

156

301

luminous sketch (Cox-Rearick 1993, pp. 101–5, 276). The present drawing, a precise and exquisitely modeled life study, fixed the final, less mobile, pose; at the bottom of the sheet Bronzino also restudied the hand holding the sword. This drawing was the basis for a painted figure of decorative splendor, elaborately costumed in blue and gold and is placed like an emblem on the vault over the altarpiece.

As so often in Bronzino's work, the St. Michael of this drawing and the corresponding fresco have points of reference in the art of Michelangelo – in this case to works that also depict the theme of the victory of good over evil. The saint evokes the judging Christ of the recently completed *Last Judgment* in the Sistine Chapel (Monbeig Goguel 1972a, no. 10), and his elegant head and contrived posture refer to the sculptor's *Victory* of 1532–34 (Florence, Palazzo Vecchio), one of the first sculptures to display the fully developed characteristics of the Maniera. In evoking these works, Bronzino declared an admiration for the master's art that informs not only the Chapel of Eleonora but also all of his mature work. Michelangelo was the subject of two sonnets by Bronzino, the first beginning with a wordplay on the names of the sculptor and the Archangel Michael, suggesting that the St. Michael was a homage to the master (Cox-Rearick 1993).

On the verso of the sheet is an elegant little black-chalk sketch for the coat of arms of the Medici–Toledo families (Cox-Rearick 1993), which Bronzino painted at the center of the vault of Duchess Eleonora's chapel.

1. In addition to references cited within the text, see Smyth 1971, pp. 7–8; and Cox-Rearick 1971.

J. C.-R.

157

AGNOLO BRONZINO
(or ALESSANDRO ALLORI)
Florence, 1503–1572

Study for the *Martyrdom of
St. Lawrence*[1]
1565–69
black chalk
46.5 × 23.5 cm

Paris, Musée du Louvre,
Département des Arts
Graphiques

CHICAGO ONLY

This large sheet is a life study
for the nude with a pole and a
sack in the lower left corner of
Bronzino's monumental late
fresco, *The Martyrdom of St.
Lawrence* in the Medici church
of San Lorenzo. In early 1565
Duke Cosimo I de' Medici
commissioned the work as one
of a pair on the nave walls near
the pulpits. Bronzino completed
it in 1569 but never executed
the second fresco. A letter of
11 February 1565 about this
commission from Cosimo to
Bronzino is one of the few
documents to mention the
artist's drawings: the Duke
writes, "as for the paintings to
be painted on the two walls of
San Lorenzo, . . . you can start to
do the drawings so that we can
see them and decide about them
because we will be happy to
have the church decorated."[2]

The Louvre drawing was
squared in black chalk so that
it could be enlarged for the
cartoon used in the execution of
the fresco, in which this figure is
lightly draped around the hips
and has a beard. There are two
other black-chalk studies for
the *Martyrdom*. One, similar in
draftsmanship to the Louvre
drawing and also squared
(Florence, Uffizi 10220F), is
for another of the four figures
attending to the fire beneath the
saint (Smyth 1971, pp. 44–45).
The other, more refined
in execution and more
Michelangelesque in figure type
(The Sterling and Francine
Clark Institute, Williamstown,
Massachusetts, Alice Steiner
Collection), is for a reclining

nude, a figure rather like a river
god, who is not part of the
narrative and is depicted, in
larger scale, in the right
foreground of the fresco
(Feinberg 1991, no. 12; Griswold
and Wolk-Simon 1994, no. 23).
The Louvre and Uffizi studies
are attributed by their respective
museums to Bronzino's pupil,
Alessandro Allori; Smyth, who
first connected the Louvre
drawing with the fresco,
attributes it to Bronzino but
doubts the attribution to him
of the Uffizi sheet. Bearing in
mind the difference in figure
style and draftsmanship between
these two drawings and the
Steiner Collection study, it is
possible that they are indeed
by Allori.

Perhaps no work by Bronzino
exhibits the Michelangelism of
his late work better than the
Martyrdom and its preparatory
studies. The fresco is a *summa* –
a gigantic demonstration piece
of Bronzino's virtuoso mastery
of the nude, filled with
quotations and references to
Michelangelo's Sistine ceiling
frescoes (the *Deluge*, the *ignudi*)
and to his sculpture in Florence,
such as the *Day* of the Medici
Chapel, to which both the
fresco's "river god" nude and
the Steiner drawing allude.

1. In addition to references cited
within the text, see Cox-Rearick
1971, p. 21; and Monbeig Goguel
1972a, cat. 13.
2. ". . . quanto alle pitture che
disegniate di fare nelle dua
facciate di San Lorenzo, . . .
potrete cominciare a farne i
disegni acciò li vediamo e ce ne
risolviamo perchè ci sarà grato
per l'ornamento di quella
chiesa." Florence, State Archives,
MDP 220, f. 78.

J. C.-R. 158

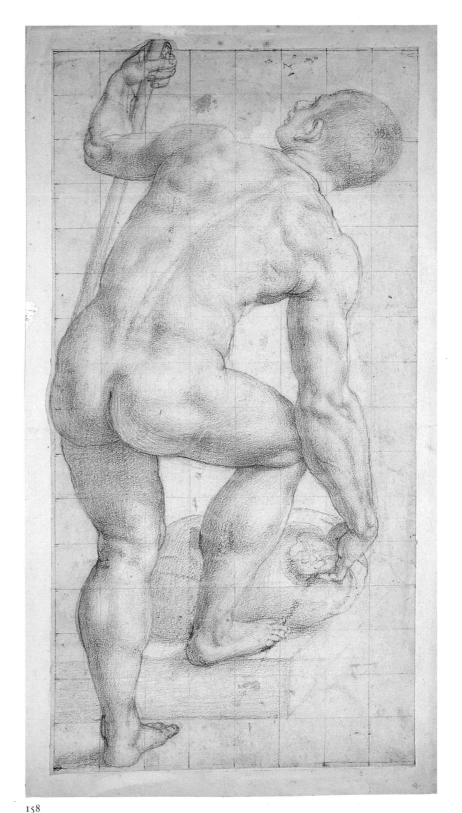

159

159

BERNARDO BUONTALENTI
Florence, 1536–1608

Design for the entrance of the
Uffizi Theater
ca. 1600
black and red chalk with traces
of pen and ink
26.9 × 17.2 cm

Florence, Gabinetto dei Disegni
e delle Stampe degli Uffizi

DETROIT ONLY

This drawing was identified by
Ferri (1885, p. 215) as a project
by Buontalenti for a tabernacle.
In 1995 Fara (1995, pp. 158–59,
n. 146, fig. 351) linked it to the
entrance door to the Medici
theater in the Uffizi, which
originally supported a balcony
with a niche and was used as a
podium for musicians. By 1589
the balcony had probably already
been put to a different use:
documents confirm that in later
years it was turned into a "secret
box"[1] for the princesses and the
Grand Duchess, so the drawing,
as Fara rightly suggests, may
relate to this new use and the
incorporation of a grille. Fara
also noted that the drawing
reveals two superimposed designs
and that the more dominant
design suggests stylistical
precedents: "the idea of
superimposing a triangular
tympanum onto a curvilinear
one derives from the project for
the façade of the cathedral,
while the articulation of the
upper part of the design recalls
the portal and balcony of the
Nonfinito Palace in Via del
Proconsolo."[2]

1. "palco segreto." Solerti 1905,
pp. 21, 26.
2. "l'idea di sovrapporre un timpano
triangolare ad uno curvilineo
retrostante, deriva dalla progettazione
della facciata del duomo, mentre
l'articolazione della parte superiore
del prospetto sembra composta
tenendo presente il disegno del
portale con terrazzino del palazzo
Nonfinito sulla via del Proconsolo."
Fara 1998, p. 174.

A. M. T.

160

BERNARDO BUONTALENTI
Florence, 1536–1608

(a) *Mount Helicon and the
Amadryad Nymphs*, design for the
second *intermezzo* of
La Pellegrina[1]
1589
pen and ink drawing,
polychrome wash
75 × 48.3 cm
inscribed under figure 8:
"13–16"; on the right upper
corner: "one dressed in half blue
and half red; two red, deep blue,
and flesh-colored; five blue,
white, and flesh-colored; six
tawny, scarlet, and flesh-colored;
seven green, scarlet, and white;
eight yellow, blue, and flesh-
colored; eleven scarlet, white,
and green; twelve flesh-colored,
blue, and white."[2]

(b) *Delphic Couple*, design for the
third *intermezzo* of *La Pellegrina*
1589
pen and ink drawing,
polychrome wash
46.9 × 37.2 cm
inscribed above the male figure:
"N.5, [Gio. batista violino –
erased] Lapi / N.7 [m. o. Jac.
Zazzerini – erased] Cornetto del
franzosino"; on the bottom: "this
goes above blue, red, and
green"[3]; above the female figure:
"n. 6 Alberto [Nicholò Castrato]
Alberigho/ n. 8 [Plauto. Ant.o
franc.o erased] Gio.bat.a del
franc.no"; on the bottom: "this
goes above [the one] dressed in
red–yellow sleeves, white and
light blue."[4]

Florence, Biblioteca Nazionale
Centrale di Florence

CHICAGO AND DETROIT ONLY

The drawings refer to the
costumes worn during the
second *intermezzo*, *The Contest
between the Muses and the Pierids*
by Giovanni dei Bardi, with
music by Luca Marenzio, and
the third *intermezzo*, *The Contest
between Apollo and Python*. They
do not represent the final
costumes but are rough designs
for the tailors, as is suggested
by the captions indicating the
colors, which often do not

correspond to the official *Descrizione* given by Bastiano De' Rossi.

The first picture illustrates the twelve Amadryad nymphs called to judge the singing contest between the Muses and the Pierids on the great heights of Mount Parnassus, which, to the astonishment of the audience, slowly emerged from the trap-cellar in the court theater of the Uffizi, rising to about 7 meters high. After losing the contest, the Pierids, by means of a costume change designed by Buontalenti, metamorphosed into leaping magpies.

The Biblioteca Nazionale collection in Florence also holds sketches for the third *intermezzo* featuring costumes "almost in the Greek fashion"[5] for the nine Delphic couples who entered the stage to the sound of violas and trombones, lamenting to the audience their grief and terror at the invasion of their island by the monster Python. The following scene featured an enormous mechanical dragon, commissioned from the sculptor Valerio Cioli, and its struggle against Apollo.

The importance of the third *intermezzo* derived from its experimental nature, which put into practice contemporary theories regarding the music of the ancient Greeks. Bardi intended to reproduce an ancient musical festival imitating the Pythian songs performed at the games of Delphi in honor of the island's ancient oracle, Apollo. Classical literature on the subject explained that these ceremonies included a song recounting the mythical contest, and Bardi therefore theorized that the song would be followed by a play representing an excerpt from Lucian (*De saltatione*, Book 16) performed by the chorus.

1. See *Il luogo teatrale a Firenze* 1975, p. 113, n. 8.14; Berti 1980, pp. 361–65; Matteini 1991, pp. 114–16, pl. 45; *Magnificenza* 1997, p. 265, n. 211; *Per un regale evento* 2000, 56.3.3, p. 107; 56.2.1, n. 105.
2. "1 vestita turchino sino meza resta rossa, 2 rosso turchino e incarnato, 5 azuro biancho e

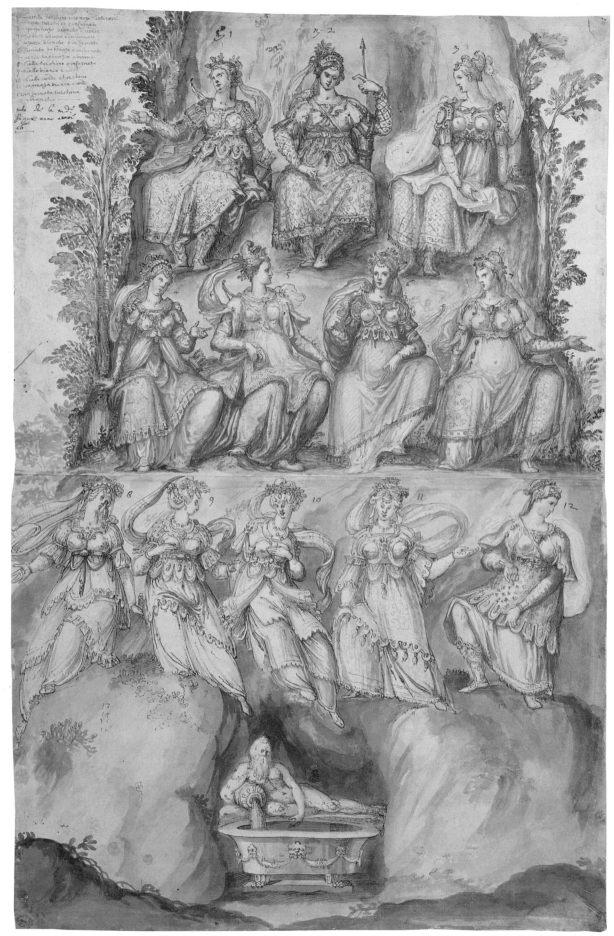

160a

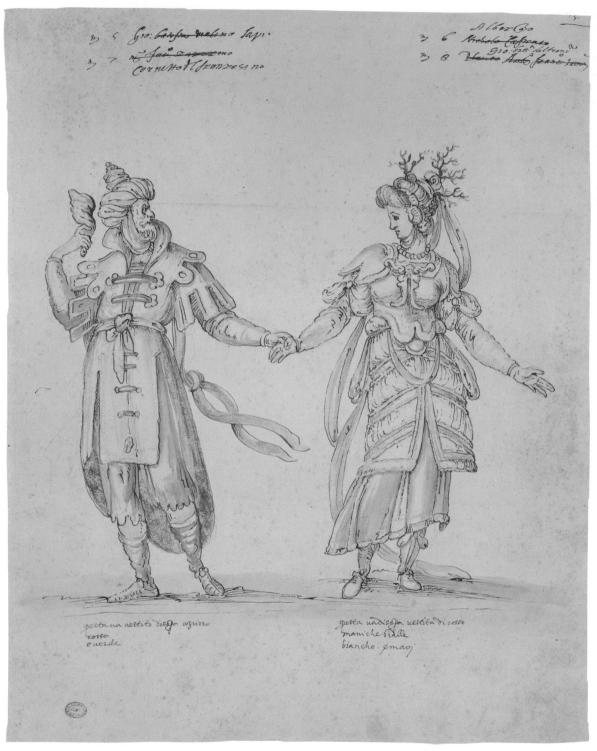

160b

incarnato, 6 lionato pagonazo e incarnato, 7 verde pagonazo e bianco, 8 giallo turchino e incarnato, 11 pagonaza bianca e verde, 12 incarnata turchina turchina e bianco."

3. "questa va di sopra azzurro/rosso/ e verde."

4. "questa vada sopra vestita di rosso/maniche gialle/biancho et maví."

5. "quasi alla greca." Rossi 1589, p. 42.

A. M. T.

161

JACQUES CALLOT
Nancy, 1592–1635

Piazza della Signoria[1]
ca. 1617
black chalk, pen, and dark brown wash
24.5 × 36.5 cm

Darmstadt, Hessisches Landesmuseum

DETROIT ONLY

In this drawing Callot, who – as Dillon (in *Il Seicento Fiorentino II* 1986, p. 185, n. 2.134) has noted – was trained in perspective, architecture, and drawing by Giulio Parigi, outlined the background of his *Feast of Tributes*, etched in the famous series of *Caprices with Various Figures* dedicated to Don Lorenzo de' Medici, Cosimo II's brother. The event shown is the annual Festival of St. John, the patron of Florence, on 24 June, when representatives of the cities of Tuscany paid homage to the Grand Dukes. The date of the sketch is unknown, but it was probably executed in 1617. Much larger than the final print (5.9 × 8.15 centimeters), it is rich in details that were eventually eliminated.

Unlike Federico Zuccaro, who represented the same scene in 1576 in a drawing now at the Louvre (Département des Arts Graphiques, in. 4624; see S. Blasio in *Firenze e la sua immagine* 1994, p. 76, n. 16) showing the Palazzo Vecchio viewed through the Loggia dei Lanzi, Callot focuses on the

square as the site of the most important sculptural works of the Renaissance. Even if only in barely outlined silhouette, its foremost sculptures are all recognizable – Michelangelo's *David*, Bandinelli's *Hercules and Cacus*, Ammanati and Giambologna's *Fountain of Neptune*, Donatello's *Judith* under the Loggia dei Lanzi, Cellini's *Perseus*, and Giambologna's *Rape of the Sabines* – in an evident homage to a cultural legacy still alive in Callot's own work and that of his contemporaries.

1. In addition to references cited within the text, see Ternois 1962, p. 46, n. 17.

M. C.

162

JACQUES CALLOT
Nancy, 1592–1635

Study for the frame for the portrait of Cosimo II de' Medici, Grand Duke of Tuscany[1]
ca. 1620
black and red chalk, brown ink
20.2 × 14.8 cm

Florence, Gabinetto disegni e Stampe degli Uffizi

FLORENCE ONLY

This is one of many sketches and preparatory drawings for the etched and engraved portrait of Cosimo II, which was to be included as the frontispiece of the funeral oration by Cosimo Minerbetti, the Archdeacon of Florence, published one month after the Grand Duke's death on 13 February 1621 and dedicated to "the Most Serene Lady, the Grand Duchess of Tuscany." In the printed portrait, Cosimo appears as the Gran Maestro of the order of St. Stephen within an oval frame: above, a monstrous creature with the wings of a bat is flanked by the emblems of the order; below, beside the Medici arms surmounted by the grand-ducal crown, are two *putti* wearing helmets, one holding a sword and shield and the other

wearing a crested helmet (*morione*).

The present drawing is a study for the oval frame containing the portrait, here reduced to a mere sketch. In another preparatory work in the Uffizi (N. 2472; Ternois 1962, p. 413), the oval frame rests on a scroll without any other decoration, but the figure of the Grand Duke already shows the features of his portrait. The frame outlined by Callot in the present drawing is set against a draped curtain, while the arms of the cross of St. Stephen form architectural elements within the composition. The influence of Florentine Mannerism deriving from Michelangelo is clear, becoming even more evident in the final print, where the mask surmounting the oval takes inspiration from one of those on the cuirass of Giuliano de' Medici in the New Sacristy of San Lorenzo (see Goldscheider 1967, fig. 194).

The preparatory drawings and the corresponding print are considered by Ternois (1962) to be probably the last works executed by Callot in Florence. The artist was forced to leave the city and to return to France following the death of Cosimo II. For the rest of his life he was nostalgic about his Florentine years and the favor he had gained at the Medici court, where he developed his mature style through contact with past and contemporary artists. His regret at leaving Florence is expressed in his letters to the Grand Duke's secretary, Curzio Picchena, and personal secretary, Domenico Pandolfini: "when I see the manner of doing things here and I think of the way of life in Florence, I feel such deep melancholy that if I had no hope of one day returning . . . certainly I believe I would die . . ."[2]

1. In addition to references cited within the text, see Ternois 1962, p. 408; and D. Ternois in *Jacques Callot* 1992, p. 259.
2. ". . . quando più vegho il modo di procedere di queste parte e che

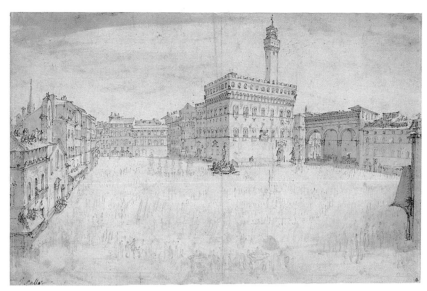

161

162

163

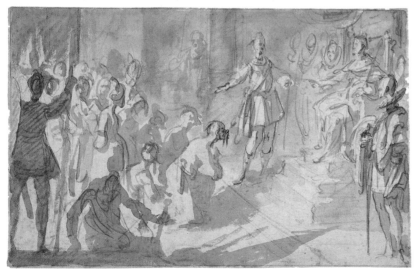

164

penso a quella di Firenze mi viene tanta granda malinconia che si non fusse la speranza che io ho un giorno di tornare . . . certo credo che mi morei . . ." Ternois 1962, p. 220.

M. C.

163

JACQUES CALLOT
Nancy, 1592–1635

Design for a table fountain[1]
ca. 1618–20
red chalk
31.9 × 27.6 cm

Florence, Gabinetto disegni e Stampe degli Uffizi

FLORENCE ONLY

This drawing belongs to a series of studies at the Galleria degli Uffizi, probably for a table fountain, perhaps made of glass (for this complex question see Heikamp 1986c, p. 311). The final work is represented in the wonderful drawing in pen and ink at the Uffizi (1016E), reproduced by Ternois (in *Jacques Callot* 1992, p. 263).

In all the drawings of the series, Callot is seduced by the complicated style of Michelangelo's work in Florence in the 1530s, in which, for the first time, anthropomorphic elements were utilized in a decorative manner that would influence the city's artists until the 1630s. The elliptic shapes employed by Michelangelo in the New Sacristy, in the architectural design of the Laurentian Library, and elsewhere, are adopted by Callot through the filter of Buonarroti's followers such as Benvenuto Cellini, Giambologna, Bartolomeo Ammanati, Pietro Tacca, and Bernardo Buontalenti, the latter a decisive model for Callot's formal choices.

The ductile handling of the red chalk tracing the contours of the image is clearly inspired by Michelangelo's style, while the combination of natural shapes transformed into abstract stylized images is reminiscent of Michelangelo's sculpture as well

as his rare designs for decorative objects (see cat. no. 190). Certain fantastic forms employed by Callot, such as the animal face at the center of the cup in drawing 1016E in the Uffizi, appear also in contemporary works by Filippo Napoletano, such as the *Triumph of Neptune and Amphitrite* (see cat. no. 28), in which the animal bust in the marine deities' chariot is clearly based on Callot's design.

The group of drawings for this fountain has been dated 1618–20 by Ternois (Ternois 1962, vol. 1, no. 549), and this date has been accepted by subsequent scholars.

1. In addition to references cited within the text, see D. Ternois in *Jacques Callot* 1992, p. 262, no. 283.

M. C.

164

JACQUES CALLOT
Nancy, 1592–1635

Admiral Inghirami Presents Prisoners to Ferdinando I[1]
ca. 1618–20
black chalk, brown wash
19.4 × 30.3 cm

The Detroit Institute of Arts
Bequest of John S. Newberry

CHICAGO AND DETROIT ONLY

This drawing shows the episode of Admiral Inghirami, who conquered the Turkish fortress of Prevesa in Albania on 3 May 1605, presenting Turkish prisoners to Ferdinando I. The composition seems to be inspired by Bernardino Poccetti's fresco of 1608–9 in the Sala di Bona of the Palazzo Pitti representing *Silvio Piccolomini Presenting Turkish Prisoners to Grand Duke Ferdinando*. The renowned Sala was a homage to Cosimo I and Ferdinando I, and its decorations formed a precedent for a series of prints that Callot, commissioned by Cosimo II, would create in 1614–16 to illustrate the most important episodes of the life of Ferdinando I (see cat. no. 218).

This scene, however, does not belong to the series, and according to Ternois (1962, vol. 2, p. 92), the drawing was executed on Callot's own initiative, perhaps to illustrate other episodes. There is another, more complex version of the same image in the Galleria degli Uffizi (2650F; Ternois in *Jacques Callot* 1992, p. 178), in which, as in Poccetti's fresco, a soldier holds a shield bearing the Medici arms.

Ternois has dated the two drawings to around 1618–20, towards the end of Callot's stay in Florence "despite the persistant Mannerism of the style, in the Tuscan tradition." However, since there is now documentary evidence that the series of burin-etched plates of the life of Ferdinando was delivered earlier than previously supposed, in September 1616, it is likely that the two drawings were executed earlier than this date.

1. In addition to references cited within the text, see A. Sutherland Harris in *The Collections of the Detroit Institute of Arts* 1992, p. 162.

M. C.

165

REMIGIO CANTAGALLINA
Borgo Sansepolcro,
ca. 1582–Florence, 1656

View of Siena[1]
ca. 1630
pen and brown ink, wash
41.8 × 90 cm
inscribed on the lower left side
with the monogram "RC"

Florence, Gabinetto Disegni e
Stampe degli Uffizi

Cantagallina was a student of Giulio Parigi, whose academy he attended. He dedicated himself to etching from 1603 and taught Jacques Callot (see cat. nos. 218–20). He was "celebrated for his pen drawings of landscapes,"[2] a specialty that greatly influenced contemporary Tuscan landscape artists.

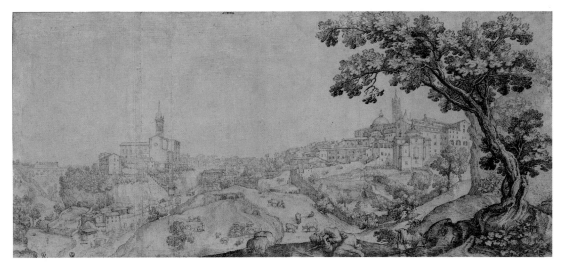

165

This view of Siena from the north-east, unusually large in size, includes, from the right, the church of San Sebastiano in Valle Piatta designed by Baldassarre Peruzzi in 1507, the cathedral, and the Hospital of Santa Maria della Scala, while on the far left is the church of San Francesco.

It is interesting to note the medieval city walls and their later additions, still well preserved at the time. Siena, the second most important city in Tuscany, had enjoyed economic, political, and artistic success between the thirteenth and fifteenth centuries during the era of the Commune and the Republic. It was torn apart subsequently by internal conflicts over state control, but it enjoyed a new period of political stability between 1502 and 1512 under the absolutist government of Pandolfo Petrucci. However, the city became caught up in the political vicissitudes that divided Italy into factions siding with either France or Spain, and in 1555 Siena and its territory were assigned, after a long siege, to Cosimo I de' Medici, who made the area part of what became the Grand Duchy of Tuscany in 1559. Siena was henceforth overshadowed by artistic events in Florence and Rome.

1. See Chiarini 1972, p. 23.
2. "celebre in disegnar paesi a penna." Baldinucci 1845–47, vol. 4, p. 142.

M. C.

166

GIOVANNI CASINI
(attributed to)
Varlungo, 1689–Florence, 1748

Drawing of the Medici grand-ducal crown[1]
1710
pencil, pen and ink, and watercolor
20 × 31.1 cm

London, Victoria & Albert Museum

This drawing shows, on the right, an incomplete depiction of the exterior of the Medici grand-ducal crown and, on the left, the interior, likewise only partially delineated. The circle below the rays on the right shows the beginning of the inscription that ran around the exterior of the crown: PIVS V PONT MAX OB, while on the lowest circle on the left is written: Corona di Casa Medici. The crown comprises a circle of rays with the red lily of Florence in the center of the front and it is set with numerous gemstones on a ground displaying Moresque and grotesque ornament. The drawing has been attributed to the Florentine artist, Giovanni Casini, on the basis of a letter to Casini from John Talman, dated 26 April 1710, soliciting the artist to draw the crown, which was in the Guardaroba (Bodleian

Library, Oxford, MS Eng. lett. e 34, f. 108).

Cosimo I de' Medici was crowned Grand Duke of Tuscany by Pope Pius V in Rome in March 1570. The crown he had hitherto worn as duke of Tuscany was replaced by a more elaborate crown suited to his new rank. But the grand-ducal crown depicted in this drawing is not the one produced for Cosimo but rather the crown made between 1577 and 1583 by the famed court goldsmith and jeweler, Jaques Bylivelt.

Other drawings of Medici crowns survive. One is found on the papal bull of 13 December 1569 according Cosimo I de' Medici the rank of Grand Duke, and this formed the starting point for the crown represented in this drawing, which shows it in a greatly embellished and much more elaborate state. A pencil sketch of a different Medici crown, inscribed "Grisoni 1715" and also associated with John Talman, is also to be found in the Department of Prints, Drawings, and Paintings of the Victoria & Albert Museum (inv no. E. 305–1940). And in the Wormsley Library, Buckinghamshire, a drawing of a crown similar to the one shown in the present drawing, also by Giovanni Casini, is annotated: "The Crown which is wore by the Great Princess of Tuscany on the Day of her Marriage" (Herrmann 1997, p. 101).

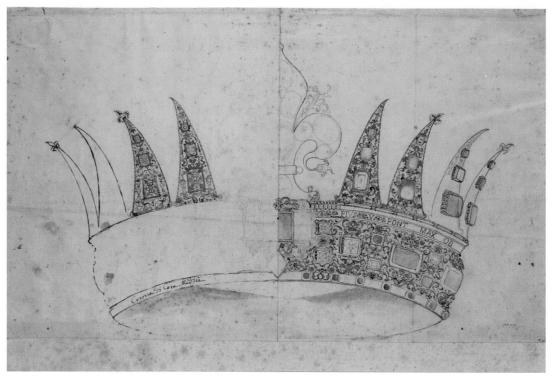

166

In addition to the drawing, contemporary and later Medici portraits (such as the one by Scipione Pulzone of 1590 showing Christine de Lorraine, now in the Museo degli Argenti, Florence) also document the crown's appearance. It was retained by the Medici through the seventeenth and eighteenth centuries (it is last mentioned in 1788) but was probably not always in use, and was certainly not worn after the Medici Grand Dukes obtained the right to wear a closed royal crown. The crown may have been destroyed by Napoleon's troops, responsible for the appropriation of so many Italian art objects at the close of the eighteenth century. No Medici crown survives, and this drawing is particularly valuable as a testimony to a splendid piece of the Medici regalia.

1. In addition to references cited within the text, see Hayward 1955; Hayward 1956; Fock 1970; Fock 1974, p. 97, fig. 78; Fock 1980, pp. 326–27, fig. 124; and M. Snodin in *Princely Magnificence* 1980, p. 117, no. G9.

M. M.

167

BENVENUTO CELLINI
Florence, 1500–1571

Design for the seal of the Accademia del Disegno (*Apollo*)[1]
ca. 1563
black chalk underdrawing; pen and brown inks, brown ink washes, white heightening
30.2 × 21.8 cm
inscribed in brown ink, in the hand of one of Cellini's amanuenses: "La inscrizione d'intorno al sigillo è questa: Apollo è sol la Luc'/Cosmo è principio à la gran scuola, e Duce. ii F. e. S."

Munich, Staatliche Graphische Sammlungen

CHICAGO ONLY

This drawing, which represents one of Cellini's proposals for the seal or *impresa* of the Accademia del Disegno, was probably executed shortly after the founding of the Academy in 1563. Whereas his alternate conceit, centering on the "Iddea della Natura," is known in four variations, this drawing is unique in featuring Apollo. Its emblem shows the Sun God, bow in one hand, arrow in the other,

emerging with billowing cape from a misty background, and standing in triumph over Python, the dragon-like monster identified with fog. This image was to be surrounded by the inscription (in one of several possible translations), "Apollo alone is the light / Cos[i]mo is principle and leader to the great school", followed by the abbreviation "ii F. e. S."[2]

The choice of Apollo reflects Cellini's attempt to give the seal two different functions. As the inscription suggests, the figure of Apollo would serve as an encomium to Grand Duke Cosimo I (Florence's second Medici duke), comparing his position in the Academy (its official *capo*) to the sun's above the earth (the analogy being rather awkwardly extended by the intentional misspelling of Cosimo's name). At the same time – as the long text following the inscription elaborates – Apollo would also be an apt figure for *disegno*, which, like the sun, is "the true lamp of all the actions that men of every profession perform."[3] The commentary explains that *disegno* makes men "burn" to compete with Apollo, for just as Apollo generates the

flowers and plants that decorate the earth, so do men create artworks. The seal thus takes up several popular ideas of the moment: that *disegno*, or design, is the common denominator of all of the arts; that "designs" are likewise the origins of other virtuous actions; and that, in the age of Michelangelo and the Medici, the artist and the statesman might be subject to similar exempla.

Stylistically, the drawing is distinctive for its use of chiaroscuro, which is comparable to the other drawing for the seal in the exhibition (cat. no. 168), also in Munich, but unlike Cellini's other surviving graphic work. The artist seems to have become interested in chiaroscuro while in Cosimo's employ: the tomb he began designing for himself in the mid-1550s was to include a *tondo*, frescoed in yellow (to suggest the sun), "in chiaroscuro."[4] Though this was eventually abandoned, the contrast of light and dark may have inspired his eventual decision to execute the crucifix intended as its centerpiece (now in the Escorial, near Madrid), as a brilliant white figure against a flat black cross. Cellini's discourse *On the Art of Disegno*, written around the time he made the Munich drawings, comments on the excellence of "painting in chiaroscuro,"[5] which Cellini associated in particular with Polidoro da Caravaggio and Matturino da Firenze, and remarks that "True drawing is nothing other than the shadow of relief."[6] In the case of the *Apollo*, the technique is well-suited to the theme. Apollo makes the earth flourish, and thus becomes the artist's "true master," by dispersing the thick fog of the serpent Python. In the drawing, Apollo appears as a body of light emerging from the fog, even as he stands on the dark dragon he has mastered.

1. See Halm 1958; Winner 1968; Calamandrei 1971; Kemp 1974; Harprath 1977; Pope-Hennessy 1985; Cole 2002.
2. Halm, Degenhart, and Wegner 1958 expand the abbreviation plausibly as "ii F[irenze] e S[iena]."

3. "la vera Lucerna di tutte le Azzioni, che fanno gli Huomini in ogni professione."
4. "dichiaro et scuro." Calamandrei 1971, p. 77.
5. "dipingere di chiaro e scuro." Quoted in Ferrero 1980, p. 808.
6. "Il vero disegno non è altra cosa che l'ombra del rilievo."

M. W. C.

168

B ENVENUTO C ELLINI
Florence, 1500–1571

Design for the seal of the
Accademia del Disegno (the
"Iddea della Natura")[1]
ca. 1563
Black chalk underdrawing; pen,
brown ink, and two brown
washes, white heightening
18.6 × 14.4 cm

Munich, Staatliche Graphische
Sammlungen

DETROIT ONLY

The drawing included here
represents a design known in
three other versions. All four
were executed in pen and brown
ink, and one of the others, that
in the British Museum, was also
worked with wash. But the
present version is unique in
using the wash in the same way
as it is used in another proposal
by Cellini for the seal, featuring
Apollo (cat. no. 167): in both
drawings the wash creates a
shadow from which the figure,
heightened in white (and
presumably representing what
would be the raised part of the
wax seal) appears to emerge. The
exposition beneath the version
in the British Museum refers to
the figure as the "Iddea della
Natura," the Goddess/Idea of
Nature, precisely the designation
that, in Cellini's account books
more than a decade earlier, was
used to refer to similar emblems
on the marble base of the
Perseus for the Piazza della
Signoria.

The pun on "Iddea" goes
some way to explaining the
basic components of the
insignia: with its herm-like
structure and many breasts, the
figure evokes ancient statues

of the nature goddess (*Iddea*)
Diana of Ephesos, "mother"
of mundane creation, while its
angelic wings and halo-like
laurel crown suggest the divine
inspiration of mind (idea). The
twin horns that spring from
beneath the figure's arms are
familiar attributes of Fame; a
further inscription on the British
Museum version explains that
"the trumpet of our fame comes
from the arms,"[2] that is, that
artists, unlike poets, achieve their
fame through manual activities.
The frame that encloses the
figure is four-sided because
those activities comprise four
fields: sculpture, painting,
architecture, and metalwork.

The use of chiaroscuro may
suggest that in this drawing, as
in that showing Apollo, "idea" is
associated with illumination. The
text on the British Museum
page attempts to use such a
notion as a means of making
reference to the Duke: the
beautiful *ingegni* of Cellini's
fellow academicians, the artist
writes there, reignite the *gran
lume* of the Florentine school,
with the aid of the "divine and
immortal *virtù* of our most
illustrious and glorious Duke
Cosimo de' Medici, Lover of
the truth."[3] In case such a
connection seems forced, Cellini
flanks the central figure with a
serpent and a lion, the former,
as he explains elsewhere, an
emblem of the Duke, and
the latter the image of the
Florentine "school." Here again,
Cellini aims to construct an icon
that will flatter his patron (the
Academy's leader), yet also
provide an example for himself
and for his virtuous colleagues.

1. See Winner 1968; Calamandrei
1971; Kemp 1974; Harprath 1977;
Pope-Hennessy 1985; Biancofiore
1998.
2. "la Tromba della nostra Fama
uiene da le Braccia."
3. "la diuina et immortal virtù del
nostro Illustrissimo e gloriosissimo
Duca Cosimo de Medici Amatore
del uero."

M. W. C.

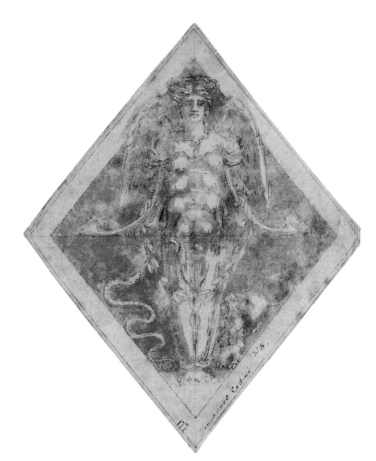

168

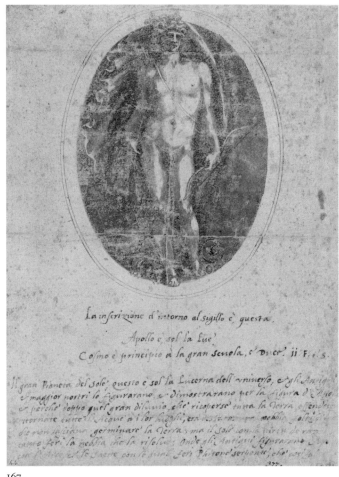

167

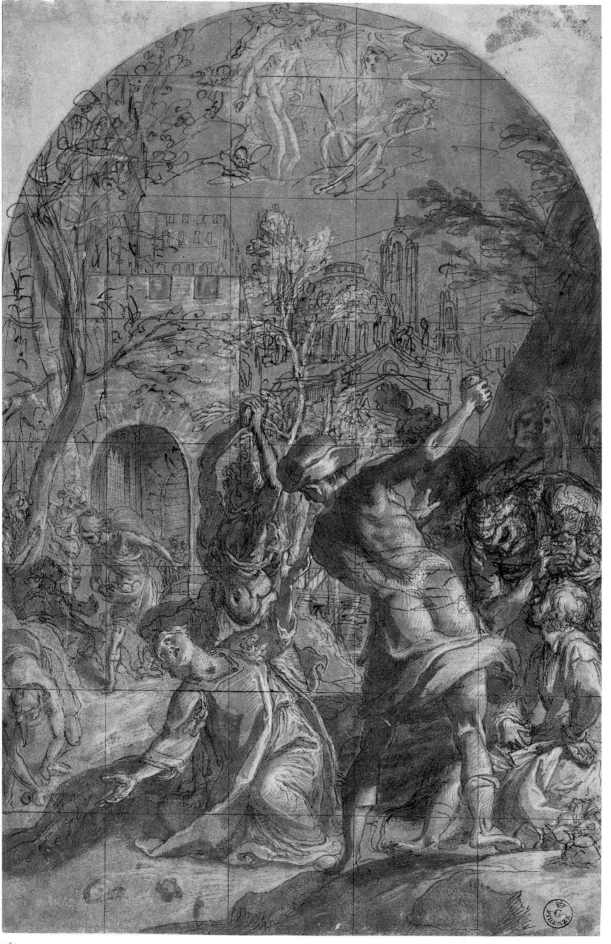

LODOVICO CARDI, CALLED IL CIGOLI
Florence, 1559–Rome, 1613

Martyrdom of St. Stephen[1]
1597
pen, brown wash, white and
black chalk on brown tinted
paper
42.2 × 28.6 cm

Florence, Gabinetto Disegni e
Stampe degli Uffizi

DETROIT ONLY

As St. Stephen, the first deacon,
succumbs to stoners outside
Jerusalem, he is transfigured with
rapture at the revelation of the
Trinity. In a manner typical of
this distinctive artist, Cigoli
conveys an extraordinary
impression of drama and
presence through the deft
drawing of the dynamic
figures and through the
strong suggestion of light
and atmospheric effects achieved
by his combination of wash and
white heightening.

Cigoli's painting of 1597 and
the many related drawings
demonstrate the realism and
dramatic pathos that made him
one of the leading painters of
the Counter-Reformation in
Florence and one of Grand
Duke Ferdinando's preferred
artists. Although commissioned
not for the Medici but for the
Convent of Montedomini in
Florence, the painting's
prominent Gate of St. Stephen
and domed structure may make
an early allusion to Ferdinando's
interest in Jerusalem and his
desire to acquire the Holy
Sepulcher from the Turks for the
Chapel of Princes, then being
planned for the church of San
Lorenzo.

In the sequence of some
twenty preparatory drawings
studied by Anna Forlani (1959),
Jack Spalding (1981), and the
present author (1992), the
present study is a late, almost
definitive composition in reverse
orientation. Great admiration for
Cigoli's painting is reflected in
its imitation by his followers and
by the judgment expressed in

1651 by the master of High Baroque invention, Pietro da Cortona, that it was one of the best paintings in Florence.

1. In addition to references cited within the text, see A. Forlani in *Mostra del Cigoli* 1959, pp. 126–27, no. 60; M. Chappell in *Il Seicento Fiorentino* 1986, vol. 2, pp. 119–20, no. 2.66; and Chappell 1992, pp. 64–68, no. 39.

M. L. C.

170

GIOVANNI BOLOGNA, CALLED GIAMBOLOGNA
Douai, 1529–Florence, 1608

Fountain of Samson and a Philistine[1]
(?)1569
ink and wash
30.5 × 26.5 cm

Florence, Gabinetto Disegni e Stampe degli Uffizi

CHICAGO ONLY

This drawing depicts the fountain that featured one of Giambologna's famous early figural groups, *Samson and the Philistine*. It was commissioned by Francesco I de' Medici and erected in the Giardine de' Semplice in the Casino di San Marco in Florence around 1569. Ferdinando de' Medici sent the fountain to Valladolid in 1601 as a diplomatic gift to the Duke of Lerma, the prime minister of Spain and the statue was in turn given to Charles I of England; today it is in the Victoria & Albert Museum, London, while the basin and pedestal are in the Royal Gardens, Aranjuez. The drawing has long been associated with another sheet in the Uffizi representing the fountain in an annotated plan; this second drawing is thought to be a diagram for reassembling the fountain's parts in Spain. Most scholars accept the present drawing as an autograph work by Giambologna, or possibly from his workshop, dating around the time of the commission. However, some

authors, such as Cristina Acidini Luchinat, relate it to the period of the moving of the fountain in 1601 and do not ascribe it to Giambologna's hand. There are too few drawings securely by Giambologna to be able to attribute graphic work to him with any confidence.

It is interesting to note how substantial the basin's pedestal is in this design compared with the trim pedestal conceived for the *Oceanus* fountain. In that instance Giambologna adapted his concept to an existing granite basin, whereas here he could design his own. Both the pedestal and the basin of *Samson and a Philistine* are notably complex and organic in form, inviting multiple viewpoints based on the four lobes and their divisions. The drawing suggests a principal view aligned with the center of one lobe, while, interestingly, the second Uffizi drawing mentioned above rotates the fountain 45 degrees to a view centered between two lobes but squared on the pedestal. This second view is not as satisfying for the sculpture as the first, though it permits a more mathematically accurate rendering of pedestal and basin. These slight shifts of viewpoint are intriguing in the case of a sculptor who so adamantly conceived his statues to be seen in the round and the drawings reinforce an understanding of Giambologna's use of the pedestal as a foil to train the viewer's eye on the statue. Whether this attractive sheet depicting the effect of light and shadow and the play of water was indeed a presentation drawing for the fountain's original commission or for a later moment in its complex history cannot be certain.

1. See Avery 1987, pp. 212–14, cat. no. 167.

I. W.

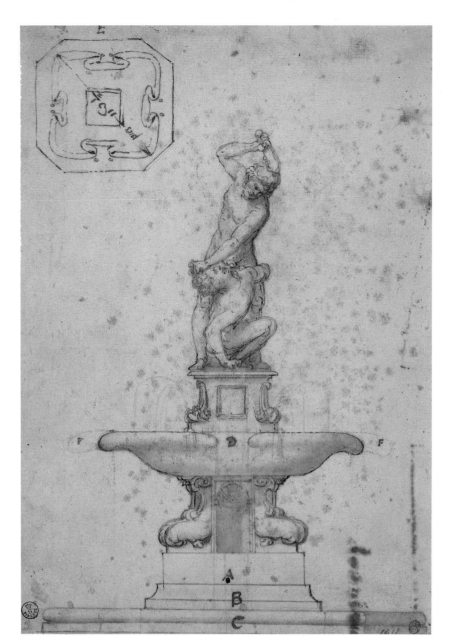

170

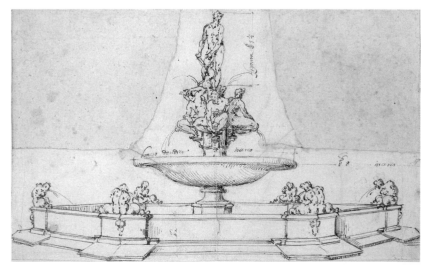

171

172

171

GIOVANNI BOLOGNA,
CALLED GIAMBOLOGNA
Douai, 1529–Florence, 1608

Design for the fountain of
Oceanus[1]
ca. 1575
sepia and black ink
20.2 × 33 cm

Visitors of the Ashmolean
Museum, Oxford

FLORENCE ONLY

The enormous granite bowl that
the sculptor Niccolò Tribolo
excavated on Elba in 1550 was
intended for a fountain on the
Prato Grande behind the Palazzo
Pitti in Florence's Boboli
Gardens. Tribolo's death in the
same year initiated a change of
plan that eventually transferred
the commission to Giambologna.
This rare drawing indicates the
sculptor's initial concept for the
fountain and may have been an
initial sketch for Duke Cosimo I
de' Medici, who did not live to
see the fountain's completion.

The granite bowl hovers
above a low hexagonal basin; six
monsters perch on the basin
edge and spout water into it.
Probably inspired by Tribolo's
similar hexagonal basins for the
fountains of *Hercules* and *Florence*
at Castello, the lower part of this
design was apparently never
realized. Although the tall
candelabrum arrangement of
figures may be indebted to
Tribolo's fountains, it is stabilized
by the horizontal sweep of the
great bowl. Documents indicate
that four blocks of marble were
sought from the Altissimo quarry
for the fountain after April 1571;
Malcolm Campbell (1991)
believes that the drawing must
date from around this time,
rather than around 1575, when
the fountain was put in place.

A comparison of the drawing
and the final work reveals the
sculptor's thinking process.
Though this is more of a
preliminary sketch than the
elaborate presentation drawing
for the fountain of *Samson and a
Philistine* (cat. no. 170), the
penned lines accurately render
the poses assumed by the marble
figures. The basin is raised higher
in its present form than the
drawing suggests. The three river
gods are shifted to the drawing's
frontal plane to be completely
visible, and they appear to
display a range of ages. This may
support the theory of Campbell
and others that the river gods
represent the ages of man and
personify the rivers of the world
of different geological ages.
Contemporary commentators
named them the Nile,
Euphrates, and Ganges, though
identification is problematic. The
figure grande is usually called
Oceanus. This deity is usually
shown as aged and rustic, but
the marble and the drawing
depict a virile god, rather like
the *Neptune* Giambologna had
recently carved for the fountain
in Bologna. Thin jets of water,
typical of Mannerist fountains,
remind us that the sculptor
had to consider not only the
proportions of figures in relation
to basins but also the pressure
and range of streams of water.

In 1618 the fountain was
moved near the Grotto della
Madama. As it now stands in its
third location on the Isolotto,
where it was moved in the
1630s, the fountain has lost its
conceptual framework. The
drawing has added significance,
therefore, as a means of
reconstructing its intended
appearance.

1. In addition to references cited
within the text, see Avery 1987,
pp. 273, cat. 168.

I. W.

172

GIUSEPPE GRISONI
Mons, Belgium, 1699–Rome,
1769

Drawing of a monumental
jeweled vase
ca. 1709–21
gouache heightened with
touches of gold paint over black
chalk on ivory laid paper
42 × 25 cm

Inscribed: "A+"

The Art Institute of Chicago,
The Leonora Hall Gurley
Memorial Collection

CHICAGO AND DETROIT ONLY

The Department of Prints and
Drawings of the Art Institute of
Chicago possesses thirty-six
drawings executed by Giuseppe
Grisoni for the Englishman John
Talman (1677–1727), a trained
architect whose most notable
achievement was the record he
made, in the form of drawings
by himself and other artists,
primarily of church antiquities
found in Italy. Drawings
commissioned by Talman are
present in a number of public
and private collections.[1] Of the
thirty-six drawings in the Art
Institute of Chicago, twenty-nine
record art objects that were in
the grand-ducal collection in
Florence at the beginning of the
eighteenth century at the time
the drawings were made.

The drawings were almost
certainly in the final lot of a sale
held by Mr. Cock's at Lincoln's
Inn Fields, London, in 1727
(Herrmann 1997, pp. 241), the
year of John Talman's death,
which included drawings
recording hard-stone objects
in the Florentine grand-ducal
collection. The drawings may
have passed into the collection
of the Duchess of Portland and
been sold in her auction of
1786. The Chicago Grisoni
drawings were next documented
in a sale held in London in
1914 (Puttick and Simpson's,
6 November 1914, lot 264),
where they were purchased by
William Gurley, whose widow
presented them to the Art
Institute of Chicago.

The present drawing bears a
mark: "A+," which has been
identified as the mark placed by
Talman on drawings made or
commissioned by him. Other
drawings at the Art Institute of
Chicago not under consideration
in this catalog show the "+"
proceeded by different letters of
the alphabet (Herrmann 1997,
pp. 228, no. 105). The
monumental jeweled vase is in
fact a rock-crystal vase with
gold-enameled and gem-set
mounts and was one of the most
famous hard-stone vases in the
Medici collections. It differs
strikingly from other late-
sixteenth-century rock-crystal
vases owned by the Medici
because of its monolithic form
and unengraved surface. Today it
is in the Museo degli Argenti,
Florence.

The craftsman who carved
the rock-crystal vessel cannot
be certainly identified, but
documents confirm that the
mount was completed in 1619
by the elderly court goldsmith
Odoardo Vallet. It was
immediately displayed in the
Tribuna of the Uffizi Gallery in
Florence (for an illustration and
full discussion with bibliography
see *Splendori di Pietre Dure* 1988,
pp. 84–85, no. 6). The vase's fame
is attested by Giulio Pignatti's
painting *Andrew Fountaine and His
Friends in the Tribuna* (Norfolk,
Norfolk Hall), painted in the
early eighteenth century around
the time that John Talman was
documenting Italian ecclesiastical
and princely collections through
his series of drawings. In the
Pignatti painting the vase is
placed in the center of a table in
the Tribuna, around which
Fountaine and his friends are
gathered. It is depicted with its
mounts in their original
condition. By 1782 one of the
handles had been removed. Only
one side is shown in the present
drawing, but presumably at the
time it was made the vase was
complete as documented in the
Pignatti painting.

1. See Herrmann 1997, a
monograph devoted to John Talman.

M. M.

173

GIUSEPPE GRISONI
Mons, Belgium 1699–Rome,
1769

Drawing of the bust of *Tiberius*
ca. 1709–21
gouache, heightened with
touches of gold paint over black
chalk on ivory laid paper
27.8 × 19.5 cm
Inscribed at the lower right of
the base of the bust: "Jos:Grisoni
delin"; at the bottom center,
directly below the base of the
bust: "The head of Tiberius. ye
head in one entire Torquois; ye
neck & busto are of/gold; ye
foot of sardonix. in ye Tribuna
of ye Gallery of ye Gr. Duke/in
Florence."

The Art Institute of Chicago,
The Leonora Hall Gurley
Memorial Collection

CHICAGO AND DETROIT ONLY

The drawing of the bust of
Tiberius bears an inscription
identifying the artist and this
and a further annotation are
both in John Talman's hand (for
other drawings commissioned by
Talman see cat. nos. 172 and
174). A larger drawing of the
bust of *Tiberius* with a Talman
provenance, also colored,
measuring 45 by 23 centimeters,
and without annotations is in
the Eton College Library,
Windsor, England (Bn 9, no. 2).
The bust of *Tiberius* was a pair
to the bust of *Cleopatra* (Millar
1967, no. 15 and Appendix,
"Contents of the Tribuna," no.
71) and was even better known
in the Medici collections (Gori
1731, vol. 1, tab. 3). The head
was once in the collection of
Cardinal Ferdinando de' Medici
(later Grand Duke Ferdinando
I), who had a gold bust added
to the turquoise head of the
emperor by the famous
sixteenth-century goldsmith
Antonio Gentile da Faenza
(Piacenti 1968, p. 140, no. 234;
Massinelli and Tuena 1992,
p. 120). The head and gold bust,
measuring 21 centimeters in
height, are supported on an
agate base, which was in place
by the late sixteenth century,
when the bust appeared in the

first inventory of the Tribuna as
"un Giulio Cesare" (dated 1589;
Gaeta Bertelà 1997, p. 23, no.
236). The subject of the portrait
bust, which has always been
named as Tiberius, is in fact the
Emperor Augustus (Boschung
1993, cat. 99, pl. 204). For
information on the display of
the bust of *Tiberius* in the
Tribuna of the Uffizi Gallery in
Florence, see cat. no. 174. The
Tiberius is today in the Museo
degli Argenti, Florence.

M. M.

174

GIUSEPPE GRISONI
Mons, Belgium, 1699–Rome,
1769

Drawing of the bust of
Cleopatra[1]
1717–before 1728
gouache, heightened with
touches of gold paint over black
chalk on ivory laid paper
27.2 × 14.4 cm
Inscribed at the lower right
of the base of the bust: "Jos:
Grisoni delin"; at the bottom
center, directly below the base
of the bust: "Cleopatra ye head
& Busto are of one piece of
Safirine Agate, ye foot is of gold.
in ye Tribuna in ye Gallery of
ye Gr. Duke in Florence."

The Art Institute of Chicago,
The Leonora Hall Gurley
Memorial Collection

CHICAGO AND DETROIT ONLY

This drawing's inscriptions, in
John Talman's hand, identify the
artist and the subject (for other
drawings commissioned by
Talman see cat. nos. 172 and
173). Talman's identification of
the subject as Cleopatra
(Cleopatra VII 70/69–30 B.C.)
did not find universal
acceptance. At the beginning of
the eighteenth century it was
named "Queen of Syria," by
none other authority than Anton
Francesco Gori (1731, vol. 1, tab.
28). Both the hairstyle (a
combination of those favored in
the Flavian and Trajanic periods)
and the bust's tunic and bare
shoulders indicate that it is
either not antique or that it is

315

The head of Tiberius. ye head in one entire Torqueil; ye neck & Gutto are of
gold; ye foot of Sardonix. in ye Tribuna of ye Gallery of ye Gr: Duke
in Florence.

Jos: Grisoni delin:

173

Cleopatra; ye head & Busto are of one piece of Sefirine Agate,
ye foot is of gold. in ye Tribuna in ye Gallery of ye
Gr: Duke in Florence.

Jos: Grisoni
delin:

174

heavily restored (Erika
Zwierlein-Diehl, written
communication). The bust's veil
further suggests that it is not
antique: coins of Cleopatra VII
do not show her veiled, but she
does appear in this manner in
Renaissance numismatic treatises,
such as Andrea Fulvio's *Illustrium
Imagines* (Rome, 1517), to which
a Renaissance or later carver
may have looked for a
prototype.

The drawing confirms that
the bust of *Cleopatra* was to be
found in the Tribuna of the

Uffizi, the centerpiece of the
grand-ducal collections, but does
not specify how it was displayed.
However, a small chalcedony
bust with a gilt bronze base
(19.5 cm high), now in the
Museo degli Argenti in Florence
and corresponding exactly to the
bust in the drawing, is depicted
by Johanne Zoffany in his
famous painting of the Uffizi's
Tribuna (Millar 1967, pp. 15 and
Appendix, Contents of the
Tribuna, no. 70) as a pair to the
bust of *Tiberius*. When Zoffany
completed his painting in the

1770s, and probably long before,
the *Cleopatra* was to be found
on the gilded wooden shelf with
drawers, supported on consoles,
that ran around the Tribuna
walls at a height allowing easy
access to the many precious
busts and small bronze and stone
sculptures it displayed.

The drawing is framed by a
double red-line border common
to a number of Talman's
drawings. Apart from the skillful
and faithful record it provides,
the drawing furnishes a
testimony to the importance

accorded the bust of *Cleopatra* in
the Medici collections.[2]

1. In addition to references cited
within the text, see Herrmann 1997.
2. For a discussion of John Talman
and the circumstances of the
drawing's acquisition by the Art
Institute of Chicago, see cat. no. 172.

M. M.

JACOPO LIGOZZI
Verona, ca. 1547–Florence, 1627

View of the Isle of Elba
1586
pen, wash, and white lead on
colored paper
43.5 × 36.9 cm

Florence, Gabinetto Disegni e
Stampe degli Uffizi

DETROIT ONLY

By the end of 1586 Jacopo
Ligozzi had completed his
decorations for the grotto of
Thetis within the colossal
personification of the *Appennine*
made by Giambologna for
Francesco I's villa at Pratolino,
near Florence. The space
frescoed by Ligozzi was
described by the Bolognese
scientist Ulisse Aldrovandi,
who recounted that the walls
represented two views showing
the isle of Elba and Livorno as
well as a variety of fish species
indigenous to the Tuscan coast,
copied from a series of tempera
panels depicting fish made by
Ligozzi for the Grand Duke.[2]

On the basis of this
description – documented also
by Agostino del Riccio –
Heikamp (1969, pp. 24) has
identified the present drawing,
which Berti (1967, fig. 144)
believed to be a design for a
tapestry, as the preparatory
drawing for the first of the two
frescoes. The work is extremely
interesting because of the
illusionistic effect of the gallery,
with spiral columns through
which the seascape can be
admired – a motif that returned
in the frescoes of Ognissanti –
confirming that the artist was
involved in the architectural
design of the space as well as its
subsequent decoration, as has
been suggested by Acidini
Luchinat (in *Risveglio di un colosso*
1988, pp. 19). The decorative
portrayal of the nets overflowing
with fishes to the sides of the
drawing shows a sophisticated
Mannerist sensibility, while the
tone of the scene remains simple
and charming, reflecting the
bucolic setting of the fresco.

175

This design for Pratolino
recalls the almost contemporary
design for the Tribuna in the
Uffizi, for which Ligozzi made a
frieze, listed in the Guardaroba
account books as showing
"several kinds of birds, fish,
water, plants, stones, shells, and
many other things,"[3] now
unfortunately lost but known
from an eighteenth-century
reproduction by Zoffany.

1. In addition to references cited
within the text, see Heikamp 1969a,
pp. 75, fig. 14, n. 13; A. Vezzosi in *Il*

giardino d'Europa 1986, pp. 42;
Conigliello 1992, pp. 23, 41–42, n.
64–66; and Heikamp 1994, pp. 137.
2. Biblioteca Universitaria di
Bologna, Ms Aldrovandi 136, Tomo
XI, cc. 73–78: "Descriptio brevis
fontium Pratolini." Quoted by
Heikamp 1969a, pp. 75, n. 13
3. "di più sorte uccielli pesci aqua
piante sassi nichi e più cose."
Archivio di Stato di Firenze,
Guardaroba Medicea 113, c. 194v; see
the transcription in Conigliello 1991,
pp. 27, 29, n. 18.

L. C.

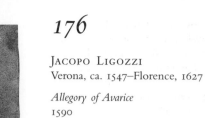

JACOPO LIGOZZI
Verona, ca. 1547–Florence, 1627

Allegory of Avarice
1590
pen and brown ink, with brown
wash and golden highlights on
paper
30.6 × 20 cm

Washington, D.C., National
Gallery of Art, Gift of Robert
H. and Clarice Smith 1984

FLORENCE ONLY

This drawing belongs to a series
representing the seven cardinal
sins. Six of the drawings survive:
Sloth and *Lust* (Paris, Louvre,
Cabinet des dessins, inv. 5037
and 5032), *Pride* and *Envy*
(Hanover, Niedersächsisches
Landesmuseum, Landesgalerie,
inv. Z42 and Z41), *Greed*
(location unknown), and the
present work. All the drawings,
with the exception of *Sloth*, are
dated 1590 and initialed by the
artist, but the letters, linked
by Ligozzi's characteristic
stroke on which a crucifix is
superimposed, have subsequently
been altered to attribute the
drawings to Hans Rottenhammer.

In 1920 Hermann Voss (1920,
fig. 165) identified the present
drawing (then in the Kuffer
Collection, Vienna) as a work by
Ligozzi, on stylistic grounds. It
is related to a painting by the
artist now in the Metropolitan
Museum in New York (inv.
1991.443) representing the same
subject but with the borders
reduced (the canvas may have
been cut) and some variations.
We cannot exclude the possibility
that Ligozzi may have based
other paintings on his drawings.
The drawings remain
unsurpassed, however, both for
the exquisite refinement of their
execution and the quality of the
line, enriched by the golden
highlights.

The composition of the
present work reflects an
undeniably northern sensibility,
with skeletons and a winged
monster dominating the vault,
while the thoughtful female
figure in the lower part presents

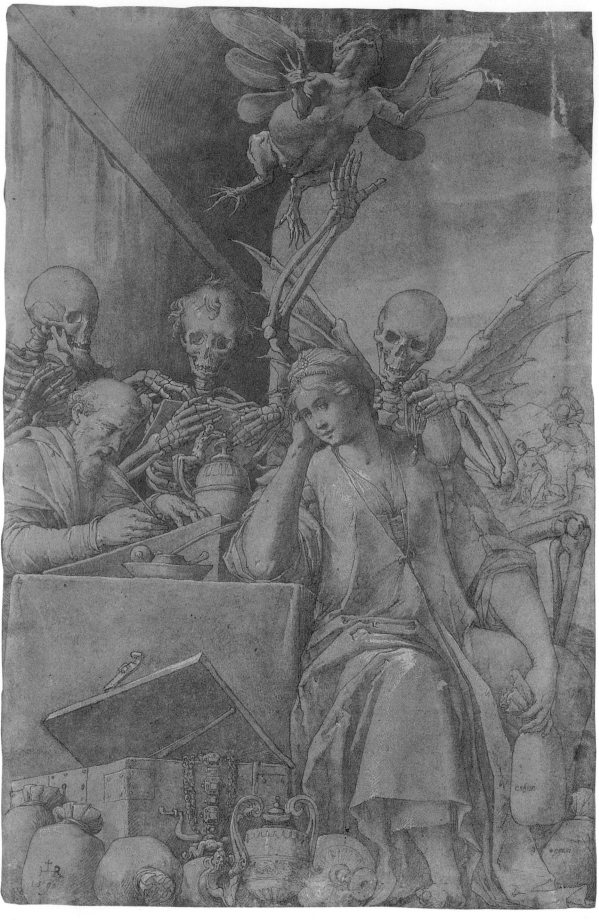

176

a host of riches: a casket, coins, jewels, and precious furnishings. The aggressive scene in the background remains unclear, while the representation of "writing" may allude symbolically to the greedy acquisition of material goods, suggesting also a different kind of contract – the "sale" of one's soul to the devil.

1. In addition to references cited within the text, see *Master Prints and Drawings* 1982, no. 13; and Feinberg 1991, ppp. 108–9, cat. no. 21.

L. C.

177

Jacopo Ligozzi
Verona, ca. 1547–Florence, 1627

Beech Tree from "The Apparition of the Virgin and Child"[1]
1607
pen and brown ink, brown wash on white paper
40.2 × 25.7 cm

New York, The Metropolitan Museum of Art, Harry G. Sperling Fund

CHICAGO ONLY

This drawing represents an ancient beech tree at the Sanctuary of Verna in Casentino – the site where St. Francis received the stigmata – in which, according to tradition, the Virgin miraculously appeared to bless the friars. The sheet belongs to a series of views of the Sacro Monte executed by Ligozzi when he visited the sanctuary in 1607. The works were commissioned by the Tuscan Franciscan friars for an illustrated guide to the mountain, which was published in 1612, featuring twenty-three plates engraved by Domenico Falcini and Raffaello Schiaminossi. Ten drawings by Ligozzi survive. The long-venerated tree no longer existed when the artist made the works, but he represented it from his imagination, taking care to show the large cavity of the trunk, reputed to have been large

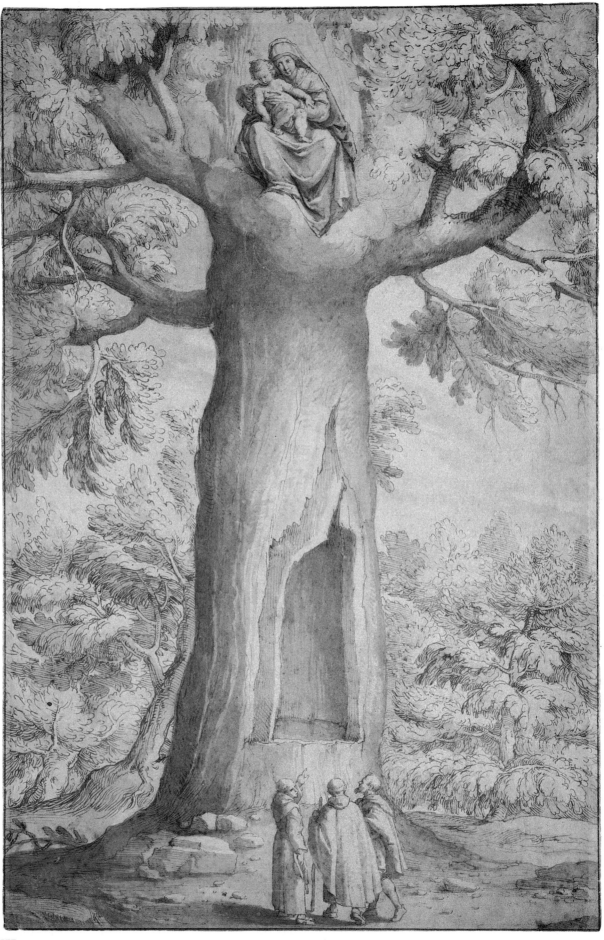

177

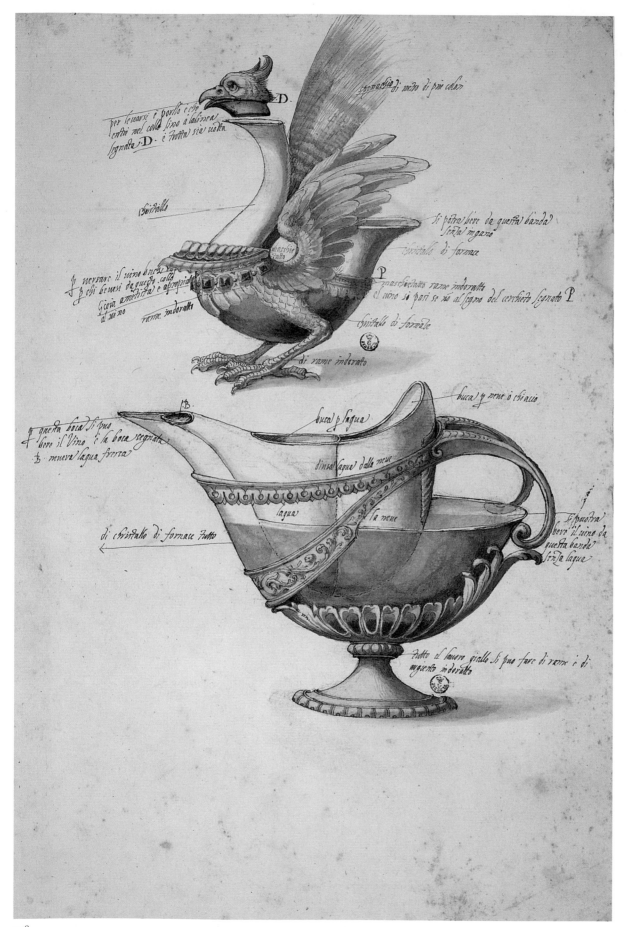

enough to hold five men. Ligozzi's extraordinary facility in representing nature is illustrated in the forest vegetation, which reveals a painterly sensibility influenced by northern art.

1. See Bean 1990; Griswold and Wolk-Simon 1994, pp. 40–41, n. 35, pp. 176, fig. 35; and Conigliello 1999, pp. 28–29, 96–97, fig. 6.

L. C.

178

Jacopo Ligozzi
Verona, ca. 1547–Florence, 1627

Caprice Glasses[1]
1618
pen, colored wash on colored paper
43.3 × 28.5 cm

Florence, Gabinetto Disegni e Stampe degli Uffizi

FLORENCE ONLY

The rise in interest in the production of virtuoso glass objects in Florence coincided with Tuscany's transformation into a grand duchy in 1569. In the same year Cosimo I invited the master glass artist Bortolo from Venice to set up a glass workshop at the Casino di San Marco. The tradition was continued by Francesco I, who admired objects in both glass (Bernardo Buontalenti produced some designs for such works for him) and in porcelain, while during the reign of Christine of Lorraine and Ferdinando I a precious collection of Milanese vases in rock crystal was assembled. Cosimo II ordered the establishment of a furnace to produce glasses with whimsical figures and it is to this area of experimentation that Ligozzi's designs belong.

On 8 October 1618 Ligozzi presented an invoice for the design of seventy-six glasses and jars, executed in pen and shaded or colored (Archivio di Stato di Firenze, Guardaroba Medicea 350, insert 2, c. 169r). In the early summer he had delivered another group of drawings, on

which he had presumably been working since the spring (Gabinetto Disegni e Stampe degli Uffizi, nos. 97155–69). Ligozzi's drawings form a substantial part of the various designs for glasses and cruets in Florentine collections, totaling about 350 drawings by different artists. The Veronese artist's works, bold, precious, with a great refinement of style, represent an extraordinary example of contemporary decorative artwork, and they display a creative approach similar to the designs for *pietre dure* inlay pieces executed by Ligozzi for the Medici court. We know from archival documents that in 1620 the artist also completed a series of drawings for knives. Ligozzi was especially appreciated at this time for his talents as a draftsman and decorative artist; when he was employed again by the Medici in August 1622 he was simply asked to draw, without any further specification, so that his work could be displayed in the Medici collections.

1. In addition to references cited within the text, see Berti 1967, pp. 123, 238, n. 30, fig. 142–43; and Heikamp 1986a, pp. 118–51, 197–212, 306, 310–11, fig. 106–33, pl. 11.

L. C.

179

179

JACOPO LIGOZZI
Verona, ca 1547–Florence, 1627

Horned Viper and Viper of Avicenna[1]
1577
chalk and colored tempera on paper
43.4 × 37.8 cm

Florence, Gabinetto Disegni e Stampe degli Uffizi

CHICAGO ONLY

This work documents the early Florentine activity of Jacopo Ligozzi, who was called from Verona to the grand-ducal court to paint an extraordinary series in tempera of plants and animals, both local and exotic, of which about 150 plates survive. The project was conceived by Francesco I, a sensitive sovereign who developed a strong interest in the arts and sciences at a time when new research was emerging as the late medieval encyclopedic approach to knowledge transformed into a more modern type of science, based on observation and on the verification of natural facts.

The drawing is known to be one of the earliest executed by the artist as it is mentioned in a letter from Ulisse Aldrovandi to the Grand Duke on 19 September 1577. The Bolognese scientist remembers that he received the two depicted snakes, which he describes as *cerastes* and *ammodytes* as a gift from Francesco I, but he regrets that he was unable to have them depicted because his painter was absent. A year later, on 8 September 1578, Aldrovandi wrote again to the Grand Duke to request a copy of a plate showing the vipers, executed the previous year by Ligozzi, as both snakes had died. He received the illustration only at the end of 1580.

An unparalleled observer of nature, in this tempera work Ligozzi still displays a Mannerist sensibility: the two reptiles are artfully arranged on the top part of the sheet, contorted into a twisted design typical of the late Renaissance.

1. See Bacci and Forlani 1961, pp. 25, cat. no. 1; M. Bacci in *Palazzo Vecchio* 1980, 594, pp. 295; M. Bacci in *Il Seicento fiorentino* 1986, vol. *Disegno, incisione, scultura, arti minori*, pp. 73, cat. no. 2.9; and *Ulisse Aldrovandi* 1989.

L. C.

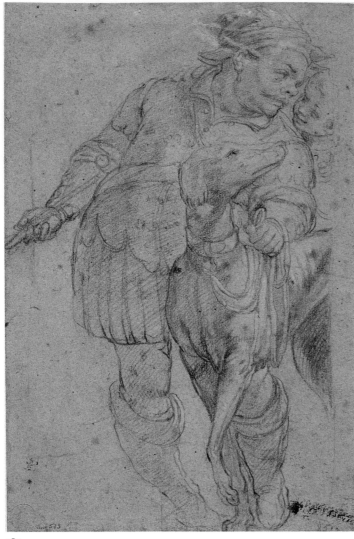

180

180

GIROLAMO MACCHIETTI
Florence, 1535–1592

Dwarf with a Dog and Boy[1]
ca. 1572–73
black chalk with traces of white
heightening on paper tinted blue
26 × 17.2 cm

Lille, Palais des Beaux-Arts

CHICAGO ONLY

Macchietti executed this lively
study in preparation for one of
his most important commissions,
the *Martyrdom of St. Lawrence*,
painted in 1573 for the Giuochi-
Compagnia di San Lorenzo
Chapel in the church of Santa
Maria Novella as part of Vasari's
grand enterprise to modernize
the altars of that church and
Santa Croce. With its dramatic

lighting, rich colors, and
dynamic, oblique composition –
elements derived from Venetian
art – Macchietti's image was one
of the most naturalistic and
progressive pictures created in
Florence up to that time. He
was almost certainly influenced
by Titian's painting of the theme
(1548–57) in the Chiesa dei
Gesuiti, Venice, and by the works
of Veronese, which Macchietti
must have viewed during an
undocumented trip to Venice,
probably made at some time
between May 1570 and January
1571 (Privitera 1996, pp. 50).

In the Lille drawing,
Macchietti has sensitively
rendered the intimate exchange
between the three observers he
would place at the center of
his painted composition, their
interested yet undisturbed
demeanors curiously at odds

with the horrific scene they
witness. In the painting,
Macchietti has portrayed several
specific individuals, including
himself at far right and the
patron, Girolamo Giuochi, and
his wife humbly posing at left.
It therefore seems likely that
the dwarf was modeled on the
ubiquitous Morgante, who
served at the courts of Cosimo
I, Francesco I, and Ferdinando I
de' Medici. Privitera (1996, pp.
142–45, nos. 46–49) has located
only four other drawings that
can be connected with
Macchietti's ambitious altarpiece
– a black-chalk *Self-Portrait*
(Munich, Staatliche Graphische
Sammlungen), two head
studies (Chatsworth, Duke
of Devonshire; and Milan,
Ambrosiana), and a study for
one of the background figures
(Paris, Musée du Louvre).

1. In addition to references cited
within the text, see Petrioli Tofani
1980, p. 137, no. 291; Brejon de
Lavergnée 1989, p. 102, no. 49;
Privitera 1989, pp. 42–43 and 47; and
Privitera 1996, pp. 57 and 142, no. 45.

L. J. F.

181

GIROLAMO MACCHIETTI
Florence, 1535–1592

*Seated Male Nude with Arms
Outstretched*[1]
ca. 1571–72
red chalk heightened with white
on paper tinted yellowish brown,
squared with black chalk
21 × 16.7 cm
inscribed on recto, in pen:
"Rosso"

Princeton, Princeton University,
Art Museum, Bequest of Dan
Fellows Platt

DETROIT ONLY

Long considered to be a
preparatory study for
Macchietti's painting of the
Baths of Pozzuoli (around
1571–72) in the Studiolo of
Francesco I in the Palazzo
Vecchio, Privitera has recently
reassigned the *Seated Male Nude*

to an earlier moment in the
painter's career. Because of
similarities of pose and what she
views as analogous inadequacies
of draftsmanship, Privitera relates
the study to Macchietti's studies
for an *Adam and Eve*, executed
in the mid- to late 1560s. In
light of the fact that the figure
in the Princeton sheet is
presented sitting on a rocky
outcrop rather than on the
dressed steps of a public bath,
Privitera is probably correct in
removing the drawing from the
group of extant studies for the
Studiolo picture. However, I find
the quality and style of
draftsmanship of the *Seated Male
Nude* to be very close to those
of his preliminary studies for the
Baths of Pozzuoli, which, like the
Princeton drawing, are strongly
reminiscent of Pontormo's life
studies of around 1525.

Macchietti, with his friend
and sometime collaborator,
Mirabello Cavalori, were
participants in a Pontormo
revival in Florence in the
1570s and 1580s. The young
academicians must have
examined carefully Pontormo's
most naturalistic drawings, such
as the life studies he created for
his *Supper at Emmaus* (1525;
Galleria degli Uffizi) formerly in
the Certosa di Val d'Ema (for
example, the study of a seated
male nude in the Uffizi, no.
6513F). Their debt to Pontormo
is especially evident in the
paintings the two artists
contributed to the Studiolo and
in their various preliminary
studies connected with these
works. In his Studiolo drawings,
Macchietti emulated Pontormo's
vibrant contours as well as his
sensitive indication of the
relative tautness or slackness of
skin, particularly in his rendering
of torsos (see Macchietti's
Reclining Figure on the Stairs,
Paris, Musée du Louvre, no.
8819; *Seated Nude*, Paris, Musée
du Louvre, no. 13717; and *Seated
Man with Beard and Hat*, Rennes,
Musée des Beaux-Arts, no.
794.I.2968). In these respects,
and in the convincing way
Macchietti has conveyed the
center of gravity and weight of
the figure, his *Seated Male Nude*,

drawn from life, significantly differs from his *Adam and Eve* studies, and approaches the quasi-Baroque naturalism of some of his later works.

1. See Gibbons 1977, no. 410; Scheafer 1982; Feinberg 1991, pp. 116–17, no. 24; and Privitera 1996, p. 111, no. 20.

L. J. F.

182

MICHELANGELO BUONARROTI (studio of)
Florence, 1475–Rome, 1564

Design for the tombs of the Magnifici[1]
1521
pen and ink with brown wash over black chalk, with extensive employment of ruler and compasses
38.4 × 24.4 cm

Visitors of the Ashmolean Museum, Oxford

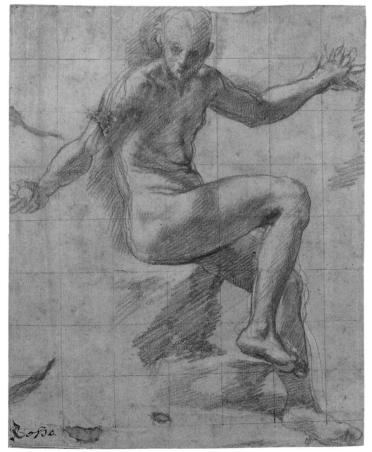

181

DETROIT ONLY

This is a replica of Michelangelo's design for the double tomb of Lorenzo il Magnifico and his brother Giuliano, planned for the entrance wall of the New Sacristy in San Lorenzo. Eleven other versions survive, many of them in the same technique (the present writer believes the version in the Musée du Louvre, Paris, inv. 838, to be autograph) and several sketch copies of different parts of the design are also known.

Michelangelo's authorship of this somewhat cluttered scheme was much doubted by twentieth-century critics and even Berenson denied it. But the number of replicas, which far outstrips any other series of copies of a Michelangelo drawing, testifies to the design's authority – one no later pastiche could claim. An advanced preparatory sketch of the scheme by Michelangelo is in the Louvre (inv. 686 verso), as is his study for the seated figure to

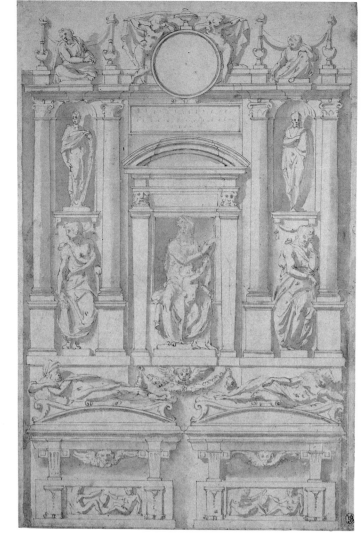

182

the viewer's left (inv. 708), and many of the scheme's forms and features find parallels in other works by Michelangelo.

The date of the scheme can be established with some precision to shortly before late April 1521, when the dimensions of the space available for the Magnifici and the ducal tombs were fixed. No work appears to have been carried out on the architectural parts of this tomb before the expulsion of the Medici from Florence in 1527, however, and the project was not resumed until 1532–33, when Michelangelo fundamentally revised the design. From this second phase he left no clearly worked-out drawings, and while the present design was no longer applicable, replicas were no doubt made with archeological intent to prevent knowledge of

an original, even out-of-date, being lost. Michelangelo's reluctance to disclose any details, demonstrated by his ambiguous responses to inquiries about the form of the Laurentian staircase, is sufficient explanation for the replication of those *modelli* that did exist, despite the fact that any attempt to construct the Magnifici tombs to this design after 1534 would have been confused by the changed forms and enlarged dimensions of the executed sculpture. A parallel example is the facsimile copy made by Jacomo Rocchetti (Berlin, Kupferstichkabinett) after Michelangelo's much damaged *modello* for the Julius tomb, which, when the copy was made, was entirely obsolete.

Although it is often claimed that the present design is modeled on a triumphal arch, its

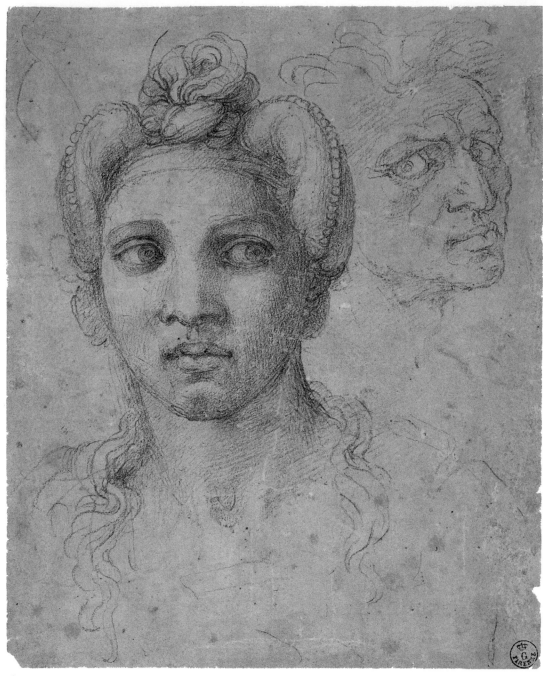

183

true antecedents lie in painting.
It is a triptych with flanking
figures on two stories – a
transposition into Romanizing
architecture and sculpture of
an ambitious late trecento
altarpiece. Complementing this
retrospection, the standing
figures on each side are based
on Nanni di Banco's *Isaiah* and
the shivering man in Masaccio's
Baptism of the Neophytes
respectively. Given that the
design was made after
Michelangelo had planned
immensely active and vital

figures for the tombs, its restraint
must have been deliberate – an
initial effort, later modified, to
achieve an over-all pictorialism in
the chapel, not to be disrupted
by unduly plastic forms.

1. See Parker 1956, no. 349; Dussler
1959, no. 674; Joannides 1972; Tolnay
1975–80, vol. 2, no. 194; and P.
Joannides in Androsov and Baldini
2000, no. 20.

183

MICHELANGELO
BUONARROTI
Florence, 1475–Rome, 1564

Heads of a Woman and a Man[1]
early 1520s
black chalk
20.3 × 16.3 cm

Florence, Gabinetto Disegni e
Stampe degli Uffizi

FLORENCE ONLY

P. J.

Traditionally attributed to
Michelangelo, this drawing was
reattributed to Bacchiacca by
Morelli (1892, col. 188) and is
still classed as his in the Uffizi.
But this work bears no
resemblance to Bachiacca's
drawings and Michael Hirst
restated Michelangelo's authorship
many years ago in an annotation
on the mount. Subsequent
criticism has unaccountably
ignored the drawing.

The technique is close to that
of the *Profile of a Woman* in the
British Museum, London (Wilde
1953, no. 42r), and the
heart-shaped face and treatment
of the hair recall those of
Michelangelo's red-chalk *Ideal
Head* in the Musée du Louvre,
Paris (inv. 12299), discovered by
Ann Sutherland Harris in 1964.
The latter is generally dated to
the early 1520s and the present
drawing is roughly contemporary.
It was probably made shortly
before Michelangelo drew three
sheets of expressive heads in
black chalk for his young friend
and pupil Gherardo Perini (all
now Florence, Galleria degli
Uffizi).

Some of Michelangelo's
presentation sheets may represent
no more than ideal types: the
Louvre *Ideal Head* and the
British Museum *Profile of a
Woman* are probably of this kind.
But Perini's *Fury* clearly
illustrates a mental or spiritual
state, and other heads by him are
of figures from history or myth:
for example, *Cleopatra*, in the
Casa Buonarroti, made for
Tommaso Cavalieri, is readily
recognizable. Another of Perini's
drawings stages a drama:
sometimes called "Venus,
Mars and Cupid," it probably
represents the ancient queen
Zenobia nursing her son and
chastely turning from her
armored husband – an example
of continence. It is the *Zenobia*
that the present drawing most
resembles in layout and action,
with the woman reacting to
the man, but while it may in
principle be a preliminary – or
alternative – idea for the same
subject, it more probably depicts
an as-yet-unidentified but similar
situation or narrative.

The close-up narrative – like the Ideal Head, of which it is a sub-branch – was put in currency by Leonardo da Vinci, but was most imaginatively developed in Venice, reaching a high point of inventiveness in Titian's *Bravo* (Vienna, Kunsthistorisches Museum). The accompanied half-length beauty was also omnipresent in Venetian painting in the second and third decades of the sixteenth century, perhaps most obviously in Titian's *Woman at Her Toilet* (Paris, Musée du Louvre). Michelangelo's design infuses the layout of the latter type with the dramatic intensity of the former and he had no doubt seen examples of such seductive and readily portable Venetian paintings either in Florence or Rome.

Michelangelo's presentation drawings, particularly those owned by Perini, were much copied and quoted by, among others, Bacchiacca, hence the reattribution of this drawing. However, the drawing seems to have had no afterlife and how and when it entered the Medici collections is unknown. Brought to a new pitch of expression by Michelangelo, the theme of the Ideal Head was much pursued in painting by Florentine artists during Cosimo's reign, notably by Michele di Ridolfo, who made a specialty of glamorous, quasi-boudoir versions of Michelangelo's designs, draining them of moral intensity. The theme was reprised again in drawings toward the end of the century by Jacomo Ligozzi, who restored to it something of Michelangelo's power.

1. In addition to references cited within the text, see Berenson 1903, no. 1630; Thode 1913, no. 207; Dussler 1959, no. 494; Tolnay 1975–80, p. 97.

P. J.

184

MICHELANGELO
BUONARROTI
Florence, 1475–Rome, 1564

Sacrifice of Isaac[1]
(?)mid-1520s
black chalk over traces of red chalk, touches of ink
40.8 × 28.9 cm

Florence, Ente Casa Buonarroti

DETROIT ONLY

The subject of the Sacrifice of Isaac had a significant history in Florentine art: it was the theme of the competition panel for the Baptistery doors in 1401, and was represented by Donatello on the campanile in 1423. Michelangelo perhaps wished to vie with these celebrated examples in this drawing, which may have been made for the double tomb of the Medici popes Leo X and Clement VII, planned for the end wall of the choir of San Lorenzo. This short-lived project, soon superseded, is known from a finished drawing in Christ Church, Oxford (no. 0992) which shows seated effigies of Leo and Clement flanking a group of the *Virgin and Child* with a narrative roundel above each pope, the right-hand one depicting the *Sacrifice of Isaac*. The present drawing is not obviously composed as a roundel but it could fit one and, if made for that relief, would be datable to 1525. Alternatively, it could be an independent variant, a development frequently found in Michelangelo's work.

Big, bold, and with loose open hatching, the *Sacrifice of Isaac* is characteristic of a type of drawing made in the early to mid-1520s and is closely comparable to a large, double-sided, and now partially dismembered sheet in the Musée du Louvre, Paris (inv. 710). It illustrates Michelangelo's desire, found also in some contemporary pen drawings, to enlarge and roughen his style. At times this manner, of relatively brief duration in Michelangelo's graphic work, comes close to

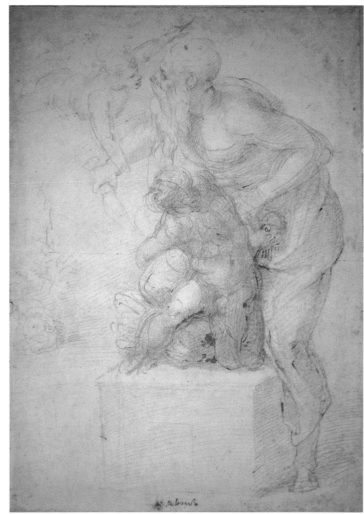

184

grotesquerie, but aspects of it anticipate the mode of the *Last Judgment*.

Abraham stands behind Isaac, his right leg raised and his foot braced on the altar. Isaac, set facing forward on a bundle of faggots, is pulled against his father's right leg, his own right leg stretched out and his left – which Michelangelo tried in two different positions – bent back. His torso is twisted to his left and his left arm is held back by his father while his right arm is bent over Abraham's right thigh. This severe constraint draws further energy from a current of intimacy found in the *Doni Tondo* and the *Bruges Madonna*. Correspondingly, Abraham's movements and gestures are not dramatic but deliberate and careful. His pose is relatively simple, registering perhaps Michelangelo's continued interest in the forms

of trecento sculpture, while that of Isaac, trembling with *pentimenti*, is exceptionally complex and reminiscent of the antique *Laocoön*.

Unusually in Michelangelo's work, the narrative is not thought through with full precision. The poses suggest that Abraham plans to cut his son's throat, but the blade faces outwards (although this would have worked better in one of the earlier poses explored for Isaac). The intervening angel points up to the viewer's right, apparently to nothing, while the head of the ram to be sacrificed in Isaac's place, which he usually indicates, is at the lower left. Such anomalies suggest that Michelangelo was planning a display piece, in which details of action were secondary to overall affect; perhaps they would have been corrected in a successive drawing.

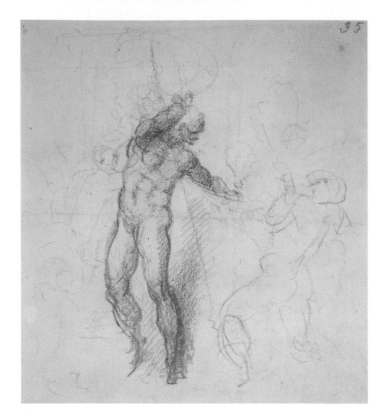

185

The drawing contrasts strongly with Andrea del Sarto's treatment of the theme in three paintings of the late 1520s, which follow a heroic, Donatellesque model.

1. See Berenson 1903, no. 1417; Frey 1909, no. 292; Thode 1913, no. 62; Dussler 1959, no. 275; Barocchi 1962, no. 140; Hartt 1971, no. 464; and Tolnay 1975–80, vol. 2, no. 283.

P. J.

185

MICHELANGELO
BUONARROTI
Florence, 1475–Rome, 1564

Descent into Limbo[1]
early 1530s
red chalk over indications in
black chalk
16.3 × 14.8 cm

Florence, Ente Casa Buonarroti

FLORENCE ONLY

This sketch, generally dated around 1530, was left relatively unresolved. No further drawings by Michelangelo developing the

design are known, nor is he recorded as having executed other treatments of the theme. Hirst (1981, p. 130) has suggested that the sketch was made to assist Sebastiano del Piombo with his *Descent into Limbo* (Madrid, Museo del Prado), but no more than the subject is common, and the identification of Sebastiano's painting as one of the wings of his *Entombment* (St. Petersburg, Hermitage), signed and dated 1516, eliminates any connection. The dynamism and lack of balance of Michelangelo's *Descent into Limbo* would be unusual in a design for an altarpiece and it seems more likely that it was conceived for a small painting or a relief.

Michelangelo received frequent requests for designs, many of which he ignored, and there must have been others of which we know nothing; this drawing could well be a response to one such request. However, it is possible that it was made for another project by Sebastiano, who in the early 1530s was planning to paint the altarpiece of the *Resurrection* in the Chigi Chapel in Santa Maria della Pace, left unfinished by

Raphael. It is generally, and surely rightly, believed that Michelangelo made drawings to assist him. In Raphael's scheme the altarpiece proper was to be flanked by two roundels in bronze, *Saint Thomas's Doubts* and the *Descent into Limbo*. If his patrons intended Sebastiano to maintain this iconography, the present drawing would find a home. The composition could fit into a roundel or, alternatively, the flanking images could have been changed to rectangles. The contract with Sebastiano refers only to the *Resurrection*, however, with no mention of subsidiary elements, so such a purpose can be no more than conjectural.

Michelangelo's treatment of the subject is unusually vigorous. Christ repels a devil with his right arm, and with his left pulls up towards him a figure, probably Adam. This double action parallels Michelangelo's conception of Christ in the *Last Judgment*, drawing the blessed towards him with his left arm and condemning the damned with his right. It also anticipates to some extent the pose of Christ in the master's much later design of *Christ Cleansing the Temple*, painted by Marcello Venusti.

The subject of the Descent into Limbo was treated by Bronzino in an altarpiece of 1552 for Santa Croce and by Alessandro Allori in a small-scale multi-figure painting that develops and extends Bronzino's model. Both Bronzino and Allori stressed Christ's compassionate rescue of the prisoners of the Old Dispensation, and neither took up Michelangelo's vision of the fierce Christ, very much in the master's mind while he was planning his fresco of the *Last Judgment*.

1. In addition to references cited within the text, see Berenson 1903, no. 1407; Thode 1913, no. 35; Dussler 1959, no. 427; Barocchi 1962, no. 135; Hartt 1971, no. 460, Tolnay 1975–80, vol. 1, no. 90; and Ragionieri 2000, p. 76.

P. J.

186

MICHELANGELO
BUONARROTI
Florence, 1475–Rome, 1564

Lamentation over the Dead Christ[1]
early 1530s
red chalk
32 × 25.1 cm

Vienna, Albertina

DETROIT ONLY

This drawing is comparable in theme, size, and medium with two others: a *Dead Christ with a Supporting Figure* also in the Albertina, also formerly dated late but now generally agreed to be of the early 1530s; and a ten-figure *Descent from the Cross* in the Ashmolean, Oxford, usually dated to around 1550, but again likely to be of the early 1530s. The Oxford drawing has been claimed by Nagel (2000, p. 205) to have been executed at two different periods, the sketchy surrounding figures around 1530 and the carefully worked central ones around 1545, but there is no trace of looser drawing under the central figures and it is improbable that Michelangelo would have omitted entirely the central section and returned to fill it in fifteen years later, leaving the remainder unchanged. The earliest known provenance of all three sheets is French and they may have gone to France in 1532, with Antonio Mini, who was perhaps responsible for the verso drawing, a fragmentary copy of Michelangelo's group of figure studies in the Musée Condé, Chantilly, of about 1505.

It is easy to understand the pressure to date these drawings late: the *Pietà* was of central importance to Michelangelo during his last two decades. The four-figure *Pietà* in Florence, and the *Rondanini Pietà* in Milan were both worked on over many years, the latter being extensively recut more than once. The *Palestrina Pietà*, which suffered an attempt at finishing in the early seventeenth century and is often now subtracted from the master's work, was probably blocked out

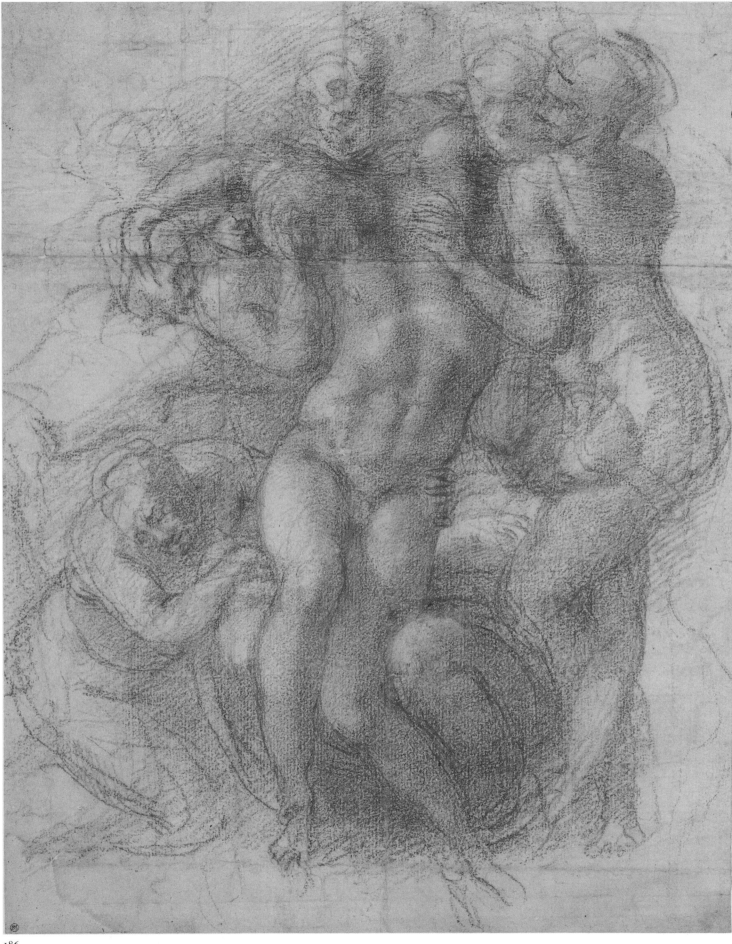

in the early 1550s; its heavy proportions correspond to those of Michelangelo's *Epifania* cartoon. Furthermore, the forms as well as the themes of all three drawings preview the stylistic imperatives of the aged Michelangelo, the Ashmolean sheet anticipating the three-dimensional complexity of the Florence *Pietà*; the angularity of the *Dead Christ's* body looking forward to the final version of the *Rondanini Pietà*; and the frontal relief-like arrangement of the present drawing anticipating the *Palestrina Pietà*. But the drawings are also retrospective. The complexity of the *Descent from the Cross* reprises the ambitions of the *Doni Tondo*; the *Dead Christ* takes up aspects of the father carrying his dead son in the *Flood*; and the *Lamentation* reworks the design of the *Entombment* in the National Gallery, London. In all three drawings Michelangelo strives for the severe and the massive: forms are confrontational, not beautiful. This, once again, looks both backwards and forwards: to the *Entombment* and to the *Doni Tondo*, to the *Last Judgment* and the Pauline Chapel. Such a style does not permit aesthetic distraction: it compels direct engagement with meaning.

The influence of this approach can be gauged in some of the paintings of Pontormo, whose forms thickened and gained in density after his contact with Michelangelo in the early 1530s. It can be seen also in Bronzino, who initially resisted Michelangelo's influence only to succumb to his late style after 1550. However, none of the three drawings discussed here had direct repercussions on Florentine art and no early copies of them are known – another indication that they left Italy early.

1. See Berenson 1903, no. 2503; Thode 1913, no. 522; Wilde 1953, p. 104; Dussler 1959, no. 697; Tolnay 1975–80, no. 432; and Birke and Kertész 1992, no. 103.

P. J.

187

MICHELANGELO
BUONARROTI
Florence, 1475–Rome, 1564

The Risen Christ[1]
early 1530s
black chalk
41.8 × 28.8 cm

Florence, Ente Casa Buonarroti

FLORENCE ONLY

In the first half of the 1530s Michelangelo made a number of drawings depicting the Resurrection. Some are multi-figure scenes with scattering guards; others show the single figure of Christ emerging in triumphant nudity from the tomb. It is improbable that both types were made for the same commission and it is the single-figure designs, of unmatched energy and power, that concern us here. As well as a number of rough sketches, mostly in the Casa Buonarroti, Michelangelo made two highly finished drawings, now in the British Museum, London, and at Windsor. A lost third drawing is known from copies in the Boymans-Van Beuningen Museum, Rotterdam, and the Galleria degli Uffizi, Florence (1450S), the latter by Alessandro Allori, who also copied the other two. The present drawing is much more fully developed than the sketches and, although looser in handling than the three finished studies, should probably be counted among them. Like them it is lit from the right.

The most likely explanation for the single-figure versions is a modification of a hypothesis first advanced by Hirst in 1961: that they were made to assist Sebastiano del Piombo with his 1530 commission to paint an altarpiece of the *Resurrection* in the Chigi Chapel in Santa Maria della Pace. The projected painting, for which no drawings by Sebastiano himself are known, would, like Raphael's sibyls and prophets frescoed above, have been lit from the right. In theory, any of the single-figure *Resurrections* could

have fitted the relatively small space available. Such figures, inappropriate for a large altarpiece, would have been acceptable for a small one, and Michelangelo may have seen single-figure altarpieces of the Risen Christ when he spent a short time in 1529 in Venice, where they were common – he often developed Venetian motifs when making drawings to assist Sebastiano. However, a drawing such as the present one, with Christ's complex pose and sinuous muscularity, would have put considerable strain on his friend's capacities as a painter of the nude, and it is notable that, in a drawing made for Sebastiano a little later, Michelangelo deliberately simplified the modeling.

Sebastiano never began the *Resurrection* and the Chigi Chapel remained without an altarpiece. Although one of Michelangelo's multi-figure *Resurrection* drawings was executed as a small painting by Marcello Venusti (Boston, Fogg Art Museum), the single-figure ones seem to have exercised only an indirect influence, probably transmitted via Alessandro Allori's copies. Bronzino's *Resurrection* in Santissima Annunziata owes some debt to Michelangelo's conception, as does Vasari's in Santa Maria Novella, and there remains a trace of Michelangelo's statuesque compactness even in later treatments, such as that by Santi di Tito.

On the verso of the present study is the most important surviving sketch for the layout of the *Last Judgment*, which Michelangelo seems to have begun planning in earnest in 1534. It no doubt succeeds the *Risen Christ* on the recto.

1. See Berenson 1903, no. 1413; Frey 1909, no. 20; Thode 1913, no. 57; Tolnay 1928, pp. 447–48; Dussler 1959, no. 55; Barocchi 1962, no. 142; Hartt 1971, no. 349; and Tolnay 1975–80, vol. 3, no. 347.

P. J.

188

MICHELANGELO
BUONARROTI
Florence, 1475–Rome, 1564

recto: Study for the *Ubeda Pietà*[1]
verso: Studies for the *Last Judgment*
ca. 1533–34
black chalk
39.9 × 28.5 cm

Florence, Ente Casa Buonarroti

CHICAGO ONLY

The main study on the recto was recognized by Berenson (1903, no. 1416) as preparatory for a sleeker, more developed drawing in the Musée du Louvre, Paris (inv. 716), and Panofsky (1927–28, p. 241) connected the two with Sebastiano del Piombo's *Pietà*, painted on slate for Francico de los Cobos, secretary of Charles V, and placed in his family chapel in San Salvador in Ubeda, Andalucia (now on deposit at the Museo del Prado, Madrid). Sebastiano seems to have received the commission in 1533 and to have completed it in 1539. As established by Brugnoli Pace (1967, pp. 105–9), the figure is based on a fragmentary and now lost Roman marble copy after a lost Hellenistic bronze by Aristonidas. In the Louvre drawing the torso is widened and somewhat flattened, the plastic emphasis of the musculature is reduced, and the play of light and shade is given a pictorial, emotive value, independent of the form, corresponding to Sebastiano's inherently simplifying style.

Michelangelo's drawings for the painting were probably made between 1534 and 1535 and his design involvement may have gone further: the woman supporting the dead Christ holds in her left hand St. Veronica's veil in foreshortening so acute that it is hard to read the face of Christ imprinted upon it. If, as is usually accepted, she is the Virgin, then she holds Veronica's attribute; if she is Veronica, she assumes one of the Virgin's functions. Such a fusion, and the

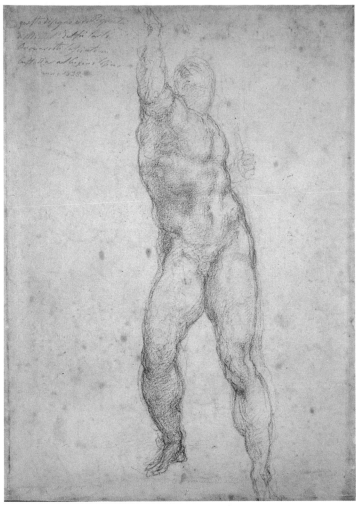

187

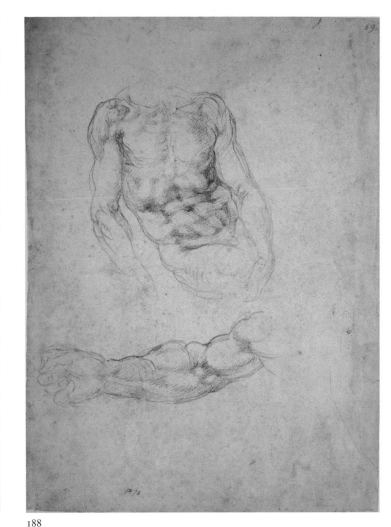

188

difficulty of descrying Christ's head, suggest Michelangelo's complex and poetic mind.

The second drawing on the recto, of a right arm and hand, is variously interpreted. Hirst thought it was for the right hand of Sebastiano's supporting woman, claiming that it was holding a nail, as in the painting, but it seems excessively masculine for a figure always intended to be female, and its extension would have created an awkward spread of arms across the picture field. Tolnay (1975–80, vol. 3, no. 91), followed by Ragionieri (2000, pp. 88–89), identified it as a study for one of the angels in the right-hand lunette of Michelangelo's *Last Judgment* and, while this remains conjectural, it is more likely that the drawing is connected with the fresco than with Sebastiano's *Pietà*. The design of the *Last Judgment* certainly underwent

changes as Michelangelo moved down the wall and this drawing, like others on the sheet, may have been intended for one of the figures in the "second tier," which were changed during execution.

On the verso, the small drawing of a turning figure is preparatory for a figure just above St. Blaise, to the right of Christ in the *Last Judgment*; the strong drawing of a right arm was probably made for St. Lawrence immediately below him on the left; and the synthetic head may have been an initial idea for that immediately to the right of St. Andrew, at the fresco's right edge. The small running figure seen from the rear presents a puzzle for critics: it is unlikely to have been intended for the *Last Judgment*, an episode that presents no possibility of flight, and the Pauline Chapel *Conversion of*

Saul was not yet envisaged. It may have been made for a project of which we have no knowledge – not to be ruled out even in the 1530s – but it is not dissimilar to some fleeing guards in at least two of Michelangelo's multi-figure drawings of the *Resurrection*, and it may have been made for another treatment of this subject which does not survive.

1. In addition to references cited within the text, see Frey 1909, no. 15; Thode 1913, no. 61; Dussler 1959, no. 274; Barocchi 1962, no. 143; Hirst 1981, pp. 128–29; Hirst 1988, p. 69.

P. J.

189

MICHELANGELO BUONARROTI
Florence, 1475–Rome, 1564

Fall of Phaeton[1]
ca. 1534
black chalk
39.4 × 25.5 cm

Venice, Galleria dell'Accademia

DETROIT ONLY

Three full compositions of the *Fall of Phaeton* by Michelangelo survive. The most famous is that now at Windsor, sent in August 1533 from Florence to Michelangelo's young Roman friend Tommaso Cavalieri. Like most of Michelangelo's gifts to Cavalieri, the drawing was educational as well as beautiful and its arrival was a public event. In his letter of thanks, dated 6 September, Tommaso

329

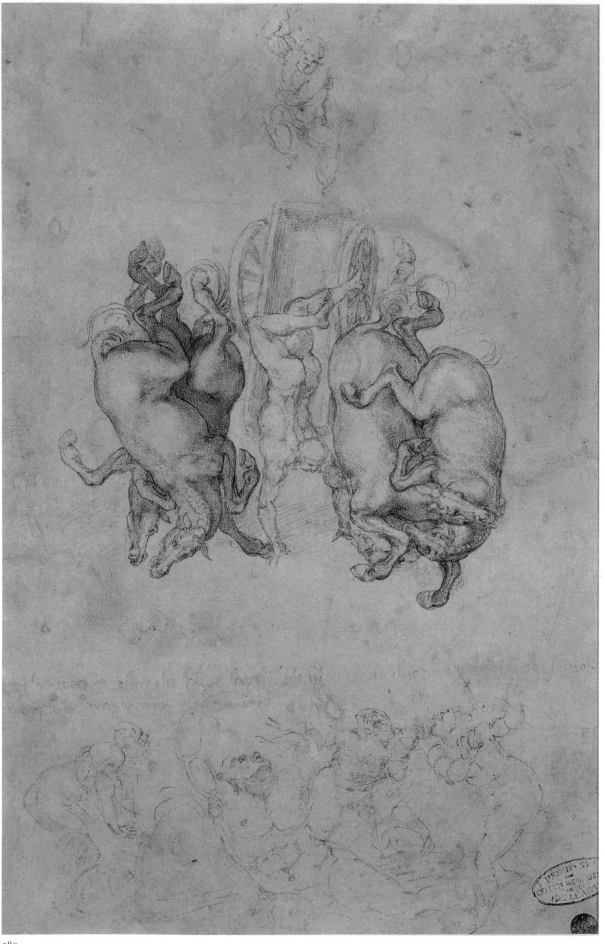

told Michelangelo that the Pope, Cardinal Ippolito de' Medici, and "ognuno" (everyone) had come to see it. Much copied and several times engraved, the drawing remained in Cavalieri's possession until his death in 1587, when it was acquired from his heirs by Cardinal Alessandro Farnese. A smaller, sketchier version, made earlier in 1533 and bearing a message to Cavalieri (London, British Museum), was also known to contemporaries, though not so widely; it too may well have been retained by Cavalieri, but its whereabouts before it first appeared in the Moselli Collection in Verona in the seventeenth century are uncertain.

Cardinal Ippolito de' Medici greatly admired Cavalieri's Michelangelos. He borrowed the *Tityus*, the *Ganymede* and the *Phaeton* to be reproduced in crystals by Giovanni Bernardi di Castel Bolognese and these were probably completed before Ippolito's death in 1536. Interestingly, the crystal of the *Fall of Phaeton* (Baltimore, Walters Art Museum), combines elements from both the Windsor and the British Museum drawings. By 1543 the three crystals had been acquired by Pier Luigi Farnese, who commissioned further complementary subjects from Perino del Vaga. Both these and the original crystals were to be set in a casket, the design of which was probably entrusted to Francesco Salviati (Robertson 1992). Vasari adds that Cardinal Ippolito commissioned a colored copy of the Windsor *Phaeton* from Salviati and that it also attracted the attention of other Florentine artists. A facsimile copy (Washington, National Gallery of Art, Woodner Collection), was made by Alessandro Allori, who was a major conduit for precise knowledge in Florence of Michelangelo's Roman presentation drawings.

The Venice *Phaeton* drawing is similar in size to that at Windsor, although less finished. No copies of it are known. Like the London sketch it bears a message, probably to Cavalieri, and its provenance is unknown:

189

either drawing may be a treatment of the subject recorded in the posthumous inventory of Fulvio Orsini. In the Venice drawing, the fall of the youth and of Apollo's chariot and horses is a precipitate plunge, unlike the starbursts of the other two drawings, which Wilde (1953, p. 92) believed to be earlier than the Venice *Phaeton*. The fact that the verso of the latter carries a study for a figure in the middle tier of the *Last Judgment*, which Michelangelo is unlikely to have drawn before 1534 and which presumably precedes the recto, supports his view. Michelangelo often made presentation drawings on used sheets.

1. In addition to references cited within the text, see Tolnay 1948, p. 112 ff; Dussler 1959, no. 234; Hartt 1971, no. 357; Tolnay 1975–80, vol. 3, no. 342; Hirst 1988, pp. 114–15; and Valenti Rodinò 1989, no. 26.

P. J.

190

MICHELANGELO
BUONARROTI
Florence, 1475–Rome, 1564

Design for a salt cellar[1]
1537
black chalk
21.7 × 15.5 cm

London, The British Museum

CHICAGO AND DETROIT ONLY

Michelangelo's achievement as a sculptor and painter of the human figure and as a supremely dynamic architect has led to a relative underestimation of his inventiveness and influence as a decorative designer. This was encouraged in part by Michelangelo himself, who in old age turned against ornament – advising Vasari, for example, not to include decorative carving in the Del Monte Chapel – and who aimed increasingly for austerity. While embellishment is not excluded in his late architecture, it is expressionistic not decorative, and even in

middle age, Michelangelo's "decorative" forms aim for meaning rather than pattern. Thus in the New Sacristy, for example, the vases at the bases of the tabernacles, the masks on the Dukes' armor, and the candelabra on the altar evoke the tomb chamber's central themes, representing a poetic advance on the grotesque panels on the lower story of Julius II's tomb, carved only a decade earlier and representing one of the few examples of "mere" ornamentation in his *oeuvre*.

Michelangelo made few designs for the applied arts. Several slight sketches of vases and urns survive but only two finished drawings for metalwork: a study for a lamp (Fogg Art Museum, Cambridge, Mass.), its purpose unknown; and the present drawing for a salt cellar, made in 1537 for the Duke of Urbino, to whom Michelangelo was obligated over his failure to proceed with the Julius tomb. The vocabulary is characteristic. The urn was a familiar form for Michelangelo; the lion's legs and paws related to early unexecuted ideas for the sarcophagus of Julius; aquiline profiles occur on designs for capitals of around 1505; and the garlands and bat-like heads are developed from those in the New Sacristy.

The energetic Cupid releasing an arrow on the lid is the sibling of one in a lost presentation drawing of around 1530, for which an autograph sketch survives in the Galleria degli Uffizi, Florence (251F). In Salviati's copy of the lost final version, also in the Uffizi, (14673F), Cupid fires an arrow outwards, while Venus, neglecting his supervision, studies herself in a hand mirror. Michelangelo's thoughts in the 1530s remained much occupied by the vagaries of Cupid and Love's archery, and here, with Venus entirely absent, Cupid is still more active than he was in the related drawing: to take salt is to risk his sting. Salt and love are analogous – enhancing flavor, they increase thirst – and, as the masks and the urn suspended from three

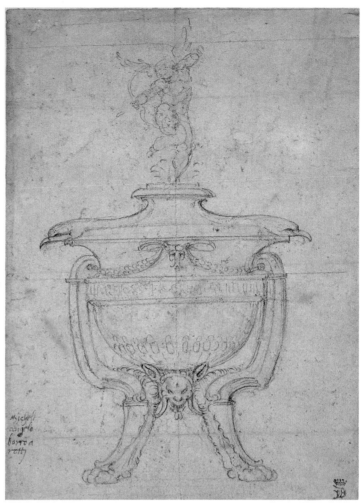

190

lion's legs imply, they are dangerous. Evoking tombs in general, this salt cellar's forms suggest the fatality of love. And since its profile as a whole so closely resembles the planned sarcophagus of Julius II – particularly clear in Michelangelo's *modello* for the tomb in the Metropolitan Museum, New York – the gift to the Duke was also a specific reference to, and partial substitute for, the stalled project. Characteristically, Michelangelo's wit is pungent, dense, and ironic.

Michelangelo appears to have had the salt cellar executed by a Roman silversmith, but there is no later record of it. Although his drawing – also known in a copy – no doubt influenced the "thematic" metalwork designs of younger artists, notably Salviati, its dense imbrication of function, form, decoration, and meaning is probably unique.

1. See Wilde 1953, no. 66; Dussler 1959, no. 582; Hartt 1971, no. 532; Tolnay 1975–80, vol. 3, no. 437, Hayward 1976, p. 343;. Hirst 1988, p. 13.

P. J.

191

BATTISTA NALDINI
Fiesole, ca. 1537–Florence, 1591

Head of the Statue of Giuliano de' Medici
ca. 1570
red chalk on white paper
22.7 × 16.3 cm

London, The British Museum

FLORENCE ONLY

In 1953 Wilde (p. 129, no. 101) cataloged this as an anonymous copy after Michelangelo, although he considered the attribution to Francesco Salviati proposed by Poham (in an

191

of decorations for the 1564 exequies of Michelangelo.

It is my opinion that the British Museum *Head of the Statue of Giuliano de' Medici*, excellent in quality and without the impersonal character typical of copies, shows a freer and less constrained treatment of line than the three aforementioned drawings, stronger in its contours and its rendering of volume through chiaroscuro. For this reason it should be considered a later work than the drawings at Princeton and Windsor Castle, probably dated around 1570. The drawing is chronologically close to two other copies by Naldini from the New Sacristy, similar both in technique and graphic style: the *Head of the Statue of Dawn* (Lille, Musée Wicar, inv. 550v) and the *Statue of Lorenzo di Urbino* (Bennington, Vermont, Held Collection).

M. C. F.

192

BATTISTA NALDINI
Fiesole, ca. 1537–Florence, 1591

Study for an *Adoration of the Shepherds*
ca. 1572–73
red chalk, brown wash on white paper
30 × 21 cm

Private Collection

This study for an *Adoration of the Shepherds*, realized with the immediacy of a sketch, has been verbally attributed by John Gere, Cristian Romalli, and David Lachenham to Battista Naldini. There can be no doubt about this attribution in view of the remarkable stylistic analogies between this and drawings certainly by this painter, in particular the energetic hatching defining the shaded areas, reminiscent of del Sarto, and the schematic and synthetic construction of the figures. Inspired by Venetian models perhaps known through Giorgio Vasari, the composition develops in depth along a diagonal line, and is delimited on the left by

annotation on the mount) convincing and worthy of further research. A closer analysis of the graphic style, carried out at the British Museum, has identified the author as Battista Naldini, who made well-known studies of Michelangelo's sculptures in the New Sacristy. The same painter has also

been identified as the author of two drawings at Princeton reproducing the statues of dukes Giuliano de' Medici and Lorenzo of Urbino in full length (see Gibbons 1977, vol. 1, pp. 141–42; vol. 2, n. 453–54), and of the copy of *Night* at Windsor Castle (Joannides 1996, pp. 144–45, n. 457). Executed in

black chalk and displaying a similar graphic style, controlled and accurate in the rendition of the smallest details, the three drawings are dated around 1565, only a short while after Naldini's return from Rome and his subsequent enrollment at the Accademia del Disegno and participation in the preparation

classical architecture. In the foreground three shepherds look towards the holy family, which is slightly further forward, on the right.

Another drawing by the artist of the same subject (Berlin, Kupferstichkabinett 15823), realized with the same technique, reproduces the composition of the present drawing with little variation, suggesting that the two were preparatory drawings for the same painting. To these must be added a third pen drawing (Galleria degli Uffizi, N.705 F), in which the scene, similarly structured, is enriched by groups of angels in the clouds above. The latter drawing is certainly related to the altar panel with the *Adoration of the Shepherds* in Santa Maria Novella in Florence, painted by Naldini for the Mazzinghi family in 1573, when the church was being refurbished by Vasari. If the sequence of the three drawings suggested here is correct and traces stages in the same creative process, the present study may constitute the initial concept for the altar panel for the Mazzinghi Family, in which the painter opted for a symmetrical composition, and abandoned the Venetian elements, conferring instead greater emphasis on the holy family, which is brought closer to the foreground.

M. C. F.

193

GIULIO PARIGI
Florence, 1571–1635

Sketch for the costume of an Indian soldier for *Guerra d'Amore*[1]

1616

pen, bister, and wash in various colors (yellow, mustard yellow, red, gray, pale blue) and highlights in purpurin; white paper, very yellowed, creased and stained, including two ink stains and one red watercolor stain

28 × 17.8 cm

inscribed on the upper part of the recto, a seventeenth-century

192

annotation: "23"; on the lower part of the verso in pen: "M.o di Giulio Parigi"

Florence, Biblioteca Marucelliana

FLORENCE ONLY

This drawing is a study for one of the costumes worn by the 164 Indians "clothed in rich and fantastic garb"[2] who held "the traditional bow of their country, and a plaque featuring a painted sun, emerging from the waves."[3] They accompanied the chariot of Lucinda, the queen of India, in the equestrian ballet *Guerra d'Amore*, staged in the Piazza Santa Croce. According to the courtier and diarist Cesare Tinghi, Giulio Parigi designed the costumes as well as the stage sets. A print by Jacques Callot showing the procession of chariots and their retinues features a figure similar to that in the present drawing, who is shown in the front row with the inscription: "Indian Soldier of the guard of the Queen."[4]

Nagler (1964, p. 127) identified two other sketches for theatrical costumes relating to this performance: an allegory of Dawn and an "Asian knight," both in the Biblioteca Nazionale Centrale, Florence.

1. In addition to references cited within the text, see Povoledo 1960; *Il disegno fiorentino* 1978, pp. 29–30, fig. 34; Blumenthal 1980, pp. 101–2, n. 47; and *I disegni dei secoli XV e XVI* 1990, p. 40, n. 144.
2. "vestiti d'habito ricco e capriccioso." Salvadori 1615, p. 8.
3. "l'arco all'usanza del paese, e la targa dove si vedeva dipinto un Sole, che usciva dall'onde." Salvadori 1615, p. 33.
4. "Soldato Indiano/della guardia/della Regina."

A. M. T.

194

BERNARDINO POCCETTI
San Gimignano, 1548–Florence, 1612

Madonna Appearing to St. Bernard[1]
ca. 1598–99
red chalk on white paper
23.2 × 19 cm

Florence, Biblioteca Marucelliana

FLORENCE ONLY

Although this sketch, first published by Thiem (1977, pp. 267–68, n. 6), shows an early stage in the development of the picture, it nevertheless contains the essential narrative and landscape components that would find a fuller realization in the final image, frescoed by Poccetti on the left wall of the Del Giglio Chapel, annexed to the church of Santa Maria Maddalena dei Pazzi in Florence. The interior decoration of the chapel, built by Tommaso Del Giglio in 1505 and bought from the Cistercian order in 1597 by the physician Nereo di Jacopo Neri, was entrusted by the latter to Passignano, the author of the altar panel with the *Death of Saints Nereus and Achilleus*, and to Poccetti, who was commissioned to paint the frescoes dedicated to the Virgin and to St. Filippo

Neri and St. Bernard of Chiaravalle.

As can be seen from the present drawing, Poccetti, an experienced interpreter of Counter-Reformation mores, chose to represent the Virgin's miraculous appearance to the founder of the Cistercian order in a clear and simple composition, inspired by the style of Andrea del Sarto. Evidently the painter initially intended to set the scene in the nave of a church with pillars, outlined swiftly and concisely in his drawing, following a diagonal sequence from left to right. In later phases of the image – a drawing squared for reproduction on a larger scale (Galleria degli Uffizi, 863F) and the fresco itself – Poccetti replaced the interior of the church with an arcade opening on the left onto the Loggia dei Innocenti. He also made significant changes to the poses of the group with the Virgin and Child, and introduced a table with books, a skull, and an hourglass.

1. In addition to references cited within the text, see Hamilton 1980, p. 65; G. Brunetti in *Disegni e incisioni* 1983, p. 84, n. 142; A. Pieraccini in *Il Seicento fiorentino* 1986, p. 87, n. 2.26; and F. de Luca and S. Vasetti in *Altari e committenza* 1996, pp. 159–72.

M. C. F.

195

Bernardino Poccetti
San Gimignano, 1548–Florence, 1612

Diana Surprised by Actaeon[1]
1607–9
red chalk on white paper
17.2 × 18.4 cm

Paris, Musée du Louvre, Département des Arts Graphiques

FLORENCE ONLY

The present drawing, believed to be by Francesco Furini when it was in the graphic collection of Filippo Baldinucci and preserving such an attribution when it was cataloged at the Louvre in 1806, was attributed to Poccetti in 1958 by Philip Pouncey (Stock and Scrase 1985, p. 154, n. 45), who recognized it as a compositional study for the monochrome showing *Diana Surprised by Actaeon* in the Sala di Bona of the Palazzo Pitti in Florence, frescoed by the artist between 1607 and 1609. As S. Vasetti (in *Magnificenza* 1997, p. 294, n. 241) has observed, the Louvre drawing, so finished in each of its parts as to look like a scale model, could almost be superimposed over the frescoed version, which was realized in brown tones and located under a statue of Diana by one of Poccetti's collaborators. Although the artist chose to work mainly on the most important scenes in the Sala, such as the Tuscan victory against the Turks at Bona and Preversa (1607), he provided his assistants with precise design instructions for the minor scenes.

Unusually, Poccetti chose to represent Actaeon, typically shown at the moment when he metamorphoses into a stag to be devoured by his own dogs, before his transformation, when the young hunter surprises the bathing Diana, thus provoking her wrath. With great narrative expediency the painter organized the composition in receding planes, placing Actaeon and the female figure on the right, who alerts her companions to the presence of the stranger, as if on the wings of a stage, opening onto the main scene where the spectator's gaze is directed towards the background to find Diana and the other nymphs in the act of covering themselves. Exploiting the white of the paper and using thick parallel chalk hatching, Poccetti shapes the volumes and evokes the tension of the scene to achieve one of the high points of his graphic work.

1. In addition to references cited within the text, see F. Viatte 1988, p. 78, n. 332.

M. C. F.

194

195

196

196

Bernardino Poccetti
San Gimignano, 1548–Florence,
1612

Studies for the draped figure of
a prophet
1598–1600
red chalk on white paper
26.3 × 18.8 cm

Florence, Gabinetto Disegni e
Stampe degli Uffizi

When Nereo di Jacopo Neri
acquired the Del Giglio Chapel,
beside the Florentine church of
Santa Maria Maddalena dei
Pazzi, in 1597, he dedicated it
to saints Nereus and Achilleus.
But he ensured that the old
dedication to the Virgin
would be remembered by
commissioning a fresco in
the dome, representing the
Coronation of the Virgin in the
presence of angels and saints.
When the Marian theme was
complete, Poccetti, who
executed all the frescoes in the
chapel between 1598 and 1600,
painted four virtues of the
Virgin in the pendentives, and,
lower down, in the spaces
between the windows, eight
seated prophets in full figure.

The present drawing is closely
related to one of these prophets,
specifically the one on the upper
right of the altar, an association
made by W. Vitzthum (note on
the laid sheet). As Hamilton
(1980, p. 64, n. 51) has noted, the
study, although it is not squared,
represents a very advanced stage
of the design and corresponds
in almost every detail – some
variation can be seen in the
draping – to the finished work.
The solid volume of the figures
in the Del Giglio Chapel, their
solemn poses, and the emphatic
gesturing of the eight prophets
are – as has been observed
before – a clear homage to
Michelangelo's Sistine Chapel,
which Poccetti sought to
evoke both in formal terms
and especially in the severe
expressions of the figures. The
prophet represented in this
drawing recalls in pose

Michelangelo's pondering
Jeremiah and Raphael's
Heraclitus in the *School of
Athens*. He emerges forcefully
from the background through a
skilled use of light and shadow,
with graduating chalk hatching
contrasting against the white
of the paper. A partial study
of his head appears on the upper
right side. On the preparatory
drawings for the other prophets
see the list compiled by
Hamilton (1980).

M. C. F.

197

Jacopo Carrucci,
called Pontormo
Pontorme, Empoli,
1494–Florence, 1556

Reclining Female Nude[1]
ca. 1533–34
black chalk on white paper
16.7 × 15.3 cm

Florence, Gabinetto Disegni e
Stampe degli Uffizi

Most literature agrees that this is
one of the drawings in which
Pontormo came closest to the
style of Michelangelo. This
tendency can be associated with
two cartoons by Michelangelo of
which Pontormo made paintings
at the beginning of the 1540s:
the *Noli me tangere* that Alfonso
d'Avalos intended to give his
aunt, Vittoria Colonna, and the
Venus and Cupid composed for
Bartolomeo Bettini. According
to Vasari (Vasaria–Milanesi
1878–85, 6, p. 277) this
allowed Pontormo to study
Michelangelo's style so that he
could imitate him convincingly.
At around the same time, at the
request of Ottaviano de' Medici
on behalf of Duke Alessandro,
Pontormo began a fresco project
for the Salone of the Villa
Poggio a Caiano, which,
according to Vasari, was to
include *Nudes Playing "Calcio,"* a
Hercules and Antaeus, and a *Venus
and Adonis*. Pontormo never
finished the decoration of the
Salone but he did produce
sketches.

197

The sketch of the female nude in the Uffizi displays a use of black chalk and treatment of outline characteristic of Michelangelo's graphic style and also evident in the preparatory drawings for Salviati's *Nudes Playing "Calcio"* (Florence, Gabinetto Disegni e Stampe degli Uffizi, inv. nos. 6505F, 6616F, 6738F, 13861F). In casual pose, the nude has often been associated with the decorative plan for the loggia at Castello executed at the beginning of Cosimo's reign, but it could just as well belong to one of Pontormo's fresco designs for Poggio a Caiano mentioned by Vasari, perhaps *Venus and Adonis*, or, more likely on the basis of recent archival research by B. Paolozzi Strozzi (1997), *Venus and Cupid*.

1. In addition to references cited within the text, see Cox-Rearick 1981, pp. 296–97; and Falciani 1996, p. 75, no. 5.9 (with bibliography).

Ph. C.

198

Jacopo Carrucci, called Pontormo
Pontorme, Empoli, 1494–Florence, 1556

Study for a reclining male nude, seen from behind[1]
ca. 1537–40
red chalk on white paper
21.2 × 28.9 cm

Florence, Gabinetto Disegni e Stampe degli Uffizi

CHICAGO ONLY

After he became duke of Tuscany in 1537, Cosimo paid special attention to the decoration of the Medici villa at Castello, which he intended to become the residence of his mother, Maria Salviati, who had played an important part in his accession. Like many other of Cosimo's commissions, the decoration of the loggia at Castello was designed to affirm his legitimacy. As Cox-Rearick has shown (1984, pp. 258–68),

the figures painted on the vault were intended to illustrate the favorable aspect of Cosimo's horoscope, setting down his destiny as the new founder of Florence, to which he would bring a golden age under the aegis of Saturn and Mars.

The young man magnificently drawn in red chalk on the sheet in the Uffizi, is in fact undoubtedly linked with the now lost allegories depicted on the vault at Castello. The reclining male nude inevitably evokes the figures that Michelangelo was producing at the time. Although it is unlikely that Pontormo had the opportunity to go to Rome during this period to study the *Last Judgment* on which Michelangelo was working, like many of his contemporaries he paid close attention to the great master's works in Florence, as is indicated by the young man's posture, inspired by Michelangelo's sculptures for the Medici tombs in the New Sacristy of San Lorenzo.

Pontormo's study of Michelangelo's style led to a transformation in his work. His figures henceforth look like exaggerated versions of Michelangelo's nudes, eliciting the censure of Vasari. They may be considered, nevertheless, as products of pure Mannerism, for which Pontormo had laid the foundations at the end of the 1520s.

1. In addition to references cited within the text, see Cox-Rearick 1981, p. 307; and Falciani 1996, pp. 158–59, no. 8.6 (with bibliography).

Ph. C.

198

199

Jacopo Carrucci, called Pontormo
Pontorme, Empoli, 1494–Florence, 1556

(a) Study for *Christ in Glory* with the *Creation of Eve*[1]
ca. 1546–56
black chalk on white paper
32.6 × 18.0 cm
CHICAGO ONLY

(b) Study for the *Resurrection of the Dead*
ca. 1546–56
black chalk on white paper
26.6 × 40.2 cm

DETROIT ONLY

(c) Study of a reclining nude for the figure of Adam from the *Creation of Eve*
ca. 1546–56
pencil on white paper
21.6 × 29 cm

Florence, Gabinetto Disegni e Stampe degli Uffizi

FLORENCE ONLY

In the 1550s Cosimo I de' Medici began a vast cultural campaign that included exploitation of the topography of Florence to symbolize his power. Plans for decorative cycles of paintings intended to legitimize and glorify the new ruling dynasty were drawn up by the most eminent members

of the Accademia Fiorentina (founded in 1542), under the direction of the Duke's major-domo, Pierfrancesco Riccio. Around 1545 Riccio obtained the commission to decorate the choir of San Lorenzo for Pontormo, passing over Francesco Salviati, who attempted to present his own preparatory scheme to the Duke. Pontormo devoted the last ten years of his life, from 1546 to 1556, to the project, which was of considerable importance to Cosimo: in preference to the cathedral of Santa Maria del Fiore, San Lorenzo, burial place of the Medici family, was to provide the setting for the funeral ceremonies of the new regime.

Already, around 1525, Pope Clement VII had turned first to Baccio Bandinelli and then to Michelangelo to decorate the choir of San Lorenzo. Twenty years later, after Michelangelo's *Last Judgment* had astounded the art world, Cosimo sought for the choir a fresco cycle of the order of that in the Sistine Chapel. The choice of Florence's most Michelangelesque artist therefore prevailed. Having received the commission, Pontormo would certainly have traveled to Rome in order to study Buonarroti's latest work. The parallel between the two fresco cycles was obvious to everyone at the time; Vasari (Vasari–Milanesi 1878–85, 6,

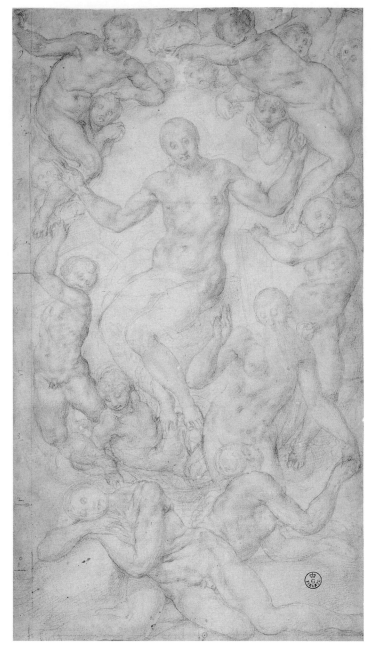

199a

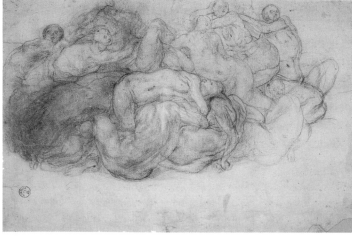

199b

p. 286) even perfidiously hinted that Pontormo intended to surpass Michelangelo.

The biographer, whose *Lives of the Painters* was published in an enlarged edition in 1568 (four years after the promulgation of the edicts on art of the Council of Trent), harshly criticized Pontormo's figures for the choir, accusing the artist of using no consistent convention, and trying to excuse Pontormo, whom he nevertheless admired, on the grounds of mental imbalance. Vasari's criticism was repeated and amplified by Raffaello Borghini (1584, pp. 78–82), prompting a general aversion towards Pontormo's frescoes that led to their destruction in 1738 when the choir of San Lorenzo was rebuilt.

It would appear that the esthetic heresy denounced by Vasari and Borghini was intended to mask a graver, religious heresy. Indeed, Vasari wrote: "But I could never understand the doctrine behind his story."[2] It has been shown that these frescoes illustrated Juan de Valdès's catechism in the form adapted by the *spirituali* of Cardinal Pole's circle. At the time of the opening of the Council of Trent (13 December 1545), the Valdesians' doctrine of justification by faith alone, far from being considered heretical, was defended by some of the most eminent members of the Curia, as well as by individuals at the court of Charles V, in the hope of reaching a reconciliation between the different sides in the dispute. The Council's recognition of the theology of *sola fide* was, for Cardinal Pole, already in line to be the next pope, the only solution to the conflict within the Church. In the early 1540s the adherence of certain Italian aristocrats, as well as Michelangelo, to Valdesian spiritualism could still appear legitimate. In 1545–46, when Cosimo de' Medici had precepts from Valdesian texts inscribed on the walls of the choir of his family church, his choice was political as much as religious; he was demonstrating his support for a reformed and unified

church, such as many Florentines desired.[3] It transpired, however, that Valdesian theology was judged heretical by the Council. Thus Vasari, in denouncing the esthetic heresy of Pontormo's cycle, was attempting to cover up its content in order to protect the frescoes from possible destruction, and above all to protect the ducal family and its entourage from suspicion.

Despite being considered scandalous by post-Tridentine bigotry, the frescoes, by virtue of the fact that they remained sacred images, were not destroyed but simply abandoned. As was long supposed but only recently proven, the complex program was conceived primarily by Benedetto Varchi (see Simoncelli 1995; and Firpo 1997, pp. 218–90). Following his return from exile in 1543, this great Florentine literatus enjoyed the favor of the Duke and his major-domo; he was appointed consul of the Accademia Fiorentina in 1545, and in 1547 Cosimo commissioned him to write a history of Florence. His links with the *spirituali* are well known. He was a close associate of Pontormo and paid him regular visits during the painting of the frescoes and was a fervent admirer of Michelangelo's *Last Judgment*, which he saw in 1544.

The San Lorenzo frescoes are irretrievably lost. Several reconstructions of their arrangement have been proposed, culminating with that of Cox-Rearick (1992), which has been supported, with modification of only a few details, in subsequent literature. The style of the frescoes is known from a vast collection of graphic documentation, most of which is today in the Galleria degli Uffizi. A preparatory study for *Christ in Glory* with the *Creation of Eve* (a), located at the upper level of the scheme in the center of the choir, shows how this crucial scene must have appeared. Christ, flanked by nude figures, is not without echoes of his counterpart in the Sistine Chapel, just as the figure of Adam visible at his feet, for which sheet (c) is a study,

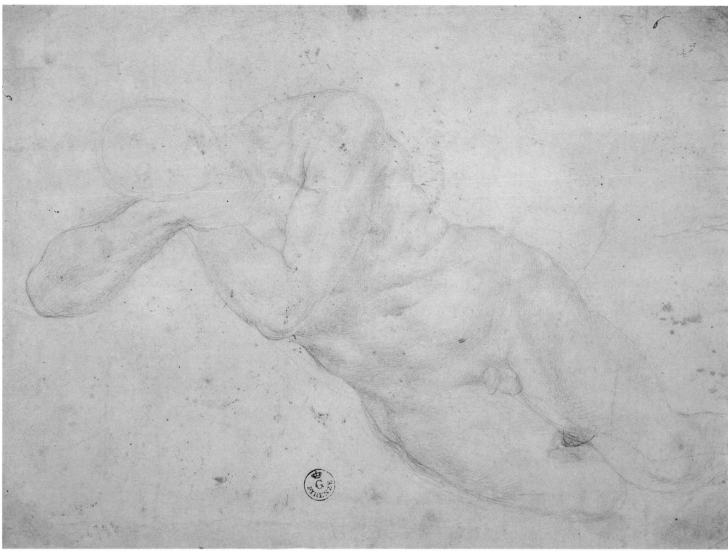

199c

presents the heroic aspect of the nudes in the Sistine. The impact of Michelangelo is equally evident in the lower frescoes that depict, at left, center, and right of the choir, the *Flood*, the *Ascension of Souls*, and the *Resurrection of the Dead* respectively.

Among the drawings shown here, (b), on the verso of which is a study for *Venus and Cupid*, has generally been related to the fresco of *The Flood*, but the number of living figures and the similarity with the lower section of drawing 6528F in the Uffizi suggest rather that this sketch is a preparatory study for the *Resurrection of the Dead*.

1. In addition to references cited within the text, see Cox-Rearick 1981, pp. 331–34, 335, 340, 340–41; Falciani 1996, pp. 186–87, no. 9.11; pp. 187–90, no. 9.12; pp. 181–83, no. 9.6; and Prosperi Valenti Rodinò 1989, p. 144, with bibliography.
2. "Ma io non ho mai potuto intendere la dottrina di questa storia." Vasari–Milanesi 1878–85, 6, p. 286.
3. On this question see most recently Firpo 1997.

Ph. C.

200

FRANCESCO DE' ROSSI, CALLED SALVIATI
Florence, 1510–Rome, 1563

Dawn (after Michelangelo)
ca. 1545–46
black chalk
38.2 × 20.9 cm
inscribed on the recto: "fra Salviati/inventio [?] de M. Angelo"; on the verso, in the same hand: "Fr. Salviati"

Edinburgh, National Galleries of Scotland

CHICAGO ONLY

The attribution is inscribed in pencil on the mounting sheet, which was cut, probably in the eighteenth century, and then pasted onto a new support, on which it was badly aligned, as noted by Paul Joannides (in Monbeig Goguel 1998, pp. 96–97, no. 8). The drawing was engraved by Jan de Bisschop and included in his volume of reproductions of well-known works of art, *Paradigmata Graphius varium Artificum*, published in the Hague in 1671 (Raphaël Rosenberg, private communication, 1993), and the attribution to Salviati is confirmed by the artist's name in the caption to this engraving.

Michelangelo's four sculptures for the Medici tombs in Florence, the *Times of Day*, were in place in 1546 when Salviati was working on the decoration of the Sala dell'Udienza in the Palazzo Vecchio. It is clear from the viewpoint in this drawing that the artist had the sculpture

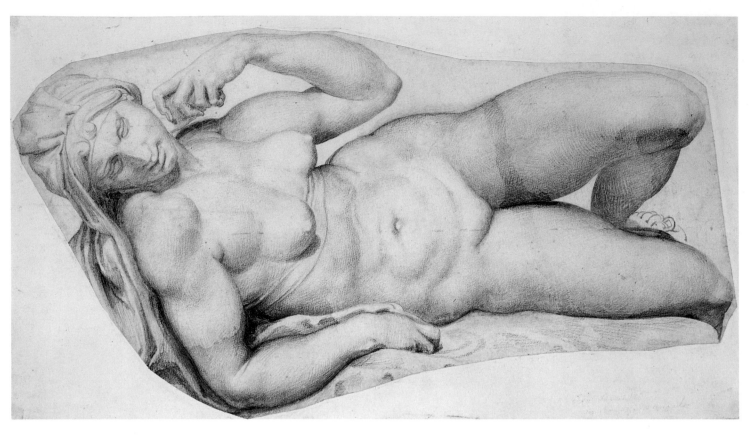

200

of *Dawn* before his eyes, suggesting that the sketch was executed before the sculpture was installed. A further study of *Dawn* in the more delicate technique of red chalk had already been made by the artist several years earlier, judging on stylistic grounds (British Museum 1900-8-24-118).[1] In the present drawing, black chalk gives a different *sfumato* effect; Salviati is less interested in elegance of drawing than in the flowing, energetic effect of musculature, and he is faithful to the ideal of female beauty pursued by Michelangelo, aiming more at fullness of form than at *grazia*.

Michelangelo was a constant and central source of inspiration for Salviati, who made copies of such major works as *David* and possessed several of the master's drawings, acquired by unknown means. In the present writer's opinion the delicate interpretation of the celebrated *Allegory of Wisdom* (Cologne, Walraf Richartz Museum, inv. no. 21999) is also Salviati's work.[2]

1. See Mortari 1992, p. 137, no. 270; and attribution to Salviati by Hirst 1963.
2. See C. Monbeig Goguel in *Il disegno di Francesco Salviati*, exhibition catalog, pp. 31–46.

C. M. G.

201

Francesco de' Rossi, called Salviati
Florence, 1510–Rome, 1563

Christ Carried by Angels Appearing to St. Thomas[1]
1544–45
pen and brown ink, and brown and gray wash, heightened with white, on black chalk
30.6 × 25.9 cm

Paris, Musée du Louvre, Département des Arts Graphiques

CHICAGO ONLY

This drawing is clearly linked to the painting *The Incredulity of St. Thomas* (Paris, Musée du Louvre) of 1545, despite its differing formal and iconographical

conception. Whereas in the painting and other preparatory studies, such as that on the Vasari page in the *Libro de' disegni* (Inv. 1642), Christ is shown standing, he is here seated and carried by cherubs as if to signify by this levitation the supernatural character of the apparition, the group being imagined to have descended from Heaven. There are strong contrasts of light and shade. The aureole, a symbol of sanctity that was the subject of fierce dispute at the time, when debate raged about the images of saints, is represented by a reserve of white paper in particularly striking relief. It is likely that this abandoned version reflects theological concerns and a desire to renew traditional iconography.

In contrast to the study on the Vasari page in the *Libro de' disegni*, St. Thomas is depicted with a young man's features, as in traditional images. Represented in a state of weightlessness, Christ parts the edges of his wound with hooked fingers. This powerfully realistic gesture is also seen in the drawing in the *Libro de'*

disegni, but thereafter Salviati progressively watered down this first imaginative if unorthodox image. Exaggerated gestures and expressions and a caricatural style (large eyes, serpent-like hair, as in Rosso, deformed hands, and simplified profiles) are Salviati's stock-in-trade through the years 1540–50.[2] There is no reason to doubt his authorship.

1. In addition to references cited within the text, see Cox-Rearick 2001; C. Monbeig Goguel in Monbeig Goguel 1998, pp. 154–55, no. 40; Mendelsohn 1998; and Rearick 2001, pp. 455–78.
2. For a typological connection with the figures of Giulio Romano, see Cox-Rearick 2001.

C. M. G.

202

FRANCESCO DE' ROSSI
CALLED SALVIATI
Florence, 1510–Rome, 1563

Peace Burning Arms[1]
1543–44
pen and brown ink, brown wash
19 × 10 cm

London, The British Museum

FLORENCE ONLY

This drawing is one of the most accomplished and subtle surviving graphic documents relating to the decoration of the Sala dell'Udienza of the Palazzo Vecchio executed by Salviati for Cosimo I between 1543 and 1548. The general theme of the decorative scheme is the glorification of the ancient Roman hero Furius Camillus, a political model of the prince liberator. Large-scale scenes on subjects drawn from ancient history alternated with allegorical figures inserted into decorative motifs. In the present work Salviati made a study for the section above the door connecting the Sala dell'Udienza with the Sala dei Gigli.

The subject of Peace burning arms had already been treated by Pierino del Vaga in the decorative scheme of the Palazzo Baldassari in Rome. Salviati's drawing, which dates from between the end of 1543 and summer 1544, introduces variations on the motifs of his final fresco – in the allegorical figure, almost nude, whose right foot is hidden and who holds a slender-leafed palm-branch; and in the discreetly indicated cartouches, the armorial trophies reminiscent of those of Polidoro at the Palazzo Milesi, and the prisoners, of whom the one on the left does not yet wear the Phrygian cap of the final version.

The drawing also documents the appearance of the statue of *Justice*, sculpted by Benedetto da Maiano, which is today mutilated: it originally carried a globe in one hand and a sword in the other.[2] The head of Virtue in the drawing, however, turned to the right, does not correspond to that of the statue of Justice and must be a whim of the artist. Salviati made a separate study of the elegant figure of Peace (Prague, National Gallery; see C. Monbeig Goguel in Monbeig Goguel 1998, p. 180, no. 54). The painted composition was celebrated from the sixteenth century onwards, as numerous copies and derivative works demonstrate: one of the best known (Frankfurt, Städelsches Kunstinstitut), attributed by Voss to Salviati in 1920, was recently attributed to Pellegrino Tibaldi (McTavish 2001).

1 In addition to references cited within the text, see A. Cecchi in Monbeig Goguel 1998, p. 180, no. 55.
2. Vasari 1967–87, vol. 3, pp. 529–30.

C. M. G.

203

FRANCESCO DE' ROSSI,
CALLED SALVIATI
Florence, 1510–Rome, 1563

Study for a helmet with crest[1]
ca. 1545
pen and brown ink, brown wash, traces of red chalk, on faded blue paper; touching up on blanks and wash
49.7 × 37.2 cm

Paris, Musée du Louvre, Département des Arts Graphiques

DETROIT ONLY

This frequently exhibited drawing is similar in style and richness of texture to the study of a vase at Oxford (Parker 1956, inv. 687; Monbeig Goguel 1998, pp. 272–73, no. 107), one of the best known ornamental drawings of the cinquecento, and it is illuminating to look at the two together and in conjunction with the goldsmith work of Benvenuto Cellini. The work is a rare source of information on the taste of the *grande maniera* and the forms that inspired the production of luxury armor in the cinquecento. It also indicates

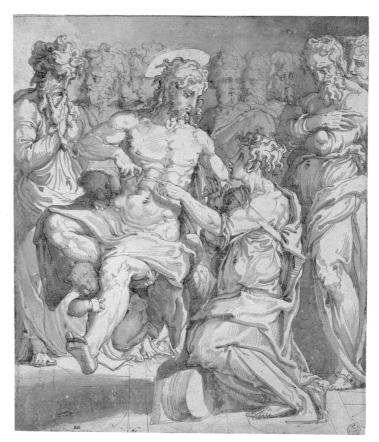

201

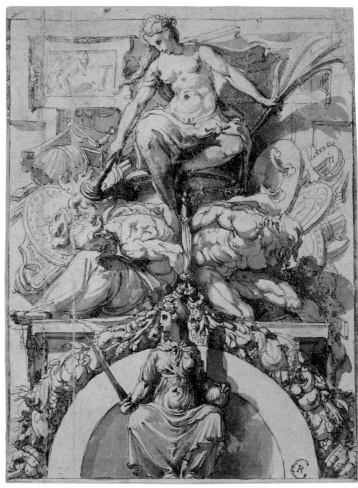

202

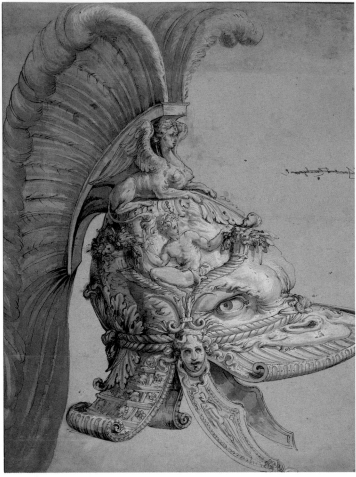

203

the level of fascination at the time with ancient Roman armor, generating advancements in the repoussé technique, in which Filippo and Francesco Negroli excelled in his work for Cosimo I.

The artist meticulously renders the chisel work and the relief elements of the mask, the youthful body, the cornucopias, sphinx, acanthus leaves, and volutes. The drawing cannot, however, be regarded as having been intended as a working guide to goldsmith work. Salviati, true heir of Polidoro da Caravaggio to whom this drawing used to be attributed, rather sought to revive the idea of Roman grandeur in his depictions of pottery and shining armor, rendered in paintings by merging shades of gold and in the present drawing by heightenings of white gouache. This decorative interest separates

Salviati from Michelangelo, who was little concerned with such Mannerist effects. In the Furio Camillo frescoes in the Palazzo Vecchio, Vasari dwelt on the decorative profusion and quality of the ornamental detail. But in Florence only Pierino del Vaga, in his cartoon – now lost – for *The Martyrdom of the Ten Thousand*, had displayed such capacity for depicting military costume *all'antica* (see Schlitt 1977, pp. 139–40).

It is hard to determine whether this drawing should be viewed in terms of myth, pictorial representation of decoration, or practical function. Its polished character makes it at the same time a presentation study for Cosimo, for whom the ceremonial helmet was a characteristic motif, and a potential source of information on metalwork. In the absence of drawings by Benvenuto Cellini

for his goldsmith work, Salviati's brilliant studies testify to the meticulous care with which such pieces were made and to Salviati's skill, certainly equal to that of Giulio Romano.

1. In addition to references cited within the text, see C. Monbeig Goguel in Monbeig Goguel 1998, pp. 269–88.

C. M. G.

204

FRANCESCO DE' ROSSI, CALLED SALVIATI
Florence, 1510–Rome, 1563

(?)*Birth of the Virgin*[1]
1541–42
pen, brown ink, and brown wash heightened with white, on black chalk and blue paper
34.8 × 26.4 cm
inscribed in pencil: "Francesco Salviati" and "9"

Vienna, Albertina

FLORENCE ONLY

This exuberant composition appears to be based largely on an engraving of the *Birth of St. John the Baptist*, after Giulio Romano, and the scene could be interpreted alternatively as showing St. John the Baptist or the Virgin. The engraving and drawing feature the same arched at the top format, the large canopy bed, the group of servants in the foreground, and some of the secondary motifs in the middle distance, such as the girl carrying a vase on her head. The girl, entering from the left, has a similar function as various figures in Salviati's frescoes, for example in two Roman works, the woman carrying a vase in the *Birth of St. John the Baptist* (Oratorio di San Giovanni Decollato, 1538), or the servant pouring water into a jar in the foreground of the *Wedding at Cana* (Refectory of San Salvatore in Lauro, 1552–53). The movement of the drapery, the dancing mode of the figures, the artist's manifest pleasure and ease

in exploiting the arabesque form, and his use of blue paper, costly to the Venetians, are all suggestive of a work linked to his journey to northern Italy in 1539–40.

In comparison with Andrea del Sarto's *Birth of the Virgin* of 1513 (Florence, Convent of Santissima Annunziata), which could have been a source of inspiration, Salviati's conception in the present drawing appears more decorative, despite a real sense of monumental space. In place of the silence and reserve of del Sarto's scene, Salviati creates a pervasive bustle that includes the woman about to give birth, whose unusual profile dominates the scene. The evident anti-classicism of the image is all the more striking when it is considered that it fell to Salviati to complete Sebastiano del Piombo's *Birth of the Virgin* (Rome, Santa Maria del Popolo, Chigi Chapel) – a monumental classical work. It might be that, knowing of Sebastiano's slow working speed, Salviati hoped that he would take over the commission even before leaving Rome for Florence in 1543, and that, while working on a project of the same format as Sebastiano's mural, he kept in mind the space above the altar in the Chigi Chapel. This hypothesis, suggested by the present writer in 1998, has been confirmed (Costamagna 2001, p. 247; see also Pinelli 2001, pp. 253–85). It would then make sense that Lorenzo Chigi, son of Agostino, the sponsor, finally appealed to Salviati to take over the work around 1548 (Hirst 1981, p. 140).

1. In addition to references cited within the text, see Cox-Rearick 2001, p. 364, fig. 6; C. Monbeig Goguel in Monbeig Goguel 1998, pp. 132–33, no. 27; McTavish 2000; and Meijer 2001, p. 648.

C. M. G.

205

Francesco de' Rossi, called Salviati
Florence, 1510–Rome, 1563

Head of a Warrior[1]
ca. 1540
red chalk
26.3 × 20 cm

Lent by Her Majesty Queen Elizabeth II

DETROIT ONLY

Like the Ideal Head, the Helmeted Warrior Head in profile was pioneered in Florence by Andrea del Verrocchio and Leonardo da Vinci, pursuing models found on ancient coins. Michelangelo, following Leonardo's lead, experimented with such heads in pen drawings of around 1505 (examples are in the Musée du Louvre, Paris, and the Kunsthalle, Hamburg) and probably continued to do so intermittently. His most famous drawing of the type is the lost *Count of Canossa*, made in Florence around 1520 and known from several copies, the finest in the British Museum, London.

The present drawing shows the influence of the type, and in around 1700 the dealer William Gibson could write "M.Angolo" on the verso. In 1949, Philip Pouncey (cited in Popham and Wilde 1949), dating the drawing to the 1540s, attributed it to Bacchiacca, probably on the basis of its resemblance to heads in paintings by this irretrievably derivative artist, who borrowed motifs from far and wide, including Michelangelo's drawings. However, the case for Bacchiacca's authorship cannot be sustained by comparison with drawings certainly by him, nor by the characterizational acuity of this drawing and its graphic exuberance. It is certainly by an artist at least one generation younger.

Although generically Michelangelesque, the image flattens, almost parodies, Michelangelo's profundity,

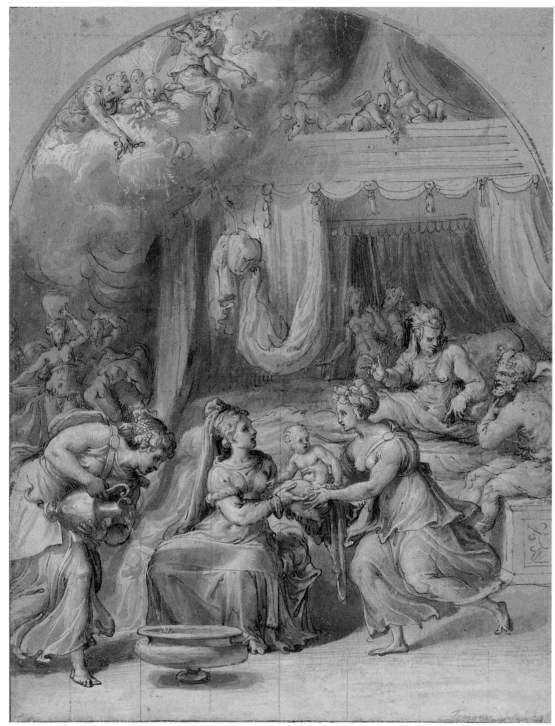

204

and the draftsman has made no attempt to imitate Michelangelo's drawing style. The handling is confident and distinctive: the long parallel hatching lines that set off the bust, the stumping in the head of the *putto* on the helmet to produce a slick surface, and the sharp herringbone hatching on the neck, are technical traits

found in the work of Andrea del Sarto and Jacopo Pontormo. But they were combined only in the drawings of an artist heavily influenced by both: Francesco Salviati. Perhaps the most immediate comparison is a sheet in the Albertina, Vienna (Birke and Kertész, no. 244), bearing the head of a *putto* on the recto and four skulls on the verso;

both sides derive from models by del Sarto and this sheet too was attributed to Bacchiacca before being transferred to Salviati by Catherine Monbeig Goguel (1998, p. 190). In the present drawing, the particular type – thin and somewhat angular, with a long neck and stringy features, against which wire-like hair is strongly

205

206

emphasized – is very much in Salviati's mode while he was working in the Sala dell'Udienza of the Palazzo Vecchio in Florence, supporting Pouncey's dating.

1. In addition to references cited within the text, see Popham and Wilde 1949, no. 68; and Joannides 1996, no. 6.

P. J.

206

FRANCESCO DE' ROSSI, CALLED SALVIATI
Florence, 1510–Rome, 1563

Page from Vasari's *Libro de' disegni* with *Christ Showing His Wound to St. Thomas*[1]
1544–45
pen, brown ink and brown wash on black chalk
35.7 × 26.2 cm

Paris, Musée du Louvre, Département des Arts Graphiques

DETROIT ONLY

Christ Showing His Wound to St. Thomas[2] relates to the altar painting executed by Salviati in 1545 at the church of Notre Dame de Confort in Lyons, commissioned by the Florentine banker Tommaso Guadagni for his funerary chapel. Vasari cites this work in his *Lives*, and explains that it was painted in

Florence and then transported to Lyons, where it remained until the French Revolution, when it was confiscated and deposited in the Louvre. The painting, which introduced the Florentine *maniera* to France, won great and immediate renown and is cited in many guidebooks and descriptions of Lyons, which was a key spot on the route between Italy and northwest Europe. Another testimony to the work's reputation is a rare anonymous French engraving,[3] which inspired the great enameller Léonard Limosin to undertake an oil painting, the only one from him that is extant (Limoges, Musée de l'Évêché), on the same subject. In the present drawing Salviati depicts St. Thomas standing, while in the painting in the Louvre he is seated. Nor is the saint here the young man of the later versions, but is rather older than Jesus.

The clumsy drawing on the frame is perhaps an imitation of

pages from the *Libro de' disegni*. The intervention of the collector Everard Jabach, who owned the sheet before it entered Louis XIV's collection in 1671, is in any case attested by the added gold band. Vasari is known to have possessed many drawings by Salviati, as is proved by numerous citations in the *Lives*.

1. In addition to references cited within the text, see C. Monbeig Goguel in Monbeig Goguel 1998, p. 356, no. 41.
2. On this work, which is cited by Vasari, see Monbeig Goguel 1998, pp. 150–51, no. 37. The drawing has been preserved in conjunction with the contract for the painting which it served (Musée du Louvre, RF 31139). On the latter, see Miller 1997.
3. Not cited by Monbeig Goguel 1998, at no. 41.
4. See for example the study in the Louvre (Inv. 6470); for the *Lady with a Long Neck* see Popham 1971, I, p. 154, no. 454, pl.354, fig. 454.
5. Cheney 1963 connected this figure with a study for *The Adoration*

344

of the Magi (British Museum, Inv. 1946-7-13-523), most likely intended as a cameo for a cardinal.

C. M. G.

207

GIOVANNI STRADANO
Bruges, 1523–Florence, 1605

The Arno with Fishermen
ca. 1580
pen and brown ink, brown and blue wash, and white gouache heightening on gray paper
20.3 × 30 cm
inscribed in pen and brown ink on recto bottom left: "j. stradanus"

Los Angeles, J. Paul Getty Museum

Against a Florentine topographic landscape of Brunelleschi's dome, the Tuscan hills, and the graduated flow of the Arno, Stradano has set the figure of a river god in the midst of fishermen at work. Dominating the frieze of figures wrapping around the sheet's lower edge, this allegorical centerpiece transforms the drawing into an ornamental tableau. Its virtuosity is born from the assimilation of Michelangelo's corporeal rhetoric, where the depicted body is twisted into poses that expose its third dimension. Like the *marzocco* (the little lion over which the river god is draped), and like the landscape itself, the Michelangelo allusion is a Florentine emblem, proudly presented in the foreground of this image made for the mass market.

Stradano drew *The Arno with Fishermen* in around 1580 to be converted into one of a series of forty-four prints of hunting and fishing scenes produced by Philip Galle. They were inspired by the great success of Stradano's tapestry designs created for Cosimo I in about 1566 and subsequently reproduced by the enterprising Hieronymous Cock (Feinberg 1991, p. 182, no. 49). The river god makes up part of an irregular segment of the sheet, apparently pieced in during Stradano's working process to replace an earlier version of the center foreground (Goldner, Hendrix, and Williams 1988, vol. 1, p. 226, no. 100). The drawing was first published in 1913, not to appear again until 1983 when it came up at auction (Baroni Vanucci 1997, p. 256, no. 345; sale Christie's, Amsterdam, 15 November 1983, lot no. 3). It exemplifies Stradano's own mixture as an expatriate Fleming of the real and the symbolic, with a "northern" concentration on landscape and everyday labor, and a "southern" stress on history and elevated design.

M. L. K.

208

SANTI DI TITO
Borgo di San Sepolcro, 1536–1603

Study for the *Resurrection*[1]
ca. 1574
pen and brown ink with brush and brown wash, heightened with white over traces of black chalk on tan paper
31.9 × 21.7 cm

The Art Institute of Chicago, Gift of William F. E. Gurley, The Lenora Hall Gurley Memorial Collection

207

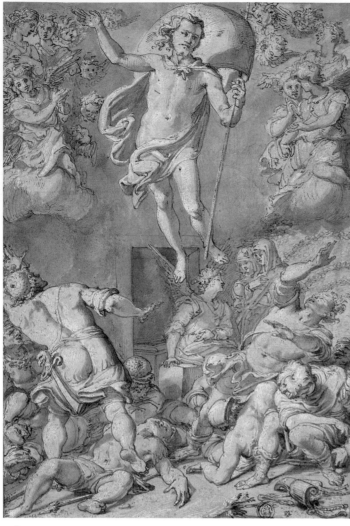

208

This sheet is one of the most finished of the compositional studies executed by Santi in preparation for his *Resurrection* altarpiece (ca. 1574) in the Medici Chapel of the Florentine church of Santa Croce. Highly esteemed, Santi was assigned to paint two other altarpieces for Santa Croce – a *Supper at Emmaus* (1574) and a *Crucifixion* (1588) – as well as a *Raising of Lazarus* (1576) and an *Annunciation* (after 1591) for Santa Maria Novella, all as part of Vasari's major renovation of these two churches, begun in 1565. Although Bronzino's acutely mannered *Resurrection* (1552) in Santissima Annunziata was a point of departure, Santi's version of the theme advances in a very different artistic direction from Bronzino's work. Among the most important

reformers of Florentine art at the end of the sixteenth century, Santi formulated a naturalistic and, in some respects, retrospective style, through his study of High Renaissance works in Rome and, it would seem, the luminosity of Venetian painting. In the *Resurrection*, quotations from Bronzino and from Michelangelo's Sistine *Jonah* (the soldier at right) coexist with realist details worthy of Caravaggio. The searching illumination, which would influence Boscoli, Cigoli, and others, is no less proto-Baroque in character.

Santi's execution of several full compositional studies for the *Resurrection* no doubt partly stems from his concern to capture and orchestrate the varied action of light on the

numerous figures. The Chicago drawing appears to be the last study he made before executing the *modello* (presentation drawing), now preserved in the Galleria degli Uffizi, Florence (7687F).

1. In addition to references cited within the text, see Lecchini Giovannoni and Collareta 1985, p. 85, no. 9; Feinberg 1991, pp. 164–65, no. 42; Prosperi Valenti Rodinò 1994, p. 70, no. 28; and Folds McCullagh and Giles 1997, pp. 222–23, no. 288.

L. J. F.

209

GIORGIO VASARI
Arezzo, 1511–Florence, 1574

The First Fruits of the Earth Offered to Saturn[1]
ca. 1555–56
pen and brown ink, brown wash over traces of red chalk
17.1 × 39.2 cm

New York, The Metropolitan Museum of Art, Rogers Fund

CHICAGO ONLY

Vasari's foremost project upon his appointment in 1555 as court artist to Cosimo I de' Medici was to transform the Palazzo Vecchio, the seat of the old Florentine Republic, into a modern ducal residence. One of the first rooms to be decorated with paintings and frescoes was the Sala degli Elementi in the eponymous *quartiere*, which formed part of the Duke's private chambers. This drawing is a finished study for the fresco of the *Element of Earth* in this room, painted by Vasari with the help of Cristofano Gherardi, his assistant of many years, between December 1555 and the end of May 1556. Two further frescoes represent the elements of fire and water while that of air is symbolized by the air flowing through the windows in the wall opposite the *Element of Fire*.

This drawing shows the figure of Saturn (or Father Time) being presented with various sorts of fruit and animals. In his right

hand he holds a snake, its tail in its mouth to form a circle, an ancient Egyptian symbol of eternity as well as a symbol of earth. Saturn is accompanied by Capricorn, the zodiac sign ascendant in Cosimo's horoscope and his personal *impresa* (emblem). In the final fresco Vasari depicted another Medici *impresa*, a tortoise with a sail, signifying *festina lente* ("make haste slowly"), a motto first adopted by Caesar Augustus and taken up by the Medici from the time of Cosimo il Vecchio.

Vasari devised the subjects of the paintings in the Quartiere degli Elementi with the help of the humanist Cosimo Bartoli, who acted as his main iconographic advisor during the first years of the decoration of the Palazzo Vecchio. In contrast to the Quartiere di Leone X, in which the imagery was historical in character, that of the Quartiere degli Elementi was mythological. Vasari described the subjects of the individual paintings in his *Ragionamenti*,[2] a hypothetical dialog in which the artist guides Cosimo's son, Principe Francesco, through the Palazzo, often comparing the mythological protagonists in the paintings with members of the Medici family and in particular with Cosimo. Explaining the significance of the fresco of the *Element of Earth*, Vasari likened Cosimo to Saturn: just as the first fruits of earth are presented to Saturn, so goods and aliment of all sorts are offered to Cosimo by his subjects to maintain the prosperity and well-being of the whole state of Florence and Siena (Vasari–Milanesi 1878–85, vol. 8, p. 32).

1. See Bean 1982, no. 262, Feinberg 1991, no. 52.; and Griswold and Wolk-Simon 1994, no. 27.
2. Vasari–Milanesi 1878–85, vol. 8, pp. 31–32.

F. H.

210

GIORGIO VASARI
Arezzo, 1511–Florence, 1574

The Forge of Vulcan[1]
ca. 1567
pen and brown ink, brown wash,
heightened with white (partly
oxidized) over black chalk on
yellow prepared paper
38.4 × 28.4 cm

Paris, Musée du Louvre,
Département des Arts
Graphiques

DETROIT ONLY

This finished drawing is for a
cabinet picture in the Galleria
degli Uffizi, Florence, belonging
to a series of allegorical
paintings celebrating Prince
Francesco de' Medici (Corti
1989, no. 88). The subjects of
the paintings were devised by
Vincenzo Borghini around 1567,
and their execution fell on
Vasari, his assistants Battista
Naldini and Jacopo Zucchi, and
on Agnolo Bronzino, Alessandro
Allori, and Giulio Clovio (see
Cecchi 1982). Drawings by Vasari
for two further paintings,
representing the *Golden Age* and
the *Hunt of Love*, survive in the
Musée du Louvre, Paris
(Monbeig Goguel 1972b, nos.
224–25).

The Forge of Vulcan is executed
in a highly finished manner on
yellow prepared paper, a
technique particularly suited to
emulate the appearance of the
final painting. It was most
probably intended as a full-scale
model for the patron as it is of
the same size as the painting,
which it matches in most details,
with the exception of the shield
– the object of Vulcan's attention
– which is left blank. The
subject matter is based on the
myth of Thetis, who asked
Vulcan to forge armor for her
son, Achilles. But Borghini
modified this story and replaced
Thetis by Minerva, goddess of
wisdom in order to combine
intellect (*ingenium*, represented
by Minerva) with art (*ars*,
represented by Vulcan). Vulcan
is shown chiseling on a shield
according to instructions shown
him by Minerva on a sheet of
paper. The subject of Vulcan's
efforts is two *imprese*, Aries and
Capricorn, the zodiacal signs
of Francesco and Cosimo de'
Medici respectively. Borghini
suggested that the background
should depict an artist's
workshop in the manner of an
accademia di certi virtuosi (artists'
academy), evidently alluding to
the Florentine Accademia del
Disegno, founded in 1563 under
the patronage of Cosimo I.

Accordingly, Vasari shows artists
making drawings and sculptures
and, on the large tables in the
back, presumably producing
architectural designs. Raised on a
podium for the artists to study
are the Three Graces, alluding
to the three natures of *disegno*
– sculpture, painting, and
architecture.

Vasari's drawing has been
interpreted as a painted theory
of art and a political allegory.
Minerva and Vulcan, representing
the theory and practice of art,
depend on each other as much
as they complement each other:
without their collaboration a
work of art – in this case the
shield – could not be created.
(On another level this concept
also reflects the close relationship
between Borghini, the inventor
of pictorial programs, and Vasari,
who carried them out.) The
shield also provides the key to
understanding the political
allegory: the two *imprese* – Aries
and Capricorn – link it directly
to Cosimo and Francesco, thus
referring to their double role as
protectors of Florence and of
the arts. Consequently, in his
dedication of the 1568 edition of
the *Vite* Vasari addressed Cosimo
as "the sole father, master, and
singular protector of our arts."[2]

1. In addition to references cited
within the text, see Barocchi 1964,
no. 42, fig. 24; Monbeig Goguel
1972b, no. 223; Kliemann 1978, p.
166, fig. 10; and Cecchi 1982.
2. "solo padre, signore e unico
protettore di esse nostre arti."
Vasari–Milanesi 1878–85, vol. 1, p. 6.

F. H.

211

GIORGIO VASARI
Arezzo, 1511–Florence, 1574

Ceiling decoration with *Rebecca
Offering Water to Eliezer at the
Well*[1]
ca. 1560–70
pen and brown ink, brown wash
over black and red chalk squared
in black and red chalk
36.2 × 23.7 cm

The Art Institute of Chicago,
The Leonora Hall Gurley
Memorial Collection

FLORENCE AND DETROIT ONLY

This is a drawing for a coffered
ceiling decoration with inserted
panel paintings, or *quadri riportati*
– a form that Vasari first
encountered during his early
stay in Venice in 1542 and
subsequently designed
throughout his career. Vasari's
most impressive coffered ceilings

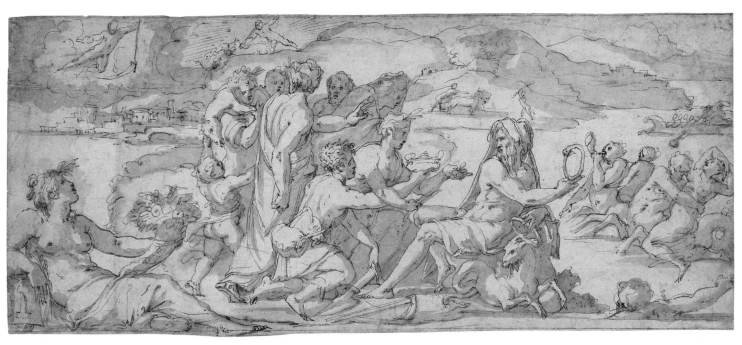

209

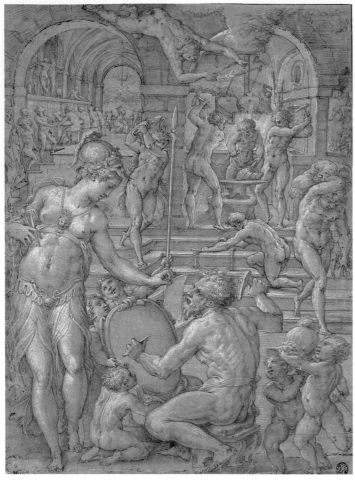

210

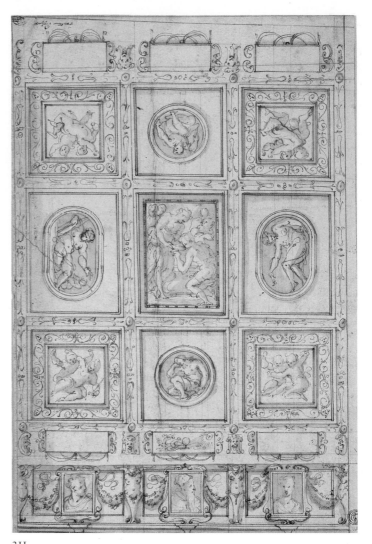

211

are in the Palazzo Vecchio, Florence, but he also designed such ceilings for rooms of more private character, such as those in his house at Arezzo.

The scene in the center of the drawing shows *Rebecca Offering Water to Eliezer at the Well*, as told in Genesis 24. Placed around it are four figures in ovals and *tondi*, not all of which can be precisely identified. The male figure in the lower *tondo* appears to be sleeping and could represent night or dream, while the female figure holding a torch in the right oval could be Aurora, goddess of dawn. Three related panel paintings survive and are probably fragments of a now-dismembered ceiling ensemble. One, in the collection of the Società Rebecca, Ficarazzi Acicastello, Catania, corresponds with the central scene in the

Chicago drawing, while two smaller panels (present whereabouts unknown; sold at Christie's, London, 27 November 1970, lot 38) each contain a pair of *putti* holding vegetables and ears of corn respectively, which suggests that they originally formed part of a set of four images representing the seasons (Corti 1981).

The frieze along the lower margin of the drawing contains a portrait of Pope Clement VII flanked by two further portraits; a small rectangular field above, with a sun shining on a crystal globe, illustrates one of Clement's personal mottoes, *candor illaeus* ("inviolate brightness"). The presence of Clement's portrait has led some authors to suggest that this might be a study for the ceiling of the Sala di Clemente VII in the Palazzo Vecchio, yet such a

connection is highly implausible. The drawing's iconography neither matches Cosimo Bartoli's program for the Sala di Clemente VII, nor corresponds with the general iconographical scheme of the other rooms in this *quartiere*, all of which represent events from the history of the Medici family not Old Testament scenes such as this sheet shows.

Instead, the drawing and related paintings could have been made for a ceiling, now lost or perhaps never implemented, in Vasari's house in Florence, as Charles Davis (in Corti 1981, p. 45, no. II/4) has suggested. Vasari is known to have planned such a ceiling decoration around 1570, and a related program written by his friend and advisor, Vincenzio Borghini, survives (Kliemann 1978, pp. 169, 189–90, no. 23).

This, however, differs in content from the iconography of the Chicago drawing. Furthermore, four recently published allegorical paintings that correspond in part with Borghini's program and have a provenance from Vasari's Florentine house, may more firmly claim to have formed part of such a ceiling (see Cecchi 1998b, p. 73, figs. 45–48). Thus, due to a lack of further evidence, the precise purpose of the Chicago drawing and its related paintings remains elusive.

1. In addition to references cited within the text, see Feinberg 1991, no. 54; and Folds McCullagh and Giles 1997, no. 324.

F. H.

212

GIORGIO VASARI
(workshop)
Arezzo, 1511–Florence, 1574

*Allegory of Disegno: Models
Entering the Studio of the Artist
and Apelles Painting Diana*[1]
ca. 1572
oil on paper
15 × 31 cm

Florence, Gabinetto Disegni e
Stampe degli Uffizi

CHICAGO ONLY

Cosimo de' Medici presented
Vasari with a house in Borgo
Santa Croce, Florence, in 1561,
yet the painter seems to have
planned its decoration only
about a decade later. It was
Vasari's second residence;
previously he had lavishly
painted a house for himself in
his native Arezzo. This small
painting on paper, the authorship
of which has not yet been
convincingly established, is
related to one of the frescoes
painted around 1570–72 in the
Sala delle Arti e degli Artisti
(Chamber of the Arts and
Artists) in Vasari's Florentine
house, and is based upon a
pen-and-ink drawing (Uffizi

1180E; Corti 1981, p. 44,
no. II/2, fig. 91) made by Vasari
for the fresco. Further frescoes in
the room represent *The Discovery
of Painting, Apelles and the
Cobbler*, and three figures
personifying Painting, Music,
and Sculpture.

On the left a painter is shown
at work, while models enter his
studio from the right. The
subject matter has often been
interpreted as an illustration of
Pliny the Elder's famous account
of the ancient painter Zeuxis
preparing a likeness of Helen.
Lacking a single flawless
exemplar of female beauty, he
chose the five most beautiful
maidens as his models, using the
most perfect part of each of
them for the portrait (*Natural
History*, XXXV, 36). However, as
Fredrika Herman Jacobs (1984)
has pointed out, the scene on
the left represents another
passage in Pliny, *Apelles Painting
Diana* (*Natural History*, XXXV,
96), for the spear and crescent
moon (the latter visible only
in the Uffizi drawing and the
fresco) clearly identify the
painter's subject as Diana. Vasari
evidently combined the two
stories, applying the selective
method of Zeuxis – represented
by the models on the right – to

the story of Apelles making
Diana's portrait. Such a selective
method was of particular
importance to Vasari, and he
promoted it throughout his life
in his own works and in the
Vite, most prominently in the
Life of Raphael, who, according
to Vasari, had formed his style
by successively adopting and
eventually surpassing the manners
of such other artists as Perugino,
Leonardo, Michelangelo, and Fra
Bartolommeo, until he finally
established his own unmistakable
maniera.

In Vasari's Uffizi drawing and
the final fresco the figure in the
niche in the center has a three-
fronted face, or *vultus trifrons*,
while in the oil on paper it is
clearly Hercules resting on his
club. The three-faced figure,
however, is crucial to an
understanding of the allegorical
meaning of Vasari's fresco,
connecting the world of nature
on the right with that of art on
the left. Its function may be
described as analogous to that of
disegno in the arts, its three faces
equaling painting, sculpture, and
architecture (Kemp 1974). Vasari's
complex composition therefore
offers both a painted theory of
art and an allegory of *disegno*, as
defined in the preface to the

third part of the 1568 edition
of the *Vite*: "*Disegno* is the
imitation of the most beautiful
in nature in all painted and
sculpted figures."

This work has been attributed
to both Vasari and his pupil,
Francesco Morandini, with
whose style, however, it seems
incompatible. It is commonly
referred to as a *bozzetto* for the
fresco, though Vasari is not
known ever to have made such
works in preparation for his
frescoes, and the facial types
of the figures as well as the
painterly handling of the brush
do not conform to Vasari's style.
More importantly, however, the
apparently slight yet significant
iconographic difference
concerning the central figure in
the niche renders the master's
participation unlikely: the figure
of Hercules would have made
little sense within the allegorical
program of Vasari's fresco and his
presence is probably the result of
a misinterpretation by another
artist of the *vultus trifrons* figure
in the Uffizi drawing.

1. In addition to references cited
within the text, see Barocchi 1964,
no. 99, fig. 16 (as Francesco
Morandini); Corti 1981, p. 44, no.
II/3 (as Giorgio Vasari); and Cecchi

212

213

1998b, pp. 68–69, fig. 36 (as Vasari).

2. "Il disegno fu lo imitare il più bello della natura in tutte le figure così scolpite come dipinte." Vasari–Milanesi 1878–85, vol. 4, p. 8.

F. H.

213

FEDERICO ZUCCARO
Sant' Angelo in Vado,
ca. 1542–Ancona, 1609

Study for a scene from the *Last
Judgment*, west octant of the
cupola decoration for the
cathedral of Santa Maria del
Fiore, Florence
1576–79
pen, brown ink, brown wash,
and red chalk
44.7 × 24.9 cm

New York, The Metropolitan
Museum of Art, Rogers Fund

FLORENCE ONLY

Federico Zuccaro's elaborate
pen, ink, and chalk drawing in
the Metropolitan Museum is a
unique presentation drawing for
the west octant of the eight
vaulted compartments of the
dome of Florence cathedral
(Mundy 1989–90, no. 66).
Filippo Brunelleschi had
completed the cupola in 1446
leaving scaffolding anchors in
place for a later mosaic
decoration and in 1568, Cosimo
I had entrusted Giorgio Vasari
with the monumental task of a
fresco decoration for the dome
(Vasari–Milanesi 1981, vol. 7, p.
719; Borghini 1857). Extending
over more than 4,000 square
meters, Cosimo's ambitious
enterprise exceeded even
Michelangelo's Sistine Chapel
frescoes in size (Heikamp
1997d). Part of a far-reaching
redecoration campaign for the
cathedral choir, the project was
intended to commemorate
Cosimo as a supporter of the
Catholic Reform.

Vasari started the decoration
in *buon fresco* in 1572, supported
by the Bolognese painter
Lorenzo Sabbatini. After the
deaths of Vasari and Cosimo I
in 1574, Francesco I gave the
project to Federico Zuccaro,

who completed the decoration
in a *secco* technique, applying the
paint to dry rather than wet
plaster, in August 1579. A major
conservation campaign between
1980 and 1995 has given new
insight into the technical and
stylistic differences between
the two workshops (Acidini
Luchinat 1995b). Most of the
preparatory drawings for the
project have survived in major
collections in Europe and the
United States (Mundy 1989–90,
Acidini Luchinat 1998, vol. 2,
p. 82, figs. 26 and 27).

In his iconographical program
Zuccaro widely followed Vasari,
who was advised by the
Florentine humanist Vincenzo
Borghini, prior of the foundling
hospital (Borghini 1584, vol. 1,
p. 77; Borghini 1857). His
concept for the *Last Judgment*
was inspired by the thirteenth-
century cupola mosaics in the
Baptistry of San Giovanni, and
his vision of hell was influenced
by Dante's *Divine Comedy*
(Acidini Luchinat 1993).

Borghini subdivided the eight
compartments of the dome into
five zones: at the apex a painted
tabernacle under the lantern
represented twenty-four kings
and elders of the apocalypse;
below this were nine choirs of
angels with instruments of the
Passion; the third zone showed
the enthroned Christ, flanked by
the Virgin Mary, St. John the
Baptist, Adam and Eve, and
the patron saints of Florence,
surrounded by groups of the
elect; the fourth zone featured
personifications of the seven gifts
of the Holy Spirit, the seven
virtues, and the seven beatitudes,
presiding over, in the final,
lowest, zone, the seven deadly
sins, punished in hell. In the
present drawing, ecclesiastical
and secular sovereigns preside
over three personifications –
Good Council, Justice, and
Mercy – overcoming the deadly
vice of avarice.

Cut into the form of a cupola
segment, the sketch on white
paper once fitted into a wooden
model, now lost, but represented
in a painting in the Palazzo
Zuccari in Rome (Koerte 1935,
pp. 67–68), in which the artist

portrayed himself discussing his sketches with Benedetto Busini, *proveditore* of the cathedral (Heikamp in *Magnificenza* 1997, cat. no. 201). In the final composition Zuccaro included Cosimo I and members of the Medici family among the representatives of ecclesiastical and worldly power.

S. T.

214

214

FEDERICO ZUCCARO
Sant'Angelo in Vado,
ca. 1542–Ancona, 1609

The Festival of St. John in the Piazza Granducale[1]
1576
black and red chalk, brown wash
24.5 × 38.2 cm
inscribed lower right: "24 Giugno 1576. Il giorno di sa[n] Giovan[n]I in fire[n]ze veduta in festa la logia a re[n]dere obidie[n]za e raprese[n]tarsi le cita ter[r]e a castelle sotto il dominio del gra[n] ducha di Firenze e Siena Toscana"; on the back: "1576 a mont'Orsoli adi 22 Giugno anda[n]do a Pratolino"[2]

Paris, Musée du Louvre, Département des Arts Graphiques

CHICAGO ONLY

Detlef Heikamp (1967) was the first to identify the subject of this drawing as the Festa degli Omaggi – the ceremony of homage to the city government of Florence, celebrated every year in the Piazza della Signoria as part of the annual Festival of St. John, the patron saint of Florence. Since the early days of the city republic this had been the highest political and religious event in the official calendar of Florence, when representatives of the towns, villages, and fortified castles of the territory of Florence paraded through the streets of the city on foot or horseback with flags and candles, paying their respects to magistrates and city officials in the Piazza della Signoria. They then proceeded to the Baptistery

of San Giovanni, where they offered candles and gifts to the saint.

Federico Zuccaro attended the festival of St. John in 1576. His intimate view is taken from inside the fourteenth-century Loggia della Signoria, which under the Medici Grand Dukes had become the Loggia dei Lanzi, used for the dukes' guard of honor. In Zuccaro's drawing, crowds of visitors have gathered inside the loggia to get a better view. Donatello's *Judith with the Head of Holofernes* under the arch to the left almost obscures the triumphal float of the Mint as it passes Ammanati's *Fountain of Neptune*. On the elevated *ringhiera* surrounding the Palazzo Vecchio, the Grand Duke and Duchess, seated beneath a *baldacchino*, attend the ceremony in the Piazza della Signoria, then known as the Piazza Granducale.

Although the Festival of St. John remained unchanged throughout the sixteenth century, the ceremony itself underwent significant modifications under the Medici Grand Dukes and displays and decorations became more elaborate. Zuccaro's drawing documents these historical changes: the Medici coat of arms

over the main entrance of the Palazzo Vecchio reminded visitors that under Cosimo I in 1540 this had become the grand-ducal residence; and the *marzocco* – the Florentine lion that once symbolized the republic and was now crowned with the grand-ducal crown – referred to the new title of the Grand Dukes of Tuscany and, since 1559, Siena.

Zuccaro's drawing was made during his second stay in Florence in the late 1570s, when he was working on the decoration of Florence cathedral and took the opportunity to travel through Tuscany: two sketches on the back record the Carro della Zecca and show his friends resting during an excursion to Montorsoli and Pratolino (Heikamp 1967; Gere 1969, no. 76, pl. 21). The sheet is part of a larger group of drawings distributed today among major collections in Europe. Heikamp (in *Magnificenza* 1997, p. 431, fig. 2; and 1997–98) has characterized them as a "sketched diary," and compared their illustrative style and unprecedented views of everyday life to contemporary guidebooks and descriptions of Florence.

1. In addition to references cited within the text, see Acidini Luchinat 1998, vol. 2, p. 101, fig. 72; and Van Veen 1999.
2. "24 June 1576, St John's Day in Florence, the festival seen from the Loggia, the cities, villages, and castles of the territory of the Grand Duke of Florence and Siena presenting themselves to pay homage."

S. T.

215

FEDERICO ZUCCARO
Sant' Angelo in Vado,
ca. 1542–Ancona, 1609

Artists Sketching after Michelangelo in the New Sacristy of San Lorenzo[1]
late 1560s or 1570s
black and red chalk
20 × 26.4 cm

Paris, Musée du Louvre, Département des Arts Graphiques

DETROIT ONLY

This elaborate drawing is a unique testimony to the artistic legacy of Michelangelo and its impact on the next generation of artists in Florence. In the New Sacristy of San Lorenzo

215

artists from the Accademia del Disegno are sketching after Michelangelo in front of the tomb of Lorenzo, Duke of Urbino, and Michelangelo's celebrated allegories, *Dawn* and *Dusk*. Concentrated observation and sketching, ongoing discussion, and an informal attitude characterize the atmosphere among artists and students of this first academy of art, where drawing was practiced as the foundation of the study of art and the work of Michelangelo. Members of the Accademia held their regular meetings in the complex of San Lorenzo, in rooms near the New Sacristy, where they would attend masses and hold drawing lessons or discussions (Rosenberg 2000, p. 138).

The New Sacristy was one of the Medici's major commissions from Michelangelo (see pp. 12–15 above). It was instigated by the Medici pope, Leo X, and his cousin, Cardinal Giulio de' Medici – then governor of Florence, later Pope Clement VII – after the sudden death in 1519 of Lorenzo,

grandson of Lorenzo il Magnifico, which destroyed the hopes of the Medici for continuity in the line of Cosimo the Elder. As well as Lorenzo's tomb, the project included the tombs of Giuliano de' Medici, duke of Nemours, and the double tomb of the Magnifici, Lorenzo il Magnifico and his brother Giuliano de' Medici (Poeschke 1996, p. 105f). When Michelangelo left Florence in 1534, the Medici tombs remained unfinished, and the chapel closed. In 1537, however, Cosimo I decided that work should continue (Androsov and Baldini 2000, p. 175f, no. 41). In the first half of the 1540s Tribolo, with the help of Vasari and other admirers and followers of Michelangelo, put the marbles in place. The Medici dukes and – in 1559 – the Magnifici, were buried in the New Sacristy and the chapel was consecrated and opened to visitors.

By the time Federico arrived in Florence in 1565 and was first admitted to the Accademia, the New Sacristy had long been a major attraction for artists and

visitors to Florence. A second sketch at the Musée du Louvre, Paris (inv. 4555) shows the same group of artists in the New Sacristy, facing the choir. Most scholars date the drawings to the second half of the 1570s, when Federico was working in Florence cathedral (Rosenberg 2000, p. 138).

1. In addition to references cited within the text, see Heikamp 1967, fig. 25; Gere 1969, p. 20, no. 82; and Acidini Luchinat 1998, vol. 2, p. 101, fig. 74.

S. T.

216

Jacopo Zucchi
Florence, ca. 1541–1590

The Story of Prometheus[1]
ca. 1572
pen, black chalk, black ink, and brown wash, with white lead highlights, on prepared ocher-colored paper
35.4 × 25.1 cm

Private Collection

In Greek mythology Prometheus stole fire from the gods to give it to mankind. In the late Renaissance he represented the medium of knowledge through which men, like the gods, could manipulate and transform matter. Zucchi's drawing, realized with an almost pictorial technique and a confident, dynamic style, shows Prometheus being freed by Hermes from the chains tying him to Mount Caucasus, to which he was condemned for the theft of fire. In the background is a female figure, perhaps Nature or Wisdom, while the author believes that the main subject of the image, on the left of the drawing, is the creative process of the artist. The torch here may have a double meaning as a symbol of knowledge and an allusion to the tireless pursuit of esthetic perfection realized through the constant destruction and renewal of the artwork.

Probably executed as a preparatory stage for one of the first documented works – now lost – executed by Zucchi for Cardinal Ferdinando de' Medici in Rome between 1572 and 1573, this drawing deals with the relationship between art and nature, a dominant theme in the complex decorations for Francesco I's Studiolo in Florence, on which Zucchi had worked before traveling to Rome. Prometheus's nude figure is clearly related to Michelangelo's *Adam* in the Sistine Chapel, a deliberate homage to the artist, confirmed by Vasari's assertion that Michelangelo was Zucchi's supreme model of artistic perfection.

1. See Pillsbury 1980; and Feinberg 1991, pp. 202–3, n. 57.

A. B. V.

217

ANONYMOUS
([?]BACCIO DEL BIANCO)
Florence, 1604–Madrid, 1656

Sketch of an ancient warrior on
horseback
ca. 1640
pen, bister, blue and light-blue
wash, traces of black chalk,
white paper
35.2 × 28 cm
inscribed on the bottom of the
verso, in pen: "Baccio del
Bianco"

Florence, Biblioteca Marucelliana

FLORENCE ONLY

This drawing was attributed by
Mannini (in *Il disegno fiorentino*
1978, p. 13) to Baccio del
Bianco, a pupil of Giulio Parigi
and an active figure in the field
of court spectacles, who, as
Baldinucci noted, "invented
fanciful costumes for comedies,
ballets, jousts, and *barriere*
[equestrian performances],
and all sorts of apparatus and
perspectives; which inventions
he drew in pen and colored
wash with great ability and
eccentricity."[2] In 1637, on his
return from Vienna, where he
had traveled with the engineer
Giovan Battista Pieroni, he
worked with Alfonso Parigi on
the scenography for the opera
Le nozze degli dei by Giovan
Carlo Coppola, staged for the
wedding of Ferdinando II to
Vittoria della Rovere in 1637
in the courtyard of the Palazzo
Pitti. According to Blumenthal
(1980, pp. 180–81, tab. 86), who
supports Mannini's attribution of
the drawing to del Bianco, the
sketch may refer to one of the
knights who featured in the
equestrian ballet performed on
the evening of 15 July for the
inauguration of the amphitheater
in the Boboli Gardens as the
new court theatrical venue.
Petrioli Tofani (1979), however,
believes that the drawing was
executed by an artist in the
circle of Lodovico Cigoli, or
by Cigoli himself.

216

217

1. In addition to references cited within the text, see Turchetti 1960; *Il disegno fiorentino* 1978, p. 13, n. 2; *Disegni e incisioni* 1983, p. 37, n. 35; and *I disegni dei secoli XV e XVI* 1990, pp. 48–49, n. 198.
2. "inventare abiti capricciosi per commedie, balletti, giostre e barriere, come anche in ogni sorte di macchine e prospettive; le quali invenzioni disegnava di penna, acquarelli colorati con gran facilità e bizzarria." Baldinucci 1845–47, vol. 5, p. 31.

A. M. T.

218

JACQUES CALLOT
Nancy, 1592–1635

(a) *The Grand Duchess of Tuscany Distributes Alms to Orphaned Girls*[1]
ca. 1614–17
burin etching
22.3 × 30.5 cm

(b) *Restoration of the Dome of Florence Cathedral*

1614–17
burin etching
22.3 × 31 cm

Florence, Gabinetto Disegni e Stampe degli Uffizi

FLORENCE ONLY

"Jacques Callot declares that today, 23 September 1616, he received 448 scudi for the execution of fourteen burin-etched copper plates in commemoration of different stories of Grand Duke Ferdinando F. M."[2] This previously unpublished document proves that in 1616 the Lorraine engraver delivered fourteen plates etched with a burin representing scenes from the life of Ferdinando I, father of the reigning Grand Duke, Cosimo II. Although the date of the commission entrusted to Callot by Cosimo II was already known, coinciding with the beginning of the engraver's employment in Cosimo's service in October 1614, when he was given use of a study in the Uffizi, the date of the completion of the work was uncertain so the document provides more information on the artist's chronology of Callot's work. The doubts expressed by Ternois (in *Jacques Callot* 1992, p. 173, nos. 66–76) about Bruwaert's (1914) suggestion that the copper etchings were dated between 1619 and 1620 were therefore justified. Based on the new document, the prints can probably be dated to 1617.

Jacques Callot arrived in Florence at the end of 1611 with Antonio Tempesta, whose workshop he had frequented during his earlier Roman sojourn. He attended the school of Giulio Parigi, who taught him the technique of etching (see Choné 1993). The prints commemorating the life of Ferdinando, largely based on drawings by other artists and therefore lacking the personal mark of Callot's style (Ternois 1992), was Callot's most important Florentine commission, as the generous payment he received from the grand-ducal Guardaroba proves.

The second print shows Ferdinando inspecting plans for the restoration of the dome of Florence cathedral, designed by the Renaissance sculptor and architect Filippo Brunelleschi and the most treasured symbol of the city of Florence. The Grand Duke is examining a large sheet of paper, supposedly showing a plan of the dome, presented to him by the architect. Through a window in the background is a view of the

dome surrounded by scaffolding on which workmen are making repairs. On the right of the composition, two men carry a coffer, probably containing money for the completion of the work. Vitzthum (1969) was the first to publish Matteo Rosselli's preparatory drawing by (Lille, Palais des Beaux-Arts) that Callot used for his etching.

1. In addition to references cited within the text, see Lieure 1924–27, n. 148–49.
2. "Jacopo Callot di contro Havere Adì 23 di sett.re /1616/ scudi quattrocentoquarantotto di m.ta /moneta/ tanti se li fanno buoni p. la resa di n. 14 piastre di rame intagliatovi a bulino diverse Istorie del Gran Duca ferd.o F M /felice memoria." State Archive of Florence, Guardaroba 349, "Journal of the Book Debtors and Creditors of the Guardaroba Generale of the Most Serene Grand Duke Cosimo II," f. 1616, p. 6.

M. C.

219

JACQUES CALLOT
Nancy, 1592–1635

The chariots and characters in costume for *Guerra d'amore*[1]
1616
etching, trimmed and laid down
22.4 × 29.7 cm
inscribed below the chariots, from left: "Carro, dell'Asia," "Carro, dell'Affrica," "Carro, di Marte e di Venere," "Carro della Regina della India sotto la Scorta/dell'Alba, sopraui 64 persone e 100 A pie"; below the group of characters, from the left: "Gradameto Re di Melinda cò/30. A Cauallo e 150 a pie," "Indamoro Re di Narsinga co/50, a Cavallo e 150 a pie," "110 Soldati Africani,/a pie," "Soldato Indiano/della guardia/ della Regina," "12 Saluatici intorno/al carro de Lafrica," "12 giganti intorno/al carro de Lasia," "110 Soldati Asiatici/a pie"; on the lower right: "In Callot.F."[2]

Florence, Biblioteca Marucelliana

218a

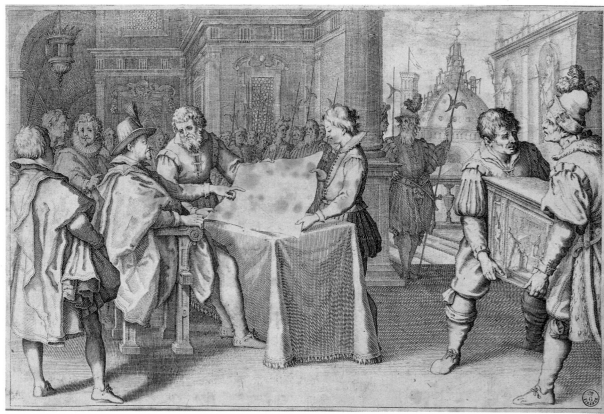

218b

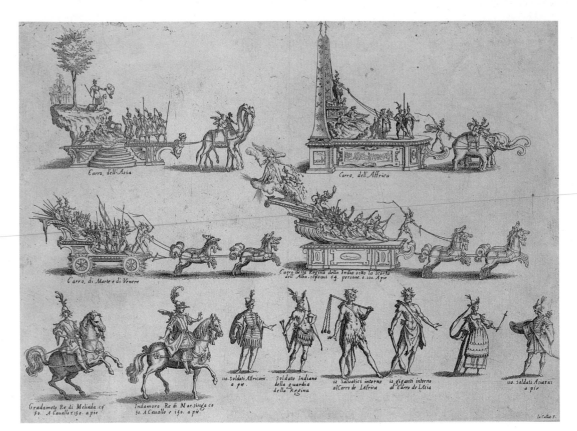

Carro dell'Asia · Carro dell'Affrica · Carro di Marte e di Venere · Carro della Regina della India sotto la Scorta dell'Alba, cõprans. 64. persone. e. 100. A pie · Gradameto Re di Melinda cõ 30. A Cauallo 150. a pie · Indamoro Re di Narsinga cõ 50. A Cauallo e 150. a piu · 110. Soldati Affricani a piè · Soldato Indiano della guardia della Regina · 12 Saluatici intorno al Carro de l'Affrica · 12 giganti intorno al Carro de l'Asia · 110. Soldati Asiatici a pie · La Callot F.

219

On 11 February 1616, an equestrian ballet entitled *Guerra d'Amore* was staged in the Piazza Santa Croce to celebrate the carnival. The display was dedicated by Cosimo II to his wife, Maria Maddalena of Austria. The story, created by the court poet Andrea Salvatori – a key figure in court spectacles during those years – included a battle between Indamorus, king of Narsinga, played by the Grand Duke himself, and Gradametus, king of Melinda, played by Cosimo's brother Don Lorenzo, over the hand of Lucinda, queen of the Indies. The performance began with the entrance of the Queen's golden coach, followed by those of the Grand Duke and his brother, forming allegories of Asia and Africa respectively. The chariot of the King of Narsinga was particularly sumptuous and ingeniously devised, "marvelous in design and in poetic invention, to which were attached some of His Highness's camels, which, with the help of some ingenious devices invisible to the audience, pulled [the

chariot] with great facility, although it was very large."[3]

The courtier Cesare Tinghi noted in his *Diario* the court technicians entrusted with staging the celebrations: "the choreography of the battle and the ballet was created by Angiolo Ricci, the dance teacher of His Most Serene Highness, who instructed the dancers and supervised the spectacle throughout; the stage sets and costumes were designed by Giulio Parigi; the music was composed by Jacopo Peri, Pagol Grati, and Giovan Battista Signorini; and the artistic director was Cavalier Giovanni del Turco, who also composed the music for the masquerade."[4]

1. See *Feste e apparati* 1969, pp. 144–45, fig. 90; Blumenthal 1980, p. 97, n. 47; Spina 1983, pp. 201–4, n. 5.1; *Jacques Callot 1592–1635* 1992, p. 190, n. 83; *Federschmuck und kaiserkrone* 1992, pp. 280–81, n. 7.5a; and *Le incisioni di Jacques Callot* 1992, pp. 135–36, 6.1.
2. "Chariot of Asia," "Chariot of Africa," "Chariot of Mars and Venus," "Chariot of the Queen of

India escorted by Dawn, carrying 64 people with 100 on foot"; "Gradametus, king of Melinda with 30 on horseback and 150 on foot," "Indamorus, king of Narsinga with 50 on horseback and 150 on foot," "110 African soldiers on foot," "Indian soldier from the Queen's guard," "12 savages around the chariot of Africa," "12 giants around the chariot of Asia," "110 Asian soldiers on foot"; "In Callot. F."
3. "meraviglioso di disegno, e di invenzione poetica, al quale erano attaccati alcuni Cammelli di S.A. che con l'aiuto di alcune ingegnose macchine non vedute dal popolo, tiravano con gran facilità, ben che fusse grandissimo." Salvadori 1615, p. 36.
4. "la composizione della batallia e del balletto fu opera di Angiolo Ricci, maestro di ballo di S.A.S., at [et?] da lui insegniata et condotta a fine. Le macchine e i disegni delli abiti e del teatro furono fatti da Giulio Parigi; le musiche di Jacopo Peri, Pagol Grati et Giovan Battista Signorini; soprintendente ne fu il cavaliere Giovanni del Turco, il quale fece anche la musica della mascherata." Quoted in Solerti 1905, p. 102.

A. M. T.

220

JACQUES CALLOT
Nancy, 1592–1635

(a) *Caprices: Soccer Game in the Piazza Santa Croce*[1]
1616–19
etching
5.4 × 7.9 cm

(b) *Caprices: Festival of St. John in the Piazza della Signoria*
1616–19
etching
6 × 8.2 cm

Florence, Gabinetto dei Disegni e delle Stampe degli Uffizi

DETROIT ONLY

Callot's *Caprices* comprise a series of forty-eight etchings dedicated to the seventeen-year-old Don Lorenzo de' Medici, Grand Duke Cosimo II's brother, of which, the artist declared, the prints "are, so to speak, the first flowers that I picked in the meadow of my sterile mind."[2] The series won immediate popularity and Callot produced a second version four years later. According to Ternois (1962, vol. 1, p. 16), the latter shows thematic and stylistic differences from the first version, coming at a later stage in Callot's Florentine production.

The first part of the series features landscapes, small figures, buffoons, and characters from the *Commedia dell'Arte*, while the second includes views of areas of Florence where, by ancient tradition, public games and court spectacles were performed. Among the former, "livery soccer" (*calcio a livrea*), played in the Piazza Santa Croce, was enormously popular with the Florentines. During the reign of the Grand Dukes the game of soccer became a regular feature of Medici spectacle and was often included in wedding celebrations and public ceremonies in honor of illustrious guests. In the foreground of Callot's image a tambourine player leads a parade of the participants.

Fireworks on the Arno were also a key part of Florentine

tradition, being regularly staged for the Festival of St. John, the Assumption, and, under Cosimo I, also for the Grand Duke's birthday on 11 June. Callot immortalized such events, illustrating the spectacle from the left bank of the Arno, between Ponte Santa Trinita and Ponte alla Carraia. In an original perspective composition he portrayed the ceremony of homage that had taken place in the Piazza della Signoria since the thirteenth century every 24 June, the day of St. John the Baptist, patron of the city. A nobleman, viewed from the back, wearing an ample cloak around his waist, points with his right hand to the display in the square. The spectacle, which originally consisted in a symbolic offering of candles, became under the Grand Dukes an implicit display of submission by the Tuscan communities to the Florentine government.

1. See *Feste e apparati medicei* 1969, pp. 166–69; Russel 1975, pp. 19–21; *Jacques Callot, Stefano Della Bella* 1976, pp. 47–58; *Il Seicento fiorentino* 1986, p. 379, 3.8; *Jacques Callot* 1992, pp. 238–40, n. 221, 222, 226; *Le incisioni di Jacques Callot* 1992, pp. 153–56, n. II.59, II.46, II.45; *Firenze e la sua immagine* 1994, pp. 95–97.
2. "sono, per così dire, i primi Fiori che io ho colti nel campo del mio sterile ingegno."

A. M. T.

221

REMIGIO CANTAGALLINA
Sansepolcro (Arezzo),
ca. 1583–Florence, 1656

after GIULIO PARIGI
Florence, 1571–1635

Armada for the *Argonautica*[1]
etching
18.2 × 28.8 cm
inscribed on the lower left: "Remigio Canta Gallina F" [Remigio Cantagallina Fecit]; in the center at the bottom: "Capitana dell'Armata di Colco fatta dalli/ Sig. Deputati"; on the lower right: "Battaglia Nauale rapp. in Arno per le Nozze del Ser. / Principe di Toscana l'Anno 1608. Giulio Parigi I."[2]

Florence, Biblioteca Marucelliana

On the evening of 3 November 1608, during the celebrations for the marriage of Cosimo II de' Medici, the future Grand Duke, to Maria Maddalena of Austria, a spectacle was staged showing the naval battle between the fleet of Jason and the inhabitants of Cholcis for the Golden Fleece. The unusual display, known as a *nuamachia*, took place between the Ponte Santa Trinita and the Ponte alla Carraia on the River Arno, a site traditionally used in Florentine spectacles. On the Ponte alla Carraia the fortified city of Cholcis was constructed, while in front of it an islet with the temple containing the Golden Fleece was built. Fireworks along the river simulated the naval battle, while on the Arno's shores steps were placed to accommodate the audience. The present etching shows the moment before battle began, when the army of Cholcis made its entrance, followed by sixteen galleons charged with soldiers dressed in sumptuous costumes, paying homage to the bride and groom.

The spectacle, an explicit political allegory, celebrated the nautical power of the Grand Duchy and functioned as a eulogy to the couple, identified with the characters of Jason,

220a

220b

Remigio Canta Gallina F. CAPITANA DELL' ARMATA DI COLÇO FATTA DALLI SIG.ᵣᵢ DEPVTATI Bottaglia Nauale rappr.ᵗᵃ in Arno per le Nolle del Ser.ᵐᵒ Principe di Toscana l'Anno 1608. Giulio Parigi I.

221

222

played by Prince Cosimo, and Medea, sister of the King of Cholcis, who falls in love with the leader of the Argonauts and leaves with him after he has won the Golden Fleece. The battle, much grander in scale than that staged in the courtyard of the Palazzo Pitti in 1589 for the wedding of Ferdinando I to Christine of Lorraine, initiated a new fashion in court spectacles of the time, aimed at involving the citizens of the city within the grandiose displays.

The *Argonautica* was created from a text by Francesco Cini, while the design and execution of the ships was entrusted to the architect Giulio Parigi, who made his official debut in this year, replacing Buontalenti, who died a few months before the wedding. Jacopo Ligozzi was commissioned to draw the ships of Euritus and Periclemene, and Cigoli drew the ship of Anfione. Nineteen etchings by Remigio Cantagallina and many preparatory drawings provide an extensive pictorial record of this event.

1. See Blumenthal 1980, pp. 57–58, n. 26; and *Il potere e lo spazio* 1980, p. 400, n. 9.70.
2. "The captain of the army of Cholcis made by the deputies"; "Naval battle performed on the Arno for the marriage of the Most Serene Prince of Tuscany in the Year 1608. Giulio Parigi Invenit."

A. M. T.

222

AFTER BERNARDO
BUONTALENTI
EPIFANIO D'ALFIANO
Italian, ca. 1591–1607

Florence, 1536–1608

The Region of the Demons, design
for the fourth *intermezzo* of
La Pellegrina
1592
etching, trimmed and laid down
25.5 × 36.1 cm
inscribed on the wheel of the
sorceress's car: "D.Epifanio d'Alf.
M.Vall.incid"

Florence, Biblioteca Marucelliana

FLORENCE ONLY

The etching of the fourth
intermezzo of *La Pellegrina*,
executed by the Vallombrosan
monk Epifanio d'Alfiano after
the performance itself, offers
a concise image of the play's
scenic sequences. In the
background is a perspective
view of the city of Pisa, which
functioned as a backdrop for the
play. According to a description
by Bastiano de' Rossi, before the
perspective of Pisa changed at
the end of the third act, the
Sorceress, played by the
celebrated actress Lucia Caccini,
appeared on stage "on a precious
chariot of gold and gems." After
invoking the "spirits from the
purest region of the air, called
fire" to predict "when the world
would enjoy supreme happiness"
a great cloud appeared. When
this mechanical prop reached the
center of the stage "it opened
up into a semicircle" revealing
the "spirits summoned by the
Sorceress's song," who sang a
madrigal of good wishes for the
bride and groom. Finally, to the
astonishment of the audience,
the stage "in one instant was all
covered in rocks, caves, full of
fires and burning flames"; then
"the stage opened up" and
Lucifer emerged, accompanied
by devils and furies singing a
lament for the coming of the
era of good.[2]

The theme of this *intermezzo*
centered on a vision of hell
intended as a dire warning
against the effects of

223

"disharmony." The author of the
intermezzi, Giovanni dei Bardi,
elaborated canto III of Dante's
Inferno, and Cristofano Malvezzi
provided the musical
accompaniment. Bernardo
Buontalenti created the vision of
hell by ingeniously opening the
floor of the stage, allowing the
monumental and terrifying figure
of Lucifer to rise before the
audience. According to Ternois
(1962, pp. 89, 233), the present
etching was probably the source
of inspiration for Jacques Callot's
Temptations of St. Anthony of 1617.

1. See *Feste e apparati* 1969, pp.
83–84; *Il luogo teatrale a Firenze* 1975,
p. 114, n. 8.17; Testaverde 1991,
pp. 120–22, fig. 46; and Saslow 1996,
pp. 233–34, n. 52.
2. "sopra un pregiato carro d'oro, e
di gemme"; "I Demoni della region
più pura dell'aria, appellata fuoco";
"quando il mondo doveva godere
supreme felicità"; "s'aperse e fecesi un
semicircolo"; "demoni che la maga
con suo canto aveva chiamati"; "in
uno istante fu coperta tutta di scogli,
d'antri,caverne, piene di fuochi, e di
fiamme ardenti"; "s'aperse il palco."
De' Rossi 1589, p. 49.

A. M. T.

223

STEFANO DELLA BELLA
Florence, 1610–1664

*Equestrian Ballet at the Boboli
Gardens*[1]
1637
etching
44.1 × 32.4 cm
inscribed above the center:
"Carro d'Amore"; on the left:
"Agno. Ricci In. Del ballo"; in
the center: "Figure della Festa A
cavallo, Rappresentata nel /
Teatro Del Ser.mo GranDuca di
Toscana/ il di. 15 Luglio 1637";
on the right: "Felice Gamb. Ing.
Ste. de. be. del. E. F."[2]

Florence, Biblioteca Marucelliana

FLORENCE ONLY

Stefano della Bella's etching was
executed to illustrate a text by
Ferdinando dei Bardi, *Descrizione
delle feste fatte in Firenze per le
Reali Nozze de Serenissimi sposi
Ferdinando II Gran Duca di
Toscana, e Vittoria Principessa
d'Urbino* (Florence, 1637). The
marriage of Grand Duke
Ferdinando II to Vittoria della

Rovere on 15 July 1637 was
celebrated with the inauguration
of the Medici court's new
theatrical venue, an amphitheater
in the Boboli Gardens,
commissioned between 1631 and
1634 from the architect Giulio
Parigi. The last of the court
theaters, the amphitheater
replaced the Uffizi Theater
as the venue for important
celebrations, prompting the
latter's final closure.

Another change was initiated
by the engineer Felice
Gamberai, who, following the
death of Alfonso Parigi, made
his debut with this spectacle.
With the choreographer Agnolo
Ricci, Gamberai created an
amazing tournament–opera,
freely adapted by Ferdinando
Saracinelli from Tasso's *Jerusalem
Liberated*. The story, centered on
the figure of Armida, was
essentially a pretext to display an
astonishing sequence of costumes
and mechanical scenography. The
present image illustrates the
various phases of the equestrian
ballet and the tournament's
contestants. In the center appears
the climax of the spectacular
action, when Armida's chariot,

224a

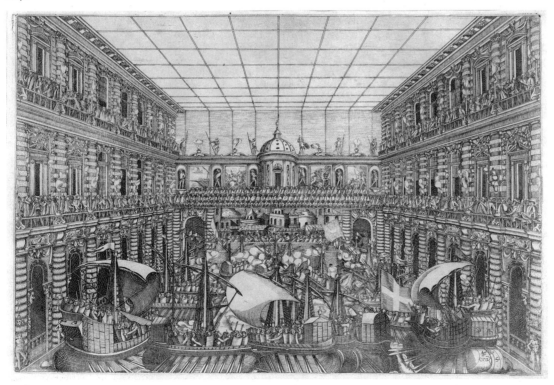

224b

drawn by four elephants, metamorphosed into a grim mountain with three large caves, from which flames billowed.

1. See *Il luogo teatrale a Firenze* 1975, p. 143, n. 9.45; pp. 152–53, n. 11.3–11.4; Blumenthal 1980, pp. 179–87, n. 86; *Alexandre De Vesme* 1991, vol. 1, p. 58, n. 50; vol. 2, fig. 18; Capecchi 1997, pp. 43–63; Fumagalli, Rossi, and Spinelli 2001, p. 171, n. 48.
2. "the chariot of Love"; "Agnolo Ricci invented the choreography"; "figures from the festival on horseback performed in the theater of the Most Serene Grand Duke of Tuscany on 15 July 1637"; "Felice Gamberai engineer, and Stefano della Bella authors."

A. M. T.

224

ORAZIO SCARABELLI
Italian, active ca. 1580–1600

(a) *Quintain Joust in the Piazza Santa Croce*[1]
1592
etching
22.8 × 34.3 cm

(b) *Naumachia in the Courtyard of the Palazzo Pitti*
1592
etching
24.2 × 25.8 cm

New York, The Metropolitan Museum of Art, Harris Brisbane Dick Fund

CHICAGO AND DETROIT ONLY

These images are part of a series of etchings illustrating the spectacles staged on the occasion of the wedding of Ferdinando I to Christine of Lorraine in 1589. Petrioli Tofani (1977, vol. 2, pp. 476–85) has proposed that the date 1592 on one of the prints suggests that the images were probably commissioned by Christine of Lorraine to send to the French court. Orazio Scarabelli based the illustrations on preparatory drawings probably provided by Andrea Boscoli.

The images exhibited here refer to two types of spectacle aimed at two different kinds of

audience. The first illustrates the quintain tilting tournament that took place on 10 May 1589 in the Piazza Santa Croce. The display, staged on one of the city's most traditional sites, offered the Florentines an opportunity to become involved in the wedding celebrations, while some of the guests (in this case Don Cesare d'Este) had a chance to exhibit their athletic and military prowess. The image depicts two sequential stages of the spectacle: the foreground shows the entry into the square of the participants, pages, and trumpet-players, including an exotic camel ridden by one of the contestants, while in the background the tournament itself is shown, opposite the incomplete façade of the church of Santa Croce.

The second etching shows a more private spectacle reserved for the court and the bride and groom. On 11 May 1589 a *naumachia* took place in the courtyard of the Palazzo Pitti, consisting of a simulated naval battle between Christians and Turks, culminating in an attack on a fortress. This performance, intended to celebrated the Grand Duke's prestigious role as the defender of Christianity, was totally unprecedented in Florentine tradition, but was familiar in French culture. A similar spectacle was staged in 1548 in Lyon, on the occasion of the coronation of Catherine de' Medici – the grandmother of Ferdinando's bride – and her husband Henry II. This type of contest became one of the subjects of the Valois tapestries, woven in Brussels in 1582 and given by Catherine to Christine of Lorraine, who subsequently brought them to Florence.

Bernardo Buontalenti, the designer of the Florentine *naumachia*, used his hydraulic engineering expertise to make the courtyard watertight and build a suitable system to flood the space. The *naumachia* was fought with small vessels ("navicelli") imported from the port of Pisa for the purpose. The spectators sat on steps arranged around the courtyard – on one side the Grand Dukes and their

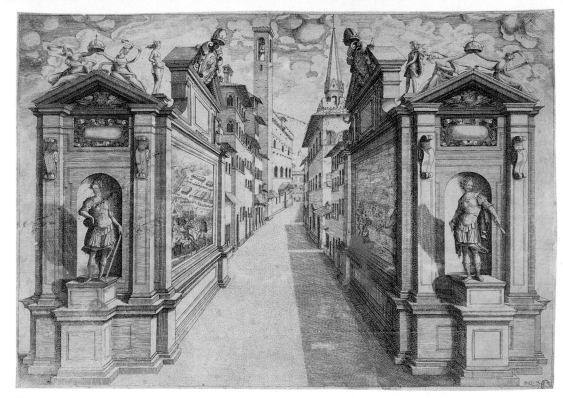

225

most eminent courtiers and on the opposite side the judges – while several of the women watched the performance from the upper-floor windows of the palace.

1. In addition to references cited within the text, see Massar 1975; *Il luogo teatrale a Firenze* 1975, 139, n. 9.36; Blumenthal 1980, pp. 13–15; Testaverde 1991, pp. 137–47; Saslow 1996, 246, n. 70; 260, n. 87; and *Magnificenza* 1997, p. 302, n. 249.

A. M. T.

225

ORAZIO SCARABELLI
Italian, active ca. 1580–1600

after TADDEO LANDINI
Florence, ca. 1550–1596

Decoration for the Canto dei Bischeri for the entry of Christine of Lorraine
1592
etching
23.5 × 24.5 cm
inscribed on the lower right:
"Oraz. S."

Florence, Biblioteca Marucelliana

FLORENCE ONLY

Scarabelli's etching, dated 1592, is faithful to a contemporary illustration executed for Raffaello Gualterotti's *Descrizione del regale Apparato per le nozze della Serenissima Madama Cristina di Lorena moglie del Serenissimo Don Ferdinando Medici III Granduca di Toscana* (Florence, Padovani, 1589). The image represents the scenography created by Taddeo Landini for the Canto dei Bischeri, the crossing of the modern via del Proconsolo and the Piazza del Duomo, celebrating the military glory of the Hapsburgs and highlighting the role of the grand-ducal fleets in the Battle of Lepanto. It provides valuable and detailed proof of the visual effect achieved by decorating urban spaces with ephemeral apparatus. At the beginning of the route, with the ancient buildings of the Bargello and the Badia Fiorentina visible in the background, two sculptural groups featured statues by Landini of Emperor Charles V and his son Philip II, while two large canvases commemorated the *Defeat of the Turks at Linz* (by Giovanni Stradano) and the *Battle of Lepanto* (by Girolamo Macchietti and Bernardino Monaldi).

The decoration was part of an ephemeral cycle created for the most significant locations along the triumphal route of the bride and her retinue into the city. The general scheme was created by Niccolò Gaddi, lieutenant of the Accademia del Disegno, and Giovannantonio Dosio, an artist from the Roman circle of academicians who in the previous year had won the competition for the execution of the façade of Florence cathedral. It was he that was probably responsible for a series of experimental structures that reflected the theory of the architectural orders, establishing a perfect harmony between formal and symbolic elements. The progression of themes and orders culminated in the rustic Tuscan order, viewed as a symbol of Tuscan royal power and the triumph of the principate.

1. See Testaverde 1990; *Firenze e la sua immagine* 1994, pp. 83–84, n. 22; and Saslow 1996, p. 194, n. 5.

A. M. T.

ACKNOWLEDGMENTS

The exhibition *Magnificenza! The Medici, Michelangelo, and the Art of Late Renaissance Florence* owes its development to the cooperation and encouragement of many individuals, institutions, government agencies, and sponsors in Europe and America.

The Detroit Institute of Arts, the Soprintendenza Speciale per il Polo Museale Fiorentino, and the Opificio delle Pietre Dure, Florence, in association with the Art Institute of Chicago and Firenze Mostre, organized the exhibition, greatly aided by the executive and advisory committees.

The organizers worked closely with Antonio Paolucci, superintendent of the State Art Museums in Florence, Cristina Acidini Luchinat, superintendent of the Opificio delle Pietre Dure and Laboratori di Restauro di Firenze, and Cristina Giannini, the exhibition coordinator in Florence. The Florentine team was supported by the staffs of the Soprintendenza in Florence and the Galleria Palatina at Palazzo Pitti. We are indebted to President Franco Camarlinghi of Firenze Mostre, the previous president, Guido Clemente, and Antonella Lojero, Alessandra Lotti Margotti, and their staff. Contemporanea Progetti, under the guidance of President Patrizia Pietrogrande, was responsible for the exhibition design and installation in Florence. From the Ente Cassa di Pisparmio, we especially thank Alberto Carmi, president; Edoardo Speranza, vice president; Antonio Gerdovich, director; and Alessandra Cavallini, administrative co-ordinator for the exhibition.

At the Art Institute of Chicago, we are most grateful for the initial enthusiasm and constant support of its director, James N. Wood, and for that of Douglas W. Druick, Searle Curator of European Painting; Suzanne Folds McCullagh, Anne Vogt Fuller and Marion Titus Searle Curator of Earlier Prints and Drawings; Ghenete Zelleke, Samuel and M. Patricia Grober Curator of European Decorative Arts; Dorothy Schroeder, Assistant Director for Exhibitions and Budget; and Ed Horner, Director of Development. We are especially grateful for the dedication and thoughtful advice of our Ian Wardropper, now at the Metropolitan Museum of Art, New York. Among the staff and volunteers of the Art Institute of Chicago, we would like to acknowledge Irene Backus, Geri Banik, Darren Burge, Tiffany Calvert, David Chandler, Caesar Citraro, Joseph Cochand, Christine Conniff-O'Shea, Lisa Deichman, Lynn Delli Quadri, Lorna Filippini, Christopher Gallagher, John Gedo, Mary Sue Glosser, Gloria Groom, William Gross, Barbara Hall, Eileen Harakal, William Heye, John Hindman, Sandra Jaggi, Adrienne Jeske, David Kaiser, Walter Karcheski, Michael Kaysen, Lisa Key, Clare Kunny, Timothy Lennon, Rebekah Levine, Constance Markey, Lia Markey, John Molini, Jeffrey Nigro, Jennifer Paoletti, Katherine Reilly, Suzanne Schnepp, Mary Solt, Harriet Stratis, Christa C. Thurman, Kirk Vuillemot, Faye Wrubel, and Frank Zuccari.

The Detroit Institute of Arts assumed many of the complex administrative responsibilities associated with organizing and planning the exhibition and its catalog. Without the continuing support of Director Graham W. J. Beal and his predecessors, Maurice D. Parrish, interim director, and Samuel Sachs II, former director, the exhibition would never have come to fruition. Particular thanks go to the members of the museum's exhibition project team, who worked tirelessly to see that all aspects of the exhibition and its many affiliated programs went smoothly. Above all, the staff of the department of European sculpture and decorative arts, both past and present, were invaluable in all facets of the project: Antonia Boström, Brian Gallagher, and Maria Santangelo, assistant curators; Michele Ryce Elliott, administrative assistant; and Susan Tipton, exhibition assistant. Educators Jennifer Wild Czajkowski, Linda Margolin, Matthew Sikora, and Jennifer Williams put together the wide variety of interpretive material and programming; Curator of Exhibitions Tara Robinson and registrars Pam Watson and Kimberly Dziurman kept track of the complicated logistics of an international exhibition. Additional thanks go to Alfred Ackerman, Dirk Bakker, Terry Birkett, James Boyle, Paul Cooney, Annmarie Erickson, Ann Friedman, Jennifer Moldwin Gustafson,

Barbara Heller, Robert Hensleigh, Maya Hoptman, Jane Hutchins, Nancy Jones, George Keyes, Iva Lisikewycz, Robert Loew, Jill McClain, Pamela Marcil, Ronald Miller, William Neal, David Penney, Laurel Paterson, Ross Pfeiffer, William Pierce, Mark Puhl, Keely Robinson, Claire Schofield, Ellen Sharp, Ernie Smith, Nancy Sojka, John Steele, and Serena Urry. In Detroit and Chicago, the exhibition was designed by Louis E. Gauci and by Joseph Cochand of the Art Institute of Chicago.

This catalog was shaped by the museum's publications department, first under the direction of Julia Henshaw and then Susan Higman. Judith Ruskin organized the materials and served as in-house edior. Carole Piechota, Kelli Carr, and Alexa Ducsay attended to the many details of text and illustrations. Yale University Press is the co-publisher of this volume for which we thank Gillian Malpass and John Nicoll. Copy editor Philippa Baker's diligence and seemingly infinite patience resulted in a consistent and highly readable text. The Italian edition of the catalog was published by Skira under the guidance of Massimo Vitta Zelman and Marzia Branca.

Our profound thanks also go to the members of the Executive and Advisory Committees and to the authors of this catalog. The twelve insightful essays place Grand-ducal Medici patronage and the influence of Michelangelo in a fresh historical context, and the more than 200 entries, written by thirty-four scholars, focus on individual works of art.

Our greatest thanks go to the many museums, institutions, and private collectors, who generously agreed to lend their works. We are extremely grateful for the support of all those mentioned above, the generous sponsors, and the many others, too numerous to list here.

Alan P. Darr,
Project Director and Walter B. Ford II Family Curator
of European Sculpture and Decorative Arts,
The Detroit Institute of Arts

Marco Chiarini,
Scientific Exhibition Commissioner for Italy, Florence

Larry J. Feinberg,
Patrick G. and Shirley W. Ryan Curator in the Department
of European Painting, The Art Institute of Chicago

BIBLIOGRAPHY

Abraham, L., *A Dictionary of Alchemical Imagery*, Cambridge, 1998.

Acanfora, E., "Un'aggiunta a Francesco Morandini detto il Poppi," *Paragone*, 45, 1994.

——, "La decorazione delle loggette," in *Palazzo Pitti: l'arte e la storia*, ed., M. Chiarini, Florence 2000, pp. 57–62.

Acidini Luchinat, C., "Niccolò Gaddi, collezionista e dilettante nel Cinquecento," *Paragone*, 31, nos.359–61, 1980a, pp. 141–75.

——, *Invenzioni Borghiniane per gli apparati nell'età di Cosimo I*, Florence, 1980b.

——, *Fiorenza in villa*, Florence, 1987.

——, "La Santa Antichità, la scuola, il giardino," in *"…per bellezza, per studio, per piacere": Lorenzo il Magnifico e gli spazi dell'arte*, ed. F. Borsi, Florence, 1991.

——, "Federico Zuccari e l'ispirazione dantesca nella Cupola del Duomo di Firenze," in *Federico Zuccaro e Dante*, ed. Corrado Gizzi, Milan, 1993, pp. 43–56.

——, "Bartolomeo Ammanati artefice di fontane," in *Bartolomeo Ammanati Scultore e Architetto 1511–1592*, conference, Florence-Lucca, 17–19 March 1994, published Florence, 1995a, pp. 31–40.

——, "Traccia per la storia delle pitture murali e degli artisti," in *La Cupola di Sata Maria del Fiore: il cantiere di restauri, 1980–95*, ed. C. Acidini Luchinat and R. Dalla Negra, Rome, 1995b, pp. 63–86.

——, ed., *La chiesa e il convento di Santo Spirito a Florence*, Florence, 1996.

——, "La pittura fiorentina di corte alla fine del Cinquecento," in *Magnificenza alla corte dei Medici: arte a Firenze alla fine del Cinquecento*, exhibition catalog, Palazzo Pitti, Museo degli Argenti, Florence, 1997a.

——, ed., *Treasures of Florence: The Medici Collection 1400–1700*, trans. E. Leckey, Munich and New York, 1997b.

——, "Dal Brunelleschi al Bernini, attraverso Michelangelo: il 'canneto'," in *Settatanta studiosi italiani: scritti per l'Istituto Germanico di Storia dell'Arte di Florence*, ed. C. Acidini Luchinat, L. Bellosi, M. Boskovits, P. P. Donati, B. Santi, Florence, 1997c, pp. 301–6.

——, *Taddeo e Federico Zuccari: fratelli pittori del Cinquecento*, 2 vols., Rome, 1998.

——, *Botticelli: le allegorie mitologiche*, Milan, 2001.

——, and G. Galletti, *Le ville e i giardini di Castello e Petraia a Firenze*, Ospedaletto, Pistoia, 1992.

——, and G. Galletti, *La villa e il giardino della Petraia a Firenze*, Florence, 1995.

Ackerman, J., *Architecture of Michelangelo*, Harmondsworth, 1961.

Adán y Eva en Aranjuez: investigaciones sobre la escultura en la Casa de Austria, exhibition catalog, Museo del Prado, Madrid, 1992.

Adelson, C., "Bachiacca, Salviati, and the Decoration of the Sala dell'Udienza in Palazzo Vecchio," in *Le Arti del Principato Medico*, Florence, 1980, pp. 141–200.

——, "Cosimo I de' Medici and the Foundation of Tapestry Production in Florence," in *Firenze e la Toscana dei Medici* 1983, vol. 3, pp. 899–924.

——, "The Decoration of Palazzo Vecchio in Tapestry: the *Joseph* Cycle and other Precedents for Vasari's Decorative Campaigns," in *Giorgio Vasari: tra decorazione ambientale e storiografica artistica, Convegno di Studi, Arezzo, 1981*; ed. Giancarlo Garfagnini, Florence, 1985, pp. 145–77.

——, *The Tapestry Patronage of Cosimo I de' Medici 1543–1553*, Ann Arbor, Michigan, University Microfilms, 1990.

——, "On Benedetto Pagni da Pescia and Two Florentine Tapestries: the Allegorical 'Portiere' with the Medici–Toledo Arms," in *Kunst des Cinquecento in der Toscana*, Essays in Honor of S. Béguin, Munich, 1992, pp. 186–96.

Adorno, F., *Accademie e istituzioni culturali a Firenze*, Florence, 1983.

——, and L. Zangheri, *Gli statuti dell'accademia del disegno*, Florence, 1998.

Agosti, G., "Un Giudizio Universale in miniatura," *Annali della Scuola Normale Superiore di Pisa*, s.3, 19, 4, 1989, pp. 1291–97.

A Grand Design, ed. M. Baker and B. Richardson, exhibition catalog, Baltimore Museum of Art, Baltimore, 1998.

Agricola, *De natura eorum quae effluunt ex terra*, Basel, 1545.

——, *De natura fossilium*, 1546, trans. Mark Chance Bandy and Jean A. Bandy, New York, 1955.

Albrecht, S., "Bühnnbild und Bühnentechnick," in *Teatro: Eine Reise zu den oberitalienschen theatern des 16–19 Jahrhunderts*, Marburg, 1991, pp. 28–48.

Alcouffe, D., *La collection de gemmes de Louis XIV, une selection*, Paris, 2001.

Aldrovandi, U., "Delle statue antiche che per tutta Roma in diversi luoghi e case si veggono," in L. Mauro, *L'antichità della città di Roma*, Venice, 1556.

Alexandre De Vesme: catalogne raisonné, with introduction by P. Deaborn Massar, New York, 1991.

Allegri, E., and A. Cecchi, *Palazzo Vecchio e i Medici: guida storica*, Florence, 1980.

Allori, A., *I ricordi di Alessandro Allori*, ed. I. B. Supino, Florence, 1908.

Altari e committenza: Episodi a Firenze nell'età della Controriforma, ed. C. De Benedictis, Florence, 1996.

Ambrosio, L., and F. Capobiano, *Le Collezione Farnese di Capodimonte: i bronzetti*, Naples, 1995.

Ames-Lewis, F., "Early Medicean Devices," *Journal of the Warburg and Courtauld Institutes*, 48, 1979, pp. 122–43.

——, *The Intellectual Life of the Early Renaissance Artist*, New Haven and London, 2000.

Ammirato, S., *I discorsi sopra Cornelio Tacito*, ed. L. Scarabelli, Turin, 1853.

Andrea del Sarto 1486–1530: dipinti e disegni a Firenze, exhibition catalog, Palazzo Pitti, Florence, 1986–87.

Andres, G. M., *The Villa Medici in Rome*, New York and London, 1976.

Andrews, K., "A Note on Bronzino as a Draughtsman," *Master Drawings*, no. 2, 1964, pp. 157–60.

Androsov, S., and U. Baldini, *l'Adolescente dell'Ermitage e la Sagrestia Nuova di Michelangelo*, exhibition catalog, Casa Buonarroti, Florence and Hermitage, St. Petersburg, 2000.

Anglani, M., "Michelangelo e la Real Galleria degli Uffizi nei primi decenni dell'Ottocento: Note di museografia," in *Bollettino della società di Studi Fiorentini*, vol. 2, 3, 1998, pp. 51–64.

Apollodorus, *The Library of Greek Mythology*, trans. Keith Aldrich, Lawrence, Kansas, 1975.

Aquinas, St. Thomas (attrib. to), *Aurora consurgens*, ed. Marie-Louise Von Franz, London, 1966.

Aretino, P., "Lettere 1526–55," in *Lettere sull'arte di Pietro Aretino*, 4 vols., ed. E. Camesasca, Milan, 1957–60.

Argan, G.C., and Contardi, B., *Michelangelo architetto*, Milan, 1990.

Ariosto, L., *Orlando furioso*, 2 vols., Florence, 1882.

Arti fiorentine: la grande storia dell'artigianato, 3 vols., Florence, 1998–2000.

Artisti alla corte granducale, exhibition catalog, Palazzo Pitti, Florence, 1969.

Attwood, P., *Italian Medals c.1530–1600 in British Public Collections*, London, 2002.

Avery, C., *Giambologna: The Complete Sculpture*, Oxford, 1987.

——, "When is a Giambologna not a Giambologna?," *Apollo*, 131, no. 336, June 1990, pp. 391–400, 442.

——, "Giovanni Bandini (1540–99) Reconsidered," in *Antologia di Belle Arti: La Scultura Studi in onore di Andrew S. Ciechanowiecki*, nos.48–51, 1994, pp. 16–27.

——, "Bartolomeo Ammanati," in *The Dictionary of Art*, ed. J. Turner, London, vol. 1, 1996, pp. 789–93.

——, and S. Barbaglia, *L'Opera completa del Cellini*, Milan, 1981.

——, and A. Radcliffe, *Giambologna 1529–1608 Sculptor to the Medici*, exhibition catalog, Victoria and Albert Museum, London, 1978.

Bacci, G., *Monsummano e la Madonna della fonte nuova: memoria storica per il Sac. G. B. pubblicata per cura del Sac. Luigi Magrini*, Prato, 1878.

Bacci, M., "Jacopo Ligozzi e la sua posizione nella pittura fiorentina," *Proporzioni*, 4, 1963.

——, and A. Forlani, *Mostra di disegni di Jacopo Ligozzi*, Florence, 1961.

Baglione, G., *Le vite de' pittori, scultori et architetti dal Pontificato di Gregorio XIII del 1572 in fino a tempi di Papa Vrbano Ottauo nel 1642*, Rome, 1642.

Balas, E., "The Iconography of Michelangelo's Medici Chapel: A New Hypothesis," *Gazette des Beaux-Arts*, 120, 10, 1992, pp. 117–26.

——, *Michelangelo's Medici Chapel: A New Interpretation*, Philadelphia, 1995.

Baldini, U., A. M. Giusti, and A. Pampaloni Martelli, *La Cappella dei Principi e le pietre dure a Firenze*, Milan, 1979.

Baldinucci, F., *Notizie dei professori del disegno da Cimabue in qua*, ed. F. Ranalli, 5 vols., Florence, 1845–47.

Baltruaitis, J., *Anamorfosi o magia artificiale degli effetti meravigliosi*, trans. Piero Bertolucci, Milan, 1969.

Bardeschi, M. dezzi, et al., *Lo Stanzino del principe in Palazzo Vecchio: i Concetti le immagini, il desiderio*, Florence, 1980.

Bareggi, C. di Filippo, "In nota alla politica culturale di Cosimo I: l'Accademia fiorentina," *Quaderni storici*, vol. 8, no. 23, 1973, pp. 527–74.

Barkan, L., *Unearthing the Past: Archeology and Aesthetics in the Making of Renaissance Culture*, New Haven and London, 1999.

Barocchi, P., *Michelangelo e la sua Scuola: i disegni di Casa Buonarroti e degli Uffizi*, Florence, 1962.

——, et al., *Mostra di disegni dei fondatori dell'Accademia delle Arti del Disegno*, Florence, 1963.

——, *Il Bacco di Michelangelo*, Florence, 1982a.

——, ed., *Michelangelo: Tondo Pitti, Apollo–David, Bruto – Michelangelo's Works*, Florence, 1982b.

——, "La storia della Galleria e la storiografia artistica," in *Gli Uffizi, quattro secoli di una galleria*, Florence, 1983, pp. 49–150.

—— ed., *Le due Cleopatre e le "teste divine" di Michelangelo*, Florence, 1989.

——, and G. Gaeta Bertelà, *Collezionismo mediceo: Cosimo I, Francesco I, e il cardinale Ferdinando, documenti 1540–1587*, Modena, 1991.

Barock in Dresden, exhibition catalog, Staatliche Kunstsammlung, Dresden, 1986.

Barolsky, P., *Daniele da Volterra: A Catalogue Raisonné*, New York and London, 1979.

——, *Michelangelo's Nose: A Myth and its Maker*, University Park and London, 1990.

——, "The Mysteries of Michelangelo," *Source*, 14, 1995, 3, pp. 37–40.

Baroni-Vannucci, A., *Jan Van Der Straet detto Giovanni Stradano, flandrus pictor et inventor*, Milan and Rome, 1997.

Barozzi, I., *Le due regole della perspettiva pratica di M.Iacomo Barozzi da Vignola…*, Rome, 1583.

Barrón, E., *Catálogo de la Escultura: Museo nacional de Pintura y Escultura*, Madrid, 1908.

Bartolomeo Ammannati Scultore e Architetto 1511–1592, ed. N. Rosselli Del Turco and F. Salvi, Florence, 1995.

Bartsch, A., *Le Peintre Graveur*, 21 vols., Vienna 1803–21.

Barzman, K., *The Florentine Academy and the Early Modern State: the Discipline of Disegno*, Cambridge, 2000.

Battistini, F., *Gelsi, bozzoli e caldaie: l'industria della seta in Toscana tra città, borghi e campagne (sec. XVI–XVIII)*, Florence, 1998, pp. 49–71.

Bauer, R., and H. Haupt, "Das Kunstkammerinventar Kaiser Rudolfs II, 1607–11," *Jahrbuch der Kunsthistorischen Sammlungen in Wien*, vol. 72, 1976, p.78.

Barzman, K. E., "The università, compagnia, ed accademia del disegno," Ph.D. diss., John Hopkins University, Ann Arbor, 1987.

——, "The Florentine Accademia del Disegno: Liberal Education and Renaissance Artists," in *Academies of Art Between Renaissance and Romanticism*, vols. 5–6, Leids, 1989, pp. 14–32.

Bean, J., with L. Turcic, *Fifteenth and Sixteenth Century Italian Drawings in the Metropolitan Museum of Art*, New York, 1982.

——, "Two Drawings by Jacopo Ligozzi," in *Festschrift to Erik Fischer: European Drawings from Six Centuries*, Copenhagen, 1990, pp. 211–16.

Beck, J., A. Paolucci, and B. Santi, *Un occhio su Michelangelo: le tombe dei Medici nella Sagrestia Nuova di S.Lorenzo a Florence dopo il restauro*, Bergamo, 1993.

Bellesi, S., "Interventi decorativi in Palazzo Pitti tra fine Cinquecento e primo Seicento," *Paragone*, 583, 1998, pp. 49–68.

——, and F. Romei, *Stefano della Bella: un episodio pittorico dimenticato*, Florence, n.d.

Bellosi, L., *Il Museo dello Spedale degli Innocenti a Firenze*, Milan, 1977.

——, "Il ritratto fiorentino del cinquecento," in *Il primato del disegno, Firenze e la Toscana nell'Europa del Cinquecento*, exhibition catalog, Palazzo Strozzi, Florence, 1980.

Berenson, B., *The Drawings of Florentine Painters*, London, 1903 (and subsequent editions).

Bernsmeier, U., "Die Nova Reperta des Jan van der Straet: ein Beitrag zur problemgeschichte der Entdeckungen und Erfindungen im 16 Jahrhundert," Ph.D. diss., Hamburg, 1986.

Bertelli, S. "Egemonia linguistica come egemonia culturale e politica nella Firenze cosimiana," in *Humanisme et Renaissance*, vol. 38, 1976, pp. 249–83.

——, *Il corpo del re: sacralità del potere nell'europa medievale e moderna*, Florence, 1990.

Berti, F., "I bozzetti per i costumi," in *Il potere e lo spazio: la scena del principe*, exhibition catalog, Milan and Florence, 1980.

Berti, L., *Il Principe dello Studiolo: Francesco I dei Medici e la fine del Rinascimento fiorentino*, Florence, 1967.

——, ed., *Gli Uffizi: catalogo generale*, 2 vols., Florence, 1979.

——, *Michelangelo: I disegni di Casa Buonarroti*, Florence, 1985.

Bertoni, L., "Cristina di Lorena", in *Dizionario biografico degli italiani*, vol. 31, Rome, 1985, pp. 37–40.

——, and E. Nardinaocci, *I tesori di San Lorenzo, 100 capolavori di oreficeria sacra*, Florence, 1995.

Bianchini, M. A., "Jacopo da Empoli," *Paradigma*, 3, 1980, p.129.

Biancofiore, A., *Benvenuto Cellini artiste-écrivain: l'homme à l'oeuvre*, Paris, 1998.

Birke, V., and J. Kertész, *Die Italienischen Zeichnungen der Albertina: Generalverzeichnis Band I. Inventar 1–1200*, Vienna, Cologne, and Weimar, 1992.

Blumenthal, A., *Theater Art of the Medici*, exhibition catalog, Hanover and New Haven, 1980.

——, *Italian Renaissane and Baroque Paintings in Florida Museums*, exhibition catalog, Winter Park, Florida, 1991.

Boccaccio, G., *Amorosa visione*, in *Tutte le opere*, ed. V. Branca, Milan, 1974, vol. 3, pp. 1–272.

Boccherini, T., and P. Marabelli, *Sopra ogni sorte di drapperia*, Florence, 1993.

Bocchi, F., *Le bellezze della città di Fiorenza*, ed. G. Cinelli, Florence, 1677; reprint Sala Bolognese, 1974.

——, *Della Imagine Miracolosa della SS. Nunziata di Firenze Opera di messer Francesco Bocchi scrittore del Secolo XVI*, Florence, 1852.

——, "Arms and Armor from the Medici Court," *Bulletin of the Detroit Institute of Arts*, Summer 1983, vol. 61, 1–2, pp. 59–64.

Bolzoni, L., "L'invenzione' dello Stanzino di Francesco I," in *Le Arti del Principato Mediceo*, Florence, 1980, pp. 255–99.

Bora, G., *I disegni del Codice Resta*, Milan, 1976.

Borea, E., ed., *La quadreria di Don Lorenzo de'Medici*, Florence 1977.

——, "Stampe da modelli fiorentini nel cinquecento," in *Il Primato del disegno, Firenze e la Toscana nell'Europa del Cinquecento*, exhibition catalog, Palazzo Strozzi, Florence, 1980, pp. 227–86.

Borghini, R., *Il Riposo*, Florence, 1584; reprint, 2 vols., ed. Mario Rosci, Milan, 1967.

——, "Invenzione per la pittura della Cupola data da Vincenzo Borghini a Giorgio Vasari," in C. Guasti, *La Cupola di Santa Maria del Fiore*, Florence, 1857.

Borsi, Franco, *Firenze del Cinquecento*, 2nd ed., Florence, 1993.

Borsook, E., "Art and Politics at the Medici Court I: the Funeral of Cosimo I de' Medici," *Mitteilungen des Kunsthistorischen Institutes in Florenz*, no. 7, 1965–66, pp. 31–54.

——, "Art and Politics at the Medici Court: the Baptism of Filippo de' Medici in 1577," *Mitteilungen des Kunsthistorischen institutes in Florenz*, vol. 13, 1967–68, 1, pp. 95–114.

——, "Art and Politics at the Medici Court: Funeral Decor for Philip II of Spain," *Mitteilungen des Kunsthistorischen institutes in Florenz*, vol. 15, 1969–70a, 1, pp. 91–114.

——, "Art and Politics at the Medici Court: Funeral Decor for Henry IV of France," *Mitteilungen des Kunsthistorischen institutes in Florenz*, vol. 15, 1969–70b, 2, pp. 201–34.

Boschung, D., *Die Bildnisse des Augustus*, Das römische Herrscherbild, series 1, vol. 2, Berlin, 1993.

Boström, A., "A Bronze Group of the *Rape of Proserpina* at Cliveden House in Buckinghamshire," *Burlington Magazine*, no. 132, 1990, pp. 829–40.

——, "Zanobi Lastricati: a Newly Discovered Document," *Burlington Magazine*, no. 136, December 1994, pp. 835–36.

——, "Aspects of the Collecting and Display of Sculpture in Florence and Rome, 1540–c.1595," Ph.D. diss., Courtauld Institute of Art, London University, 1995a.

——, "Daniele da Volterra and the Equestrian Monument to Henry II of France," *Burlington Magazine*, 137, December 1995b, pp. 809–20.

——, "A New Addition to Zanobi Lastricati: *Fiorenza* or the *Venus Anadyomene*; the Fluidity of Iconography," *Sculpture Journal*, no. 1, 1997, pp. 1–6.

Bottari, G., and S. Ticozzi, *Raccolta di lettere sulla pittura, scultura ed architettura*, 8 vols., Milan, 1822–25.

Bracciali, S., and A. D'Alessandro, "L'accademia del;l'arte del disegno di Firenze: prime ipotesi di ricera," in *La nascita della Toscana . . . 1980*, vol. 2, pp. 133ff.

Bracciante, A. M., *Ottaviano de' Medici e gli artisti*, Florence, 1984.

Bredekamp, H., *Calcio Fiorentino: il Rinascimento dei giochi. Il Calcio come festa medicea*, Genoa, 1993.

Brejon de Lavergnée, B., *Renaissance et Baroque: dessins italiens du Musée de Lille*, exhibition catalog, Musée des Beaux-Arts, Lille, 1989.

Brook, A., "Sixteenth Century 'Genre' Statuary in Medici Gardens and Giambologna's Fontana del Villano," in *Boboli 90*, conference, Florence, 9–11 March 1989, published Florence, 1991, vol. 1, pp. 113–30.

——, "Giovanni Battista Caccini," in *The Dictionary of Art*, ed. J. Turner, vol. 5, London, 1996, pp. 359–62.

——, "A graphic source for Giambologna's *Fata Morgana*," in *Giambologna tra Firenze e L'Europa, Atti del convegno internazionale, Firenze*, Florence, 2000, pp. 47–63.

Brown, H. M., "Psyche's Lament: Some Music for the Medici Weddings in 1565," in *Words and Music: the Scholar's View, Studies in Honor of A. Tilmann Merritt*, Cambridge, 1972, pp. 1–27.

Brown, J. C., "Concepts of Political Economy: Cosimo I de' Medici in a Comparative European Context," in *Firenze e la Toscana dei Medici nell'Europa del '500*, Florence, 1983, vol. 1, pp. 279–93.

Brown, S. A. (now Suzanne B. Butters), "Introduction," *Catalogo dell'arredamento esistente nella Villa Medicea "La Ferdinanda" di Artimino*, S. Marco sales catalog 4–8 October 1969, pp. 6–25.

Brugnoli Pace, M. V., "Un modello antico e dei disegni attribuito a Michelangelo," in *Essays in the History of Art Presented to Rudolf Witthower*, ed. D. Fraser, H. Hubbard, and M. J. Lewine, London, 1967, pp. 104–9.

Brunon, H., "La forêt, la montagne et la grotte: Pratolino et la poétique pastorale du paysage a la fin du XVIe siècle," in *Mélanges de l'Ecole Française de Rome: Italie et Méditerranée*, 112, 2, 2000, pp. 785–811.

Bruwaert, E., "Jacques Callot à Florence," *Revue de Paris*, 15 June 1914.

Bryce, J., "The Oral World of the Early Accademia Fiorentina," *Renaissance Studies*, vol. 1, no. 9, 1995, pp. 77–103.

Buonnaroti, M., *Rime*, ed. G. Papini, Florence, 1928, p.81.

——, *Rime di Michelangelo Buonarroti*, ed. E. N. Girardi, Bari, 1960.

——, *Il carteggio di Michelangelo*, ed. P. Barocchi and R. Ristori, 5 vols., Florence, 1965–83.

——, *Ricordi di Michelangelo*, ed. L. Bardeschi Ciulich and P. Barocchi, Florence, 1970.

——, *Il carteggio indiretto di Michelangelo*, ed. P. Barocchi, K. Loach Bramanti, R. Ristori, Florence, 1988.

——, *Michelangelo, Lettere: Concordanze e indice di frequenze*, 2 vols., ed. P. Barocchi, S. Maffei, G. Nencioni, U. Parrini, E. Picchi, Pisa, 1994.

Bulgarella, M., "Un damasco mediceo: Ricerche sulla sua origine, significato e uso nella pittura fiorentina del Cinque e Seicento," *Jacquard*, 30, 1996–97, pp. 2–6.

Burresi, M., *L'abito della Granduchessa nel Palazzo Reale di Pisa (a cura di Mariagiulia Burresi)*, Pisa 2000.

Bury, M., "Bernardo Vecchietti, Patron of Giambologna," *I Tatti Studies*, 1, 1985, pp. 13–56.

——, "Giambologna's *Fata Morgana* Rediscovered," *Apollo*, 131, February 1990, 336, pp. 96–100.

Buss, C., and G. Butazzi, *Tessuti serici italiani 1450–1530*, Milan, 1983.

Butters, S. B., "Le Cardinal Ferdinand de Médicis," in *La Villa Médicis*, vol. 2, *Etudes*, Rome, 1991a, pp. 170–96.

——, "Ammannati et la villa Médicis," in *La Villa Médicis*, vol. 2, *Etudes*, Rome, 1991b, pp. 257–316.

——, "Ferdinando et le jardin du Pincio," in *La Villa Médicis*, vol. 2, *Etudes*, Rome, 1991c, pp. 350–409.

——, *The Triumph of Vulcan: Sculptors' Tools, Porphyry, and the Prince in Ducal Florence*, 2 vols., Florence, 1996.

——, "*Magnifico, non senza eccesso*: riflessioni sul mecenatismo del cardinale Ferdinando de' Medici," in *Villa Medici: il sogno di un cardinale, collezioni e artisti di Ferdinando de' Medici*, ed. Michel Hochmann, exhibition catalog, Académie de France a Rome, Rome, 1999, pp. 22–45.

——, "'Una pietra eppure non una pietra': *pietre dure* e le botteghe medicee nella Firenze del Cinquecento," in *Arti fiorentine: la grande storia dell'artigianato*, vol. 3, *Il Cinquecento*, ed. G. Fossi and F. Franceschi, Florence, 2000, pp. 133–85.

——, "Pressed Labour and Pratolino: Social Imagery and Social Reality in a Medici Garden," in *Villas and Gardens in Early Modern Italy and France*, ed. Mirka Bene and Dianne Harris, New York and Cambridge, 2001a, pp. 61–87.

——, "The Duomo Perceived and the Duomo Remembered: Sixteenth-Century Descriptions of the Cathedral of Florence," in *Atti del VII Centenario di Santa Maria del Fiore*, ed. A. Innocenti and T. Verdon, vol. 2.ii, Florence, 2001b, pp. 456–501.

——, "Land, Women, and War: Identities Portrayed at Ferdinando de' Medici's Artimino," in Acts of *"L'arme e gli amori": The Poetry of Ariosto, Tasso, and Guarini in Florentine Culture in the Sixteenth and Seventeenth Centuries*, conference at the Harvard Center for Italian Renaissance Studies, Villa I Tatti, 27–29 June 2001.

——, "Making Art Pay: the Meaning and Value of Art in Late Sixteenth-century Rome and Florence," in *The Art Market in 16th and 17th-century Italy*, ed. S. Matthews Grieco and Marcello Fantoni, Florence, forthcoming.

Byam Shaw, J., *Drawings by Old Masters at Christ Church Oxford*, 2 vols., Oxford, 1976.

Cadogan, J. K., ed., *Wadsworth Athenaum Paintings*, vol. 2, *Italy and Spain: Fourteenth Through Nineteenth Centuries*, Hartford, Conn., 1991.

——, "Michelangelo in the Workshop of Domenico Ghirlandaio," *Burlington Magazine*, 135, 1993, pp. 30–31.

——, *Domenico Ghirlandaio: Artist and Artisan*, New Haven and London, 2000.

Caglioti, F., *Donatello e i Medici: Storia del "David" e della "Giuditta,"* 2 vols., Florence, 2000.

Calamandrei, P., *Scritti e inediti celliniani*, ed. Carlo Cordiè, Florence, 1971.

Calonaci, S., "Ferdinando dei Medici: la formazione di un cardinale principe (1563–72)," *Archivio Storico Italiano*, vol. 4, 1996, pp. 635–90.

——, "'Accordar lo spirito col mondo': il Cardinal Ferdinando de Medici a Roma negli anni di Pio V e Gregorio XIII," *Rivista Storica Italiana*, 112, 1, 2000, pp. 5–74.

Cambiagi, G., *L'Imperiale e Reale Giardino di Boboli*, Florence, 1757.

Camesasca, E., *Tutta l'opera del Cellini*, Milan, 1955.

——, and U. Galetti, *Enciclopedia della pittura italiana*, Cernusco sul Naviglio, 1951, 3 vols.

Campbell, M., "Observations on the Salone dei Cinquecento in the Time of Duke Cosimo I de' Medici, 1540–1574," in *Firenze e la Toscana dei Medici 1983*, vol. 3, pp. 819–30.

——, "Giambologna's *Oceanus Fountain*: Identifications and Interpretations," in *Boboli 90*, conference, Florence, 9–11 March 1989, published Florence, 1991, pp. 89–106.

Caneva, A., *Caccini Giovan Battista* in *Il Seicento Fiorentino: arte a Firenze da Ferdinando I a Cosimo III. Biografie*, exhibition catalog, Florence, 1986, pp. 44–46.

Cantelli, G., *Il Museo Stibbert a Firenze*, Milan, 1974.

——, *Repertorio della pittura fiorentina del seicento*, Florence, 1983.

Capecchi, G., "Stefano della Bella e lo spettacolo delle armi," in *Stefano della Bella un dipinto riemerso dal buio dei secoli*, ed. M. Gregori, F. Romei, and G. Capecchi, Florence, 1997, pp. 43–63.

Capolavari sconosciutia a palazzo Pitti, exhibition catalog, Milan, 1995.

Cappelli, A., *Cronologia, Cronografia e Calendario Perpetuo dal Principio dell'Èra Cristiana ai Nostri Giorni*, 4th edition, Milan, 1978.

Carman, C. H., "An Early Interpretation of Tasso's *Gerusalemme liberata*," *Renaissance Quarterly*, 31, no. 1, 1978, pp. 30–38 (trans. in *Torquato Tasso tra letteratura, musica teatro e arti figurative*, ed. A. Buzzoni, exhibition catalog, Castello Estense, Casa Romei, Ferrara, 1985, pp. 225–30. n.68).

Carofano, P., "Una pala dimenticata di Jacopo Coppi," *Prospettiva*, 87–88, 1997, pp. 140–45.

Cartari, V., *Le imagini de i dei de gli antichi*, Vicenza, 1996.

Casarosa Guadagni, A., "Le gemme dei Medici nel Quattrocento e nel Cinquecento," in *Tesori dalle collezioni medicee*, ed. C. Acidini, Florence, 1997, pp. 73–92.

Casciu, S., *Il Museo Statale d'Arte Medievale e Moderna di Arezzo*, Sansepolcro, 1994.

Caselli, S., "La commedia e la questone della lingua nella Florence di Cosimo I," *Italianistica*, 9, 1980, pp. 478–90.

Casini, M., *I gesti del principe: la festa politica a Firenze e Venezia in età rinascimentale*, Venice, 1996.

Cassarino, E., *La Villa Medicea di Artimino*, Florence, 1990.

Castelli, S., "Il teatro e la sua memoria: la compagnia dell'arcangelo Raffaello e il 'Don Gastone di Moncada' di Giacinto Andrea Cicognini," in *Tradurre, riscrivere, mettere in scena*, ed. M. G. Profeti, Florence, 1996, pp. 85–94.

Castro Moscati, D. di, "The Revival of the Working of Porphyry in Sixteenth-Century Florence," *Apollo*, 126, October 1987, pp. 242–48.

Catalano, M. I., *Il pavimento della Biblioteca Medicea Laurenziana*, Florence, 1992.

Catalogo della Galleria Colonna in Roma: Sculture, ed. F. Carinici, L. Musso, M. G. Picozzi, and H. Keutner, Rome, 1990.

Cecchi, A., "'Invenzioni per quadri' di don Vincenzo Borghini," *Paragone*, 33, 1982, nos. 383–85, pp. 89–96.

——, "Le perdute decorazioni fiorentine di Giovanni da Udine," *Paragone*, 34, 1983, no. 399, pp. 20–44.

——, "La peche des perles aux Indes: une peinture d'Antonio Tempesta," *La Revue du Louvre et des Musées de France*, 36, no. 1, 1986, pp. 45–57.

——, "La 'Prudenza' del Bronzino per Ser Carlo Gherardi," *Antichità viva*, 26, no. 3, 1987, pp. 19–22, fig. 2.

——, "La collection de tableaux," in *La Villa Médicis*, vol. 2, *Etudes*, Rome, 1991, pp. 486–505.

——, "L'estremo omaggio al 'padre e maestro di tutte le arti': Il monumento funebre di Michelangelo," in *Il Pantheon di Santa Croce a Florence*, Florence, 1993, pp. 57–81.

——, *Bronzino*, Florence, 1996.

——, "Il Maggiordomo ducale Pierfrancesco Riccio e gli artisti della corte medicea," *Mitteilungen des Kunsthistorischen Institutes in Florenz*, 43, 1998a, pp. 115–43.

——, *Le case del Vasari as Arezzo e Firenze*, in *Case di artisti in Toscana*, ed. Roberto Paolo Ciardi, Milan, 1998b, pp. 29–77.

——, "La collezione di quadri di Villa Medici," in *Villa Medici: il sogno di un cardinale, collezioni e artisti di Ferdinando de' Medici*, ed. Michel Hochmann, exhibition catalog, Académie de France à Rome, Rome, 1999, pp. 58–65.

Cecco Bravo, Florence 1601–Innsbruck 1661, Pittore senza regola, ed. A. Barsanti and R. Contini, exhibition catalog, Casa Buonarroti, Florence, 1999.

Chappell, M., "Cigoli's *Resurrection* for the Pitti Palace," *Burlington Magazine*, 141, 1974, n.857, pp. 469–74.

——, *Cristofano Allori*, exhibition catalog, Palazzo Pitti, Florence, 1984.

——, *Disegni di Lodovico Cigoli (1559–1613)*, exhibition catalog, Gabinetto Disegni e Stampe degli Uffizi, Florence, 1992.

——, "Renascence of the Florentine Baroque," *Dialoghi di Storia dell'Arte*, 7, 1998, pp. 56–111.

Chantelou, M. de, *Journal du voyage du Cavalier Bernini en France*, Paris, 1885.

Chater, J., "Bianca Cappello and Music," in *Renaissance Studies in Honor of Craig Hugh Smyth*, Florence, 1985, vol. 1, pp. 569–79.

Cheluzzi, L., and G. M. Galganetti, *Serie cronologica degli Uomini di merito più distinto della città di Colle Val d'Elsa*, Colle, 1841.

Chency, I. H, "Francesco Salviati's North Italian Journey," *Art Bulletin*, 45, no. 4, 1963, p.345.

Chiabrera, G., *Il Vivajo di Boboli*, in *Opere*, Venice, 1730, vol. 3, p.100.

Chiarini, M., "Pittura su pietra," *Antichità viva*, 9, no. 2, 1970, pp. 29–37.

——, *I disegni italiani di paesaggio dal 1600 al 1750*, Treviso, 1972.

——, "Due ritratti medicei: Maria Maddalena d'Austria e Cosimo II de' Medici ricongiunti," in *Ex Fumo Lucem: Baroque Studies in Honour of Klára Garas*, vol. 2, Budapest, 1999, pp. 127–30.

——, "La Cappella delle Reliquie," in *Palazzo Pitti*, Florence, 2000a, pp. 54–56.

——, "Cosimo II e l'inizio della quadreria," in *Palazzo Pitti*, Florence, 2000b, pp. 66–70.

——, and S. Casciu, ed., *Bizzarrie di pietre dipinte*, exhibition catalog, Opificio delle Pietre Dure, Florence 2000.

——, and M. de Luca Savelli, ed., *Visite reali a Palazzo Pitti*, exhibition catalog, Palazzo Pitti, Florence 1995.

——, and A. Marabottini, ed., *Firenze e la sua immagine: cinque secoli di vedutismo*, exhibition catalog, Florence, 1994.

——, A. Maetzke and A. Pampaloni Martelli, ed., *Pittura su pietra*, exhibition catalog, Palazzo Pitti, Florence 1970.

Choné, P., "Images discrètes, images secrètes: Callot et l'art de la pointe," in *Jacques Callot 1592–1635: Actes du colloque*, Paris, 1993, pp. 595–615.

Ciabani, R., *I Canti. Storia di Firenze attraverso i suoi Angoli*, Florence, 1984.

Cialoni, D., "Il ciclo del Pontormo nel coro di San Lorenzo a Firenze (1546–56): un'ipotesi interpretiva," *Storia dell'arte*, 93–94, 1998, pp. 235–58.

Cianchi, M., *Pierino da Vinci (Atti della giornata di studio: Vinci Biblioteca Leonardiana 26 maggio 1990)*, Florence, 1995.

Ciardi, R. P., "Alessandro Allori," in *Allgemeines Künstlerlexikon*, Leipzig, 1985, vol. 2, p.647.

——, "Uno stemma e una statua," *Artista*, 3, 1991, pp. 38–47.

——, and L. Tongiorgi Tomasi, *Immagini anatomiche e naturalistiche nei disegni degli Uffizi. Secc. XVI e XVII*, Florence, 1984.

Ciseri, I., "Scenari festivi in San Lorenzo: apparati, cerimonie, spettacoli," in *San Lorenzo, i documenti e i tesori nascosti*, exhibition catalog, Complesso di San Lorenzo, Florence, 1993, pp. 41–48.

Civai, A., *Dipinti e sculture in Casa Martelli. Storia di una collezione patrizia fiorentina dal Quattrocento all'Ottocento*, Florence, 1990.

Clements, R. J., *Michelangelo's Theory of Art*, New York, 1961; in Italian *Michelangelo e le idee sull'Arte*, trans. Eugenio Battisti, Milan, 1964.

——, "Unità nel pensiero di Michelangelo: il binomio dì-sole-notte-luna," in *Atti del Convegno di Studi Michelangioleschi*, Rome, 1966, pp. 427–42.

Cochrane, E., *Florence in the Forgotten Centuries 1527–1800*, Chicago, 1973.

Coffin, D. R., *The Villa in the Life of Renaissance Rome*, Princeton, New Jersey, 1979.

Colasanti, A., "Il Memoriale di Baccio Bandinelli," in *Repertorium für Kunstwissenschaft*, vol. 28, no. 1, 1905, p.428.

Cole, M., *Cellini and the Principles of Sculpture*, New York, 2002.

Collareta, M., "Tecniche, Generi ed Autografia: Sondaggi sui rapporti tra storiografia e pratica artistica nella decorazione vasariana di Palazzo Vecchio," in *Giorgio Vasari tra decorazione ambientale e storiografia artistica*, conference in Arezzo, 8–10 October 1981, ed G. C. Garfagnini, Florence, 1985.

——, *Palazzo Vecchio: committenza e collezionismo medicei*, exhibition catalog, Palazzo Vecchio, Florence, 1980.

——, "Le 'luci della fiorentina gloria,'" *Artista*, 3, 1991, pp. 136–43.

Collezione Gianfranco Luzzetti, dipinti, sculture, disegni, XIV–XVIII secolo, ed. Angelo Tartuferi, exhibition catalog, Florence, 1991.

Condivi, A., *Vita di Michelagnolo Buonarroti*, ed. G. Nencioni with essays by M. Hirst and C. Elam, Florence, 1998.

Conforti, C., *Vasari architetto*, Milan, 1993.

Conigliello, L., "Pesci, crostacei e un'iguana per l'imperatore Rodolfo II," *Paragone*, 493–95, 1991.

——, *Jacopo Ligozzi*, Poppi, 1992.

——, "Francesco di Jacopo Ligozzi," *Paragone*, 527, 1994.

——, "I busti di Pietro Francavilla," in *Il chiostro camaldolese di Santa Maria degli Angeli a Firenze: restauro e restituzione del ciclo di affreschi*, Florence, 1998.

——, and S. Vasetti, "Gli affreschi e le sculture," in *Il chiostro camaldolese di Santa Maria degli Angeli a Firenze: Restauro e restituzione del ciclo di affreschi*, Florence, 1998, pp. 47–81.

——, *Le vedute del Sacro Monte della Verna: Jacopo Ligozzi pellegrino nei luoghi di Francesco*, Florence, 1999.

Conisbee, P., et al., *The Ahmanson Gifts: European Masterpieces in the Collection of the Los Angeles County Museum of Art*, Los Angeles, 1991.

Conti, A., "Niccolo Tribolo nel Giardino di Castello," *Antichita viva*, 28, 1989, 51–61.

——, *Pontormo*, Milan, 1995.

Conti, C., *Ricerche storiche sull'arte degli arazzi in Firenze*, Florence, 1875.

——, *La prima reggia di Cosimo*, Florence, 1893.

Contini, R., *Bilivert*, Florence, 1985.

——, *Il Cigoli*, Soncino, 1991.

Coppel Aréizaga, R., *Museo del Prado: Catálogo de la escultura de época moderna. Siglos XVI–XVIII*, Madrid, 1998.

Cora, G., and A. Fanfani, *La Porcellana dei Medici*, Milan, 1986.

Corazzi, R., *La gabbia dei grilli: loggia di Baccio d'Agnolo sulla cupola di Santa Maria del Fiore*, Florence, 1995.

Corrias, P., "Don Vincenzo Borghini e l'iconologia del potere alla corte di cosimo i e di Francesco I de'Medici," *Storia dell'Arte*, 81, 1994, pp. 169–81.

Corsini, D., "Botteghe 'dentro la città' e laboratori in Galleria: gli orafi a Firenze nel Cinquecento," in *Arti fiorentine*, 3, *Il Cinquecento*, Florence, 2000, pp. 107–31.

Corti, L. et al., ed., *Giorgio Vasari, principi, letterati e artisti nelle carte di Giorgio Vasari: Pittura vasariana dal 1532 al 1554*, exhibition catalog, Casa Vasari and Sottochiesa di San Francesco, Arezzo, Florence, 1981.

——, *Vasari: Catalogo completo dei dipinti*, Florence, 1989.

Costamagna, P., *Pontormo: Catalogue raisonné de l'oeuvre peint*, Paris and Milan, 1994.

——, "Le mécénat et la politique culturelle du cardinal Giovanni Salviati," in *Francesco Salviati e la Bella maniera: Actes des colloque de Rome et de Paris, 1998*, Ecole Française de Rome, Rome, 2001, pp. 217–52.

Cox-Rearick, J., "Some Early Drawings by Bronzino," *Master Drawings*, 2, 1964, pp. 363–82.

——, "Les Dessins de Bronzino pour la Chapelle d'Eleonora au Palazzo Vecchio," *Revue de l'Art*, 14, 1971, pp. 7–22.

——, *The Drawings of Pontormo*, 2 vols., revised edition, New York, 1981.

——, *Dynasty and Destiny in Medici Art: Pontormo, Leo X, and the Two Cosimos*, Princeton, 1984.

——, "A 'St. Sebastian' by Bronzino," *Burlington Magazine*, 129, 1987, pp. 158–59.

——, "An Important Painting by Pontormo from the Collection of Chauncey D. Stillman," Christies' sales catalog, New York, 1989.

——, "Pontormo, Bronzino, Allori and the lost *Deluge* at San Lorenzo," *Burlington Magazine*, 134, 1992, pp. 239–48.

——, *Bronzino's Chapel for Eleonora di Toledo in the Palazzo Vecchio*, Berkeley and London, 1993.

——, *The Collection of Francis I: Royal Treasures*, Antwerp, 1995.

——, "Beyond Eclecticism: Salviati and Giulio Romano," in *Francesco Salviati e la Bella maniera: Actes des colloques de Rome et de Paris, 1998*, Ecole française de Rome, Rome, 2001, pp. 355–76, 370, n.43.

Cropper, E., *Pontormo, Portrait of a Halberdier*, Los Angeles, 1997.

Crum, R., "Cosmos, the World of Cosimo: The Iconography of the Uffizi Facade," *Art Bulletin*, 71, 1989, pp. 237–53.

Currie, S., "Discerning the Sculptural Content of Bronzino's Early Male Portraits: A Preliminary Investigation," in *The Sculpted Object 1400–1700*, ed. S. Currie and P. Motture, Brookfield, 1997, pp. 123–26.

Dallington, .R., *Descrizione dello stato del granduca di Toscana nell'anno di Nostro Signore 1596*, ed. Nicoletta Francovich Onesti and Leonardo Rombai, Florence, 1983.

Darcel, H., "Les faïences françaises et les porcelaines au Trocadéro," *Gazette des Beaux-Arts*, 18, November 1878.

Darr, A. P., "A Valentiner Legacy: Italian Sculpture in Detroit," *Apollo*, 124, December 1986, pp. 476–85.

——, "Introduction to Recent ESDA Acquisitions," *Bulletin of the Detroit Institute of Arts: European Sculpture and Decorative Arts*, 73, no. 1/2, 1999, pp. 3–7

——, *Catalog of Italian Sculpture in the Detroit Institute of Arts*, London 2002.

——, and T. Albainy, "Acquisitions of European Sculpture and Decorative Arts at the Detroit Institute of Arts 1988–99," *Burlington Magazine*, June 2000.

David, E., *Harvest of the Cold Months: The Social History of Ice and Ices*, ed. Jill Norman, London, 1994.

Davis, C., "Vincenzo Danti, San Luca", in G. Vasari, *Principi, letterati e artisti nelle Carte di Giorgio Vasari*, exhibition catalog, Arezzo, 1981.

——, "Working for Vasari: Vincenzo Danti in Palazzo Vecchio." in *Giorgio Vasari tra decorazione ambientale e storiografia ambientale*, Congress Acts, Arezzo, 8–10 October 1981, ed. G. C. Garfagnini, Florence, 1985, pp. 205–71.

De Francqueville, R., *Pierre de Francqueville: Sculpteur des Médicis et du Roi Henri IV 1548–1615*, Paris, 1968.

DeGrazia, D., *Le stampe dei Carracci con i disegni, le incisioni, le copie e i dipinti connessi*, trans. and ed. A. Boschetto, Bologna, 1984.

Del Bravo, C., "Quella quiete, e quella libertà," *Annali della Scuola Normale Superiore di Pisa (Classe di lettere e filosofia)*, series 2, vol. 8, 1978, pp. 1455–90; reprint, *Il Tribolo* in *Le risposte dell'arte*, Florence, 1985.

——, "Silvio e la magia," *Artista*, 1992, pp. 8–19.

——, "Francesco a Pratolino," in *Bellezza e pensiero*, Florence, 1997, pp. 167–74.

Della Pergola, P., *Galleria Borghese: i dipinti*, vol. 2, Rome. 1959.

Del Riccio, A., *Istoria delle pietre*, ed. Paola Barocchi, Florence, 1979.

Dempsey, C., *The Portrayal of Love: Botticelli's Primavera and Humanist Culture at the Time of Lorenzo the Magnificent*, Princeton, 1992.

Deswarte-Rosa, S., "Le cardinal Ricci de Montepulciano," in *La Villa Médicis, vol. 2, Etudes*, Rome, 1991, pp. 110–69.

Detroit Institute of Arts, exhibition catalog, 1937.

Dezzi Bardeschi, M., *Lo stanzino del Principe in Palazzo Vecchio: i concetti, le immagini, il desiderio*, exhibition catalog, Florence, 1980.

Dhanes, E., *Jean Boulogne, Giovanni Bologna Fiammingo*, Brussels, 1956.

Diaz, F., *Il Granducato di Toscana: i Medici*, Turin, 1976.

Die Bronzen der Fürstlichen Sammlung Liechtenstein, ed. James David Draper et al., exhibition catalog, Frankfurt am Main, 1986.

Diemer, D., "Giov. Ambrogio Maggiore und die Anfange der Kunstdrechseln um 1570," *Jahrbuch des Zentralinstituts fur Kunstgeschichte*, 1, 1985, pp. 295–342.

Die Pracht der Medici: Florenz und Europa, ed. C. Acidini Luchinat and M. Scalini, exhibition catalog, Kunsthalle der Hypo Kulturstiftung, Munich, 1998.

Digiesi, C., "I Ricci e la chiesa di Santo Stefano e Caterina a Pozzolatico: committenza e patronato," *Antichità viva*, 37, no.1, 1998, p. 10.

Disegni e incisioni della Raccolta Marucelli (sec.XV–XVIII), ed. G. Brunetti, M. Chiarini, and M. Sfarmeli, exhibition catalog, Florence, 1983.

Distelberger, R., "Beobachten zu den Steinschneidewerkstätten de Miseroni in Mailand und Prag," *Jahrbuch der Kunsthistorischen Sammlungen in Wien*, 74, 1978, p.83.

——, "Thoughts on Rudolfine Art in the 'Court Workshops' in Prague," in *Rudolf II and Prague: The Court and the City*, ed. Elika Fuiková, James M. Bradburne, Beket Bukovinská et al., London, 1997, pp. 189–98.

Dizionario biografico degli italiani, Rome, 1984.

Dolinek, V. and J. Durdik, *The Encyclopedia of European Historical Weapons*, London, 1993.

Doni, A. F., *Marmi*, Florence, 1552.

Dorini, U., *I Medici e i loro tempi*, Florence, 1982.

Drappi, velluti, taffettà et altre cose, ed. Marco Ciatti, exhibition catalog, Chiesa di Sant'Agostino, Siena, 1994.

Dussler, L., *Die Zeichnungen des Michelangelo*, Berlin, 1959.

Edelstein, B. L., "The Early Patronage of Eleonora di Toledo: The Camera Verde and its Dependencies in the Palazzo Vecchio," Ph.D. diss., Harvard University, 1995.

——, "Nobildonne napoletane e committenza: Eleonora d'Aragona ed Eleonora di Toledo a confronto," *Quaderni storici*, 104, 2000, pp. 295–319.

——, "Bronzino in the Service of Eleonora di Toledo and Cosimo I de' Medici: Conjugal Patronage and the Painter–Courtier," in *Beyond Isabella: Secular Women Patrons of Art in Renaissance Italy*, ed. David Wilkins and Sheryl Reiss, Kirksville, Missouri, 2001a, pp. 225–61.

——, "Observations on the Genesis and Function of Bronzino's Frankfurt Modello for the Vault Decoration in the Chapel of Eleonora," in *Festschrift for John Shearman*, ed. L.C. Matthew et al., Cambridge, 2001b.

Eisenbichler, K., *The Boys of the Archangel Raphael: A Youth Confraternity in Florence, 1411–1785*, Toronto, 1998.

——, ed., *The Cultural Politics of Duke Cosimo I de' Medici*, Aldershot, 2001.

Eisler, C., *Sculptor's Drawings*, New York, n.d.

Elam, C., and A. Hughes, "Michelangelo," in *The Dictionary of Art*, ed. J. Turner, London, 1996, vol. 21, pp. 431–60.

Emiliani, A., *Il Bronzino*, Busto Arsizio, 1960.

——, *Leggi, bandi e provvedimenti per la tutela dei*

beni artistici e culturali negli antichi stati italiani, 1571–1860, Bologna, 1978.

Estella, M., "La Venus del Jardin de la Isla de Aranjuez," in *Adán y Eva en Aranjuez 1992*, pp. 71–88.

Euripides' Medea and Other Plays, trans. Philip Vellacott, Harmondsworth and Baltimore, 1963.

Evans Dee, E., *Views of Florence and Tuscany by Giuseppe Zocchi 1711–67: Seventy-Seven Drawings from the Collection of The Pierpont Morgan Library New York, Circulated by the International Exhibitions Foundation 1971–72*, 2nd ed., New York, 1971.

Evelyn, J., *The Diary*, ed. William Bray, London, 1936.

Fagiolo, M., ed., *La città effimera e l'universo artificiale del giardino*, Rome, 1980.

Falciani, C., "Maria Salviati ritratta dal Pontormo," in *Rosso e Pontormo, fierezza e solitudine: esercizi di lettera e rendiconti di restauro per tre dipinti degli Uffizi*, ed. A. Natali, Sorecina, 1995, pp. 120–31.

——, *Pontormo: disegni degli Uffizi*, exhibition catalog, Gabinetto Disegni e Stampe degli Uffizi, Florence, 1996.

Fantoni, M., *La corte del granduca: forme e simboli del potere mediceo tra cinquecento e seicento*, Rome, 1994.

Fara, A., *Bernardo Buontalenti: l'architettura, la guerra e l'elemento geometrico*, Genoa, 1988.

——, *Bernardo Buontalenti*, Milan, 1995.

——, *Bernardo Buontalenti e Firenze: architettura e disegno dal 1576 al 1607*, Florence, 1998.

Faranda, F., *Ludovico Cardi detto il Cigoli*, Rome, 1986.

Fasano Guarini, E., "Ferdinando de' Medici," in *Dizionario biografico degli italiani*, XLVI, Rome, 1996, pp. 258–78.

——, "Roma officina di tutte le pratiche del mondo: dalle lettere del cardinale Ferdinando de' Medici a Cosimo I e a Francesco I," in *La Corte di Roma tra Cinque e Seicento: "teatro" della politica Europea*, ed. Gianvittorio Signorotto and Maria Antonietta Visceglia, Rome, 1998, pp. 265–97.

Federschmuck und kaiserkrone: Das barocke Amerikabild in den habsburgichen Ländern, ed., F. Polleross, A. Sommer Mathis, and C. F. Laferl, exhibition catalog, Schlosshof im Marcfeld, 1992.

Fedi, R., "Un retratto di Giovanni Della Casa," in *Studi di filologia e letteratura italiana in onore di Gianvito Resta*, ed. V. Masiello, 2 vols., Rome, 2000, I, pp. 355–77.

Feinberg, L. J., "The Works of Mirabello Cavalori," Ph.D. diss., Harvard University, 1986.

——, *From Studio to Studiolo: Florentine Draftsmanship under the First Medici Grand Dukes*, exhibition catalog, Allen Memorial Art Museum, Oberlin College, Seattle, 1991.

——, "A New Drawing by Mirabello Cavalori," *Master Drawings*, 30, 1992, pp. 423, 425–26.

Felipe II, Un Príncipe del Renacimiento, exhibition catalog, Madrid, 1993.

Fenlon, I., "Preparations for a Princess, Florence 1588–89," in *In cantu et in sermon: for Nino Pirrotta on his 80th Birthday*, ed. F. Della Seta and F. Piperno, Florence, 1988, pp. 259–81.

Fenton, J., *Leonardo's Nephew*, London, 1998.

Ferrero, G. G., ed., *Opere di Benvenuto Cellini*, Turin, 1980.

Ferri, P. N., *Indice geografico – analitico dei disegni di architettura civile e militare, esistenti nella R. Galleria degli Uffizi in Firenze*, Rome, 1885.

Ferrone, S., *Attori mercanti corsari: La commedia dell'arte in europa tra Cinque e seicento*, Turin, 1993.

Feste e apparati medicei da Cosimo I a Cosimo II: mostra di disegni e incisioni, ed. G. Gaeta Bertelà and A. M. Petrioli Tofani, exhibition catalog, Florence, 1969.

Ficino, M., *Three Books on Life*, trans. C. V. Kaske and J. R. Clark, New York, 1989.

Fidanza, G. B., *Vincenzo Danti (1530–1576)*, Florence, 1996.

——, "Danti, ital. Künstler-Fam. in Perugia," in *Saur Allgemeines Künstler-Lexikon*, vol. 24, Munich and Leipzig, 2000, pp. 209–15.

Fiore, F. P., "Egnazio Danti," in *Dizionario biografico degli italiani*, Rome, 1986a, vol. 32, pp. 659–63.

——, "Vincenzo Danti," in *Dizionario biografico degli Italiani*, Rome, 1986b, vol. 32, pp. 667–73.

Firenze e la sua immagine: cinque secoli di vedutismo, exhibition catalog, ed. M. Chiarini and A. Marabottini, Forte del Belvedere, Florence, 1994.

Firenze e la Toscana dei Medici nell'Europa del Cinquecento, vol. 3, *Relazioni artistiche: il linguaggio architettonico*, Florence, 1983.

Firpo, M., *Gli affreschi di Pontormo a San Lorenzo: eresia, politica e cultura nella Firenze di Cosimo I*, Turin, 1997.

Fischer Thompson, B. G., *The Sculpture of Valerio Cioli, 1529–99*, Ann Arbor, Michigan, 1980.

Fock, C. W., "The Medici Crown: Work of the Delft Goldsmith Jaques Bylivelt," *Oud Holland* 85, 1970.

——, "Der Goldschmied Jaques Bylivelt aus Delft und sein Wirken in der Mediceischen Hofwerkstatt in Florenz," *Jahrbuch der Kunsthistorischen Sammlungen in Wien*, 70, 1974, pp. 89–173.

——, "Vases en lapis-lazuli des collections médicéennes du seizième siècle," *Münchner Jahrbuch der bildenden Kunst*, 27, 1976, pp. 124–26.

——, "Francesco I e Ferdinando I mecenati di orefici e intagliatori di pietre dure," in *Le arti del Principato Mediceo*, Florence, 1980, pp. 317–63.

Folds McCullagh, S., and L. M. Giles, *Italian Drawings before 1600 in The Art Institute of Chicago*, Chicago, 1997.

Forster, K. W., "Metaphors of Rule: Political Ideology and History in the Portraits of Cosimo I de' Medici," *Mitteilungen des Kunsthistorischen Institutes in Florenz*, 15, 1971, pp. 65–104.

Fortnum, C. D. E., "On the Bronze Portrait Busts of Michelangelo Attributed to Daniele da Volterra and Other Artists," *Archaeological Journal*, 33, 1876, pp. 168–82.

Franchi, S., "Monodia e coro: tradizione classica, scritti critici e origini del melodramma: Sopravvivenze di una danza greca nell'europa medievale e moderna," in *La musica in Grecia*, ed. B. Gentili and R. Pretagostini, Bari, 1988.

Freeman, M. B., *The Unicorn Tapestries*, New York, 1976.

Frey, K., *Die Handzeichnungen Michelagniolo's Buonarroti*, Berlin, 1909–11.

——, and H. W., ed., *Der Literarische Nachlass Giorgio Vasaris*, 3 vols., Munich, 1923–40.

Fuchs, L., *De historia stirpium commentarii insignes*, Basel, 1542.

Fumagalli, E., M. Rossi and R. Spinelli, ed., *L'arme e gli amori: la poesia di Ariosto, Tasso e Guarini nell'arte fiorentina del Seicento*, exhibition catalog, Palazzo Pitti, Florence 2001.

Furlani, G., "Sardanapolo," in *Enciclopedia Italiana di Scienze, Lettere ed Arti*, vol. 30, Rome, 1936, pp. 835–36.

Gaborit, J-R., "Un relief du musée des Beaux-Arts d'Orléans: la Flagellation par Baccio Bandinelli," *Bulletin de la Société Nationale des Antiquaires de France*, 1994, pp. 146–52.

Gabriele, M., *Le Incisioni alchemico-metallurgiche di Domenico Beccafumi*, Florence, 1988.

Gaeta Bertelà, G., *La Tribuna di Ferdinando I de' Medici: inventari 1589–1631*, Modena, 1997.

——, and A. Petrioli Tofani, ed., *Feste e apparati Medicei da Cosimo I a Cosimo II: mostra di disegni e incisioni*, exhibition catalog, Gabinetto Disegni e Stampe degli Uffizi, Florence, 1969.

Gager, J. G., *Moses in Greco-Roman Paganism*, Nashville and New York, 1972.

Galilei, G., *Discoveries and Opinions of Galileo*, trans. and ed. S. Drake, New York, 1957.

——, *Scritti letterari*, Florence, 1970.

Galluzzi, R., *Storia del Granducato di Toscana*, Florence, 1822, lib.III, cap.VI.

Gamber, O., and C. Beaufort, *Kunsthistorisches Museum Wien, Hofkagd- und Ruestkammer (ehem. Waffensammlung) Katalog der Leibruestkammer, II. Teil, Der Zeitraum von 1530–1560*, Busto Arsizio, 1990.

Gambuti, A., "Lodovico Cigoli Architetto," *Studi e Documenti di Architettura*, vol. 2, June 1973, pp. 39–136.

Gandolfo, L. F., *Il "dolce tempo": musica, ermetica e sogno nel cinquecento*, Rome, 1971.

Gareffi, A., *La scrittura e la festa: Teatro, festa e letteratura nella Florence del rinascimento*, Bologna, 1991

Garnier, E., *La Porcelaine tendre de Sèvres*, Paris, n.d.

Garofalo, C., *Da Raffaello a Rubens: Disegni della Fondazione Horne*, exhibition catalog, Horne Museum, Florence, 2000.

Gasparri, C., "La collection d'antiques du cardinal Ferdinand," in *La Villa Médicis*, vol. 2, *Etudes*, Rome, 1991, pp. 443–85.

Gasparotto, D., "Baccio Bandinelli, *Busto ritratto di Cosimo I de' Medici*," in *Magnificenza alla corte dei Medici*, 1997, pp. 227–28, no. 180.

Gasparri, Carlo, "I marmi antichi di Ferdinando. Modelli e scelte di un grande collezionista," in *Villa Medici: il sogno di un cardinale, collezioni e artisti di Ferdinando de' Medici*, ed. Michel Hochmann, exhibition catalog, Académie de France à Rome, Rome, pp. 46–57.

Gathan, M. W., and P. J. Jacks, *Vasari's Florence, Artists and Literati at the Medicean Court*,

exhibition catalog, Yale University Art Gallery, New Haven, 1994.

Gaye, G., *Carteggio inedito d'artisti dei secoli XIV, XV, XVI*, , 3 vols., Florence, 1839–40.

Geisenheimer, H., "Gli Arazzi nella Sala dei Dugento a Firenze," *Bollettino d'arte*, 3, 1909, 4, pp. 137–47.

Gentile, S., and C. Gilly, *Marsilio Ficino e il ritorno di Ermete Trismegistus*, exhibition catalog, Bibliotheca Medicea Laurenziana and Bibliotheca Philosophica Hermetica, Florence and Amsterdam, 1999.

Gere, J. A., *Dessins de Taddeo e Federico Zuccaro*, Cabinet des Dessins, Museé du Louvre, Paris, 1969.

Gerin-Jean, P., *Prix des oeuvres d'art et hiérarchie des valeurs artistiques au temps des Médicis*, Paris, 1998.

Gesner, C., *De Rerum fossilium, Lapidum et Gemmarum maxime, figuris et similitudinibus Liber*, Tiguri, 1565.

Giannotti, A., "Precisazioni e aggiunte per il 'fiammingo' Willem Tetrode," *Prospettiva*, 95–96, 1999, pp. 173–81.

Gibbons, F., *Catalog of Italian Drawings in the Art Museum, Princeton University*, Princeton, 1977.

Gibbons, M. W., "Cosimo's Cavallo: a Study in Imperial Imagery," in Eisenbichler 2001, pp. 77–102.

Gilbert, C., *Complete Poems and Selected Letters of Michelangelo*, Princeton, 1963.

Ginori-Conti, P., *L'apparato per le nozze di Francesco de' Medici e di Giovanna d'Austria: Da lettere inedite di Vincenzo Borghini*, Florence, 1936.

Ginori Lisci, L., *Cabrei in Toscana: raccolte di mappe, prospetti e vedute sec. XVI–sec. XIX*, Florence, 1978.

Giovannetti, A., "Morandini Francesco, detto il Poppi," in *La pittura in Italia: il Cinquecento*, Milan, Electa, 1988, vol. 2, p.775.

——, "Note sul Poppi disegnatore," *Kunst des Cinquecento in der Toskana*, Munich, 1992, pp. 265–66.

——, *Gli esordi di Jacopo Zucchi (1540?–1596) e alcuni problemi della bottega del Vasari*, Ph.D. diss., University of Siena, 1994–95.

——, *Francesco Morandini detto Il Poppi*, Florence, 1995.

Giovinezza di Michelangelo, ed. K. Weil-Garris Brandt, exhibition catalog, Palazzo Vecchio, Casa Buonarroti, Florence, 1999.

Giusti, A. M., "Origine e sviluppi della manifattura granducale," in *Splendori di Pietre Dure*, Palazzo Pitti, Florence, 1988, pp. 10–23.

——, *Pietre Dure: L' arte europea del mosaico negli arredi e nelle decorazioni dal 1500 al 1800*, Turin, 1992; trans. J. Condie and M. Roberts, London, 1992.

——, *Guida al Museo dell' Opificio delle Pietre Dure di Florence*, Venice, 1995.

——, "L'ingegnoso artificio delle pietre dure," in *Magnificenza* 1997a, pp. 380–84.

——, "Le botteghe granducali al tempo di Fredinando I e Cosimo II," in *Tesori dalle collezioni medicee*, ed. C. Acidini, Florence, 1997b, pp. 115–143

——, P. Mazzoni, and A. Pampaloni Martelli, *Il Museo dell' Opificio delle Pietre Dure a Florence*, Milan, 1978.

Göbel, H., *Wandteppiche*, 7 vols., Leipzig, 1923–34.

Goldberg, E., *Patterns in Late Medici Patronage*, Princeton, 1983.

Goldenberg Stoppato, L., in *Il Seicento fiorentino*, exhibition catalog, Palazzo Strozzi, Florence, 1986, pp. 315–16.

Goldner, G. R., L. Hendrix, and G. Williams, *European Drawings*, Malibu, 1988.

Goldscheider, L., *Michelangelo: Sculptures, Paintings, Architecture, Complete Edition*, London, 1967.

Goldthwaite, R. A., *The Building of Renaissance Florence: An Economic and Social History*, Baltimore, 1980.

——, *Wealth and the Demand for Art in Italy, 1300–1600*, Baltimore, 1993.

——, *Banks, Palaces, and Entrepreneurs in Renaissance Florence*, Aldershot, and Brookfield, Vermont, 1995.

——, "Realtà economico-sociali e status culturale dell'artigiano," in *Arti fiorentine*, vol. 2, *Il Quattrocento*, ed. G. Fossi and F. Franceschi, Florence, 1999, pp. 9–25.

——, "Il contesto economico," in *Arti fiorentine*, vol. 3, *Il Cinquecento*, Florence, 2000, pp. 9–23.

Golfieri, E., *Pinacoteca di Faenza*, Faenza, 1964.

Gombrich, E. H., M. Tafuri, S. Ferino Pagden et al., *Giulio Romano*, Milan, 1989.

Gonzàlez Palacios, A., *Mosaici e pietre dure*, Milan, 1981.

——, *Le arti decorative in Italia fra classicismi e barocco. Il tempio del gusto: la Toscana e l' Italia settentrionale*, Milan, 1986.

——, *Il gusto dei Principi. Arte di corte del XVII e XVIII secolo*, 2 vols., Milan, 1993.

——, "Trionfi barocchi a Firenze" in *I mobili di Palazzo Pitti: il periodo dei Medici 1537–1737*, Florence, 1996, pp. 15–43.

——, *Las colecciones reales espanolas de mosaicos y piedras duras*, Madrid, 2001.

Gori, A. F., *Museum Florentinum*, Florence, 1731.

Gotti, A., *Vita di Michelangelo Buonarroti narrata con l'aiuto di nuovi documenti*, 2 vols, Florence, 1875.

Gould, S. J., *The Lying Stones of Marrakech*, New York, 2000.

Gramberg, W., "Beitrage zum Werke und Leben Pierino da Vinci," *Jahrbuch der Preussischen Kunstsammlungen*, 52, 1932, pp. 223–28.

Grassini, R., "La Chimica e la farmacia in Firenze sotto il governo Mediceo," *Rivista di fisica, matematiche, e scienze naturali*, 94, 1906, pp. 335–46, and 95, 1907, pp. 426–41.

Gregori, M., "Catalogo e stima della collezione Martelli a Firenze," 1986, in the archive of the Galleria Martelli.

Griswold, W. M., and L. Wolk-Simon, *Sixteenth-Century Italian Drawings in New York Collections*, exhibition catalog, Metropolitan Museum of Art, New York, 1994.

Grünwald, A., "Über einige unechte Werke Michelangelos," *Münchner Jahrbüch der bildenden Kunst*, 5, 1910, pp. 11–70.

Gschwantler, K., "El Joven del Magdalensberg," in *Adan y Eva en Aranjuez*, 1992, pp. 49–70.

Guerzoni, G., "Cultural Heritage and Preservation Politics: Notes on the History of the Italian Case," in *Economic Perspectives on Culture Heritage: an Introduction*, ed. M. Hutter and I. Rizzo, London, 1997, pp. 107–32.

Gurrieri, F., *Artisti granducali nel tempio della Madonna della Fontenuova a Monsummano*, Pistoia, 1973.

——, and J. Chatfield, *Boboli Gardens*, Florence, 1972.

Gussoni, A., "Relazione dello Stato di Fiorenza," in E. Alberi, *Relazioni degli ambasciatori veneti al Senato*, Florence, 1841, vol. 2, p.353 ff.

Hale, J. R., *Florence and the Medici: The Pattern of Control*, London, 1977.

Hall, M. B., *Renovation and Counter-Reformation: Vasari and Duke Cosimo in Santa Maria Novella and Santa Croce 1565–77*, Oxford, 1979.

Halm, P., B. Degenhart, and W. Wegner, *Hundert Meister Zeichnungen aus der staatlichen Graphische Sammlung München*, Munich, 1958.

Hamilton, P., *Disegni di Bernardino Poccetti*, exhibition catalog, Florence, 1980.

Härb, F., "Modes and Models in Vasari's Early Drawing Œuvre," in *Giorgio Vasari: Artists and Literati at the Medicean Court*, ed. P. Jacks, Cambridge, 1998, pp. 83–110.

Harness, K., "La Flora and the End of Female Rule in Tuscany," *Journal of the American Musicological Society*, 3, 51,1998.

Harprath, R., *Italienische Zeichnungen des 16 Jahrhunderts aus eigenem Besitz*, Munich, 1977.

Hartt, F., *The Drawings of Michelangelo*, London and New York, 1971.

——, G. Corti, and C. Kennedy, *The Chapel of the Cardinal of Portugal, 1434–1459, at San Miniato in Florence*, Philadelphia, 1964.

Haskell, F., and N. Penny, *Taste and the Antique: The Lure of Classical Sculpture 1500–1900*, New Haven, 1981.

Hayward, J., "An Eighteenth-century Drawing of the Grand-ducal Crown of Tuscany," *Burlington Magazine*, 97, no. 631, October 1955, pp. 308–11.

——, Letter to *Burlington Magazine*, 98, no. 640, July 1956, p.243.

——, *Virtuoso Goldsmiths 1540–1620, the Triumph of Mannerism*, London, 1976.

Heikamp, D., "Arazzi a soggetto profano su cartoni di Alessandro Allori," in *Rivista d'arte*, 31, 1956–58, 31, pp. 105–55.

——, "Zur Geschichte der Uffizien Tribuna und der Kunstschränke in Florenz und Deutschland," *Zeitschrift für Kunstgeschichte*, 26, 1963, nos.3–4, pp. 226, 251–52, doc.46; 254, doc 57.

——, "Baccio Bandinelli nel Duomo di Firenze," *Paragone*, 15, 1964, pp. 32–42.

——, "La Manufacture de tapisserie des Médicis," *L'Oeil*, 164–65, 1968, pp. 22–31.

——, "On margine alla *Vita di Baccio Bandinelli* del Vasari," *Paragone*, 17, no. 191, 1966, pp. 51–62.

——, "Federico Zuccari a Firenze 1575–1579, I, La Cupola del Duomo: Il Diario disegnato," *Paragone*, no. 205, 1967, pp. 44–68.

——, "Die Arazzeria Medicea im 16. Jahrhundert: Neue Studien," *Münchner Jahrbuch der bildenden Kunst*, 20, 1969a, 20, pp. 133–74.

——, "Les merveilles de Pratolino," *L'Oeil*, 171, 1969b, p.75.

——, "Ammanati's Fountain for the 'Sala Grande' of the Palazzo Vecchio in Florence," in *Fons Sapientiae: Renaissance Garden Fountains*, Dumbarton Oaks, 1978, pp. 115–73.

——, "Scultura e politica: Le statue della Sala Grande di Palazzo Vecchio," in *Le Arti del Principato Mediceo*, vol. 3, Florence, 1980, pp. 201–54.

——, "The Grotto of the *Fata Morgana* and Giambologna's Marble Gorgon," *Antichità viva*, 20, 1981, no. 3, pp. 12–31.

——, "Studien zur mediceischen Glaskunst: Archivalien, Entwurfszeichenungen, Gläser und Scherben," *Mitteilungen des Kunsthistorischen Institutes in Florenz*, 30, 1986a.

——, "'Villani' di marmo in giardino," in *Il Giardino d'Europa: Pratolino come modello nella cultura europea*, exhibition catalog, Palazzo Medici Riccardi, Florence and Villa Demidoff, Pratolino, 1986b, pp. 61–65.

——, *Mediceische Glaskunst*, Florence, 1986c.

——, "Lo 'Studiolo Nuovo' ovvero il Tempietto della Tribuna degli Uffizi," in *Splendori di Pietre Dure*, exhibition catalog, Palazzo Pitti, Florence, 1988, pp. 53–61.

——, "Animali e piante a Pratolino," in *Studi di storia dell'arte in onore di Mina Gregari*, Milan, 1994.

——, "La fontana del Nettuno in piazza della Signoria e le sue acque," in *Bartolomeo Ammanati Scultore e Architetto 1511–1592*, conference, Florence-Lucca, 17–19 March 1994, published Florence, 1995, pp. 19–30.

——, "Le sovrane bellezze della Tribuna," in *Magnificenza,* 1997a, pp. 329–45.

——, "Arte vetraria a Firenze," in *Magnificenza,* 1997b.

——, "Sulla scultura fiorentina fra Maniera e Controriforma," in *Magnificenza*, 1997c, pp. 346–69.

——, "Federico Zuccari e la cupola di Santa Maria del Fiore: La fortuna critica dei suoi affreschi," in *Federico Zuccaro, le Idee, gli Scritti: Atti del Convegno di Sant'Angelo in Vado, a cura di Bonita Clerici*, Milan, 1997d, pp. 139–58.

——, "Le porcellane medicee: Le Manifatture di maioliche di Niccolò Sisti a Pisa," in *Magnificenza* 1997e, pp. 403–4.

——, "Arte vetraria a Firenze," in *Magnificenza* 1997f, pp. 405–6.

——, "Zu den Reisezeichnungen Federico Zuccaris," in *Römisches Jahrbuch der Bibliotheca Hertziana*, 323, Munich 1997–98, pp. 347–68.

Heinzl-Wied, B., "Studi sull' arte della scultura in pietre dure durante il Rinascimento: I fratelli Sarachi," *Antichità Viva*, 12, no. 6, 1973, p.48.

Herrmann, L., ed., *The Fifty-Ninth Volume of the Walpole Society*, London, 1997.

Hesiod, *The Homeric Hymns and Homerica*, trans. H. G. Evelyn-White, Cambridge and London, 1982.

Hibbert, C., *Florence: The Biography of a City*, London, 1993.

——, *The House of Medici: Its Rise and Fall*, New York, 1974, rev. ed. *The Rise and Fall of the House of Medici*, London, 1998.

Hierarchia Catholica medii et recentioris aevi sive Summorum Pontificum, S.R.E. Cardinalium, Ecclesiarum Antistitum Series, inchoavit Guilelmus Van Gulik, absolvit Conradus Eubel, vol. 3, Regensberg, 1923.

Hill, J. W., "Nuove musiche 'ad usum infantis': le adunanze della compagnia dell'arcangelo Raffaello fra cinque e seicento," in *La musica e il mondo*, ed. Di Claudio Annibaldi, Bologna, 1993, pp. 113–37.

Hippocrates, trans. P. Potter, Cambridge and London, 1938.

Hirst, M., "Three Ceiling Decorations by Francesco Salviati," *Zeitschrift für Kunstgeschichte*, 36, 1963, pp. 146–65, 156.

Hirst, M., *Sebastiano del Piombo*, Oxford, 1981.

——, *Michelangelo and His Drawings*, New Haven and London, 1988.

——, and J. Dunkerton, *Making and Meaning: the Young Michelangelo*, London, 1994; in Italian, *Michelangelo giovane: scultore e pittore a Roma 1496–1501*, Modena, 1997.

Hochmann, M., ed., *Villa Medici: il sogno di un cardinale, collezioni e artisti di Ferdinando de' Medici*, exhibition catalog, Académie de France a Rome, Rome, 1999.

Holanda, F. de, *Diálogos em Roma*, Lisbon, 1548; in Portuguese, trans. José da Felicidade Alves, Lisbon 1984; in Portuguese-Italian, trans. Rita Biscetti, Rome, 1993.

Holderbaum, J., "Recuperi moderni di sculture di Pierino da Vinci, e l'identificazione di un ritratto del Bronzino che raffigura Pierino con la statua di Bacco" in *Pierino da Vinci (Atti della giornata di studio. Vinci, Biblioteca Leonardiana 26 maggio 1990)*, ed. M. Cianchi, Florence, 1995, pp. 17–23.

Holmyard, E. J., *Alchemy*, Baltimore, 1957.

Holo, S., "A Note on the Afterlife of the Crouching Aphrodite in the Renaissance," *J. Paul Getty Museum Journal*, 6/7, 1978–79, pp. 23–36.

Homer, *The Odyssey*, trans. A.T. Murray, Cambridge and London, 1978.

Höper, C., et al., *Raffael und die Folgen. Das Kunstwerk in Zeitaltern seiner grahischen Reproduzierbarkeit*, exhibition catalog, Graphische Sammlung, Staatsgalerie Stuttgart, 2001.

Hoppe, I., "Eleonora de Toledo," in *Frauen der italienischen Renaissance: Dichterinnen, Malerinnen, Mazeninnen*, ed. I. Osohls-Wehden, Darmstadt, 1999, pp. 227–45, 279–81.

I bozzetti michelangioleschi della Casa Buonarroti, ed. P. Ragionieri, Florence, 2000.

I disegni dei secoli XV e XVI della Biblioteca Marucelliana, ed. G. Brunetti, exhibition catalog, revised R. Todros, Rome, 1990.

I disegni e le incisioni della Raccolta Marucelli (secoli XV–XVIII), ed. G. Brunetti, M. Chiarini, and M. Sframeli, exhibition catalog, Florence, 1984.

I Gioielli dell'Elettrice Palatina, Florence, 1988

Il carteggio di Michelangelo, ed. P. Barocchi and R. Ristori, 5 vols., Florence, 1965–83.

Il carteggio indiretto di Michelangelo, ed. P. Barocchi, K. Loach Bramanti, R. Ristori, Florence, 1988; reprint 1995.

Il Crocifisso di Santo Spirito, Florence City Council, Assessorato alla Cultura, Florence, 2000.

Il disegno fiorentino del Seicento nella Marucelliana: 6 a Biennale Internazionale della Grafica d'Arte, ed. M. Gregori and G. Cantelli, exhibition catalog, Or San Michele, Florence, 1978.

Il Giardino d'Europa: Pratolino come modello nella cultura europea, exhibition catalog, Palazzo Medici Riccardi, Florence and Villa Demidoff, Pratolino, 1986.

Il giardino di San Marco: maestri e compagni del giovane Michelangelo, ed. P. Barocchi, exhibition catalog, Casa Buonarroti, Florence, 1992.

Il luogo teatrale a Firenze: Brunelleschi Vasari Buontalenti Parigi, ed. L. Zorzi, M. Fabbri, E. Garbero Zorzi, A. M. Petrioli Tofani, exhibition catalog, Palazzo Medici Riccardi, Florence, 1975.

Il museo di Santa Maria all'Impruneta, ed. R. C. Proto Pisani, Florence, 1996.

Il Museo Stibbert a Firenze, ed. Giuseppe Cantelli, Milan, 1974.

Il potere e lo spazio: la scena del principe, exhibition catalog, Florence, 1980.

Il primato del disegno, Firenze e la Toscana nell'Europa del Cinquecento, exhibition catalog, Palazzo Strozzi, Florence, 1980.

Il Seicento fiorentino: arte a Firenze da Ferdinando I a Cosimo III, 3 vols., exhibition catalog, Palazzo Strozzi, Florence, 1986.

Immagini anatomiche e naturalistiche nei disegni degli Uffizi, ed. R. P. Ciardi and L. Tongiorgi Tomasi, exhibition catalog, Florence, 1984.

Il Tesoro di Lorenzo il Magnifico, ed. D. Heikamp, 2 vols., exhibition catalog, Palazzo Medici Riccardi, Florence, 1972.

Innocenti, D. degli', "Il parato di Santo Stefano della cattedrale di Prato," in *Il ricamo in Italia dal XVI al XVIII secolo*, ed. F. Fiori and M. Accorsero, Novara, 2001, pp. 200–8.

Italies: Peintures de musées de la région Centre, exhibition catalog, Musée des Beaux-Arts, Tours, Musée des Beaux-Arts, Orléans, and Musée des Beaux-Arts, Chartres, 1996.

Jacks, P., ed., *Vasari's Florence: Artists and Literati at the Medicean Court*, Cambridge, 1998.

Jacobs, F. H., "Vasari's Vision of the History of Painting: Frescoes in the Casa Vasari, Florence," *Art Bulletin*, 66, 1984, pp. 399–16.

Jacquemart, A., "La porcelaine des Médicis," *Gazette Des Beaux-Arts*, 3–4, July–December 1859.

Jacques Callot, Stefano Della Bella, dalle collezioni di stampe della Biblioteca degli Intronati di Siena, ed. P. Ballerini, S. Di Pino Giambi, and M. P. Vignolini, exhibition catalog, Florence, 1976.

Jacques Callot 1592–1635, ed. P. Choné and D. Ternois, exhibition catalog, Musée Historique Lorrain, Nancy, 1992.

Jacquot, J., "Dalla festa cittadina alla celebrazione medicea: storia di una trasformazione," *Il teatro dei Medici: quaderni di teatro*, 2, no. 7, 1980, pp. 9–21.

Jaffé, D., ed., *Rubens and the Italian Renaissance*, exhibition catalogue, Canberra and Melbourne, 1992.

——, Review of the exhibition *Rome and Paris: Francesco Salviati*, *Burlington Magazine*, 140, 1998, p.345.

Jervis, S., "*Les Blasons domestiques* by Gilles Corrozet," *Furniture History*, 25, 1989.

Jestaz, B., "A propos de Jean Bologne", *Revue de l'art*, 46, 1979, pp. 78–79.

Joannides, P., "Michelangelo's Medici Chapel, Some New Suggestions," *Burlington Magazine*, 114, no. 833, August 1972, pp. 541–51.

——, *Michelangelo and His Influence: Drawings from Windsor Castle*, London, 1996.

Johnson, C., "Cosimo I de' Medici e la sua 'storia medallica' nelle medaglie di Pietro Paolo Galeotti," *Medaglia*, 12, 1976, pp. 14–46.

Jones, M., *A Catalogue of French Medals in the British Museum*, London, 1988.

Karwacka Codini, E., and M. Sbrilli *Il quaderno della fabbrica della cappella di Sant'Antonino in San Marco a Firenze*, Pisa, 1996.

Katritzky, M. A., "A German Description of the Florentine Intermedi of 1565," *Italian Studies*, 1999, pp. 63–93.

Kauffmann, G., "Das Forum von Florenz," in *Studies in Renaissance and Baroque Art Presented to Anthony Blunt on His 60th Birthday*, ed. Michael Kitson and John Shearman, London, 1967, pp. 37–43.

Kemp, M., *The Science of Art: Optical Themes in Western Art from Brunelleschi to Seurat*, New Haven and London, 1990.

——, *Behind the Picture: Art and Evidence in the Italian Renaissance*, New Haven and London, 1997.

Kemp, W., "Disegno, Beiträge zur Geschichte des Begriffs zwischen 1547 und 1607," *Marburger Jahrbuch für Kunstwissenschaft*, 19, 1974, pp. 219–40.

Kent, D., *Cosimo de' Medici and the Florentine Renaissance: The Patron's Oeuvre*, London and New Haven, 2000.

Kerwin, W. C., "Vasari's *Tondo of Cosimo I with his Architects, Engineers, and Sculptors* in the Palazzo Vecchio," *Mitteilungen des Kunsthistorischen Institutes in Florenz*, 15, 1971, pp. 105–22.

Ketterer, R. C., "Classical Sources and Thematic Structure in the Florentine Intermedi of 1589," *Renaissance Studies*, vol. 13, no. 2, 1999, pp. 192–222.

Keutner, H., "Der Giardino Pensile der Loggia dei Lanzi und seine Fontäne," in *Kunstgeschichtliche Studien für Hans Kauffmann*, Berlin, 1956, pp. 244–51.

——, "The Palazzo Pitti *Venus* and Other Works by Vincenzo Danti," *Burlington Magazine*, 100, 1958, pp. 427–31.

——, "Die Bronzevenus des Bartolomeo Ammannati. Ein Beiträg zum problem des Torso im Cinquecento," *Münchener Jahrbuch der Bildenden Kunst*, 15, 1963, pp. 79–92.

——, "Niccolò Tribolo und Antonio Lorenzi: Der Äskulapbrunnen im Heilkräutergarten der Villa Castello bei Florenz," in *Studien zur Geschichte der Europäische Plastik: Festschrift für Theodor Müller*, Munich, 1965, pp. 235–44.

——, "Die künstlerische Entwicklung Giambolognas bis zur Aufrichtung der Gruppe des Sabinerinnenraubes," in *Giambologna-Ein Wendepunkt der Europäischen Plastik*, exhibition catalog, Kunsthistorisches Museum, Vienna, 1978–79, pp. 19–30.

Kinney, P., *The Early Sculpture of Bartolomeo Ammanati*, New York and London, 1976.

Kirkendale, W., "Emilio de' Cavalieri," in *Dizionario biografico degli italiani*, vol. 20, Rome, 1979, pp. 659–64.

——, *Court Musicians in Florence During the Principate of the Medici*, Florence, 1993.

——, *Emilio de' Cavalieri, "gentiluomo romano": His Life and Letters, His Role as Superintendent of All The Arts at the Medici Court, and His Musical Compositions*, Florence, 2000.

Kirkham, V., "Laura Battiferra degli Ammanati's First Book of Poetry: A Renaissance Holograph Comes out of Hiding," *Rinascimento*, 36, 1996, pp. 351–91.

——, "Dante's Phantom, Petrarch's Specter: Bronzino's Portrait of the Poet Laura Battiferra," *Lectura Dantis*, 22–23, 1998, pp. 63–139.

Kliemann, J., "Zeichnungsfragmente aus der Werkstatt Vasaris und ein unbekanntes Programm Vincenzio Borghinis für das Casino Med_ceo in Florenz – Borghinis 'inventioni per pitture fatte,'" *Jahrbuch der Berliner Museen*, 20, 1978, pp. 157–208.

Klossowski de Rola, S., *Alchemy: The Secret Art*, London, 1973.

Koerte, W., *Der Palazzo Zuccaro in Rom*, Leipzig, 1935.

Kris, E., *Catalogue of Post-classical Cameos in the Milton Weil Collection*, Vienna, 1932.

Kunz, G. F., *The Curious Lore of Precious Stones*, New York, 1971.

Labarte, J., *Description des objets d'art qui composent la Collection Debruge Dumenil*, Paris, 1847.

La corte, il mare, i mercanti: la rinascita della scienza. Editoria e Società. Astrologia, magia e alchimia, exhibition catalog, Florence, 1980.

L'Adolescente dell'Ermitage e la Sagrestia Nuova di Michelangelo, ed. S. Androsov and U. Baldini, exhibition catalog, Casa Buonarroti, Florence, 2000.

La Galleria Palatina: Storia della quadreria granducale di Palazzo Pitti, ed. M. Mosco, exhibition catalog, Palazzo Pitti, Florence, 1982.

Lamberini, D., "I Parigi: una famiglia di artisti pratesi alla corte medicea," in *Prato e i Medici del '500. Società e cultura artistica*, Rome, 1980.

——, "Boboli e l'ingegneria idraulica alla scuola dei Parigi," in *Boboli '90*, conference, Florence, 1990, vol. 3, pp. 467–79.

La morte e la gloria: apparati funebri medicei per Filippo II di Spagna e Margherita d'Austria, ed. M. Bietti, exhibition catalog, Cappelle Medicee in San Lorenzo, Florence, 1999.

La natura morta a palazzo e in villa: le collezione dei Medici e dei Lorena, exhibition catalog, Livorno, 1998.

Landais, H., "Note sur un groupe de bronze du Louvre: Arie e Petus ou le Gaulois se poignardant," *Revue des Arts*, 8, 1958, pp. 43–44.

Landini, R. O., "L'amore del lusso e la necessità della modestia. Eleonora fra sete e oro," in *Moda alla corte dei Medici: Gli abiti restaurati di Cosimo, Eleonora e don Garcia*, exhibition catalog, Florence, 1993, pp. 43–44.

——, "Alcune considerazioni sul significato simbolico dei velluti quattrocenteschi," *Jacquard*, 1997, n.33, pp. 2–6.

——, "Il velluto da abbigliamento. Il rinnovamento del disegno," in *Velluti e moda tra XV e XVII secolo*, ed. Annalisa Zanni, exhibition catalog, Milan, 1999.

Landolfi, D., "Su un teatrino medíceo e sull'Accademia degli Incostanti a Firenze nel primo Seicento," *Teatro e Storia*, 6, 1991, 1, pp. 57–88.

Lane, A., *Italian Porcelain*, London, 1954.

——, "A Rediscovered Cruet of Medici Porcelain," *Bulletin of the Museum of Fine Arts, Boston*, 56, 1958, no. 304, pp. 77–83.

Langdon, G., "Decorum in Portrits of Medici Women at the Court of Cosimo I, 1537–1574," Ann Arbor, 1994.

Langedijk, K., "Baccio Bandinelli's *Orpheus*: A Political Message," *Mitteilungen des Kunsthistorischen Institutes in Florenz*, 20, no. 1, 1976, pp. 33–52.

——, "Ritratti granducali a Firenze, una volta all'Ospedale di Santa Maria Nuova e a Palazzo Pitti," *Prospettiva*, 13, 1978, pp. 64–67.

——, "A Lapis Lazuli Medallion of Cosimo I de' Medici," *Metropolitan Museum Journal*, 13, 1979, pp. 75–78.

——, *The Portraits of the Medici: Fifteenth–Eighteenth Centuries*, 2 vols., Florence, 1983.

——, *Portraits of the Medici, Fifteenth to Eighteenth Centuries*, 3 vols., Florence, 1981–87.

Lapini, A., *Diario Fiorentino di Agostino Lapini dal 252 al 1596*, ed. G. O. Corazzini, Florence, 1900.

L'arme e gli amori: la poesia di Ariosto, Tasso e Guarini nell'arte fiorentina del seicento, ed. E. Fumagalli, M. Rossi, and R. Spinelli, Florence, 2001.

La Via, "Concentus Iovis adversus Saturni voces: Magia, musica astrale e umanesimo nel IV intermedio fiorentino del 1589," *I Tatti Studies*, 1993, pp. 11–156.

La Villa Médicis, vol. 5, *Sources Ecrites*, dir. A. Chastel, co-ord. O. Bonfait-P. Morel, ed. scientifiques O. Bonfait, E. Fumagalli, J. Guillemain, Rome, forthcoming.

La Villa Médicis, vol. 2, dir. André Chastel, co-ord. Philippe Morel, Rome, 1991.

Lazzaro, C., *The Italian Renaissance Garden: From the Conventions of Planting, Design, and Ornament to the Grand Gardens of Sixteenth-century Central Italy*, New Haven and London, 1990.

Lazzi, G., "Un eccezionale occasione di lusso: l'incoronazione di Cosimo I de' Medici (1569)," in *Archivio Storico Italiano*, ed. Leo Olschki, Florence, 1989, pp. 99–119.

——, "La moda alla corte di Cosimo I de' Medici," in *Moda alla Corte dei Medici*, Florence, 1993, pp. 27–34.

Le Arti del Principato Mediceo, ed. C. Adelson et al., Florence, 1980.

Lecchini Giovannoni, S., "Alcune proposte per l'attivita ritrattistica di Alessandro Allori," *Antichita viva*, 7, 1968, pp. 48–57.

——, *Mostra di disegni di Alessandro Allori (Firenze 1535–1607)*, exhibition catalog, Florence, 1970.

——, *Alessandro Allori*, Turin, 1991.

——, "Ferdinando I dei Medici e Cristina di Lorena: immagini del potere e della devozione: Osservazioni su alcuni dipinti inediti," *Arte Musica Spettacolo: Annali del Dipartimento di Storia delle arti e dello spettacolo*, year 2, 2001, p.192, fig. 5.

——, and M. Collareta, *Disegni di Santi di Tito (1536–1603)*, exhibition catalog, Gabinetto Disegni e Stampe degli Uffizi, Florence, 1985.

Lefébure, A., "Un singe en bronze de Jean Boulogne," *La Revue du Louvre*, 1984, no. 3, pp. 184–88.

Le incisioni di Jacques Callot nelle collezioni italiane, exhibition catalog, Milan, 1992.

Leithe-Jasper, M., Renaissance Master Bronzes from the Collection of the Kunsthistorisches Museum, Vienna, exhibition catalog, National Gallery of Art, Washington, D.C., 1986.

Lensi, A., Il Palazzo Vecchio, Milan and Rome, 1929.

Lensi-Orlandi, G., Il Palazzo Vecchio di Firenze, Florence, 1977.

——, Cosimo e Francesco de' Medici alchimisti, Florence, 1978.

Leonardi, C., Michelangelo, l'Urbino, il Taruga, Città di Castello, 1995.

Leonardo e il mito di Leda: modelli, memorie e metamorfosi di un'invenzione, ed. Gigetta Dalli Regoli, Romano Nanni, and Antonio Natali, exhibition catalog, Museo Leonardiano, Vinci, 2001.

Les Bronzes de la Couronne, exhibition catalog, Musée du Louvre, Paris, 1999; 2nd edition 2001.

Levenson, J. A., K. Oberhuber, and J. L. Sheenan, Early Italian Engravings from the National Gallery of Art, Washington, 1973.

Levey, M., "Sacred and Profane Significance in Two Paintings by Bronzino," in Studies in Renaissance and Baroque Art Presented to Anthony Blunt on His 60th Birthday, ed. M. Kitson and J. Shearman, London, 1967, pp. 30–33.

Levey, M., Florence: A Portrait, Cambridge, Massachusetts, 1996.

Licata, B. and A., Vanzulli, "Grano, crestie, banditismo in Toscana ai tempo di Ferdinando I," in Architettura e Politica da Cosimo I a Ferdinando I, ed. Giorgio Spini, Florence, 1976, pp. 333–460.

Liechtenstein: The Princely Collections, exhibition catalog, Metropolitan Museum of Art, New York, 1985.

Lietzmann, H., "Albrecht V und Wilhelm V von Bayern, Zwei Kristallschnitte von Valentin Drausch," Weltkunst/Heft, 13, Jg. 64, 1994.

Lieure, J., Jacques Callot: Catalogue de l'oeuvre gravé, 6 vols., Paris, 1924–27.

Lightbown, R., "Nicholas Audebert and the Villa d'Este," Journal of the Warburg and Courtauld Institutes, 51, no. 27, 1964, pp. 164–90.

——, "A Medici Casket," Victoria and Albert Museum Bulletin, July 1967, pp. 81–89.

——, Sandro Botticelli, London, 1978.

Lillie, A., "Lorenzo de' Medici's Rural Investments and Territorial Expansion," Rinascimento, second series, 33, 1993, pp. 53–67.

Lipinsky, A., "Exotische Meermuscheln in der Europäischen Goldschmiedekunst des 16. und 17. Jahrhunderts," Alte und moderne Kunst, 22, no. 151, 1977, pp. 1–13.

Liscia Bemporad, D., ed., Argenti fiorentini dal XV al XIX secolo, 3 vols., Florence, 1992–93.

Liverani, G., Catalogo delle porcellane dei Medici, Faenza, 1936.

——, "Premières porcelaines européenes: Les essais des Médicis," Cahiers de la Céramique et des Arts du Feu, 15, 1956, pp. 141–58.

Livorno: progetto e storia di una città tra 1500 e il 1600, exhibition catalog, Livorno, 1980.

Livorno e Pisa: due città e un territorio nella politica dei Medici, exhibition catalog, Pisa, 1980.

Lloyd, C., Italian Paintings before 1600 in The Art Institute of Chicago: A Catalog of the Collection, Princeton, 1993.

L'officina della maniera: varietà e fierezza nell'arte fiorentina del Cinquecento fra le due repubbliche 1494–1530, exhibition catalog, Galleria degli Uffizi, Florence, 1996.

Lomazzo, G. P., Gli sogni e raggionamenti, ca.1563, in Scritti sulle Arti, ed. R. P. Ciardi, Florence, 1973a.

——, Trattato dell'arte della pittura, scoltura et architettura, Milan, 1584, in Scritti sulle Arti, ed R. P. Ciardi, Florence, 1973b.

Longhi, R., Opere complete di R. Longhi, vol. 2, 1967.

Lorenzoni, A., Carteggio artistico inedito di Don Vincenzo Borghini, Florence, 1912.

Macandrew, H., Italian Drawings in the Museum of Fine Arts Boston, Boston, 1983.

MacDougall, E. B., "'L'Ingegnoso Artifizio': Sixteenth-Century Garden Fountains in Rome," in Fons Sapientiae: Renaissance Garden Fountains, Dumbarton Oaks, 1978, pp. 109–11.

Machiavelli, N., The Prince and the Discourses, trans. Max Lerner, New York, 1950.

Magnificenza alla corte dei Medici: arte a Firenze alla fine del Cinquecento, ed. C. Acidini Luchinat, M. Gregori, D. Heikamp, and A. Polucci, exhibition catalog, Palazzo Pitti, Museo degli Argenti, Florence, 1997.

Malanima, P., La decadenza di un'economia cittadina: l'industria di Firenze nei secoli XVI–XVIII, Florence, 1982.

Mamone, S., Firenze e Parigi: due capitali dello spettacolo per una regina Maria de' Medici, Milan, 1987.

——, "Callot e lo spettacolo fiorentino: il risparmio e lo spreco," in Le incisioni di Jacques Callot nelle collezioni italiane, exhibition catalog, Rome, Pisa, Naples, 1992, pp. 69–77.

——, "Tra tela e scena: vita d'accademia e vita di corte nel primo seicento fiorentino," in Biblioteca teatrale, 1996a, pp. 37–38, 213–28.

——, "Parigi, Lotti, Callot, Cicognini et Adimari: 'Andromède' dans le spectacle florentin au temps de Cosme II," in Andromède ou le héros à l'épreuve de la beauté, conference papers, ed. F. Siguret and A. La Framboise, Paris, 1996b.

——, "Li due Alessandri," in La passione teatrale: Tradizione, prospettive e spreco nel teatro italiano: otto e novecento, Studi per Alessandro d'Amico, ed. A. Tinterri, Rome, 1997a, pp. 223–45.

——, "Lo spettacolo nella Toscana del seicento," Medioevo e Rinascimento, vol. 11, no. 8, 1997b, pp. 197–446.

——, Il sistema dei teatri e le accademie a Firenze sotto la protezione di Giovan Carlo, Mattias e Leopoldo principi impresari, in Teatro e spettacolo nella Firenze dei Medici: modelli dei luoghi teatrali, ed. E. Garbero Zorzi, M. Sperenzi, Florence, 2001, pp. 83–97.

Mandel, C., "An Autograph Satyr by Vincenzo de' Rossi on the Neptune Fountain in Florence," Source, 14/4, Summer 1995, pp. 26–35.

Mannucci, G. B., Pienza, i suoi monumenti e la sua Diocesi, Montepulciano, 1915.

Mansuelli, G., Galleria degli Uffizi: le sculture, 2 vols., Rome, 1958.

Marabottini, A., Jacopo di Chimenti da Empoli, Rome, 1988.

Marcenaro, G., and P. Boragina, ed., Viaggio in Italia: un corteo magico dal Cinquecento al Novecento, exhibition catalog, Milan, 2001.

Markova, V., "Un Baccanale ritrovato di Giorgio Vasari, proveniente dalla Galleria Gerini," in Kunst des Cinquecento in der Toskana, ed. Kunsthistorisches Institut in Florenz, vol. 17, Munich, 1992, pp. 237–41.

Martelli, F., "Cristina di Lorena, una lorenese al governo della Toscana medicea," in Il granducato di Toscana e i Lorena nel secolo XVIII, ed. A. Contini and M. G. Parri, Florence, 1999, pp. 71–81.

Martelli, N., Dal primo e dal secondo libro delle lettere, ed. C. Marconcini, Lanciani, 1916.

Massar, P. D., "A Set of Prints and a Drawing for the 1589 Medici Marriage Festivals," Master Drawings, 13, 1, 1975, pp. 12–23.

Massinelli, A. M., "I bronzi dello stipo di Cosimo I de' Medici," Antichità Viva, 26, 1987, vol. 1, pp. 36–45.

——, "Magnificenze medicee: gli stipi della Tribuna," Antologia di Belle Arti, 35–38, Studi sul Neoclassicismo II, 1990, pp. 118, 120.

——, and F. Tuena, Il Tesoro dei Medici, New York 1992; Novara and Milan, 2000.

Masterpieces from the Detroit Institute of Arts, exhibition catalog, the Bunkamura Museum of Art, Tokyo, 1989.

Master Prints and Drawings, exhibition catalog, Artemis Fine Arts, London, 1982.

Materassi, C., "Il cerimoniale festivo dell'Accademia del Disegno da Cosimo I a Cosimo II (1563–1621)," Ph.D. diss., University of Florence, 2001.

Maylender, M., Storia delle accademie d'Italia, 5 vols., Bologna, 1930.

Mazzoni, S., Lo spettacolo delle accademie in Storia del teatro moderno e contemporaneo: la nascita del teatro moderno, Turin, 2000.

McCorquodale, C., Bronzino, New York, 1981.

McCrory, M., "The Symbolism of Stone: Engraved Gems at the Medici Grand-Ducal Court (1537–1609)," in Engraved Gems: Survivals and Revivals, ed. Clifford Malcolm Brown, Studies in the History of Art, no. 54, Washington, 1997.

——, "Immutable Images: Glyptic Portraits of the Medici Court in Sixteenth-century Florence," in The Image of the Individual, Portraits in the Renaissance, ed. N. Mann and L. Syson, London, 1998, pp. 48–49.

McGrath, E., "Il senso nostro: The Medici Allegory Applied to Vasari's Mythological Frescoes in the Palazzo Vecchio," in Giorgio Vasari: tra decorazione ambientale e storiografica artistica, Convegno di Studi, Arezzo, 1981, ed. Giancarlo Garfagnini, Florence, 1985, pp. 117–34.

McTavish, D., Review of Francesco Salviati ou la Bella Maniera, Master Drawings, 38, 2000, p. 68.

——, "Some Suggestions for the Work of Francesco Salviati, with Comments on his Relationship with Pellegrino Tibaldi," in Francesco Salviati e la bella maniera: actes des colloques de Rome et de Paris, 1998, Ecole française de Rome, Rome, 2001, pp. 429–53.

Medici, L. de', *Ambra*, in *Tutte le opere*, ed. P. Orvieto, vol. 2, Rome, 1992, pp. 887–910.

Meijer, B., "A propos de quelques dessins de Lambert Sustris," in *Francesco Salviati e la bella maniera: actes des colloques de Rome et de Paris, 1998*, Ecole française de Rome, 2001, p. 648.

Meller, P., "Un gruppo di bronzetti di Pierino da Vinci del 1547," *Mitteilungen des Kunsthistorischen Institutes in Florenz*, 18, Heft 2, 1974, pp. 251–72.

Mellini, D., *Descrizione dell'entrata della serenissima reina Giovanna d'Austria et dell'apparato fatto in Firenze nella venuta, e per le felicissime nozze di sua altezza et dell'illustrissimo, et eccellentissimo, signor Don Francesco de Medici, principe di Fiorenza, et di Siena*, Florence, 1565.

Meloni Trkulja, S., "Lodovico Buti (Butti)," in *Dizionario biografico degli italiani*, vol. 15, Rome, 1972, pp. 607–8.

Mendelsohn, L., "The Sum of the Parts: Recycling Antiquities in the Maniera Workshops of Salviati and His Colleagues," in *Francesco Salviati ou la Bella Maniera*, exhibition catalog, Villa Medici, Rome, and Musée du Louvre, Paris, 1998, pp. 107–47, 146 no. 98.

Meoni, L., *Gli arazzi nei musei fiorentini: la collezione medicea, catalogo completo*, vol. 1, *La manifattura da Cosimo I a Cosimo II (1545–1621)*, Livorno, 1998.

Mercati, M., *Metallotheca Vaticana*, Rome, 1717.

Mette, H., *Der Nautiluspokal: Wie Kunst und Natur miteinander spielen*, Berlin and Munich, 1995.

Meyer, F. G., E. Emmart Trueblood, and J. L. Heller, *The Great Herbal of Leonhart Fuchs*, Stanford, 1999.

Micheletti, E., *Le donne dei Medici*, Florence, 1983.

Michiel, M., "Diary 1512–21," in *Intorno la vita e le opere di Marc'Antonio Michiel patrizio veneto della prima metà del secolo XVI: memoria*, ed. E. A. Cicogna, Venice, 1861.

Middeldorf, U., "Additions to the Work of Pierino da Vinci," *Burlington Magazine*, 53, 1928, pp. 299–306; reprint in *Raccolta di scritti*, vol. 1, *1924–38*, Florence, 1979–80, pp. 47–54.

——, "Alessandro Allori e il Bandinelli," in *Rivista d'Arte*, 14, 1932, p.486.

Mignani, D., *Le Ville Medicee di Giusto Utens*, Florence, 1993.

Millar, O., *Zoffany and his Tribuna*, London and New York, 1967.

Miller, R., "Documents for Francesco Salviati's *Incredulity of St. Thomas*," *Dialoghi di Storia dell'Arte*, 1997, no. 4.

Millon, H. A., and C. Hugh Smyth, *Michelangelo architetto: la facciata di San Lorenzo e la cupola di San Pietro*, exhibition catalog, Casa Buonarroti, Florence, 1988.

Miniati, M., "'Un fabbro che sia buon maestro': produzione di strumenti scientifici a Firenze nel Cinquecento," in *Arti fiorentine*, vol. 3, *Il Cinquecento*, Florence, 2000, pp. 263–95.

Minor, A., and B. Mitchell, *A Renaissance Entertainment: Festivities for the Marriage of Cosimo I, Duke of Florence, in 1539*, Columbia, 1968.

Mirandola, P. della, "Quaestio Quinta de Magia Naturali et Cabali Hebraeorum," *Opera omnia* Basel, 1557, pp. 175–77.

——, "Oration on the Dignity of Man" in *The Renaissance Philsophy of Man*, trans. Elizabeth Livermore Forbes, Chicago and London, 1948, p.251.

Mitchell, B., *Italian Civic Pageantry in the High Renaissance: A Descriptive Bibliography of Triumphal Entries and Selected Other Festivals for State Occasions*, Florence, 1979.

Moda alla Corte dei Medici, exhibition catalog, Galleria del Costume, Florence, 1993.

Molà, L., "Artigiani e brevetti nella Firenze del Cinquecento," in *Arti fiorentine*, vol. 3, *Il Cinquecento*, Florence, 2000, pp. 57–79.

Molinari, C., "Delle nozze medicee e dei loro cronisti," in *Il teatro del rinascimento*, ed. F. Cruciali and D. Seragnoli, Bologna, 1987, pp. 263–71.

Monbeig Goguel, C., *Musée du Louvre, Cabinet des Dessins, Inventaire General des Dessins Italiens: I, Maitres toscans nes apres 1500, morts avant 1600, Vasari et son Temps*, Paris, 1972.

——, *Vasari et son temps: Inventaire Général des Dessins Italiens*, vol. 1, Paris, 1972b.

——, ed., *Francesco Salviati ou la Bella Maniera*, exhibition catalog, Villa Medici, Rome, and Musée du Louvre, Paris, 1998.

——, "Pour Bronzino: Un nouveau modele de Christ mort entre Pontormo et Allori," in *L'intelligenza della passione: Scritti in onore di Andrea Emiliani*, ed. Michela Scolaro and Francesco Di Teodoro, Bologna, 2001a.

——, "Francesco Salviati e la Bella Maniera. Quelques points à revoir. Interprétation, chronologie, attributions," in *Francesco Salviati e la Bella maniera. Acte des colloques de Rome et de Paris, 1998*, Ecole française de Rome, Rome, 2001b.

Montaigne, M. de, *Journal de voyage en Italie par la Suisse et Alegmagne*, ed. A. d'Ancona, Città di Castello, 1895.

——, *Journal de voyage*, ed. F. Garavini, Paris, 1983.

Montigiani, V., *Fauna che munge una capretta: il ritorno inatteso di un'opera di Valerio Cioli per la Villa di Francesco I de' Medici a Pratolino*, Paris, 2001.

Moreni, D., *Pompe funebri celebrate nell'Imp: e Reale Basilica di S.Lorenzo dal secolo XIII a tutto il Regno Mediceo*, Florence, 1827.

Morel, P., "Sirene e demoni celesti: Fonti filosofiche e precedenti iconografici degli intermezzi fiorentini del 1589," *Biblioteca teatrale*, 19–20, 1990, pp. 71–90.

——, "Le Parnasse astrologique: les décors peints pour le cardinal Ferdinand de Médicis. Etude iconologique," in *La Villa Médicis*, vol. 2, *Etudes*, Rome, 1991a.

——, "Sirènes et démons célestes: Sources philosophique et précedents iconographiques des intermèdes florentines de 1589," in *Le Parnasse astrologique: Les décors peints pour le cardinal Ferdinand de Mèdici, Etude iconologique*, Rome, 1991b, pp. 291–333.

——, "Portrait éphémère et théatre de mémoire dans les entrées florentines (1565 et 1589)," in *Il ritratto e la memoria*, ed. A. Gentili, P. Morel, and C. Cieri Via, Rome, 1993.

Morelli, G., "Handzeichnungen Italienischen Meister in Photographischen Aufnahmen von Braun und Co. in Domach," ed. E. Habich, *Kunstchronik*, 1892.

Morozzo, F., *Memorie di istoria Ecclesiastica Civile e Letteraria di Colle Valdelsa*, Florence, 1775.

Morrogh, A., *Disegni di architetti fiorentini 1540–1640*, trans. Silvia Dinale, exhibition catalog, Gabinetto Disegni e Stampe degli Uffizi LXIII, Florence, 1985a.

——, "Vasari and Coloured Stones," in *Giorgio Vasari: tra decorazione ambientale e storiografia artistica*, ed. Gian Carlo Garfagnini, Convegno di Studi, Arezzo, 8–10 October 1981, Florence, 1985b.

Mortari, L., *Francesco Salviati*, Rome, 1992; reprint 1998.

Moryson, F., *An Itinerary containing his ten years travel…*, Glasgow, 1907.

Mosco, M., *La Galleria Palatina*, exhibition catalog, Palazzo Pitti, Florence, 1983.

Mostra del Cigoli e del suo ambiente, exhibition catalog, San Miniato, 1959.

Mostra del Cinquecento Toscano, exhibition catalog, Florence, 1940.

Mostra di disegni vasariani: carri trionfali e costumi per la Genealogia Degli dei (1565), ed. A. M. Petrioli, exhibition catalog, Florence, 1966.

Mundy, J. E., ed., *Renaissance into Baroque: Italian Master Drawings by the Zuccari, 1550–1600*, exhibition catalog, Wisconsin Art Museum, Milwaukee, 1989–90.

Museo e Gallerie Nazionali di Capodimonte: la collezione farnese (le arti decorative), Naples 1996.

Muzzarelli, M. G., *Guardaroba medievale: vesti e società dal XIII al XVI secolo*, Bologna, 1999.

Nagel, A., *Michelangelo and the Reform of Art*, Cambridge, 2000.

Nagler, A. M., *Theatre Festivals of the Medici 1539–1637*, New Haven and London, 1964.

Natali, C., *Il Santuario di Maria SS. Della Fontenuova patrona della diocesi di Pescia*, Monsummano terme, 1963.

Nelson, J., "Creative Patronage: Luca Martini and the Renaissance Portrait," *Mitteilungen des Kunsthistorischen Institutes in Florenz*, 39, 1995, pp. 285–93.

Newcombe, A., *The Madrigal at Ferrara 1579–1597*, Princeton, 1980.

Newman, K., "The Politics of Spectacle: 'La Pellegrina' and the Intermezzi of 1589," *Modern Language Notes*, 51, 1986, pp. 95–113.

Nucci, E., *La Madonna della Fonte Nuova Patrona di Monsummano*, Pescia, 1923.

O'Grody, J. A., "'Un semplice modello': Michelangelo and His Three-Dimensional Preparatory Works," Ph.D. diss., Case Western Reserve University, 1999.

Old Master Drawings, exhibition catalog, Margot Gordon Gallery, New York, and Galleria Marcello Aldega, Rome, 1992.

Ongpin, S., *An Exhibition of Master Drawings*, Adam Williams Fine Art Ltd. and Colnaghi (New York and London, 2001).

Orsi Landini, R., "L'amore del lusso e la necessità di modestia. Eleonora fra sete e oro," in *Moda alla corte dei Medici*, Florence, 1993, pp. 35–45.

Ostrow, S. F., "Marble Revetment in Late Sixteenth-Century Roman Chapels," in *Il 60: Essays Honoring Irving Lavin on His Sixtieth Birthday*, ed. Marilyn Aronberg Lavin, New York, 1990, pp. 253–66.

Ovid, *Fasti*, trans. James George Frazier, Cambridge and London, 1989.

——, *Metamorphoses*, trans. Frank Justus Miller, Cambridge and London, 1984.

Padovani, S., "Il Quartiere dei Cardinali e Principi forestieri," in *Palazzo Pitti*, Florence, 2000, pp. 45–53.

——, "Precisazioni su Jacopo Ligozzi nelle Gallerie fiorentine," *Arte Cristiana*, 89, no. 803, 2001, pp. 131–42.

Palazzo Pitti: l'arte e la storia, ed. M. Chiarini, Florence 2000.

Palazzo Pitti:.tutte le opere, Città di Castello, 2001.

Palazzo Vecchio: committenza e collezionismo medicei 1537–1610, Firenze e la Toscana nell'Europa del Cinquecento, exhibition catalog, Palazzo Vecchio, Florence, 1980.

Palisca, C., "Gli alterati di Florence e gli albori del melodramma," in *La musica e il mondo: Mecenatismo e committenza musicale in italia tra quattro e settecento*, ed. C. Annibaldi, Bologna, 1993, pp. 171–93.

Panichi, O., "Cenni storici," in *Villa di Poggio Imperiale*, Florence, 1975.

Panofsky, E., "Die Pietà von Ubeda. Ein kleiner Beitrag zur Lösung der Sebastianofrage," in *Festschrift für Julius Schlosser. Zum 60. Geburtstage*, ed. A. Weixlgärtner and L. Planiscig, Zurich, Leipzig, and Vienna, 1927, pp. 160–71.

——, *Galileo as a Critic of the Arts*, The Hague, 1954.

Paolozzi Strozzi, B., "Scherzi d'omonimia: Nuovi documenti e una precizione sul Pontormo," in *Settanta studiosi italiani: scritti per l'Istituto Germanico di Storia dell'Arte di Firenze*, Florence, ed. C. Acidini Luchinat et al., 1997, pp. 265–68.

Paolucci, A , "Un capolavoro di gioielleria medicea del '600: la corona della Vergine di Monsummano," *Paragone Arte*, vol. 315, 1976, pp. 27–32, pl.13–16.

——, "Il catalogo dei beni culturali di interesse storico e artistico in Pescia e nella Val di Nievole," in *I beni culturali della Valdinievole: Studi e contributi per la conoscenza sistemica del patrimonio storico, artistico e ambientale*, ed. Francesco Gurrieri and Donatella Salvestrini, Florence, 1978, pp. 36–37.

——, *Il Seicento Fiorentino*, ed. Giuliana Guidi and Daniela Marcucci with Elisa Acanforfi, exhibition catalog, Florence, 1986.

——, *La pittura a Firenze nel Cinquecento*, in *La Pittura in Italia: il Cinquecento*, Milan, 1988, pp. 288–334.

——, and A. M. Maetzke, *La casa del Vasari in Arezzo*, Florence, 1988.

Parigino, G. V., *Il Tesoro del Principe: funzione pubblica e privata del patrimonio della famiglia Medici nel Cinquecento*, Florence, 1999.

Parker, D., *Bronzino: Renaissance Painter as Poet*, Cambridge, 2000.

Parker, K., *Catalogue of the Collection of Italian Drawings in the Ashmolean Museum*, vol. 2, *Italian Schools*, Oxford, 1956.

Pastor, L. von, *Storia dei Papi dalla fine del Medio Evo*, 8 vols., ed. Angelo Mercati, Rome, 1958–64; vols.9–16, ed. Pio Cenci, Rome, 1955; vol. 17, ed. P. Cenci, Rome, 1964.

Pegazzano, D., "Lorenzo Sirigatti: gli svaghi eruditi di un dilettante del Cinquecento," *Mitteilungen des Kunsthistorischen Institutes in Florenz*, 42, 1998, pp. 144–75.

Penny, N., *Catalogue of European Sculpture in the Ashmolean Museum, 1540 to the Present Day*, vol. 1, *Italian*, Oxford, 1992.

Pera, F., *Memoria sopra il Monumento inalzato al Granduca Ferdinando I in Livorno Estratta dalla Filza degli Affari della Direzione del R. Archivio Centrale di Stato in Firenze, anno 1855 e Relazione sulla Presa di Bona*, Livorno, 1988.

"Per un regale evento": spettacoli nuziali e opera in musica alla corte dei Medici, ed. M. A. Bartoli Bacherini, exhibition catalog, Florence, 2000.

Petrini, A., "L'arte fabrile," in *Armi antiche, bollettino dell'Accademia di San Marciano*, ed. A. Gaibi e Pietro Gay, 1962, pp. 111–39.

Petrini, A., La *"Signoria di madonna finzione": Teatro, attorie poetiche nel rinascimento italiano*, Genoa, 1996.

Petrioli Tofani, A. M., "Uno spettacolo a Pitti nel 1589," in *Scritti di storia dell'arte in onore di Ugo Procacci*, ed. M. G. Ciardi Duprè Dal Poggetto and P. Dal Poggetto, Milan, 1977.

——, Review of C.Thiem's *Florentiner Zeichner des Frühbarock*, *Prospettiva*, 19, 1979, pp. 74–88.

——, *Il primato del disegno*, exhibition catalog, Palazzo Strozzi, Florence, 1980.

——, ed., *Gabinetto Disegni e Stampe degli Uffizi. Inventario: Disegni di figura. 1*, Florence, 1991.

——, and G. Smith, *Sixteenth-Century Tuscan Drawings from the Uffizi*, New York and Oxford, 1988.

——, "Francesco Salviati e Polidoro da Caravaggio: sulle tracce di una consonanza," in *Francesco Salviati e la bella maniera: actes des colloques de Rome et de Paris, 1998*, Ecole Française de Rome, 2001, pp. 217–52.

Pevsner, N., *Academies of Art: Past and Present*, Cambridge, 1940; in Italian trans. A. Pinelli, Turin, 1982.

Piacenti, K. Aschengreen, "Documented Works in Ivory by Balthasar Permoser and some documents related to Filippo Sengher," *Mitteilungen des Kunsthistorischen Institutes in Florenz*, 10, IV, February 1963, pp. 282–83.

——, "Two Jewellers at the Grand Ducal Court of Florence around 1618," *Mitteilungen des Kunsthistorisches Institut in Florenz*, December 1965, pp. 107–24.

——, *Il Museo degli Argenti a Firenze*, Milan, 1967.

——, "Un gioiello di Maria Anna di Baviera," *Antichità Viva*, 24, 1985, pp. 198–99.

——, "Gli eburnei calici," *FMR*, November 1989, pp. 65–96; English edition, December 1989.

——, "Un'immagine del Paliotto d'oro restituitoci," in *Studi di Storia dell'Arte in onore di Mina Gregori*, Milan, 1994, pp. 229–31.

——, "Un tesoro principesco riscoperto: vicende dinastiche e collezionismo" in *Museo e Gallerie Nazionali di Capodimonte: la collezione farnese (le arti decorative)*, Naples 1996, pp. 11–14.

Pieraccini, G., *La stirpe de' Medici di Cafaggiolo: saggio di ricerche sulla trasmissione ereditaria dei caratteri biologici*, 3 vols., Florence, 1986.

Pilliod, Elizabeth, "Review of Simona Lecchini Giovannoni, *Alessandro Allori*," *Burlington Magazine*, vol. 134, November 1992, p.728.

——, "The Earliest Collaborations of Pontormo and Bronzino: The Certosa, the Capponi Chapel, and the *Dead Christ with the Virgin and Magdalene*," in *The Craft of Art: Originality and Industry in the Italian Renaissance and Baroque Workshop*, ed. Andrew W. Ladis and Carolyn Wood, Athens, Georgia, and London, 1995, pp. 134–64.

——, *Pontormo, Bronzino, Allori: A Genealogy of Florentine Art*, New Haven and London, 2001.

Pillsbury, E., "The Cabinet Paintings of Jacopo Zucchi: Their Meaning and Function," *Monuments et Mémories*, 63, 1980, pp. 187–226.

Pillsbury, T. and J. Caldwell, *Sixteenth-Century Italian Drawings: Form and Function*, exhibition catalog, Yale University Art Gallery, New Haven, 1974.

Pinelli, A., "La cappella delle tombe scambiate: Novità sulla cappella Chig in Snta Maria del Popolo," in *Francesco Salviati e la bella maniera: actes des colloque de Rome et de Paris, 1998*, Ecole Française de Rome, Rome, 2001, pp. 253–85.

Pirrotta, N., and E. Povoledo, *Li due orfei: da Poliziano a Monteverdi*, Turin, 1975.

Pistoia: una città nello stato medieuo, ed. Cecilia Mazzi and Carlo Sisi, exhibition catalog, Fortezza Santa Barbara, Pistoia, 1980.

La Pittura in Italia, vol. 2, *Il cinquecento*, Milan, 1987.

Pizzorusso, C., *Ricerche su Cristofano Allori*, Florence, 1982.

——, *A Boboli e altrove: Sculture e scultori fiorentini del Seicento*, Florence, 1989.

——, "Il 'Ratto' del secolo: Da Bandinelli a Giambologna," in *Storia delle arti in Toscana: il Cinquecento*, ed. R. P. Ciardi and A. Natali, Florence, 2000, pp. 211–30.

Plaisance, M., "Une premiere affirmation de la politique culturelle de Côme I^er: La transformation de l'Academie des Humidi en Academie Florentine (1540–42)," in *Les ecrivans et le pouvoir en Italie a l'epoque de la Renaissance*, ed. A. Rochon, Paris, 1972, vol. 2, pp. 361–438.

——, "Culture et politique a Florence de 1542 a 1551: Lasca et les Humidi aux prises avec l'Academie Florentine," in *Les ecrivans et le pouvoir en Italie a l'epoque de la Renaissance*, vol. 3, Paris, 1974, pp. 149–242.

——, "L'académie florentine de 1541 à 1583," *Italian Academies of the Sixteenth Century*, London, 1995.

——, "Le accademie fiorentine negli anni ottanta del cinquecento," in *Neoplatonismo, musica, letteratura nel rinascimento: i bardi di Vernio e l'Accademia della Crusca*, ed. P. Gargiulo, A. Magini, S. Touissant, Prato, 2000, pp. 31–39.

Plazzotta, C., "Bronzino's Laura," *Burlington Magazine*, 140, 1998, pp. 251–63.

Pliny, *Natural History*, trans. H. Rackham, Cambridge and London, 1979.

Plon, E., *Benvenuto Cellini: Orfévre, Médailleur, Sculpteur*, Paris, 1883.

Poeschke, J., *Michelangelo and His World*, New York, 1996.

Poggi, G., "Di un cammeo di Giovan Antonio De'Rossi nel R. Museo Nazionale di Firenze," *Rivista d'Arte*, 9, January–March 1916, pp. 41–48.

Poliziano, A., Stanze, in *Stanze, Orfeo, Rime*, ed. D. Puccini, Milan, 2000, pp. 1–141.

Pollard, J. G., *Medaglie italiane del Rinascimento*, 3 vols., Florence, 1984–85. English translation *Italian Renaissance Medals in the Museo Nazionale of Bargello*, 3 vols., Florence, 1985.

Pope-Hennessy, J., *Italian High Renaissance and Baroque Sculpture*, London, 1963.

——, *Catalogue of Italian Sculpture in the Victoria and Albert Museum*, 3 vols., London, 1964a.

——, "Two Models for the Tomb of Michelangelo," in *Studien zur Toskanischen Kunst: Festschrift für Erich Ludwig Heydenreich*, Munich, 1964b, pp. 237–43, reprint in J. Pope-Hennessy, *Essays on Italian Sculpture*, London, 1968.

——, "A Sketch Model by Benvenuto Cellini," *Victoria and Albert Museum Bulletin* 1, 1965, pp. 4–9.

——, Essays on Italian Sculpture, London, 1968.

——, "Portrait Sculptures by Ridolfo Sirigatti," *Victoria and Albert Museum Bulletin*, 1, no. 2, 1965, pp. 33–36.

——, *Essays on Italian Sculpture*, London and New York, 1968.

——, *Paolo Uccello*, London, 1969.

——, "The Gherardini Collection of Italian Sculpture," *Victoria and Albert Museum Yearbook*, 1970, pp. 7–26 (22).

——, *Cellini*, London, 1985.

——, *Italian High Renaissance and Baroque Sculpture*, 3rd ed., Oxford, 1986.

——, and A. F. Radcliffe, *The Frick Collection: An Illustrated Catalog*, New York, 1970.

Popham, A. E., *The Drawings of Parmigianino*, 3 vols., New Haven and London, 1971.

——, and J. Wilde, *The Italian Drawings of the XV and XVI Centuries in the Collection of His Majesty the King at Windsor Castle*, London, 1949; reissued 1984 with an appendix by R. Wood.

Porta, J. B. della, *Natural Magick*, ed. Derek J. Price, New York, 1957, facsimile of London edition of 1658.

Povoledo, E., "Giulio Parigi," in *Enciclopedia dello Spettacolo*, Florence and Rome, 1960, pp. 1675–78, pl.31.

Pratesi, G., *Repertorio della Sculptura Fiorentina del Seicento e Settecento*, Turin, 1993.

Pratilli, G. C. and L. Zangheri, *La Legislazione Medicea sull'Ambiente*, 2 vols, Florence, 1994.

Praz, M., *Il giardino dei sensi: Studi sul manierismo e il barocco*, Milan, 1975.

Princely Magnificence: Court Jewels of the Renaissance, 1500–1630, exhibition catalog, ed. A. Somers-Cocks, London, 1980.

Privitera, M., "Disegni di Girolamo Macchietti per il *Martirio di San Lorenzo* in Santa Maria Novella," *Paragone*, 477, 1989.

——, *Girolamo Macchietti: Un pittore dello Studiolo di Francesco I (Florence 1535–1592)*, Milan and Rome, 1996.

Procacci, U., *La Casa Buonarroti a Florence*, Milan, 1965.

Prosperi Valenti Rodinò S., *Disegni romani, toscani e napoletani: Galleria dell'Accademia di Venezia*, Milan, 1989.

——, *The Golden Age of Florentine Drawing: Two Centuries of Disegno from Leonardo to Volterrano*, exhibition catalog, Kimbell Art Museum, Fort Worth, 1994.

Pyhrr, S. W., and J.-A. Godoy, *Heroic Armor of the Italian Renaissance: Filippo Negroli and his Contemporaries*, exhibition catalog, The Metropolitan Museum of Art, New York, 1998.

Quint, D., *The Stanze of Angelo Poliziano*, Amherst, 1979.

Radcliffe, A., "Schardt, Tetrode and Some Possible Sculptural Sources for Goltzius," in *Netherlandish Mannerism: Papers Given at a Symposium in Nationalmuseum, Stockholm*, Stockholm, 1985, pp. 97–108.

——, *The Robert H. Smith Collection: Bronzes 1500–1600*, London, 1994.

——, M. Baker, and M. Maek-Gérard, *The Thyssen-Bornemisza Collection: Renaissance and Later Sculpture with Works of Art in Bronze*, London, 1992.

Raggio, O., *Notable Acquisitions, 1983–84, Metropolitan Museum of Art*, New York, 1984, pp. 29–30.

Ramban (Moses ben Nahman or Nachmanides), *Commentary on the Torah*, trans. Charles B. Chavel, New York, 1971.

Ragionieri, P., "Notizia sulla Collezione di disegni di Michelangelo della Casa Buonarroti," in U. Baldini and M. Bertozzi, *La Lanterna della Pittura, L'Adolescente dell'Ermitage e i Disegni della Casa Buonarroti: Michelangelo e l'Idea della scultura*, exhibition catalog, Palazzo Ducale, Massa, 2000, pp. 59–83.

——, *Michelangelo, Drawings and Other Treasures from the Casa Buonarroti, Florence*, exhibition catalog, High Museum of Art, Atlanta, 2001.

Rappresentazioni del destino: Immagini della vita e della morte dal XV al XIX secolo nella Raccolta delle Stampe A, Bertarelli, ed. G. Mori and C. Salsi, Milan, 2001.

Rearick, W. R., "Francesco Salviati, Giuseppe Porta and Venetian Draftsmen of the 1540s," in *Francesco Salviati e la bella maniera: actes des colloque de Rome et de Paris, 1998*, Ecole Française de Rome, Rome, 2001, pp. 455–78.

Ricci, G. de', *Cronaca (1532–1606)*, ed. Giuliana Sapori, Milan and Naples, 1972.

Ricci, S., "La vita quotidiana: tra l'essere e l'apparire," in *Moda alla corte dei Medici*, Florence, 1993, pp. 17–25.

Riccio, Agostino del, *Istoria delle pietre (di Agostino del Riccio)*, ed. Gnoli, R., and A. Sironi, Turin, 1996.

Richelson, P. W., "Studies in the Personal Imagery of Cosimo I de' Medici, Duke of Florence," Ph.D. diss., New York University, 1978.

Ridolfi, R., "Diario fiorentino di anonimo delle cose occorse l'anno 1537," *Archivio Storico Italiano*, 116, 1958, pp. 544–70.

Rigoni, C., *Catalogo della R. Galleria degli arazzi*, Florence and Rome, 1884.

Riklin, A., *Giannotti, Michelangelo und der Tyrannenmord*, Bern, 1996; Italian edition, *Giannotti, Michelangelo e il tirannicidio*, ed. A. Scarpelli, Siena, 2000.

Rinaldi, A., "Ideologia e tipologia del giardino urbano a Florence tra XV e XVI secolo: il giardino come rappresentazione della natura e la costruzione della città "autre" di ordine rustico," in *Il giardino storico italiano: problemi di indagine; fonti letterarie e storiche*, conference at San Quirico d'Orcia, Siena, 6–8 October 1978, published Florence, 1981, pp. 125–46.

——, "'Quattro epitaffi sanza le lettere': i primi anni del giardino di Boboli e lo 'spartimento' del Tribolo," in *Boboli 90*, conference, Florence, 9–11 March 1989, published Florence, 1991, vol. 1, pp. 19–30.

Rinehart, M., "A Drawing by Vasari for the Studiolo of Francesco I," *Burlington Magazine*, 106, 1964, pp. 74–76.

——, "A Document for the Studiolo of Francesco I," in *Art the Ape of Nature: Studies in Honor of H. W. Janson*, ed. Mosche Barasch and Lucy Freeman Sandler, New York, 1981, pp. 275–89.

Risveglio di un colosso, Florence, 1988.

Rizzo, A. P., "L'Incoronazione della Vergine di Giovanni Bizzelli a Pratovecchio e qualche notizie sul pittore," *Rivista d'Arte*, 42, ser. 4, 6, 1990, pp. 249–52.

Roberts, G., *The Mirror of Alchemy: Alchemical Ideas and Images in Manuscripts and Books from Antiquity to the Seventeenth Century*, London, 1994.

Robertson, C., *"Il Gran Cardinale": Alessandro Farnese, Patron of the Arts*, New Haven and London, 1992.

Robinson, J. C., *The Drawings by Michelangelo and Raffaello in the University Galleries*, Oxford, 1870.

Rolands, E. W., *The Collections of the Nelson-Atkins Museum of Art: Italian Paintings 1300–1800*, Kansas City, 1996.

Rondinelli, F., *Relazione del contagio stato in Firenze l'anno 1630–1633 con un breve ragguaglio della miracolosa immagine della Madonna dell'Impruneta*, Florence, 1634.

Rosenberg, R., *Beschreibungen und Nachzeichnungen der Skulpturen Michelangelos*, Munich and Berlin, 2000.

Rossi, B. de, *Descrizione dell'apparato e degl'intermedi fatti per la commedia rappresentata in Firenze*, Florence, 1589.

Rosso Fiorentino: Drawings, Prints and Decorative Arts, exhibition catalog, National Gallery of Art, Washington, 1987.

Rousseau, C. J., "Cosimo I de' Medici and Astrology: the Symbolism of Prophecy," Ph.D. diss., Ann Arbor, 1985.

Rubin, P. L., "Vasari, Lorenzo and the Myth of Magnificence," in *Lorenzo il Magnifico e il suo mondo*, ed. G. Garfagnini, Florence 1994, pp. 427–42.

——, *Giorgio Vasari: Art and History*, New Haven and London, 1995.

Rudnick, M. J. S., *The Meaning of Fossils: Episodes in the History of Paleontology*, London and New York, 1972.

Rudolf II and Prague, exhibition catalog, Prague, 1997.

Russel, H. D., *Jacques Callot: Prints and Related Drawings*, Washington, 1975.

Saltini, G. E., "L'Educazione del principe Francesco de'Medici," *Archivio Storico Italiano*, vol. 4, no. 2, 1883, pp. 49–84.

Salvadori, A., *Guerra d'Amore Festa del Serenissimo Gran Duca di Toscana Cosimo II, fatta in Firenze il carnevale del 1615*, Florence, 1615.

Salvatici, L., *Posate, pugnali e coltelli da caccia*, exhibition catalog, Museo Nazionale del Bargello, Florence, 1999.

Sandberg, G., *The Red Dyes: Cochineal, Madder, and Murex Purple*, Stockholm, 1994.

Sanfilippo, M. and M., "Profilo biografico d'un cardinale di Santa Romana Chiesa poi Granduca di Toscana: Ferdinando de' Medici," in *Roma Europa, la piazza delle culture*, Rome, Presidenza del Consiglio dei Ministri, Dipartimento dell'informazione e dell'editoria, 1991, pp. 78–101.

San Lorenzo 393–1993: L'architettura: le vicende della fabbrica, ed. G. Morolli and P. Ruschi, exhibition catalog, Cappelle Medicee in San Lorenzo, Florence, 1993.

San Lorenzo, i documenti e i tesori nascosti, exhibition catalog, Complesso di San Lorenzo, Florence, 1993.

Sannazzaro, J., *Arcadia*, in *Opere volgari*, ed. A. Mauro, Bari, 1961.

Santangelo, A., *Tessuti d'arte italiani dal XII al XVIII secolo*, Milan, 1959.

Santi, F., *Vincenzo Danti scultore*, Bologna, 1989.

——, *The Medici Wedding of 1589: Florentine Festival as "Theatrum Mundi,"* New Haven and London, 1996.

Scalini, M., *Il Saracino e gli spettacoli cavallereschi nella Toscana Granducale*, Florence, 1987.

——, *L'Arte Italiana del Bronzo 1000–1700: toreutica monumentale dall'alto medioevo al barocco*, Busto Arsizio, 1988.

——, "Il poema epico cinquecentesco, armi all'eroica e da pompa," in *Armi e armati: arte e cultura delle armi nella Toscana e nell'Italia del tardo Rinascimento dal Museo Bardini e dalla Collezione Corsi*, ed. Fiorenza Scalia, exhibition catalog, Museo Bardini, Florence, 1988–90, pp. 13–27.

——, *Armature da Cosimo I a Cosimo II de' Medici*, Florence, 1990.

——, "L'armamento difensivo dei contendenti della guerra di Siena," in *La fortuna di Cosimo I: La battaglia di Scannagallo*, exhibition catalog, Foiano della Chiana, 1992, pp. 85–110.

——, "Armeria europea e orientale," in *Magnificenza alla corte dei Medici: arte a Firenze alla fine del Cinquecento*, ed. C. Acidini Luchinat, M. Gregori, D. Heikamp, and A. Paolucci, exhibition catalog, Palazzo Pitti, Museo degli Argenti, Florence, 1997, pp. 396–98.

——, "Pracht und Geschichte – Die Kunsthandwerklichen Sammlungsobjekte," in *Die Pracht der Medici, Florenz und Europa*, ed. C. Acidini Luchinat and M. Scalini, exhibition catalog, Munich, 1998.

Sceve, M., *The Entry of Henry II into Lyon, September 1548*, facsimile with an introduction by R. Cooper, Tempe, 1997.

Schaefer, S. J., "The Studiolo of Francesco I de' Medici in the Palazzo Vecchio in Florence," Ph.D. diss., Bryn Mawr College, 1976.

——, "The Studiolo of Francesco I de' Medici: A Checklist of the Known Drawings," *Master Drawings*, 20, 1982, pp. 126–27.

Schlitt, M., "Francesco Salviati and the Rhetoric Style," Ph.D. diss., Johns Hopkins University, Ann Arbor, 1977.

Schmidt, E. D., "Scultura sacra nella Toscana del Cinquecento," in *Storia delle arti in Toscana: il Cinquecento*, ed. Roberto Paolo Ciardi and Antonio Natali, Florence, 2000, pp. 231–54.

Schmidt, J. K., *Studien zum statuarischen Werk des Giovanni Battista Caccini*, Cologne, 1971.

Schwarzenberg, E., and B. Paolozzi Strozzi, "Norzia o la costante Fortuna – la lunetta di Alessandro Allori a Poggio a Caiano," in *Kunst des Cinquecento in der Toskana*, Munich, 1992, p.204, n.24.

Scocchera, G., "Il programma e l'apparato: Contributi allo studio dell'allestimento della 'talanta'," *Teatro e storia*, 17, 1995, pp. 365–401.

Scorza, R., "Vincenzo Borghini and the 'Invenzione': The Florentine Apparato of 1565," in *Journal of the Warburg and Courtauld Institutes*, 44, 1981, pp. 57–75.

——, "A New Drawing for the Florentine Apparato of 1565: Borghini, Butteri, and the Tuscan Poets," *Burlington Magazine*, 127, 1985, no. 993, pp. 887–90.

——, "*Imprese* and medals: *invenzioni all'antica* by Vincenzo Borghini," *The Medal*, 13, 1988, pp. 18–32.

——, "A Florentine Sketchbook: Architecture, Apparati and the Accademia del Disegno," *Journal of the Warburg and Courtald Institutes*, 54, 1991, pp. 172–85.

——, "Borghini and the Florentine Academies," in *Italian Academies of the Sixteenth Century*, London, 1995, pp. 136–64.

——, "Vasari's Painting of the Terzo Cerchio in the Palazzo Vecchio: A Reconstruction of Medieval Florence," in Jacks 1998, pp. 182–205.

Scritti di storia dell'arte in onore di Roberto Salvini, Florence, 1984.

Segarizzi, A., ed., *Relazioni degli ambasciatori Veneti al senato*, Bari, 1912–16.

Sepher Rezial Hemelach, ed. and trans. Steve Savedow, York Beach, Maine, 2000.

Sframeli, M., "Gioie perdute, gioie ritrovate," in *I Gioielli dell'Elettrice Palatina*, Florence, 1988, pp. 15–23.

——, "Bellissime segreti e mirabili modi: la grand'arte dell'oreficeria nell'età di Francesco e Ferdinando," in *Magnificenza alla corte dei Medici: arte a Firenze alla fine del Cinquecento*, exhibition catalog, Milan 1997, pp. 385–91.

Shapiro, M., "Mirror and Portrait: The Structure of *Il Libro del Cortegiano*," *The Journal of Medieval and Renaissance Studies*, 5, 1975, pp. 37–61.

Shearman, J., *Mannerism*, Harmondsworth, 1967.

——. "Cristofano Allori's *Judith*," *Burlington Magazine*, 121, 1979, no. 910, pp. 3–10.

——, *The Early Italian Pictures in the Collection of Her Majesty the Queen*, Cambridge, 1983.

Simenon, G., *Les Mémoires de Maigret*, Paris, 1950.

Simon, R. B., "Bronzino's Portraits of Cosimo I de' Medici," Ph.D. diss., Columbia University, Ann Arbor, 1982.

——, "Bronzino's Portrait of Cosimo I in Armour," *Burlington Magazine*, 125, 1983, pp. 533 and 539.

Simon, R. B., "Bronzino's *Cosimo I de' Medici as Orpheus*," *Philadelphia Museum of Art Bulletin*, 81, 1985, pp. 16–27

Simoncelli, P., "Pontormo e la cultura fiorentino," *Archivio storico italiano*, 153, 1995, pp. 510–27.

Simonicini, S., "Suggestioni, modelli e sperimentazioni medicee in un secolo di storia teatrale aretina (1515–1612)," *Arte musica spettacolo: annali del dipartimento di storia delle arti e dello spettacolo*, 2, 2001, pp. 67–82.

Simons, P., "Homosexuality and Erotics in Italian Renaissance Portraiture," in *Facing the Subject*, ed. Joanna Woodall, Manchester and New York, 1997, pp. 29–51.

Skinner, Q., *The Foundations of Modern Political Thought*, 2 vols. Cambridge, London, New York, and Melbourne, 1978.

——, "Political Philosophy," in *The Cambridge History of Renaissance Philosophy*, ed. Charles B. Schmitt et al., Cambridge, New York, Port Chester, Melbourne, and Sydney, 1988, pp. 389–452.

Smith, G., "Cosimo I and the Joseph Tapestries for the Palazzo Vecchio," *Renaissance and Reformation*, 6, 1982a, pp. 183–96.

——, "Bronzino's Holy Family in Vienna: A Note on the Identity of its Patron," *Source*, 2, 1982b, pp. 21–25.

——, "Bronzino's Portrait of Laura Battiferri," *Source*, 15, 1996, pp. 30–38.

Smyth, C. H., "The Earliest Works of Bronzino," *Art Bulletin*, 21, 1949, pp. 184–210.

——, *Bronzino as Draftsman*, Locust Valley, New York, 1971.

——, "An Instance of Feminine Patronage in the Medici Court of Sixteenth-Century Florence," in *Women and Art in Early Modern Europe*, ed. C. Lawrence, University Park, Pennsylvania, 1997, pp. 72–98.

Solerti, A., *Musica, Ballo e Drammatica alla Corte Medicea dal 1600 al 1637*, Florence, 1905.

Soly, H., "Social Relations in Antwerp in the Sixteenth and Seventeenth Centuries," in *Antwerp, Story of a Metropolis, 16th–17th Century*, ed. J. van der Stock, Ghent, 1993, pp. 37–47.

Sotto il cielo della cupola: il coro di Santa Maria del Fiore dal Rinascimento al 2000, Milan, 1997.

Spalding, J., "The Sequence of Cigoli's Studies in the Uffizi for the *Martyrdom of St. Stephen*," *Master Drawings*, 29, 1981, pp. 293–99.

Spallanzani, M., "The Courtyard of the Palazzo Tornabuoni-Ridolfi and Zanobi Lastricati's Bronze *Mercury*," *Journal of the Walters Art Museum*, no. 37, 1978, pp. 6–21.

——, "Medici Porcelain in the Collection of the last Grand Duke," *Burlington Magazine*, 132, 1990, pp. 316–20.

——, *Ceramiche alla Corte dei Medici nel Cinquecento*, Modena, 1994.

Spicer, J., *The Allure of Bronze: Masterpieces from the Walters Art Gallery*, Baltimore, 1995.

Spina, A. M. Nigro, *Giulio Parigi e gli incisori della sua cerchia*, Naples, 1983.

Spinelli R., in *L'arme e gli amori: la poesia di Ariosto, Tasso e Guarini nell'arte fiorentina del Seicento*, exhibition catalog, Palazzo Pitti, Florence, 2001.

Spini, G., "Il principato dei Medici e il sistema degli stati europei del Cinquecento," in *Firenze e la Toscana dei Medici nell'Europa del '500*, Florence, 1983, vol. 1, pp. 177–216.

——, *Michelangelo politico e altri studi sul Rinascimento fiorentino*, Milan, 1999.

Spinosa, N. *Dipinti dal XIII al XVI seulo: le collezioni barboniche e post-unitarie*, exhibition catalog, Naples, 1999.

Splendori di Pietre Dure: l'arte di corte nella Firenze dei Granduchi, ed. A. M. Giusti, exhibition catalog, Palazzo Pitti, Florence, 1988–89.

Starn, R., and L. Partridge, *Arts of Powers: Three Halls of State in Italy 1300–1600*, Berkeley, Los Angeles, and Oxford, 1992.

——, *Arts of Power: Three Halls of State in Italy*, 1300–1600, Berkeley and London, 1993.

Steinmann, E., *Die Portaitdarstellungen des Michelangelos*, Leipzig, 1913.

Stock, J., and D. Scrase, *The Achievement of a Connoisseur: Philip Pouncey, Italian Old Master Drawings*, Cambridge, 1985.

Stockbauer, J., *Die Kunstbestrebungen am bayerischer Hofe unter Herzog Albert V und seinem Nachfolger Wilhelm V*, 1874, reprint Osnabruck 1970.

Strabo, *The Geography of Strabo*, trans. Horace Leonard Jones, Cambridge and London, 1983.

Strainchamps, S., "New Light on the Accademia degli Elevati of Florence," *The Musical Quarterly*, 62, 1976, pp. 507–35.

Strinati, C., "Note sur Jacopo et Francesco Zucchi," in *La Villa Médicis*, vol. 2, *Etudes*, Rome, 1991, pp. 553–66.

Strocchia, S., "Burials in Renaissance Florence," Ph.D. diss., University of Michigan, Ann Arbor, 1983.

——, *Death and Ritual in Renaissance Florence*, Baltimore, 1992.

Suida, W. E., *Catalogue of Paintings of the John and Mable Ringling Museum of Art*, Sarasota, 1949.

Summers, D., *Michelangelo and the Language of Art*, Princeton, 1981.

Summers, J. D., "The Sculpture of Vincenzo Danti, " Ph.D. diss., Yale University, 1969–70.

——, "The Sculpture of Vincenzo Danti: A Study of the Influence of Michelangelo and the Ideals of the Maniera," New York and London, 1979.

Supino, I. B., *Catalogo del Real Museo Nazionale di Firenze*, Rome, 1898.

Sustermans: Sessant'anni alla corte dei Medici, exhibition catalog, Palazzo Pitti, Florence, 1983.

Sutherland, A., "A New Michelangelo Drawing in the Louvre," *Burlington Magazine*, 106, 1964, pp. 572–75.

Tarchi, R., "Una lettera di Maria Maddalena d'Austria sulla reliquia della Santa Croce in S. Maria Impruneta," *Rivista d'Arte*, 41, 1989, pp. 159–65.

Tassi, F., *Prose e poesie di Benvenuto Cellini con documenti la maggior parte inediti*, Florence, 1829.

Tasso, T., *La Gerusalemme liberata*, Florence, 1881.

Teatro e spettacolo nella Firenze dei Medici: modelli dei luoghi teatrali, ed. E. Garbero Zorzi and M. Sperenzi, exhibition catalog, Florence, 2001.

Ternois, J., *L'art de Jacques Callot*, 2 vols., Paris, 1962.

Tesori dalle collezioni medicee, ed. C. Acidini Luchinat, Florence, 1997.

Terribile, C., "Il volto napoletano di monsignore della Casa," *Venezia Sixteenth century: Studi di storia dell'arte e della cultura*, 9, 17, 1999, pp. 55–61.

Tesoroni, D., *Il Palazzo di Firenze e l'eredità di Balduino del Monte fratello di papa Giulio III: notizie e documenti*, Rome, 1889.

Testaverde, A. M. Matteini, "L'ingresso in Firenze di Maria Maddalena d'Austria: Notizie e documenti inediti sugli artisti e apparatori," *Città e regione*, Florence, 1979, 8–9, pp. 170–92.

——, *Trattino i cavalier d'arme e d'amori" epica spettacolare ed etica dinastica alla corte medicea nel secolo XVII in print*, 2001.

——, *La città effimera e l'universo artificiale del giardino: La Firenze dei Medici e l'Italia del '500*, ed. Marcello Fagiolo, Rome, 1980a, pp. 69–100, 213–17.

——, "Una fonte iconografica francese di don Vincenzo Borghini per gli apparati effimeri del 1565," in *Quaderni di teatro*, 2, 1980b, 7, pp. 135–44.

——, "Il ruolo della soprintendenza granducale nell'organizzazione delle feste fiorentine del 1589," *Quaderni di teatro*, 5, 1982, 17, pp. 69–83.

——, "La decorazione festiva e l'itinerario di 'rifondazione' della città negli ingressi trionfali a Firenze tra XV e XVI secolo," *Mitteilungen des Kunsthistorisches Instututes in Florenz*, 32, 1988, 3, pp. 323–52; 34, 1990, 5, pp. 165–98.

——, "L'officina delle nuvole: Il teatro mediceo del 1589 e gli intermedi del Buontalenti nel memoriale di Girolamo Seriacopi," *Musica e teatro: quaderni degli amici della Scala*, 7, 1991, pp. 11–12.

——, "Informazioni sul teatro vasariano del 1565 dai registri contabili," *Medioevo e Rinascimento*, 6, 1992, pp. 83–95.

——, "La scrittura scenica infinita: la Pellegrina di Girolamo Bargagli," *Drammaturgia*, 1, 1994, pp. 23–38.

——, "Episodi di architettura effimera e stereotipi iconografici di Firenze tra i secoli XVI–XVII," in *Iconographie et arts du spectacle*, Paris, 1996, pp. 29–58.

——, "Margherita d'Austria, regina e 'perla' di virtù" in *La morte e la gloria: apparati funebri medicei per Filippo II di Spagna e Margherita d'Austria*, ed. Monica Bietti, exhibition catalog, Florence, 1999, pp. 132–37.

The Age of Caravaggio, exhibition catalog, Naples and New York, 1985.

The Age of Vasari, exhibition catalog, Art Gallery, University of Notre Dame, Indiana, 1970.

The Collections of the Detroit Institute of Arts: Italian, French, English, and Spanish Drawings and Watercolors, 16th–18th Centuries, New York, 1992.

The Genius of the Sculptor in Michelangelo's Work, exhibition catalog, Montreal Museum of Fine Arts, Montreal, 1992.

The Toledo Museum of Art: European Painting, Toledo, Ohio, 1976.

Thiem, C., *Florentiner Zeichner des Frühbarock*, Munich, 1977.

Thode, H., *Michelangelo. Kritische Untersuchungen über seine Werke*, Berlin, 1913.

Thomas, B., "'The Lantern of Painting': Michelangelo, Daniele da Volterra and the *Paragone*," *Apollo*, 154, no. 474, August 2001, pp. 46–53

Thornton, P., and H. Dorey, *A Miscellany of Objects from Sir John Soane's Museum*, London, 1992.

Tietze-Conrat, E., "Zur Höfischen Allegorie der Renaissance," *Jahrbuch der Kunsthistorischen Sammlungen des Allerhöchsten Kaiserhauses*, 34, 1918, pp. 25–32.

Tinagli, P., "Claiming a Place in History: Giorgio Vasari's *Ragionamenti* and the Primacy of the Medici," in Eisenbichler 2001, pp. 63–76.

Tinghi, Cesare, "Diario di Ferdinando I e Cosimo II gran Duca di Toscana scritto da Cesare Tinghi da' 22 luglio 1600 sino a' 12 settembre 1615," Florence, Biblioteca Nazionale Centrale, Fondo Gino Capponi.

Tiraboschi, G., *Storia della Letteratura Italiana*, Milan, 1824.

Toderi, G., and F. Vannel, *Le medaglie italiane del XVI secolo*, 3 vols., Florence, 2000, vol. 2, pp. 520–27, nos.1562–83.

Tolnay, C. de, "De Handzeichnungen Michelangelos im Archivio Buonarroti," *Munchner Jahrbuch der Bildenden Kunst*, NF, 5, no. 4, 1928, pp. 377–476.

——, *Michelangelo*, 5 vols., Princeton, 1947–60.

——, *Michelangelo, III: The Medici Chapel*, Princeton, 1948; 2nd edition with Foreword, 1970.

——, *Michelangelo: The Sistine Ceiling*, Princeton, 1949.

——, *Michelangelo: The Final Period*, Princeton, 1960.

——, "Contributi michelangioleschi: un bozzetto di legno di Michelangelo," *Commentari* 16, 1965, pp. 93–97.

——, "Un bozzetto di legno di Michelangelo," in *Stil und Überlieferung in der Kunst des Abendlandes, Akten des 21: Internationalen Kongresses für Kunstgeschichte in Bonn 1964*, Berlin, 1967.

——, *Corpus dei Disegni di Michelangelo*, 4 vols., Novara, 1975–80.

——, and P. Squellati, ed., *Brunelleschi e Michelangelo*, Florence, 1977.

Tomory, P., "Raffaello Gualterotti (?)," *Ringling Museums Newsletter* 5, 4, 1972.

——, *Catalogue of the Italian Paintings before 1800 in the John and Mable Ringling Museum of Art*, Sarasota, 1976.

Toulier, B., "Les étapes de construction du bâtiment principal: essai de restitution," in *La Villa Médicis*, vol. 2, *Etudes*, Rome, 1991, pp. 201–13.

Trachtenberg, J., *Jewish Magic and Superstition: A Study in Folk Religion*, New York, 1939.

Trento, D., *Benvenuto Cellini: opere non esposte e documenti notarili*, exhibition catalog, Museo Nazionale del Bargello, Florence, 1984.

——, "Pontormo e la corte di Cosimo I," in *Kunst des Cinquecento in der Toskana*, Munich, 1992, pp. 139–45.

Trexler, R. C., and M. E. Lewis, "Two Captains and Three Kings: New Light on the Medici Chapel," *Studies in Medieval and Renaissance History*, 4, 1981, pp. 91–177.

Treves, L., "Daniele da Volterra and Michelangelo: A Collaborative Relationship," *Apollo*, 154, no. 474, August 2001, pp. 36–45.

Tucker, M. S., "Discoveries Made During the Treatment of Bronzino's *Cosimo I de' Medici*

as Orpheus," *Philadelphia Museum of Art Bulletin*, 81, 1985, pp. 28–32.

Tuena, F., "Appunti per la storia del commesso romano: il "Franciosino" maestro di tavole e il cardinale Giovanni Ricci," *Antologia di Belle Arti*, 33–34, 1988, pp. 54–69.

Turchetti, P., "Baccio del Bianco," in *Enciclopedia dello Spettacolo*, Florence and Rome, 1960, vol. 1, p.1213, tab.24.

Turner, N., and C. Plazzotta, *European Drawings 3: Catalog of the Collections, The J. Paul Getty Museum, Los Angeles*, Los Angeles, 1997.

Ulisse Aldrovandi e la Toscana, Florence, 1989.

Ulivi, F., "I giardini del Tasso," in *Il giardino storico italiano: problemi di indagine; Fonti letterarie e storiche*, conference at San Quirico d'Orcia, Siena, 6–8 October 1978, published Florence, 1981, pp. 309–18.

Urry, S., "Evidence of Replication in a Portrait of Eleonora of Toledo by Agnolo Bronzino and Workshop," *Journal of the American Institute for Conservation*, 37, 1998, pp. 211–21.

Usimbardi, P., "Istoria del Gran Duca Ferdinando I: scritta da Piero Usimbardi," ed. G. E. Saltini, *Archivio storico italiano*, vols. 4 and 6, 1880, pp. 365–401.

Utz, H., "Neue Dokumente und Anmerkungen zu einigen Werken des Pierino da Vinci," *Storia dell'arte*, 14, 1972, pp. 101–25.

Valentiner, W. R., "A Florentine Fountain Figure of the High Renaissance," *Bulletin of the Detroit Institute of Arts*, 13 May 1932, pp. 90–93.

Valenti Rodinò, S. P., *Gallerie dell'Academia di Venezia: disegni romani, toscani el napolitani*, Milan, 1989.

Van Puyvelde, L., *La Peinture flamand à Rome*, Brussels, 1950.

Vannugli, A., "Per Jacopo Zucchi: un annunciazione a Bagnoregio ed altre opere," *Prospettiva*, 75–76, 1994, pp. 161–73.

Van Veen, H. T., "Circles of Sovereignty: the *Tondi* of the Sala Grande in Palazzo Vecchio and the Medici Crown," in Jacks 1998, pp. 206–19.

Varchi, B., *Orazione funerale di Benedetto Varchi fatta e recitata da Lui pubblicamente nell'esequie di Michelagnolo Buonarroti in Florence, nella Chiesa di San Lorenzo*, Florence, 1564.

——, *Storia fiorentina*, ed. G. Milanesi, Florence, 1857.

——, and V. Borghini, *Pittura e Scultura nel Cinquecento*, Livorno, 1998.

Vasari on Technique, trans. L. S. Maclehose, New York, 1960.

Vasari, G., "Memoriale di Giorgio Vasari al Granduca Cosimo I sullo spazio e il costo delle pitture," in C. Guasti, *La Cupola di Santa Maria del Fiore*, Florence, 1857.

——, *Le vite de' piu eccellenti pittori scultori ed architettori*, 9 vols., ed. G. Milanesi, Florence, 1568; reprint Florence, 1878–85; trans. G. C. de Vere, *Lives of the Most Eminent Painters, Sculptors, and Architects*, 10 vols., London, 1912.

——, *La Vita di Michelangelo nelle redazioni del 1550 e 1568*, 5 vols, ed. P. Barocchi, Milan and Naples, 1962.

——, *Le Vite de' più eccellenti pittori, scultori e architettori nella redazione del 1550 e 1568*, 11 vols., ed. P. Barocchi and R. Bettarini, Florence, 1966–.

——, *Le vite de' più eccellenti pittori, scultori e architettori*, 7 vols., ed. R. Bettarini and P. Barocchi, Florence, 1967–87.

——, *Le vite de, più eccellenti pittori scultori e architettori*, ed. P. della Pergola, L. Grassi, and G. Previtali, Novara, 9 vols., 1967.

——, *Le Opere di Giorgio Vasari con nuove annotazioni e commenti di Gaetano Milanesi*, ed. P. Barocchi, Florence, 1976.

——, *Le vite de' più eccellenti Architetti, Pittori e Scultori italiani, da Cimabue insino a' tempi nostri*, ed. L. Bellosi and A. Rossi, Turin, 1986.

——, *Le Vite de' più eccellenti pittori scultori e architettori nelle redazioni del 1550 e 1568: Concordanze; Frequenze*, 3 vols, ed. P. Barocchi, S. Maffei, G. Nencioni, U. Parrini, E. Picchi, Pisa, 1994.

——, *Ragionamenti sopra le invenzioni delle storie dipinte ne le stanze nuove del Palazzo Ducale*, in *Le vite de' piu eccellenti pittori scultori ed architettori*, 9 vols., ed. G. Milanesi, Florence, 1568; reprint Florence, 1878–85, vol. 8, pp. 9–225.

Vasic Vatovec, C., *L'Ambrogiana: una villa dai Medici ai Lorena*, Florence, 1984.

Vasoli, C., "Considerazioni sull'accademia fiorentina," in *La nascita della . . .* , 1980.

Vecellio, C., *Habiti antichi et moderni di tutto il mondo*, Venice, 1st edition 1590, 2nd 1598.

Veen, H. Th. Van, "The Crown of the Marzocco and The Medici Dukes and Grand Dukes," *Mitteilungen des Kunsthistorischen Institutes in Florenz*, 43, 1999, p.652–64.

Venturi, G., "Il giardino e la letteratura: saggi d'interpretazione e problemi metodologici," in *Il giardino storico italiano: Problemi di indagine; Fonti letterarie e storiche*, conference at San Quirico d'Orcia, Siena, 6–8 October 1978, published Florence, 1981, pp. 251–77.

Vermeule, C., *European Art and the Classical Past*, Cambridge, Mass., 1964.

Viale, M., "Arazzi," in M. and V. Viale, *Arazzi e tappeti antichi*, Turin, 1952, p.83.

Viatte, F., *Inventaire général des dessins italiens III: Dessins toscans, IVᵉ–XVIIIᵉ siècles*, vol. I, *1560–1640, Musée du Louvre, Cabinet des Dessins*, Paris, 1988.

Villani, G., *Istorie Fiorentine*, Milan, 1802.

Vinci, L. da, *The Notebooks*, 2 vols., ed. J. P. Richter, New York, 1970, vol. 1, p.254.

Virgil, *Aeneid*, trans. H. Rushton Fairclough, Cambridge and London, 1978.

Vita di Michelangelo, ed. L. Bardeschi Ciulich and P. Ragionieri, exhibition catalog, Florence, 2001.

Vitzthum, W., "Callot und sein Kreis," *La Revue de l'Art*, 5, 1969, pp. 92–93.

Vliegenthart, A. W., *La Galleria Buonarroti: Michelangelo e Michelangelo il Giovane*, Florence, 1976.

Von allen Seiten schön: Bronzen der Renaissance und des Barock, ed. V. Krahn, exhibition catalog, Altes Museum, Berlin, 1995.

Von Bode, W., *The Italian Bronze Statuettes of the Renaissance*, ed. J. D. Draper, New York, 1980.

Voss, H., *Die Malerei der Spätrenaissance in Rom und Florenz*, Berlin, 1920.

Vries, J. de, and A. M. van der Woude, *The First Modern Economy: Success, Failure, and Perseverance of the Dutch Economy, 1500–1815*, Cambridge, 1997.

Waldman, L. A., "Bronzino's Uffizi *Pieta* and the Cambi Chapel in S. Trinita, Florence," *Burlington Magazine*, no. 139, 1997, pp. 94–102.

——, "A Case of Mistaken Identity," *Burlington Magazine*, 140, 1998, pp. 788–98.

Wallace, W. E., *Michelangelo at San Lorenzo: the Genius as Enterpreneur*, Cambridge, 1994.

——, "A Week in the Life of Michelangelo," in *Looking at Italian Renaissance Sculpture*, ed. S. Blake McHam, Cambridge, 1998a, pp. 203–23.

——, *Michelangelo: The Complete Sculpture, Painting, Architecture*, New York, 1998b.

Ward, R., "Baccio Bandinelli as a Draughtsman," Ph.D. diss., Courtauld Institute of Art, University of London, 1982.

——, *Baccio Bandinelli 1493–1560: Drawings from British Collections*, exhibition catalog, Fitzwilliam Museum, Cambridge, 1988.

——, "New Drawings by Bandinelli and Cellini," *Master Drawings*, 31, no. 4, Winter 1993.

Watson, K. J., "Sugar Sculpture for Grand-Ducal Weddings from the Giambologna Workshop," in *Connoisseur*, 199, no. 799, September 1978, pp. 20–26.

——, *Pietro Tacca, Successor to Giovanni Bologna*, New York and London, 1983.

Watteville, C. de, *La Pittura in Italia: Il Cinquecento*, Milan, 1988.

Wazbinski, Z., *Vasari e la storiografia dell'arte moderna*, Breslavia and Warsaw, 1975.

——, "La prima mostra dell'Accademia del Disegno," *Prospettiva*, 1978, 14, pp. 47–57.

——, *L'Accademia medicea del disegno a Firenze nel cinquecento: idea e istituzione*, 2 vols., Florence, 1987.

Webster, M., ed., *Firenze e l'Inghilterra: rapporti artistici e culturali dal XVI al XX secolo*, exhibition catalog, Palazzo Pitti, Florence 1971.

Weihrauch, H. R., *Europäische Bronzestatuetten*, Brunswick, 1967.

Weil-Garris, K., "Bandinelli and Michelangelo: A Problem of Artistic Identity," in *Art the Ape of Nature: Studies in Honor of H. W. Janson*, New York, 1981, pp. 223–51.

——, "On Pedestals: Michelangelo's David, Bandinelli's *Hercules and Cacus* and the Sculpture of the Piazza della Signoria," *Römisches Jahrbuch für Kunstgeschichte*, 20, 1983, pp. 377–415.

Weil-Garris Brandt, K., "The Nurse of Settignano: Michelangelo's Beginnings as a Sculptor," in *The Genius of the Sculptor in Michelangelo's Work*, exhibition catalog, Montreal Museum of Fine Arts, Montreal, 1992.

Weirauch, H. R., *Die Bildwerke in Bronze und in anderen Metallen mit einem Anhang: Die Bronzebildwerke des residenzmuseums. Bayerisches Nationalmuseum Munchen*, Munich 1956.

Weinberg., B., *Trattati di poetica e retorica del cinquecento*, ed. B. Weinberg, Bari, 1972.

Wengraf, P., "Letter to the Editor," *Apollo*, 131, June 1990, no. 336, pp. 438–39.

Westerman Bulgarella, M., "Un damasco mediceo: ricerche sulla sua origine, significato

e uso nella pittura fiorentina del Cinque e Seicento," *Jaquard*, 30, 1996–97, pp. 2–6.

Western Decorative Arts, Part I, Systematic Catalogue, ed. R. Distelberger et al., National Gallery of Art, Washington, 1993.

Whitfield, C., *Discoveries from the Cinquecento*, exhibition catalog, Colnaghi's, London, 1982.

Wilde, J., *Italian Drawings in the Department of Prints and Drawings in the British Museum, Michelangelo and His Studio*, London, 1953.

Wiles, B. Harris, *The Fountains of Florentine Sculptors and Their Followers from Donatello to Bernini*, Cambridge, Mass., 1933; reprint New York, 1975, p.84, fig.169.

Williams, R., *Art, Theory, and Culture in Sixteenth-Century Italy: From Techne to Metatechne*, Cambridge, 1997.

Williams, R., "The Sala Grande in the Palazzo Vecchio and the Precedence Controversy between Florence and Ferrara," in *Giorgio Vasari: Artists and Literati at the Medicean Court*, ed. P. Jacks, Cambridge, 1998, pp. 163–81.

Winner, M., "Federskizzen von Benvenuto Cellini," *Zeitschrift für Kunstgeschichte*, 31, 1968, pp. 293–304.

Wirszubski, C., *Pico della Mirandola's Encounter with Jewish Mysticism*, Cambridge and London, 1989.

Wittkower, R. and M., *The Divine Michelangelo: The Florentine Academy's Homage on His Death in 1564*, London, 1964.

Wright, D. R., "The Medici Villa at Olmo a Castello: Its History and Iconography," Ph.D. diss., Princeton University, University Microfilms, 1976.

——, "Some Medici Gardens of the Florentine Renaissance: An Essay in Post-Aesthetic Interpretation," in *The Italian Garden: Art, Design and Culture*, ed. John Dixon Hunt, Cambridge, 1996, pp. 34–59.

Wright, T. D., *Master Drawings*, exhibition catalog, Los Angeles, 2000.

Yates, F. A., *Giordano Bruno and the Hermetic Tradition*, London, 1964.

——, *The Art of Memory*, Chicago, 1969.

Zangheri, L., *Pratolino: il giardino delle meraviglie*, 2 vols., Florence, 1979.

——, *Gli accademici del Disegno: elenco cronologico*, Florence, 1999.

——, ed., *Gli Accademici del Disegno: elenco alfabetico*, Accademia delle Arti del Disegno, Monografie 5, Florence, 2000.

Zobi, A., *Notizie storiche sull'origine e progressi dei lavori di commesso in pietre dure*, Florence, 1853.

Zorzi, L., *Il teatro e la città: saggi sulla scena italiana*, Turin, 1977.

PHOTOGRAPH CREDITS

Except where otherwise noted, photographs were provided by the owners.

Arte Fotografica s.r.l., Rome: cat. nos. 36, 86.

© The Art Institute of Chicago. All Rights Reserved: cat. nos. 22, 34, 87, 151–52, 172–74, 208, 212; photo by Greg Williams, cat. no. 174.

Marcello Bertoni, Florence: cat. nos. 3, 142.

© The J. Paul Getty Museum: fig. 21; cat. nos. 155, 207.

Hirmer Velag, Munich: figs. 8–9.

Lensini, Florence: cat. nos. 143–44.

© Erich Lessing/Art Resource, NY: cat. no. 70.

The Metropolitan Museum of Art. All Rights Reserved: © 1978, cat. no. 105; © 1983, cat. nos. 77, 177; © 1986, cat. no. 109; © 1989, cat. no. 214; © 1990, cat. nos. 135 a and b; © 2001, cat. nos. 209, 224 a and b.

MicroFoto, Florence: cat. nos. 117, 160 a and b, 193–94, 219, 221–23, 225.

Cliché Musée des Beaux-Arts d'Orléans: cat. no. 50.

© Museo Nacional del Prado: cat. nos. 10, 46, 60, 125

© 2001 Museum Associates/LACMA: cat. no. 42.

Paolo Nannoni, Florence: figs. 10, 22, 30, 58–61; cat. nos. 1, 5–7, 12, 14–16, 20, 27–30, 37–39, 51, 62, 88–89, 132, 134c, 145, 149, 154, 159, 162–63, 165, 169–70, 175, 178–79, 183, 196, 198, 199 a and c, 218 a and b.

Robert Newcombe: cat. no. 61.

Luciano Pedicini, Naples: cat. nos. 31, 69.

Franca Principe, Florence: fig. 31.

Studio Fotografico Antonio Quattrone, Florence: figs. 2, 6, 11, 18–19, 20, 25–29, 34, 55–57; cat. nos. 13, 18, 47, 54–56, 59, 74, 81–83, 89, 124, 136–37, 139, 184–85, 187–88.

Rabatti & Domingie, Florence: figs. 3–4, 6, 10, 30–33; cat. nos. 35, 40 a and b, 57, 68, 107, 110–14, 116, 120.

© Réunion des Musées Nationaux/Art Resource, NY: photo by D. Arnaudet, cat. nos. 73, 75, 85b; photo by M. Bellot, cat. nos. 195, 215; photo by J. G. Berizzi, cat. nos. 206, 210; photo by Gerard Blot, cat. no. 203; photo by Quecq d'Henripret, cat. no. 180; photo by Herve Lewandowski, cat. nos. 94, 147, 158, 201, 212, 214.

The Royal Collection © 2002, Her Majesty Queen Elizabeth II: cat. nos. 146, 150, 205.

Giuseppe Schiavinotto, Rome: fig. 43.

Sillabe s.r.l., Livorno: figs. 47–48; cat. nos. 138, 140.

Alessandro Vasari, Rome: cat. nos. 43–45.

Ole Woldbye: cat. no. 52.

Artwork for figs. 27 a and b: Tiffany Calvert.